# Roads of Arabia

ARCHAEOLOGY AND HISTORY OF
THE KINGDOM OF SAUDI ARABIA

Principal national cosponsors of the tour of *Roads of Arabia* in the United States:

Further generous support:

Additional support:

First published by Musée du Louvre and Somogy Art Publishers, Paris. Copyright 2010, all rights reserved.

Published in 2012 by the Arthur M. Sackler Gallery, Smithsonian Institution, in conjunction with the exhibition *Roads of Arabia: Archaeology and History of the Kingdom of Saudi Arabia*, organized in association with the Saudi Commission for Tourism and Antiquities of the Kingdom of Saudi Arabia.

FREER | SACKLER
THE SMITHSONIAN'S MUSEUMS OF ASIAN ART

الهيئة العامة للسياحة والآثار
Saudi Commission for Tourism & Antiquities

Cover : Dedan (al-Ula),
Photograph by Humberto da Silveira

www.louvre.fr
www.somogy.net

© Musée du Louvre, Paris, 2010
© Somogy Art Publishers, Paris, 2010

ISBN Musée du Louvre : 978-2-35031-288-0
ISBN Somogy Art publishers : 978-2-7572-0395-8

www.asia.si.edu
ISBN 978-0-934686-22-8

# Roads of Arabia

ARCHAEOLOGY AND HISTORY OF
THE KINGDOM OF SAUDI ARABIA

*edited by*

Ali Ibrahim Al-Ghabban, Béatrice André-Salvini
Françoise Demange, Carine Juvin and Marianne Cotty

SOMOGY
ART
PUBLISHERS

LOUVRE
éditions

FREER | SACKLER
THE SMITHSONIAN'S MUSEUMS OF ASIAN ART

خادم الـحرمين الشريفين
الملك عبدالله بن عبدالعزيز آل سعود
عاهل المملكة العربية الـسعودية

The exhibition *Roads of Arabia: Archaeology and History of the Kingdom of Saudi Arabia*
is under the patronage of

CUSTODIAN OF THE TWO HOLY MOSQUES
KING ABDULLAH
BIN ABDULAZIZ AL SAUD
KING OF SAUDI ARABIA

مقدمة

صاحب السمو الملكي الامير سلطان بن سلمان بن عبد العزيز

رئيس الهيئة السعودية للسياحة والآثار

إن المملكة العربية السعودية هي مهد الإسلام وموطن العرب وهي جسر للتواصل الإنساني ومحور للتفاعل الثقافي بين قارات العالم.

وقد كانت شبه الجزيرة العربية ممراً للطرق التجارية القديمة وازدهرت فيها حضارات متعاقبة، لاتزال آثارها باقية حتى الوقت الحاضر، وهذا دليل على ثراء المملكة الثقافي والحضاري، فالحضارات المزدهرة على صعيدها يرجع تاريخها إلى آلاف السنين.

إن معرض "طرق الجزيرة العربية : آثار وتاريخ المملكة العربية السعودية" يؤكد على متانة العلاقات السعودية الأمريكية المتميزة تحت رعاية خادم الحرمين الشريفين الملك عبد الله بن عبد العزيز آل سعود ملك المملكة العربية السعودية.

وهذا المعرض يضم ما يقرب من خمس مئة قطعة من الآثار والأدوات التي تم اختيارها من أثمن مقتنيات المتاحف السعودية التي تم جمعها من خلال المسوحات ونشاطات التنقيب عن الآثار خلال الأربعين سنة الماضية والتي شملت جميع مناطق المملكة.

وتمثل هذه القطع الأثرية ثراء، وتنوع ثروة الآثار السعودية والتراث السعودي. وبانعقاد هذا المعرض في متحف آرثر م . ساكلر بمؤسسة سميثونيان فإن الهيئة العامة للسياحة والآثار تهدف إلى تطوير التواصل الثقافي عن طريق تمكين زوار المعرض من التعرف على الأبعاد الثقافية للمملكة العربية السعودية وعلى الحضارات التي استقرت فيها أو عبرت أراضي شبه الجزيرة العربية، وكذلك التعرف على إسهام سكانها في إثراء التراث الإنساني عبر العصور.

وأود أن اغتنم هذه الفرصة لأرفع تقديري وامتناني العميق لخادم الحرمين الشريفين الملك عبد الله بن عبد العزيز. حفظه الله . لرعايته ودعمه الكريم . كما أشكر معالي الأستاذ عادل بن أحمد الجبير سفير خادم الحرمين الشريفين لدى الولايات المتحدة الأمريكية على دعمه المستمر لهذا المجهود . وأود أن أعبّر عن شكري لجميع المسؤولين في مؤسسة سميثونيان، وفي مقدمتهم أمين مؤسسة سميثونيان، ومدير متحف آرثر م. ساكلر وقاعة فرير للفنون الذين ساهموا بجهودهم في تطوير العلاقات الثقافية بين المملكة والولايات المتحدة . وشكري لجميع المؤسسات والشركات وفرق العمل التي ساهمت في تنظيم هذا المعرض من الجانبين السعودي والأمريكي

# FOREWORD BY HIS ROYAL HIGHNESS PRINCE SULTAN BIN SALMAN BIN ABDULAZIZ AL SAUD

*President of the Saudi Commission for Tourism and Antiquities (SCTA)*

The Kingdom of Saudi Arabia is the cradle of Islam, home of the Arabs, bridge of human communication and hub of cultural interaction among the continents of the world.

The "Roads of Arabia: Archaeology and History of the Kingdom of Saudi Arabia" exhibit reaffirms the distinguished Saudi-US relationship under the patronage of
The Custodian of the Two Holy Mosques
King Abdullah bin Abdulaziz Al Saud
Monarch of the Kingdom of Saudi Arabia

The Saudi peninsula was the roadbed for ancient trade routes. Successive civilizations flourished there, their traces remaining to the present time as living evidence of the Kingdom's cultural richness and prosperous civilizations dating back thousands of years.

The exhibition will showcase close to 500 pieces of antiquities and artifacts selected from the most precious objects of Saudi museums, the result of archeological surveys and excavation activities carried out during the past forty years and covering all regions of the Kingdom.

Those items exemplify the richness of Saudi antiquities and heritage. By cosponsoring this exhibition, the SCTA aims to promote cultural communication by enabling visitors to the exhibition to become acquainted with the cultural dimension of the country and civilizations that have settled or passed through the lands of the Arabian peninsula, as well as the contribution of its inhabitants to the enrichment of human heritage through the ages.

I would like to avail myself of this opportunity to extend heartfelt appreciation and gratitude to the Custodian of the Two Holy Mosques for his kind patronage and support. Thanks are also extended to H. E. Adel bin Ahmed Al-Jubeir, Ambassador of the Custodian of the Two Holy Mosques to the USA, for his constant support for this effort. Moreover, I would like to thank all those in charge at the Smithsonian Institution, particularly the Secretary of Smithsonian and the Director of the Arthur M. Sackler Gallery and Freer Gallery of Art, who have contributed to the development of the cultural relations between our two countries by their efforts. Appreciation is furthermore due to all the institutions, companies, and staff teams that participated in organizing this exhibition in both Saudi Arabia and the United States.

مقدمة جوليان رابي

مدير صالات عرض متاحف دام جيليان ساكلر وصالة آرثر ساكلر وفرير للفنون والآداب بمجمع سميثونيان

في عام 622م، خرج النبي محمد (صلى الله عليه وسلم) في أكبر وأشهر رحلة في تاريخ العرب عندما غادر مكة المكرمة مع أتباعه قاصداً المدينة المنورة فيما عرف بمسمى "الهجرة". لقد كانت هذه اللحظة محورية فارقة في تطور المجتمع المسلم: فلا غرو إذاً أن تصبح تلك السنة هي نقطة الانطلاق للتأريخ الهجري لدى المسلمين – ذلك أنها بحق وحقيقة إيذاناً بعهد جديد؛ كيف لا، وهي السنة الأولى (للهجرة النبوية). أما القرن الذي تلى ذلك، فقد شهد تمدداً واسعاً للإسلام الذي انداحت دائرة انتشاره لتترامى أطرافها فتمتد من مضيق جبل طارق حتى صحارى "تكلامكان". وبعبارة أخرى، بزغ فجر الإسلام ساطعاً ناصعاً لامعاً متلألئاً أنواره، طاغياً على ما سبقه، فيما بدا ما قبله متوارياً إلى ما وراء المشهد خلف الظلال الكثيفة.

وبكل حال، ظل علماء الآثار العاملون بالمملكة العربية السعودية طوال الأربعين سنةً الماضية في حالة مستمرة من البحث الدؤوب والتنقيب والاستكشاف في المواقع الأثرية على نطاق شبه الجزيرة العربية ليميطوا اللثام عن ماضٍ عريق لم تمتد إليه يد التوثيق العلمي والأدبي بعد إلا بالنذر اليسير، حتى لا يكاد يعرف عنه خارج المملكة إلى الآن إلا الشيء القليل. أما هذا المعرض، "الطرق التجارية في شبه الجزيرة العربية (روائع آثار المملكة عبر العصور)"، فإن من شأنه أن يفتح أعيننا، لا سيَّما وأنه يحتوي على أكثر من اربع مئة قطعة أثرية يعود تاريخها إلى حقب ما قبل التاريخ حتى تاريخ توحيد المملكة العربية السعودية في عام 1932م؛ وبالتالي فهو يمثل نافذة يمكن الإطلال من خلالها على ماضي شبه الجزيرة العربية قبل الإسلام التي تشكل المملكة العربية السعودية ثلثي مساحتها، وكذلك على مهوى أفئدة العالم الإسلامي من أقصاه إلى أدناه: الكعبة المشرفة في مكة المكرمة.

وأما الأعمدة الحجرية التي يحمل كل منها نقشاً تذكارياً تكتنفه الأسرار والتماثيل الأثرية ومنحوتات أقنعة الذهب البراقة الأخاذة وتماثيل المعبودات البرونزية المصغرة، فهي تقف شاهداً يدل على ما يتصف به تاريخ الجزيرة العربية قبل الإسلام من عمق وثراء. لم يجد أي من تلك القطع والأعمال طريقه إلى العرض خارج حدود المملكة العربية السعودية حتى عام 2010م عندما أقدمت الهيئة العامة للسياحة والآثار على تنظيم أول معرض لتلك الأعمال خارج المملكة بالتعاون مع متحف اللوفر. أما الأماكن الأخرى التي شهدت تنظيم المعرض في أوروبا، فقد شملت كلاً من "كاشيا" في برشلونة و"الإرميتاج" في سانت بيترسبورغ ومتحف "البيرغامون" في برلين. ولعل من دواعي سرورنا أن نكون نحن في صالة عرض آرثر إم ساكلير - "فرير آند ساكلير" بمجموعة متاحف مجمع "سميثونيان" - أول محطة لمعرض "روائع آثار المملكة عبر العصور" في الولايات المتحدة، وأن نتشرف بتنظيم المعرض في محطاته الأخرى بأمريكا الشمالية.

تدل القطع التي تم اختيارها لمعرض "روائع آثار المملكة عبر العصور/ الطرق التجارية القديمة في شبه جزيرة العرب" بما لا يدع مجالا للشك على أن شبه الجزيرة العربية لم تكن معزولة في تلك الأزمنة السابقة والعصور الخالية، وإنما كانت بمثابة معْبَر تجاري لنقل التوابل والعطور من ساحلها الجنوبي الشرقي ومن القرن الأفريقي إلى المحافل والموانئ والدواوين الملكية في الشرق الأوسط والبحر الأبيض المتوسط. لقد أفضت تلك التجارة الرابحة إلى نمو وتطور شبكة من الواحات المرتبطة معاً بحركة القوافل التجارية التي كانت تمر عبر شبه الجزيرة العربية وتربطها من ثم بالمراكز الحضرية والتجمعات السكانية الكبرى في الشرق الأدنى القديم – متمثلاً في مصر وسوريا وبلاد الرافدين وإيران – والعالم الإغريقي الروماني. إن العديد من المواقع التي كانت هدفاً للاستكشاف والتنقيب والبحث الأثري تكشف النقاب عن ازدهار ثقافي ظهرت تجلياته في المواد المستوردة المستجلبة من الخارج وتلك التي تم استحداثها محلياً لتقف شاهداً على قوة الأفكار المذهبية والجمالية على المستويين المحلي والإقليمي.

# FOREWORD BY JULIAN RABY

*The Dame Jillian Sackler Director of the Arthur M. Sackler Gallery*
*and the Freer Gallery of Art, Smithsonian Institution*

In 622 CE the Prophet Muhammad made the most momentous journey in the history of Arabia. He and his followers left Mecca (Makkah) for Medina in a migration known as the *hijra*. This was a pivotal moment in the development of the Muslim community, and it is little wonder that this year marks the launch of the Muslim *hijri* calendar, for indeed it was the inception of a new era, Year One. The century that followed saw Islam extend its reach from the Straits of Gibraltar to the deserts of the Taklamakan. Islam, in other words, emerged in an effulgent blaze, and what preceded it seems cast in deep shadow.

Over the last forty years, however, archaeologists working in Saudi Arabia have been uncovering sites across the peninsula, revealing an ancient past for which there is scant literary testimony and hitherto no tangible evidence. This exhibition, *Roads of Arabia*, can open all our eyes, as it includes well over four hundred objects that date from prehistoric times to the birth of the Kingdom of Saudi Arabia in 1932. It offers, then, a window on the peninsula's pre-Islamic past and on the axis of the entire Muslim community, the Holy Shrine of the Ka`ba in Mecca.

Mysterious stone steles, monumental statues of humans, haunting gold masks, and bronze statuettes of Roman gods testify to Arabia's rich and complex history before the coming of Islam. None of the works had been seen outside of Saudi Arabia until 2010, when the Saudi Commission for Tourism and Antiquities (SCTA) in collaboration with the Musée du Louvre organized the first exhibition of the material. Other venues in Europe included the CaixaForum in Barcelona, the Hermitage Museum in St. Petersburg, and the Pergamon Museum in Berlin. We at the Smithsonian's Arthur M. Sackler Gallery are delighted to be the first US venue for *Roads of Arabia*, and also to serve as the organizer of its North American tour.

The objects selected for *Roads of Arabia* demonstrate that the Arabian Peninsula was not isolated in ancient times. Arabia acted as the conduit for the spices and incense from its southern coast and the Horn of Africa that supplied the temples and royal courts of the Middle East and the Mediterranean. This lucrative trade encouraged the development of a network of oases linked by caravan trails that traversed the peninsula, which was thus connected to the great metropolitan centers of the Ancient Near East—Egypt, Syria, Mesopotamia, and Iran—and the Greco-Roman world. Many of the excavated sites reveal a cultural efflorescence, with objects imported from abroad and objects created locally that witness the strength of local and regional ideologies and aesthetics.

على سبيل المثال، لم يكن موقع تيماء في المنطقة الشمالية الغربية من المملكة العربية السعودية محطة توقف رئيسية على درب القوافل التجارية فحسب، وإنما أيضاً كان ملجأ لاذ به وفزع إليه آخر ملوك بلاد بابل، نبو نيد (الذي اعتلى سدة العرش في عام 556 وتنحى عنه في عام 539 ق م). وفي غضون قرنين من الزمان، أقام اللحيانيون (حكام لحيان) دولة في موقع ديدان (حالياً العلا) على بعد حوالي (110) كيلومتر من تيماء. وقد رافق ذلك إقامة سلسلة من المنحوتات الضخمة المثيرة للإعجاب. وعلى غرار تماثيل قدماء الإغريق والتي كانت متأثرة في المقام الأول بالمنحوتات والنقوش الموجودة في مصر، تجاوب النحاتون اللحيانيون بطريقتهم الخاصة مع نماذج المنحوتات والنقوش وطرازاتها الأجنبية: حيث أبدعوا تماثيلهم ونقوشهم الخاصة بهم.

لقد كانت حركة القوافل التجارية مصحوبة بموجات من الهجرة؛ وفي منتصف الألفية السابقة للإسلام، كانت القبائل العربية موجودة في أجزاء من الأردن وسوريا والعراق. وبرز من بين تلك القبائل بصورة ملحوظة النبطيون. ففي حين أن مدينتهم البتراء في الأردن معروفة ذائعة الصيت، فإن شقيقتها مدائن صالح في المملكة العربية السعودية ليست كذلك مع أنها تستحق باعتبارها واحدة من أهم المواقع والمعالم ذات المناظر الطبيعية اللافتة للنظر في الشرق الأوسط؛ وقد نجحت المملكة العربية السعودية مؤخراً في تسجيلها على قائمة التراث العالمي باليونسكو، فهي عبارة عن طبقة بارزة من الحجر الرملي فوق سطح الأرض وتخترقها مقابر على هيئة كهوف ذات واجهات منحوتة بارزة. ولما كان أغلب مكوناتها غير قابل للنقل والتحريك، لذا لم يكن لها حضور تمثيلي بشكل كبير في هذا المعرض. ولعل إحدى القطع المشمولة منها في المعرض هي عبارة عن نقش لاتيني يشير إلى المقايضات التجارية ذات الطابع العالمي لحركة القوافل التجارية آنفة الذكر.

هنالك موقع أثري آخر في الجنوب الغربي، على تخوم الربع الخالي تلك الصحراء الكبرى التي تحتل جزءً كبيراً من جنوب الجزيرة العربية. ففي قرية الفاو، حقق علماء الآثار السعوديون واحداً من أهم منجزاتهم في مجال الآثار باكتشافهم لمدينة احتوت على مواد طبق الأصل لما كان سائداً في جنوب الجزيرة العربية  جنباً إلى جنب مع نقوش رمزية وأشكال تعود إلى الحقبة الهيلينية (وهي فترة متأخرة من الحضارة الإغريقية) من سوريا ومن مصر.

مع ظهور الإسلام في القرن الميلادي السابع، أصبحت مكة المكرمة المركز الديني للعالم الإسلامي مترامي الأطراف. وإذا كان لنا أن نتخيل شكل "الطرق" وهي تفترق خارجة من الجزيرة العربية قبل الإسلام إلى المناطق المحيطة بها، فإن "الطرق" بعد الإسلام  كانت جاذبة نحو المركز داخلة إليه لتلتقي في مكة المكرمة. وعوضاً عن التماثيل المجسمة في شكل بشري على نحو ما كان سائداً قبل الإسلام، انتقل محور التركيز ليدور حول الكلمة المكتوبة على إثر نزول الوحي بالقرآن الكريم. ففي معرض "روائع آثار المملكة عبر العصور/ الطرق التجارية القديمة في شبه جزيرة العرب" يتمثل عرض الآثار الإسلامية في العديد من القطع من بينها بابين ضخمين من الفضة يعود تاريخهما إلى القرن السابع عشر الميلادي، تبرع بهما السلطان العثماني مراد الرابع. وفي مقابل تلك الرعاية السلطانية القادمة من مسافات طويلة، تقف سلسلة كبيرة من شواهد القبور التي توجد عليها كتابات منقوشة هي عبارة عن مجموعة من المراثي العديدة المتمثلة في تعداد محاسن الموتى من حجاج بيت الله الحرام – العديد منهم من النساء – ممن قادتهم أشواقهم الدينية وتقواهم وورعهم للحجيج إلى مكة المكرمة.

في حين أن علماء الآثار يواصلون عملهم التنقيبي بلا هوادة تحت طبقات الرمال في الصحراء، فإن معرض "روائع آثار المملكة عبر العصور/ الطرق التجارية القديمة في شبه جزيرة العرب" يفتح لنا نافذة نطل من خلالها على ثراء الماضي العريق في المملكة العربية السعودية عبر مراحله المختلفة كما يؤصِّل المعرض للتحول الجذري الذي حدث في جزيرة العرب في القرن السابع الميلادي، القرن الأول في التقويم الهجري.

The site of Tayma in the northwest region of Saudi Arabia, for example, was not only a major stop on the caravan route but the refuge for some ten years of the last king of Babylon, Nabonidus (reigned 556–39 BCE). Within a couple of centuries, some 110 kilometers away, at the site of Dedan (modern al-`Ula), the Lihyanite rulers erected a temple preceded by an avenue of awe-inspiring, monumental standing figures. Like the sculptors of Archaic Greece, whose styles were initially influenced by the statuary of Egypt, the Lihyanite sculptors created their own response to foreign models.

The caravan trade was accompanied by emigration, and in the half-millennium before the rise of Islam, Arab tribes were present in parts of Jordan, Syria, and Iraq. Notable among these were the Nabataeans, and, while their city of Petra in Jordan is well known, its sister site of Mada'in Saleh in Saudi Arabia is not. Yet it deserves to be, for it is one of the most impressive landscapes in the Middle East, a sculpture park of sandstone outcrops, pierced by funerary caves with imposing carved façades. Because little from the site is movable, it is not greatly represented in this exhibition. One item that is included is a Latin inscription that indicates the cosmopolitan interchanges of this caravan trade.

Another site is located to the southwest, at the edge of the Empty Quarter, the great desert that occupies so much of southern Arabia. At Qaryat al-Faw, Saudi archaeologists made one of their most spectacular discoveries, uncovering a city that contained material typical of southern Arabia alongside Hellenistic figurative sculpture from Syria and Egypt.

With the arrival of Islam in the seventh century, Mecca became the religious focus of the expanding Muslim world. If we imagine the "Roads" prior to Islam leading out from Arabia to surrounding regions, the "Roads" after Islam are centripetal, converging on Mecca. Instead of the anthropomorphic sculpture that dominates in the pre-Islamic period, the emphasis shifts to the written word following the revelation of the Koran. In *Roads of Arabia*, the shrine is represented by two great seventeenth-century silver doors donated by the Ottoman sultan Murad IV. In contrast to this imperial and long-distance patronage stands a large array of epigraphic tombstones—elegies to the Muslim pilgrims, many of them women, whose piety drew them to Mecca.

While archeologists continue their work beneath the shifting sands of the desert, *Roads of Arabia* offers us a timely glimpse into the peninsula's richly layered past, and underlines the fundamental transformation that took place in Arabia in the seventh century of our era, the first century of the *hijra*.

His Royal Highness Prince Sultan bin Salman bin Abdulaziz Al Saud

President of the Saudi Commission for Tourism and Antiquities

Wishes to thank

For the generous support that made this edition possible

معرض روائع آثار المملكة العربية السعودية. بين ماضٍ عريق وحاضر مزدهر

تروي الكنوز الأثرية التي يحتضنها معرض روائع آثار المملكة العربية السعودية قصة مذهلة لحقبة امتدت لأكثر من مليون سنة من تاريخ شبه الجزيرة العربية، حيث تأخذ المشاهدين والزوار في رحلة إلى أرض شهدت على مرّ آلاف السنين تعاقب العديد من الحضارات والثقافات والمجتمعات والطرق التجارية.

وتفتخر إكسون موبيل برعايتها لجولة معرض روائع آثار المملكة العربية السعودية في الولايات المتحدة الأمريكية، إذ يوفر فرصة مثلى لتمكين عامة الجمهور من تكوين فهم معمّق وشامل للإرث التاريخي الغني والمتنوع للمملكة العربية السعودية.

إن شركتنا ترتبط بعلاقة وثيقة مع المملكة العربية السعودية تعود إلى أكثر من 80 عاماً - وهي شراكة تنبع من تقديرنا العميق لشعبها وثقافتها. ومن خلال تعاوننا في العديد من المشاريع المشتركة في المملكة، لمسنا عن كثب مسيرة التطور الاستثنائي الذي مكّن السعودية من لعب دور فعال في تطور وازدهار بلدان العالم. فباعتبارها من كبار منتجي النفط، كانت المملكة ولا تزال وراء الكثير من التحسينات التي طرأت على حياة الناس وأنماط عيشهم في جميع أنحاء العالم.

وكلنا أمل بأنكم من خلال جولتكم في المعرض وتنقلكم بين تلك الروائع النادرة التي تروي قصة الحضارات المتعاقبة على أرض المملكة العربية السعودية وسط مناظر طبيعية ساحرة، ستكتشفون الروابط المتينة التي تجمع بين ماضي المملكة العريق وحاضرها الديناميكي المزدهر.

# LINKING THE PAST TO THE PRESENT
## ALONG THE *ROADS OF ARABIA*

The collection of archeological treasures in the *Roads of Arabia* exhibition spans the rich and vibrant history of the Arabian Peninsula, connecting viewers to a land that has bridged civilizations, cultures, commerce and communities for millennia.

ExxonMobil is proud to sponsor the *Roads of Arabia* U.S. tour. This major event provides an excellent opportunity to deepen the public's understanding and appreciation of the broad cultural heritage of Arabian history.

Our company shares a spirit of partnership with the Kingdom of Saudi Arabia dating back more than 80 years – a partnership rooted in an appreciation for its people and culture. Through our joint venture partnerships in the Kingdom, we have seen up close the extraordinary development that has made Saudi Arabia instrumental to global progress. Saudi Arabia's role as a leading energy producer powers many of the improvements in living standards and lifestyle experienced by people around the globe.

We hope that as you journey through the *Roads of Arabia's* fascinating rare artifacts, depiction of civilization, and beautiful landscapes you will discover the links between the Kingdom's rich past and its dynamic present.

احتفاء بتاريخ الجزيرة العربية: استكشاف ماضي أمة

عبر مسيرة التاريخ الإنساني، لم يقتصر مفهوم التجارة بالنسبة للثقافات والحضارات المختلفة على تبادل السلع والمواد فحسب، بل امتد ليشمل الأفكار والمعارف والمبتكرات والفنون. ويأتي معرض *روائع آثار المملكة العربية السعودية* بمثابة الشاهد على مدى التفاعل الحي بين الشعوب ذات الثقافات المتنوعة مما أسهم في إثرائها، وهو أمر لا يزال متواصلاً في عالم اليوم المتسم بعلاقاته المتشعبة.

لذا فإن من دواعي سرور وفخر أرامكو السعودية، باعتبارها شركة الزيت الوطنية في المملكة العربية السعودية، أن تكون في طليعة داعمي جولة معرض *روائع آثار المملكة العربية السعودية* في الولايات المتحدة الأمريكية لعرض الثروات الأثرية الفريدة لشبه الجزيرة العربية. ومن خلال هذه الآثار، وباختلاف أحجامها وتعدد أشكالها، سيتمكن زوار المعرض للمرة الأولى من الاطلاع على صفحة يجري اكتشافها من صفحات الماضي الآسر لتاريخ الحضارة الإنسانية.

إن أرامكو السعودية نفسها، هي نتاج شراكة بين المملكة العربية السعودية وشركات بترولية عالمية، وقد كنا ولا نزال نقدر العلاقات التي تربطنا مع عملائنا في جميع أرجاء العالم، وتلك التي تربطنا بشركائنا التجاريين، والموردين ومقدمي الخدمات، ومع الجامعات والمراكز البحثية، ومجموعة واسعة من الأفراد والمنظمات العالمية الأخرى. وهذه العلاقات العريقة والمتبادلة تذكرنا بتلك العلاقات التي ازدهرت منذ آلاف السنين في صحارى وواحات شبه الجزيرة العربية، فارتقت وأنتجت هذه الآثار الاستثنائية الخالدة التي يحتوي عليها هذا المعرض.

*نتمنى لكم رحلة ملهمة ومفيدة مع روائع الكنوز والآثار من شبه الجزيرة العربية.*

# EXPLORING A NATION'S PAST,
# CELEBRATING HUMAN HISTORY

Throughout mankind's history, culture and civilization have depended on trade, not just in goods and materials, but also in ideas, knowledge, innovation and the arts. As the *Roads of Arabia* exhibition demonstrates, a lively exchange between people of different backgrounds served to enrich and enlighten everyone involved—a process which continues in today's complex, interconnected world.

As the national petroleum enterprise of the Kingdom of Saudi Arabia, Saudi Aramco is both pleased and proud to be a principal sponsor of the U.S. tour of *Roads of Arabia*, which showcases the unique archeological riches of the Arabian Peninsula. Through artifacts both large and small, exhibition visitors gain a window into a little-known past, and insight into a captivating chapter of human history.

Saudi Aramco is itself the product of a partnership between Saudi Arabia and American oil companies, and we continue to value the ties that bind us with our U.S. customers and business partners, our suppliers and service providers, with universities and research institutions, and a wide variety of other North American organizations and individuals. Our mutually beneficial relationships recall those which existed millennia ago in the deserts and oases of Arabia, and which gave rise to the exceptional works of art on display in this exhibition.

We hope you enjoy your journey down the *Roads of Arabia* through these timeless treasures.

## ACKNOWLEDGMENTS

*Roads of Arabia* is a hugely ambitious and innovative show, and it could never have been realized without the vision and energy of His Royal Highness Prince Sultan bin Salman bin Abdul Aziz Al Saud, president of the Saudi Commission for Tourism and Antiquities (SCTA).

Prince Sultan is most ably supported by the vice president of antiquities and museums, Professor Ali Al-Ghabban, to whom we owe an essential debt with regard to the exhibition's concepts, scholarship, and implementation. He was an inspiring and generous host to several of us who were fortunate to visit the kingdom.

Many colleagues in the SCTA have provided assistance, and among these we extend special thanks to Majid Al-Shiddi, director of media; Fahad Al-Ammar, director of protocol; and Abdullah N. Abdulaziz, director of engineering.

Sincere thanks also go to Dr. Abdullah S. Al-Saud, director general of the National Museum; Mohammed Hamad Al-Najm, director of the Tayma Museum; and Nasser A. Al-Arifi, director of the Masmak Museum.

We received invaluable help from Dr. Said F. Al-Said, dean of the faculty of tourism and archaeology at King Saud University in Riyadh; Talal Sha'ban, director of archaeology; Mohammad Babilly, the photographer from Desert Publisher; Dr. Moshalleh K. Almoraekhi, College of Tourism and Archaeology; Khalid Al-Nassar, the King Abdul Aziz Foundation for Research and Archives; Abdul Aziz M. Al-Basuoni, Deraiyah Impact Office; Mutlaq Al-Mutlaq, al-Ula Museum; and Saud Mohammad Al-Mady, archaeologist, Tayma Region.

I am most grateful to the ambassador of the Kingdom of Saudi Arabia to the United States, H. E. Adel A. Al-Jubeir, for his kind support. I want to express my special gratitude to Naila Al-Sowayel, general director, information center, who has been a tremendous help, and to Nail Al-Jubeir, director of the information office.

The interest in this project demonstrated by James Smith, US ambassador to the Kingdom of Saudi Arabia, and his staff—in particular, Bridget Gersten, counselor for public affairs; Catherine Schweitzer, cultural attaché; and Robert Greenan, soon-to-be cultural attaché—has been genuine and steadfast.

I also offer our sincere gratitude to the corporate sponsors that supported the *Roads of Arabia* US tour, especially our principal sponsors, Saudi Aramco, the oil company of the Kingdom of Saudi Arabia, and ExxonMobil. Rex Tillerson, chairman of the board of ExxonMobil, and Khalid A. Al-Falih, president and chief executive officer of Saudi Aramco, exhibited leadership that made it possible to bring *Roads of Arabia* to the United States. We are truly fortunate to have such generous sponsors. I am grateful for the hospitality and assistance extended by Desmond Carr, former CEO of ExxonMobil in Saudi Arabia, when Massumeh Farhad and I visited Saudi Arabia in September 2011. Desmond really made this project his own. I thank Tom Walter, Desmond's successor in Saudi Arabia, for his help and interest in the months that followed. Since the project's earliest days, Mohammed Giraud, vice president, public and government relations in the Kingdom of Saudi Arabia; Kathryn Ryan, public and government affairs manager at ExxonMobil; and Alan Fleischmann, principal at Albright Stonebridge Group, have gone well beyond the call of duty to ensure its success.

Saudi Aramco has been a generous supporter of Saudi culture for decades, and we are fortunate to have such a dedicated partner. Among the many there, I would like to especially thank Tafiq Gabsani, president of Saudi Refining, Inc.; Haitham Al-Jehairan, administrator of the support services division for the King Abdulaziz Center for World Culture; Jack Moore, director of Aramco Services Company's Washington office; and Elif Gokcigdem, public affairs advisor. I am also grateful to the chairman of The Olayan Group, Khaled Suliman Olayan; Richard Hobson, vice president, corporate communications at Olayan America; and David Seaton, chairman and chief executive officer of Fluor Corporation. At the Boeing Company, I would like to thank Shephard W. Hill, president, Boeing International, and senior vice president, business development and strategy, and Ahmed Abdulgader Jazzar, vice president, Boeing International, and president, Boeing Saudi Arabia. I also thank Eng. Samir Al-Abdrabbuh, vice president, and Hisham Al-Johar, acting vice president, corporate communications, SABIC (Saudi Basic Industries Corporation), as well as the air carrier for the exhibition, the Saudi Arabian Airlines.

Colleagues from numerous museums have been very gracious with their help, and I would like to thank Professor Mikhail Piotrovsky, director of the State Hermitage Museum, St. Petersburg, which is where I first saw the exhibition on its European tour. Dr. Stefan Weber, director, and Ute Franke, curator, Museum für Islamische Kunst, Berlin, have been outstandingly generous with information and access. Other colleagues who provided help and advice include Venetia Porter, assistant keeper, British Museum, London; Linda Komaroff, curator of Islamic art and head of the Middle East art department, Los Angeles County Museum of Art; and from the Library of Congress, Mary Jane Deeb, chief of the African and Middle Eastern division; Christopher Murphy, head of the Near East section; and Edward J. Redmond, reference librarian, and Ralph Ehrenberg, former chief, geography and map division.

It always seems invidious to single out members of the Freer|Sackler staff who have contributed to an exhibition, as endeavors such as this require the participation of almost every department. Our exhibitions, design, conservation, development, and public affairs staff have all worked tirelessly. Yet I do not think anyone will begrudge me offering a special vote of thanks to Massumeh Farhad, our chief curator and curator of Islamic art, who guided this project from the outset. She has been assiduously aided by Sarah Johnson, research assistant, and the design of the show has been masterminded by Jeremiah Gallay. We have all enjoyed working once again with the president of Blue Bear Films, Maggie Burnette Stogner.

Both from a personal and professional point of view it has given me great pleasure to work with a friend of very long standing, Rifaat Sheikh Al-Ard. He encouraged us to initiate the show in the United States and has been a tireless advocate and advisor, generous to a fault.

This exhibition is the fruit, then, of the labors of many people, including many who are not mentioned by name here. This has been a collaboration that has brought insights and friendship to those of us involved, and most importantly, resulted in an exhibition that promises to create new understanding within the United States.

Julian Raby
*Dame Jillian Sackler Director of the Arthur M. Sackler Gallery and the Freer Gallery of Art*

# PUBLICATION

Musée du Louvre
Direction of Cultural Production

**Violaine Bouvet-Lanselle**
*Head of Publication Service*

**Christine Fuzeau**
*Editorial coordination*

**Ariane Guéroult-Freyder**
*Iconographic coordinator, Image and
Documentation Service*

**Fabrice Douar** and **Timothy Stroud**
*Index*

*Translators*
*German*
**Irène Imart**
*French*
**Lydie Échasseriaud** and **Anne-Marie Terel**
*Arabic*
**Rita Haddad** and **Faysa El Qasem**

Somogy Art Publishers

**Nicolas Neumann**
*Director*

**Clémentine Petit**
*Editorial coordinator*

**Nelly Riedel**
*Graphic design*

**Brownyn Mahoney** and
**Helen Downey, Kathleen Gray, Sandra
Freland, Christine Schultz-Touge**
*Copy editing*

**Julia Bouyeure, Christine Dodos-Ungerer,
Valentina Gardet, Céline Moulard** and
**Tiffanie De Gregorio**
*Proofreading*

**Michel Brousset, Béatrice Bourgerie**
and **Mathias Prudent**
*Production*

**David Jaggard, Jennifer Kaku, Nancy Li,
Timothy Stroud, David Wharry** and
**Susan Wise**
*Translators into English*

# AUTHORS

**Hussein bin Ali Abu Al-Hasan**
*Deputy vice-chairman of the Department of Antiquities and Museums, Saudi Commission for Tourism and Antiquities, Riyadh*

**Béatrice André-Salvini**
*General curator, director of the Department of Ancient Near East, Musée du Louvre, Paris*

**Abdulrahman Muhammad Al-Tayeb Al-Ansari**
*Honorary Professor of Archaeology of the Arabian Peninsula, Riyadh*

**Jacqueline Chabbi**
*Professor, Université Paris VIII*

**Marianne Cotty (M. C.)**
*Exhibitions coordinator, Department of Ancient Near East, Musée du Louvre, Paris*

**Patricia Dal Pra**
*Art conservator (textiles), Paris*

**Françoise Demange (F. D.)**
*Curator in chief, Department of Ancient Near East, Musée du Louvre, Paris*

**Jacqueline Dentzer-Fendy (J. D.-F.)**
*Research director at the Centre national de la recherche scientifique, Paris*

**Saba Farès (S. F.)**
*Lecturer, Université Nancy II*

**Ali I. Al-Ghabban**
*Vice-president of Antiquities and Museums, Saudi Commission for Tourism and Antiquities, Riyadh*

**Abdulaziz Saud Al-Ghazzi**
*Professor of archaeology at the Faculty of Tourism and Archaeology, King Saud University, Riyadh*

**Arnulf Hausleiter (A. H.)**
*Researcher, Deutsches Archäologisches Institut, Orient-Abteilung, Berlin*

**Marie-Louise Inizan**
*Honorary research director at the Centre national de la recherche scientifique, Paris*

**Andrea Intilia (A. I.)**
*Researcher for the "Tayma" project, DFG-Orient-Abteilung, Berlin*

**Carine Juvin (C. J.)**
*Scientific Advisor, Department of Islamic Art, Musée du Louvre, Paris*

**Abdul Majeed Khan**
*Advisor to the Department of Antiquities and Museums, Saudi Commission for Tourism and Antiquities, Riyadh*

**Hayat bint 'Abdullah Al-Kilabi**
*Doctor of Islamic archaeology, Riyadh*

**Julien Loiseau**
*Assistant Professor, Université Paul-Valéry – Montpellier III*

**Saleh Al-Marih**
*Director of Antiquities, Najran Region*

**Gabriel Martinez-Gros**
*Professor, Université Paris X-Nanterre*

**Charlotte Maury**
*Scientific advisor, Department of Islamic Arts, Musée du Louvre, Paris*

**Laïla Nehmé**
*Researcher, Centre national de la recherche scientifique, UMR "Orient et Méditerranée", Paris*

**D. T. Potts**
*Professor, Department of Archaeology (Edwin Cuthbert Hall Professor of Middle Eastern Archaeology), University of Sydney*

**Sa'd bin Abdulaziz Al-Rashid**
*Professor of Islamic archaeology, advisor to the president of the Saudi Commission for Tourism and Antiquities, Riyadh*

**Claire Reeler (C. R.)**
*Archaeological advisor to the Saudi Commission for Tourism and Antiquities, Riyadh*

**Christian Julien Robin**
*Research director at the Centre national de la recherche scientifique, membre de l'Institut, Paris*

**Said F. Al-Said**
*Dean of the Faculty of Tourism and Archaeology, King Saud University, Riyadh*

**Paul Sanlaville**
*Honorary research director at the Centre national de la recherche scientifique, Lyon*

**Abdullah S. Al-Saud**
*Director General of the National Museum, Riyadh*

**Hanspeter Schaudig (H. S.)**
*Professor, University of Heidelberg (Seminar für Sprachen und Kulturen des Vorderen Orients – Assyriologie)*

**Nabiel Al-Shaikh**
*Researcher, Dammam Regional Museum*

**Fahd A. Al-Simari**
*General Secretary of the King Abdulaziz Foundation for Research and Archives*

**'Awad bin Ali Al-Sibali Al-Zahrani**
*Director of Museums, Saudi Commission for Tourism and Antiquities, Riyadh*

**Tara Steimer-Herbet**
*Archaeologist, Paris*

**Daifallah Al-Talhi**
*Assistant Professor, University of Ha'il*

**Muhammad bin 'Abdulrahman Rashid Al-Thanayan**
*Professor, Faculty of Tourism and Archaeology, King Saud University, Riyadh*

**'Abdullah bin Ibrahim Al-'Umayr**
*Professor of Islamic archaeology, Faculty of Tourism and Archaeology, King Saud University, Riyadh*

**Gilles Veinstein**
*Professeur au Collège de France, Paris*

**François Villeneuve (F. V.)**
*Professor, Université Paris-I-Panthéon-Sorbonne, Paris*

**Ahmad bin 'Umar Al-Zayla'i**
*Member of the Consultative Council, Honorary Professor, King Saud University, Riyadh*

In most cases the transcription of Arabic words is based on the charter adopted by the Encyclopaedia of Islam, except for the written forms of place names, proper nouns and common nouns now in everyday use (Mecca, for example). Wherever possible, ancient names have been unified. The spelling and diacritic signs most widely used by modern authors served as models for this. There are exceptions to this principal, since certain terms and proper nouns (of people, deities and places) have no unified transcription and it is difficult to find a consensus among authors.

Certain graphic transcriptions of ancient languages have been modified to simplify their understanding by the general reader, whom we hope will excuse a certain arbitrariness.

The bibliography in Arabic is included alphabetically under the author's name in the general Latin script bibliography. However, to respect the text's alignment and avoid errors, the Arabic titles of books have been grouped together at the end of the general bibliography.

A. J. Arberry's translation was used for the passages from the Quran.

As a general rule, Gregorian dates are used. When necessary, Hegirian dates (the Muslim calendar) are indicated first, followed by "H" then the Gregorian date. A Hegirian (lunar) year very rarely corresponds exactly to a Gregorian (solar) year, for example, 800 H./1397–98.

Some authors prefer to use the dating "before the present" (BP).

Although the uniqueness and great age of certain iconographic documents has considerably affected their quality, they have been included for scientific reasons.

# CONTENTS

MINOR ASIA

CASPIAN SEA

Diyarbakir

Karkemish

Urfa/Harran

Ninive

Alep

Assur

MESOPOTAMIA

Ougarit

CYPRUS

Palmyre
Tadmor

Mari

Anah
Sur Jar'a

Tepe Sialk

MEDITERRANEAN SEA

Sidon

Tyr

Damascus

S Y R I A

*Euphrates*

Baghdad

Sippar

Babylonia

*Tigris*

ZAGRO

Alexandria

Jerusalem

Amman

Gaza

J O R D A N

Kaf

Kish

Nippur

Suse

Kufa

Hira

Tello

Uruk

Fustat

*Nile*

Petra

w. Ramm

Kilwa

Shuwayhitiyah

al-Jawf

Sakakah

Dumat al-Jandal

Rajajil

Qedar

Obeid

Eridu

Ur

Basra

Malyan

'Aqaba
Ayla

S I N A I

Qurayya

Tabuk

N A F U D

as-Sabiyah

Failaka

KUWAIT

Halilih

al-Bad

al-Assafiah

S A U D I   A R A B I A

A R A B I A N

E G Y P T

Leuke
Kome

Tayma

Jubbah

Ha'il

Hafr al-Batin

H A S A '

Qusayr
Leukos
Limen

Rawwafa

Mada'in Saleh/Hegra

BAHRAIN

Koptos

Al-'Ula
Dedan

al-Mabiyat

Shuwaymis

QATAR

Qus

Khaybar

al-Rabadha

Thumama

Dalr

al-Hawra'

Hanakiyah

Dir'iyya

Dawadmi

RIYADH

al-Yamama

Berenike

Medina/Yathrib

H I J A Z

*wadi al-Dawasir*

*Jabal Tuwaiq*

R U B '

Yabrin

'Aydhab

A L - K H A

w. Fatima

Jedda

Mecca

Ta'if

al-'Ukaz

*Jabal*

Dhathami

Qaryat al-Faw/Dhukhal

R E D   S E A

Sharq
Bir Hima

'A S I R

Jebel Kawkab

E N

Abha

Najran/al-Ukhdud

Farasan
Islands

Y E M E N

Dahlak
Islands

Ma'in/Qarna

T I H A M A

SANAA

*JAWF*

Sirwah

Marib

Shabwa

Tamna'

H A D R A M A W T

Zafar

Dhamar

Axoum

Bi'r 'Ali/Qana

Mouza/Okelis

Aden

*Bab al-Mandab*

GULF OF ADEN

N

0        500 km

## Inset map (Bahrain / al-Hasa region)

Abu Khamis

Khursaniyah

*al-Hasa oasis*

Gerrha

Dosariyah

Thaj

Ayn Jawan

Qatif

Tarut Island

Dhahran

Khobar

Diraz

Qalat
al-Bahrain

'Ayn as-Sayh

Saar

Uqayr

BAHRAIN

Abqaiq

Sabkha Hammam

Ain Qannas

QATAR

Hofuf

0            100 km

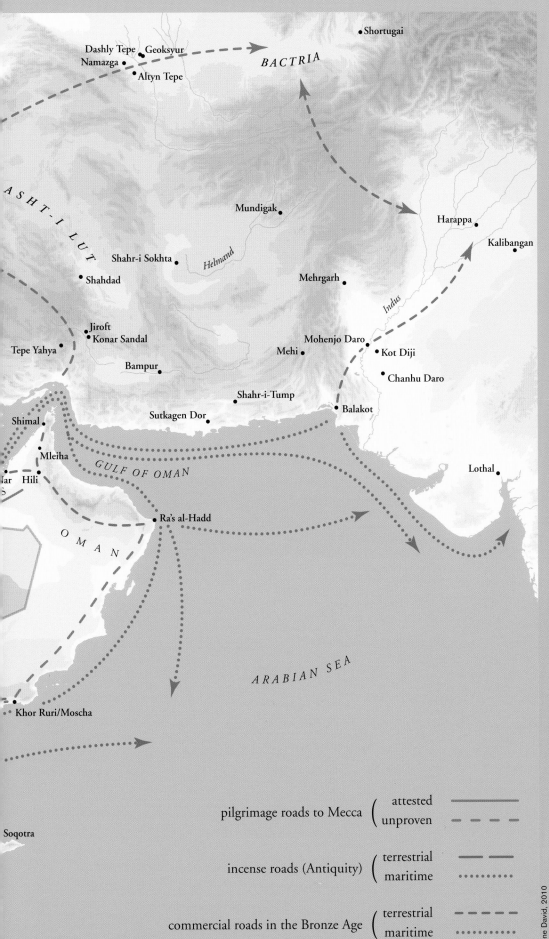

Shortugai

Dashly Tepe ● Geoksyur
Namazga ●
● Altyn Tepe

*BACTRIA*

*D A S H T - I   L U T*

Mundigak ●

Shahr-i Sokhta ●
● Shahdad

*Helmand*

Mehrgarh ●

Harappa ●

Kalibangan ●

Jiroft ●
● Konar Sandal

*Indus*

Tepe Yahya ●

Mohenjo Daro ●
Mehi ●          ● Kot Diji

Bampur ●

● Chanhu Daro

Shahr-i-Tump ●

Sutkagen Dor ●          Balakot ●

Shimal ●

Lothal ●

● Mleiha

*GULF OF OMAN*

Jar  Hili ●

*O M A N*

Ra's al-Hadd ●

*ARABIAN SEA*

Khor Ruri/Moscha ●

Soqotra

pilgrimage roads to Mecca ⎛ attested ————————
⎝ unproven – – – – – – –

incense roads (Antiquity) ⎛ terrestrial ————————
⎝ maritime ·················

commercial roads in the Bronze Age ⎛ terrestrial – – – – – – –
⎝ maritime ·················

Hélène David, 2010

Map of Roads of Arabia

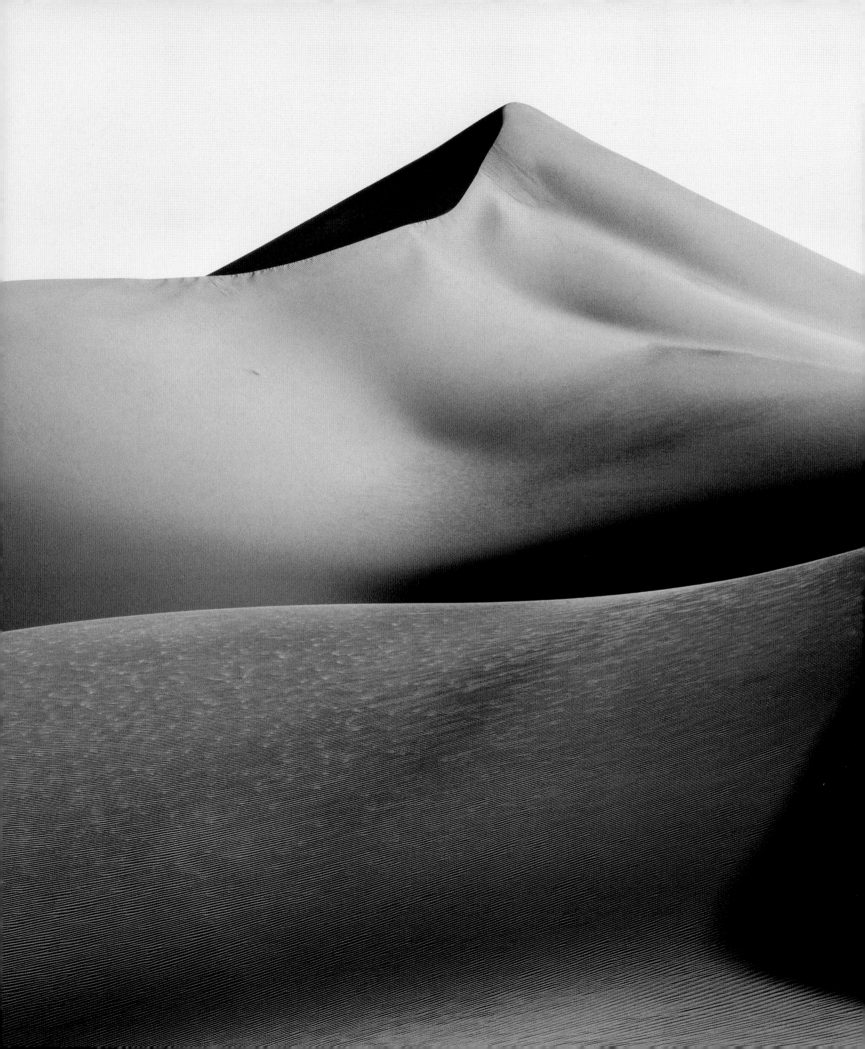

# INTRODUCTION

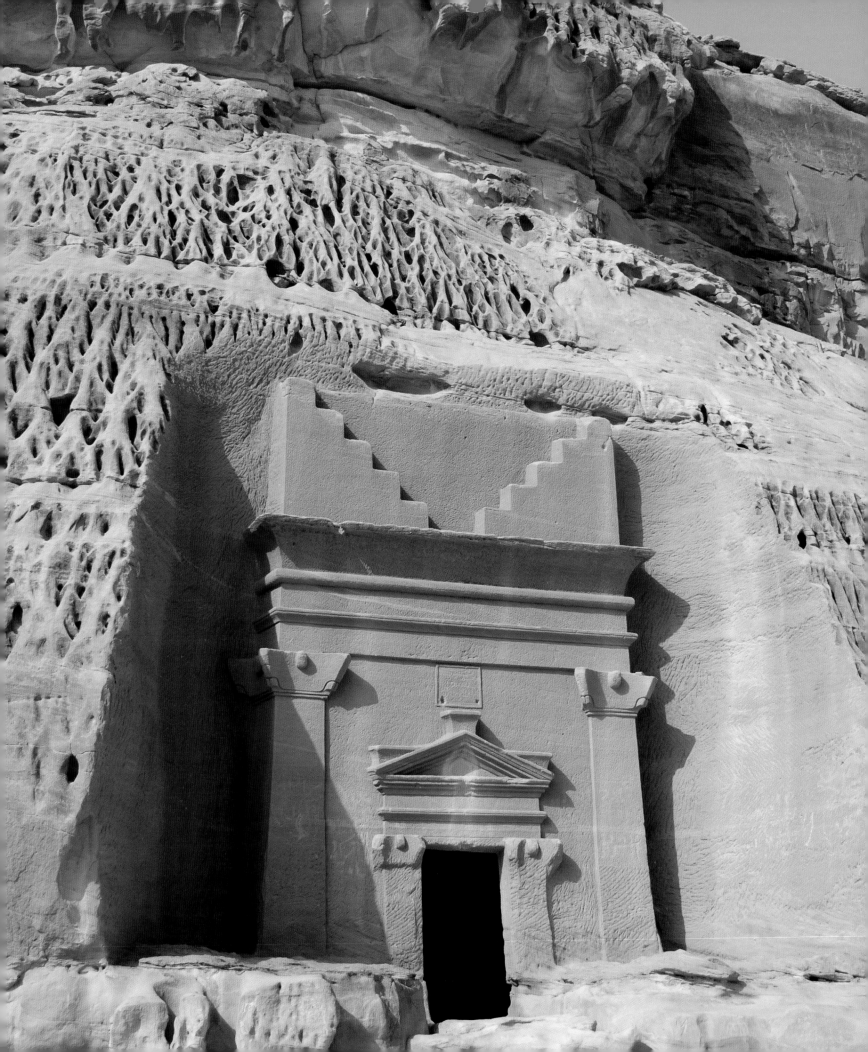

# THE KINGDOM OF SAUDI ARABIA
## AND ITS HERITAGE

*Ali I. Al-Ghabban*

## First official measures in favour of archaeology

Aware of the importance of the country's archaeological heritage, the Council of Ministers of the Kingdom of Saudi Arabia decided in 1383 H./1963 to found a department devoted to the discipline as part of the Ministry of Education. In 1392 H./1972 a royal decree approved the creation of a Supreme Council of Antiquity in charge of outlining the department's main activities and overseeing its operations. The adoption of ambitious development plans in the early 1390 H./1970s enabled the council to enlarge its scope of action, compiling a register of archaeological sites, taking steps to ensure their preservation and creating new museums. The initial results of this immense undertaking were published in 1395 H./1975 in a book entitled *An Introduction to Saudi Arabian Antiquities.*[1] This bilingual book, in Arabic and English, was the first such work devoted to the topic.

## The Department of Antiquities and Museums

In 1396 H./1976 the department introduced a long-term action plan to carry out topographical surveys throughout the territory and create a National Museum in Riyadh. One of its main missions was to publish Annals of Archeological studies (*Atlal: The Journal of Saudi Arabian Archeology*). The first edition, issued in 1397 H./1977, presented the findings of the surveys and other research carried out at several sites. *Atlal* is now in its twentieth edition.

In just over forty years, more than ten thousand archaeological sites were identified in the kingdom's various regions and provinces. The largest of these include al-Ula, Mada'in Saleh, Tayma, al-Jawf, Thaj, Dharan, Hofuf and Najran, in addition to other sites in the regions of Riyadh, al-Qassim, Jizan and Mecca. Excavations and probes have been carried out, in particular in Qaryat al-Faw and al-Rabadha, based on the topographical surveys conducted under the patronage of the Department of Antiquities and Museums of King Saud University, which has played a key role in the development of archaeological research in the

*(preceding pages)*
Dune, photograph by Humberto da Silveira

*(opposite)*
Rock-cut tomb, Mada'in Saleh

1. Al-Rashid 1975.

kingdom. All of these operations have contributed to the education of students in the discipline while promoting scientific research and encouraging more in-depth archaeological projects. Many important artefacts have been discovered that now enrich the collections of museums all over the country.

Since its founding, the Department of Antiquities and Museums has also been in charge of the restoration of major historic edifices. A number of local and regional museums have been opened, including in Najran, Jizan, al-Ula, Tayma, Dumat al-Jandal and Hofuf. The department made a point of locating the museums near the archaeological sites in each of these cities. Several historic structures in Jedda and Ta'if have been restored and transformed into museums.

Many programmes for the preservation and restoration of important historic buildings have been undertaken, including:
– the palace of Nasir ibn Saud in Dir'iyah, as well as the site's defensive walls and towers, and Masmak Fort (Qasr al-Masmak) in Riyadh;
– Al-Murabba'a Palace, built for King Abdulaziz in Riyadh;
– Qasr al-Imara, the former governor's palace in Najran;
– Al-Qishla Palace and Barzan Tower in Ha'il;
– the minaret of the great mosque and the house of al-Bassam (Bayt al-Bassam) in Aniza;
– the city wall and al-Dalm Tower in al-Dalm;
– the house of al-Sabai (Bayt al-Sabai) in al-Shaqra;
– the 'Umar mosque in al-Jawf;
– the Tarif hammam;
– Shubra Palace in Ta'if;
– King Abdulaziz's Al-Zahir Palace in Mecca;
– Al-Ahanana Tower in al-Rass, in the al-Qassim region north-west of Riyadh;
– the al-San'a Madrasa in al-Majma'.

Other sites have also benefited from restoration and development projects, such as the Hijaz–Medina railroad, the archaeological sites of al-Ula and Mada'in Saleh, and the hydraulic installations in the northern part of the country, including the Birkat al-Jumaymah and al-Thulaymah reservoirs on the pilgrimage route (Darb Zubaydah).

### The Department of Antiquities and Museums under the auspices of the Supreme Commission for Tourism and Antiquities

On May 28, 1424 H./July 28, 2003 the government decided to place the Ministry of Education's Department of Antiquities and Museums under the authority of the Saudi Commission for Tourism and Antiquities, thus defining a new global vision of its activity based on modern methodology. Convinced that this approach would contribute to the development of this field of research, the commission initiated a five-year action plan and a strategic programme to promote archaeology and museology in the kingdom. To reflect this new direction, the name of the commission was changed to the Supreme Commission for Tourism and Antiquities, as of last year the Saudi Commission for Tourism and Antiquities.

### Cultural development strategy

One of the department's projects is to develop a working method in line with the best practices and experience on a worldwide scale. Its guiding policy aims to implement major projects

concerning field research (at historical, archaeological and monumental architectural sites), museums and collections, and the preservation and restoration of the kingdom's rich cultural heritage. Procedures have also been defined for data archiving, documentation and the management of archaeological sites and discoveries.[2]

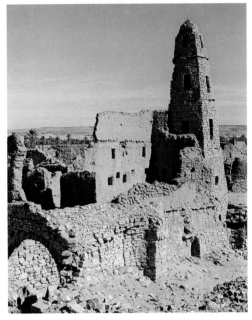

The 'Umar mosque in al-Jawf

## The preservation and enrichment of the architectural heritage

In cooperation with the Ministry of Municipal and Rural Affairs and the Ministry of Interior the commission has initiated a programme for the preservation and development of the kingdom's architectural heritage sites. The goal is to introduce well-adapted systems and criteria for monitoring the condition of the sites in order to counter their deterioration. The commission is also in charge of defining regulations for the care of privately owned archaeological and architectural heritage sites.

The project for the development of historic villages and monuments is a joint effort with the Ministry of Municipal and Rural Affairs, regional governments and the Ministry of Social Affairs. In its first phase, five villages and municipalities were chosen for the implementation of this programme: the ancient village of al-Ghat, the ancient village of al-Ula in Medina province, the municipality of Jabba in Ha'il, the village of Rijal al-Ma'a in the 'Asir region, and the village of Dhi 'Ain near al-Baha in Tihama (the south-western mountain region).

## Programme for the improvement of historic city centres

In cooperation with the Ministry of Municipal and Rural Affairs and the municipalities concerned, the commission has launched an initiative for the improvement of historic city centres containing notable examples of traditional architecture or other elements of the architectural heritage. The purpose of the programme is to encourage Saudi towns to cultivate their touristic appeal, preserve their cultural and historical identity and develop plans to take advantage of their heritage through tourist activities, cultural events and markets featuring local crafts.

## The restoration of architecturally significant monuments in the Red Sea ports of Yanbu', Amlaj, al-Wajh and Dhaba

This restoration programme is one of the primary projects developed to meet the strategic goals of the Department of Antiquities and Museums. In its first phase, all of the efforts were focused on the renovation of the historic centres of Yanbu', Amlaj, al-Wajh and Dhaba. The project aims to realize the objectives defined as a result of studies and plans implemented with the backing of the Ministry of Municipal and Rural Affairs and the Royal Commission of Jubail and Yanbu'. These objectives include preserving the architectural monuments that have survived in the historic city centres of the northern Red Sea coast, carrying out the general plan for the renovation of these sites and monuments,[3] and developing tourist activities, all of which implies the establishment of management structures that can ensure the protection and improvement of the sites.

2. A system for the management of museums and archaeological assets has been instituted in compliance with the decision by the Saudi government of May 28, 1424 H./July 28, 2003 authorizing the commission to review the management system for archaeology and the national architectural heritage, and to replace it with a better-adapted system. This project aims to develop a system already established by executive order on June 23, 1372 H./August 3, 1972 as part of the action plan for the development of the Department of Archaeology and Museums.

3. This plan consists of: mapping the borders of the historic centres and surrounding protected regions and defining research plans; determining the current state of the sites and assessing the related risks and opportunities; facilitating access to the sites as well as traffic within and near them; equipping the sites for opening to the public.

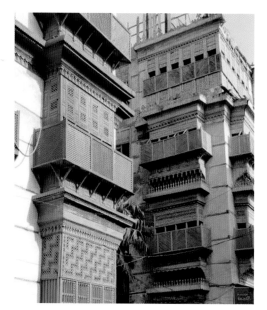

The old city of Jedda

## The development of local markets (first phase)

This project was conceived to preserve, restore and expand existing local markets as a means of promoting the country's economic, cultural and touristic development. It also aims to improve conditions in certain markets in order to make them a model for the creation of similar markets in other regions. The project encourages the weekly or seasonal organization of commercial, public and tourist-oriented events, emphasizing the touristic character of the markets and the appeal of social, cultural and leisure activities in these public settings. It is being implemented in collaboration with the Ministry of Municipal and Rural Affairs.

## Guide for the restoration of clay and stone monuments

In cooperation with the Ministry of Municipal and Religious Affairs and the High Authority for the development of the city of Riyadh, the commission has published a guide for the restoration of clay and stone monuments in the kingdom. It is used to monitor and oversee the work of the consultants, experts and contractors in charge of the restoration and operation of these monuments.

## Improvement of archaeological and historic sites and inclusion on the UNESCO World Heritage List

A list of twenty-six archaeological sites of touristic and cultural interest have been registered. They are divided into two categories: large well-known sites like Mada'in Saleh, and ancient buried cities whose ruins have been exposed by excavations, like Qaryat al-Faw. The department has also identified ten other historic sites to be opened to the public as soon as possible, in keeping with the policy of developing tourism. Most of these sites relate to episodes in the life of the Prophet, the Arabic literary heritage or the history of the Saudi state and King Abdulaziz. Several of them are already popular destinations for tourists from all over Saudi Arabia and other countries, and the government's decision to select the most important natural, historic and archaeological sites as candidates for the World Heritage List is expected to boost the number of tourists even further. In 2008 Mada'in Saleh was selected to join the World Heritage List.[4]

The new policy requires that the sites be improved so as to accommodate tourists and visitors under the best possible conditions while, most importantly, ensuring their protection and preservation. The Saudi Commission for Tourism and Antiquities is working toward this goal through a special programme comprising a number of projects, notably including the installation of all the facilities, equipment and service structures needed for the operation of the historic Islamic sites. The Supreme Authority for the development of the holy city of Mecca, Medina and al-Mashair-Muqaddasa, the municipal governments of Mecca and Medina and the Hajj Research Centre are all involved in this programme.

## The renovation of historic public buildings built under King Abdulaziz

The historic buildings that belonged to the state under the reign of King Abdulaziz Al Saud, who founded the current kingdom in the early 20th century, are characterized by the use of local construction materials and city centre locations. These sites illustrate the effort made at the time to consolidate the kingdom as a stable, unified nation and offer an exceptional example of the quality of the architecture from that period. The purpose of this programme is to renovate all the buildings that reflect the early history of the modern Saudi

4. In compliance with the criteria stipulated in Convention 1 adopted by the UNESCO General Conference in 1972 under the title "Convention for the Protection of the World Cultural and Natural Heritage", ratified by the Kingdom of Saudi Arabia in 1978 (1398 AH).

state and the unification of the kingdom under King Abdulaziz. The project is being pursued in collaboration with the Supreme Authority for the development of the city of Riyadh and the entourage of King Abdulaziz.

## Improvements at the palaces of King Abdulaziz

King Abdulaziz ordered the construction of palaces in nearly every region that he visited, including al-Badia, Dawadmi and Kharj, as well as the palaces of al-Zahir in Mecca, Khozam in Jedda and Shubra in Ta'if. All of these sites were of great strategic importance, and today they retrace the story of the new kingdom's formation. For these reasons it was decided to renovate and improve these palaces to make them suitable for new functions. This programme has already been partially completed in recent years, supervised by the Ministry of Education. With their striking scale and exceptional forms, most of these edifices were built in city centres, serving as highly visible symbols of the creation and unification of the Saudi Kingdom. Thus it was a natural choice to transform them into museums or multifunctional cultural centres that recount the nation's history by reconstituting the three stages in the development of the Saudi Kingdom.

To this end, each of the palaces can now be used to host exhibitions on the history of the city where it is located and its cultural heritage. It is also important to highlight the elements that embody the kingdom's architectural identity and the characteristics of its current architectural fabric.

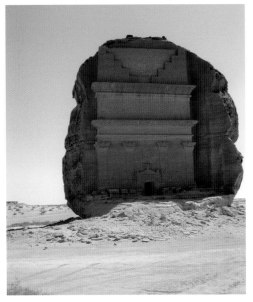

Qasr al-Farid, "the solitary tomb", Mada'in Saleh

## The creation and development of regional museums

Seven regional museums are currently being built to showcase the heritage of their local provinces. Their collections reflect the history of their region, in particular its architectural heritage. Products of traditional craftsmen are also presented to the public through events and programmes for visitors of all ages and socio-economic categories. The project also calls for the development of six other existing museums so that each of the kingdom's thirteen provinces will have its own museum.

The six national and local museums already completed are in the regions of al-Ula, Tayma, Dumat al-Jandal, Najran, Sabya and Hofuf. Most of them were opened in the 1980s and are similar in their overall design. However, after twenty-plus years of existence they are beginning to show their age. Especially considering the unprecedented intensification of large-scale museum renovation and museography projects worldwide, the kingdom's museums need to be brought up to international standards. The planned refurbishments will emphasize cultural activities and events to supplement educational programmes in the arts and to enrich tourist activities. The exhibition spaces will be doubled to accommodate all of the most beautiful relics of a civilization that dates back thousands of years, most of which were acquired in the past two decades. A radical "rejuvenation cure" is needed in order to breathe new life into all of the museums, expand their exhibition spaces and enable them to host high-profile events and programmes.

The kingdom is also home to a few specialized government-run museums, like the one devoted to King Abdulaziz, known as Museums of Saqr al-Jazira, the Falcon of the Peninsula, under the auspices of the Ministry of Defence and Aviation, the Coin Museum operated by the national mint, and the museum devoted to the possessions of the Holy Mosque of Mecca. The commission is working on the creation of several other specialized museums in cooperation with the corresponding government institutions. These include a museum of

the Quran in Medina, an Islamic heritage museum in Jedda, another one dedicated to palm trees and dates, an Arabian horse museum, a museum of folk traditions, costumes and jewellery and a falconry museum.

## Support for private museums

Many of the kingdom's private museums belong to enlightened collectors with an informed taste for archaeology and history. The commission seeks to assist and reward these eminent art lovers through a support programme specifically for private museums. Its purpose is to make these venues known to a wider public and offer them technical assistance to optimize the presentation of their works. The programme also aims to preserve and restore these museums' archaeological collections, which are listed on the national heritage registry, while ensuring their proper management and use.

## The digitization of national monuments

A digital database developed using leading technology will store information on all of the archaeological sites and their most valuable artefacts, as well as all of the monuments that make up the kingdom's rich architectural and ethnographic heritage, including maps, photographs and sketches. The database will be accompanied by a digital 1:250,000 scale map that will be used to monitor the pieces in the museum collections and new discoveries, in keeping with international standards for the documentation and archiving of archaeological assets.

In parallel, for documentary purposes, a task force reporting to the Department of Antiquities and Museums will be in charge of defining a joint action plan with the Saudi oil company Aramco to unite all the documents and studies relating to the kingdom's archaeological assets and historical monuments.

## Protecting the kingdom's heritage

The archaeological database will also make it easier to protect the kingdom's national assets and ensure compliance with national and international regulations on antiquities. The management and preservation of the archaeological heritage are carried out according to the stipulations of the laws on archaeology and museums, enabling the department to protect and develop the various assets within its jurisdiction. In keeping with international practice, the responsible parties in this department are individually committed to identifying, protecting, preserving and improving the elements of cultural and natural heritage in their territory, in view of transmitting them to future generations. The department also strives to combat the theft of archaeological assets through establishing one or more teams for the protection, preservation and improvement of the cultural heritage, endowed with all the human and material resources they need to fulfil their responsibilities.

## A restoration and preservation programme

Given the natural processes of deterioration, aggravated by climatic conditions and socio-economic evolutions, the kingdom's architectural heritage and archaeological sites are under ever-increasing threat of destruction. The government recognizes the need to act quickly against these phenomena in order to limit their impact on the country's heritage. In addition,

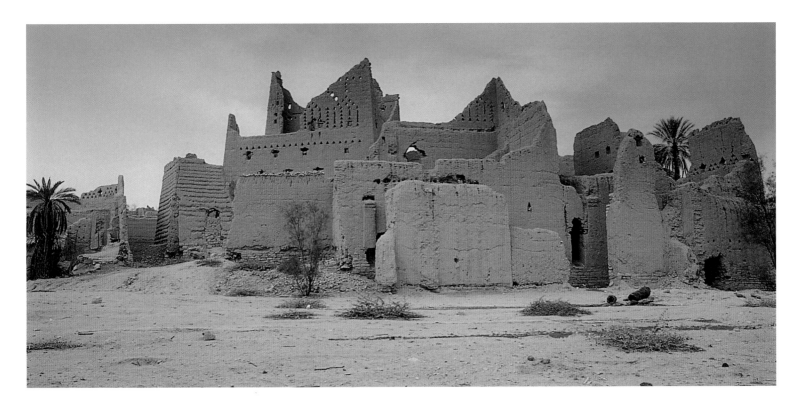

certain sites on the national architectural heritage registry belong to private parties who do not have the experience and resources needed to ensure their renovation, improvement and proper operation. For these reasons, this programme includes preventive restoration operations and provides technical support for the owners of registered properties.

## Archaeology: Awareness and initiation

The Saudi authorities have instituted a public awareness campaign to inform citizens and residents of all ages on the importance of the national heritage, including museums and archaeological monuments as well as historical values and practices. One goal of the programme is to involve the public in the protection of the country's resources and assets. It seeks to propagate a genuine culture of heritage consciousness by shaping public perception of the kingdom's history and instilling new concepts of Saudi identity and values. This project offers programmes of activities and special events to highlight the major elements of the national heritage, with an emphasis on the importance of protecting them and optimizing their use. Information is disseminated through a variety of channels, including traditional means of communication and the publication of cultural brochures and general-interest periodicals, which are made available to the public at national events and other celebrations.

## International scientific cooperation in topography and archaeological excavations

A cooperation programme with a number of foreign universities, organizations and institutes specializing in archaeology has been initiated to develop exploratory missions and to gain from the experience of other countries that have made advances in this field. Saudi Arabia currently maintains cooperative relations with France, Italy, the US, the UK, Germany and

Australia. The most important joint projects now underway include:
– a French–Saudi archaeological mission on the site of Mada'in Saleh, near al-Ula;[5]
– a German–Saudi archaeological mission on the site of Tayma in the Tabuk region;
– a French–Saudi topographical survey mission on the Kilwa sites in the Tabuk region;
– a US–Saudi archaeological mission on the site of Jarash in the 'Asir region (agreement in progress);
– US–Saudi excavations on the site of Tarut in the eastern part of the country (agreement in progress);
– a Saudi–Australian topographical survey mission on the Yabrin sites south-east of Riyadh (agreement in progress);
– a French–Saudi topographical survey mission on the sites harbouring ancient Arabic inscriptions in Bir Hima in the Najran region;
– a topographical survey mission in collaboration with a British team on the Farasan islands off Jizan;
– an Italian–Saudi excavation project on the site of Dumat al-Jandal in the al-Jawf region;
a German–Saudi excavation project on the sites of Ayn Qannas and Dosariyah in the eastern part of the country.

## The national programme of the Department of Antiquities and Museums on topographical surveys and archaeological excavations

Since 1975 the department has been supervising scientific, topographical and prospecting programmes on sites throughout the Saudi territory in order to formally recognize their archaeological interest and include them on the national monuments registry. Scientific studies have been conducted on each of the sites that are being restored, preserved and protected under the best possible conditions, and some of which have been opened to the public. Drilling operations have led to the discovery of many exceptional artefacts. All archaeological finds are carefully analysed in preparation for their restoration, and ultimately their display in the local and national museums. The most important topographical surveys and archaeological excavations now in progress are:
– Excavations on the sites of al-Khurayba and al-Mabiyat in al-Ula province (in collaboration with the College of Tourism and Archaeology of King Saud University);
– Excavations on the site of al-Dafi and Marduma in Jubail (in collaboration with the Royal Commission of Jubail and Yanbu');
– Excavations on the site of al-Khabar (in collaboration with the Saudi corporation Aramco);
– Excavations on the site of Al Okhdood in Najran;
– Excavations on the site of Fayd in Ha'il (in collaboration with the Ha'il development authority);
– Topographical surveys of the archaeological sites of Dawadmi, in the Riyadh region;
– Topographical surveys of the archaeological sites in the area of al-Qawaia, in the Riyadh region;
– Topographical surveys of the archaeological sites in Tathlith province in the 'Asir region;
– Topographical surveys of the archaeological sites in the area of al-Namas in the 'Asir region.

5. See article by L. Nehmé, D. Al-Talhi and F. Villeneuve, p. 287.

## The development of communication and publication

The quantity and diversity of publications by the Department of Antiquities and Museums bear witness to the importance of the print medium as a means of disseminating the findings of the research projects. The department issues brochures, periodicals, journals and reports on the results of the field missions, notably *Atlal,* the national archaeological review, founded more than thirty years ago and distributed worldwide. However, most of these publications are printed using traditional techniques and take the form of illustrated booklets or journals with very conventional bindings, making them ill-suited for large-scale distribution to libraries and specialized centres, or for exchanges with foreign scientific institutions. To remedy this problem, the department has introduced a plan to upgrade its communication and publication methods. It calls for a complete revamping of the periodicals, journals and scientific publications, in terms of both form and content, as well as the preparation of guides and maps of the archaeological sites and museums, the launch of a high-profile website, the enhancement of the museums' educational resources and the development of electronic media devoted to archaeology.

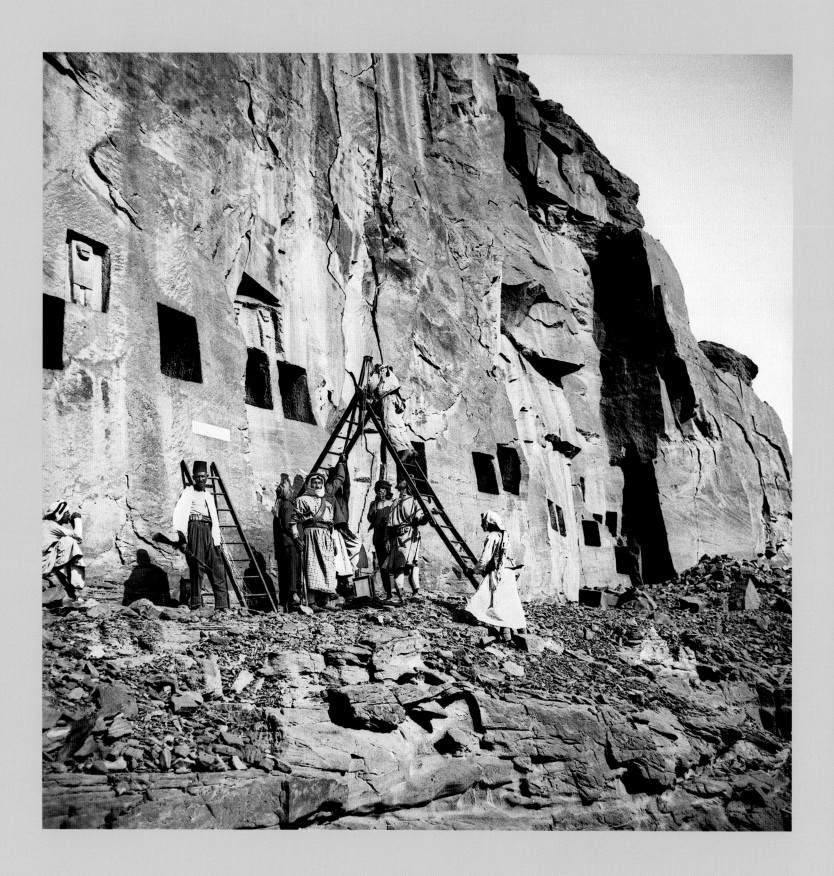

# THE FRENCH AND ARABIA

## A HISTORY OF DISCOVERY AND SCHOLARLY COLLABORATION

*Béatrice André-Salvini*

By the end of the 15th century, the discovery of new lands had become a major ambition in Europe. At the time, European knowledge of Arabia was based on descriptions by the classic authors[1] and Ptolemy's *Geography,* which dates back to the 2nd century. The opening of trade with India would enable the more detailed mapping of the Arabian Peninsula, whose ports were stopovers on the maritime route connecting Europe to India via the Cape of Good Hope. Information was gleaned from the maps and accounts of Arab historians and geographers, while the humanism of the Renaissance was fostering an interest in Oriental languages. In 1538, the French Arabist Guillaume Postel explained, in the introduction to his Arabic grammar, the necessity of creating teaching chairs in that language, given the vast extent of the regions where it was spoken. This intellectual fascination was often linked to a missionary ideal: it was thought that the study of Arabic could broaden the knowledge of the Semitic peoples' roots and help elucidate the more obscure passages of the Old Testament. However, scholars of the early 17th century, most prominently Joseph Justus Scaliger, a French-born professor from the University of Leiden, would begin taking a genuine interest in Arab culture – a culture that arose in the heart of the region believed to be the historical kingdom of the Queen of Sheba.

The 16th and 17th centuries saw a sharp increase in travel and exploration by sea. A great deal of new information on the Arabian Peninsula was brought back to Europe, first by Portuguese and later by Dutch, English and French sailors. Their visits to Arabian ports enabled geographers to map the region with greater precision. France was a latecomer to the reconnaissance of Arabian waters and coastal territories. Louis XIV founded the Compagnie française des Indes orientales (French East India Company) in 1664, well after the similar English and Dutch companies (1600 and 1602 respectively). The *Carte des trois Arabies,* (*Map of the three Arabias"* (fig. 2) published in 1654 as part of the *Atlas* of French geographer Nicolas Sanson, included many local place names, which replaced the names inherited from Classical Antiquity. It mentions the stages in the pilgrimage to Mecca and gives data on the waterways and the Red Sea, called the "Sea of Mecca". Such maps would gradually become more accurate as travellers, more and more inspired by scientific curiosity, went deeper into the mainland.

Fig. 1. Group of Minaean tombs at al-Khurayba (ancient al-Ula), April 1910. R. Savignac sets up a large 18 x 24 cm view camera on ladders held up by Bedouins to photograph the grimacing beasts in the form of lions carved into the rock to protect the tombs.See Jaussen and Savignac 1914, *Atlas,* pl. 23. A. Jaussen, stereoscopic glass plate (inv. 01196-J1213).

1. Essentially Herodotus (*Histories,* 3, 106–13); Strabo (*Geography,* 16, 3–4) was inspired by the Greek astronomer Eratosthenes of Alexandria (3rd century BC) and "the methodical table he had drawn of Arabia", according to which Arabia was divided into two large parts: *Arabia Felix* ("Fortunate Arabia") in the south and *Arabia Deserta* ("Desert Arabia") in the north. In the 1st century, Pliny (*Natural History,* 12) drew up lists of tribes and names of cities and villages in central Arabia, and showed a knowledge of the inhabitants, both nomadic and sedentary.

In addition to the information supplied by sailors, diplomatic missions and journeys motivated by intellectual curiosity resulted in accounts that proved immensely popular, introducing the exotic and the unknown to cultivated readers. The interior of the Arabian territory was alluring but remained mysterious, and the Europeans were eager to know more about the holy cities that were forbidden to non-Muslims. A few managed to make it through. One well-known report was by the Italian adventurer Ludovico di Varthema, who in 1503 travelled from Venice to Cairo, where he joined a caravan bound for Medina and Mecca. He entered Arabia from the north and crossed the Nafud Desert, passing within sight of a number of ghost cities – probably Mada'in Saleh (ancient Hegra) and the ruins of al-Ula (ancient Dedan) – which he thought to be Sodom and Gomorrah. His description of the *Hajj* (pilgrimage) and the holy sites, gives an objective, if not an erudite account of what he saw and heard.[2]

Avid for information, the French used these sources in a variety of ways. The adventures of Vincent Le Blanc, the son of a shipowner from Marseilles, who embarked for the Orient in 1570, at the age of fourteen, and supposedly visited the holy cities and the southern parts of the peninsula, are probably a partially or totally fictionalized account elaborated by the "transcriber" of his memoirs, the Parisian geographer Pierre Bergeron. Nonetheless, the book, published in Paris in 1648 and later translated into English (Le Blanc 1648), summarized the knowledge of the region at the time.

More realistic, although partisan, descriptions of the holy sites were written based on hearsay, notably by Jean de Thévenot, who travelled in the Middle East in 1655 and again from 1664 to 1667, bringing coffee back to France. In addition to detailed observations on the vegetation and populations, he mentioned Mecca as it was described to him by a Muslim. He also noted the decline of the Ottoman Empire, commenting that "all these peoples have nothing illustrious left save their ruins and remnants" (Thévenot 1665).

The diplomat Laurent d'Arvieux, a renowned Orientalist and special envoy of Louis XIV to the Ottoman Porte as consul of France, was a direct and candid eyewitness of Arab society of the mid-17th century. The account of his travels in Palestine and among the desert-dwelling Arabs dates from 1664–1665, but was not published until 1717 (Arvieux 1717 and 1735). His writing evinces an intelligent and benevolent understanding of the nomadic Bedouins' customs of northern Arabia, herding their livestock with no regard to political borders. Extensively quoted by subsequent authors, his works made an important contribution to the spirit of a genuine knowledge based on objective observation that developed in the late 17th and early 18th centuries.

The fascination for Arabia started to spread, and continued to intensify in France. The growing interest of the academic world and the evolution of European attitudes toward the Arabs coincided with a historic event. In 1683 the Ottoman army was defeated at the gates of Vienna, and the empire's power began to decline. Sympathy toward the Arab peoples and their struggle against the oppressor was growing. Several books on Arab society and culture had a considerable impact on the general knowledge of central Arabia, the cradle of Islam. French academics played a fundamental role in this process of discovery, especially Barthélemy d'Herbelot, an eminent Orientalist who set about compiling a cultural, religious and historical dictionary of the Muslim world. He died in 1695 before completing his monumental work, the first edition of which was published in 1697 by Antoine Galland, translator of *The Thousand and One Nights* (Herbelot 1697). This dictionary would remain the best source of knowledge on Islam until the publication of the modern *Encyclopaedia of Islam*. Galland, appointed

2.  See Varthema 1888, and Pirenne 1958, p. 33 and foll.

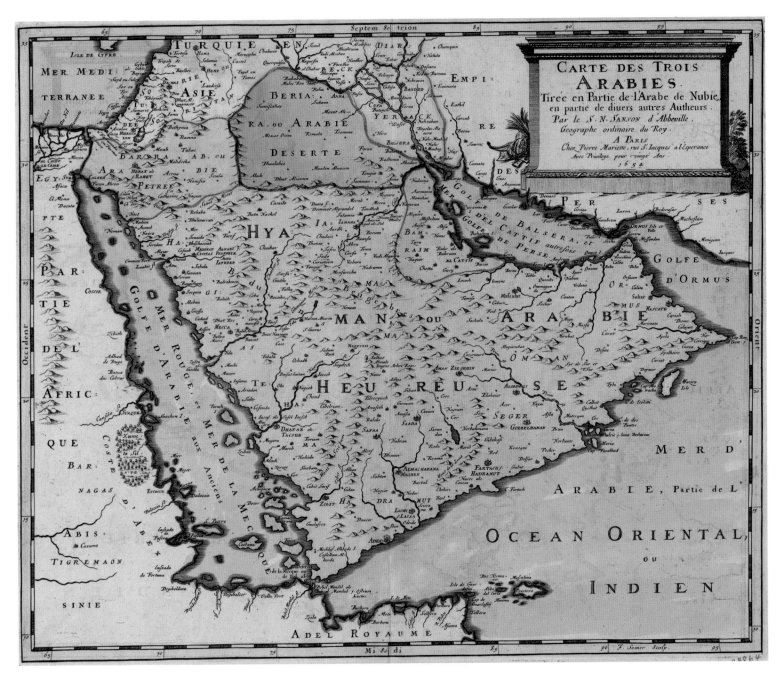

Fig. 2. "Map of the Three Arabias"
("Carte des Trois Arabies tirée en partie de l'Arabe de Nubie, en partie de divers autres autheurs / par le S. N. Sanson d'Abbeville Geographe ardinaire du Roy; J. Somer sculp."), Nicolas Sanson, 1654, ed. Pierre Mariette, Paris, 39 x 47 cm. Library of Congress Geography and Map Division, Washington.

professor of Arabic at the Collège de France in 1709, fired enthusiasm for oriental exoticism throughout Europe. In the course of his many travels he collected the tales of *The Thousand and One Nights,* introducing Arab literature to the educated elite and the general public alike (Galland 1704–1717). Soon translated into all the major European languages, his work depicted the Arab world as a romantic, poetic and colourful Orient, permanently set in a vision of the Middle Ages and thus remarkably different from ever-changing Europe, a fascinating realm exerting an ambiguous appeal. In his *Vie de Mahomed* (1730), Henri de Boulainvilliers saw the Prophet as a hero whose authentic piety contrasted with Christian hypocrisy – the opposite of Voltaire's point of view in his play *Le Fanatisme, ou Mahomet le prophète* (1741). The lives of the Prophet, written by Abu al-Fida in the early 14th century and translated by Jean Gagnier in 1723, would also have a positive impact on the approach to Islam.

Throughout the 18th century, France rivalled England for mastery of the seas around the Arabian Peninsula, establishing military bases and trading posts in the ports of Arabia and Persia, which would have a key influence on the evolution of the maps of the region. Following the map of the Red Sea, the *Carte Particulière de la Mer Rouge,* by Pierre Mortier in 1700, the world map by Guillaume Delisle of 1701 corrected many errors that dated back to Ptolemy. Even though the information was incomplete, the method relied on precise and scientific observations. The first expeditions of the 18th century concentrated on the southern part of Arabia. In 1716, Jean de La Roque, the son of a trader from Marseilles, incorporated several reports by French sailors and merchants in his *Voyage de l'Arabie Heureuse,* and published a map of the southern peninsula by Delisle (La Roque 1716). The book contains five letters to the author from a Mr de Champloret, captain and agent of the Compagnie des Indes, written between 1708 and 1710 during the first of two French naval expeditions that embarked from Marseille in 1708 and 1713 to buy coffee in Al Makha (Moka) in Yemen. La Roque's account followed in the footsteps of Herbelot and Galland, and contributed to the growing interest in all the regions of the peninsula, many of which were still shrouded in mystery and largely uncharted.

After 1750, as a result of the French navy's efforts to exert control over the Red Sea, the maps charting the Arabian coastlines became more accurate. Louis XV's geographer Jean-Baptiste Bourguignon d'Anville used travellers' reports to rectify the older maps. He consulted the writings of Arab geographers, translated in the late 16th century, including Al-Idrisi, who had lived in the 12th century at the court of the King of Sicily, and Abu al-Fida, who followed the pilgrimage route and whose *Description of Arabia* appeared in a French translation as an appendix to Arvieux's account in the edition by La Roque in 1717. Although still erroneous in some respects, his first *Map of Arabia*, published in 1751, provides precise data on the difficult-to-reach and still secret inland (fig. 3).[3]

The first truly scientific mission to the Arabian Peninsula was a Danish expedition sent to Yemen by King Frederick V of Denmark in 1761. It was inspired by the philosopher Johann David Michaelis, who invited foreign scientists and scholars to submit questions in preparation for the undertaking. The Académie Royale des Inscriptions et Belles-Lettres de France formulated the largest number of requests, and the most notable. All the questions were related to Biblical knowledge, but were also motivated by the desire for a more comprehensive and accessible body of knowledge on the geography, history, flora and fauna of the region: "The travellers will strive to satisfy specific questions…. Here we submit to them first of all those presented by the Académie des Inscriptions et Belles-Lettres in Paris, as well as by various other learned men from foreign lands".[4] This focus on scientific knowledge would characterize all subsequent French initiatives and future cooperation with Arabia.

Together with four companions, the engineer–geographer Carsten Niebuhr, who was to be the sole survivor of the expedition, reached Yemen on October 29, 1762. Having lost all of his colleagues in the course of the journey, he returned alone to Copenhagen with their documents, which he published in three volumes under the title *Description of Arabia*. It was published in German (1772) and in French (1773–1776), supplemented by a fourth volume by Michaelis containing the original list of questions (Niebuhr, 1773–1776). The findings of this mission constituted a major leap forward in the European knowledge of the entire Arabian Peninsula. Niebuhr was inspired by Arvieux's accounts, and the map that he drew up was derived from that of the chevalier d'Anville, which he improved and enriched. Even though Yemen was the primary destination, Niebuhr collected information on other parts of Arabia, in particular the Hijaz, a coastal region on the Red Sea and the site of Islam's holy cities. He took an interest in

3. Anville 1751; see also Anville 1771, which includes descriptive notes and an ornamental inset by Gravelot. (Other editions of the map of Arabia appeared before the century's end.)

4. "Recueil de questions proposées […] par Monsieur Michaélis," in Niebuhr 1774, vol. IV, p. 27, para. 14.

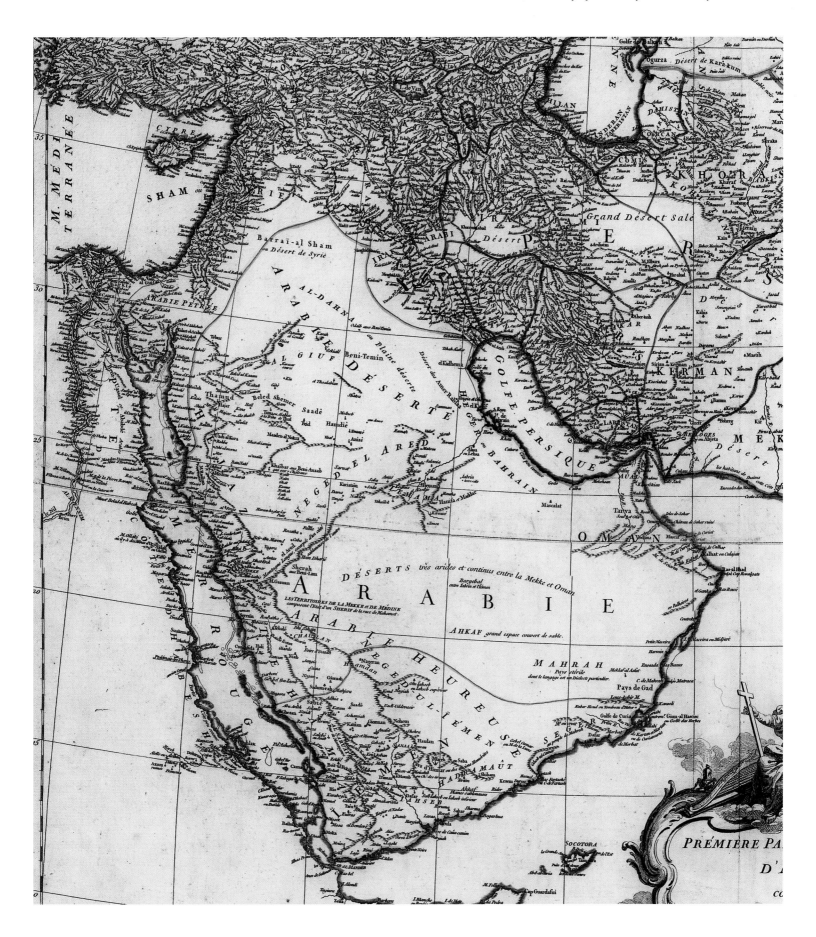

the central desert province of Najd, where political and religious events centred around the city of Dir'iyah, the fief of Muhammad bin Saud, founder of the first Saudi kingdom and a convert to the religious reforms of Muhammad bin 'Abd al-Wahhab. Niebuhr reported the presence of ancient inscriptions and included copies of several of them in his publication. His work sparked the scientific interest of many 19th-century travellers, not the least of which was Napoleon 1st: the Danish engineer's experience gave Bonaparte the idea of including scientists in his Egyptian campaign of 1798–1801.

In the 19th century, central Arabia, along with Arabia Petraea further to the north, was to become the focal point of Western political and scholarly interest. It was seen as an authentic and noble land of great beauty. Since the holy cities of Medina and Mecca were accessible only to Muslims, the map remained very sketchy. The European fascination for these mysterious places led many travellers to convert to Islam in order to visit the holy sites and undertake the pilgrimage. Meanwhile, more scientific expeditions were mounted and funded by the scholarly societies of Britain and France. The antique nomenclature dividing the peninsula into *Arabia Felix* and *Arabia Deserta* fell into disuse and the maps identified places by their contemporary Arab names. The charting of Arabia's unexplored regions became a priority for the French scientific community. The geographer Edme-François Jomard, one of the scientists who had accompanied the Napoleonic army to Egypt, compiled a map of central Arabia based on a large body of data from older maps and travellers' reports, as well as information gathered in Cairo from the grandson of Muhammad bin 'Abd al-Wahhab, a shaykh from the Najd region described by Jomard as "an educated man with an in-depth knowledge of his country".[5] He then drew a map of the western province of Asir, situated along the Red Sea between the Hijaz and Yemen, based on information provided by Maurice Tamisier and three other French officers in the health service who had been to the region with the army of the Egyptian, Pasha Mehemet Ali.

The French were motivated primarily by a desire to improve their knowledge of the geography and of the peoples of Arabia. Tamisier landed in Jedda in 1836. Out of respect for the population, he dressed in local costume and was able to travel through several provinces that had seen few, if any, Western visitors. His *Voyage en Arabie* offers a description of Jedda, Taif and the Asir region (Tamisier 1840). On the route to Taif near Zeima, he spotted ruins that remain unidentified; he reported finding "no trace of any inscription or sculpture". This nascent interest in archaeology was encouraged by the French consul in Jedda, Fulgence Fresnel, who had studied with the great Orientalist Silvestre de Sacy and had researched the local dialects and Himyaritic inscriptions of the Arabian peoples, referred to by classical authors as "Homerites". Fresnel died in Baghdad in 1855 after heading the "French scientific expedition to Mesopotamia", which produced the first map of the ruins of Babylon. He pioneered the study of Arabia's distant past by encouraging Th.-J. Arnaud to go to Yemen, copy ancient inscriptions and discover the ruins of Marib.[6] In parallel, in the 1840s, the Finnish explorer Georg August Wallin led three expeditions to the Nafud and Najd regions of central Arabia. He copied rupestrian inscriptions and identified early graffiti, later called "Thamudic", for which he was honoured by the Royal Geographical Society of London and the Société de Géographie de Paris.

The Institut de France was instrumental in expanding the knowledge of ancient Arabian civilisations, starting in 1761 when it made a prolific and brilliant contribution to the list of questions put before the members of the Danish expedition prior to their departure. France's

5. Jomard 1823, p. 7.
6. See Arnaud 1845. Alexandre Dumas, published the journal of Arnaud and his companion Vayssière as a fictionalized serial in the daily newspaper *L'Ordre*, and later under the pseudonym Abd el-Hamid bey as *Journal d'un Voyage en Arabie Rédigé par Alexandre Dumas* (1856) and *Pélerinage de Hadji Abd el-Hamid bey, Médine et La Mecque* (1856–1857).

scientific contribution to the philology of the Semitic languages developed greatly during the 19th century, with the Académie des Inscriptions et Belles-Lettres playing an international unifying role. In 1867 Ernest Renan presented to the Académie a project entitled *Corpus Inscriptionum Semiticarum,*[7] conceived as a collection of all "ancient texts in Semitic languages written in Semitic characters". A network of French and foreign correspondents had been enlisted to gather epigraphic documentation in the field and send the texts to the project's commission in the form of a copy and a paper print in order to ensure the accuracy of the reproduction and the authoritative value of the publication.[8] The scientific team was made up of the most respected experts. A great many philologists and foreign travellers on missions to Arabia helped enrich the *Corpus,* including Doughty and Philby from Britain, Huber from France and Euting from Germany. To this day, the work is a superb scholarly resource.

Charles M. Doughty travelled through northern Arabia in 1876. He was the first to describe and draw the monuments of Mada'in Saleh, the ancient Hegra of the Nabataeans, formerly called Heger by Arab geographers and historians (Doughty 1888). He brought back rubbings of inscriptions found there and at other sites in northern Arabia, which were entrusted to the Académie des Inscriptions et Belles-Lettres along with his written notes. Renan had them published (Renan 1884). Doughty was soon followed by the Frenchman Charles-Auguste Huber, who brought back new information on northern and central Arabia. Huber's first journey to central Arabia in 1879 was financed by the Ministry of Public Education for the purpose of conducting scientific, anthropological and geographic research (Huber 1884). On March 18, 1883 he embarked on a second Arabian expedition with Julius Euting, a correspondent member of the Institut de France. The aim was to explore the country "from a geographic point of view," but the two men were unable to work together and eventually parted ways.[9] In 1884 Huber arrived at the oasis of Tayma, situated at the crossroads of the caravan routes between southern Arabia and the countries of the Fertile Crescent. The explorer met a violent end: after returning from this expedition he was assassinated by nomads on July 29, 1884. His *Journal* was published posthumously by Renan (Huber 1891). He had copied and acquired several inscriptions that were brought back to France after his death. Consigned to the Louvre in 1885, they form a modest endowment reflecting the preference for epigraphic documents over objects typical of the 19th century. The goal of these pioneers was to stimulate research based on the French scholarly point of view, as set forth by Renan in his monumental *Mission de Phénicie*: "We tried not so much to attain glory as to serve the progress of science. . . . In particular, we avoided diverting our attention from the major historical issues. . . . France . . . has retained the wise principle that the goal of scientific expeditions is not to cater to the vain curiosity of the public but to push science forward".[10] Huber's copies of inscriptions and carefully detailed records of his travels have shed light on the languages spoken in pre-Islamic northern Arabia: Aramaic, "Thamudic" and Nabataean.[11]

In 1902, while King 'Abdul Aziz Al Saud was recreating the State of Saudi Arabia in the centre of the peninsula, much progress was being made in the deciphering of various languages and further scientific expeditions were unearthing traces of ancient Arabian cultures that would enrich the *Corpus Inscriptionum Semiticarum.* In the early 20th century, the north-western Hijaz region was the destination of a new epigraphic and archaeological mission, organized by the École Biblique in Jerusalem under the auspices of the Société Française des Fouilles Archéologiques and later the Institut de France. The Dominican Fathers Antonin Jaussen and Raphaël Savignac led three campaigns, in 1907, 1909 and 1910, to Mada'in Saleh, al-Ula and

Fig. 4. Sketch of the "Tayma stele" (Musée du Louvre, Paris AO 1505) by J. Euting, 17 February, 1884. From Charles Huber, *Journal*, 1891, p. 319.

7. Or *Corpus des Inscriptons Sémitiques*, abbreviated as *CIS*.

8. See foreword of *Rapport sur le Projet d'un "Corpus Inscriptionum Semiticarum,"* Paris, Imprimerie Impériale 1870, p. 10, and also Briquel-Chatonnet and Fauveaud-Brassaud 2008, pp. 215–28.

9. Euting published the rubbings of the Nabataean inscriptions (Euting 1885) and entrusted the other rubbings to D. H. Müller (Müller 1889); see Lozachmeur and Briquel-Chatonnet, *Anabases* 12, 2010 now printing.

10. Ernest Renan, *Mission de Phénicie*, Paris, Imprimerie Impériale 1864, p. 815.

11. The inscriptions copied in Mada'in Saleh were published by Berger in 1884 (*CRAI*).

Tayma, in a political atmosphere that reflected the Arab provinces' hostility toward the Ottomans. The construction of the Hijaz railway along the pilgrimage route from Damascus to Medina made travel faster and more convenient, but also aggravated the instability of the region. The mission made extensive use of photography as a scientific tool. The rubbings of the inscriptions it found, most notably during the first visit to Mada'in Saleh in 1907, were sent to the Académie to be included in the *Corpus*. In the preface to the second volume of the monumental publication reporting their findings (Jaussen and Savignac 1909 and 1914), Jaussen and Savignac defined their research according to strict scientific criteria that made the project the touchstone for all subsequent studies of the region to the present day, linking their discoveries to the inscriptions described by their predecessors. They were, however, aware that "the archaeological part is especially original and unprecedented, dealing exclusively with the funerary and religious monuments of Mada'in Saleh. We… made numerous photographs, drawings and maps".[12] Their work made a significant contribution to the knowledge of the roots of the Arab civilization. The glass plates brought back by the Dominicans, now in the possession of the École Biblique et Archéologique Française in Jerusalem, offer an exceptional body of documentation on the northern region and western coast of Saudi Arabia, especially Mada'in Saleh, al-Ula, Tayma and Dumat al-Jandal, as well as the area around Jedda, Yanbu and al-Wajh.

The enduring memory of the Jaussen–Savignac expeditions helped foster scientific cooperation between France and Saudi Arabia. A programme to digitize their images was undertaken with the support of the Al-Turath Foundation, in charge of perpetuating knowledge of the Saudi nation's past by compiling the national historical photographic archives. All of the photos of the Ecole Biblique's *Mission archéologique en Arabie, "Archaeological Mission in Arabia"* are now part of the foundation's endowment. In the catalogue of an exhibition entitled *Photographs of Arabia: Hijaz, 1907–1917*, shown in Riyadh during the kingdom's centennial celebrations and in Paris in 1999, Abdel Rahman Al Tayeb al-Ansari wrote, "The work carried out by the two scholars is a tribute to their national culture and their scientific method. It has helped forge a bond between two prestigious peoples: the Arab people of the Arabian Peninsula, anchored in their ancient roots, and the French people, impelled by progress and advancement from the Renaissance to the current era".[13]

The enrichment of the *Corpus Inscriptionum Semiticarum* (CIS) would exert an influence over all later epigraphic missions to Saudi Arabia. King 'Abdul Aziz ibn Saud was an enlightened patron of historical research into the origins of his country. The British Arabist and Muslim convert Harry St John Bridger Philby, who adopted an Arab identity as Shaykh Abdullah and became a friend of the king, visited Hijaz after World War II (Philby 1957). He copied inscriptions and graffiti, which he submitted to French and Belgian experts for the *CIS* (in particular Van den Branden and Philby 1956). Under the king's patronage, he laid the groundwork for an epigraphic mission to the southern provinces of Saudi Arabia in 1951–1952 by Gonzague Ryckmans, a Belgian correspondent member of the Institut de France, and his nephew Jacques Ryckmans. Some of the inscriptions they found are still being studied.[14]

Archaeological research in Saudi Arabia continued to gain momentum as the country became increasingly interested in its past in order to retrace the history of the Saudi nation. The Department of Antiquities was founded in 1975 and museums were built to house and preserve the discoveries. Foreign institutions were invited to participate in the programme, at first for specific studies. Prehistoric research was undertaken in the eastern region with the help of

12. Jaussen and Savignac 1909, preface.
13. Al-Ansari 1999, p. 37.
14. According to Ryckmans 1952, p. 508, the mission yielded "12,000 inscriptions, for the most part rupestrian Pre-Islamic graffiti, which we have copied and whose most remarkable specimens we have photographed"; see also Lippens 1956, p. 200: "twelve thousand 'Himyaritic' inscriptions will enrich the *Corpus Inscriptionum Semiticarum,* doubling the content of the section of this index devoted to ancient Arabia."

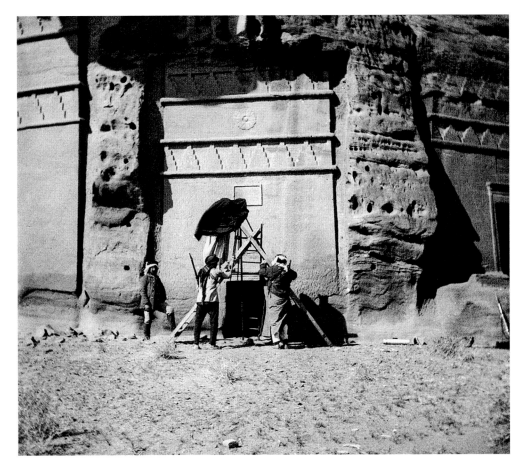

Fig. 5. Mada'in Saleh (ancient Hegra),
April 1907. French priest, Raphaël Savignac
sets up one of his view cameras and his black
cloth on crossed ladders to take a picture
of the Nabataean inscription on tomb C17.
The funerary inscription is dated 16 AD.
A. Jaussen, stereoscopic glass plate,
very small format (inv. 01659-STN-246)
Bibliography: Jaussen and Savignac 1909,
vol. 1, fig. 122

15. See Al-Rashid 2005, p. 210; *Atlal*, 11, 1988, p. 49.
16. See in *Topoi*, 6/2, 1996, the articles by M. Sartre, G. W. Bowersock and J.-F. Salles; al-Wohaibi 1973 and in particular Farès-Drappeau, 2000.
17. While the first campaign was financed by the French embassy in Saudi Arabia, the expedition now receives subsidies from the Commission for the archaeological excavations of the French Ministry of Foreign Affairs. The permanent mission comprises two members, Christian Robin and Guillaume Charloux.
18. Mission led by Saba Farès, lecturer at the University of Nancy II.
19. The exhibit at the Louvre, *Roads of Arabia: Archaeology and History of the Kingdom of Saudi Arabia*, was organized under the auspices of an agreement concluded in 2004 between the Louvre museum and the Saudi Supreme Commission for Tourism and Antiquities. The exchange programme initiated by the memorandum of understanding started in 2006 with the loan by the Louvre of works from its Islamic Arts Department to the Riyadh National Museum for an exhibit entitled *Wonders of Islamic Art – Masterpieces from the Islamic Arts Collection of the Louvre Museum.*

In addition to the bibliography referenced in this article, see in particular Hamilton 1993; Calvet and Robin 1997; Al Ankary 2001; Ménoret 2003; Morlin 2006.

French palaeontologists. In 1979 a mission by the Institut Géographique National, in collaboration with the Saudi Department of Antiquities and Museums, prepared a numbered index of the kingdom's rupestrian sites.[15] Coordinated excavation programmes were initiated, with findings regularly published in *Atlal,* the journal of Saudi Arabian archaeology (al-Rashid 2005; al-Ghabban, in this catalogue, p. 35). The 1997 re-edition of Jaussen and Savignac's report further boosted scientific cooperation between the Kingdom of Saudi Arabia and France, with a series of study mission exchanges and colloquia on research in Arabia.[16] Currently three French archaeological and philological missions are carrying out fieldwork in cooperation with Saudi institutions, in keeping with the Saudi government's policy of promoting and expanding tourism. In Mada'in Saleh (ancient Hegra) systematic research has been in progress since 2001, and the site was added to the UNESCO World Heritage register in 2008 (see L. Nehmé, D. al-Talhi and F. Villeneuve, see in this catalogue, p. 287). A research programme on pre-Islamic inscriptions has been underway in Bir Hima, in the Najran region, since 2006.[17] In 2009 an initial campaign of topographic surveys and excavations began at the Kilwa site in the northern Tabuk region on the Jordanian border, bringing to light an establishment from the monastic period including a Byzantine church and ruins dating from High Antiquity.[18]

The large-scale exhibition at the Louvre, devoted to the archaeology and history of the Kingdom of Saudi Arabia, is meant to offer the museum's vast public a unique opportunity to discover a civilization whose roots stretch back to the earliest stages of world history, representing the culmination of a keen interest that began in Renaissance Europe for an immense and fascinating land.[19]

**Bibliography:**
Al-Ankary 2001; Al-Ansari 1999, pp. 35–37; Anville 1751; Anville 1771; Arnaud 1845, pp. 208–45, 309–435; Arvieux 1717; Arvieux 1735; Berger 1884, pp. 377–93; Bowersock 1996, pp. 553–63; Briquel-Chatonnet and Fauveaud-Brassaud 2008, pp. 215–28; Calvet and Robin 1997; Doughty 1888; Euting 1885; Farès-Drappeau 2000, pp. 325–30; Galland 1704–17; Hamilton 1993; Herbelot 1697; Huber 1884, p. 289–363, 468–531; Huber 1891; Jaussen and Savignac 1909; Jaussen and Savignac 1914; Jomard 1823; La Roque 1716; Le Blanc 1648; Lippens 1956; Lozachmeur and Briquel-Chatonnet, now printing; Ménoret 2003; Morlin 2006, pp. 15–36; Müller 1889; Niebuhr 1773–76; Paris 1999; Philby 1957; Pirenne 1958; Al-Rashid 2005, pp. 207–14; Renan 1884; Ryckmans 1952, pp. 501–10; Salles 1996, pp. 564–607; Sartre 1996, pp. 533–52; Tamisier 1840; Tarragon 1999, pp. 11–25; Thévenot 1665; Van den Branden and Philby 1956; Varthema 1888; Al-Wohaibi 1973.

# GEOGRAPHIC INTRODUCTION

## TO THE ARABIAN PENINSULA

*Paul Sanlaville*

The conformation of the Arabian Peninsula is that of a huge massive quadrilateral measuring approximately three million square kilometres, two-thirds of which are occupied by Saudi Arabia, the other third being divided between six other States (Kuwait, Bahrain, Qatar, United Arab Emirates, Sultanate of Oman and Yemen). The peninsula is bounded on three sides by seas (the Arabian Gulf, the Arabian Sea and the Red Sea) and to the north bordered by Jordan and Iraq. Located directly on the Tropic of Cancer in the subtropical high-pressure system zone, Arabia is subject to severe dryness but is not without resources and possibilities.

Deep, narrow valley carved into the western slope of the 'Asir Mountains and stretching down to the Red Sea (Tihamah)

### A peninsula tilted eastwards

The Arabian peninsula, part of the vast Arabian–Nubian shield, split away from Africa during the Miocene Epoch, when the shield was markedly uplifted on the flanks of the present Red Sea, then fractured and tilted eastwards, while the fault line of the Red Sea began to open up some twenty million years ago; it continues to widen today at the average rate of 1.6 centimetres a year. This geological history produced a profound dissymmetry in Arabia: very high reliefs gradually decline eastwards down to the plains bordering the Arabian Gulf where the Arabian plate is subducted under the Iranian plate (fig. 1).

The Red Sea and the Arabian Gulf emphasize the dissymmetry of the Arabian Peninsula. Formed in the sunken part of the shield, the Red Sea is deep, reaching 2,000 to 2,500 metres in its middle part. The Arabian Gulf is shallow (an average of 31 metres, with the depths only rarely exceeding 80 metres) and edged by low plains.

The western mountains and high plateaus are constituted by crystalline rocks belonging to the Arabian–Nubian shield, often covered in the Hijaz and in Yemen with gigantic volcanic fields (*harra*) capped by a great number of volcano cones. Lava outflows again affected the region of Medina in 1256. However, the central area, the Nadj, is less elevated and hilly but stretches out more widely eastwards. At each end the altitudes rise: in the

Fig. 1. Geomorphological map and
geological section of Arabia

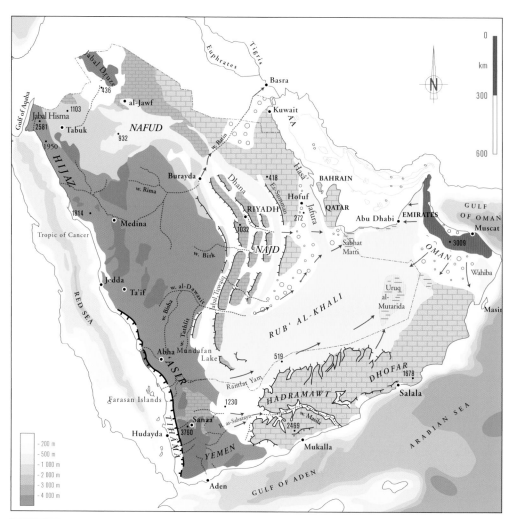

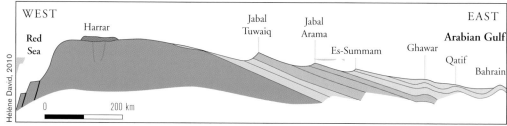

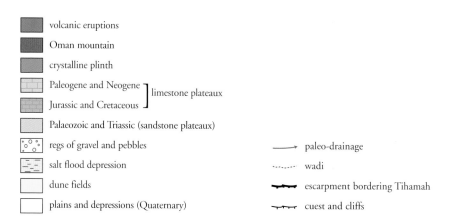

volcanic eruptions

Oman mountain

crystalline plinth

Paleogene and Neogene ⎤
⎥ limestone plateaux
Jurassic and Cretaceous ⎦

Palaeozoic and Triassic (sandstone plateaux)

regs of gravel and pebbles

salt flood depression

dune fields

plains and depressions (Quaternary)

paleo-drainage

wadi

escarpment bordering Tihamah

cuest and cliffs

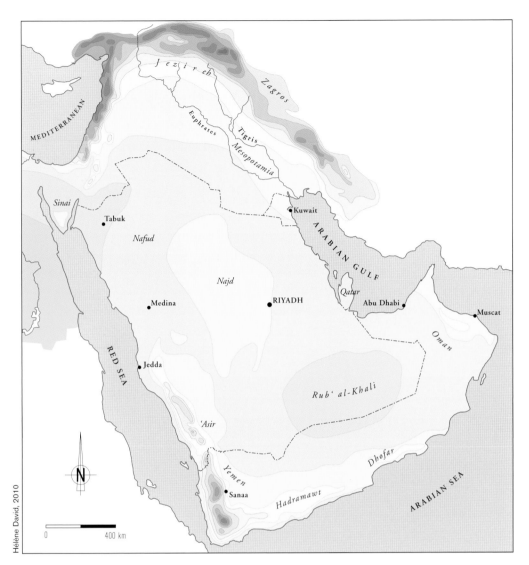

Fig. 2. Average annual rainfall in Arabia

north, in Jabal Hisma on the edge of the Gulf of Aqaba, they reach 2,681 metres and in the south are even higher, attaining 2,000 metres, not far from Mecca in the Hijaz, 3,000 metres near Abha in the 'Asir, and even more in Yemen, a country of high plateaus of between 2,500 and over 3,000 metres with mountains culminating at 3,760 metres in the Nabi Shu'ayb, not far from the capital, Sanaa. Mountains and plateaus abruptly decline towards the Red Sea, especially in the 'Asir and in Yemen where the valleys plunge into impressive gorges. In the north there is only a narrow and discontinuous coastal plain, whereas in the south the coastal region, the Tihamah, widens extensively.

In the eastern half of the peninsula a succession of sedimentary layers, more recent from west to east, can reach considerable thicknesses. Erosion scooped out a series of meridian depressions in the soft rock, throwing into relief escarpments and plateaus carved in hard rock, sandstone or limestone. Thus Jabal Tuwayq, culminating at 1,500 metres, forms a vast arc of a circle over 800 kilometres long, presenting to the west a rocky cliff over 200 metres high.

Everywhere rocky scarps are sculpted by desert erosion with very steep slopes going down to the flat surfaces of the regs – formed of coarse sands – that surround them. Mechanical erosion plays a major role (frost in the high or northern regions, thermoclastic

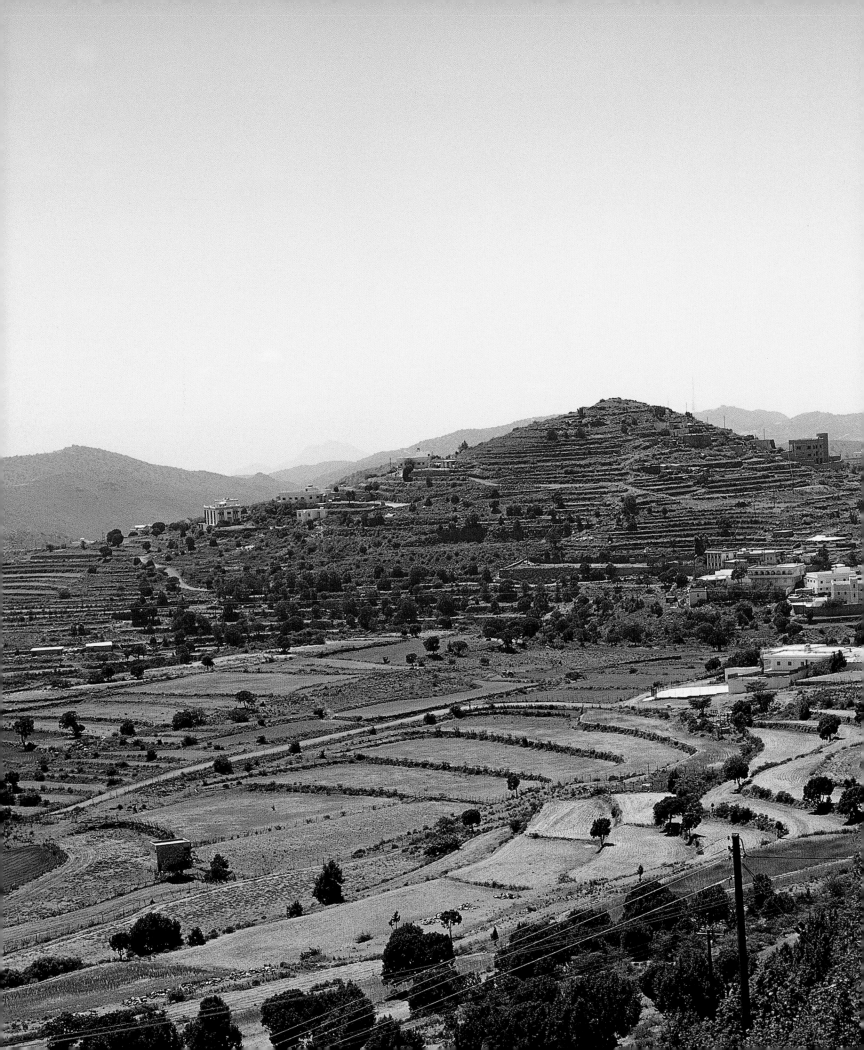

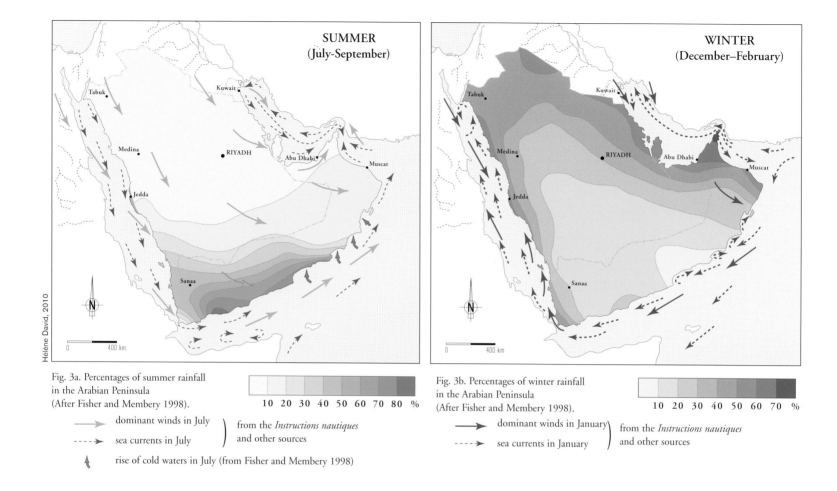

Hélène David, 2010

**SUMMER**
(July–September)

Tabuk
Kuwait
Medina
• RIYADH
Abu Dhabi
Muscat
Jedda
Sanaa

N
0    400 km

Fig. 3a. Percentages of summer rainfall
in the Arabian Peninsula
(After Fisher and Membery 1998).

10  20  30  40  50  60  70  80  %

→ dominant winds in July ⎫
⋯→ sea currents in July   ⎬ from the *Instructions nautiques*
                          ⎭ and other sources

🡇 rise of cold waters in July (from Fisher and Membery 1998)

**WINTER**
(December–February)

Tabuk
Kuwait
Medina
• RIYADH
Abu Dhabi
Muscat
Jedda
Sanaa

N
0    400 km

Fig. 3b. Percentages of winter rainfall
in the Arabian Peninsula
(After Fisher and Membery 1998).

10  20  30  40  50  60  70  %

→ dominant winds in January ⎫
⋯→ sea currents in January  ⎬ from the *Instructions nautiques*
                            ⎭ and other sources

*(preceding pages)*
Village and cultivated terraces on the western side
of the 'Asir highlands

weathering linked to extreme temperature variations, mechanical action of the salt crystals and gypsum, often brutal and powerful runoffs, action of sandstorms), eroding rocks, blowing the fine elements and accumulating them in dunes. Physical-chemical processes should not be overlooked: alternating rain and intense evaporation, for example, favour the migration of iron and manganese and the deposit on the surface of rocks of a dark varnish characteristic of desert landscapes.

The meridian depressions, often occupied by dunes, open northwards and southwards on the vast sandy basins of the Nafud (57,000 square kilometres) and the immense Rub al-Khali (600,000 square kilometres), also called the Empty Quarter. In fact, dunes cover more than one-third of the Arabian Peninsula. They are either barchan fields shaped like arcs of a circle resting on a reg of coarse sands or, as in the Rub al-Khali, mega-dunes of reddish sand, a hundred metres and up to 300 metres high, extending over hundreds of kilometres, separated by flat, kilometres-wide corridors consisting of coarse sands. This erg largely overflows into the Sultanate of Oman and the United Arab Emirates.

In the south, the peninsula presents the vast plateaus of Hadramawt and Dhofar and, in the east, the high arc-shaped mountain of Oman, spread over 700 kilometres and culminating at 3,009 metres at Jabal Shams.

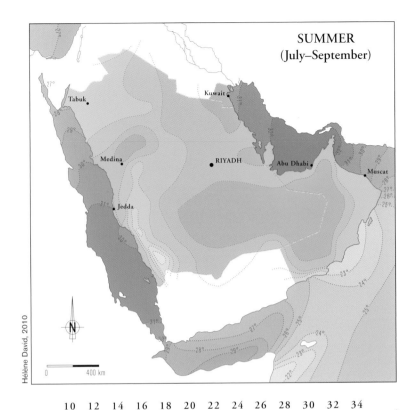

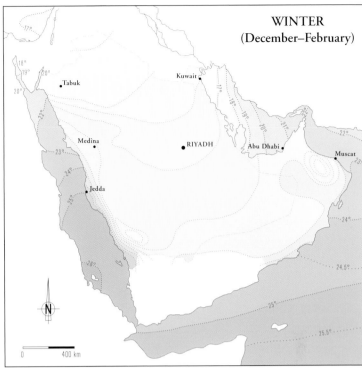

Fig. 4a. Average temperatures in the Arabian Peninsula
(After Fisher and Membery 1998).

Fig. 4b. Sea surface temperatures
(After the *Instructions nautiques*)

## A desert climate

The Arabian Peninsula, like the African Sahara, owes to its latitude a harsh desert climate with slight and irregular rainfall, very hot summers, extreme temperature variations and very dry air. However, considerable differences exist between the milder north and the more tropical south, depending also on altitude or distance from the sea (figs 2 and 3).

Most of the peninsula receives less than 100 millimetres of rain per year (101 millimetres at Riyadh, 54 millimetres in Jedda). The figures fall below 50 millimetres in the Rub al-Khali; they rise in the mountains, but the average annual rainfall only exceeds 200 millimetres on the mountain summits of Oman and up to 400 millimetres in the lofty regions of 'Asir and Yemen. Moreover, there is substantial variability from year to year: Riyadh recorded 99 millimetres in December 1995, with an annual average of 77 millimetres, while Dhahran registered an annual maximum of 277 millimetres and a minimum of 5 millimetres. The north of the peninsula has a Mediterranean-type winter and spring rains that are also felt in the entire Arabian Gulf and the Emirates, whereas the south is affected in summer by monsoon rains (July–August "main rains") and has a second maximum in spring (March–April "small rains"), their percentage diminishing very rapidly as you move away from the coast of the Arabian Sea.

The only permanent rivers are on the western slopes of the highest western zones. Elsewhere there are only spasmodic surface runoffs, sporadic and violent during storms,

whereas the mountains benefit from seasonal watercourses. The water issue is therefore crucial and agriculture could only appear where there are karstic sources (Hasa' oasis and Bahrain), possibilities of floodwater derivation (eastern foothills of 'Asir and Yemen) or tapping the groundwater of the wadis, thanks to ingenious techniques like subterranean drainage channels (*falaj* in Oman).

The average winter and spring temperatures rise quite regularly from the north-west (an average of 10°C in the three winter months) to the south-east (20°C), depending on latitude. These averages conceal extreme temperature variations. Nights are cold and frost is not unusual, especially in the high regions. In summer, temperatures are more uniform on the overall peninsula, with averages in the summer months of between 30 to 34°C in the centre and the east of the peninsula and even higher in the Rub al-Khali basin, with maximums over 48°C (52°C at Abqaiq and in Kuwait in July). And we should not forget that these are temperatures recorded under shelter, and that reflection from the sun, sand and rocks produces much higher temperatures. With frequent winds and high temperatures, the air is very dry. The evapotranspiration rate everywhere is extremely high: it reaches 4,496 millimetres per year at Mannqala for rainfalls not exceeding 93 millimetres. On the coasts the great atmospheric humidity makes the intense summer heat even more unbearable than inland despite the sea breeze.

These very constraining climatic conditions require highly adaptable vegetation, notably with deep root systems and very small foliage. Flora is concentrated in the wadi beds; it consists mainly of perennial species, annual species appearing only briefly after the rains. Very few plants grow in the Rub al-Khali, whereas the high regions of the west side have relatively dense shrubby vegetation. In the south tropical species dominate, mainly acacias. Trees producing incense (*Boswellia sacra*) and myrrh (*Commiphora myrrha*) are found as well. Date palms are limited to the oases.

## The bordering seas

The three seas bordering the Arabian Peninsula play a major role on the climate and economic activities (figs 1, 2 and 3). The Arabian Sea and the two adjoining gulfs of Oman and Aden are deep seas in which depths exceeding 1,000 metres are quickly reached and where the tidal range is of the order of 2 to 3 metres. Scarcely indented, often rocky and edged with coral formations, the Arabian coast is generally oriented WSW–ENE; winds and currents connected with the monsoon follow this direction. The north-easterly winter monsoon blows mainly from early November to late February providing stable and moderate breezes; the period is favourable for navigation. The summer monsoon from the south-west lasts longer, and is more regular and more violent. Attracted by the low pressures formed in India during that period, the rains are replenished by the Austral hemisphere trade winds which shift directions when crossing the equator and bring moisture and rain to the south of the Arabian Peninsula, in particular on the Yemenite mountains and the Dhofar coast. It sets in during the month of May and blows with great force from June to September. Then the sea is very rough and fishing boats have to remain ashore. This coast is episodically struck by cyclones occurring in May–June and especially in October–November bringing flooding and destruction. Lastly, the winds, notably from the north, along the Arabian coast cause cold waters, rich with nutritious compounds and providing a great halieutic potential, to rise from the depths.

The Red Sea is practically closed, communication with the Arabian Sea is through the Strait of Bab al-Mandeb, which is both narrow (20 kilometres wide) and shallow (less than

137 metres deep). Subject to intense evaporation and receiving no permanent rivers, it is fed by water coming from the Indian Ocean. Most often rocky, the shores of the Red Sea are bordered by coral reefs (fringing reefs) separated from the coast by a lagoon several hundred metres wide, while beyond, in the open sea, lies a discontinuous coral barrier (barrier reef): off the coast of 'Asir, the Farsan bank – a multitude of islands and coral islets – is over 500 kilometres long and a hundred or so kilometres wide. The sea is very hot in summer (averaging 27°C in the north and 31°C in the south) and extremely salty (around 37‰ in the south and 41% in the north); the tide is insignificant. The wind regime is complex but largely linked to the Indian Ocean monsoon. From May to October the north wind (*shamal*) blows throughout the Red Sea, with marine currents travelling in the same direction; if in the north, from November to April, winds and currents are still moving south, south of 20° latitude, they go in the other direction, interfering with sailing navigation. As unreliable local winds occur and coral reefs surfacing everywhere make navigation very dangerous, so sailing vessels had to call in at a port overnight and commercial traffic preferred land travel.

Less elongated than the Red Sea (850 kilometres) but wider (from 180 to 300 kilometres) and shallow, the Arabian Gulf has a semi-diurnal tide with a wide tidal range (one metre in Dubai, two in Bahrain and three in Kuwait). Despite the water brought by the Tigris, the Euphrates and the Iranian rivers, and considering the intense evaporation, the hydrological balance of the Gulf is negative and therefore compensated by waters coming from the Gulf of Oman. This generates a south to north current along the Iranian coast with a north to south reversal along the Arabian coast, driven by the *shamal*. The coast is generally low and flat, with sloping rocky points separating vast sand-silt foreshores upon which the fishermen set up huge fishing traps. There are also immense lagoons called *khors*. Normally very shallow, they gradually fill up, becoming *sabkhas*, periodically flooded mudflats, rich in gypsum and salt, bare or bearing halophilic plants. This is particularly the case on the coast of the Emirates but also between Bahrain and Saudi Arabia. These fine sediments prevent the development of coral formations, which are limited to the well-exposed rocky coasts and impeded in the north of the Arabian Gulf by the excessively low temperatures of the sea water in winter (below 18°C). Conversely, in the south as on the coast of the Arabian Sea there are vast swamps of mangroves (*Avicennia marina*) that were intensely exploited in Antiquity for wood, leaves (livestock fodder) and shell gathering. The monsoon and tropical cyclones do not reach the Arabian Gulf but, while the north wind prevails, it is subject to shifting winds of various strengths which can produce a short hard swell, which when complicated by tidal currents, makes navigation difficult, and even dangerous, especially in the south.

## The role of climatic changes

The Arabian Peninsula reveals the presence of major drainage organisms coming from the higher regions of the west and directed towards the Arabian Gulf (fig. 1). One of them had its source in the Hijaz mountains and flowed into the Shatt al-Arab, near Basra, under the name of Wadi Batin; another, with its source in the 'Asir (Wadi al-Dawasir) crossed the Jabal Tuwayq and reached the Arabian Gulf south of Qatar. In Yemen, the wadis of the eastern foothills get lost in the sands of Ramlat as-Sabatayn, whereas formerly they fed the Wadi Hadramawt. These hydrographic networks, presently disorganized, were functional in periods offering more humidity than today. Thus the region had a pluviometric optimum between 11,000 and 7,000 years BP[1]; longer and more accentuated humid phases occurred during the interglacial periods of the Quaternary and even more during the Mio-Pliocene.

1. BP: Before Present. We could also write "before 1950". According to convention radiocarbon datings ([14]C) are presented as of the year 1950. This is the date of the first [14]C dating tests: since then the level of atmospheric carbon dioxide has greatly changed.

Lakes were formed then, the sediments of which can be found under the sands of Nafud and the Rub al-Khali. At al-Mudawwara, in the south of Jordan, lake deposits have been dated with 230 Th/234 U,[2] to the last Interglacial period (between 120,000 and 85,000 years BP). The sands carried by the big wadis coming down from granitic or sandstone massifs accumulated in the depressions. During the dry phases, sands were picked up by the winds, producing the ergs of Nafud and Rub al-Khali. It was in these periods that the great deep aquifers found in the sedimentary formations in the north-west of the peninsula and even more in the eastern regions and under Rub al-Khali, sometimes several thousand metres deep and often more or less associated with oil deposits. But these aquifers are mostly fossil and today are over-exploited.

The great climatic changes of the Quaternary were also manifested by important variations of the sea level. In the last glacial period the sea level fell approximately 120 metres. The Arabian Gulf at the time was entirely dewatered, the common estuary of the Tigris and the Euphrates then being on the edge of the Gulf of Oman, human settlement was possible. At the end of the glacial age the Gulf was gradually replenished in water, but complex movements of isostatic compensation occurred, causing more or less significant modifications of the shoreline.

The humid periods offered prehistoric man very different living conditions from the ones humans have today, as vegetation was far more developed and there were more watering points.

## Conclusion

The Arabian Peninsula confronts man with particularly challenging conditions: the extent and massiveness; often hostile landscape, steep mountains and high plateaus broken by deep gorges, immense and unwelcoming dune fields; dangerous navigation in the bordering seas due to winds and currents, the presence of coral reefs and sandy or silty shallows; a harsh climate, intense heat, considerable temperature contrasts and, above all, great aridity and the serious problem of water supply.

Nevertheless, men were able to settle and live there from very early on thanks to a certain number of favourable conditions. Certain regions were probably more viable than others: the coasts with resources for fishing and shell gathering, the high zones in the west and their foothills, the areas benefiting from karstic springs.

The peninsula opens widely to the north towards Syria and Iraq while the three bordering seas facilitate connections with the outside world. The Arabian Gulf enjoys an excellent position, between Mesopotamia and Oman and between Arabia and Iran and, through the Strait of Hormuz, possibilities of relations and exchanges with Asia and Africa via the Indian Ocean. Thanks to the Bab al-Mandeb and the Isthmus of Suez, contacts and exchanges with Africa were possible and established early. Moreover, men were able to find raw materials for making their tools: flint, quartzite, volcanic materials (obsidian, andesite, basalt) and subsequently mining resources like copper and iron, or plant resources such as incense and myrrh. Itineraries were set up and the domestication of donkeys and camels allowed the increase of travel and trade.

2. U/TH: technique for dating carbonate materials based on the thorium (230Th)-uranium (234U) ratio, uranium 234 naturally decaying into thorium 230.

**Bibliography:**
Fisher and Membery 1998; Fleitmann, Burns, Mangini *et al.* 2007; Jado and Zötl 1984; Lézine, Saliège, Robert *et al.* 1998; Petit-Maire, Carbonel, Reyss, Sanlaville, Abed, Bourrouilh, Fontugne and Yasin 2010 (in press); Sanlaville 2000; Al-Sayari and Zötl 1978.

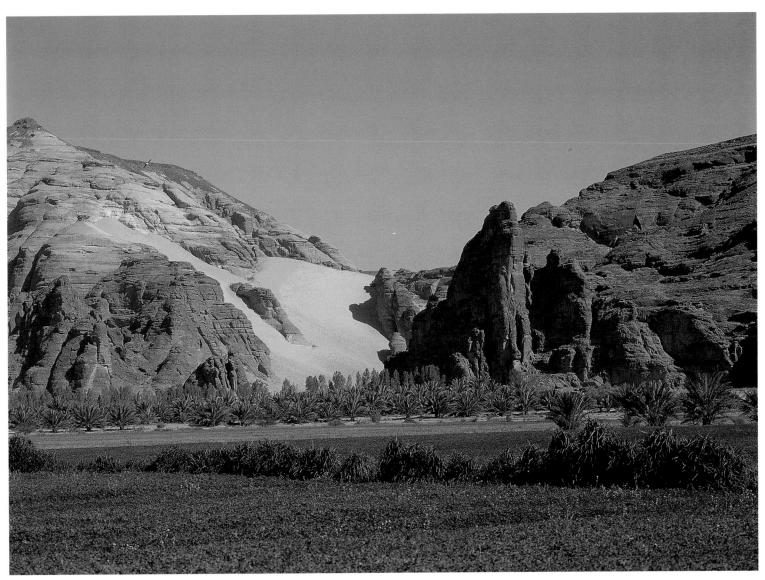

The existence of lush, more or less extensive oases is made possible by springs (al-Ula region, Hijaz)

# THE STORY OF
# THE ORIGINS

*D. T. Potts*

Because of its size and environmental diversity, Saudi Arabia has been home to many different populations throughout its past who had little in common with each other, thus making the writing of a continuous narrative of the country's ancient history particularly difficult. The sedentary fishing communities settled along the eastern and western coasts of the peninsula may have had more in common with each other than was once thought, but they were probably quite different in social organization and economy than contemporary hunting and gathering societies, herders or oasis agriculturalists of the interior, or indeed than the later camel-herding groups that lived in the desertic regions after the domestication of the camel round 1200/1100 BC.[1] Although these early inhabitants of Saudi Arabia were illiterate, and thus provide us with no primary sources on which to draw in writing their history, there are some relevant sources in the areas surrounding Saudi Arabia that help us to piece together the earlier periods in the region's past.

By 3400 BC the southern Mesopotamian alluvial plain, directly to the north-east of Saudi Arabia, was home to a number of rapidly growing cities. At Uruk, one of the largest settlements in the region, writing was invented about this time and amongst the earliest, proto-cuneiform texts there are a number containing the geographical name Dilmun.[2] Much later, from c. 2200 BC onwards, Dilmun referred to Bahrain but in the late 4th and earlier 3rd millennium BC there was no significant settlement there, whereas in the Eastern Province we have many finds that point to contact with Mesopotamia.[3] This suggests that the eastern seaboard of Saudi Arabia, which had been visited by sailing vessels from Mesopotamia for several thousand years, was in more or less constant communication with the literate civilization of southern Iraq, home of the ancient Sumerians.

Meanwhile, the western portions of Saudi Arabia, particularly in 'Asir and the Hijaz, are likely to have had a very different orientation. For many years scholars have speculated on the extent to which Pharaonic Egypt had contact with the peoples of western Arabia.[4] Very little clear evidence exists, however. Obsidian sources in Wadi Jizan and at Jabal Abyad, near Khayber, have been cited as possible places of origin for some of the obsidian found in

Bas-relief from the North Palace of King Assurbanipal in Nineveh depicting an Arab tribe fleeing the Assyrian troops. British Museum, London

1. Uerpmann and Uerpmann 2002.
2. Potts 1986.
3. See in this catalogue D. T. Potts, p. 173-183.
4. On the political situation in the region, see Van de Mieroop 2007.

Predynastic, Archaic and Old Kingdom Egypt.[5] Nevertheless, Saudi Arabian sites do not figure in accounts of Egyptian trade down the Red Sea to the Land of Punt[6] and most suggestions that western Arabia traded actively with Egypt before the 1st millennium BC are highly speculative.

By the Late Bronze Age, however, a historically documented people and land can be identified with a portion of the north-western Saudi Arabian province of Hijaz. Midian, and its people the Midianites, are well-documented in the Bible (Genesis 25: 4; Exodus 2: 15–22; Numbers 31: 1-12; I Kings 11: 17–18 etc.). Midian was beyond the control of Egypt and located south of Moab, near the Red Sea coast, and post-Biblical sources such as Josephus's *Jewish Antiquities* and Claudius Ptolemy's *Geography*, as well as the Holy *Quran*, suggest that the centre of ancient Midian was in the region of modern Tabuk, extending from the entrance to Wadi Arabah in the north to the area of al-Wejh in the south.[7] Surface survey at Qurayyah[8] in 1968 identified this as one of the largest sites in the region, with a massive settlement *tell*, lower town, ceramic kilns, field systems and enclosure walls clearly visible on the surface[9] and a distinctive style of painted pottery once called "Midianite" and now known as Qurayyah Painted Ware.

Even though there are many textual nuances associated with the Biblical narrative and its interpretation, it is clear that the Midianites were depicted in at least two major contexts. On the one hand, Numbers 25: 6–18 and 31: 1–12 and Judges 6–9 recount the stories of Israel's two wars with Midian, probably in the early 11th century BC. Politically, the Midianites were depicted as having a decentralized structure with five "kings" (Evi, Rekem, Tsur, Hur and Reba) at the time of the first war and two (Zebah and Zalmunna) at the time of the second, suggesting that the Midianites were a confederation of different tribes or kin groups, each with its own paramount leader. Alternatively, Knauf has suggested that the "kings" are in fact toponyms, names of important Midianite settlements or regions,[10] as Levine has suggested, though exactly where these were located in disputed by Biblical scholars.[11] The Midianites had large herds of livestock (Numbers 31: 9), towns (Numbers 31: 10) and enclosures, perhaps like those at Qurayyah (see below). The booty seized by the Israelites in the first war included gold armlets, bracelets, signet rings, earrings and pendants (Numbers 31: 50). After the second war the Israelite king Gideon collected the gold earrings of the slain Midianites, said to have amounted to 1,700 shekels, along with other ornaments, collars, and chains hung about the necks of the Midianite camels, and had an *ephod* [12] made that was set up in a sanctuary in Ophrah (Judges 8: 24–27).[13]

A reference to Gideon's seizure of the Midianite kings' purple garments (Judges 8: 26) suggests that Midian had access to, whether directly or indirectly, some of the elite products of the Late Bronze Age Levantine coast. This inference is also made plausible by the ceramic motifs of Qurayyan painted ware, emphasized by Peter Parr, which suggest Aegean connections (e.g. running spirals, lozenges and chevrons). Although some scholars have viewed the Midianites as nomads, the clear references to their towns and the substantial wealth seized from them suggests rather that Midian was a land with a sedentary population living in towns like Qurayyah, with its substantial architectural remains.[14] Additionally, some Midianites may have been specialized camel herders[15] attached to these settlements, not necessarily full-time nomads. As we know from recent research on the date of camel domestication in Arabia, the Midianites were some of the earliest exploiters of this extraordinary resource. Fabled for its ability to travel long distances, the Midianite merchants (Genesis 37: 25) with their domesticated dromedary camels and their location in north-

5. Zarins 1989a.
6. Phillips 1997.
7. Koenig 1971; Payne 1983; Briggs 2009.
8. Parr, Harding and Dayton 1970 and 1972.
9. On the other surveys there, also see Ingraham *et al.*, 1981.
10. Knauf 1988.
11. Levine 2000.
12. A statue of Yahweh? An elaborate priestly garment?
13. Boling 1975.
14. Parr 1988 and 1996.
15. Judges 6: 5, "they and their camels were without number".

Assyrian bas-relief showing Arab women captured
during Tiglath-Pileser's campaign against Samsi,
British Museum, London, 118901

western Arabia were in an ideal position to transport and distribute aromatics like frankincense and myrrh from what is today Yemen or Dhofar.[16]

Bearing this in mind, it has been suggested that the Midianites[17] and their towns may be implicated in the Egyptian references to Shoshu during the New Kingdom. If, as some scholars have suggested, the Midianites were amongst the suppliers of aromatics to New Kingdom Egypt during the 19th and 20th Dynasties, then this is likely to have been South Arabian in origin, and distributed using the famous Midianite camels. Further, Parr has suggested that the decline of large towns like Qurayyah and the eventual demise of the Midianites may have been caused by the gradual weakening of Egyptian power during the 20th Dynasty and their eventual withdrawal from the region after the reign of Rameses VI, though environmental and climatic factors may have played a role as well. In either case, the Midianites are very likely to have played an important economic role in the Late Bronze Age, exploiting both their location and their superior locomotion, in the form of the domestic dromedary.

We have no historical evidence for the early 1st millennium BC in Saudi Arabia but in the mid-8th century BC a cuneiform text from Sur Jar'a, near Anah on the Middle Euphrates in western Iraq, provides us with important testimony. The text, written by Ninurta-kudurri-usur, governor of Suhu and Mari (the district along the Middle Euphrates from Anah at least as far north as Mari in modern Syria) is a report of an attack on a caravan on its way to Tayma, an important oasis in the Saudi Arabian Hijaz, and Saba (South Arabia).[18] According to the writer, two hundred camels and their loads, consisting of blue-purple wool (*takiltum*), other wool, iron, *pappardilu* stones, "every kind of merchandise", were seized. As Michael Macdonald has pointed out, the goods carried by this caravan make it clear that it was headed from the Mediterranean or Levantine coast to Arabia, and was not coming north from Tayma.[19] The blue-purple wool, dyed with the dye made from the murex shell, was manufactured in and typically demanded as tribute, e.g. by Shalmaneser III (858–824 BC), from the Phoenician cities by the Assyrians.

In 733 BC the Taymanites appeared in one of the so-called Summary Inscriptions of Tiglath-Pileser III (744–727 BC) as one of a number of groups, including Massa', Saba', Hayappa, Badanu, Hatte and Idibailu, that sent tribute to him following the Assyrian subjugation of Samsi, queen of the Arabs. Tayma is mentioned in a Neo-Assyrian recension of the so-called Sargon *Geography*, a text purporting to describe the empire of Sargon of Akkad, who lived in the 24th century BC, but which was probably reconfigured during the reign of his namesake, Sargon II of Assyria (721–705 BC). The site's importance is again documented in 694 BC when gifts from its people were recorded as having passed through the Assyrian capital Nineveh's "Desert Gate" (*abul madbari*).

Assyria's increasing desire to control Syria and the Levant,[20] as well as its near constant struggle to subdue Babylonia and her allies,[21] not to mention its interest in the benefits of dominating the overland trade just described, meant that what is today northern Saudi Arabia found itself squarely at the heart of Assyrian interests. In 691 BC Sennacherib's army campaigned in northern Arabia, pursuing Te'elhunu, queen of the Arabs, and Haza'el, king of the Arabs (later called, perhaps anachronistically, king of the Qedarites in the inscriptions of Assurbanipal), to *Adummatu* "in the midst of the desert". This is our first glimpse of another important oasis settlement in northern Saudi Arabia – ancient Adummatu, Biblical Dumah, Greek Doumaitha, Islamic Dumat al-Jandal, modern Al-Jawf.[22] While Te'elhunu was captured along with thousands of camels and the cult statues of a number of unnamed Arabian deities, Haze'el surrendered and sent tribute to Senncherib. This included a variety

16. Macdonald 1997.
17. Giveon 1971; Ward 1972; Saleh 1973.
18. On Tayma during the Neo-Assyrian period, see Winnett and Reed 1970; Eph'al 1982; Potts 1991. On the German excavations, see Eichmann, Schaudig and Hausleiter 2006.
19. Macdonald 1997.
20. See Eph'al 1982.
21. On the situation in Babylonia, see Frame 1992.
22. On al-Jawf archeology, see Al-Muaikel 1994. On History, also see Macdonald 1995.

of semi-precious stones, cypress wood and aromatics. In the palace at Nineveh, some of the stone beads were inscribed with a label identifying them as "booty from Duma/Dumetu" (*kišitti ᵘʳᵘDumeti*). Also mentioned in the same account, in association with Te'elhunu, was a town called Kapānu which Eckart Frahm has plausibly identified with modern Kaf,[23] at the opposite end of the Wadi Surhan from Adummatu. An Assyrian presence in the Wadi Sirhan may have had decisive consequences for the caravan trade from South Arabia and Tayma documented half a century or more earlier in the Ninurta-kudurri-usur text from Sur Jar'ah. Indeed this may have influenced Karibili, in whom we can recognize Karib'il Watar of Saba, to himself send Sennacherib a gift (*nāmurtu*) of semi-precious stones and aromatics in about 683 BC.[24] These events no doubt explain why Herodotus[25] gave Sennacherib the double title "king of the Arabs and Assyrians".

In 678 BC Esarhaddon restored the plundered cult images to Adummatu as a result of a visit to Nineveh by the Haza'el, whom his father Sennacherib had defeated.[26] Esarhaddon's gesture may have been meant to cement the vassal relationship of Haza'el, but in addition the Assyrian king increased the Arabian's tribute (*maddattu*) by demanding an additional sixty-five camels per year. At the same time, an Arabian princess named Tabu'a who had grown up at the Assyrian court in Sennacherib's "palace without rival" and who had presumably gone there with Te'elhunu after her capture in 691 BC, returned to Adummatu where she was installed as queen of the Arabs. Whether she was Te'elhunu's daughter or not is unclear.

Sometime before 677 BC Haza'el died and was succeeded by his son Yauta' with the sanction of Esarhaddon. This, however, came at a price, namely an additional ten minas of gold, one thousand semi-precious stones, fifty camels and one thousand leather containers of aromatics. Although a high price to pay, this tribute proved its worth when a certain Uabu and "all the Arabs" revolted against Yauta' between 676 and 673 BC and an Assyrian force was dispatched, capturing the ringleader and many of his men and deporting them to Assyria. Just a few years later, however, when Yauta' tried to free himself from the Assyrian yoke, he was treated in the same manner by Esarhaddon who sent an armed force to capture him. Although Yauta' escaped capture, his supporters were defeated and his cult statues were seized, including one of 'Atar-samain, a goddess often associated with Venus.

When Esarhaddon was succeeded by his son Assurbanipal,[27] Yauta' approached the Assyrian king "about his gods", receiving the statue of 'Atarsamain in return. But again, Yauta' rebelled, "he sinned against my treaty; he did not guard my favours; and he cast off the yoke of my dominion", inciting "the people of Arabia" to revolt and plunder the Western Lands (Amurru).

In reporting on the suppression of this revolt by Yauta', Edition B of Assurbanipal's annals, from 649 BC, refers to troops that were stationed "in the territory of his land" that were dispatched against him, suggesting a stable Assyrian presence around Adummatu in the mid-7th century BC. The annals speak of widespread destruction, the burning of the Arabs' tents and dwellings,[28] the plundering of their livestock – sheep, donkeys, camels, cattle – and slaves, so many camels that the people of Assyria "could buy camels for a shekel and a half of silver at the market gate". Famine struck the north Arabians, we are told, all of the great gods of Assyria brought their curse upon them. A defeat of the Qedarites is reported in a letter to Assurbanipal from Nabu-shumu-lishir, a military officer stationed in Birati, who wrote, "Concerning the Qedarites about whom the king, my lord, gave me orders: after I went to the highland, [I inflicted] a cru[shin]g defeat on them by the destiny of the king, my lord" (*SAA* 18, no. 143). In an apparently different action, Adiya, wife of Yauta', was captured along with Ammuladi, another king (*shaykh*) of the Qedarites who had

23. Frahm 1997 and 1999.
24. Frahm 1999; Potts 2007.
25. Hérodote, *Histoires*, II, 141.
26. Luukko and Van Buylaere 2002.
27. On Assurbanipal's campaigns against the Arabians, see Gerardi 1992; Retsö 2003.
28. On the illustrations of the campaigns against the Arabians in the Assyrian hills, see Reade 1998.

rebelled and attacked the Western Lands, where he was captured by Assyria's vassal Kamash-halta, king of Moab, and sent in chains to Nineveh. A raid by Ammuladi (called Ammi-leti of Napisu) is in fact reported in a letter (*CT* 53 289), probably written by Itti-Shamash-balatu, an Assyrian agent stationed somewhere in the Phoenician region, to Esarhaddon.[29]

In the wake of the Assyrian campaign Yauta' fled deeper into Arabia, to Natnu, king of Nabayyate (perhaps located around Tayma, since a "war against Nabayyate" is mentioned in a rock inscription from Jabal Ghunaym, about 14 kilometres south of Tayma).[30] Natnu, however, feared that he would make himself a target of Assyrian revenge if he gave refuge to Yauta' and thus rejected his appeal, whereupon he sent emissaries to Assurbanipal for the first time and became tributary to Assyria. In what appears to be a separate, possibly earlier incident, Assurbanipal's officer in Birati, Nabu-shumu-lishir, wrote to him about the fact that the "king of Babylon", i.e. Assurbanipal's brother Shamash-shum-ukin, had received emissaries from Natnu and had given them one Biratian (Birati may be the same as the fortress of Birthôn mentioned by Procopius and located east of Amida, modern Diyarbakir) and five Assyrians captured at Cutha in Babylonia. Shamash-shum-ukin, who was in a state of revolt against his brother from 652 to 648 BC, had captured these men in the course of his fighting against Assyrian forces, and it seems very clear now that in rebelling against Assyria, both Yauta' and Ammuladi were not only trying to throw off the yoke of Assyrian oppression, but were siding with Shamash-shum-ukin.

We also know that at least two other Arab chieftains, Abiyate' and his brother Ayamu, sons of Te'ri, who were apparently unrelated to Yauta', brought troops to Babylon in 650 BC when it was under siege by Assyrian forces, thereby breaking an oath of loyalty to Assurbanipal in siding with Shamash-shum-ukin. Even though Babylon was under siege at the time, some of the Arabian troops managed to enter the city, though the Assyrian sources say that a number were killed in doing so. Moreover, before Assurbanipal finally defeated his brother, a loyalist at Sippar named Nergal-ibni wrote to Assurbanipal announcing that Ammini-ilu, "a merchant from Tema" had been arrested at the city gate *en route* from Sippar to wherever it was that Shamash-shum-ukin was then staying. The prisoner had been put in fetters and was at Dur-Sharruku and Nergal-ibni urged the Assyrian king to have him transported and questioned since he was completely unknown by the local populace.

After Abiyate' and Ayamu were defeated, Abiyate' submitted himself to Assurbanipal's authority – "came to Nineveh and kissed my feet" – and was installed by him as king of the Qedarites. But Abiyate' soon allied himself with Natnu, king of Nabayyate, and together they caused "an evil uprising against my border", prompting Assurbanipal to launch a second Arabian campaign. Following the defeat of the Arab forces, Assurbanipal installed Natnu's son Nuhuru as king of the Nabayyate in his place.

Although they have been known for over a century, the accounts of these campaigns are complex, particularly as there are two virtually homonymous protagonists, Yauta' son of Haza'el and his cousin Uaite' son of Birdada, and getting the story straight clearly troubled the ancient Assyrian scribes writing a decade after the events as well as modern historians reading about them 2,800 years later. Careful reconstructions of the campaigns and their identites by Israel Eph'al and Pamela Gerardi[31] have helped clarify many otherwise incomprehensible points of chronology and identity.

While these events were occurring in northern and north-western Saudi Arabia, we have little information on developments elsewhere. Although there is considerable Neo-Assyrian documentation on relations with Dilmun (Bahrain), only one episode seems to concern north-eastern Saudi Arabia. Between 668 and 648 BC an Assyrian official in sou-

**29.** Reynolds 2003.
**30.** See Winnett and Reed 1970.
**31.** Eph'al 1982; Gerardi 1992.

thern Babylonia sent a report to another official at Assur in which he states that four men carrying a letter from the king of Babylon were apprehended at "Hafiru in the desert". Scholars have long thought that this might be Hufayr/Hufir on the pilgrim route between Basra and Mecca but it is also possible that this is Hafr, modern Hafr al-Batin, which sits at the entrance to the Wadi al-Batin, an important route leading from southern Iraq into the heart of what is today Saudi Arabia.[32]

Thus far we have seen that Adummatu (al-Jawf), Kapanu (Kaf) and Tayma all figured in Assyrian accounts as important places in northern Arabia during the earlier 1st millennium BC. Some of the Arab tribes in the region were identified as Qedarites, a term that occurs in the Bible where it was prophesied by Jeremiah (Jeremiah 49: 28–33) that they would be attacked by the Babylonian king Nebuchadnezzar. Beyond this, we have little way of ascertaining whether the change of government in Mesopotamia – the fall of Assyria and the rise of Babylon – impacted directly on the northern Arabs until we reach the reign of the last Babylonian king, Nabonidus (556–539 BC).

Top of a stele of Nabonidus (Harran)

Nabonidus (Nabu-na'id) is one of the most enigmatic rulers in Mesopotamian history and much has been written about his seeming eccentricity.[33] In the third year of his reign, Nabonidus named his son Belshazzar regent and went, with an army, to Tayma, where he spent the next decade of his life, returning to Babylonia only just in time to experience its conquest by Cyrus the Great, founder of the Persian Empire, in 539 BC. In a long inscription on a stele discovered at Harran (Sultantepe) near modern Urfa in south-eastern Turkey, Nabonidus praises the moon god Sin (we know from another inscription that Nabonidus's mother, Adad-guppi, was a priestess of Sin) and recounts a dream he had in which Sin commanded him to build a temple for the god at Harran. He says that Sin allowed him to flee the city of Babylon and go to Tēmā (Tayma), Dadanu (al-Ula),[34] Padakku (Fadak), Hibrā (Khaybar), Yadi'u (Yadi') and Yaṯribu (Yathrib, i.e. al-Madina). It has generally been assumed that Nabonidus's aim in settling at Tayma was to seize control of the lucrative overland caravan trade in aromatics from South Arabia, and that his enumeration of towns in northern Saudi Arabia is a list of the places he conquered or annexed in the process. As Michael Macdonald has pointed out, Yathrib is the point at which the caravan route from the south forked, after which one branch headed north to Tayma and another bore slightly north-west to Dedan and on towards Gaza. At Tayma the route again divided, one branch heading north to Adummatu and from there up into Syria; another tending north-east towards Babylon; and a third leading eastwards towards southern Babylonia. By controlling this entire region, Nabonidus effectively had a stranglehold on the distributory segment of the caravan route, and his control of it may explain why "the king(s?) of Egypt, the Medes and the Arabs, and all the kings (who were) hostile" sent envoys to him and sued for peace.

Several economic texts from Uruk in southern Mesopotamia confirm Nabonidus's presence in Arabia. One text, from the fifth year of his reign, is a record of a payment of 50 shekels in silver to Nabu-mushetiq-urra, a camel driver sent to deliver provisions (literally "flour") to Tayma, while a text from the tenth year of Nabonidus's reign is an order for the payment of the services of a camel carrying "the king's food" from Uruk to Tayma. In addition to the cuneiform sources attesting to Nabonidus's presence in north-western Arabia, we also have several inscriptions on rock outcrops in the North Arabian dialect now called Taymanitic that are relevant. One of these, at al-Mushamrakha, about 10 kilometres south-west of Tayma, was written by "Māridān (*mrdn*), the companion of Nabonidus (*nbnd*), king of Babylon (*mlk bbl*)" who tells us he came there with his commander on a raid against the Bedouin of La'aq. A second one, written by "Sktrsl, sohn of Srtn", also says that he came

32. Potts 1990.
33. On Nabonidus and his stay at Tayma, see Beaulieu 1989; Schaudig 2001.
34. On the archeology of this oasis, see Nasif 1988.

with his commander, while two more, written by Andāsu or Endios (*'nds*), identifies the author in one case as a companion of Nabonidus' and in another as the bodyguard or chamberlain who led the vanguard of the king of Babylon. Apart from providing independent testimony of the presence of Nabonidus and a Babylonian army in north-western Arabia, these inscriptions are important because of the personal names they contain. Whereas Māridān is cognate with Mārid, the name of the famous fortress in the al-Jawf oasis (ancient Adummatu), and has parallels in Hebrew (*Märäd*), Nabataean (*mrdw*) and Palmyrene (*mrd*), Sktrsl and Srtn find their closest parallels in several languages of Asia Minor (Luwian, Lydian, Lycian and Cilician) while Andāsu/Endios is probably Greek. We know, moreover, from other sources that Greek mercenaries served in the forces of Nabonidus, including Antimenidas, the brother of the poet Alkaios (Alcaeus) of Mytilene.

Finally, four Taymanitic inscriptions from the Tayma area refer to a "war against Dedan". When this is set alongside the inscriptions just mentioned, that were patently written by officers in the service of Nabonidus, and the reference to Dadanu (Dedan, modern al-Ula) in Nabonidus's Harran stele inscription, it seems clear that Nabonidus campaigned in the region and did not simply visit the towns he lists there.[35]

**35.** On the inscriptions mentioning Nabonidus in the Tayma area, see Hayjneh 2001; Müller and Al-Said 2002.

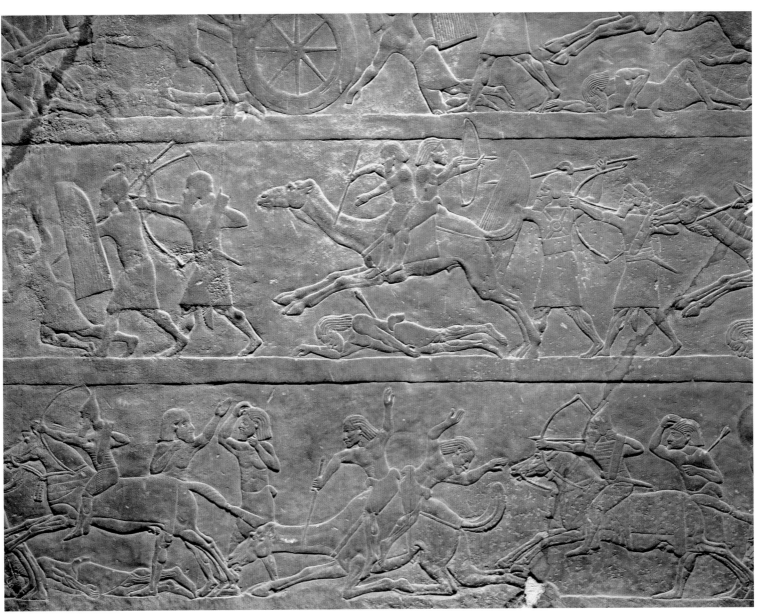

Bas-relief from the North Palace of King Assurbanipal
in Nineveh depicting an Arab tribe fleeing the Assyrian troops,
British Museum, London

# ANTIQUITY

*Christian Julien Robin*

Although the immense Arabian Peninsula embraced a huge diversity of peoples and ways of life, whereas the northern and eastern fringes were naturally integrated into the exchange systems that served the passage of foreign influences, factors promoting unity had been at work there since earliest Antiquity.

View of the Hijaz

If we deem that the history of a people begins when they start to write and produce texts, the history of Arabia dates back to at least the 8th century BC. During the fourteen centuries of Antiquity between that time and the formation of the Muslim empire in the decade 630–640, two phases of unequal length can be discerned. During the first, the dominant cultural model, whether with regard to writing, the composition of texts, architecture or the iconographic repertoire, was South Arabia, in particular its leading kingdom, Saba. The second phase was marked by the progressive development of an Arab identity, which can be detected from the Hellenistic period (from the reign of Alexander the Great to the Roman conquest, 3rd–1st centuries BC), but which above all established itself politically and culturally from the 4th century AD.

## The Arabia of the caravan principalities (8th–1st centuries BC)

We cannot yet be certain about the time and manner in which the first complex societies developed, where task specialization and resource management allowed the formation of towns, but it was very early, in the second or perhaps even the third millennium.

The oldest Arab texts, from roughly 750 BC, reveal that three centres of major civilizations existed, all situated in west Arabia: from south to north they were Saba' (in Yemen), Dedan and Tayma (in Saudi Arabia). The three used the same script, which originated in Ugarit in Syria. However, it is not known how the script was transmitted from Ugarit (which disappeared at the start of the 12th century BC) to the Arab kingdoms.

This first Arab script was an alphabet of twenty-seven consonants, and was extended at Dedan and Saba' independently. It evolved so rapidly that it was soon possible to distinguish between the Sabean, Dedanite and Taymanite alphabets.

### The Sabean model

At that time Saba' was the greatest power in Arabia. Its name appeared about 750 BC in the list of titles of the first known monarchs. Its capital was Marib, a town that lay on the edge of the inland desert at the mouth of a valley that drained the waters of a vast mountain basin. Saba was distinguished by its own language (Sabaic), pantheon, calendar and dating system.

As early as the 720s BC, Saba' extended its hegemony over a large part of Yemen thanks to two rulers, Yatha' Amar and Karib'il, who are referred to in the Assyrian sources as "Ita'amra the Sabean" (c. 716 BC) and "Karibilu king of Saba'" (689–681 BC).

It is therefore not surprising that the Sabean cultural model radiated across all Yemen, Ethiopia, the regions neighbouring Yemen (Najran), western Arabia between Najran and the Levant, and as far as the shores of the Arabian Gulf where the Sabean alphabet was used. This model is apparent in the manner in which inscriptions (lexicon and phraseology) were composed, and in the use of script as a decorative motif. It is equally revealed in the iconographic repertoire, which made use of the same geometric figures (dentils, striation, empty rectangles), the same emblematic animals (ibex, oryx, bull, bucrane, ostrich), the same symbols (hand, crescent, circle, etc.) and the same stylized representations (as in the "eye-stelae"). The model would probably also be recognized in other domains (ceramics, architecture, defensive system, irrigation works, etc.) if they had been studied.

It is not always easy to distinguish between what results from an influence and what belongs to a common cultural background – for the latter most certainly exists. Here is a single example: the very obvious reluctance to represent divinities in either human or animal form anywhere in Arabia at all times.

The Sabean model was not established right across Arabia on a long-term basis. From the Neo-Babylonian age (first half of the 6th century BC), the Arameans offered an alternative. Their alphabet was first preferred on the fringes of the Syrian desert, then in the Arabian Gulf (in the Hellenistic period), and finally in the oases of the Hijaz (Roman period). It was the Aramaic model that asserted itself on a permanent basis with the creation of the Arabic alphabet (which was derived from Aramaic rather than Sabean script) at the start of the 6th century AD, then with the adoption of this Arabic alphabet by the Muslim principality of Medina a century later.

### Busy trading networks controlled by the South Arabian kingdoms of Saba', then Ma'in

From the end of prehistory, certain types of costly products circulated over long distances but it is not sure whether men did likewise: the movement of the goods may have been the result of successive short-range exchanges.

The first products in Arabia to be exchanged with distant trading partners were copper (exported) and bitumen (imported). It appears that they had been transported by sea between Oman and Mesopotamia since the dawn of history. But the most important commerce was in incense, myrrh and gum arabic, of which South Arabia was the leading producer. From the end of the 2nd millennium BC, trade with the Levant greatly increased. This long-distance commerce occurred overland, across the immense steppe-like wastes of western Arabia. It was made possible by the domestication of the camel and its ability to carry heavy loads. Contrary to expectation, in spite of the problem of water and fodder, overland travel was much faster and safer than sailing up the Red Sea, which was made awkward by the action of the winds and uncertain by the existence of pirates.

The huge trading network that the kingdom of Saba' represented in western Arabia is referred to by the biblical prophets (Isaiah **21**:13–14, Jeremiah **25**:23–24, Ezekiel **27**:20–23,

Job 6:19) and the kings of Assyria, who chose to present the taxes collected as a tribute. Inscriptions in Yemen, which unfortunately are very few as commerce was not considered a prestigious livelihood, complete the information available. The most important text, which dates from the first half of the 6th century BC, was written by a Sabean leading a trading expedition to Cyprus, passing through Dedan, the cities of Judah, and finally Gaza. This Sabean later conducted a diplomatic mission to the four countries of Arabia: Dhakr (whereabouts unknown), Lihyan (the kingdom that had Dedan as its centre), Abi'aws (whereabouts unknown, perhaps the biblical Buz) and Hanak (probably Qaryat al-Faw). It seems likely that these four countries were the leading trading partners of Saba' in the Arabian Desert at that time.

Archaeology confirms the written data: we observe the emergence and development of outstanding civilizations in Tayma, Dedan (today al-Ula) and Najran.

Organization of the caravan trade was transformed during the 6th century BC. Saba' became overshadowed by one of its tributaries, the small kingdom of Ma'in. The reasons for this turnaround are unknown, though they may have been related to the upheavals that shook the Near East, notably the conquest of the oases of the Hijaz by the Neo-Babylonian king Nabonidus. The capital of Ma'in was Qarna, in the Jawf, about a hundred kilometres northwest of Marib. The Mineans had their own language (Ma'inic), institutions and pantheon, but the rest of their culture (script, architecture, decorative motifs, etc.) hardly differed from their Sabean equivalents.

We know where Minean caravans travelled thanks to four texts that make reference to Egypt, Gaza, Tyre, Sidon, Trans-Euphratesia (more or less modern Syria) and Assyria-Babylonia.

Another way to know the routes followed by the Minean caravans is to examine the inscriptions that they left in Arabia and the Near East. A large number have been found at al-Ula, a handful at Qaryat al-Faw, and a few at Najran. They date from the Persian and Hellenistic periods (from the mid-6th century to the 1st century BC approximately). Two others, discovered in Egypt and on the Greek island of Delos, date from the Hellenistic period.

Altar from Delos with a bilingual inscription
(in Greek and Minean)

A last means of knowing where the Mineans were active is given by texts that recorded the "naturalization" of foreign wives. These are lists of entries of the following type: "A, the son of B, from (group) C, of clan D, has handed over and paid the price of E, from place F". Seventy-nine such entries can be studied for this purpose. They tell us that Minean caravaneers married thirty-two women from Gaza, sixteen from North-West Arabia, eight from Egypt and one from eastern Arabia. Thus, the primary destination of Minean caravans would have been Gaza and Egypt.

The places and tribes in the Arabia Deserta mentioned in the lists are: in North-West Arabia, Qedar, Dedan, Lihyan, Qaryan (the Arab Wadi al-Qura), and Yathrib (today Medina); in eastern Arabia, Hagar (today Hofuf). Seven names remain unidentified, notably "Tamlah", which was probably important as it is mentioned five times, and "Yarfa'" (the Assyrian *Ya-ra-pa*). Two important oases from North-West Arabia are distinguished by their absence, Tayma and Khaybar, perhaps because they fall under the name "Lihyan". And the absence of Najran and Qaryat in southern Arabia is probably explained by the fact that the oases were considered to be Minean.

The kingdom of Ma'in was not a political or military power, and none of the Minean inscriptions commemorates military exploits. The king, assisted by various councils, was invested with powers that seem to have been limited. He did not have coins struck, nor was he responsible for construction of the walls around the most important cities; that was organized by the leading families. It would also appear that he did not even have a real palace, a symbol of power and legitimacy, unlike the rulers of other kingdoms in southern Arabia. All in all, Ma'in very much gives the impression of having been a "merchant republic" that controlled various alliances, as Mecca was to do just before the birth of Islam.

### The end of South Arabia's monopoly of the caravan trade

Shortly after the middle of the 2nd century BC, Agatharchides of Cnidus, a Greek historian and geographer, reported in his treatise *On the Erythrean Sea* that at Petra: "Mineans and Gerrheans, as well as all the neighbouring peoples, transport the shipments of spices".[1] Petra, the Nabataean capital, had just dethroned Gaza as the principal market for the redistribution of Arabian aromatic plants and spices, but the Nabataeans did not stop there: they also became leading players in the transportation of goods between Yemen and Petra. Inscriptions in the Nabataean language, as yet unpublished, have been found at Qaryat al-Faw and in Yemen. German archaeologists have also discovered a very fine bilingual inscription in Sabaic and Nabataean at Sirwah in Yemen. This record, which is being prepared for publication by Norbert Nebes, is a dedication to dhu' Shara', the Nabataean god, a little earlier than the Christian era. A Nabataean graffito scratched a hundred or so years later has been found not far from Najran.

Other North Arabians followed the example of the Nabataeans and sent caravans to Yemen. Inscriptions have been found in the Dedanite language at Qaryat al-Faw, and three dedications to Shams, found in Marib in the Yemen, were probably made by Hagarites.

These developments opened the way to a much more formidable competitor. After annexing Cleopatra's Egypt in 30 BC, the Romans tried to exploit the Nabataeans' great familiarity with the caravan route to venture upon the conquest of the country of incense. The expedition was placed under the command of the prefect of Egypt, Aelius Gallus, and comprised an army of ten thousand men, which included Judean and Nabataean contingents. The legions mobilized were the *III Cyrenaica* and the *XXII Deiotariana*. As the route chosen required good knowledge of the terrain, the Nabataean minister Syllaios was asked to be the expedition guide.

The army crossed the Red Sea on 130 ships and disembarked in Arabia in the Nabataean port of Leuke Kome (which may be the modern 'Aynuna in the north of the Hijaz). The description of the route that has survived is unfortunately very brief. After leaving Leuke Kome, "he [Aelius

1. Strabo, *Geography*, XVI, 4, 18.

Gallus] crossed such regions that even water had to be carried by the camels, due to the perversity of the guides. After many days he reached the country of Aretas, the father of Obodas. Aretas probably received him in a friendly manner and offered him presents but Syllaeus's treachery made the march difficult in this region too (there being no road, the crossing took thirty days); it only offered them spelt, a few palm trees, and butter instead of oil. The following region that he entered belonged to nomads and was for the most part desert; it was called Ararene. The king of it was Sabos. He also crossed without roads: fifty days were required to reach the town of Negranes [Najran], a peaceful, fertile region. The king fled and the town was taken by assault".

From Najran the army marched to Marib without meeting any military resistance. After a siege lasting a week, Aelius Gallus gave up and ordered the retreat due to lack of water. To his great anger, the return was much quicker than the outward journey. In total the Roman army had spent between twelve and fourteen months in Arabia, probably in the years 26–25 BC.

On his return, Aelius Gallus accused Syllaeus of treason and put him to death. Syllaeus cannot be excluded from all responsibility for the failed expedition, for the Nabataean had no reason to reveal the route taken by his caravans and thus to facilitate the conquest of Yemen. But it is equally clear that Aelius Gallus would thus be exonerated of responsibility for his failure, assuming that someone was to be held responsible.

Nonetheless, the Romans were able to turn Aelius Gallus's defeat to advantage: they had found out exactly where the country of incense lay and went to get their supplies by sea. The result was an immediate and almost total abandonment of the caravan route.

## The emergence of an Arab identity in Arabia under the domination of Himyar (3rd–6th centuries AD)

### *The emergence of an Arab identity*

Around the start of the Christian era, the first signs became apparent of the emergence of an Arab identity. The term "Arab" had probably existed since the middle of the 9th century BC, but it was indicative of a way of life – that of the nomad peoples living from stock-breeding on the steppes and in the desert – rather than a people. On the other hand, it only appeared in external sources in foreign languages (Akkadian, Hebrew, Greek, etc.), and never in the inscriptions made by the peoples of Arabia.

Apparently, the ruling classes of Nabatea were the first to use the appellation "Arab". However, this term does not appear in Nabataean inscriptions, only among authors who wrote in Greek. It is necessary to wait until the late 2nd or early 3rd century AD to find inhabitants of Arabia who called themselves "Arabs" in their local languages, as was done, for example, by the authors of two inscriptions found in Hadramawt.

Several decades later, in 328, a king of the Syrian desert, the Nasrid Imru' al-Qays, son of 'Amr, proclaimed himself "king of all the Arabs" in an inscription discovered at al-Namara in South Syria, which was written in the Arabic language using late-Nabataean script, in other words, after the end of the Nabataean kingdom (Musée du Louvre, AO 4083).

Yet, at the moment when the peoples of the Arabia Deserta began to refer to themselves as "Arabs", Greek and Latin sources ceased to employ the term and began to use "Saracens" instead. It was probably a question of clearing up an ambiguity: to both the Romans and the Byzantines, the Arabs were first and foremost the inhabitants of the province of Arabia (approximately modern Jordan).

The Arab identity that began to assert itself was based principally – as far as can be judged – on shared language and culture. It is also to be noted that the Quran uses the term "Arab" to

describe a dialect or a document, but not an ethnic group. Logically enough, the Arabic language had been written since the start of the 6th century using its own alphabet. This was a new variety of the Aramaic script, which borrowed letters from the late-Nabataean alphabet (used by the Arabs of the Near East and northern Hijaz) and assembled them in the manner of the Syriac script.

The earliest example of this Arabic alphabet, which was found close to Alep in Syria, dates from the start of the 6th century, 512 AD to be precise. It represents the birth certificate of the Arabic alphabet that is still in use today. A second inscription, found at Jabal Usays, a hundred or so kilometres east of Damascus, dates from 528–529. A third, discovered at Harran in the Laja' (south of modern Syria), is dated to 568.

These three inscriptions, to which a fourth can be added – marking the foundation of the convent of Hind at al-Hira (southern Iraq), which is only known of through the copy made by two scholars from the Islamic period, al-Bakri and Yaqut – show that the Arabic script, which was at that time still rudimentary, appeared in Syria and southern Iraq in a Christian milieu. Its elaboration probably had the purpose of making the teaching of the Christian religion easier to the Arabs of the desert.

The emergence of an Arab identity was also expressed in the development of a poetic language common to all the tribes, of which the Arabic Tradition has preserved important examples. The origin of this poetic language has not yet been clarified. It is possible that it needs to be researched in Yemen, where three rhymed poems have already been discovered which were written between roughly 100 and 330 AD.

The Arab identity is equally founded on a remarkable undertaking – begun just before the birth of Islam and continued for several generations – which has had no parallel in the history of humanity: the assembly of a record of all the distinctive genealogies (above all those of the chiefs and nobles who derived their legitimacy from the antiquity of their lineage) in a single tree, thus creating a faithful image of the whole of the nation. The most thorough of the various contributions to this enterprise was by the historian Hisham, son of Muhammad al-Kalbi (died c. 819). His *Jamharat al-Nasab* (*The Abundance of Kinship*) contains some thirty-five thousand names and permanently defined the contours of the Arab nation as well as links of "kinship" that united tribes and aristocratic lineages.

Quite clearly, the genealogical tree of the Arab nation, which divides that nation into two branches, to the north the descendants of Adnan and to the south those of Qahtan, is an allegory: it only records a tiny proportion of the individuals who had really existed and defined the "kinships" by simply translating geographical proximity and the political alliances that existed around the 8th century AD. These genealogies nonetheless played an important role in the power struggles during the early centuries of Islam and gave an easily comprehensible structure to the coalitions. It is not rare for them to be invoked even today in Arabia and the Near East.

### *The Himyarite protectorate in the* Arabia Deserta

The assertion of an Arab identity was, at least partly, a reaction against the attempts at the domination of the Arabia Deserta by Himyar. Whereas the Sabean armies ventured no further than Qaryat al-Faw, after achieving the unification of Yemen around 300 AD, the kings of Himyar threw themselves into the conquest, particularly in the Hijaz, the Najd and Hasa'.

During the following century, around 435–445, vast territories in central and western Arabia were annexed by the Himyarite king Abikarib As'ad (about 375–445. To his official title "king of Saba, dhu Raydan, Hadramawt and the South" he added: "and of the Arabs of the Highland (*Tawd* = Najd) and the Coast (*Tihama* = the coastal regions of the Hijaz)". It is significant that the Arabs, who previously were simple auxiliaries, were now explicitly mentioned.

Funerary inscription of Imru' al-Qays, son of Amr,
king of all the Arabs. Paris, Musée du Louvre,
département des Antiquités orientales, AO 4083

Himyar imposed its authority over the vast tribal confederation of Ma'add in central Arabia, as is recorded in three Himyarite royal inscriptions carved in the centre of Najd (not far from modern Riyadh). The mention of "*Tihama*" in the list of titles indicates that Himyar also exerted control over the coastal regions of western Arabia, though we cannot know if this was all or only part of them.

While the kings of Himyar's expansion into central Arabia took the form of an annexation, this was not how it was seen in the Arabic tradition. The latter claims that the Himyarites created a vassal kingdom whose rulers stemmed from the Yemenite Arab tribe of Kinda. The kings are said to have been, in order, Hujr, son of 'Amr "the Eater of Bitter Herbs", his son 'Amr, and his grandson al-Harith (killed in 528 at the latest). An inscription in the vicinity of Najran confirms this. It was written by Hujr, son of 'Amr, who gave himself the title "king of Kinda" rather than "king of Ma'add". It can be deduced from this that Hujr did not found a new kingdom in central Arabia, but that he acted there as a simple representative of the king of Himyar relying on his prestige as a tribal chief.

It is difficult to trace precisely the boundaries of the territories controlled to a greater or lesser extent by the Hujrids on behalf of Himyar, but it is highly probable that it was almost all of the Arabian Desert. For instance, close to Iraq, the tribes of Taghlib and Bakr accepted the authority of al-Harith and participated in the struggles for his succession.

With regard to North-West Arabia, a precise piece of information was recorded for posterity by the Byzantine historian Procopius. He observed that at the end of the 520s Byzantine territory stretched as far as the "Palm Grove" (his term for the large oases of the northern Hijaz), and that immediately afterwards "other Saracens, the neighbours of these men, occupied the coast: they are called Maaddites [Ma'add] and are subjects of the Homerites [Himyar]".[2]

The Himyarites thus gathered in a single tribal confederation – Ma'add – a large number of tribes of the *Arabia Deserta* (principally from the centre, north-east and west), the government of which they entrusted to the Hujrids, a princely lineage from Kinda. The Himyarite expansion into central Arabia was made at the expense of the Nasrid kings of al-Hira, client kings of the Sassanians. At the start of the 4th century, one of them, Imru 'al-Qays bin 'Amr (died in 328), "king of all the Arabs", boasted of having launched a raid against Madhhij, reaching "Najran, the city of Shammar" (the Himyarite king Shammar Yuhar'ish) and reigning over Ma'add (the al-Namara inscription). A century later the Himyarites had taken Imru's place in Arabia. If the Sassanians, who were very watchful over what was going on in Arabia, did not react, it was probably because the Himyarites offered them excellent guarantees, in particular a religious policy that countered the spread of Christianity of the Byzantine persuasion.

2. Procopius, *Wars*, I, 7–14, 19.

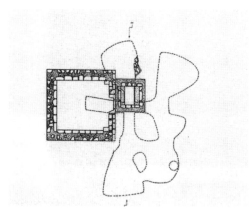

Plan of the tomb of Mu'awiyat, Qaryat al-Faw

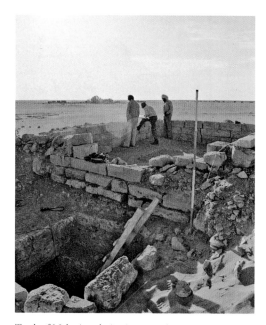

Tomb of Mu'awiyat during its excavation

With reference to western Arabia, an official Himyarite text, undated but which was probably written when Himyarites had imposed their authority on Ma'add, mentions "Nu'manan and Mudar at Ma'sil Gumhan". Mudar was the large confederation of West and North-West Arabia, while Nu'manan (in Arabic, al-Nu'man) was its king or chief. Mention of Nu'manan at Ma'sil (the centre of Ma'add) suggests that this king had come to offer allegiance to the Himyarite kings. An identification can be proposed for Nu'manan: he may have been al-Nu'man bin 'Amr bin Malik, the first Salihid king. According to Arab-Islamic tradition, the Byzantines placed a dynasty of Christian rulers of the Salih lineage at the head of the Arab tribes connected with the empire (particularly at Quda'a and Mudar). According to Ibn Qutayba, this dynasty had three kings: al-Nu'man, his son Malik, and his grandson 'Amr. It is possible that the Salihid 'Amr was himself referenced in an epigraph: a late-Nabataean inscription in the northern Hijaz, apparently from 456–457 AD, mentions a king of this name.

The tribes under the authority of the Salihids were answerable – if we are to believe the majority of Arab sources – to Quda'a. But one source also cites Mudar: "The Salihs levied tax on behalf of the Byzantines on the tribes of Mudar and others that were settling in their territory"[3].

The Himyarite domination of the Arabia Deserta very probably reduced the political autonomy of the large tribes. In the 3rd and 4th centuries, Sabean and Himyarite inscriptions in Yemen and the late-Nabataean inscriptions in North-West Arabia mentioned many tribal chiefs who awarded themselves the title "king":

– the al-Asd tribe: kings al-Harith, son of Ka'b (about 230–255), and Malik, son of Ka'b (about 300–310);

– the Ghassan tribe: king Harithat, son of Zaydmanat (c. 3rd–4th centuries);

– the Kinda tribe: king Malik (c. 230–240);

– the Kinda and Madhhij tribes: kings Malik b. Badda' (c. 230–255) and Malik b. Mu'awiyat (late 3rd–early 4th centuries);

– the Kinda and Qahtan tribes: king Rabi'at, son of Mu'awiyat of the lineage of Thawr (c. 220);

– the al-Khasasa tribe: king Mar'alqays, son of 'Awf (c. 230–240);

– the Nizar tribe: no mention of the king;

– the Qahtan and Madhhij tribes: Mu'awiyat b. Rabi'at (c. 2nd century).

By the middle of the 4th century the process was over; from this time on the only king was the king of Himyar.

In parallel to its conquests Himyar implemented an astonishingly voluntarist religious policy. Its kings decided to reject polytheism and to give their support to Judaism. The rejection of polytheism was radical and permanent. No explicitly polytheist inscription exists in all Yemen after the year 380. The large polytheist temples ceased to be frequented officially. The temple of Marib, where some eight hundred inscriptions were found dating from the first four centuries of the Christian era, has none dated after 380. This absence of all epigraphic reference to polytheism is important given that the number of inscriptions (in the order of 120) for the period 380–560 is not negligible. Of course, this does not mean that polytheism had totally disappeared, just that it had been excluded from the public sphere. It is probable that pagan cults quietly continued to exist pretty much everywhere except among the ruling classes.

This rejection of polytheism was not the result of an internal development that progressively changed a pagan divinity into a supreme, then sole god. A rupture took place, as is demonstrated by the abandonment of the old terminology and sudden influx of terms of Aramaic or Hebrew origin, such as *amen*, *'alam* (world), *baraka* (bless), *kanisat* (meeting room), *halom*, *salat (prayer) and zakat* (grace), not to mention proper names like Judah, Isaac, Joseph and Israel.

3. Ibn Habib, al-Muhabbar, p. 370-371.

## *The crisis of the 6th century*

Around 500 the kingdom of Himyar became a tributary of Aksum (today in Ethiopia), which was Christian. We have no knowledge of how this reversal came about. From this time the kingdom of Himyar must have been Christian and allied to Byzantium.

On the death of the Himyarite king Ma'dikarib Ya'fur, which occurred between June 521 and June 522, the Aksumites placed a new king on the throne called Joseph (Yusuf As'ar Yath'ar). In the Arabic tradition he was known as dhu-Nuwas. Shortly afterwards, in autumn 522, Joseph rebelled. After massacring the three hundred or so men in the Aksumite garrison of the capital, Zafar, and burning down their church, he led an army that ravaged the coastal regions of the Red Sea opposite Abyssinia. He then attacked Najran, which refused to recognize him.

The massacre of Christians in Najran offered a pretext to the Aksumite king Kaleb Ella Asbeha to mobilize a very determined army. It left Aksum after Pentecost in 525 and boarded seventy ships at Adoulis to cross the Red Sea. As the Aksumites arrived in Arabia, Joseph led his troops in an attack to prevent the enemy disembarking, but he was killed in the attempt. Consequently, the Himyarite army was put to rout, then crushed. The date of Joseph's defeat is debated: later than Pentecost 525 and prior to September 531, probably in either autumn 525 or between 528 and 530 depending on the source preferred. The king's death put a permanent end to the independence of the Himyarite kingdom, which survived as an Aksumite protectorate for about fifty years before disappearing.

The Aksumites took possession of Zafar, the capital, then San'a, Marib, Jawf and Najran. The Jews were murdered systematically, churches founded in abundance and an ecclesiastical hierarchy installed. But Kaleb did not change the political organization at all: he retained the Himyarite throne, on which he placed a Christian Himyarite named Sumuyafa' Ashwa' (Esimiphaios according to Procopius), then returned to Africa leaving some of his army in Arabia to control the country and ensure the payment of an annual tribute.

Sumuyafa' Ashwa', however, quickly lost control of the situation. He was removed from his office by Abraha, the chief of the Aksumite army in Arabia, who reigned in his place, deriving his authority from the power of his army (the army is mentioned in both inscriptions and in the Arabic tradition) but also presenting himself as a Himyarite king. In addition, he had inscriptions compiled in the Sabaic language, adopted the traditional form of royal titles and fully assumed the political and cultural heritage of Himyar. The only changes were those that affected the country's foreign policy and religion.

Abraha reigned for about thirty years, from 535 to approximately 565. Of the first ten years we know nothing except that he was obliged to fight off two attempts at reconquest made by Kaleb. In 547 he defeated a tribe from Kinda that revolted against his rule, and later repaired the broken Marib Dam.

While in Marib, Abraha had a church consecrated. Shortly after, in the fall of 547, he organized a diplomatic conference with the participation of delegations from all the region's powers. The delegations were classed in three categories. Those belonging to the two suzerain powers (the Negus and the "king of the Romans") were called "embassies", the king of Persia was represented by a "diplomatic mission" and the three Arab princes, vassals of Persia and Byzantium, by "envoys". It is impossible to know the agenda of the conference in Marib, but it possibly dealt with the attribution of power zones in Arabia between Byzantium, Aksum and Persia, after the conflict which opposed Byzantium and Persia from 540 to 546. Another important event in Abraha's kingdom, narrated in two of his inscriptions, was an expedition to central Arabia in 552. It enabled him to extend nominal control over eastern and northern Arabia, in particular over Khatt, Tayy and Yathrib.

Abraha's inscription commemorating
the stability of his regime (Marib, Yemen)

Himyar's re-established authority over central Arabia was short-lived, lasting at most ten years. Abraha's kingdom came to an end with a disastrous campaign in western Arabia that is only known through the Arab Tradition. It said that Abraha, who had placed an elephant at the head of his army, had the intention of destroying the Ka'ba in Mecca in order to spur believers to make their pilgrimage to San'a and visit the large church he had just built there. But his army was mysteriously destroyed. The Quran refers to this defeat, one of the founding myths of the Qurayshite tribe's supremacy in western Arabia, in the surat "The Elephant" (105). Some historians debate whether this campaign really took place. Though the motives attributed to Abraha and the role of the Meccans are manifestly apologetic, nevertheless, this undertaking probably provides a background to later events; in other respects, the fact that Abraha's campaign has become a chronological reference point under the name of the "Year of the Elephant" argues in favour of its historicity.

Thanks to its victory over Abraha, Quraysh won immense esteem, which was unexpected for such a small and poor tribe settled in an inhospitable region. The tribe became known as "the people of God" (*ahl Allah*) and its temple the object of general veneration. The large Quraysh fair, which was held at al-'Ukaz, was founded fifteen years after the Year of the Elephant. The cult association of the *Hums*, which linked members of many tribes in western Arabia to the sanctuary at Mecca, was also formed after the expedition. After the death of Abraha (about 565?), his sons Yaksum/Aksum and Masruq succeeded one another briefly on the Himyarite throne but their authority was undermined by dissension. When the Aksumite kingdom of Arabia collapsed around 570 or 575, Byzantium lost its last ally in the peninsula. This marked the final failure of the Arab policy of Byzantium, which had once dreamed of dominating the Red Sea.

### Arabia devastated, under Sassanian rule (575–630)

From the 550s, the stable and powerful states that still controlled the greater part of Arabia began to fall apart, then disappeared one after another in less than fifty years.

To the south Abraha's kingdom was the first to collapse. Around 560 it lost control of the Arabia Deserta, then, about ten years later, it was swept away by a succession crisis. While two of Abraha's sons (Yaksum/Aksum and Masruq) were disputing the throne and struggling to get the upper hand, a Jewish Yemenite prince named Sayf b. dhi Yazan rebelled and easily overthrew the last ruler of Aksumite origin with the assistance of a small Sassanian force (around 570 or 575). At this point Himyar once again regained a little influence: according to al-Waqidi, Sayf sent his son to Mecca to be its governor (*wali*). But Sayf was soon assassinated and Yemen reduced to the rank of a Sassanian province with a resident governor in San'a. No monument or inscription from this period is known, which is indicative of the general decline and the degree to which the South Arabian civilisation had foundered.

The power of the last Hujrid princes at the centre of the peninsula had long been symbolic. The decay had begun with the murder of al-Harith in the spring of 528. Byzantine sources mention only one successor to al-Harith, his grandson Kaisos (Qays) (about 530–540), who ended his career in Palestine in the service of Byzantium. Arabic Tradition has it that the Hujrid principality was shared between the sons of al-Harith, who soon ended up fighting one another. The last representatives of the dynasty wandered from tribe to tribe, like one of al-Harith's grandsons, the famous poet Imru' al-Qays, and finally returned to the Hadramawt. At this point the Hujrids were replaced in the Arabia Deserta by the Nasrid kings of al-Hira, agents of the Sassanian Persians. It is known, for example, that the Nasrid 'Amr (554–569) sponsored a peace treaty between Bakr and Taghlib at the market of dhu l-Majaz, about 35 kilometres east of Mecca.

In the Diocese of the East in the Byzantine Empire, the royal title awarded to Arab chiefs of the Jafnid dynasty (often called "Ghassanid") was abolished in 582. This was probably an error of judgement: if we are to believe the Syriac chronicler Michael the Syrian, "the kingdom of the Tayyites [Arabs] was divided between fifteen princes: most of them sided with the Persians".

In the Sassanian Empire, the Nasrid monarchy, which had been founded at the end of the 3rd century, was suppressed in 602 at al-Hira, probably as the consequence of the eclipse of Byzantine power and the translation of growing disinterest in Arabia, which was no longer a menace on account of the economic and demographic crisis it was suffering.

This was to all intents and purposes an age of disorder. The reliability of the communication routes was no longer guaranteed. The Sassanian rulers were constrained, as the need arose, to negotiate the safety of their messengers and caravans with tribal chiefs to whom they accorded titles and honorific attributes, such as the right to wear a diadem over a turban or headdress (the origin of the appellation *dhu l-ta* – wearer of the diadem). It also happened that caravans were looted by their very escorts.

The Persians, who were present militarily in Yemen and the Arabian Gulf, maintained a certain influence. It was to them that claimants to power turned. Allusions have even been recorded that taxes were levied on their behalf at Yathrib (Medina): a tradition relates that the Persian governor of the Arabian Gulf entrusted this responsibility to the Jewish tribes of Qurayza and al-Nadir, then to a member of the Khazraj tribe, "king" 'Amra, son of al-Itnaba.

To offset the disastrous effects of the state of anarchy, different solutions were attempted. The simplest was to establish or reactivate sacred months, during which all violence was prohibited. During this time it was possible to go on pilgrimages and to fairs without running great risk. A truce of eight months was put in place by the peoples of Banu Murra b. Awf (a division of Dhubyan, about 250 kilometres north of Medina), while Quraysh defended the principle of two annual truces, one of a month and the other of three months. Respect for the Qurayshite truce implied recognition of the sacred nature of the sanctuary (*haram*) at Mecca. Tribes who accepted this principle were called *muhrimun*, while those who opposed it were *muhillun*.

The Quraysh, which proposed that the tribes of Arabia should gather in an association of equals, distinguished themselves by their dynamism and inventiveness. This association, which M. J. Kister calls the "Commonwealth of Mecca", could take several forms. The least restrictive was the *ilaf*, a security pact that linked the Quraysh to a tribe, allowing it free movement, without an alliance (*hilf*) being agreed. The cult association of the *Hums*, which brought together individuals and groups sharing the same religious beliefs and practising the same demanding rites, was first and foremost religious but it clearly had important economic consequences. Representing the beginnings of a community that overcame tribal divisions, it allowed the Qurayshites to secure relationships of trust with distant partners. Finally Quraysh succeeded in linking a number of tribes closely to its affairs: thus several Tamimites acted as judges at the fair of al-Ukaz, Tamim participated in a sort of intertribal militia, and many Tamimite women married Qurayshite men.

The complex commercial networks developed by the Meccans after their victory over Abraha prompted a Belgian scholar, Henri Lammens, to refer to Mecca as a "merchant republic" at the start of the 20th century. However, this description was criticized a few years ago by Patricia Crone, who showed that just before the birth of Islam Mecca was a very modest town of limited resources where the inhabitants were often short of food. Compared to the large caravan cities of the Near East, like Petra and Palmyra, Mecca offered a very lame figure. Nevertheless, it remains that at the time it was one of the most dynamic, with Najran and

'Adan, in the peninsula, and was probably one of the most prosperous and safe since, unlike many other towns of the period, such as Najran, it had no town wall.

There is unanimous agreement that during the fifty years before the Hegira Arabia was a devastated and ruined land, but this unanimity does not exist when it comes to defining the origins of the disaster. Do the roots of the crisis extend back several centuries, or was it caused by a sudden collapse following wars, massacres and epidemics (like the famous "Plague of Justinian")?

On one hand, the climate of Arabia, which had become progressively drier over several thousands of years, began to affect the vegetation and make agriculture in many regions of the Arabia Deserta uncertain.

On the other, it is possible that the ecological crisis had been magnified by a natural cataclysm, such as a large volcanic eruption that might have caused climatic mayhem and brought several years of food shortages. As a matter of fact, several sources relate that during the tenth year of Justinian's reign (536), the sun was so veiled over a period of eighteen months that it resembled the moon.

In short, during the second half of the 6th century Arabia experienced a crisis following unpredictable and sudden events while also suffering an increasingly dry climate. It was an age of unrest, destitution, confusion and apocalyptic expectation reflected by the term "Age of Ignorance" (*Jahiliyya*), coined by the first historians of the Muslim period.

### The remarkable history of the principalities and kingdoms of the Arabia Deserta

The factual history of the many political entities in Arabia mentioned by the sources is not known in detail. We are, however, well informed about the principalities that benefited from the caravan trade of the 1st millennium BC thanks to the combination of important archaeological remains and epigraphic texts. The tribal kingdoms that took over from these principalities around the start of the Christian era have left hardly any trace, with the exception of Qaryat al-Faw.

### *Najran*

The name Najran has always known great renown in the Arabian Peninsula. A stay in this vast and well-watered oasis is made even more pleasant by the fact that the heat is relatively tempered by the altitude. Many times over, throughout history, its agricultural wealth and geographical location made Najran a leading political and commercial centre and an obligatory stop over for caravans travelling between Yemen and the Near East. Actually, the etymology of the name Najran expresses the idea of a "lock". In practice, Najran is the "lock" of the door that gives access to Yemen.

History in Najran began around 700 BC. The oasis, which already bore the name Najran, fell within the small kingdom of Muha'mir. Its fame had already spread across the borders of Arabia as Ragmat, its capital, is twice mentioned in the Bible under the form "Ra'mah". For the prophet Ezekiel (6th century BC), it was clearly an economic power associated with Saba': "Dedan [today al-Ula in the Hijaz] traded in saddlecloths with you. Arabia and all the princes of Qedar [today al-Jawf in the north of Arabia] were your favoured dealers in lambs, rams and goats. In these they did business with you. The merchants of Sheba [Saba' in Yemen] and Ra'mah [Najran] traded with you; for your wares they exchanged the finest of all kinds of spices and precious stones, and gold. Haran, Kanne and Eden traded with you, and merchants of Assur and Media traded with you."[4]

Around 700 a ruler of Saba' tried to take possession of Muha'mir but he failed and had to be satisfied with pillaging the kingdom and imposing a tribute upon it. In the inscription

4. Ezekiel 27:20–23, *English Standard Version.*

written to commemorate his victories, he claims to have killed five thousand men, to have captured twelve thousand and to have seized two hundred thousand camels, cows, donkeys and small livestock, numbers that reflect the abundance of the oasis.

Muha'mir, whose name is only mentioned in the inscriptions found in Yemen and the 'Awad al-Zahrani excavations in Najran, had a very long history as its name was still cited around the 5th century BC. We know the names of three of its kings.

Like most of the tribes, at that time the tribe of Najran worshipped its own gods. The most important was dhu l-Samawi ("The One of the heavens"). A temple named Ka'bat – whose name survived among Arabic-Muslim traditionists as "Ka'ba of Najran", was consecrated to him. The inscriptions also mention the god Yaghuth and the goddesses Allat and al-'Uzza, all three of which appear in the Quran.

The Najran inscriptions are generally written in Sabaic using the Sabean alphabet, more rarely in Ma'inic. But it seems that the languages were not spoken by the local population, which probably used a variant of North Arabic.

Towards the start of the Hellenistic period, or a little earlier, control of the Najran oasis was lost by Muha'mir to Amir, an allied tribe. Around the same period – it is not possible to say to what extent the two events were linked – Najran became a tributary of the small Yemenite kingdom, Ma'in.

In 26 or 25 BC, a Roman army with the intention of conquering the country of incense took Najran without difficulty. Two centuries later it passed into the hands of the Yemenite kingdom of Saba', and then to Himyar (which annexed Saba' around 275). At the start of the 3rd century, the Abyssinians who had invaded western Arabia, seized the oasis and maintained control of it for several years. When it was reconquered by the Sabeans (before 250), the Sabean kings "killed nine hundred and twenty-four and took captive five hundred and sixty-two men in the municipality of Najran, and looted sixty-eight towns in the two valleys named Najran". The number sixty-eight is very close to the seventy-three villages that Najran numbered when it pledged allegiance to Muhammad in 630.

But Najran's great fame is linked above all to the tragic events of the 6th century AD. Christianity had appeared in the oasis about the middle of the 5th century. The proselytism of the followers of the new religion antagonized the king of Yemen, who had a certain Azqir executed around 475. The kings of Yemen, who had rejected polytheism back in 380, were at that time favourable to Judaism.

Fifty years later, in 523, Najran refused to recognize the authority of a new king who officially claimed to be a follower of Judaism. This king, named Joseph (Yusuf), is better known by his Arabic appellation of dhu Nuwas.

Joseph sent a powerful army to capture Najran. The oasis at first resisted, then offered to surrender in exchange for a promise that the lives of the rebels would be spared, but Joseph did not keep his promise. He burned down the church in which the clerics and faithful were assembled, had the city notables beheaded and killed a large number of Christians. The best known of his victims was the famous al-Harith b. Ka'b, who is celebrated as a martyr by most Christian churches, particularly those of the Syriac, Greek and Ethiopian languages. Al-Harith b. Ka'b is the ancestor of the tribe of the same name which still exists today.

Nearby Ethiopia took the massacre as a pretext for invasion, and during the disembarkation of their troops, Joseph was killed. Yemen was entirely conquered and given a Christian Yemenite king to rule over it. A number of Christian kings succeeded one another until 570–575, of which the most famous was the Ethiopian Abraha (535–c. 565).

At the birth of Islam, Najran was still an important financial and commercial centre, apparently the largest after Mecca, with which its economic ties seem to have been strong. It is reported

that when the Meccan Walid b. al-Mughira died, he asked his sons to pay 100 ounces – probably of gold – to the bishop of Najran to settle a commercial debt. This Walid was the father of the famous general Khalid b. al-Walid, who conquered Syria at the head of Muslim armies.

Najran was also an intellectual centre. The oasis was, with Medina (then called Yathrib), one of the few towns to have schools in Arabia. The famous itinerant poet Maymun b. Qays al-A'sha (c. 570–c. 629) liked to visit Najran every year, where he was splendidly welcomed, we are told, with wine and Byzantine songs.

With the creation of a vast empire centred on Syria, then Iraq, the Muslim conquest marginalized Najran, which became a small provincial town. Some of its Christians were sent into exile in 640.

### Qaryat

A little less than 300 kilometres north-north-east of Najran, the oasis of Qaryat (today called Qaryat al-Faw) was an important relay between Yemen and the Arabian Gulf. As has been mentioned, inscriptions inform us that the caravans from South Arabia headed first towards the Levant and Egypt, but this was not an exclusive destination. The development of Qaryat demonstrates that the gulf route was used, particularly during the 3rd and 2nd centuries BC, when Alexander's successors in Asia, the Seleucids of Syria, controlled the Arabian Gulf.

Qaryat – which was excavated for more than twenty years by Professor Abdulrahman Tayeb al-Ansari (King Saud University, Riyadh) – was abandoned before the end of Antiquity, perhaps because its wells had dried up. The vestiges can be seen of a large town, very well preserved since it was never reoccupied, with a necropolis and a business district, including a caravanserai and sanctuaries.

The Qaryat where the Yemeni caravans stopped off was closely tied to the kingdom of Ma'in. It adopted the latter's divinities, and worshipped them alongside its own, Kahl and al-Lah. It does not seem to have been a simple dependency of Ma'in, but – as is shown by various specific characteristics – an ally that enjoyed a certain autonomy. Qaryat's most important tribe was then called "Hanak".

Most of the inscriptions of this period were drawn up in Ma'inic (Minean), nonetheless some are in a North Arabian language (probably the one spoken locally) though written in the

Inscription of Mu'awiyat, son of Rabi'at (see p. 95)

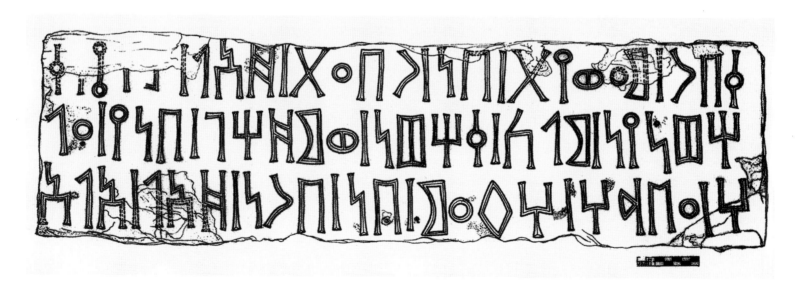

Sabean alphabet. Given its role as an international trade centre, the town was accustomed to welcoming foreigners. On the tombs of those who died there, funerary stelae were inscribed in the tongue of the tomb's occupant, among others Dedanic and Nabataean.

Towards the start of the Christian era, Qaryat recovered its independence and became the centre of a small kingdom dominated first of all by the tribe of Madhhij, then the tribe of Kinda. The titular god here was always Kahl. His name is found on the small bronze coins struck locally, which signals that the temple probably played a role in their minting or the collection of taxes. It is noteworthy that, with Hagar, Qaryat was one of the rare states in the peninsula to have struck coins, even if they were only of poor-quality bronze and confined to local exchanges. The importance of Kahl can also be deduced from the name the Sabeans gave to the oasis: "Qaryat dhat Kahl", meaning "Qaryat of the (god) Kahl".

The first known king, whose title was "king of Madhhij and Qahtan", was Mu'awiyat b. Rabi'at, and reigned about 100 AD. It seems that Qahtan was the name of a local tribe whereas Madhhij was the name of the tribe of Mu'awiya, who conquered the oasis. Saudi excavators have found his tomb, which comprises a large funeral chamber hollowed out of the ground and a fine limestone monument.

Mention is made of a second king in the 220s. Probably in reaction to raids against his kingdom, the king of Saba' attacked Qaryat. He plundered the oasis and captured its ruler Rabi'at b. Mu'awiyat, "king of Kinda and Qahtan", whom he took back to Marib, his capital, as a prisoner. Inscriptions tell us that Rabi'at was a descendant of Thawr, the name that five centuries later Arab genealogists gave to Kinda.

Although the tribe of Kinda later enjoyed a brilliant period, particularly in central Arabia where three of its kings became the governors of a vast Arab confederation on behalf of the kings of Himyar, it does not seem that Qaryat was still its capital. It appears to have been shifted to the Hadramawt, where the elite of the tribe seems to have emigrated around the year 300.

No indication of Christianization (which contradicts a claim by a 10th-century author) or Judaization has been found in Qaryat, which suggests that the oasis was abandoned around the 4th century.

## Hajar

Caravans heading for Mesopotamia from South Arabia had a choice of two routes. The first ran alongside the Red Sea, then passed through Tayma and Dumat al-Jandal, and led into the Euphrates Valley upstream of Babylon. When this route was impracticable, an alternative for traders leaving from Najran was to join the coast of the Arabian Gulf and travel by sea and river. In this case, it was obligatory to pass through the kingdom of Hajar (Gerrha in Greek), whose territory approximately corresponded to the present province of Hasa' in Saudi Arabia.

First mention of this little kingdom is given by a few silver coins minted in the Hellenistic period. These are tetradrachmas that imitate those of Alexander and refer to "Harithat king of Hajar". Hajar is also mentioned in two inscriptions in southern Arabia: in the first a woman from Hajar was naturalized in Ma'in; in the second, two women who stated they were "Hajarites" were buried in Haram in the Jawf.

If we are to believe Greek writers in the Hellenistic period, a powerful city-state named Gerrha existed in the same region at the same time. Its precise localization is still debated. According to D. T. Potts, Gerrha can be located at Thaj because it is the only large archaeological site from the Hellenistic period in eastern Arabia. Another possibility is al-Hufhuf (Hofuf). But given the similarity of the names (as "Hajar" was then pronounced "Hagar"), it is certain that Gerrha was the Greek name for Hajar.

One source seems to differentiate Hagar and Gerrha. Eratosthenes of Cyrene (died c. 195 BC), who is cited by Strabo, mentions the Agreans and Gerrheans as though they were two different peoples. That is probably explained by the fact that the author juxtaposes citations taken from different sources.

The importance of Hajar/Gerrha in the redistribution of the aromatic products from southern Arabia is underlined by the fact that at that time two varieties of incense were recognized: "Minean" and "Gerrhean". Moreover, according to Agatharchides of Cnidus, "no people seems more prosperous than the Sabeans and Gerrheans, as they have stored all that is due to them as profits from Europe and Asia".[5]

This opulence probably explains the reason for the expedition that took the Seleucid king, Antiochos III, to Gerrha in 205 BC. The king did not succeed in taking the city but, in exchange for a decree passed in his honour and matched by a gift of 500 talents of silver (more than 10 tonnes), 1,000 talents of incense and 200 talents of *stactè* (liquid myrrh), he agreed to recognize the "perpetual peace and freedom" the city enjoyed.

Two Gerrhean merchants are referred to in the Mediterranean world. Temallatos (Taymallat) made several offerings in the sanctuaries of Delos during the 140s BC, and Kasmaios, the son of Abidos, dedicated an altar to Helios (Sun) on the island of Cos around the same time.

Hagar's greatest divinity was the Sun, called Shams in the local language. Various series of coins were struck in his name, which was written in full or with only the initial.

The North Arabians that made offerings to Shams in a temple in Marib in Yemen were probably from Hagar. In any case they came from eastern Arabia, as Norbert Nebes has shown, because they date their text from the time of the first king Seleucos in the Babylonian style. One of the texts also mentions a goddess called "She who is in the heavens".

Writing about the population of Gerrha, Strabo makes an interesting remark: that after fleeing Babylon, Chaldeans went to live in the city. This would explain why Aramean progressively replaced South Arabic in the inscriptions and on coins.

In the 3rd century AD, eastern Arabia passed into the sphere of control of Sassanian Persia. It was given the name Bahrain and had Hajar (today Hofuf) as its capital. Nestorian Christians had many followers. The compendium of Nestorian synods, which was written in a Syriac type of Aramean, mentions two bishoprics on the mainland (Hagar and Khatt) and three in the islands just offshore.

### The oases of the northern Hijaz

The oases of the northern Hijaz always had a key political and economic importance. It was in one of them – Yathrib (renamed Madinat al-Nabi, the "Town of the Prophet", or Medina in English) – that Muhammad founded Islam.

For the caravans travelling between Yemen and the Mediterranean world, these oases, scattered in a particularly desolate and inhospitable region, were a necessary point of passage. As a result they controlled trade closely and made large profits from it.

The principal oases are four in number. From south to north, they are: Yathrib (Medina), Khaybar (it has kept its name), Dedan (al-Ula) and Tayma (same name). The distances between them are:
– Yathrib – Khaybar: 145 kilometres;
– Khaybar – Dedan (al-Ula): 170 kilometres;
– Dedan –Tayma: 130 kilometres.

5.  Strabo, *Geography*, XVI, 4, 19.

Thus the distance between the southernmost (Yathrib) and northernmost (Tayma) is 365 kilometres. All four have a large farming population and vast gardens, orchards and palm groves irrigated by the abundant underground water.

The interests shared by these oases – the need to protect themselves against hostile enterprises and to profit from the caravan trade – led them to ally themselves, apparently without forming a unified political group. For them, it was unquestionably the rules of the tribal world that prevailed.

**Tayma**

Between the 8th and 6th centuries BC, the oasis of Tayma was the site of an important walled town dating back to the 2nd millennium, which seems to have enjoyed a certain pre-eminence.

Its writing appears to have been known as far as North Syria, if we are to believe a curious text from Carchemish (on the current Syrian–Turkish border) drafted in Luwian hieroglyphs. The author of this document, a certain Yariris, who acted as regent during the minority of the ruler in the 8th century BC, boasts mastering twelve languages and various scripts. The four scripts of which the names survive are: ". . .the writing of the city, the writing of Surat, the writing of Assyria and the writing of Taiman. . .". There is little doubt that "the writing of the city" refers to Luwian hieroglyphs and that "the writing of Assyria" is Akkadian cuneiform. "Surat" may mean Tyre, thus its writing would have been Phoenician. That leaves "Taiman": the probability is very strong that the reference is to the script of Tayma, that is to say the Arabic alphabet of which one variety was used in North-West Arabia and another in the rest of the peninsula.

Tayma, whose name was often associated with that of Saba (see the Assyrian text of Ninurta-kudurri-usur) and Dedan (Job 6:19; Isaiah 21:13-14), was an important centre of the caravan trade. According to the prophet Jeremiah (early 6th century BC) it was a power to be reckoned with in Arabia: ". . .what Jeremiah prophesied against all the nations [. . .] Edom, Moab, and the sons of Ammon; all the kings of Tyre, all the kings of Sidon, and the kings of the islands beyond the sea; Dedan, Tema, Buz, all the shaved heads; all the kings of Arabia and all the kings of the mixed tribes who dwell in the desert; all the kings of Zimri, all the kings of Elam, and all the kings of Media."[6]

The conquest of the large oases of the Hijaz by the Neo-Babylonian king Nabonidus (see above) probably shocked the peoples who thought the desert protected them. It is no surprise that several rock graffiti close to Tayma, written in the local language but using the Tayman script, mention "Nabonidus, king of Babylon" or "the king of Babylon". Inscriptions discovered in Tayma itself date from the period of Nabonidus or later. The most important are written in Aramaic.

The Tayma oasis probably received many refugees after the defeat of the two revolts against the Romans led by the Jews in the province of Judea in 67–73 and 132–135 AD. At the start of the 3rd century, the ruler of the oasis had a Jewish name, like most of the members of his family, which suggests that he was Jewish. And this was also the case in the middle of the 4th century. This information appears in two inscriptions written in Nabataean-type Aramaic, one found in Tayma and the other in Mada'in Saleh.

Another reference to Tayma appears in a report by the historian of Medina, 'Umar b. Shabba, of one of the few conversions by Arabs to Judaism. A group from the tribe of Bali, who had been threatened with a vendetta, asked the people of Tayma to give them protection. The Taymanites welcomed them into their fort, but on one condition, that the Baliyotes converted to Judaism. The term was met.

Excavation of the site, which was begun by the Department of Antiquities of the Kingdom of Saudi Arabia, was resumed five years ago by a joint German and Saudi team.

6. Jeremiah 25:13, 21–25.

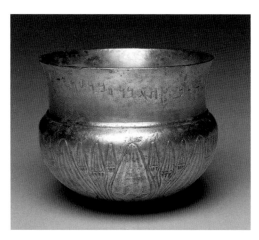

Silver vessel with an inscription from Tell al-Maskhuta
(see "Qedar" below)

## Dedan and al-Hijr

For several centuries from the 5th century BC on, the oasis of Dedan seems to have supplanted Tayma. The Bible mentions it nine times in all, a reflection of its importance.

The identification of Dedan with al-Ula is above all based on local inscriptions written in the Dedanic language, along with the Arabic alphabet. They mention Dedan, notably in the title "king of Dedan". The centre of the oasis initially lay in the southern part beside the palm grove. Today this area is under excavation by a mission from King Saud University of Riyadh. At the start of the Christian era, the centre was shifted to al-Hijr (Higra' in Aramaic, today Mada'in Saleh), about 30 kilometres north.

About one thousand inscriptions from around the 7th century BC were discovered at al-Ula. They mention a kingdom whose rulers bore the title "king of Dedan". Later, during the Persian and Hellenistic periods, a number of rulers called themselves "king of Lihyan". This would suggest that the royal title had been changed to the name of a tribe rather than the name of a place. It is possible that the kingdom of Lihyan then dominated a territory much larger than the oasis of Dedan, perhaps incorporating Tayma.

During the period of the kings of Lihyan, Dedan welcomed a large Minean colony, which had its own temple (dedicated to the god Wadd) and market. Conversely, the Lihyanites left inscriptions at Qaryat al-Faw in southern Arabia.

At about the start of the Christian era, the Nabataeans took control of the oasis. They settled at al-Hijr, which grew considerably. It was from this period that the famous rock necropolis dates, with its splendid façades cut in the sandstone like those at Petra.

In 106 AD, Rome annexed the Nabataean kingdom. Al-Hijr became a Roman town, as is illustrated by a superb Latin inscription from the end of the reign of Marcus Aurelius (161–180).

An inscription in Nabataean-type Aramaic, dating from the middle of the 4th century, mentions princes of al-Hijr with biblical names. This fact is indicative that Judaism was probably the dominant religion.

Al-Hÿr was abandoned before Islam. The Quran refers to it as one of the victims of divine anger (15:80–84). A French and Saudi archaeological team has been studying the site for about ten years.

## Qedar

In the extreme north-west of the Arabian Peninsula, close to Syria, the oasis of Dumat (today Dumat al-Jandal) was once another important centre. It was the residence of the "Arab" rulers of Qedar that the Assyrians attempted to subject.

Some two hundred and fifty years later, a certain Qaynu, the son of Gusham, king of Qedar, offered a silver container to the goddess han-Ilat (the archaic form of al-Lat) in a temple at Tell al-Maskhuta to the east of the Egyptian delta. Quite logically, its inscription is in Aramaic, the administrative language of the western provinces of the Persian Empire. Around the same time, lists found in Ma'in of "naturalized" foreign women make three mentions of Qedar. Lastly, between 445 and 443 BC, Nehemiah, the governor of Judea, complained about his neighbour "Geshem [Gusham] the Arab".[7]

The kingdom of Qedar disappeared during the 4th century. Gaza, which it seems was a dependent of Qedar, became linked to Syria and Edom an autonomous province. This critical political reorganization permitted the emergence of a new regional power – Nabat. In 312 BC it was this tribe and no longer Qedar that the Greek king Antigonus confronted in the south of the Levant.

7. Nehemiah, 2:19, 6:1.

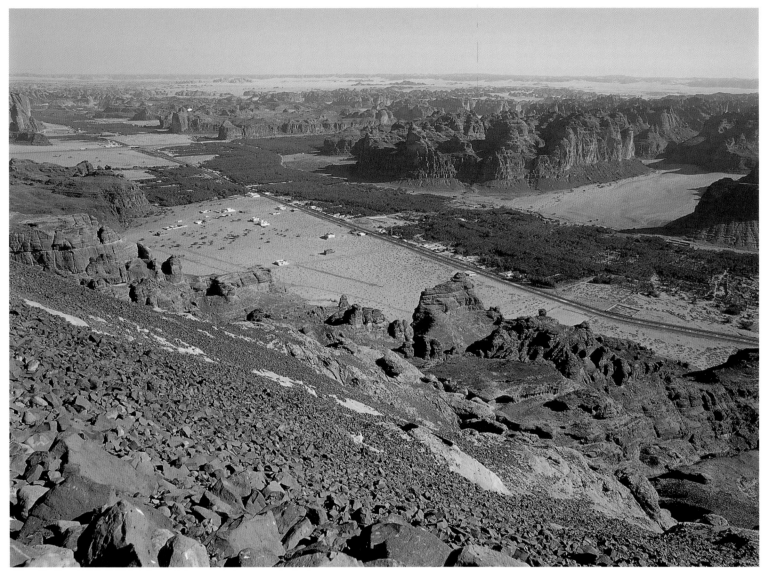

Oasis at al-Ula

**Bibliography:**

Abdul Nayeem 2000; Anati 1968 a; Anati 1968 b; Anati 1972; Anati 1974; Al-Ansari 1982; Avanzini 1997; Beaulieu 1989; Beeston 1982, pp. 178–86; Brock 1999, pp. 85–96; Callot 1990, pp. 221–40; Calvet and Robin 1997; Caskel 1966; Caussin de Perceval 1847; Chabot 1902; Conti Rossini 1910, pp. 705–50; Crone 1987; Cuvigny and Robin 1996, pp. 697–720; Detoraki and Beaucamp 2007; Drewes 1986, pp. 767-9; Edens and Bawden 1989, pp. 48–103; Eichmann, Schaudig and Hausleiter 2006, pp. 163–76; Eph'al 1982; Fabietti 1988, pp. 348–56; Fahd 1987; Farès-Drappeau 2005; Faure 1987; Gadd 1958, pp. 35–92 and pl. I-XVI; Gagé 1950; Gajda 1996, pp. 65–73 and pl. I; Galter 1993, pp.ppp. 29–40; Gil 1984, pp. 145–66; Groom 1981; Hawting 1999; Hayajneh 2001 a, pp. 22–64; Hayajneh 2001 b, pp. 81–95; Healey 1993; Hirschfeld 2006, pp. 19–32; Hoyland 2001; Jameson 1968, pp. 71–84; Jaussen and Savignac 1909; Jaussen and Savignac 1914; Kennedy 1997, pp. 531–44; Korotayev, Klimenko and Proussakov 1999, pp. 243–76; Kennet, 2005, pp. 107–18; Kennet 2007, pp. 86–122; King 1980, pp. 37–43; Lammens 1911; Langfeldt 1994, pp. 32–60; Liverani 1992, pp. 111–15; Macdonald 1994, pp. 132–41; Macdonald 1995 a, pp. 1351, 1355–369; Macdonald 1997, pp. 333–49; Macdonald 2009; Macdonald and King 2000, pp. 467–69; Maigret 1997, pp. 315–31; Marek 1993, pp. 121–56; Mollat and Desanges 1988; Morony 1995, pp. 73–87; Müller 1978; Müller and Al-Said 2002, pp. 105–22; Al-Najem and Macdonald 2009, pp. 208–17; Nehmé 2004, pp. 631–82; Nehmé 2005, pp. 155-75; Nehmé 2005-2006, pp. 179–225, 345–56; Nehmé, Arnoux, Bessac, *et al.* 2006, pp. 41–124; Newby 1986, pp. 121–38; Newby 1988; Noja 1979, pp. 283–316; Olinder 1927; Patrich 1990; Peters 1988, pp. 3–26; Potts 1990; Potts 1991; Potts 1994; Pritchard 1974; Retsö 1991, pp. 187–219; Retsö 2003; Robin 1991; Robin 2001 a, pp. 206–17; Robin 2001 b, pp. 113–92; Robin 2003, pp. 97–172; Robin 2004, pp. 831–906; Robin 2006; Robin 2008 a, pp. 167–202; Robin 2008 b, pp. 233–44; Rubin 1986, pp. 313–47; Ryckmans 1947, pp. 307–32, 526–34; Ryckmans 1951; Ryckmans 1956; Ryckmans 1964, pp. 413–54; Ryckmans 1986 a, pp. 407–17; Ryckmans 1987, pp. 297–305; Ryckmans 1989, pp. 113–33; Al-Sa'id 2000; Al-Sa'id 2002, pp. 11–38; Salles 1988; Sanlaville 1992, pp. 5–26; Sanlaville 2000; Schiettecatte and Robin 2009; Shahîd 1971; *Silsilat athar al-Mamlaka al-'arabiyya al-sa'udiyya*, 2003; Sima 1999; Simon 1970; Simon 1989; Al-Talhi and Al-Daire 2005, pp. 205–17; Tardieu 1992, pp. 15-24; Tardieu 1994, pp. 59–75.

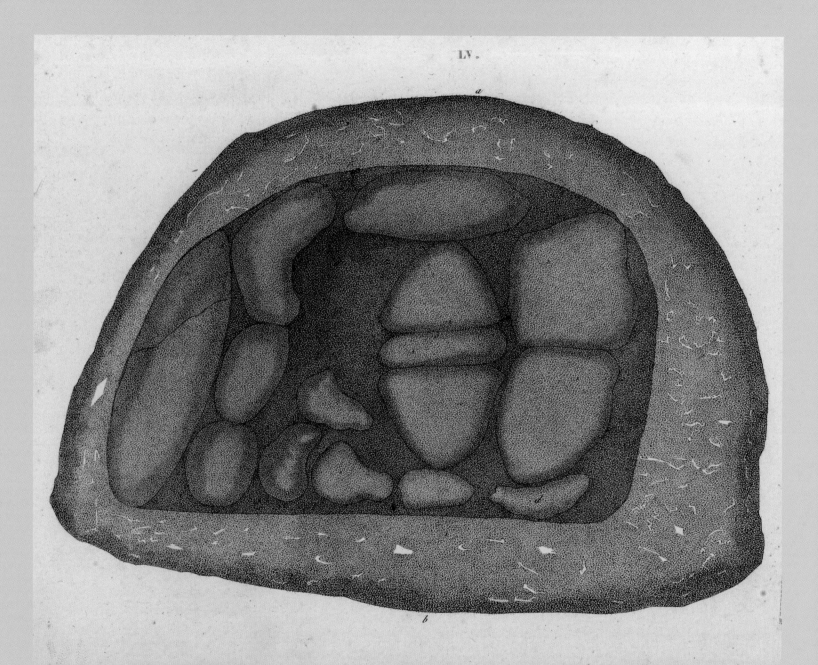

LV.

Déssiné par Ali Bey.

# THE ORIGINS
# OF ISLAM

*Jacqueline Chabbi*

Islam arose in Western Arabia in the early 7th century in the city of Mecca. According to Muslim tradition a man of this city named "Muhammad" was inspired by a divine revelation to "warn" his people of the dire fate threatening them if they did not reform their ways. The name Muhammad means "he who is worthy of praise". Praise is first given to the divinity, who is glorified when *al-hamdu li-llah* is pronounced. This man Muhammad was the son of Abd Allah (literally "God's slave"). Abd Allah must have died very early, because in the Quran (**93**, 6) Muhammad is said to be an orphan, reportedly first raised by his grandfather, Abd al-Muttalib, and following his death, by his uncle Abu Talib. Muhammad belonged to a patriarchal Meccan clan, the sons of Hashim (the Hashemites) whose descendants are still known today in several important Arab families. Muhammad's tribe, the Quraysh, was made up of a score of leading clans that constituted the *mala*, the "assembly of notables, clan chiefs" who governed the city. Originally nomadic, following the steppe around Mecca, the Quraysh tribe took root in the city only a few generations before Islam, after having prevailed over the Khuza'a tribe that formerly ruled the city.

For this claim historians rely on the Quran itself and the works that reached us in the form of manuscripts taking up the tradition of Muslim historiography, which was established by the late Muslim 2nd century (8th century AD) and especially during the next century. Many of these manuscripts began to be published in Arabic in the 19th century, but very few of these works have been translated. The historiographic tradition of the first centuries of Islam, produced in the composite, complex circles of the Abbasid caliphate whose newly founded capital was Baghdad (in 762), examines the period of the origins of Islam with presuppositions, especially religious, tending to idealize the past, its events and actors. Therefore all these books must be subjected to the critical interpretation practised by today's social sciences if we wish to understand early Islam from a historical viewpoint.

The Black Stone, *Voyages d'Ali Bey el Abbassi*, Paris, 1814, vol. 2, pl. LV, Bibliothèque nationale de France, Paris

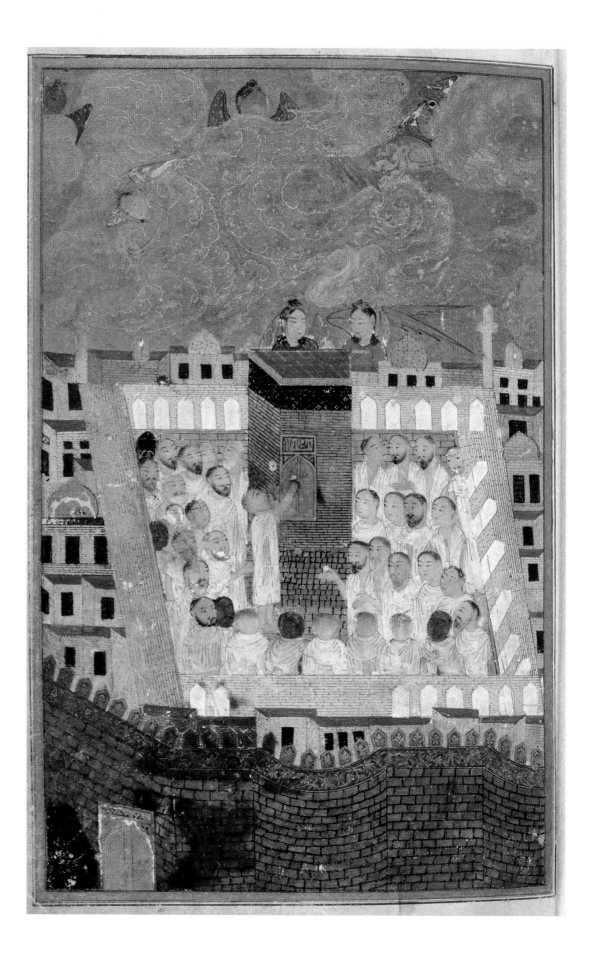

Pilgrims in the sanctuary at Mecca,
*Anthology of Iskandar Sultan*, Shiraz,
1410–11, British Library, London,
Add. 27261, fol. 362v–363r

Mecca, the cradle of Islam, is an Arabian settlement offering an outstanding characteristic; it is not an oasis, unlike the other cities of Arabia and notably Medina, the second city in Western Arabia where Islam was established. Located in an extremely arid environment, it owes its creation to the presence of a permanent and sufficiently abundant watering place in the lower part of the city, where several valleys converge draining rainwater runoffs. This well, called Zamzam and located near the east corner of the Ka'ba, still exists. Today contemporary Muslim pilgrims still wish to bring back from it a bottle of water to which all kinds of virtues are attributed. The date of the city's birth is not known, even if we can assume it was founded in the Nabataean period when caravans from the far south of Jordan travelled the tracks of the façade of Western Arabia parallel to the Red Sea, seeking incense and myrrh in eastern Yemen and Hadramawt. Ptolemy, in the 2nd century AD, knew the city under the name Macoraba. Muslim tradition, based on several passages of the Quran, ascribes to the city an Abrahamic origin. Abraham and his son Ishmael are said to have raised the Ka'ba as the first "Holy House [*bayt*]" on Earth and sanctified the site so men could come there in pilgrimage, according to the Quran (**2**, 125, 127).

The Quran was a word before becoming a discourse and even more, a book. This word is presented as revealed to a recipient named "Muhammad" four times in the text (for example, Quran, **3**, 144) and once "Ahmad" (Quran, **61**, 6), making him responsible for "faithfully transmitting" the word that reaches him in the form of a "remote sound" (*wahi*) audible to him alone. "Faithful transmission" is the meaning of the word "*qur'an*" in Arabic before it became a proper noun, the Quran we know. Revelation is very often described as a "fall", *tanzil*, with several derivatives of the same root (*nzl*), like rain that "falls" on the arid earth to enrich it. The first addressee of the Quranic words was the Meccan tribe to which Muhammad belonged. His mission was to "warn" the tribe of what awaited it, "Judgement Day", *yawm al-din*, and the eschatological punishment that would ensue if it did not want to hear the Revelation transmitted to it and which directly concerned it. Thus for a long time Muhammad was designated in the Quran as the "warner", *mundhir*, of his tribe, before receiving the qualifier *nabi*, "prophet", like those whom the Quran presents as Biblical "prophets". Noah, Abraham, Moses, David and Solomon, etc. are in fact all designated in the Quran as prophets. The Quranic text presents their mission for their people as prefiguring and thereby ratifying Muhammad's mission for his people. These Quranic "prophets" of Biblical origin equally received – collectively or individually – the qualification *rasul* which in the Quran and in ulterior Islam became the principal denomination designating Muhammad as *rasul Allah*, "messenger of God". In this Quranic perspective which links Muhammad's mission to that of predecessors, the *rasul* is a messenger insofar as he is the bearer of the (divine) message which he must transmit to his people, because the divinity elected this people to consign to it its "writing", *kitab*, in other words to reveal to it its fate. Writing always retains its supernatural essence, whether it be the fate of peoples, transmitted by the prophets, or the record of the acts of men, laid before them on Judgement Day (record also called *kitab*). Human actions are duly recorded, without anything being omitted, by the divine "scribes" who are also presented as infallible memorizers. This representation of supernatural writing as "supreme memory" or "inscribed" fate refers to the context of oral character which prevailed in the society of early Islam. The stereotype of the *maktub*, "it is written", which is sometimes attributed to Islam in a rather caricatured way, is its remote relic.

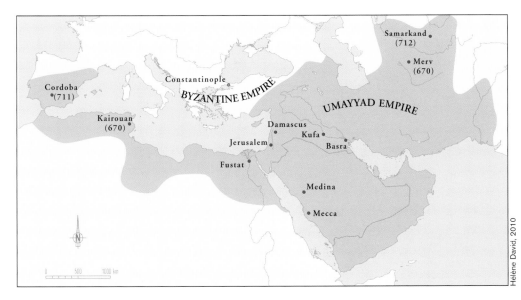

Map of the Umayyad Empire, c. 750

The Quranic discourse, despite its sound demonstration and dramatic description of the eschatological consequences its rejection would produce, was denied by those to whom it was addressed. First Muhammad was described by his opponents – the clan chiefs, leaders of the tribe – as one possessed (by an evil *djinn* – or genie), *majnun*, a wrongly inspired soothsayer or a raving poet (Quran, **52**, 29). He was even accused of repeating stories told him by a stranger to the tribe (Quran, **25**, 5). These accusations feature in the Quranic text, which answers and refutes them as in a kind of polemical contest between the inspired one and his contradictors. Throughout this period Muhammad remained in his city of Mecca. After some twelve years he began to preach and in 622 according to traditional Muslim dating he was excluded from his own clan by his uncle Abu Lahab, who is cursed in the Quran (**111**), and was exiled. This is the Hegira, *al-hijra*, in other words "the flight" from his family and birthplace. The Meccans who followed Muhammad in this banishment would be called "the immigrants", *al-muhajirun*. Subsequently, their speed in rallying became a claim to glory for them and their descendants.

It was at this time that what is known as the "Medinese" part of Muslim preaching began. The rejected messenger sought refuge in the Medinese oasis, four hundred or so kilometres north of Mecca, with another tribe than his own but to which he was reportedly related by his paternal grandmother. The Revelation continued in this city. But its content changed in several ways. The tribal context was new. Muhammad, henceforth identified as the "prophet", was confronted by two local pagan Arab tribes. Soon most of them rallied to his cause and belief, especially because he had become a leader of men conducting victorious actions (raids or "expeditions of the Prophet", *maghazi*), both against his former tribe and hostile neighbouring cities and tribes. In the ambit of this culture human success was normally imputed to the effective protection of a supernatural instance. This inspired the belief that the union of a human group with a divine protector bringing it victory was the good "alliance", *wala'*, in which one should enter. In the case of Islam it meant validating the mission and the word of the one who called to form an alliance with Allah. The god of the Quran was considered the true maker of Muhammad's victories and therefore became the best "ally", *wali*, of the tribes who sought his protection and entered into an alliance with him.

But the Prophet, whose words began to be heard by the local pagan Arabs, was confronted with yet another major obstacle to the credibility of his speech. The oasis of Medina counted in its midst powerful Jewish tribes of farmers and craftsmen legitimately belonging to the tribal confederation assembling the resident tribes. One of them, the craftsmen's tribe, lived in the centre of the oasis. The other two occupied outlying villages near the palm grove they cultivated. Guided by their "masters of the doctrine", *abhar*, and their "rabbi", *rabbaniyyun* (Quran, **5**, 44), they read and commented on their "sacred scrolls", *asfar* (Quran, **62**, 5), "written by their own hands", as claims the Quran (**2**, 79).

Apparently these Jewish tribes and especially their doctrine teachers soon directly opposed the Quranic word, beginning in controversy and ending in armed conflict. Two tribes were banned from the city. The men of the third tribe, that of the Qurayza, were executed, their wives and children enslaved. The pretext for this violent action against these tribes was a breach of the contract of the tribal alliance for which they were made responsible. No "religious" reason was put forth. That would have been far too serious a breach of the social pact governing relations between the different components of Medinese society. Jewish families allied to several mighty Medinese clans remained there, without converting, enjoying the tribal protection these clans warranted them. The Quran refers allusively to the different episodes of this clash, repeating and then refuting the arguments opposed to it by those who at the time were called either "people of the book", *ahl al-kitab*, in the customary translation, or simply *yahud*, "Judeans" (that is, Jews). This terminology was not yet used in the presumed Meccan part of the Quranic Revelation. As for Christians – much less known because scarcely present locally and never in organized groups – they were called *nasara*, meaning Nazarenes. For a while Christians benefited from a favourable prejudice opposing them to the Medinese Jews (Quran, **5**, 82). But they were soon represented in as negative terms as the Judeans, notably when, as if a chance discovery, the dogma of the Trinity was mentioned (Quran, **4**, 171; **5**, 73). They equally ended up by being stigmatized in the same way as the Judeans because of their "monks", *ruhban*, who, just like the "Judean masters" were accused of "squandering" people's money for futile things (Quran, **9**, 34).

Relations between the inspired Meccans and local Judaism seem to have been particularly complex. In the perspective of tribal genealogy that governed this society, the people of the present time were represented as the descendants and heirs of their assumed ancestors. Thus Medinese Jews were seen as somehow belonging to the "tribe" of Abraham and Moses, "prophets" highly lauded in the Meccan Revelation of the Quran. Indeed, when Muhammad was still preaching only in Mecca, the contemporary descent of these great ancestors vouched for the Quranic word against the Meccan pagans who rejected it. Presented under the global denomination of "sons of Israel", *banu isra' il*, they were said to know the true meaning of the divine word because they had already received their Revelation (*kitab*, their "writing" or "book"), a word they had also diffused among their people in the form of a *quran*, a "faithful transcription" (Quran, **10**, 94). It was in this atmosphere, at first seemingly favourable, that Muhammad arrived in Medina. His disappointment was cruel because the hoped-for recognition of his status as conveyor of the divine message by these presumed allies did not produce the expected effect. Instead the Quranic word, as in Mecca, was rejected and derided.

It seems that the change in the orientation of the sacred – the change of the *qibla*, "the direction which the worshipper faces" to adore the divinity – results from this initial incomprehension. When Muhammad was in Mecca this direction pointed northwards. Muslim tradition of the Classical era identified it with Jerusalem which under the Umayyads became the third holy city of Islam. The Quran text seems rather to indicate it was the site of the burning bush, where Moses received from his God the special mission of confronting the Pharaoh (the place designated as "holy valley", *wadi muqaddas*, in the Quran, **79**, 16 and **28**, 30). The new direction, after a hesitation which the Quran allows to clearly perceive, henceforth became the "well-sheltered [by God] place of prostration", *al-masjid al-haram*, in other words the Meccan Ka'ba (Quran, **2**, 142–45), which contemporary Muslims always face during prayer and of which a niche, called *mihrab*, points the direction in mosques.

Quranic inscription from Wadi al-Hurman, near Mecca, dated 84 H./703

Another major consequence of the breach with Medinese Judaism involved the figure of Abraham and secondarily his son Ishmael. They both were among the prophetic figures cited in the Meccan Revelation. Abraham had been named with Moses as the recipient of the "primordial scrolls" (of the Revelation), *suhuf Ibrahim wa-Musa* (Quran, **87**, 19). Later he mostly appeared in loans from Biblical passages as the destroyer of idols in the land of his father (Quran, **37**, 83–97; **43**, 26) and therefore as first defender of the one God and monotheism. Ishmael appeared as a far more secondary figure, often not even related to the Abrahamic lineage, unlike Isaac and Jacob (Quran, **19**, 54; **38**, 48). The brutal breach with Medinese Judaism led to an appropriation of the Biblical patriarchal figure, tending to separate Abraham from his last descendants who had sinned in refusing to recognize the authenticity of Muhammad's prophesy. Henceforth he became Abraham's true successor to the prejudice of his own people, definitively fallen from the election the deity had conceded it (Quran, **3**, 70–71; **7**, 4, 7). In this way the Quran, grouping "Judeans" and "Nazarenes" in the same reprobation, claimed that Abraham was neither Judean, *yahudi*, nor Nazarene, *nasrani*, but "submissive to God", *muslim*, and "follower of a pure cult", *hanif*, (Quran, **3**, 67). The word *hanif*, used only in Medina, has a problematic meaning. It is used to distinguish the true believers from those who strayed (Quran, **4**, 46) among the "people of the book", despite having initially received an authentic Revelation. It is in the logic of this appropriation that the "place of prostration", *masjid*, of the "sons of Israel", in other words the place we identify today as their "Temple", was declared everlastingly destroyed (Quran, **17**, 7) to be replaced by the Meccan Ka'ba, henceforth declared the primordial holy place, raised and sanctified, in keeping with divine instruction, by Abraham accompanied by Ishmael (Quran, **2**, 125, 127).

The prophetic era ended in 632 with Muhammad's death, thus also marking the end of the Quranic Revelation. Mecca had been won over two years before (630), notably thanks to the alliance reversal performed by one of its most powerful clans whose chief was the clever Abu Sufyan, father of the future caliph of the Umayyad dynasty. At Muhammad's death the Medinese confederation included the totality of the fixed settlements of Western Arabia and controlled the surrounding nomadic tribes. Expeditions had been launched in the north towards the Byzantine *limes* and in the Yemenite south. But it is difficult to have a clear vision of the historic presence of early Islam in these regions.

On the other hand Central Arabia remained entirely outside of the Muslim alliance. Subsequent historiographic tradition introduced the problematic figure of a "false prophet"

who wished to rival Muhammad. The Medinese caliphs, Muhammad's direct successors whom the Muslim tradition designates as "Rightly Guided", *rashidun*, all came from Muhammad's Meccan tribe. They belonged to his close circle and were his oldest companions. They were able to preserve the intertribal alliance, albeit recent, which had been formed. At the cost of several battles they soon controlled the entire Arabian peninsula. The Arab tribes' first incursions beyond their familiar territory historically conformed to the peninsula tribes' traditional forays. But this time – entirely unexpectedly – the initial impetus led them much further, towards outer lands, whether it be Iraq and Iran ruled at the time by the Sassanid Persians, or Syria, Palestine and Egypt, tributaries of the Byzantine Empire. However these conquests cannot be claimed to have been in the name of religion, as for over a century and a half after the tribes' exit from Arabia the populations of the conquered countries, who did not belong to the tribal society, were not at all urged to convert to Islam. This tendency was only discontinued under the dynasty of the Baghdad Abbasids who overthrew the Umayyad caliphs in the mid-8th century.

The great Muslim conquests of the second quarter of the 7th century seem more like a series of opportunistic raids, which sustained their progression with their successes and belief in the effective protection of a god granting victory. In the east they were aided by the war of succession ravaging the Sassanid Empire which sank without trace. In the west the conquerors took advantage of the difficulties the Byzantine Empire encountered in the management, in particular religious, of the Near East populations. The progression of the conquests was halted for ten years or so under the Medinese caliphate due to internecine conflicts. They show the difficulties encountered by the men of the tribe, in such a short lapse of time, in governing societies and territories which in no way resembled the collective living conditions they knew in their native habitat. The Meccan family of the Umayyads triumphed over what we might describe as an adaptation crisis and growing pains. Henceforth settled in Damascus, which became the political capital of the caliphate, it pursued the Muslim expansion until the 7th century. This empire extended from the Iberian Peninsula, which was almost entirely controlled, all the way to the great steppe of the plains of Central Asia and the eastern part of the Iranian dominion, present-day Afghanistan, including all the territories of the southern coast of the Mediterranean and temporarily some of its islands, such as Sicily. The Damascus Umayyads directly governed this huge empire for over a century. However in the early days of the dynasty a second internecine conflict arose involving in particular the two prophetic cities of Mecca and Medina. In fact the caliph Yazid, son and successor of Mu'awiya, founder of the dynasty, as soon as he began his reign in 680 had to grapple with the revolt of several important Meccan families who refused to yield the monopoly of caliphal power to the Umayyad clan. The uprising, led by the Zubayrid family, was crushed in 693. Mecca was not spared; during the various assaults of the caliph's troops, catapults were used, destroying in part the Ka'ba, which was subsequently devastated by a fire. The rebel Abd Allah, son of al-Zubayr, who still occupied the city, had the edifice rebuilt with countless precautions, fearful of incurring a divine curse. The Black Stone, *al-hajar al-aswad*, the holy stone, placed in the east corner of the building, had been broken in three pieces. It was returned to its place and mounted in a silver ring. The Umayyads having seized the city restored the edifice and its immediate surroundings to their original configuration – which had been altered by the Zubayrid, who had included in its north-west part the semi-circular area called *hijr* containing, according to some traditions, the tombs of Ishmael and his mother, Agar.

The city of Medina equally suffered during this troubled period: the battle of the Harra in 683 is said to have led the victorious troops to commit many acts of violence in the city. The holy site of the Prophet's mosque remained unscathed. The original mosque consisted of a large inner courtyard overlooked by the rooms of the Prophet's wives. The place was used as the home of the Prophet, his wives, his daughter Fatima, married to Ali, and her two boys, Hasan and Husayn, the Prophet's grandsons. The Prophet's mosque was also a headquarters and place of worship, prefiguring the mediaeval role of the *jami'*, the "great mosque" for the Friday common prayer but also for sheltering pilgrims and teaching students, who formed a circle around their masters seated at the base of a column. Actually the city of Medina, politically downgraded under the Umayyads, became a refuge for the important families excluded from power, distinguished itself as a scholarly city playing the role of a crucible for the study of the holy text and the first Muslim historiographic tradition. The mosque was successively enlarged under the Medinese caliphs and then rebuilt again and expanded in the early 8th century by the Umayyad Caliph al-Walid who had the minarets raised. With successive extensions the mosque incorporated not only the Prophet's tomb but also the graves of the two first caliphs and then those of the Prophet's wives.

Historiographic tradition, which only began to be written in the Abbasid period, presents the Umayyads as worldly rulers, *muluk*, scarcely mindful of religion. It is true that Muslim religious thinking only began to be formulated, through its exegesis of the Quranic text, its legalism, theology and mysticism, after the fall of the Umayyads. The Damascene sovereigns were still very close to their original tribal world where the religious is mostly expressed in terms of alliance. The massive hybridization of Islam with the non-tribal populations who joined Islam as of the Abbasid period had not yet taken place. We should do justice to the Umayyads: by the end of the 7th century they strived to show the world the specificity of their belief compared to the rival religions. This was particularly aimed at the Christianity of the Byzantine imperial adversary. This dynasty was especially responsible for the promotion of Jerusalem as the third holy city of Islam, beside Mecca and Medina. A magnificent monument highlights the religious and political ambitions of the Umayyad dynasty: the Dome of the Rock, highly visible on the Temple Mount, and of which the golden dome overlooks the entire city of Jerusalem. This monument dates to 691. It is not a mosque as we might assume. The mosque known as "of 'Umar", Muhammad's second successor, is located nearby on the esplanade but is clearly apart from the dome. Unique in Islam, this octagonal edifice covers a rock on which was grafted the non-Quranic legend of the "ascension" to Heaven of Muhammad, the *mi'raj*. But the inscriptions on the mosaic cover running along the top of the building are of the highest interest. Quranic verses are inscribed there, like a challenge flaunted in this city which was Christian at the time of its conquest in 638. These verses in particular claim that Jesus was the son of Mary (and not the son of God) and reject the dogma of the Trinity (Quran, 4, 169–171). The conquest of these lands – which were Byzantine – was accompanied by the claim of a new religion displaying its truth. The three holy cities are so intricately linked in the Muslim collective imagination since its Classical period that some mediaeval authors were led to consider that Jerusalem belongs to the Hijaz, the geographic territory which unites the city of Mecca to that of Medina.

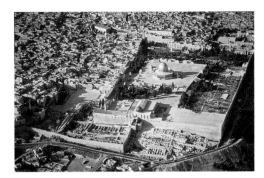

Aerial view of Haram al-Sharif with the Dome of the Rock and the Mosque of 'Umar in Jerusalem

**Bibliography:**
Chabbi 1997; Chabbi 2008; Quran 1955; Déroche 2009; Donner 1981; McAuliffe 2001–06; Paret 1977; Prémare 2002; Prémare 2004; Sourdel 1968; Watt 1953; Watt 1956.

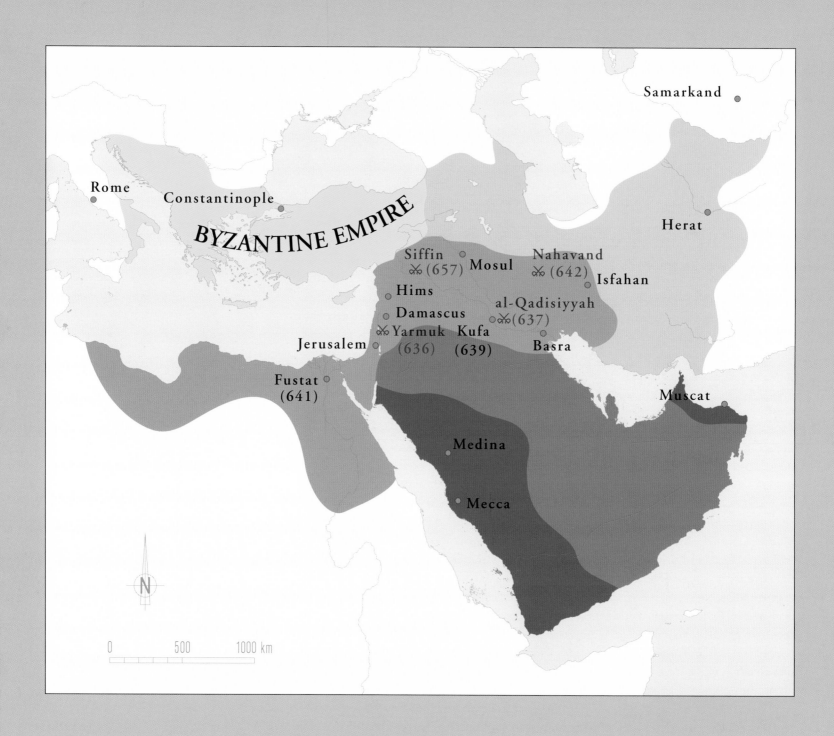

Rome

Constantinople

**BYZANTINE EMPIRE**

Samarkand

Herat

Siffin
⚔ (657)   Mosul

Nahavand
⚔ (642)

Isfahan

Hims

Damascus

al-Qadisiyyah
⚔ (637)

⚔ Yarmuk   Kufa
(636)      (639)

Basra

Jerusalem

Fustat
(641)

Muscat

Medina

Mecca

N

0        500       1000 km

# ARAB

## CONQUESTS

### (630—750 AD)

*Gabriel Martinez-Gros*

The history of Islam began with a century of astounding conquests, unprecedented in speed and scope, and especially impressive for the stability and durability of the empire at first, and later for the civilization that they spawned. Seen in this light, these Arab conquests were more than a phenomenon of social or ethnic expansion. It is clear that they were Arab first and foremost, and contributed to the foundation of a Muslim empire. But whereas the glory years of the Muslim people and their empire are now past, the era of Islam is far from over. Comparing the outcome of the Arab conquests with their nearest counterpart in Mediterranean history, namely the campaigns of Alexander the Great, it is interesting to note that the Greek conqueror's eastward push halted at the same geographic point as the Arabs in the 7th and 8th centuries: the Indus Valley. Yet barely a century after coming under Alexander's rule, the territory of modern-day Iran had already slipped away from his successors. This was not really surprising: ultimately, the Greeks did not have a large enough population pool to exert lasting control over the vast regions they had dominated militarily. But one could say the same about the Arabs, who achieved greater success, and in particular instilled in their successors a concept of continuity through the religion of Islam.

The Barbarian invasions in Europe followed the same pattern as the Macedonian conquests; the victors were rapidly integrated into the vanquished population, a process that generally included the adoption of the latter's Romance languages and Christian religion. Logically, the Arabs would likewise have been assimilated, but nothing of the sort took place, at least in appearance. As they took control of a territory, the Arabs introduced a new religion and even a new civilization. Was this a significant turn of events? Were the Arab conquests a singular phenomenon – perhaps even an anomaly – in human history?

## The drive to conquer

The wars of conquest were closely linked to the life of the Prophet and the beginnings of Islam, making it difficult to separate the wars waged by the Prophet himself from the Islamic conquests that followed his death (in 632). It all began in 622, when Muhammad migrated from

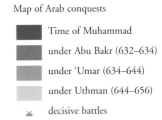

Map of Arab conquests

- Time of Muhammad
- under Abu Bakr (632–634)
- under 'Umar (634–644)
- under Uthman (644–656)
- ✂ decisive battles

Mecca, his birthplace, where he had started preaching a decade earlier. Condemned by a majority of the population, he took refuge in the other large Arabian city, Medina, whose two main tribes converted to the new faith and offered him political control of the town. With their support, and the help of the Meccans who had joined him in his new city, Muhammad mounted a war against the "infidel" city of Mecca. All of the *surats* of the Quran that would later be cited to justify *jihad* were revealed during this war, and the infidels in question were, in the concrete historical context of the revelation, the people of Mecca.[1]

After a series of successes and setbacks, Muhammad finally won the war, albeit after striking a compromise that reflected a rather even balance of power between the two enemy forces. Mecca converted to Islam, and even became the centre of the new faith, the holy city to which all believers must make a pilgrimage at least once in their lifetime. It should also be noted that Muhammad's former fierce Meccan adversaries, notably the Umayyad clan, who had led the city's resistance against Islam, were immediately granted positions of power and responsibility in the new state that united Mecca, Medina and all the tribes of central and western Arabia. The first *jihad* thus ended in reconciliation and the expansion of Islam.

Even as he set about imposing Islam upon the rest of Arabia (a conversion that came with the payment of a tribute; spiritual submission to Allah went hand-in-hand with political submission to His Prophet), Muhammad launched the first Islamic expeditions to the north. Upon his death in 632, the Muslim state was in full expansion but had not yet reached beyond the Arab-populated lands, which casts doubt on what Muhammad's ultimate intentions had been. Did he want the Arabs to set out to conquer the world? Or was his vision limited to the union under his authority of all Arab peoples, including those, already numerous at the time, living in the steppes of modern-day Syria and Iraq? In any case, it was the former principle – world conquest – that his successors would embrace.

## Conquest: The first wave

Muhammad died in Medina on the morning of June 8, 632. It is not an exaggeration to say that the fate of Islam, and of a major part of the world, was determined that day. As soon as the news had spread, the Muslim leaders met to decide on the way forward, and two camps emerged from the initial discussions. The first, headed by dignitaries from Medina, proposed to dissolve the Muslim state and designate two successors to the Prophet, one Medinese and the other Meccan. The Meccan migratories represented, who had backed Muhammad from the beginning, proved a powerful enough voice to impose the second solution, namely the maintenance of a unified Muslim state and the designation of a sole successor, the caliph. The first caliph (632–34) was Abu Bakr, a Meccan emigrant and the Prophet's closest friend. This marked the beginning of a tradition that soon became an established precept: the caliph, successor to the Prophet and head of the Islamic state, must be a citizen of Mecca and a member of Muhammad's tribe, the Quraysh. Throughout the Middle Ages, this title could not be claimed by any other Arab, much less any of the non-Arab Muslims whose numbers would grow rapidly, and who would eventually constitute the majority of believers. Thus, from the day of Muhammad's death, Islam would remain firmly anchored in its land of origin.

However, the discontent engendered by this Meccan hegemony would erupt in the form of periodic revolts in eastern and southern Arabia after the death of the Prophet. Some were fomented by "false prophets"; all had in common the rejection of political submission and by extension of the Islamic state. Meanwhile, Hijaz, Medina and Mecca remained faithful to Abu Bakr as he unfalteringly crushed these uprisings, traditionally termed *ridda* – "apostasy". It was

1. See Morabia 1993, in particular the chapter "Le gihad dans le Coran", pp. 119–43.

the conquests that transformed the begrudging subservience of many Arabs into enthusiastic acceptance of the new religion. A few centuries later the renowned historian Ibn Khaldun (1332–1406) would say that Arab unity was the great miracle worked by the non-miracle-working Prophet who was Muhammad. But that unity was achieved through the conquests. So that one might consider that the conquests were the very miracle that established the irrefutable authenticity of Islam[2] in the eyes of the Arabs.

At the time of the death of Abu Bakr, who was succeeded by 'Umar (634–644), Arab unification was not yet complete. There were large Arab populations beyond the Arabian Peninsula, in the territories that now make up Jordan, Syria and Iraq. The Middle East, which would become the theatre of Arab conquest, was divided between two great powers, the Byzantine and Persian Empires, with roots stretching so far back in history as to obliterate the memory of what had preceded them. It had been centuries since anyone could read the hieroglyphs of the Egyptian temples, the cuneiform tablets of Mesopotamia or the rupestrian inscriptions of Iran.

The two empires, constantly engaged in petty skirmishes if not open warfare, had each had their Arab outposts since as far back as the 4th century. These Arab kingdoms, guardians of the Byzantine and Persian borders, became the first targets of Muslim expansion, beginning in 634–635. They offered no great resistance to the occupying forces, and their populations readily enlisted in the grand adventure undertaken by their cousins from Arabia, striking out against two adversaries at once. The years 634–636 were decisive. The victory over the Byzantines at Yarmuk preceded the occupation of Syria (634–638). An even more spectacular victory at al-Qadisiyyah in 636 brought Iraq under Arab control. To the west, the conquest of Egypt by 'Amr ibn al-'As followed that of Syria (640–642). The first Arab raids reached Cyprus and Tunisia in the same year (647). To the east, the Arabs who now ruled over Iraq pursued their advantage on the Iranian plateau with the victory of Nihawend (642). The last Sassanid Persian emperor died in 652 in what is today north-eastern Iran.

## The second wave of conquests

The victorious Arabs massively occupied their new territories, which would henceforth be a source of wealth and splendour. But even though Arabia experienced a veritable exodus, losing perhaps more than half of its population in two generations, the conquerors still remained a small minority in relation to the subjugated populations. They settled in large garrison towns, or *amsar*: Kufa in central Iraq, Basra to the south, Hims and Qinnasrin in Syria, Fustat in Egypt. Many of these *amsar* grew into the large metropolises of Classical Islam: Kufa gave rise to Baghdad, founded in 762; Fustat was annexed by Cairo after 970; Qinnasrin was replaced by Aleppo in the 9th and 10th centuries.

This initial wave of expansion was interrupted, at least between 656 and 661, by the first Muslim civil war. By rallying to the cause of the Islamic state, the Quraysh had taken the leading role in its administration. Their military capabilities and the scope of their alliances allowed them to gain control over the conquered territories, especially in Syria and Egypt. The dominant Quraysh clan, the Umayyads, found themselves at the head of a religious community and an Islamic empire whose rise they had first sought to repress, a situation that scandalized the earliest converts from Medina and eastern Arabia, who backed the Prophet's cousin and son-in-law 'Ali against the Umayyad leader Mu'awiya during the civil war. Before and especially after his death, Ali's faction would continue to place its hopes on his lineage, which was also that of Muhammad. This was the origin of Shi'ism.

It was the Umayyads who resumed and completed the Muslim conquests. In 670 Mu'awiya established the military camps of Kairouan in North Africa and Merv on the Amu Darya River to

Camp at 'Arafat, photograph by Sadiq Bey, Institut de France Library, Paris, Schlumberger Collection

2. In his assertion that the Arab union exceeded the capacities of purely human action, thus indicating God's intervention in favour of His envoy. Ibn Khaldun quotes the Quran several times (8, 63): "Even if you had expended all the treasures on Earth, you would not have achieved no unity among them", Ibn Khaldun 1958, T. 1, p. 319.

serve as bases for the annexation of the Maghreb and Transoxiana. Both campaigns were difficult. After several advances in the Maghreb, 'Uqba ibn Nafi', the governor of Kairouan, was defeated and killed by the Berbers in 683. The central territories, where the civil war had flared up again between the Umayyads and their enemies, could not send reinforcements before 695. Only then did Carthage fall (698), marking an end to Byzantine power in the region. In 702 the Berber resistance in the Aurès Mountains was broken, and in 710 the troops of the Arab vanguard reached the Atlantic. Called to Spain by a civil war in 711, they wrested control of the peninsula from the Visigoths in just a few battles, advancing as far as Narbonne in 721.

Similarly, in the east, the conquest of Transoxiana did not begin until 695 and ended in 711–713. But these would be the Arabs' final victories. To choose one event that characterizes the subsequent turn of fate in the field of battle, they failed to take Constantinople in 717–718 despite deploying considerable forces. This was not the first Arab assault against the Byzantine capital – Mu'awiya had tested its defences every year between 674 and 678 – but it was the last led by Muslim armies until the Ottoman attack of 1452–1453. This setback was echoed and exacerbated by the defeat and death of the governor of Spain in Poitiers in 732, and by the strong Chinese resistance in Central Asia, even though the latter was successfully but temporarily countered at the Battle of Talas (751). The house of Umayyads fell in 750. The next dynasty, the Abbasids, would propel Islam to its cultural peak without significantly altering its borders, which were merely defended for three centuries. It would be the middle of the 11th century before Muslim conquest resumed, under the impetus of two emerging peoples: the Berbers to the west and, most importantly, the Turks to the east.

## Problems to consider

The most obvious question concerns the reasons behind the stunning, and seemingly inexplicable, military victories of Islam. The Byzantine Empire (or Eastern Roman Empire) ruled over part of Italy, Sicily, the Balkans, Asia Minor, Syria, Egypt and Tunisia, with a total of twenty to twenty-five million subjects. Sassanid Persia, which encompassed present-day Iraq, Iran and Central Asia, probably had a population of about twelve million. In all, the Muslim campaigns pitted thirty to thirty-five million people against a few hundred thousand inhabitants of Arabia, which by any estimate must have had a population well below one million. How did the Arabs manage to prevail in the face of such a demographically unfavourable balance of power?

## Empires in decline

A few explanations have been forwarded: however acute the demographic imbalance, the civilizations that Islam attacked had already been languishing for several centuries. The Byzantine Empire's population had been slowly but steadily falling, with sharp drops caused by outbreaks of the plague in the 6th to 8th centuries. The shrinking of the cities and the contraction of trade were pointing the way toward the "ruralization" of European society in the high Middle Ages. This decline not only reduced the empire's human resources, but also led to the increasing insularity of its many and widely dispersed provinces. Despite a very strong sentiment of "Romanness", provincial autonomy gained ground between the 4th and 7th centuries, weakening the regions' capacity to unite against a potential threat.

Not much is known about the economic and demographic evolution of the Byzantine world, and even less about the Persian Empire. Given the location of the Sassanid capital Ctesiphon near Baghdad, as well as the subsequent history of Islamic Iran, it seems probable

that the two most dynamic regions of the empire were the western tip, in modern-day Iraq, and Khurasan in north-eastern Iran. In both cases, the empires' richest regions, Iraq and Syria, were the nearest to Arabia and the most permeated with Arab populations, who would be the first to submit to Muslim rule, and indeed welcome the arrival of the conquerors. This situation may help explain not only the success of the conquests but also the difficulty of mounting a counter-attack from the less populated and less prosperous provinces that remained under Persian and Byzantine dominion.

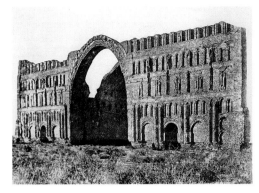

The arch of Kusraw's palace in Ctesiphon (Iraq), 6th century, photograph by Dieulafoy, before 1888

## Religious and ethnic strife

Another reason for the success of the Arab conquests has long been recognized: the resistance that the ruling powers, Persian or Romano–Byzantine, encountered in the provinces that would later be dominated by the Arabs. The demographic decline of the Mediterranean world and the progressive insularity of provincial life served to fuel these resistance movements, dividing the territories along religious and linguistic lines. In the Persian Empire, the Semitic-speaking Mesopotamians were in conflict with the inhabitants of the Iranian plateau, who spoke Indo-European languages, the ancestors of today's Kurdish and Farsi. From the 3rd century to the time of the Arab conquest, this linguistic difference has been accompanied by religious distinctions. While the majority of the Iranian zone seems to have adhered to the ancient Zoroastrian faith, which the Sassanids made a state religion, Christianity in its Nestorian version and Manichaeism[3] were widespread in Mesopotamia. In any case, the Muslim conquerors evidently did not meet great resistance among the Mesopotamian populations.

Similarly, in the Byzantine Empire, Semitic-speaking Syria and Coptic Egypt opposed the Greek-speaking authority of Constantinople on issues of Christian dogma, in the name of Monophysitism or Nestorianism. The simple fact that one could speak of an Egyptian Church or Syrian Church is a strong indication of the revival of local languages, or at least of writing in languages like Coptic in Egypt and Syriac in Syria, linked to the expansion and popular dissemination of Christianity starting in the 3rd and 4th centuries. This cultural rebirth came about to the detriment of Greek, the imperial language, and helped weaken the social cohesion of the Byzantine Empire. Arabic is a Semitic language and a close relative of Syriac. The Arabization of Syria no doubt preceded the country's Islamization, starting in the first centuries after the founding of Islam.[4]

## War and taxes

There is one more reason that could explain the success of the conquests, and perhaps of the conversion to Islam in subsequent generations as well: taxes. The populations were no doubt all the more willing to trade Greek or Persian for Arab rule given the sudden lightening of their tax burden due to the Bedouin Arabs' initial inability to maintain the disorganized imperial administrations. This argument touches upon both the organizational nature of an empire, in comparison with that of the Arab world, and the underlying reasons for the Arabs' success. The Byzantine and Persian empires were states, political entities characterized by the levying of taxes on a disarmed and subjugated populace. Taxation enabled the concentration of wealth in the hands of the administration, which could then supervise the division of labour and the diversification of urban activities; these in turn would lead to gradual gains in productivity and a modest form of capital accumulation. However, as the historian Ibn Khaldun pointed out, no doubt offering the first real insight into this mechanism, the state must disarm its citizens in order to collect taxes, which an armed public might refuse to pay. Thus, the armies of the state

3. Manichaeism is a dualism inspired both by Zoroastrianism, with its division of the world into the realms of light and shadow, and Christianity, with the theme of salvation through the suffering and death of the Annunciator, the prophet Mani, who died in a Sassanid prison.

4. Today the Arabization of the country is nearly total. The Christian minority in Syria consists almost entirely of Arabic speakers. The Kurdish minority is the only exception to the nearly exclusive domination of Arabic.

were by definition made up of professional soldiers, warriors paid from tax revenues. An imperial state, be it Roman, Persian, Byzantine or later Islamic, is antithetical to an army formed by conscription.

In contrast, the Arabs of the 7th century had no concept of the state, taxes, cities and their relative wealth. They had no structured army, no police, no justice system and no silos for long-term grain storage. Their only guarantee against famine or enemy aggression was the traditional solidarity of families and clans. As it happened, this unifying organization proved marvellously effective on the battlefield, for two reasons: first of all, everyone fought, even if there weren't enough weapons to go around, as opposed to the state system in which the warrior function was limited to a small number of specialists who required a sizeable budget. To protect its twenty to twenty-five million inhabitants, the Byzantine Empire had no more than one hundred fifty thousand to two hundred thousand soldiers.[5] The Persian Empire fielded thirty thousand troops at the battle of al-Qadisiyyah (636). The Arab forces were similar in number: between thirty and forty thousand fighters at Yarmuk and twelve to fifteen thousand at al-Qadisiyyah – in all, about one hundred thousand men mobilized out of a population of perhaps half a million souls.[6]

The clannish solidarity that governed Bedouin societies kept them divided into very small groups of a few hundred individuals that could pose no threat to the empires' multitudes. It took extraordinary circumstances – a religious calling, an exceptional leader, an imbalance caused by fortuitous demographic factors that favoured an emerging dominant group – for this solidarity, originally restricted to a few hundred persons (a tribe in the anthropological sense), to expand and unite thousands or tens of thousands of warriors (the Arabs in this case, or the Mongols in a later era, etc.).

## The end of the conquests

As concerns quality of weaponry and the science of warfare, the empires had the advantage. Military sophistication proved to be the determining element in the Arabs' biggest defeat: the siege of Constantinople in 717–718. The city was able to withstand the Arab assault thanks to its fortified walls and, more importantly, the quality of the Byzantine navy and its "Greek fire" incendiary weapon. At the time, there was already a type of combat in which technical know-how was decisive: sea warfare. The Muslims would control the waters of the Mediterranean only for a brief period between the 9th and 11th centuries, from the end of the Byzantine hegemony to the beginning of Italian domination. It was to take them more than two centuries before they could hope to rival Byzantium in terms of sea power.

In any case, for all of these reasons the tax system collapsed for a few short generations in the lands conquered by the Arabs. The breakdown of administrative channels played a role, but was secondary to the fact that the Arabs, at first contented themselves with the pillaging of visible resources like gold and silver. The primary reason for state taxation was to finance an army, and the primitive Arab army had no payroll, or relied for compensation on the resources of the conquered countries – a situation that could not last.

Starting in the early 8th century with the reign of the Umayyad Caliph 'Abd al-Malik (685–705), the new Arab empire reorganized the fiscal system in its favour as voluntary military service became less appealing to the Arabs and the new empire was forced to hire mercenaries. This is one of the reasons behind the halt of the conquests, along with more obvious considerations: the very small total population of Arabs and the far distant theatres of operation in the Maghreb, Spain and Central Asia. To these impediments were added the resistance of the adversaries, especially those who shared the Arabs' type of stateless society,

5. They were divided between two fronts, the Orient and the Balkans, which also collapsed in the face of Slavic advances in the early 7th century.
6. On the composition of the Arab armies, and more generally for an in-depth analysis of the conquests, see Donner 1981.

namely the Berbers in the Maghreb and the Turks of Central Asia, who had contained Arab expansion by the middle of the 8th century. However, physical distance was not always the key problem. The occupation of Spain was secured in ten years (711–721), much faster than the conquest of the Maghreb (670 to 710), which was lost soon after.

Another essential factor that brought the conquests to a close was the Arab transition to a sedentary society. Having conquered two empires, the Arabs quickly adopted imperial methods, not the least of which was maintaining a mercenary army. Starting in the 8th century, the "Arab" armies were less and less Arab and increasingly Berber or Persian. Furthermore, the Islamic state encouraged this evolution in its desire to disarm its subjects, as behoves any state. The civil wars of the early generations of Islam ended with the defeated being either disarmed or exiled to the outer lands.[7] The empire was depleting its own expansionary force, or rather, like all state structures, it preferred domestic peace, obtained by disarming the Arabs, to outward expansion.

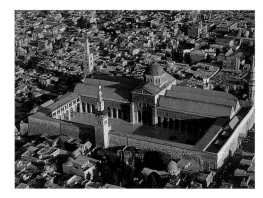

Aerial view of the Umayyad Mosque
in Damascus, 706–715

7. Especially the Arabs of Iraq, who were very hostile to the Umayyads based in Syria, after their final defeat in 692.

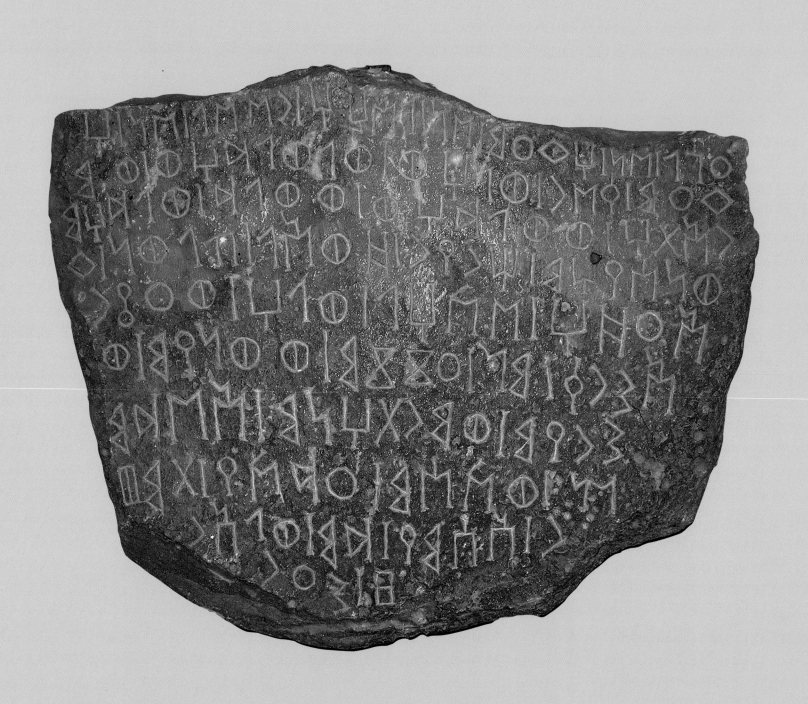

# LANGUAGES
## AND
# SCRIPTS

*Christian Julien Robin*

The languages and scripts of ancient Arabia are known chiefly from epigraphic documents, i.e. from texts written on durable materials such as stone and bronze and, climatic conditions permitting, wood. These documents always had a practical purpose and the most carefully executed were intended for display. They commemorated rituals or the completion of constructions, determined rights or limits, decreed laws, reproduced protective formulae, named the occupant of a tomb, etc. Other documents (letters, contracts and lists for private use) were simply incised on short sticks. No literary texts (founding narrative, historic annals, religious hymn, edifying tale, collection of maxims, poetry, etc.) or technical documents (agriculture, construction, metallurgy, water management, etc.) have survived except 6th century Pre-Islamic Arab poetry. We therefore know nothing about how the ancient Arabians regarded themselves. It is not even certain that such texts existed.

External sources in the principal classical and oriental languages, either contemporary or later, contain very little information on the languages and scripts, usually merely mentioning a technical term or noting the use of an unusual language. The Roman encyclopaedist Pliny the Younger (who died rescuing a friend during the eruption of Vesuvius in 79 AD) recorded the Sabaean names of the two incense crops, *carfiathum* and *dathiathum*, terms clearly derived from *kharif* (autumn), and *datha'*, (spring). Another example is a 6th century Syriac source mentioning a document in the "Najranite language".

The Arab-Islamic tradition is somewhat richer, although its field of visibility extends little beyond circa 550 AD. It was interested primarily in the Arab tongues of western and central Arabia, particularly when they presented irregularities. Muslims paid little attention to the monumental antique inscriptions, except in Yemen, where a few 9th- and 10th-century scholars still able to read the Sabaean alphabet attempted to understand them.

Epigraphic documents are therefore almost our sole source. Although extremely diverse in form and content, they fall into two main categories: the "sophisticated texts" and the "graffiti". The "sophisticated texts" are carefully executed and reflect a more or less concerted process of orthographic, grammatical and phraseological codification. They are written and

Funerary inscription in Arabic and south Arabic script (late 1st century BC), Qaryat al-Faw (cat. no. 130).

executed by professionals usually trained and employed by stable, structured institutions such as the the monarch's office or the major temples. In Saudi Arabia, a comparatively large amount of sophisticated texts come from two regions, the oases of the north-west (Tayma, Mada'in Saleh and al-Ula) and south-west (Najran and Qaryat al-Faw).

The "graffiti", on the other hand, are texts engraved on any available surface, usually stone, by individuals with no particular skill. They commemorate a personal event (passing through a place, good fortune in combat or hunting, etc.) or affirm a regular presence and ownership rights. The quality of the graffiti varies considerably, depending on their author's social background. Some are comparable to sophisticated texts, while others seem to follow no rule at all. They usually reflect more the spoken language, expressed in writing that can stray from the norm. They are brief and allusive documents, consisting of little more than names of persons and, in the north-west, of deities. A great many have been found in Saudi Arabia, on caravan routes and in areas close to the above-mentioned oases.

## The languages of ancient Arabia
### *More than ten languages*

Any inventory and classification of the languages of Pre-Islamic Arabia has to be principally based on the formal texts, whose content is considerably more substantial than the graffiti. Unfortunately, even these texts do not enable an exhaustive investigation. The alphabetic Semitic scripts (the only ones used in Arabia) do not use short vowels and hardly the long ones, so that very different words such as the Arab *malaka*, "he reigned", *malik*, "king", *mâlik*, "possessor", *malâk*, "angel" and *mulk*, "reign", are written the same way (*mlk*). A second limit stems from the fact that all these texts belong to a few highly specific literary genres (commemorations and accounts in the past tense, legal texts, correspondence), and therefore use only a small number of grammatical forms. The identification of common traits and differences on which to base a classification is therefore extremely difficult and vast grey areas still remain.

Eight different languages are currently identified: three are specific to Saudi Arabia (Dedanitic, Hagaric and Old Arab), and two to Yemen (Qatabanic and Hadramitic), two Yemeni languages were also spoken in south-west Saudi Arabia (Sabaic and Minaic) and a Syro-Iraqi tongue was spoken in the Arabian Gulf and the oases of north-west Arabia (two varieties of Aramaic, the Aramaic of the empire and Nabataean). These languages were named after the populations who spoke them.

To these languages one has to add a nebula of other languages, little known due to insufficient documents. These are especially difficult to identify and delimit because there are no abrupt changes in the linguistic and graphic codes from one location to another, merely a continuum with progressive transformations. Usually, these languages have geographically derived names: Safaitic (after the al-Safa hills in Syria), Hismaic (after the Jordanian Hisma), Taymaic (after the Tayma oasis), because we do not know what the populations who spoke them were called. As the only exception, the word "Thamudic", designating unclassified graffiti, refers to the Pre-Islamic tribe of Thamud, to which some scholars had mistakenly ascribed all the graffiti found between southern Syria and northern Yemen. The same appellations are used to designate the corresponding scripts.

All the languages of ancient Arabia belong to the Semitic linguistic family. The Semitic group has several branches: an eastern branch in Mesopotamia (Akkadian, Assyrian, Babylonian), now extinct; a western branch with two sub-branches, one in the north (in the Levant)

with Hebrew and Aramaic, the other in the south (in Arabia) with Arabic; and a southern branch in South Arabia (modern South Arabian languages) and Ethiopia (Ethiopian Semitic languages). Several aspects of this classification, based principally on a reconstruction of the evolution of the verbal system, are still being debated.

The fact that the languages of ancient Arabia belong to the same Semitic family does not mean that they are all similar. Some are closely related but others have many original features. From analysis of these languages and of the contemporary linguistic situation, it can be assumed that intercomprehension was almost impossible. In Arabia today there are two groups of tongues which are not understood outside their specific regions: on the one hand Arabic and its dialects, which can be considered varieties of the same language even if some dialects are very divergent, and on the other, the modern South Arabian languages spoken in Yemen (Socotri, Mahrite and Hobyot) and Oman (Jibbâli, Bathari and Harsûsî). The obstacles to intercomprehension are chiefly phonetic, morphological, syntactical and lexical. Several examples can illustrate this.

The modern South Arabian languages have lateral consonants, non-existent in Arabic, and glottalized emphatics, whereas in Arabic they are velarized. There is no definite article, whereas Arabic has *al-*. Verbs in the present-future tense are conjugated with a vowel after the first consonant (*ikôteb* in the third person masculine singular), whereas Arabic does not have one (*yaktub*). The most commonly used words stem from totally different roots from those used not only in Arabic but by all the eastern and western Semitic languages, for example *riho*, "water", and *ferehin*, "daughter" (*mâ'* and *bint* in Arab).

The Semitic family belongs to the larger Chamito-Semitic group (Afro-Asiatic in American terminology), which also includes ancient Egyptian, Cuchitic in the Horn of Africa, Berber in North Africa and the Chadic languages in Central Africa. It therefore has no recognizable relation with Indo-European, which stretches from India to Western Europe and includes Sanskrit, Persian, Greek, the Celtic languages, the Germanic languages, the Slavic languages, etc. The major Indo-European language in the Near East is Hittite.

Even with the very scanty material at our disposal, it is clear that the languages of ancient Arabia could differ considerably. Taking the best-known language, 6th- and 7th- century "Ancient Arabic" (the Quran, Pre-Islamic poetry, Pre-Islamic Arabic inscriptions and the most ancient Islamic Arabic texts) as the reference, four degrees of distance can be distinguished.

## *Languages very close to Ancient Arabic*
### Old Arabic

The language closest to Ancient Arabic, and also its more or less direct ancestor, is Old Arabic (cat. no. 130). An archaic form of Arabic, preceding the appearance of the Arabic alphabet in the early 6th century AD, Old Arabic is known from a small number of inscriptions in Dedanite (al-Ula), Sabaean (Qaryat al-Faw) and Aramaic scripts (al-Namara, 'En 'Avdat et Mada'in Saleh). The most ancient, from the oasis of al-Ula, certainly date from earlier than the third century BC and could date back to the fifth century. Old Arabic differs in its *al-* type definite article (immediately before the word) and by the factitive verb (a derivative form that can mean "have the action done") of the *'af'ala* type. Its third-person pronouns are formed with the letter /*h*/ (*huwa, hiya, humâ, hum, hunna*, "him, her, both of them, them"). It also has only two sibilants, /*s*/ and /*sh*/.

The *al-* article in Old Arabic is derived from an initial form *han-* and an intermediate form *hal-* (attested in the Najran region and possibly at al-Ula).

### Dedanitic

The language spoken in the kingdom of Dedan (c. 8th–6th centuries BC) and the ensuing kingdom of Lihyan (c. 5th–1st centuries BC) (cat. no. 119, 120). The hub of the kingdom of Dedan was the oasis of al-Ula, *Ddn* in Dedanitic, a name which can be pronounced as Dedan, as in biblical Hebrew, or Dadan, as in Akkadian. The kingdom of Lihyan, named after a tribe which dominated a quite vast territory encompassing al-Ula and also apparently Tayma, used the same language with the same script and was in this respect the continuator of the kingdom of Dedan. Dedanitic (formerly called Dedanite and Lihyanite) is known from about a thousand monumental inscriptions and graffiti, chiefly at al-Ula (ancient Dedan) and in the surrounding area. The definite article initially had the *han-* form, then seems to have evolved into *hal-* and *an-/al-*. Even though Dedanic belongs to the group of languages from which Arabic emerged, its comprehension is still incomplete.

### Hagaric

A number of inscriptions discovered on the southern shores of the Arabian Gulf, mainly in Hasa' province in Saudi Arabia, but also in southern Iraq, are regarded as forming a distinct ensemble because they are written in a distinct variety of the Sabaean alphabet.[1] To which can be added a few coins with the caption "Abiyatha'". The content of these inscriptions, all on funerary stelae, is very poor: only a few words and proper names can be recognized (cat. no. 228). The article, used only with people's names, is *han-*.

These inscriptions, called "Hasaean", after the name of the Saudi province where they were found, could be better described as "Hagaric" because they were probably written by inhabitants of the kingdom of Hagar, better known by the Greek name of Gerrha.

### Safaitic, Hismaic, Taymaic and the many variants of "Thamudic"

We know these languages of the Arabian Deserta from very short and often difficult to read texts composed mainly of proper names. Due to their limited content, these documents are classified by provenance and the alphabet in which they were written, rather than a language about which very little is known. The most important and best known group is Safaitic, written in more than twenty thousand graffiti already copied in the open country and desert between Damascus and the north of the Hijaz. It is named after a mountain range in the Syrian Desert, the Tulul al-Safa – to the east of which the first graffiti were found. The most original feature of Safaitic is its *ha-* article.

Several types of graffiti have been found in great number throughout western Arabia, Jordan and Yemen. Some scholars called them "Thamudaean" or "Thamudic" because they thought they could attribute them to the Thamud, a nomadic tribe from the Tabuk region of the northern Hijaz, in the first centuries AD. Thamud probably disappeared before the advent of Islam. Islamic tradition says nothing about this and according to the Quran the Thamud were one of the peoples God annihilated. The appellation "Thamudic" is now questioned because nothing proves that even some of these graffiti were written by members of the Thamud tribe. The Canadian scholar F. V. Winnett observed that five groups of graffiti can be distinguished in so-called Thamudic, designated first as groups A to E then by geographic denominations. This method was broadly accepted but the appellations were disputed. Following the research on this question by Michael Macdonald and Geraldine King, it is generally agreed that Winnett's ex-Thamudic categories A and E can be respectively called Taymaic and Hismaic. The term Thamudic now applies only to groups B, C, D, and the thousands of texts found in the south-west of the peninsula yet to be studied and classified are for convenience sake called "South Thamudic".

1. Potts 1990b, II, pp. 69–85.

As far as we can tell, Safaitic, Hismaic and Taymaic are closely related to Dedanitic and Hagaric. When these languages have a definite article – a few poorly attested varieties may not have had one – it has the *h-* form (*hn-* in Dedanitic and Hagaric). Third-person pronouns are composed with an /*h*/. The factitive verb is of the *'af'ala* type. These languages have only two sibilants.

### Himyarite

In Yemen, the language of the Himyar tribe also seems very close to Ancient Arabic. It is chiefly known via the Arab grammarians of the Islamic period, who describe some of its singular traits. It wasn't written before Islam but the authors of the latest Himyaritic inscriptions (5th and 6th centuries AD) borrowed many of its terms and turns of phrase.

Safaitic rock decorated with a hunting scene
1st century AD. Musée du Louvre, AO 4980.

### *Sabaic, a language quite close to Ancient Arabic*

Although Sabaic is a different language from Arabic, it wouldn't have been impossible to understand by Arabic speakers. Reading middle or recent period Sabaean texts requires little training for present-day Arabic-speaking students. Sabaic is the most ancient and prestigious language of ancient Arabia. The first substantial text, recounting the victories of the monarch Yatha''amar Watâa, son of Yakrubmalik, dates from the late 8th century BC. It has some five hundred words, and served as the model for all the southern Arabian languages, which use the same phraseology and alphabet and also, to some extent, for the languages of the Hijaz and the Hagaric spoken in the Arabian Gulf. Most of the thousands of inscriptions found are in Sabaic; thousands of archive documents incised on sticks were also written in Sabaic. This is why it is the best-known language of ancient Arabia. It is the only language of which we have a good knowledge.

Sabaic and Arabic differ primarily in their phonetics. Sabaic has three sibilants, /*s*/, /*sh*/ and /*ś*/, whereas Arabic only has two, /*s*/ and /*sh*/. The /*ś*/ is a lateral, spoken by expelling air from only one side of the tongue and not from the middle as with other consonants. This is not specific to Sabaic: it also exists in most of the other ancient Yemeni languages, in modern South Arabic and ancient Hebrew. Sabaic has twenty-nine consonants, all the Arabic ones and the /*ś*/.

As regards morphology and lexicon, Sabaic is close to Arabic, although different in a few aspects such as the place and form of the definite article (-*an* suffixed to the word in Sabaic, *al-* in Arabic) and the prefix of the factitive verb (*haf'ala* in Sabaic, *'af'ala* in Arabic).

Sabaic is so-called because it is attested first in the regions occupied by the Saba' tribe, in the Marib and Sirwah in Yemen. After the conquests by the sovereigns Yatha''amar Watâr and Karib'il Watar (late 8th and early 7th centuries BC), it spread to a number of regions until it was pushed back by Qatabanic, Minaic and Hadramitic, and it was confined to northern Yemen and south-west Saudi Arabia (Najran and Qaryat al-Faw; cat. nos 127, 128, 129). In the 1st century BC, it was adopted by the communities which split from Qataban, particularly Himyar. Following Himyar's unification of southern Arabia, from 300 AD on it became the only attested language in Yemen. In Saudi Arabia, it was the language of the regions controlled by the kingdom of Himyar, such as Najd (al-Ma'sal), 'Asir (Murayghan) and Najran.

During this final period (4th–6th centuries), Sabaic evolved rapidly, with substantial syntactic and lexical changes clearly influenced by Himyaritic and Arabic. It seems that Sabaic was no longer spoken and used only for official and scholarly purposes by the few people capable of using it.

### *Languages different from Ancient Arabic in the south of the peninsula*
#### Minaic

Along wadi Madhab, in the Jawf region of Yemen, five small kingdoms (Nashshan, Kaminahu, Haram, Inabba' and the most important, Ma'in) used the Minaic language. They left about one thousand inscriptions, dating from the 8th century (the beginning of South Arabian civilization) to the 1st century BC.

Minaic is also represented by a number of texts discovered in Saudi Arabia, at Najran, Qaryat al-Faw (cat. nos 135 and 136) and al-Ula. For several centuries at Qaryat al-Faw, during the Hellenistic period and possibly at the end of the Persian period (c. 4th–1st centuries BC), Minaic was the language of the oasis, competing with Old Arabic, before being supplanted by Sabaic. One can assume that the authority of the kingdom of Ma'in was then the prime power within the commercial alliance between many western Arabian tribes. This may have been the case at Najran, where an inscription written in Minaic has been found.

The case of al-Ula is different. The oasis, then the capital of the kingdom of Lihyan, hosted a small but highly autonomous Minaean community with its own temple and laws. It seems that Lihyan was then closely associated with Ma'in in the caravan trade.

Minaic, attested in the mid-8th BC, was the first South Arabian language to disappear, not surviving beyond the end of the kingdom of Ma'in, now dated to the first half of the 1st century AD.

Discounting inscriptions either fragmented or too short, there are only a few dozen texts in Minaic. Stereotyped and repetitive, they are often difficult to understand, particularly when they record the public confessions of those who have transgressed the rules set out by a god, especially those governing ritual purity. Minaic, like Sabaic, has three sibilants and the postponed definite article *-an*. But it differs in its third-person pronouns (which have an /sh/ instead of the /h/), its *shaf'ala*-type factitive verb, the preposition *ka-* to express "to, for", (whereas Sabaic, Qatabanic and Arabic use *la-*) and many other grammatical and lexical particularities.

#### Qatabanic and Hadramitic

Qatabanic, which has a position comparable to Minaic, and Hadramitic, the ancient language most different from Arabic, are merely mentioned in passing here, since the kingdoms of Qataban and Hadramawt never encroached on modern Saudi Arabian territory.

### *Was Aramaic spoken in Arabia?*

On the Arabian coast of the Gulf and in northern Hijaz from the 6th century BC, inscriptions are often written in Aramaic language and script or, more precisely, in several of its varieties. At Tayma, the use of Aramaic, in competition with the local language, seems to have been introduced by the Babylonian conquest in 552 BC. It remained in use there for at least eight centuries, despite political upheavals (cat. nos 103, 105, 108, 109). At Mada'in Saleh, the first inscriptions in Aramaic (the Nabataean variety) date back to the very beginning of the 1st century AD. Aramaic continued to be used there until the mid-4th century, well after the end of the kingdom of Nabataea (106 AD).

These formal texts, found at Tayma and Mada'in Saleh, are not isolated documents. They are complemented by a huge amount of graffiti discovered in the Sinai and northern Hijaz, written in Aramaic language and script. For this reason, it is probable that at least part of the population of these regions, particularly the elite, used Aramaic as a language of culture and communication and also as a spoken language.

In the Arabian Gulf, it seems that during the Persian and Hellenistic periods, there was hesitation between the local language, Hagaric, written in Sabaean characters (cat. no. 228), and a variety of Aramaic. Only Aramaic is still attested after the beginning of the Christian era. We also know that Aramaic was the liturgical language of the Nestorian Christians in the Arabian Gulf, who provided a large number of ecclesiastics and religious authors.

It seems that there were Aramaic-speaking populations living around the Gulf, possibly descendants of the Chaldaeans who fled Bablyon. Strabon mentions their presence at Gerrha.[2]

### Foreign languages

The foreign powers who dominated various parts of Arabia often left written traces of their presence. The Mesopotamian states very probably occupied two islands in the Arabian Gulf, Failaka (in present Kuwait) and Bahrain, where Akkadian inscriptions on stone and clay tablets have been found. At Tayma, a German archaeologist unearthed an inscription by King Nabonidus (556–539), who lived in the oasis for about ten years from 552 (cat. nos 100 and 101). Under Persian domination, Aramaic was one of the languages spoken in northern Hijaz and the Arabian Gulf, and again after the fall of the Seleucids. Alexander's successors wrote texts in Greek in the regions of the Gulf that they dominated, mainly in Failaka and Bahrain, and the local populations sometimes used this language (cat. no. 227). The Nabataeans left numerous inscriptions in northern Hijaz, especially at Mada'in Saleh. After their conquest of Nabataea, the Romans established themselves at Mada'in Saleh and on the Farasan islands, where official inscriptions in Latin dating from the second half of the 2nd century have been found (cat. no. 121). Around the same time, a Roman military detachment recruited from the Thamud tribe built a temple at Ruwwafa whose foundation inscription is written in Greek (the lingua franca in the Roman Orient) and Nabataean. One should also mention the Aksumites in Ethiopia, whose domination of Himyar in the 6th century is commemorated by several inscriptions.

Caravans, travellers, artisans, artists and clerics left numerous traces of their movements. Graffiti in Greek, Latin Nabataean and Hebrew have been found in Hijaz, and a few in Greek and in Nabataean in the Najran region. Rhodean amphorae with Greek stamps have been found in eastern Arabia and Yemen.

In the south, there is a Nabataean inscription near Najran, two bilingual Sabaitic and Nabataean inscriptions at Qaryat al-Faw and another one at Sirwah. A short text in Greek, probably Jewish, was incised in the stone facing of a monument at Bir 'Ali, ancient Qani', the signature of a Greek founder was inscribed on a large bronze statue portraying the king of Himyar, and there are Indian graffiti in a cave on the island of Suqutra. Inscriptions in the languages of Iran and Egypt are conspicuously absent.

### The liturgical languages of the Christians and Jews in Arabia

The liturgical language of the Christians in the Arabian Gulf, chiefly the "Nestorians", was Syriac. Many of the Nestorian church's dignitaries and scholars came from Beth Qatraye, (eastern Arabia). The Christians of Najran were probably either "Monophysites" (anti-Chalcedonians) or "Nestorians". The former, who had close ties with Byzantine Syria, used either Syriac or Greek in their worship, with a probable preference for Syriac, a language close to Arabic. The Nestorians naturally adopted Syriac as their liturgical language.

As regards Himyar after the Aksumite conquest it is more difficult to tell. In churches such as those in Marib and San'a', it could have been Greek, Syriac or Gueze.

Latin inscription, Farasan Islands
(drawing and photograph).

2. Strabon, *Geography*, XVI, 3, 3.

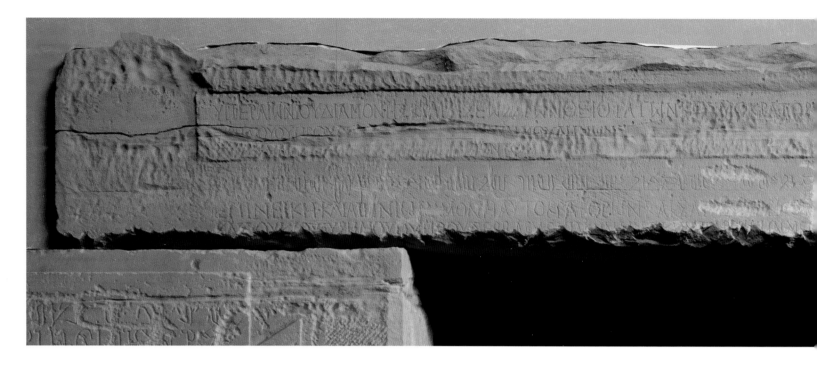

Rawwafa bilingual inscription.

The Jews used Sabaic, Hebrew and Judaeo-Aramaean in their inscriptions in Yemen, but only different varieties of Aramaic in north-west Arabia. The local language was very probably preferred for social purposes and Hebrew and Judaeo-Aramaean for religion and teaching. The many Judaeo-Aramaic terms used in the Himyar tongue confirms this hypothesis. Another clue to this was supplied by the Muslim theologian al-Bukhari, in a commentary on the "Cow" surat, in which he notes that Jews read the scriptures in Hebrew then explained them in the local language.

### *The language of the Jews of Hijaz during Prophet Muhammad's (PBUH) time*

According to Arab-Islamic Tradition, the Jews of Hijaz spoke an Arabic dialect called *yahudiyya,* slightly different from that of the region's other inhabitants. Several anecdotes mention this. It is recounted for example that an inhabitant of Medina called 'Abd Allah b. 'Atik, could speak this Jewish dialect because his mother was a Jew from Khaybar. For this reason, he was appointed head of the expedition which secretly entered Khaybar and killed Sallam b. Abu 'l-Huqayq Abu Rafi', one of Muhammad's leading Jewish opponents. It is also written that during the Battle of the Trench, the sentinel of the Jewish tribe of Qurayza, which captured Khawwat b. Jubayr, spoke *yahudiyya* with his companions. One assumes that this "Yiddish Saracen" was an Arabic full of special turns of phrase and locutions, probably borrowed from Aramaic. However, Jewish poets such as al-Samaw'al de Tayma , whose works have survived, wrote in classical Arabic.

### A single script with numerous varieties

The Arabic alphabets and their manifold varieties can be divided into two families, the "South Arabic or "Sabaean" family in Yemen and neighbouring regions, and the "North Arabic" family between Syria and Yemen. The South Arabic group largely consists of the so-called "monumental" writing used in formal inscriptions in South Arabia and its cursory variety, and the various closely related alphabets used in graffiti in Yemen and southern Saudi

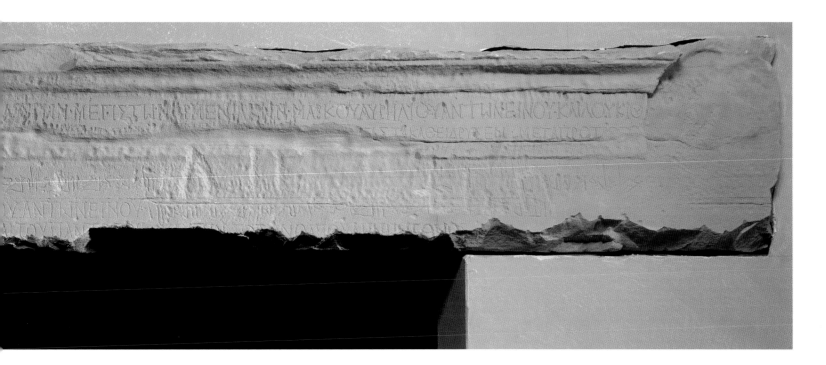

Arabia. It also includes the script used for writing Hagaric in the Arabian Gulf (why the kingdom of Hagar chose to do so is a mystery). South Arabic monumental script can be called "Sabaean" because it was elaborated and formalized in the kingdom of Saba.

The North Arabic family is more complex, with the so-called "Dedanite" monumental alphabet of al-Ula (ancient Dedan), and the wide variety of alphabets used in graffiti. These two families are clearly derived from the same model: the most ancient forms of the Sabaean and Dedanite alphabets are very similar. Nevertheless, this model is neither attested nor clearly situated in time and space. The ensemble can be called "Arabic alphabet".

## The Sabaean alphabet

All the peoples of southern Arabia, the Sabaeans, Qatabanites, Hadramites, Himyarites and the inhabitants of Najran and Qaryat al-Faw, use the same alphabet. Cultural unity is manifest. Only a few letters, usually infrequently used ones such as *ghayn* and *ẓa'*, sometimes have a local form.

Although letters have the same form, modes of execution can vary slightly in time and place (from one kingdom to another), as Jacqueline Pirenne has well shown. Texts can be approximately dated and attributed to a region according to their graphic style. The Sabaean alphabet has twenty-nine letters, all of which note consonants. The order of the letters is known from a handful of alphabet primers: *h l ḥ m q w s² r b t s¹ k n ḫ ṣ s³ f ' ' ḍ g d ġ ṭ z ḏ y ṭ ẓ*

In the most ancient of these alphabet primers, probably dating from the 7th century, the *ḏ* and *z* are inverted. The vowels are generally not written, but when the consonants /w/ and /y/ come at the end of the word they can have a vocalic value instead of their consonantic signification. In Minaic and Hadramitic, the /h/ is sometimes used to indicate the /a/ timbre.

Sabaean script has another six numeric symbols, only used before the Christian era. Four of these symbols are the first letter of a number ('for *'alf*, "thousand"; *m* for *mi'at*, "hundred"; ' for *'ashara*, "ten" and ḫ for *amsa*, "five"). The fifth is derived from such a letter (the half-*m* signifying "fifty"). The sixth is merely a vertical line to denote the unit. To avoid confusion, the letters and symbols used with a numerical value are placed between two specific signs (a double vertical line linked by several horizontal segments). There is a

thirty-seventh and last graphic symbol, the single vertical line, used to separate words. Each letter has its specific form so that it can be distinguished from others. The only ambiguity concerns the *l* and *g*, often written similarly from the beginning of the Christian era. There was a certain wavering in the *ductus* of several letters (particularly *g*, *s³* and *ṣ*) until the reign of Karib'il Watâr in the early 7th century BC, when they were definitively fixed at the same time as strict aesthetic canons. Jacqueline Pirenne considers the formal characteristics of Karib'il Watar's last inscriptions are comparable to those of classical Greek inscriptions (second half of the 5th century BC). She inferred from this that Karib'il had copied a Greek model and therefore must have reigned towards the end of the 5th century. She also observed that after his reign the graphic qualities of the South Arabic inscriptions seem to have evolved in a similar fashion to that of Greek inscriptions: the broadening of the downstrokes, the appearance of *apices* (small points) at the ends of downstrokes, the increasingly pronounced curving of rectilinear segments and the addition of decorative lines and triangles. It is now certain that the inscription in South Arabia did not imitate those of Greece because Karib'il reigned two hundred and fifty years before Pericles's government. Why, then, are Greek inscriptions so similar to South Arabian inscriptions? At the outset, inscriptions could be written from right to left or from left to right, with a marked preference for right-left. The latter became the norm even before the Karib'il Watar period, although for texts of several lines one could begin in the normal direction then change direction with each line. This system, is called "boustrophedon" (from the Greek "ox-turning") because it is like an ox ploughing. It facilitates the reading of texts composed of very long lines on some monuments, but nothing proves that this is why it was used. Boustrophedon ceased to be used several centuries before the birth of Christ. From then on texts were written only from right to left, as in Arabic, Syriac and Hebrew but not Gueze (Ethiopian).

Alongside monumental Sabaean, a cursive variety of script was discovered in the early 1970s. It was used for correspondence, contracts and lists. This cursive is not written in ink, as is often the case, but incised in cigar-shaped or conical lengths of wood. It was deciphered by the Jordanian Mahmud al-Ghul. Cursive texts are extremely interesting since they were spontaneously written by ordinary people in the first or third person. They enriched everyday vocabulary with words such "sesame" and "lentils", not previously attested.

### *Alphabets derived from Sabaean*

In diverse regions of Yemen and southern Saudi Arabia, particularly around Najran and Qaryat al-Faw, the graffiti carved on rocks used a wide variety of alphabets derived to varying extents from Sabaean. Usually, these documents are not difficult to read. This is also the case with Hagarite, because only the letter *ghayn* has a different form from the Sabaean model.

In Ethiopia, the Sabaean alphabet came into use very early, around 700 BC. It was used by Sabaeans living there but also by the local population. From then on it evolved independently and gave rise to diverse local scripts, all purely consonantic. One of these became the alphabet of the kingdom of Aksum. The notation of seven vowels was introduced during the reign of the Negus 'Ezana (mid-4th century). This was done by various modifications to the letter's form, such as the elongation of a downstroke, a gap introduced into a rectilinear segment, the adding of an appendage, etc. The Sabaean alphabet thus became a syllabary script, i.e. one in which each sign represents a consonant and a vowel. This amelioration probably stemmed from the need to have a more precise script for the Gueze translation of the Bible. Due to its status as the liturgical script of the Ethiopian church, the Gueze syllabary script survived all upheavals and is the only descendant of the Sabaean alphabet still in use.

## Dedanite and alphabets of Arabia

Alongside Sabaean in southern Arabia, at al-Ula, the ancient kingdom of Dedan, in Northwest Arabia, Dedanite was another variety of the Arabic alphabet. It has twenty-eight consonants, all the Sabaean ones except the $s^3$, and the only known alphabet primer confirms it has the same letter order as Sabaean. The Sabaean and Dedanite alphabets were originally very similar and one can assume that they were derived from the same model or that one gave rise to the other (either Sabaean was the prototype for Dedanite or the contrary). Sabaean rapidly stabilized and hardly evolved, whereas Dedanite continued to innovate. It is therefore hardly surprising that during the Hellenistic period, after centuries of autonomous evolution, the two scripts became extremely dissimilar.

Taymanite is a script related to Dedanite used in a few inscriptions at the oasis of Tayma, but above all in the graffiti found in the surrounding area. It dates back to at least the 6th century BC, since several graffiti mention King Nabonidus (556–539 BC), who stayed at Tayma for about ten years from 552 BC. It is probably the "Tayman" script which the ruler of Karkemish (on the present-day Syrian-Turkish border) prided himself on having mastered in the 8th century, but we do not yet have enough texts in Taymanite script (F. V. Winnett's ex-Thamudic A) definitely dating as far back.

There is an entire group of Arabic alphabets related to Dedanite: the "Thamudics" B, C and D in western Arabia, "Hismaic" (F. V. Winnett's ex-Thamudic E or ex-Thamudic Tabukite) and Safaitic, and the "South Thamudic" in south-west Saudi Arabia. The history is especially difficult to establish because very few texts are even approximately dated.

Unlike the previous scripts, these were not used by sedentary, dense and stable communities governed by lasting institutions, but by people living in the open country or desert, practising agriculture and itinerant livestock rearing to varying degrees. They were not taught in specialized places of study or apprenticeship of a craft, but more informally, within the family or via contacts between people able to write. Remarkably, each Safaitic alphabet primer places the letters in its own way, as if there was no set order. One can imagine that the alphabet was taught in camps by elders, who ordered the letters in their own way to facilitate their memorization.

Inhabitants of the open country or desert clearly contented themselves with a minimal knowledge of reading and writing, which were used for practical and also playful purposes. This knowledge emerged with the development of long-distance caravan trading and seems to have regressed from the 3rd or 4th century AD, because graffiti written in Arabic script gradually decreased and eventually disappeared. It seems that the anarchic innovations facilitated by the absence of organized teaching progressively reduced the number of potential readers and caused a decline in the use of writing.

## The origin of the Arabic alphabets

The most ancient examples of the Arabic alphabet – a few letters incised or painted on pottery fragments found in Yemen at Yala, Hajar ibn Humayd and Raybun, date from the 9th century BC at the latest.

The Arabic alphabet therefore seems to have appeared later than the alphabetic scripts of the Near East, Pro-Sinaitic, Ugaritic (the script of a small kingdom in the Lattaquieh region of Syria) and Phoenician. It is therefore *a priori* possible, if not probable, that South Arabic script was based on a foreign model. This hypothesis is confirmed by two arguments. First of all, the Arabic alphabet has a high proportion of characters with the same or similar form and the same value as those in Proto-Sinaitic Ugaritic and Phoenician. The order

of the letters of the Sabaean and Dedanite alphabets is the same as Ugaritic alphabets attested at Ugarit (RS 88.2215) and Beth Shemesh in Palestine, the former certainly and the latter probably predating Ugarit's disappearance around 1185 BC. The most compelling argument, however, is that one of the letters of the Dedanite and Sabaean alphabets, the /ẓ/, has a different form. In Sabaean, the /ẓ/ is derived from the /ṣ/, whereas in Dedanite it is the result of a slight modification of the /ṭ/. Both alphabets must have created this letter independently, and consequently the model of the Sabaean and Dedanite alphabets do not have the letter /ẓ/. And nor does the Ugaritic alphabet.

It is therefore probable that the model for the Arabic alphabet was Ugaritic. There is a problem with this, however: the Ugaritic alphabet ceased to be used in the early 12th century BC, whereas the first Arabian alphabetic texts date from the 9th century or a little earlier.

This gap of two or three centuries would imply the existence of an unknown intermediary, possibly to be found at Tayma.

### The Arabic alphabet

Not until the early 6th century AD did Arabic begin to be written in its own alphabet, a new variety of Aramaic script inspired by Syriac script and the late Nabataean script used by Arabs between Syria and the Hijaz. Its first known use is at Zabad, about sixty kilometres south-west of Alep. A short text, naming several people, it complements a large bilingual inscription in Greek and Syriac commemorating the construction of a Christian sanctuary in honour of Saint Serge in 512. The second text, in chronological order, was carved on a rock in Jabal Usays (30 kilometres east of Damascus) by someone sent there on a mission by "al-Harith the king". It is dated 528–529.

The third text, in Greek and Arabic, records the construction of a Christian sanctuary in honour of Saint John at Harran, in the Laja' region of southern Syria. Dated 568–569, it was written by an Arab chieftain ("phylarch" in Greek) unknown elsewhere.

There is a fourth inscription, known solely by a copy made by two medieval Arab authors, al-Bakri and Yaqut, and recalling the foundation of the convent of Hind at al-Hira (the capital of a small Arab kingdom on the lower Euphrates in Iraq). All these examples show that Arabic writing appeared in Syria and Iraq, in a Christian context, and that it was created to facilitate the teaching of Christianity to the Arabs from the desert. This script is still rudimentary. Although it uses the long vowels *i* and *u*, it ignores the *a* (not transcribed as the *alif* until the Muslim period, during the rule of the Caliphs of Medina). There are only fifteen consonants to transcribe the twenty-eight Arabic phonemes, so that the same letter can have two to five different readings. The diacritic points used to distinguish consonants noted by the same letter (*ba', ta', tha', nun, ya', ra', zayn,* etc.) did not appear until the Medina Caliphate, the most ancient example dating back to 22 H./643.

According to Arab-Islamic tradition, the Arabic script was "invented" in the Euphrates valley and rapidly spread from there to al-Hira. A few dates are given. For example, Zayd b. Hammad is said to have learned to speak and write Arabic *before* he learned Persian. As he was in charge of the post of Khosroes (Kusraw I, 532–579) and the regent of the kingdom of al-Hira around 575, between the reigns of Qabus (569–574) and al-Mundhir IV (576–580), one can date his learning Arabic to the second quarter of the 6th century. His son, 'Adi b. Zayd, the famous Christian poet of al-Hira, was secretary to Kusraw I and continued as secretary to Kusraw II (590–628) early in his reign. He was the first in Kusraw's chancellery to use Arabic script. He was executed around 590 by an-Nu'man III (580–602). His son Zayd b. 'Adi l succeeded him as secretary for the affairs of the "Arab kings". Arabic

Ugarit alphabet primer, 13th century BC.
Musée du Louvre, Paris, AO 19992.

script spread from al-Hira to several centres of northern and western Arabia, principally Dumat al-Jandal and Mecca. It appeared at Mecca when Muhammad was still young and it was practised only by very few people at the advent of Islam (al-Baladhuri lists the names of seventeen men and a few women).

It is noteworthy that this script was preferred by Prophet Muhammad at Medina to the old Arabic writing previously in use throughout Pre-Islamic Arabia and then still in use in the Yemen and to the diverse varieties of Aramaic script used by the Christians and the Jews. The reason for this is very probably to be found in the more "Arab" nature of this new writing and in the break it marked with the liturgical languages.

**Bibliography**
Brock 1999, pp. 85–96; Contini 2003, pp. 173–81; Gatier, Lombard and Al-Sindi 2002, pp. 223–33; Lemaire 1993, p. 59–72; Macdonald 1986, pp. 101–68; Macdonald 1995 b, pp. 785–87; Macdonald 2000, pp. 28–79; Macdonald 2004, pp. 488–533; Macdonald 2008, pp. 464–77; Macdonald and King 2000, pp. 467–69; Puech 1998, pp. 31–55; Robin 1974, pp. 83–125 and pl. I; Robin 2005, pp. 1–51; Robin 2006, pp. 157–202; Ryckmans 1981, pp. 698–706; Ryckmans 1985, pp. 343–59; Ryckmans 1986 b, pp. 185–99; Ryckmans 1988, pp. 219–31; Ryckmans, Müller and Abdallah 1994; Sass 2005; Al-Talhi and Al-Daire 2005, pp. 205–17; Villeneuve, Phillips and Facey 2004, pp. 143–90 and figs 63-67 (pp. 229–32).

# THE FRANKINCENSE CARAVANS

*Françoise Demange*

"Arabia is the last of inhabited lands towards the south, and it is the only country which produces frankincense, myrrh, cassia, cinnamon, and ledanum."
Herodotus, *Histories*, III, 107

Throughout antiquity, myrrh and frankincense were highly sought-after commodities. They were considered so precious as to be equal in value to the gold in the gifts offered by the Three Magi to the Holy Child. The Arab merchants who had a monopoly on these products brought them from the southern part of the peninsula to Egypt, Mesopotamia and the Mediterranean regions where they were in great demand. In addition, they supplied these markets with the often rare and costly goods from India and the Horn of Africa that arrived by boat at the Arabian ports on the Erythraean Sea.

From the 8th century BC, when the Arab-Assyrian conflicts[1] first began – attesting to the interest the great Mesopotamian empires showed in this trans-Arabian trade – to the advent of Islam, convoys consisting of hundreds of camels plied the endless paths that criss-crossed the peninsula: for over a thousand years they transported precious spices and heavy loads up and down the legendary Incense Road.

The practical aspects of this trade remain relatively unknown. The writings from local sources, when they exist, describe exploits of war, commemorate the construction of buildings or hydraulic systems, attest to the devotion of worshippers in long dedications to the gods, but provide only bits and pieces of information on how the merchant caravans were organized. This business, though highly lucrative, was not regarded as a very noble activity.

Most of the information we have comes from Assyrian and Biblical sources, and, above all, from the texts of classical writers. All of these elements, backed by the results of archaeological research, provide us with a glimpse into the organization of this long-distance trade network that gave rise to one of the most lucrative commercial systems of the Near East in Pre-Islamic times.

Regular commercial exchanges between the northern and southern parts of the peninsula were already starting to be established, it seems, by the 12th and 11th centuries BC. Trans-Arabian trade, however, did not develop on a massive scale until the 8th century. One of the key factors behind its expansion was the introduction of

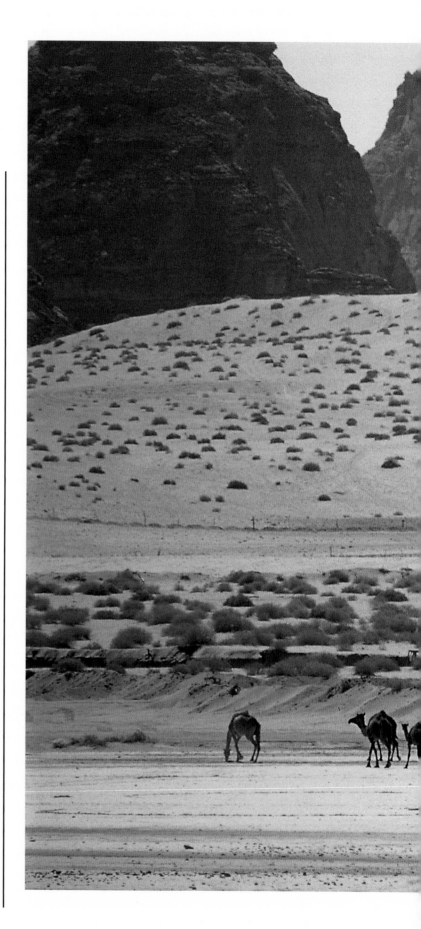

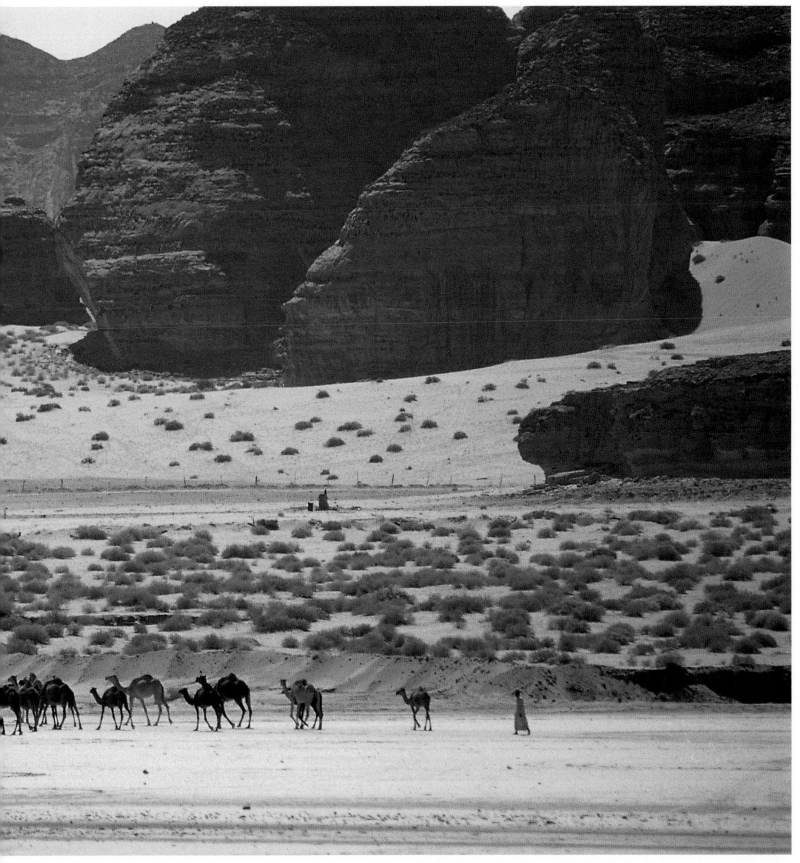

Hijaz landscape

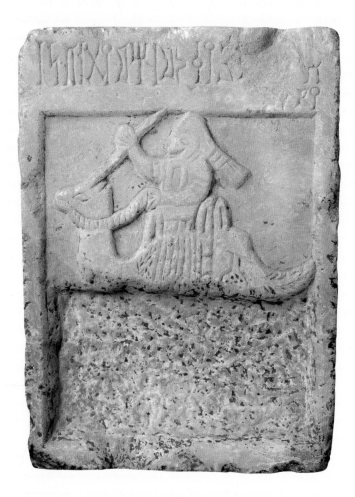

Funerary stele of a camel-driver. Alabaster. Yemen, 2nd–3rd century AD, Musée du Louvre, Paris, Department of Ancien Near Est, AO 1128

dromedary camels as pack animals. In the fourth millennium, camels were hunted as game in south-eastern Arabia; it was not until the third millennium that a gradual process of domestication was initiated and little by little camels began to spread to other parts of the territory.[2] Dromedaries were raised in herds by nomadic herders for their milk and wool, and it was only toward the end of the second millennium that they began to be used as beasts of burden. Camels greatly outperformed the donkeys and small equines that had previously been employed to transport merchandise; their stamina and temperance, in addition to their travelling speed, enabled them to cover long distances across the barren deserts of Arabia. As a result, it became possible to undertake long journeys through inhospitable, previously impassable regions and lengthen the distance between the rest stops.

Pliny the Elder (23–79 AD) furnishes us with a considerable amount of information on the caravan routes that linked the southern part of the peninsula to the markets in the north. It was as a

botanist that the author of *Natural History* took an interest in frankincense.[3] He describes the *Boswellia sacra,* a thorny tree found exclusively in Arabia in the regions of Hadramawt (in present-day Yemen) and Dhofar (in the Sultanate of Oman). He explains in detail how an incision was made in the trunks to collect the sap that oozed out; after it was dried, the resin was separated into large white-coloured lumps that burnt, when placed on heated coals, with a sweet white smoke that rose to the heavens where it was received with delight by the gods.

During the Assyrian period in Mesopotamia and the Levant, frankincense was preferred over the local aromatic herbs as a fumigant; large quantities were used in temples for rituals, as well as in daily life to perfume houses and palaces. Then, as the Mediterranean markets developed, demand increased even further. Much later, consumption of frankincense in Rome rose to phenomenal heights; the Emperor Nero is said to have burned more frankincense for the funeral of his wife Poppaea than Arabia could produce in an entire year.

Pliny states that the resin was collected twice a year. The entire crop was then taken to the great temple in the city of Shabwa in Hadramawt where an export duty had to be paid to the priests: the first of many taxes that would be levied along the way.

After the animals were loaded, the camel train took off towards the west, going around the terrible Rub' al-Khali desert and moving along the foot of the mountains on the outer edges of the deserts. The route went through Tamna, the capital of the kingdom of Qataban, where the frankincense caravans were joined by those that transported myrrh,[4] an aromatic gum made from another kind of tree (*Gommiphora myrrha*) growing in that area. After paying another tax to the king of Qataban, they headed north and finally reached Gaza after a journey of "4,436,000 steps . . . divided into sixty-five camel stations".[5] The heavily laden camels were able to cover approximately 38 kilometres a day, with at least six hours of travelling between each station. From the land of the Sabaeans in the south to Nabataea, Pliny cites not less than twenty-eight peoples and cities that were encountered along the way.

The Incense Road should not be imagined as a single route that went from one place to the next, but, rather, as a web of paths and trails that crossed, intersected and ran parallel to each other. The caravans had to go around or overcome many obstacles, including climatic conditions, winds that shifted the dunes, rocky massifs, and all of these made the journey a difficult process. Different routes were taken based on the time of year, the experience of the guide, how safe the area was, with the latter depending on the often ephemeral alliances between the tribes that controlled the region. Stopping at watering holes was a welcome respite, but it could also be risky. The

wells were known to attract bandits for whom the heavily loaded caravans were easy prey. Instead, the caravaneers often sought out the temporary ponds that formed during the sparse winter rains: they could sometimes provide enough water for the entire camel train while enabling it to avoid dangerous areas.

The big oases served as important stopovers along the way. Over time, they grew into large cities, becoming the capitals of prosperous kingdoms and busy marketplaces that drew many merchants. They provided caravanserais where, as the remains at Qaryat al-Faw show, the merchants could stop and restore themselves.

These cities were famous far and wide for their opulence and wealth – which certain archaeological findings have indeed confirmed – and the numerous taxes paid by the caravans were one of the main sources of their prosperity: "There are certain portions also of the frankincense which are given to the priests and the king's secretaries: and in addition to these, the keepers of it, as well as the soldiers who guard it, the gate-keepers, and various other employees, have their share as well. And then besides, all along the route, there is at one place water to pay for, at another fodder, lodging at the stations, and various taxes and imposts. . .".[6]

Al-Hasan ibn Ahmad al-Hamdani, the renowned Yemeni author of *Geography of the Arabian Peninsula*, describes the arrival of the camel trains at the stations.[7] Although he was writing in the 10th century, we can reasonably imagine that travelling conditions had changed very little over the centuries. When the route was difficult, the caravan with its hundreds of camels would stretch for several kilometres so that if the "the group at the head reached the station at dawn, the last group would arrive around noon; or if it arrived at dusk, the last group would not arrive until well into the night when it would receive nothing but a bit of muddy water and a few scraps of fodder. And, indeed, it might not receive even that, in spite of all of the perils it had had to overcome as a result of the brigands, bandits and desert creatures who, on the heels of the travellers, lie in wait in the early morning hours for the tail of the caravan". He also mentions the hardships of daily life endured by the merchants and camel drivers, their frugal meals, "bread baked in hot ashes, fat and meat", and how "they ate their food fresh for the first half of the journey and afterwards dried, ground and crushed".

The western route was one of the busiest routes, but many other paths existed across the peninsula: for example, the itinerary from Najran went through Qaryat al-Faw up to north-eastern Arabia and Gerrha and from there on to southern Mesopotamia. In Tayma, one branch of the western route forked eastward towards the oasis of Dumat al-Jandal and the Euphrates valley.[8] Current archaeological

fieldwork is attempting to reconstruct these different trade routes and identify, outside of the main stopover towns, the simple way stations where the caravaneers often left inscriptions and graffiti.

While frankincense, myrrh and other aromatics were among the main commodities traded along these routes, the goods that arrived at the ports on the "Erythraean Sea" also used this network. From the Horn of Africa, came gold dust, ivory, leopard skins, tortoise shells; from India, pepper, cardamom, cloves and other fragrant spices. Sandalwood, precious stones, silk fabrics woven in China were also part of the cargoes shipped to the eastern coast of Arabia.

This enormous trade network was controlled by different peoples or tribes[9] at different times, depending on the changing political structure of the peninsula, but its basic structure, in terms of the roles played by the various nomadic and sedentary communities, always remained the same. The inhabitants of the oases provided "services": shelter, water, fodder; the merchants who lived there organized the trade and formed a rich and powerful group that was undoubtedly open to foreign influence. The nomadic herders, who became increasingly important over time, were also "service providers"; their involvement was vital to the successful operation of this transport business for they supplied the mounts, worked as camel drivers or caravan leaders and could furnish the convoys with a protective escort.

However, around the 1st century AD, this well-coordinated system began to fall into decline as maritime routes across the Red Sea gradually began to replace land routes over the peninsula. Traffic on the overland routes decreased, but did not completely disappear, and other travellers would soon join the merchants: pilgrims journeying to the holy places would take to the routes of Arabia.

1. See Potts, pp. 71–79.
2. Jasmin 2005, pp. 49–62.
3. Pliny the Elder, *Natural History*, XII, 30–32.
4. Myrrh was used to make ointments, perfumes and medicines; it was in high demand in Egypt because it was a necessary ingredient in the mummification process.
5. Pliny the Elder, *Natural History*, XII, 32 (5).
6. *Ibid.*
7. Jazim and Leclercq-Neveu 2001.
8. See Potts, pp. 71–79; Potts 1988, pp. 127–62; De Maigret 2003.
9. See Potts, pp. 71–79 and Robin, pp. 81–99.

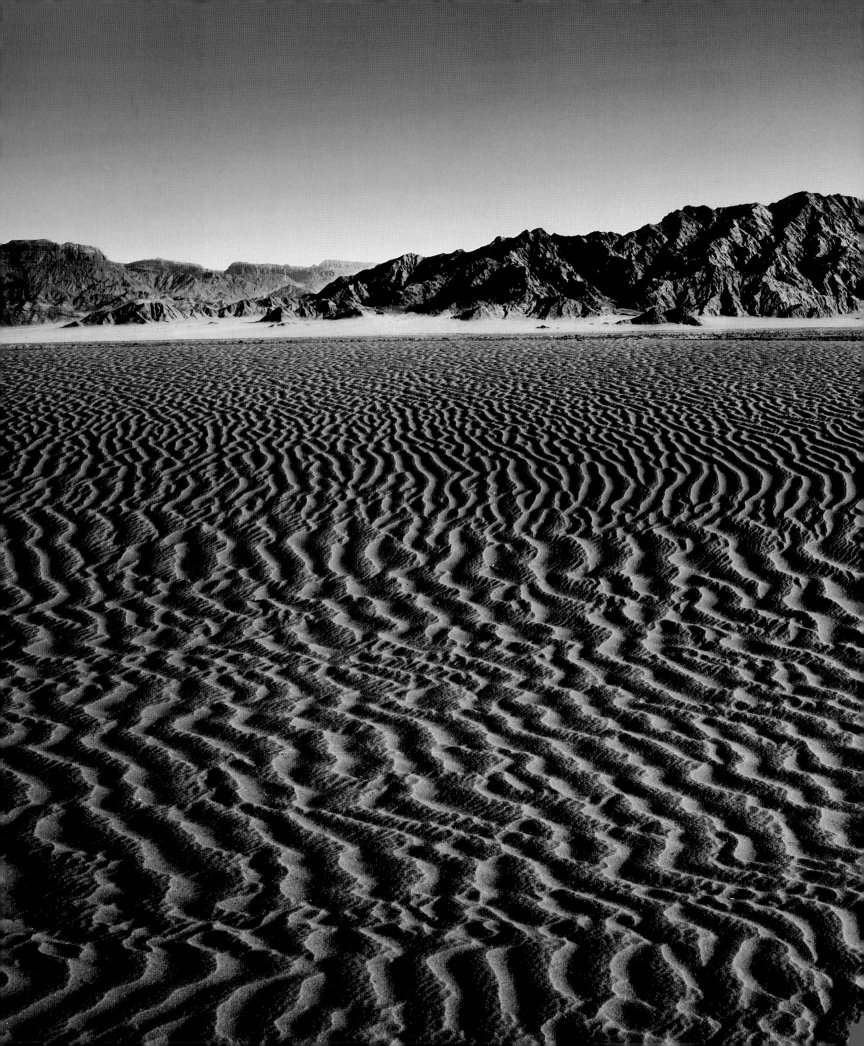

# ARABIA
# BEFORE HISTORY

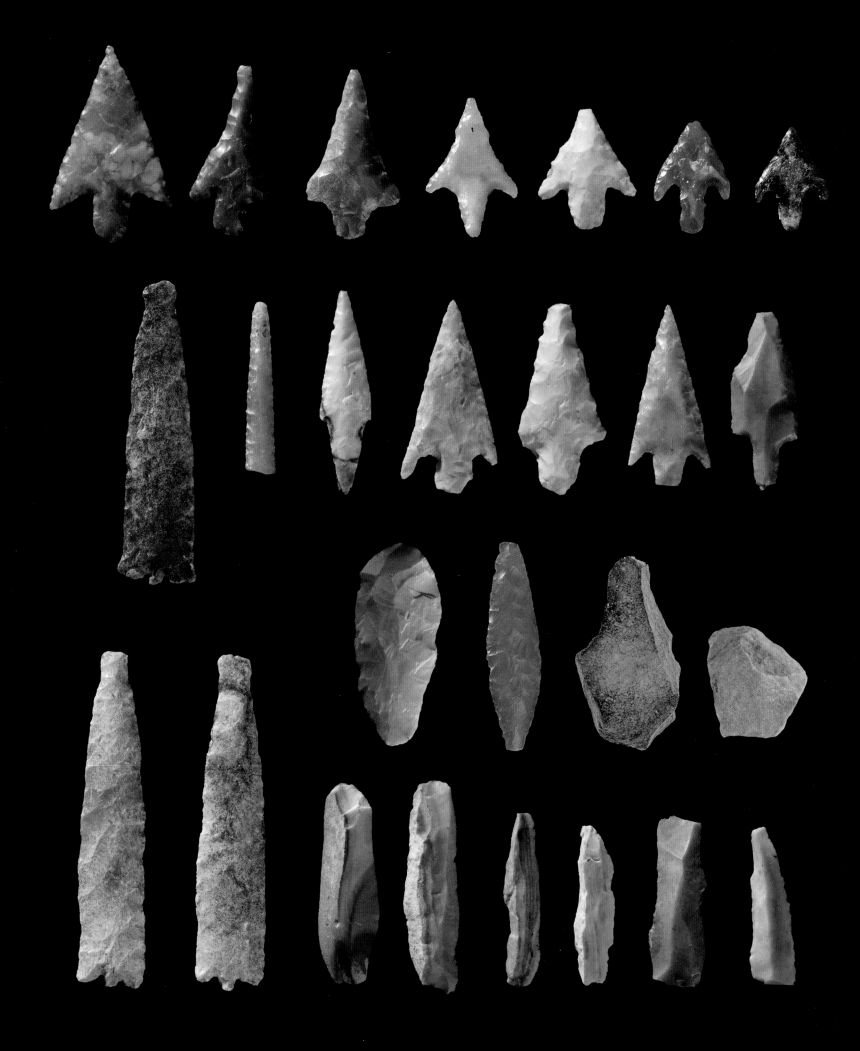

# THE PREHISTORIC POPULATIONS

*Marie-Louise Inizan*

The Kingdom of Saudi Arabia, with its deserts – the Nafud in the north and the Rub' al-Khali, the largest expanse of sand in the world, in the south – was long thought to be a land where no form of life had ever been sustainable. As a result, there was no point in attempting to trace the history of its remote prehistoric past.

Nowadays, however, the country is seen as occupying a unique geographical position, for just beyond the Red Sea on its western border lies East Africa, the recognized cradle of humanity. Recent discoveries have shown that only a single species of the genus *Homo* (*Homo erectus*) left East Africa for Eurasia approximately two million years ago, and this has spurred renewed interest in the routes our very distant ancestors took to journey out of Africa and conquer the planet Earth.

For a long time, there was one predominant scenario: a land route along the Nile. However, in the last few years, another scenario has arisen involving the Arabian Peninsula (fig. 1). Could Arabia be a geographical bridge between East Africa and Asia, separated as it is from the former only by the Red Sea? East Africa, as we know, is also considered the cradle of modern humans, *Homo sapiens,* who emerged roughly two hundred thousand years ago, and *Homo sapiens* may have also migrated to Eurasia across the Red Sea. Finally, a mystery enshrouds the entire Arabian Peninsula: what happened during the Upper Palaeolithic (40,000 to 12,000 years ago)? No prehistoric site has ever been found from that period, either on land or under water.

Starting with the last warming period, however, which corresponds to the "Arabian Humid Period" approximately 10,000 to 12,000 years ago, things start to change: archaeological exploration and better-preserved artefacts have enabled us to identify the presence of original indigenous cultures across the entire Arabian Peninsula. And the discovery of rock art – a continuous practice whose earliest specimens go back at least 8 or 9,000 years – provides us with a valuable symbolic and aesthetic resource for exploring the long history of the nomadic peoples of Arabia.

*(preceding pages)*
Hijaz landscape,
photographs by Humberto da Silveira

*(opposite)*
Prehistoric tools

(preceding pages)
Dunes

## The history of prehistoric discoveries in Saudi Arabia

Prehistory is a recent discipline whose timeline tends to vary as new discoveries are made and with the increasing accuracy of absolute dating techniques, which have progressed considerably in the last twenty years.

For instance, the beginning date for the most recent geological era, the Quaternary Period – when the genus *Homo* emerged – is placed at either 1.8 million or at 2.6 million years ago, depending on the author. Throughout the Quaternary, in Eurasia, climate shifts resulted in alternating glacial and interglacial phases. In tropical latitudes these shifts corresponded to dry periods, characterized by intense wind activity, and humid periods that were favourable to human development. In the present-day deserts of Africa and Arabia, lakes were formed during these wet phases.

For a long time, these violent changes in climate, coupled with the extremely arid conditions that prevail across most of Saudi Arabia, impeded any systematic effort to search for prehistoric sites and made it difficult to preserve their remains. In fact, prehistoric research in the country did not take off until 1970.

Prior to 1920,[1] travellers and ancient historians only mentioned monumental archaeological remains in their descriptions, mainly those along the legendary caravan route that was used to transport spices, incense and myrrh. From time to time, knapped flints, such as the famous arrowheads discovered among the dunes, would be observed by travellers or military men. In 1933, John Philby reported the existence of Neolithic flints and noted the absence of Palaeolithic remains in the Rub' al-Khali desert (see in this catalogue Sanlaville, pp. 62–63).

Then, with the influx of foreign companies prospecting for oil in the early 1950s, large numbers of scientists began to arrive. Among them were geologists who would compile the first collections of prehistoric lithic artefacts. They ventured out into unknown territory and brought back substantial evidence of prehistoric occupation, mainly in the form of arrowheads and bifacial elements that confirmed the existence of hunting groups.

A few rare prehistorians, the pioneers, would set out to conduct methodical surveys and lay the foundations for a prehistoric chronology of this virtually unexplored territory. Henry Field[2] regularly published articles and books after 1929 about the discoveries he made all over Arabia. Holger Kapel[3] meticulously recorded the existence of prehistoric remains in the Eastern Province on the Gulf and in the emirate of Qatar. He established a preliminary typology that would be used for many years by archaeologists. H. McClure,[4] who paved the way for palaeo-climatological studies in the peninsula, discovered and dated the outcrops of former lakes in the Mundafan region of the Rub' al-Khali desert.

Finally, in 1970, the Directorate General of Antiquities and Museums began to play a major role in developing archaeological research throughout the country. It implemented a five-year survey program (1976–81) and created a national archaeological journal, *Atlal*, that covered all the archaeological periods. The country was divided into six provinces (Eastern, North, Northeastern, Western, Southwestern, and Central).

In just a few years, several hundred prehistoric Palaeolithic and Neolithic occupation sites had been discovered. Yet despite the fact that highly skilled multi-disciplinary teams had been sent out, almost all of these finds were located on the surface.

It is unfortunately very difficult to establish the origin and sequence of such prehistoric occupations when dated, stratified Palaeolithic sites, human remains and Quaternary fauna are lacking. Moreover, the only evidence of these cultures prior to the last warming period (the Holocene) comes from knapped stone assemblages, and the typology used to order and classify them was devised fifty years ago in Europe by F. Bordes and in Africa by M. Leakey[5] at the Olduvai sites in Tanzania.

1. Alsharekh 2006, p. 12–39.
2. Field 1971.
3. Kapel 1967.
4. McClure 1976.
5. Leakey 1971.

The artefacts have been classified chronologically from the oldest to the most recent (fig. 2): Oldowan or early Lower Palaeolithic (use of pebble tools or "choppers"), Lower Palaeolithic (Acheulean, bifaces), Middle Palaeolithic, Mousterian (crude tools), often with some Levallois debitage. Reduction was accomplished by using a hammerstone to shape various raw materials: quartzite, andesite, flint, etc. It is notable that no blade tools corresponding to the Upper Palaeolithic (based on the typology conventionally employed for European and Near Eastern traditions) have been found anywhere in the entire peninsula.

For later occupations, however, dating from the Middle Holocene period 10,000 years ago, we have more than just arrowheads. There are sites, a wide range of undisturbed archaeological material and absolute dating techniques that can help us shed light on these cultures.

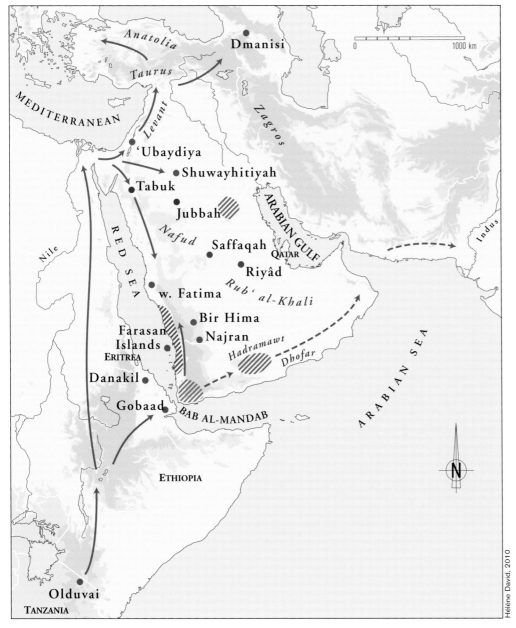

Fig. 1. The first populations in Arabia

● **Jubbah** — Middle Palaeolithic (Mousterian)
● **Riyâd** — Lower Palaeolithic (Acheulean)
● **Bir Hima** — Early Lower Palaeolithic (Oldowan)
⟶ *Homo erectus*'s exit from Africa

Fig. 2. Palaeolithic lithic industry
1, 2, 3: **Oldowan**
1, 2: Quartzite choppers
3: Quartzite side scraper (Shuwayhitiyah)
4, 5, 6: **Acheulean**
4, 5: Andesite bifaces (Saffaqah)
6: Flint biface (Northeastern Province)
7, 8, 9: **Mousterian**
7, 8: Andesite end scraper and biface (Bir Hima)
9: Andesite biface (Wadi Fatima)

## Our ancestors of the genus *Homo* disperse out of Africa through Arabia

Anthropologists believe that archaic *Homo erectus* first left Africa two million years ago following a dispersal rather than a migration pattern – for our remote ancestors undoubtedly expanded into Eurasia in successive, opportunistic waves, and probably via different routes.

## Homo Erectus: *The genus* Homo *first moves out of Africa*

During the story of hominids' evolution, only one species left Africa: *Homo erectus*. The only traces we have of hominids outside of Africa are both fragmentary and exceptional (fig. 1). The remains of the earliest hominids associated with fauna and knapped stone tools have been dated at 'Ubaydiya (1.5 million years old) in the Levantine Corridor and at the Dmanissi site (1.77 million years old) in the Georgian Caucasus where an exceptional number of individuals have been found. In northern China, evidence of *Homo erectus's* migration is based on the production of *in situ* lithic artefacts of anthropic origin (1.66 million years old).[6]

What routes did the first humans take when they moved out of Africa? Were there any geographical and/or ecological barriers? The debate currently revolves around two main scenarios.

The first theory postulates a land route northward along the Nile Valley or up the African coast of the Red Sea to the Levantine Corridor. Although there is no archaeological data to support this, the main argument is based on the assumption that *Homo erectus* would not have had the technical and intellectual capacity to undertake a sea crossing over a body of water like the Red Sea. On the other hand, travelling north over land from one ecological niche to another was certainly possible. To support this theory, it is pointed out that there is no evidence to show that before modern humans, our direct ancestors, emerged, the genus *Homo* had ever left Africa by crossing the sea, either via the straits of Gibraltar, Messina or Bab al-Mandab. The earliest known occurrence of maritime migration has been linked to the settlement of Australia and New Guinea, established not more than 60,000 years ago.[7]

The other theory, which is much more recent, involves a very early water crossing over the Red Sea and the Bab al-Mandab Strait. According to this model, migration took place during the Middle Pleistocene (one million years ago) through Arabia and spread from there to Iran, India, China, etc.[8] A certain number of Lower and Middle Pleistocene sites in Africa are in fact situated near the coast of the Red Sea, in the Danakil Depression in Eritrea, for example (fig. 1). Knapped stone industries, faunal and human remains have been found on these sites dating back to approximately one million years. This is also the case in the Gobaad Basin in Djibouti where human occupations go back to the Lower Pleistocene era.[9]

In Arabia, archaic lithic industries have been identified in the Northern Province at Shuwayhitiyah: sixteen sites have yielded choppers, polyhedrons and a few flakes (figs. 1 and 2). By comparing them with the industries at Olduvai Gorge in Tanzania, a date of 1.3 million years has been assigned to them. Similar assemblages have been discovered on the surface at Bir Hima in the region of Najran in south-western Saudi Arabia, as well as in the south-east at Bab al-Mandab in Yemen and in the east at Hadramawt, prompting several writers to claim that southern Arabia might have been occupied as early as the Lower Pleistocene (fig. 1).[10]

Can we currently date material based on typological comparisons with African industries? And which ones? In the last thirty years, an increasing number of undisturbed Pliocene and Lower Pleistocene sites have been discovered in East Africa, and they are changing our assessment of the tool-making abilities of hominids. Refittings of lithic artefacts found at a Kenyan site dating from the end of the Pliocene (2.3 million years ago) have shown that they already possessed organized strategies, and above all, various ways of knapping, including several

6.  Prat 2008, p. 34–44.
7.  Derricourt 2005.
8.  Petraglia 2003.
9.  Harmand, DeGusta, Slimak *et al.* 2009.
10. Whalen and Schatte 1997.

# PALAEOLITHIC

*Oldowan*

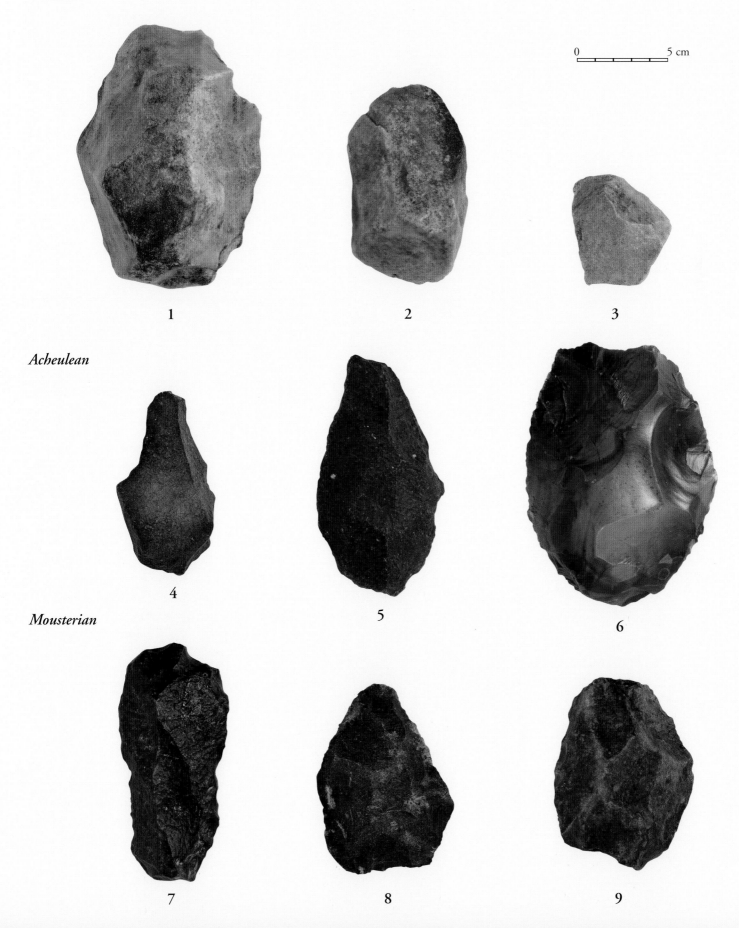

0 _____ 5 cm

1

2

3

*Acheulean*

4

5

6

*Mousterian*

7

8

9

Fig. 3. Wadi Fatima

Oldowan-type techniques, with or without the use of choppers.[11] This is also the case several hundred thousand years later with regard to bifacial shaping, which emerged approximately 1.7 million years ago in Africa and continued to develop for over one million years!

Assignment to the Acheulean (Lower Palaeolithic) was based on evidence of a biface industry with the use of hammerstones, such as in Saffaqah and in Wadi Fatima in the west (fig. 3). Although it is quite possible that human occupation in Arabia goes as far back as the Lower Palaeolithic, it remains very difficult to date it and to trace its origins.[12]

### *Did* Homo Sapiens *also leave Africa 150,000 years ago?*

Since we acknowledge that modern humans had the physical, technological and cognitive abilities to build and navigate boats, they could have taken the Arabian route by crossing the Red Sea, provided that climatic conditions were tolerable once they reached the Arabian shores.

It just so happens that the first undisturbed Palaeolithic site has been found on the Arabian Peninsula. It was discovered by R. Macchiarelli and his team in the Yemeni Tihama in 2006.[13] The Shi'bat Dihya site (SD1), dated to approximately 80,000–70,000 years ago, is characterized by a lithic industry with Levallois debitage. Lithic refitting and a large number of artefacts without patina have made it possible to evaluate the technical skills of its inhabitants, and this site could eventually be linked to several other localities in the Saudi Tihama where, twenty years ago, tools with Levallois flakes and cores were found, some of which were embedded in a coralline terrace two metres above sea level. Prospecting has recently begun on the Tihama coast and in the Farasan Islands, and underwater surveys are being conducted to investigate ancient geological strata that are now below sea level.[14] In addition to the many Middle Holocene shell mounds that have been found, an older coralline terrace has been located that could lead to the discovery of other prehistoric Palaeolithic sites. Indeed, the Levallois debitage industries that have been found, containing bifaces and crude tools (end scrapers, side scrapers, denticulates),

11. Delagnes and Roche 2005.
12. Crassard 2008.
13. I am infinitely grateful to R. Macchiarelli who told me about these results. They were presented at the *Meetings of the Paleoanthropology Society* in Vancouver in 2008 and have not yet been published.
14. Bailey, Al Sharekh, Flemming *et al.* 2007.

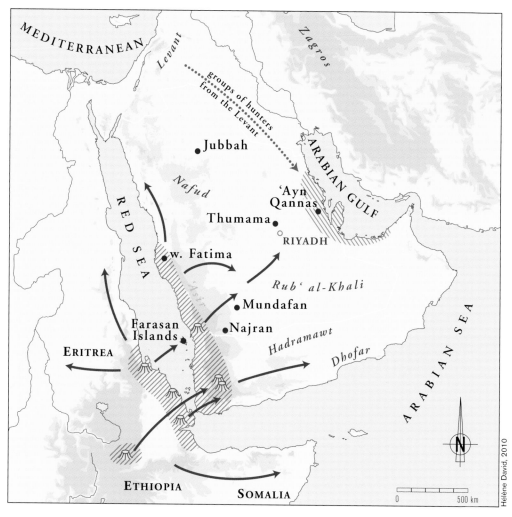

Fig. 4. The last prehistoric cultures

→ Obsidian circulation

▨ Obsidian source

● Jubbah    Neolithic site

▨ Near-eastern type blade

have been assigned to the Middle Palaeolithic and can be compared to those collected in the Jubbah Basin in the north (fig. 4).

## The last of the prehistoric cultures

There is one mystery that persists concerning the entire peninsula: no evidence of any human presence dating from the Upper Palaeolithic (40,000–12,000 years ago) has ever been found in all of Arabia! Since hyperaridity cannot explain this complete absence of occupation, it is most likely due to insufficient research.[15] The possibility of vanished habitats needs to be taken into account. For example, in the Eastern Province, large sections of land emerged when the sea level dropped along the gulf following the subsidence of the Arabian plate. In addition, the mountainous areas in the west and south-west offered favourable conditions for the growth of flora and fauna, as they do today.

### *Expansion models and the Neolithic*

Ten thousand years ago, during the last warming period, the number of dated prehistoric occupations increased throughout the peninsula. However, the origin of these populations has not yet been established.

Generally speaking, all around the world, a major transformation was taking place: Neolithisation. It involved the domestication of animals and plants, a process that arose

15. Uerpmann, Potts and Uerpmann 2009.

147

Fig. 5. Knapped flint tools from the Eastern Province
1, 2: Bifacial piece shaped with a soft hammerstone
3: Scraper on flake
4, 5, 6: Winged and tanged arrowheads retouched by pressure-flaking
7, 8, 9, 10: Flint bladelets (Ayn Qannas)

independently in several different areas. In the Near East, the oldest known centre of domestication, it is believed to have developed at least ten thousand years ago. This process was often linked to an increasingly sedentary way of life.

In Arabia, however, the hunter-gatherer model persisted for another several thousand years, mainly due to the area's climatic conditions.

The domestication of bovids (cattle, sheep, goats) from the east did not occur until six thousand years ago, at the very most. Nevertheless, Arabia may have played a role in the domestication of donkeys – assuming that the domestication of these pack animals originated in Africa – for the importance of donkey hunting throughout the Tihama in the 7th millennium BC is something that has often been observed.[16]

However, the populations in Arabia were not at all confined to an archaic way of life. Prehistoric provinces were being formed with ties to neighbouring regions, sometimes over long distances. And rock art, which began to emerge in the 7th millennium BC, particularly in the western highlands, would help to explain these developments. Rock art is an invaluable source of information, not only about hunting and its rituals, or extinct animals (buffalo, felines), but also about certain affinities with Africa and the Near East.[17]

The material culture, dominated by knapped stone (often the only industry that was preserved), reveals the importance of hunting throughout the territory. Flint was the type of stone preferred for hunting weapons, most of which were bifacial.[18] Various lithic reduction techniques were employed, from the widespread use of hammerstones to retouch by pressure-flaking (fig. 5). The technology of pottery making was not developed until later.

In the Eastern Province, the results of the stratigraphic excavations at Jabrin Oasis and along the gulf coast were first published in the 1970s by Abdullah Masry.[19] They revealed the influence of interregional interaction with Mesopotamia in the north and the Near East in the west (fig. 5). Several layers of occupation were uncovered at Ayn Qannas. One of the early levels contained blade arrowheads similar to the Amuq points found in the southern Levant that belonged to a pre-pottery, pre-Neolithic culture dating from the 7th millennium BC: the same alternated blade debitage with double striking platforms, the same retouching of blade arrowheads (fig. 6).[20] This technology is unique. It has been identified in several localities along the gulf coast, as far south as the Sultanate of Oman, and in several blade workshops in the emirate of Qatar, but it was never adopted by local populations who used a method of flake knapping with bifacial shaping to make their hunting weapons (fig. 5). It probably indicates the presence of hunting groups who came from the Levant and settled along the shores of the gulf (fig. 4).

In this area along the gulf, coastal fishing in boats, rather than hunting, was developed during the 7th and 6th millennia BC. In addition, the number of fish-head remains left in archaeological deposits suggests that the fishermen had also learned to preserve fish.

Along the Red Sea in the west, in another coastal province, the archaeological deposits are very different from those in the east. They contain piles of shells commonly called "shell-middens".[21] These shell-middens can be found by the hundreds, particularly in the Farasan Islands, in the form of low mounds.[22] The faunal remains provide evidence of fishing, shellfish gathering, and donkey (*asinus africanus*) hunting. In the 7th millennium BC, the latter was practised all over the Tihama where gazelles and other game were much rarer than donkeys.

An obsidian industry existed from the Neolithic to the Historical Periods. Obsidian is an easily worked volcanic glass that is found in lava flows around the Red Sea, in Saudi Arabia and Yemen on the Arabian side, in Ethiopia and Eritrea on the African side (fig. 4). The physical and chemical signature of the flows makes it an excellent indicator of circulation and trade

16. Inizan and Rachad 2007.
17. See in this catalogue M. Khan.
18. Edens 1982.
19. Masry 1974.
20. Inizan 1988, pp. 40–8.
21. Zarins, Murad and al-Yaish 1981.
22. Bailey, Al Sharekh, Flemming *et al.* 2007.

# NEOLITHIC

*Eastern province*

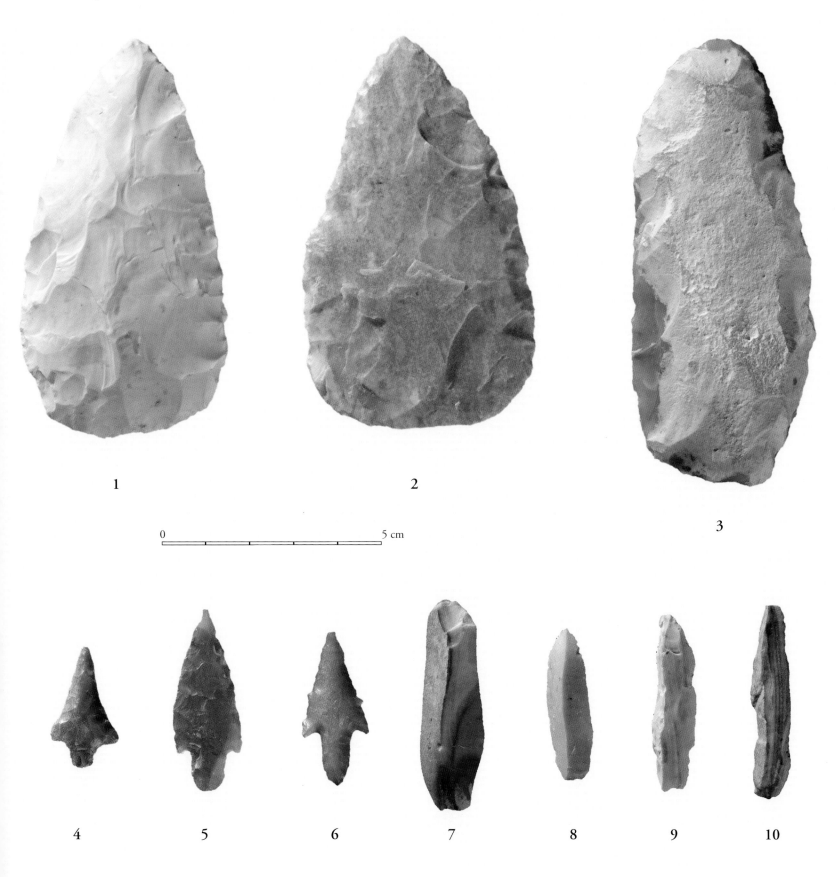

1          2

0          5 cm

3

4      5      6      7      8      9      10

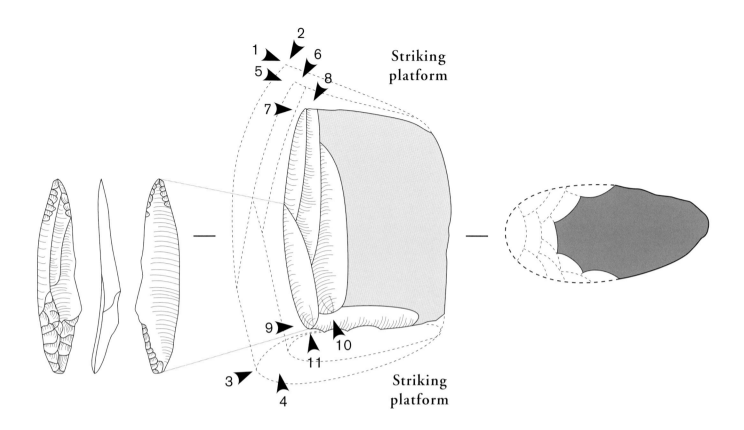

Striking platform

Striking platform

*(above)*
Fig. 6. Knapping sequence for a tanged arrowhead on a bladelet

*(opposite)*
Fig. 7. Knapped flint tools from the Central Province
1, 2, 3: Arrowheads (Thumamah)
4: Scraper
5: Ovular leaf-shaped arrowhead
6: Broken tang or borer meticulously retouched by pressure-flaking
7, 8, 9, 10, 11, 12: Different types of arrowheads

routes, as J. Zarins pointed out in the 1980s.[23] Obsidian always circulated in small quantities and it was knapped by percussion rather than pressure flaking, a method that was often used in the Near East and the Mediterranean. It has been found in a large area in the south-western part of the Arabian Peninsula, indicating the presence of cultural communities around the Red Sea (fig. 4).[24]

In the Rub' al-Khali and the central regions dominated by deserts, hunting seems to have been the primary activity, as indicated by a material culture that mainly consists of hunting weapons (fig. 7).

In conclusion, in spite of the peninsula's hyperarid climate (with periodic phases of greater humidity), human occupation in Arabia goes as far back as the Lower Palaeolithic: when and how did the first peoples arrive? It is still too early to map out their migration routes. However, with the discovery of the first dated, stratified Palaeolithic site in the Yemeni Tihama and the preliminary results of the surveys on the Saudi coast, resources are finally becoming available to help us elucidate the beginning of human occupation in Arabia.

On the other hand, we have significant resources dating from the end of the prehistoric era, corresponding to the "Arabian Humid Period" approximately ten thousand years ago. Recent findings show, first of all, that the area supported cultures that were both diverse and dynamic – implicated, for example, in the development of fishing and navigation – and secondly, that Arabia was involved in exchange networks with Africa to the west, the regions along the Gulf to the east, and Mesopotamia to the north.

23. Zarins 1990.
24. Khalidi 2009.

*Central Province*

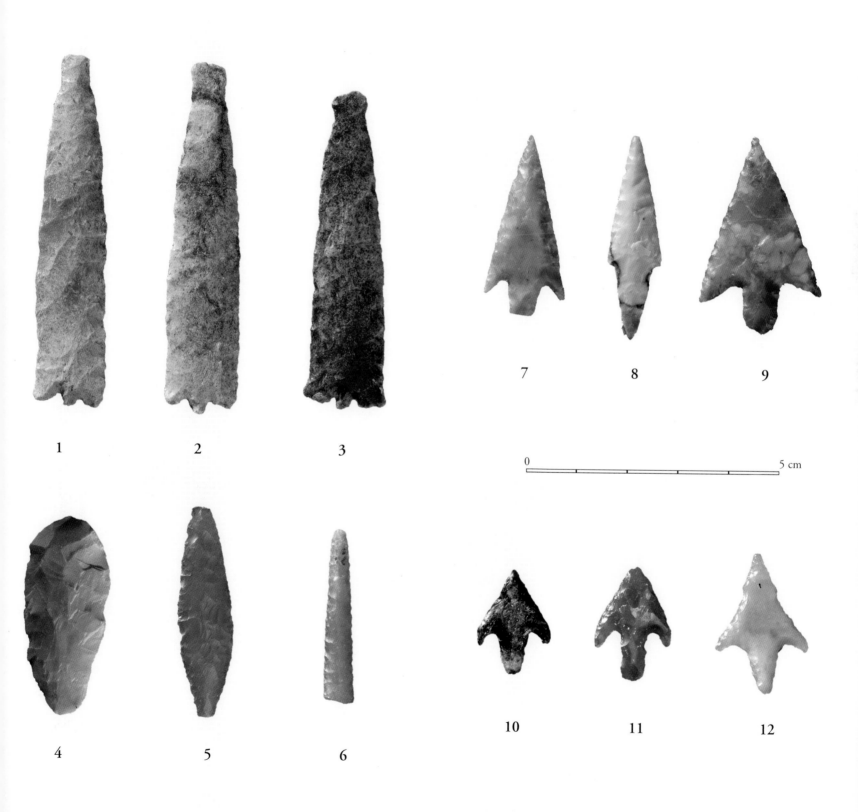

1    2    3

7    8    9

0 |———|———|———|———|———| 5 cm

4    5    6

10    11    12

## OLDOWAN

**1. Chopper**
Oldowan (Early Lower Palaeolithic)
Quartzite
14 x 10.3 x 8 cm
Shuwayhitiyah
National Museum, Riyadh, 10/19

Bibliography: Riyadh 2009, p. 160.

**2. Chopper**
Oldowan (Early Lower Palaeolithic)
Quartzite
10.6 x 6.3 cm
Shuwayhitiyah
National Museum, Riyadh, 12

Bibliography: Riyadh 2009, p. 160.

**3. Chopper**
Oldowan (Early Lower Palaeolithic)
Quartzite
9.5 x 7.8 x 6.2 cm
Shuwayhitiyah
National Museum, Riyadh, 1/3

Bibliography: Riyadh 2009, p. 160.

## ACHEULEAN

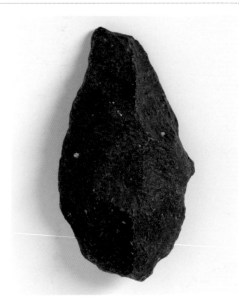

**4. Chopper**
Acheulean (Lower Palaeolithic)
Andesite
11 x 5.5 x 4.7 cm
Wadi Fatima
National Museum, Riyadh, 84/1

**5. Biface**
Acheulean (Lower Palaeolithic)
Andesite
9.1 x 5.6 x 3.7 cm
Saffaqah
National Museum, Riyadh, 490/1

Bibliography: Riyadh 2009, p. 160.

**6. Biface**
Acheulean (Lower Palaeolithic)
13.2 x 6.8 x 5.2 cm
Saffaqah
National Museum, Riyadh, 502/2

Bibliography: Riyadh 2009, p. 160.

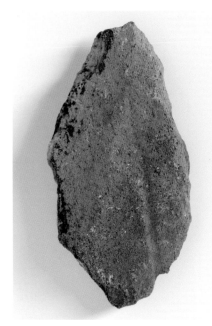

**7. Biface**
Acheulean (Lower Palaeolithic)
Andesite
14 x 8 x 3.8 cm
Saffaqah
National Museum, Riyadh, 493/1

Bibliography: Riyadh 2009, p. 160.

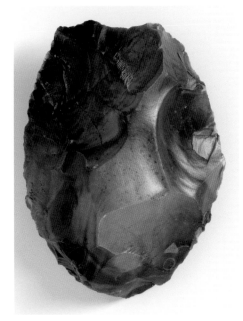

**8. Biface**
Acheulean (Lower Palaeolithic)
Flint
14.1 x 10.5 x 3.8 cm
Eastern Province
National Museum, Riyadh, 306/2

Bibliography: Riyadh 2009, p. 160.

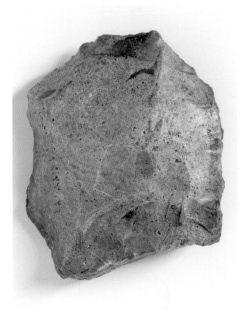

**9. Scraper**
Acheulean (Lower Palaeolithic)
Flint
9.8 x 9.2 x 3 cm
Eastern Province
National Museum, Riyadh, 303/3

Bibliography: Riyadh 2009, p. 160.

## MOUSTERIAN

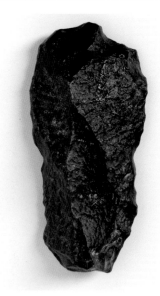

**10. Scraper**
Mousterian (Middle Palaeolithic)
Andesite
12 x 5.4 x 2.3 cm
Bir Hima
National Museum, Riyadh, 121/1

Bibliography: Riyadh 2009, p. 161.

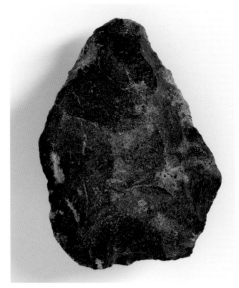

**11. Biface**
Mousterian (Middle Palaeolithic)
Andesite
9.8 x 7.4 x 4.4 cm
Bir Hima
National Museum, Riyadh, 113/1

Bibliography: Riyadh 2009, p. 161.

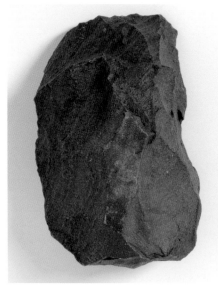

**12. Backed blade**
Mousterian (Middle Palaeolithic)
Andesite
12.1 x 7.6 x 6 cm
Bir Hima
National Museum, Riyadh, 175/1

Bibliography: Riyadh 2009, p. 162.

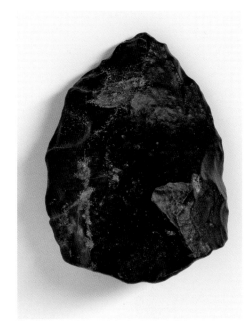

**13. Biface**
Mousterian (Middle Palaeolithic)
Andesite
7.3 x 5.4 x 2.8 cm
Bir Hima
National Museum, Riyadh,164/1

Bibliography: Riyadh 2009, p. 161.

**14. Backed Blade**
Mousterian (Middle Palaeolithic)
Andesite
11 x 4.5 x 3.3 cm
Bir Hima
National Museum, Riyadh, 104/4

Bibliography: Riyadh 2009, p. 161.

**15. Borer**
Mousterian (Middle Palaeolithic)
Andesite
12.5 x 9.5 x 5.8 cm
Wadi Fatima
National Museum, Riyadh, 108/6

Bibliography: Riyadh 2009, p. 161.

**16. Scraper**
Mousterian (Middle Palaeolithic)
Andesite
10.3 x 6.5 x 3.1 cm
Bir Hima
National Museum, Riyadh, 115/1

Bibliography: Riyadh 2009, p. 162.

**17. Biface**
Mousterian (Middle Palaeolithic)
Andesite
10 x 7.5 x 3.8 cm
Wadi Fatima
National Museum, Riyadh, 648

# EASTERN PROVINCE NEOLITHIC

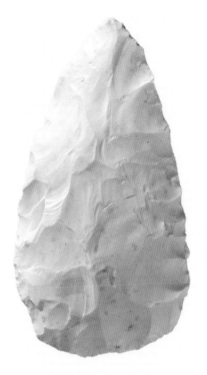

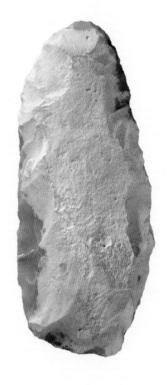

**18. Bifacial pieces**
Neolithic
Flint
8 to 8.9 x 2 x 0.4 cm
Eastern Province
National Museum, Riyadh, 002 001 t.t (2)

**19. Scraper on flake**
Neolithic
Flint
9.8 x 4.2 x 1.4 cm
Eastern Province
National Museum, Riyadh, 002 008 t.t (1)

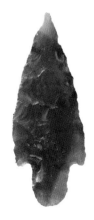
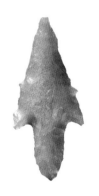

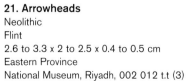

**20. Arrowheads**
Neolithic
Flint
3 to 4 x 2 to 2.5 x 0.4 – 0.5 cm
Eastern Province
National Museum, Riyadh, 002 014 t.t (3)

**21. Arrowheads**
Neolithic
Flint
2.6 to 3.3 x 2 to 2.5 x 0.4 to 0.5 cm
Eastern Province
National Museum, Riyadh, 002 012 t.t (3)

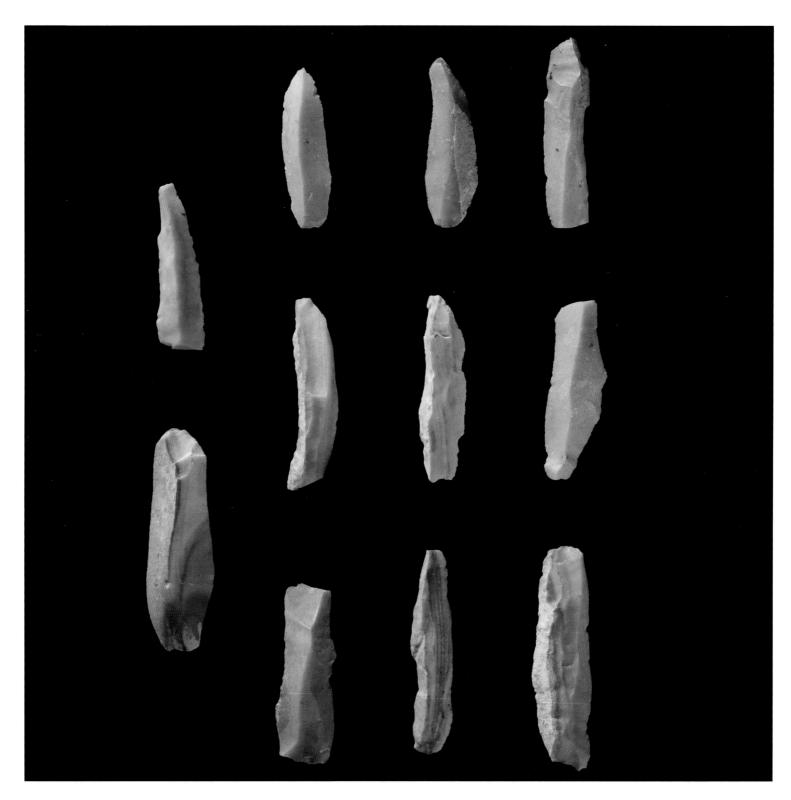

**22. Bladelets**
Neolithic
Flint
3.1 to 4.4 x 0.9 to 1.4 x 0.3 to 0.7 cm
Eastern Province
National Museum, Riyadh, 002 016 t.t (11)

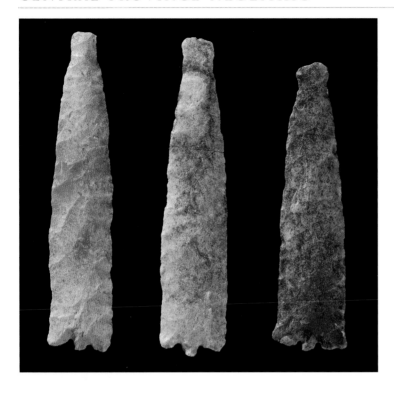

**23. Arrowheads**
Neolithic
Flint
6.6 to 6.8 x 3.6 to 4 x 0.3 to 0.5 cm
Thumama
National Museum, Riyadh, 002 003 t.t (3)

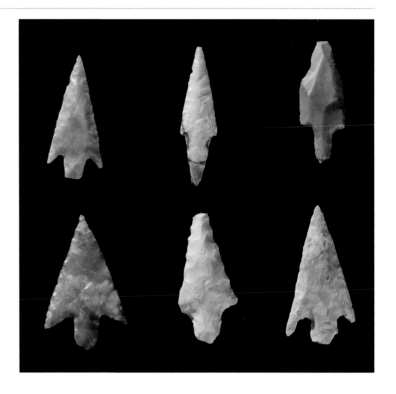

**26. Arrowheads**
Neolithic
Flint
L. from 2 to 4 cm
Central Province
National Museum, Riyadh, 002 010 t.t (6)

**25. Bifacial pieces**
Neolithic
Flint
3.3 to 3.8 x 2 x 0.5 cm
National Museum, Riyadh, 002 006 t.t (3)

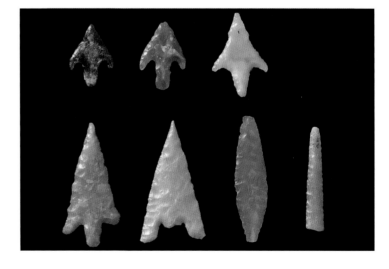

**24. Arrowheads**
Neolithic
Flint
3.4 to 3.9 x 1.3 to 2.1 x 0.4 to 0.6 cm
Central Province
National Museum, Riyadh, 435.6H

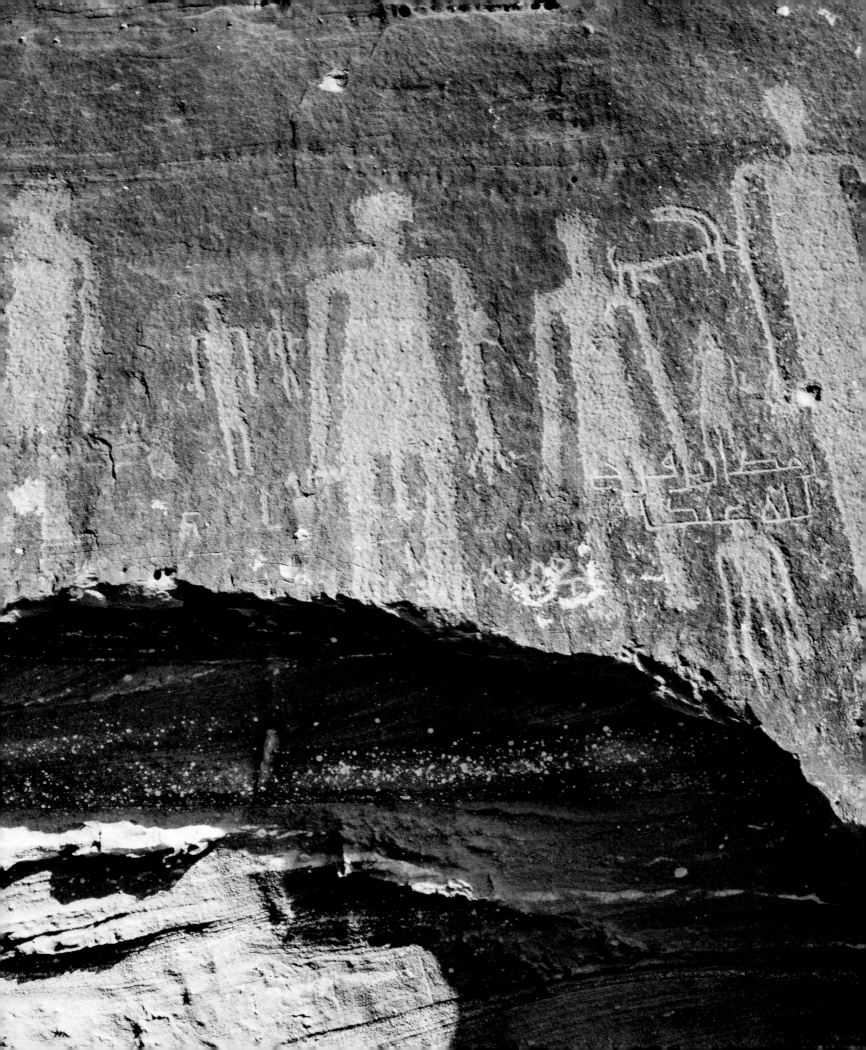

# FROM PREHISTORIC ART TO NOMADIC ART:

## THOUGHTS ON THE HISTORY AND DEVELOPMENT OF ROCK ART IN SAUDI ARABIA

*Majeed Khan*

Human presence in the Arabian Peninsula dates back one million years, as evidenced by lithic material discovered at sites like Shuwayhitiyah in northern Saudi Arabia, Dawadmi in the central part of the country, Bir Hima in the south and the Wadi Fatima area in the west.[1] Ten thousand years ago, the inhabitants of the peninsula still subsisted on hunting and gathering, but between 10,000 and 8,000 BP, these activities were supplemented with herding and a form of primitive agriculture in the valleys and flood plains. Five thousand years ago the population was essentially nomadic, although circular stone structures and other archaeological remains seem to indicate that small sedentary communities were beginning to form during this period. These various populations have left behind precious testimonies of their everyday life in the form of petroglyphs and paintings[2] depicting hunting and fighting scenes, as well as social and religious activities.

*(opposite)*
Detail of a rock panel, photograph by Humberto da Silveira

Fig. 2. Figure of the so-called "king", Jubbah

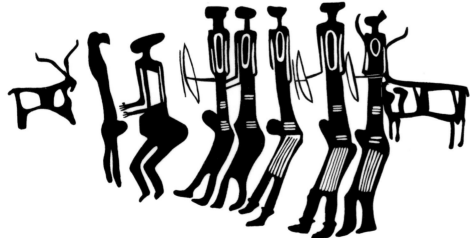

Fig. 1. Group of anthropomorphic figures, Jubbah

1. Whalen *et al.* 1983.
2. Khan 1993 c.

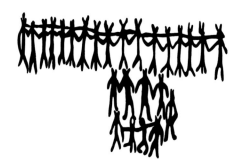

Figs 3 and 4. Masked dancers, Jubbah

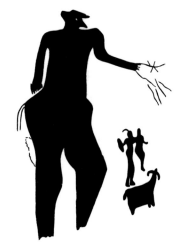

Fig. 5. Rainstorm god, Jubbah, c. 10,000 BP

3. Khan 1993.

The Kingdom of Saudi Arabia has a rich cultural heritage: of its more than four thousand registered archaeological sites, one thousand five hundred include rock art, and many more are no doubt still waiting to be discovered. The settlement of the peninsula began in the Acheulean era (one million years ago), but the earliest examples of rock art date from the early Neolithic, around 12,000 BP, and this form of expression endured until the advent of the Islamic period, c. 650 AD.

The cultural origins of the Arab nomads, or Bedouins, are rooted in prehistory, in particular the tribal system that has perpetuated powerful social and cultural traditions since Antiquity.

Certain Arab dances today still have elements in common with millennia-old tribal art.

A large carved panel found at Jubbah (figs 3 and 4) seems to depict masked men and women dancing. These could also be mythological figures with a human body and a kind of equine head. Interestingly, modern-day Arab men still practise a traditional group dance called the *ardha* that has points of resemblance to rock art representations in Jubbah, Milihiya, Janin and Tabuk in northern Saudi Arabia. As far as can be deduced from the ancient images, the way the dancers are grouped, the positions of their legs, arms and hands (each dancer holds the hand of another) and their symmetrical movements correspond to the way the *ardha* tribal dance is performed today.

It is tempting to see in the modern Bedouins' devotion to tribal links and the cultural and social values of their respective tribes – like the dances – the survival of cultural traditions that have been handed down since prehistoric times.[3]

In nearly all the compositions that can be attributed to the Neolithic period, between about 10,000 and 7,500 BP, the human figures are associated with animals, especially cattle

and dogs. Presumably these animals had been domesticated and were part of the everyday life and the social and cultural activities of the early tribes.

Figure 4 represents a social or religious event; men (with slim, flat bodies) and women (identifiable by their wider hips), all dressed in long robes and wearing some type of shoes, seem to be dancing in a group. Are they masked humans or mythological beings with a human body and an animal head?

Figure 5 represents a figure that could be a storm god.

As they became sedentary, men built temples and sculpted images of their deities in stone or cast them in metal, but they also continued to carve them on rock faces.

One intriguing female figure was chiselled into a hard sandstone surface at the peak of a 200-metre hill, facing east. The rays of the rising sun fall directly onto the image, which is visible at a great distance. It can be interpreted as a mother goddess, the goddess of love and fertility. A number of similar depictions of goddesses have been found in the Najran area, with wide hips, hands half raised, palms open and fingers extended (fig. 7).

Hunting scenes are symbolic and the animals in them are never depicted wounded or pierced with arrows. Are they illustrations of magical practices, specific events or rites performed to ensure a bountiful hunt? All of these assumptions could simply be hypotheses bolstered by our modern point of view.

Fig. 6. Human figure with oval head, Jubbah

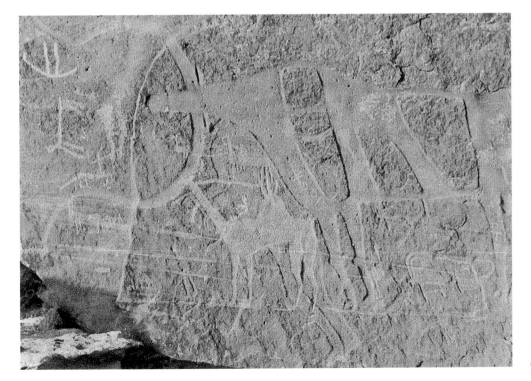

Fig. 8. A panel of several phases with fine carvings of a horned bovid, human figure, camel, etc

Fig. 7. Representation of a goddess

Fig. 9. Footprint, northern Arabia

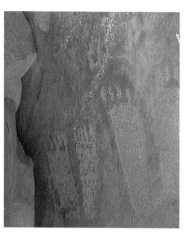

Fig. 10. Footprints, northern Arabia

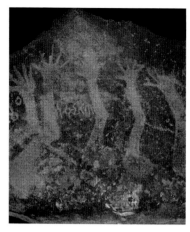

Fig. 11. Handprints

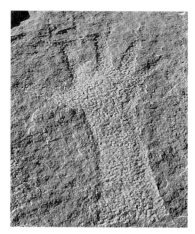

Fig. 12. Handprint

## Representations of foot- and handprints

One of the earliest signs of human presence in Arabia is a nearly life-size representation of a human footprint (fig. 9) carved deep into the horizontal surface of a sandstone boulder at Shuwaymis in northern Saudi Arabia. The oldest such print ever found on the Arabian Peninsula, it dates from c. 10,000–8,000 BP. Representations of handprints with open palms and extended fingers have been found on one of the vertical surfaces of a hill in the northwestern Tabuk region (fig. 11). The date remains unknown. The hyena and dog were added later.

A few petroglyphs are accompanied by inscriptions. Figure 13 shows two women apparently in the midst of a fight, plus a third woman watching them with arms raised, as though she were a kind of referee reminding them to obey the rules of combat. Each of the two inscriptions gives the name of a person: it is possible to decipher *B-j a dh*, or Bajadh, on top and *B- Pbh*, or Balabh, below. These could be the names of the two opponents.

The inhabitants of Arabia continued to create rock art after the invention of writing. Bedouin writing, the earliest tribal writing system, also known as "Thamudic" script, was rudimentary. Only the names of persons or tribes have been found carved on the rocks; no extended inscription has yet been discovered.

The gradual change of style, content, context and conceptualization between prehistoric art and tribal or Bedouin art can be traced through the use of animal figures, tribal symbols and the later developments of Bedouin writing in the early Iron Age. The depiction of Bedouin folk dances and branded camels, as well as the presence of names of tribes or individuals carved next to certain images, show that rock art played an important role in the description of the social, cultural and religious entities of Arabia from the Prehistoric period up to the beginning of the Islamic era.

The beginning of the large-scale domestication of the camel, which went hand-in-hand with the sedentarization of large communities and the development of tribes and clans, is

Fig. 13. Two women fighting

evidenced in the rock depictions by the inclusion of brands, locally called *wusum*. Each tribe used a specific mark to define its territories, sign documents and differentiate its tombs, tents and encampments.[4] The branding of animals is a universal phenomenon. Still practised in modern times on horses and livestock, in Arabia it is an ancient tradition deeply rooted in the local customs. The Bedouins still roaming the desert today use geometrical or non-figurative motifs to denote their respective tribes. They have not left their territories for millennia, and their social and cultural values remain unchanged.

The *wusum* system is a sort of code developed for limited use relying on a complex combination of non-phonetic signs. These *wusum* are symbols related to language or writing but instantly conveying their meaning, like traffic signs that require no linguistic knowledge and are understandable by all.

Fig. 14. A camel with three circles branded on its shoulder

## Open-air sanctuaries

The people of Pre-Islamic Arabia venerated a great many different deities. In the desert, the nomadic Bedouins created open-air sanctuaries, carving representations of gods and goddesses on high-standing rocks.

At Wadi Bajdha, north-west of Tabuk in the northern part of the country, a rock art composition featuring bulls and human figures (fig. 15) marks the location of an open-air sanctuary in the middle of the desert. As in Egypt, the bull was a sacred animal in Arabia. This tableau, whose date cannot be precisely determined, was carved about 5 metres above the present-day ground level on one of the smooth surfaces of a sandstone hill. Offerings might have been placed in the fissures below the image.

In another panel, the carving of female figures (fig. 16) over earlier Bedouin inscriptions would indicate that they date from a period after the development of writing. These figures have a triangular torso with an elongated neck, narrow waist, wide hips and long hair. They could represent a goddess, perhaps Alia, the goddess of love and fertility.

Fig. 15. Bulls and deities, Wadi Bajdha

Several figures representing Alia appear on a readily visible vertical surface high up on a hill (fig. 17). The site is close to a watering place that is now dry, possibly a spring or a rainwater reservoir. Sheltering spots under the rock, water and a few plants made this an ideal location for social or religious gatherings. It is possible that rituals took place here and an image of the goddess was created each time, once per year or according to another periodicity. The site remained a gathering place for centuries: there are hundreds of ancient Arabic inscriptions carved all around the reservoir that have been dated to c. 1500 to 1000 BC.

These images of goddesses show that the artist(s) worked within precise guidelines, each time using the same theme, motif and style, from which they could not deviate. Some ancient artists probably specialized in religious images, always reproducing the same subject(s) with no formal or stylistic variation. This would explain why identical representations of the goddess Alia have been found at nearly all the sites. There must have been a few recognized artists who, conforming to their society's religious and cultural prescriptions, depicted only authorized figures strictly according to the imposed rules, which explains the absence of aesthetic differences and indeed of variety in the artistic creations.

Fig. 16. Worshipper, Jabal Thaer

4.  Field 1952; Dickson 1959; Bagdadir 1991; Al-Jodi 1991; Khan 1993.

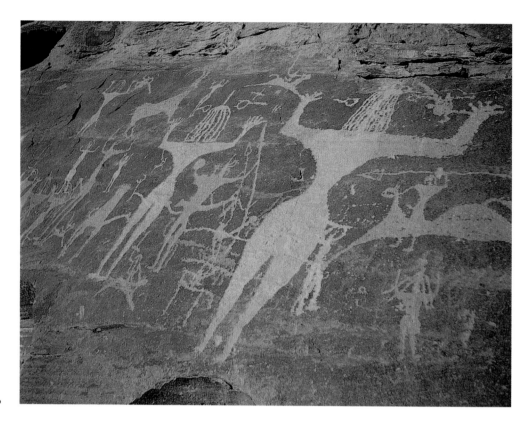

Fig. 17. Worshippers, Jabal Kawkab

In the Najran region of southern Arabia, a prehistoric artist adorned the smooth surface of a large rock with one of the most remarkable and fascinating works of art ever created (fig. 18). When the sun rises each day, the figures of this panel, which faces east, gleam and sparkle in the first rays of sunlight.

Originally the composition apparently consisted of only the male and female figures, plus the stag off to the right, which was carved using the same pecking technique and has the same kind of chisel marks as the main figures. Over time, this tableau lost its importance. The place was no longer considered sacred and the local population forgot about its traditions. Visitors began carving their own names and other texts on the rock and over the figures, which are nonetheless well preserved and still have all of their beauty and evocative power. This work has not been precisely dated, but it certainly preceded writing by at least two thousand years.

For a long time archaeologists thought that the Bedouins, as nomadic herders, had left few traces of their presence. But more recent studies, including many devoted to rock art, have disproved this assumption by discovering a considerable quantity of cultural materials in the deserts of Saudi Arabia.

The animals depicted correspond to the local fauna: cattle, camels, stags, gazelles, dogs, snakes, lizards, goats, etc. The flora is surprisingly absent from the images, except for representations of date palms at a few sites, as are birds, with the exception of ostriches. The artists seemed to choose the elements of their compositions from among a few animals that were part of their environment, to the exclusion of others also present. This same phenomenon has been observed in Europe, Africa, Australia and Asia, indicating that artists in different parts of the world all shared the same mental, intellectual and ideological approach.[5]

5. Khan 1993.

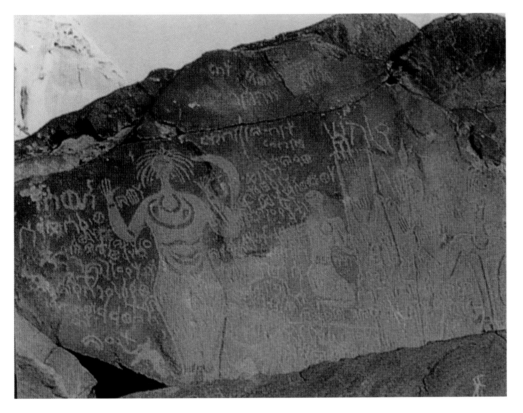

Fig. 18. Rock panel in the Najran region

From the Neolithic to the early Islamic period, the evolution of rock art shows that the desire for aesthetic achievement is not specific to contemporary civilizations, but was already a deep-seated preoccupation in the minds of our ancestors.

Fig. 19. Combat on horseback, Tabuk.
Arabian horses are renowned worldwide

**Bibliography:**
Anati 1972; Anati 1999; Bednarik 1994; Bednarik and Khan 2002; Bednarik and Khan 2005; Clarke 1979; Field 1952; Garrard and Stanley Price 1981; Horsefield 1983; Howe 1950; Jaussen and Savignac 1914; Al-Jodi and Ghazi 1995; Khan 1985; Khan 1988 a; Khan 1988 b; Khan 1990; Khan 1991 a; Khan 1991 b; Khan 1993 a; Khan 1993 b; Khan 1993 c; Khan 1996; Khan 1998; Khan 1999; Khan 2000 a; Khan 2000 b; Khan 2004–2005; Khan 2007 a; Khan 2007 b; Khan 2008; Khan, Kabawi and Al-Zaharani 1986; Zarins 1982.

# THREE FUNERARY STELAE
## FROM THE 4TH MILLENNIUM BC

*Tara Steimer-Herbet*

At the end of the 4th millennium, as they entered the Bronze Age, the societies of the Arabian Peninsula underwent profound transformation: the use of metal became general and the various landscapes became dotted with constructions made of uncut stone with thousands of tombs rising to more than 2 metres above the ground. As these tower-tombs became more widespread, an innovative creation appeared, which was destined to start a long tradition: sanctuaries. The representation of a human being seems to have first appeared with statue-menhirs and stone anthropomorphic stelae.

The three stelae discovered in Saudi Arabia can be linked with a corpus of several dozen, of which sixteen were found in Yemen and more than fifty on the site of Riqseh in the region of Hisma in southern Jordan, where they stood on the perimeter of an open, circular sanctuary built at the end of the 4th millennium.[1] At Rawk in Yemen, one of the five stelae discovered *in situ* was associated with a funerary deposit.[2] The set of objects had been placed at the foundation level of a standing stone belonging to a sanctuary. Fragments of an adult skull and the skeleton of an infant have been dated to 3499 and 3198 BC)[3]. These examples of low-relief sculptures in human form, separated by a distance of 2,300 kilometres, share a common archaeological context and chronology. However, the stelae at Riqseh had been exposed whereas those at Rawk were buried near the bodies and at the feet of the dressed slabs. The geographic area is vast, the functions differ and the number of excavations is insufficient to be able to talk of a "stelae culture". Nonetheless, the themes relating to these three stelae can be described and compared with those of the stelae discovered elsewhere in Arabia over the past thirty years.

Fig. 1. Sketch from a rock wall in Wadi Damm

Stele (cat. no. 27) in al-Ula represents an upright man measuring one metre high. The two flat sides are sculpted but emphasis is placed on the front, in particular on the face, the bust and the hips. The trapezoidal head rests on the shoulders, which are suggested by a projection. The base is narrow and irregular. The outline of the face is accentuated by a fine relief and frames two closely-spaced eyes and a long flattened nose. The torso is hung with a necklace and two cords, to which a sort of awl is attached. A double-bladed dagger is held by a wide belt. The cords and belt continue on the rear of the statue. The height of the stele is exceptional when compared to those in South Arabia, which are no more than 40 centimetres tall. The distribution map (fig. 2) shows that the human representations in the northern regions (Ha'il, al-Ula and Riqseh) are taller. Nonetheless, a common repertoire can be recognized. In the lower part, the absence of details is a characteristic of the stelae found at Rawk in Yemen. With regard to the dagger, similarities are seen among those featured on the many statue-menhirs in these territories. Geographically closer, at Riqseh there is a broken stele adorned with a double dagger and an awl. On a rock wall at Tabuk (Wadi Damm) (fig. 1), two human silhouettes from the late Neolithic have been found with the same attributes.

Stele (cat. no. 28) from Ha'il is the one of an upright man 92 centimetres tall. The head and neck are clearly depicted. The details of the face are very delicate, the eyes bulge and are emphasized by thick brows that extend into the strong, straight nose. A single necklace adorns the trunk, which is probably nude as the sculptor has shown the collar-bones. The posture is hieratic, the arms are folded over the belly and the fingers visible. The man wears a belt on which a circular object is hung. His legs and knees are indicated. The general appearance, the shape of the head, the short, round necklace and the belt all recall their counterparts found in Yemen. The position of the arms, however, seems to be characteristic of the northern regions. At Rawk, different degrees of technical skill are evident in the manner of sculpting (figs 3 and 4); with its remarkable symmetry, the stele found at Ha'il was probably executed by an artist of great expertise. The circular object has no equivalent in all the other stelae. We know of several examples of statue-menhirs[4] in which daggers and circles are shown together, however, the most pertinent representation is seen in the rock carvings in the region of Saada,[5] where the muffle of an ox is held by a ring. During the 4th millennium man became increasingly settled and practised stock breeding.

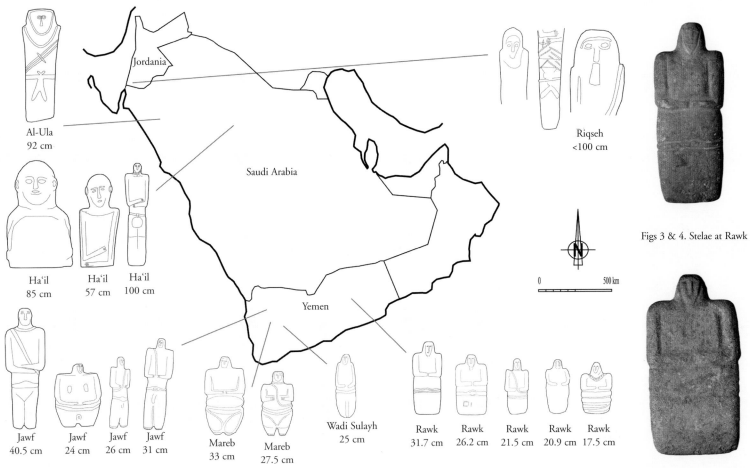

Fig. 2. Map of stelae locations (T. Steimer-Herbet)

Stele (cat. no. 29), also at Ha'il, differs from the two others as only the man's bust and head are represented. The figure is tall: 57 centimetres. The round head is proportionally larger and has a short, thick neck. The representation of the ears and a well-drawn mouth is a distinctive regional feature. Another example of a bust can be seen at the museum in Ha'il (see fig. 2, on the left). The trunk is rectangular, slightly curved, and has a flat base. The styles of the head and bust are very different: the reliefs in the top section are created using curved lines, whereas the torso and arms are straight. The closest parallels are to be seen at Riqseh. On this site representations exist simultaneously of upright human figures, busts and just heads.

Fig. 5. Traces of red pigment at Rawk

Whether above ground or buried, these stelae were sometimes covered in red pigment (fig. 5). The quality and expressive nature of the carving, the details of the finery and the attributes give an accurate idea of the appearance and clothing traditions of this ancient people. As the characteristics differed from one region to another, it is not impossible to imagine their costume was tribal; even today such elements are representative of a region, village or tribe. The existence of stylistic influences and the presence of exogenous materials confirm the circulation and exchange of these objects across vast swathes of territory. The representation of reality and the under-representation of female figures reveal that at the end of the 4th millennium humanity was at the birth of a patriarchal society in which identities were being affirmed.

1. Kirkbride 1969, pp. 116–21, 188–95.
2. Steimer-Herbet *et al.* 2007, pp. 281–94.
3. Pa 2388 and Pa 2389, dating performed by J.-F. Saliège (research engineer, UPMC, Paris).
4. Newton and Zarins 2000, pp. 154–79.
5. Inizan and Rachad 2007.

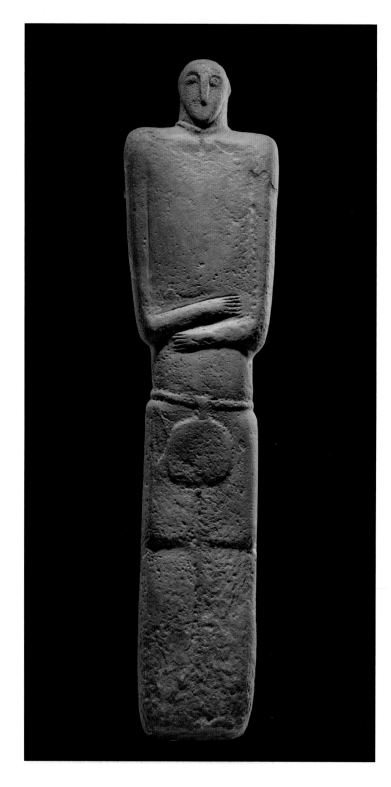

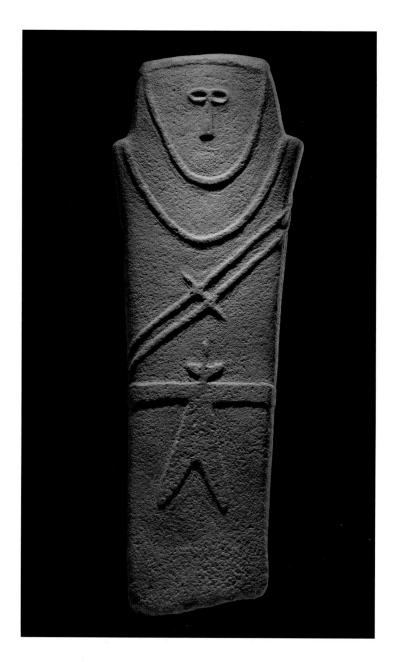

**28. Anthropomorphic stele**
4th millennium BC
Sandstone
92 x 21 cm
El-Maakir-Qaryat al-Kaafa, near Ha'il
National Museum, Riyadh, 997

Bibliography: Al-Rashid, 1975, p. 57 ; Pirenne, 1990, p. 30, fig. 10.

**27. Anthropomorphic stele**
4th millennium BC
Sandstone
100 x 36 x 9 cm
Near al-Ula-Mada'in Saleh-Tayma
National Museum, Riyadh, 996

**29. Anthropomorphic stele**
4th millennium BC
Sandstone
57 x 27 x 7 cm
El-Maakir-Qaryat al-Kaafa, near Ha'il
National Museum, Riyadh, 998

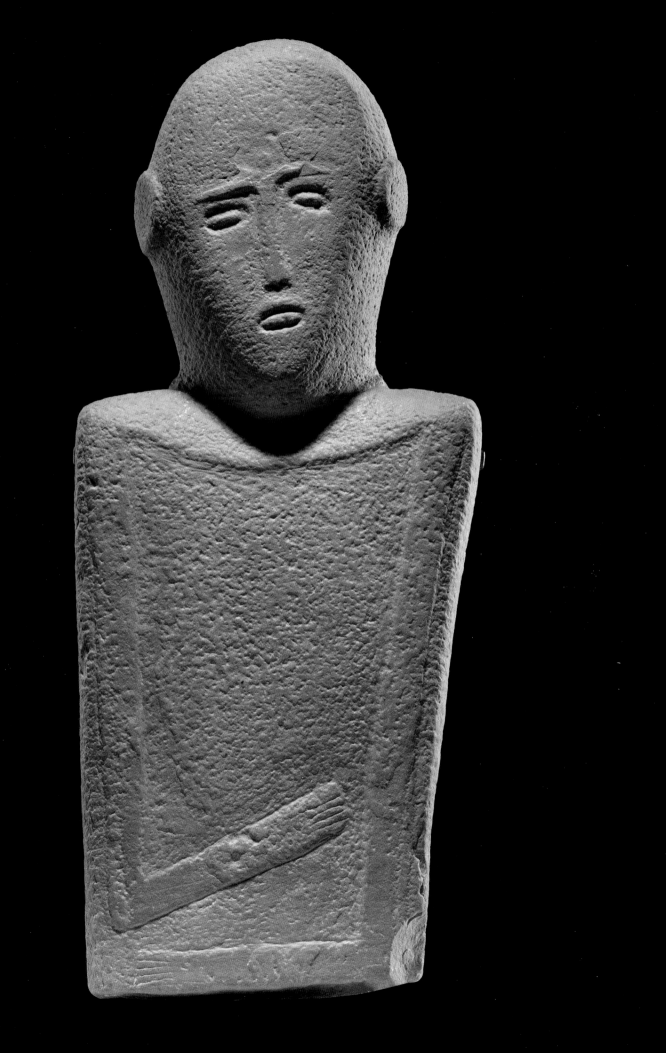

# THE EASTERN PROVINCE

## CIVILIZATIONS AND EXCHANGES

### FROM THE 5TH MILLENNIUM TO THE 2ND MILLENNIUM BC

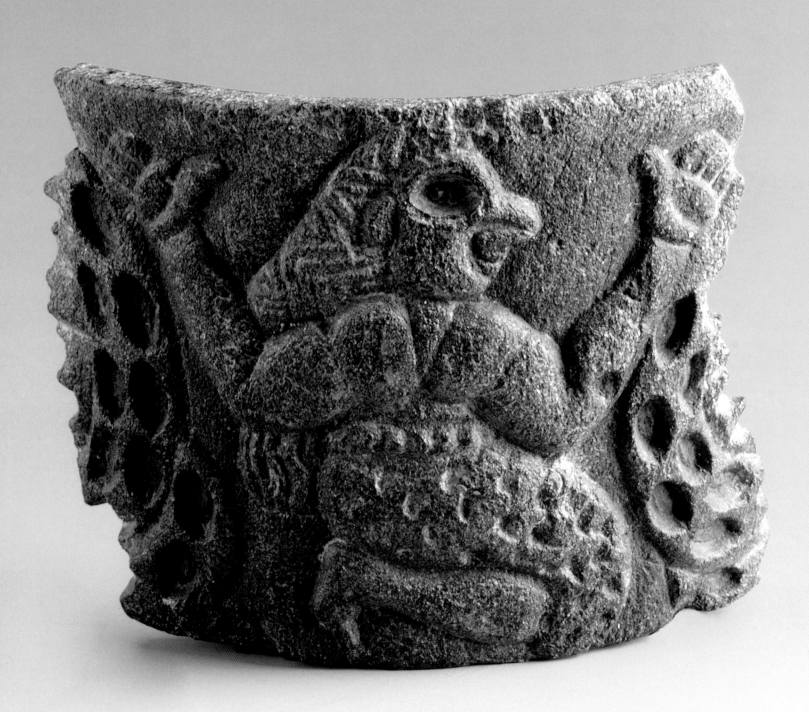

# NORTH-EASTERN ARABIA

## (CIRCA 5000–2000 BC)

*D. T. Potts*

The lithic industry of the early/mid-Holocene found on sites throughout the Eastern Province (cat. nos 293 and 295) is the most obvious manifestation of the indigenous, Neolithic population of this region. From Yabrin in the south to the Kuwaiti border in the north, thousands of finely flaked arrowheads and other tools attest to the presence of a substantial population of herders – perhaps originally from the southern Levant, judging by the similarities between the earliest, post-Palaeolithic lithics in the Eastern Province, Qatar and the UAE[1] and with material that is typical of the Pre-Pottery Neolithic B (PPNB) horizon there – who also engaged in hunting and gathering. Although many sites only have evidence of a shallow and perhaps ephemeral occupation, others must have been in use for a much longer time. Thus Ayn Qannas, near Hofuf, is a mound around 250 metres in diameter with some 3.8 metres of archaeological deposit. Dosariyah, on the coast south of al-Jubayl, is situated in an area of dunes and consists of an area over 100 metres long with around 3.5 metres of archaeological deposit. And the largest site yet identified from this era, Abu Khamis, measures 350 x 850 metres and has an estimated 10 metres of archaeological deposit. Even if these sites were occupied seasonally, they were clearly occupied repeatedly, probably for centuries. In addition to grinding stones and pounders, suggesting the processing of domestic cereals or wild plants, some of these sites have yielded the remains of reed-impressed plaster, suggesting that the inhabitants lived in houses built of palm fronds and wood.[2]

Beyond the evidence of their stone-tool technology, we know something about the economy of these sites thanks to test excavations conducted by Abdullah Masry in 1972. Although the presence of large numbers of finely flaked, barbed and tanged arrowheads at these sites might lead one to think of their ancient inhabitants as principally hunters, this is probably incorrect. Apart from the fact that coastal sites like Abu Khamis have abundant evidence of fishing, shellfish gathering and the hunting of turtles, all of the sites excavated by Masry yielded evidence of herd animals. Cattle, goat and possibly sheep were present in each case and even if the faunal remains could not be confidently identified in 1972 as domestic rather than wild,

*(preceding pages)*
Al-Hasa oasis,
photograph by Humberto da Silveira

*(opposite)*
Chlorite vessel fragment, Tarut,
2nd half of the 3rd millennium BC.
National Museum, Riyadh (cat. no. 51)

1. Uerpmann, Potts and Uerpmann 2009.
2. Generalities on these sites: Potts 1990a; Boivin and Fuller 2009.

the fact that these animals were present so far from their natural habitats further north is a fairly clear indication that they must have been herded, domestic animals.

Sheep and goat, in particular, are extremely useful in such an arid environment as the Eastern Province since they are able to drink brackish water and convert it into milk that can be either drunk or transformed into cheese or yoghurt. Goat hair and sheep fleece are also important secondary products. Thus, the domestic animals kept at Abu Khamis, Dosariyah and Ayn Qannas, although they were probably slaughtered and eaten when they reached old age, would have been more valuable for the secondary products they provided than as a source of protein. To obtain meat, wild ass, gazelle and, on the coast, turtle were hunted. Interestingly, none of the sites excavated by Masry yielded any evidence of wild camel, an animal that was surely present as we can deduce from excavations elsewhere in eastern Arabia.

Just as the faunal evidence indicates that the Eastern Province had contacts with neighbouring areas to the north, so do other artefacts. Perhaps most startling is the fact that several blades of volcanic glass, or obsidian, were found on the surface of Dosariyah (cat. no. 34). Neutron activation analysis suggests that these came from a source somewhere in the region of Lake Van in eastern Turkey, or in nearby Azerbaijan or Armenia.

Just as important as the obsidian, however, was the distinctive painted pottery found at these sites, not in the first instance by professional archaeologists, but by petroleum engineers and others working in Dhahran. With the growth of Saudi Arabia's oil industry in the post-World War II years, and of the Arabian American Oil Company (ARAMCO) in the Eastern Province, thousands of Americans came to live in what was then a relatively untouched part of the Arabian Peninsula. Like their British counterparts in India, Afghanistan and elsewhere during the 19th century, many ARAMCO employees developed an active interest in the archaeology and antiquities of the region in which they lived, spending their free time driving and walking across the landscape in search of artefacts. In the course of these explorations, one ARAMCO school teacher, the late Grace Burkholder, discovered over one thousand sherds of painted pottery at Dosariyah in March 1968, and eventually recorded similar pottery (cat. nos 30, 31 and 32) at thirty-nine sites. When these sherds were shown to T. G. Bibby, who was in the Eastern Province at the time directing a Danish survey, they were immediately recognized as examples of imported, Obeid ceramics. This realization forever changed the face of Arabian prehistory.

Obeid pottery is named after the site of Tell al-'Obeid near Ur in southern Iraq where excavations by H. R. Hall and Sir Leonard Woolley in the 1920s discovered a distinctive type of painted pottery with largely geometric decoration in black on an often overfired, green-buff ware. Later, similar material was found at sites like Eridu and Hajji Muhammad, and a four-stage sequence of stylistic development over time – Obeid 1–4 – was proposed. In 1967, however, the French archaeologist André Parrot discovered the site of Tell el'Oueili, near Larsa, where French excavators (Jean-Louis Huot, Jean-Daniel Forest and Yves Calvet) documented an even earlier phase, which they called Obeid 0, beginning at about 6000 BC.

When the Obeid sherds were discovered at Dosariyah, however, the full development of the Obeid sequence was not understood, anymore than were the origins of this, the ear-

liest sedentary culture in southern Mesopotamia. In fact, one of the first impulses following the discovery of Obeid pottery in the Eastern Province was to declare this the homeland of the earliest settlers in Mesopotamia and, by extension, the probable homeland of the Sumerians themselves. Soon, however, experts like Joan Oates in Cambridge had an opportunity to see the variety of decoration present in the Obeid assemblage from the Eastern Province and it was then realized that, far from representing the origins of the Obeid "culture", the sites in Saudi Arabia nearly always dated to the last two phases, Obeid 3 and 4, while some of the motifs present could be classified as either Obeid 2 or 3. No examples of Obeid 1-type were found nor has any evidence of the even earlier phase, Obeid 0, ever been found. Thus, the idea that colonists from eastern Saudi Arabia had emigrated to southern Mesopotamia and established the region's first sedentary culture had to be abandoned. Quite clearly the direction of influence was exactly the reverse. All of the ceramics indicated movement from southern Mesopotamia to the Eastern Province. What is more, the association of a crude, chaff-tempered redware on some sites in the Eastern Province suggested that the idea and technology of pottery manufacture reached the area at this time as well.

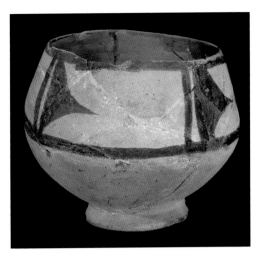

"Obeid" vessel, Tello (Mesopotamia), Musée du Louvre, Paris, AO 25138

Recent excavations in Kuwait have discovered pieces of bitumen with reed impressions, in association with Obeid pottery, as well as a sherd with a simple, painted representation of a boat with mast and ropes. These have plausibly been interpreted as evidence of open-water sailing by this time and even though Kuwait is much closer to southern Iraq than the Eastern Province is, the distribution of Obeid pottery at sites along the Saudi Arabian coast from Musallamiyah Island in the north to Dhahran, strongly suggests that boats, rather than overland transport, were responsible for the diffusion of Mesopotamian material to this region. Moreover, Obeid pottery has also been found at sites on Bahrain, on the coast of Qatar and on the coast of the United Arab Emirates, all of which suggests maritime rather than terrestrial contact.

The mechanisms at work are, however, unclear. Several explanations have been offered. It has been suggested that Mesopotamian fishermen may have come to the waters off the coast of Saudi Arabia on a seasonal basis. While they may have brought pottery with them for their own use, they may have also traded some of it with the local herding and fishing communities along the coast for whom pottery must have seemed like a startling invention. Visiting Mesopotamian fishermen would have had no problem feeding themselves on fish, but they may have traded pottery for other things like milk, cheese, yoghurt, hides, wool, dates, etc. Certainly the ubiquity of the local stone-tool industry on the sites where Obeid pottery has been found suggests that these were the sites of local Arabian groups, who acquired some Obeid pottery, not the sites of Obeid visitors who settled in the area.

Another possibility is that the Obeid pottery found in the Eastern Province was not brought by fishermen but by traders in search of something valuable. Excavations in the UAE on contemporary sites, both on the coast and in the interior, have recovered a substantial number of pearls and of course much later in time pearling in the waters around Bahrain, Qatar and Abu Dhabi became an important industry. It is possible, therefore, that already at this date pearls were a highly sought-after commodity. Because they are organic, however, pearls often disintegrate and it is not surprising therefore that very few have been found on excavations in Mesopotamia. There were probably many more in circulation than we can imagine.

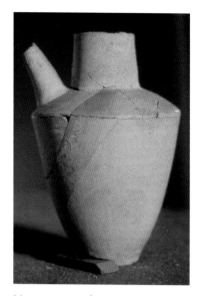

Mesopotamian jar from the Dhahran area, Early Dynastic period

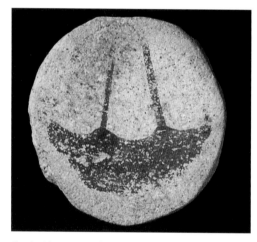

Sherd with an image of a boat, As-Sabiyah, Kuwait

Interestingly, the distribution of Obeid pottery extends into the interior of Saudi Arabia as well. Sites located west of Dhahran, near Al Midra al Janubi, Abqayq, Ayn Dar, Jau al-Ghar and Fuda have yielded Obeid sherds, as have a handful of sites around Hofuf and, perhaps most surprisingly, one site in the Yabrin oasis, about 250 kilometres south of the Hofuf group. It seems highly unlikely that Mesopotamians journeyed so far inland, but it is perfectly possible that groups living in the Eastern Province exchanged this exotic painted pottery with each other.

The chronology of the Obeid-related sites in the Eastern Province is difficult to determine with great certainty. There are three radiocarbon dates from Ayn Qannas, two from Dosariyah, one from Khursaniyah and two from Abu Khamis, but these have quite broad standard deviations. Conservatively we can say that these sites were in use from the mid-6th century to the late 5th/early 4th millennium BC. It is interesting to note, however, that this phase of contact did not, apparently, lead to major changes in the local social system. Beyond the manufacture of the local coarse redwares, nothing suggests that the inspiration of seeing and using Obeid pottery led to the development of an indigenous ceramic industry.

The Obeid contact with the Eastern Province corresponds to the mid-Holocene "climatic optimum" when rainfall was higher due to the northward displacement of the summer monsoon. Climatic change and the onset of aridity may have brought about the end of this phase of settlement, for there is very little archaeological evidence from the succeeding millennium. In fact, a ceramic spout and a clay bulla, both found near Dhahran, are the only finds in the Eastern Province that might be dated to the later 4th millennium BC.

The settlement history of the region picks up again in the early 3rd millennium BC,[3] however, at two settlements – Umm an-Nussi in the Yabrin oasis and Umm ar-Ramadh in the northern part of the Hofuf oasis – and a cemetery – Sabkha Hammam, about 13 kilometres south-east of Abqayq. In addition to demonstrating that villages with mudbrick architecture existed at this time, presumably sustained by herding and agriculture relying on water from hand-dug wells, these sites clearly demonstrate a resumption of contact with southern Mesopotamia. Storage jars (cat. nos 36 and 37) of a type known in southern Mesopotamia and the Diyala region north-east of Baghdad during Early Dynastic I and II times (c. 2900–2500 BC) have been found at these sites, suggesting the movement of goods, possibly oil (contained in the jars), and perhaps people as well, given the range of ceramic forms found. We also find, in the tombs, both lapis lazuli and carnelian beads, the former originating in the Badakshan region of Afghanistan, and probably arriving via eastern Iran, and the latter coming from Gujarat in western India.[4]

Perhaps the most striking collection of material, however, comes from Tarut Island. Located just a few kilometres east-north-east of Qatif, one of the largest date-palm oases in the Eastern Province, Tarut has traditionally been accessible at low-tide from the mainland, although a modern causeway has linked the island with the rest of Saudi Arabia since the 1960s. In the late 19th and early 20th centuries, Tarut was a centre of pearl-diving and date cultivation, favoured by two natural springs – "Ayn Umm al-Fursan" and "Ayn al-Hammam" – that provide excellent water in abundance. In 1964 P. V. Glob and T. G. Bibby, members of the Danish archaeological expedition on Bahrain, visited Tarut and noticed a great deal of sand being quarried in an area of several low mounds. In 1966 a large quan-

3. For a long-term perspective in this region, see Potts 2009.

4. On circulation and exchanges, see Amiet 1986.

tity of objects was found in a mound near the village of al-Rufayah, approximately 1.5 kilo-metres south-east of the main town on Tarut. Eyewitnesses report that the mound, around 1–2 metres high and 20 x 100 metres, was being mined, its coarse sand and shell surface being taken away by donkey carts and later by mechanical equipment for use in the con-struction of the causeway linking Tarut with the mainland. The quantity of softstone (steatite and chlorite), alabaster and ceramic vessels and fragments that were dislodged sug-gested that the mound contained many graves.

Although a few of the objects that came to light in this way were eventually sold on the antiquities market, most of the objects were acquired by local ARAMCO employees and eventually donated to the National Museum in Riyadh. Chronologically, these objects sug-gest that the Tarut cemetery was in use for perhaps a thousand years, and then again in the Hellenistic period.[5] What is particularly remarkable about the Tarut collection is the fact that so much of the material was imported. On the one hand this makes identification and cultural attribution relatively straightforward. On the other hand, such a situation demands an adequate explanation.

The earliest finds from Tarut include a biconical ceramic jar of the sort common in Mesopotamia around 2900 BC during the Early Dynastic I period (see fig. p. 189). Only slightly later are several undecorated softstone vessels (cat. nos 40 and 41) that find close parallels in the so-called "Jamdat Nasr cemetery" at Ur and which date to Early Dynastic II. Also thought to date to this period is a nearly one-metre high anthropomorphic statue in limestone of a nude male (cat. no. 38). The figure has a smooth head and wears a triple-belt, much like the nude heroes on Early Dynastic Mesopotamian cylinder seals. His upper arms are held close to his sides and his forearms are crossed over his chest, right hand folded over the left. In many ways this posture recalls Early Dynastic II statues from the Diyala region with their rather angular depictions of the human form, and the triple-belt is cer-tainly a feature familiar in Mesopotamia. The squareness of the legs, however, is certainly not Mesopotamian and the head has been compared by some scholars with a well-known bust from Mohenjo-Daro, one of the main sites of the Harappan civilization in Pakistan. Given the apparently hybrid nature of this piece, the possibility must be considered that it is a local work reflecting diverse foreign influences.

Contemporary with or slightly later than these finds, if we judge by parallels amongst the material from the Jamdat Nasr and Royal Cemetery at Ur, are a number of alabaster bowls (cat. nos 44 and 45) as well as a beaker made of argillaceous limestone with coral inclusions (cat. no. 42). Based on parallels with material from a late 3rd millennium tomb at Tell Abraq in the UAE, these simple alabaster bowls could also date to c. 2000 BC. A bell-shaped bowl (cat. no. 43) also finds close comparison in the Royal Cemetery.

By far the largest and best known are the carved softstone vessels and fragments with figurative, low-relief decoration, and with hollows for inlays made of paste, semi-precious stones and mother-of-pearl. This assemblage includes numerous pieces with vividly depicted creatures, such as spotted felines or snakes (marked by circular depressions that would originally have held inlays) with elongated, entwined necks in association with human figures (cat. no. 51 and fig. 1, p. 184); lions (cat. no. 49); eagles (cat. no. 48); lion-headed eagles (Anzu bird, fig. 2, p. 184); and humans and animals (cat. nos 50 and 47).

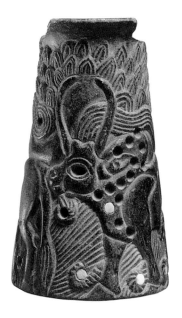

Tarut vessel depicting a zebu, Metropolitan Museum of Art, New York, L. 1978-31

5. See in this catalogue, Potts, pp. 375–81.

Vessel inscribed with the name of "Rimush, king of Kish" and decorated with a feline and a snake, Vorderasiatisches Museum, Berlin, VA 5298

Muscovite schist (cat. no. 60) was also used to make vessels with entwined snakes. Stylized mountains and buildings appear on one piece (cat. no. 58), while a number have repeated patterns such as the basket-weave (fig. 5, p. 185), guilloche (cat. no. 63), imbricate (cat. nos 54 and 57) and rosette (cat. no. 55 and fig. 4 p. 185).

Preliminary publications of this material began to appear in the early 1970s and it was at once recognized that many of the pieces from Tarut had parallels in Mesopotamia during the Early Dynastic II–III periods, and even further afield at sites like Mari in Syria. At the same time, excavations at Tepe Yahya in south-eastern Iran identified a site at which such softstone had been carved. More recently, hundreds of complete vessels of precisely the same types have been found in the Jiroft plain, less than 100 kilometres to the east of Tepe Yahya, largely in the course of illicit excavations in a cemetery there, and to a lesser extent at the site of Konar Sandal, excavated by Y. Majidzadeh. X-ray diffraction analyses by P. L. Kohl, E. V. Sayre and G. Harbottle in the early 1970s suggested the existence of several sub-groups within the corpus, based on the mineralogical composition of the stone. One of these groups comprised material from Susa, Adab in southern Mesopotamia and Tarut, and it was once thought that the material from Tarut had been produced in workshops on the island itself using stone from a Saudi Arabian source. The Jiroft discoveries, however, coupled with the evidence of production at Tepe Yahya, makes this highly unlikely. The decoration and iconography exhibited in this corpus of material is so consistent that it seems clear it was all produced in south-eastern Iran. Although considered an "intercultural style" by some scholars, it is now clear that the style, identified by Pierre de Miroschedji in 1973 as the "*série ancienne*", was anything but intercultural. Rather, it was indigenous to south-eastern Iran, from which examples of this finely carved softstone were traded widely, as far away as Palmyra and Mari in Syria, Tarut in Saudi Arabia, the UAE and Soch in the Ferghana Valley of Uzbekistan.

One example with figurative carving of this type, acquired in 1913 by the Pergamon Museum in Berlin, bears an inscription which reads "Rimush, king of Kish, the slayer of Elam and Marhashi". It shows a spotted feline or snake remarkably similar to those seen on nos 51 and 60 from Tarut. This inscription makes it very probable that Marhashi was the name of the area in which the Pergamon fragment originated. It is also interesting to note that in one of his royal inscriptions, Rimush (2278–2270 BC) says that he obtained *duhshia* stone from Marhashi. Piotr Steinkeller has suggested that this was very probably the word for softstone, the favoured material in Marhashi for the production of the elaborately carved vessels of the sort found on Tarut.

We are faced, therefore, with clear evidence of considerable trade or contact in the mid-late 3rd millennium BC between south-eastern Iran, ancient Marhashi, and the island of Tarut. The discovery of a few fragments of similar *série ancienne* softstone at sites such as Sharm and Umm an-Nar in the UAE, and on Bahrain, strongly suggests that the movement of this material was affected by sea. In 1986 Pierre Amiet suggested that émigré artisans from south-eastern Iran may have settled on Tarut and there made the softstone that we have just been discussing. Despite the great similarity between the softstone from Tepe Yahya and Tarut, this possibility seemed plausible when it was believed that the Susa, Adab and Tarut material was made of Saudi Arabian stone. Now, however, it seems clear that while the pieces analysed from these sites might share similar mineralogical characteristics,

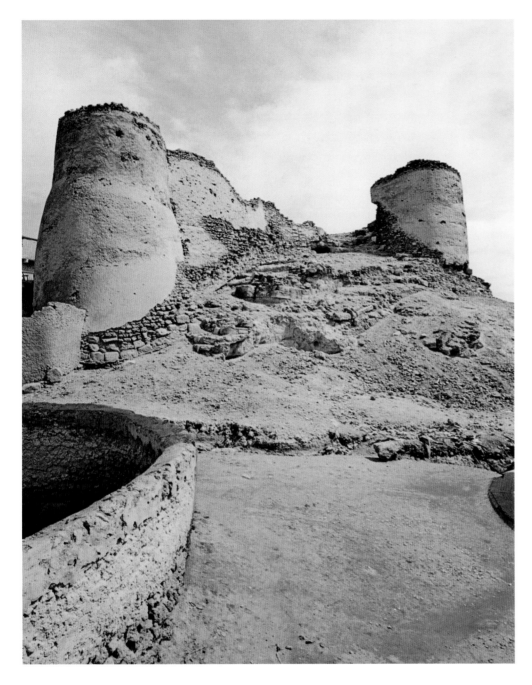

View of Tarut fort

this says nothing about their shared place of origin. In view of the overwhelming evidence of production in south-eastern Iran, it seems much more likely that all of the Tarut material, with the possible exception of the "copy" made of muscovite schist (cat. no. 60), was imported from Marhashi and was not made locally.[6]

The presence of such objects on Tarut, and the likelihood that they were deposited, along with alabaster vessels, imported ceramics (cat. nos 68 and 69) and an anthropomorphic figure in lapis lazuli (cat. no. 39), implies the existence of a society that desired to possess such status symbols and had an ideological use for them. Can we perhaps suggest a name for that society? In fact, the cuneiform sources of southern Mesopotamia do suggest a possible answer to this question. Beginning in the late 4th millennium BC, the earliest written records from Uruk in

6.  Potts 2005; Steinkeller 2006.

southern Mesopotamia refer to a place called Dilmun, associated in several cases with copper. Later, during the Early Dynastic period, Dilmun was a source of imported woods brought to Lagash. By the end of the 3rd and early 2nd millennium it is clear that Bahrain was the centre of the land of Dilmun. The name, in its Akkadian form Tilmun, survived into the Hellenistic period as Tylos, and from Greek geographical descriptions it is very clear that Tylos denoted the large island of Bahrain, and Arados, mentioned in association with it, the smaller island of Muharraq (where the modern airport of Bahrain is located).

However, in the period we have been discussing, during the early and mid-3rd millennium BC, there is absolutely no evidence on Bahrain of a developed society, or a major settlement, that could represent the archaic stage of Dilmun. Therefore, a number of scholars have suggested that the name Dilmun originally referred to the Eastern Province of Saudi Arabia – with its settlements at Umm an-Nussi and Umm ar-Ramadh in the interior and Tarut on the coast. In addition to the cemetery in which the finds described above originated, Tarut has a large mound capped by a much later fort on top. Given the richness of the grave inventories, Tarut was quite possibly the main port, or even the capital, of early Dilmun.

Importantly, the elite goods in the Tarut graves may help us to place in context an Early Dynastic letter (VAT 4845) in the Pergamon Museum.[7] Probably from the reign of Lugalanda (ED III, c. 2400 BC), the letter was written in Sumerian by one Niginmud, a chief scribe, to an individual whose name is unfortunately lost. The letter reports that twelve baskets of dates, three baskets of pitted dates, three linen garments and 120 *minas* (approximately 60 kilograms) of copper were sent by the queen of Dilmun to the queen of Lagash. The reference at this early date of a queen of Dilmun – although we cannot be certain exactly what the Sumerian scribe meant by that – suggests that some form of hierarchically organized political structure existed in the Eastern Province by the middle of the 3rd millennium BC.

For unknown reasons, by about 2200 BC the centre of gravity in Dilmun shifted from Tarut and the Saudi Arabian mainland to the island of Bahrain. In a short time, we see the appearance there of major settlements at Qalat al-Bahrain and Saar, an impressive temple complex at Barbar and thousands of burial mounds. Why might the centre of Dilmun have shifted from the mainland to Bahrain? This is a question that has often been asked but never adequately answered. In fact, there is a possible analogy for the removal of a capital from the mainland to an island in the mediaeval era. From 1100 to 1300 AD, a semi-independent kingdom of princes ruled at Hormuz, a town located about 10 kilometres south-west of Minab in southern Iran near the Straits of Hormuz. Hormuz was an important trade centre with large warehouses and was considered the chief maritime outlet for Kerman. Politically, the princes of Hormuz were alternately dependent on the Atabeg rulers of Fars and the rulers of Kerman. Marco Polo visited Hormuz in 1272 and 1293, describing it as a flourishing centre of trade. After the Mongol conquest of Iran, however, Hormuz became a target of the Chaghatay Turks and as a result, in 1300, the Hormuzi ruler Baha'-al-Din Ayaz moved his people and the entire Hormuzi trading establishment from the mainland to the island of Jarun in the Straits of Hormuz. Located around 60 kilometres west of the original town of Hormuz, Jarun, which became known as New Hormuz and eventually just as Hormuz, lacked many things, including fresh water and vegetation, but it was eminently defensible and remained an important trading centre until it was finally conquered by the Portuguese in 1501.

7. Selz 1989; Kienast and Volk 1995; Marchesi 2004, pp. 178–9.

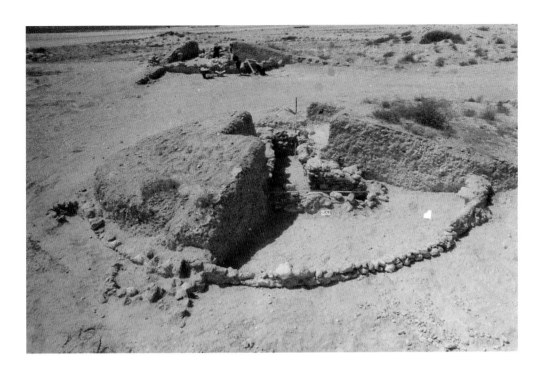

Tomb B13, Dhahran

Could something similar have driven the movement of Dilmun's centre from Tarut or elsewhere on the east Arabian mainland to Bahrain? We have no sources documenting such a process, but it is certainly possible that rivalries with other groups on the mainland, challenges to the authority of the ruling house of Dilmun by a rival leader, or disputes within the ruling house, may have led to the shifting of Dilmun's power base from the mainland to Bahrain. Judging by the available archaeological evidence on Bahrain, the population there must have been small until the last quarter of the 3rd millennium BC, and it is thus conceivable that an ambitious dynast saw an opportunity to set up a rival kingdom on the island based in a large, defensible settlement at Qalat al-Bahrain. With abundant springs and an excellent position on the maritime lanes of traffic between Mesopotamia and the east, Bahrain was eminently suited for such a role. This is, of course, highly speculative, but the example of Hormuz may help us to understand how it was that a culture so well-established in the Eastern Province seems to have been transplanted to an island just a short distance away.

As the hundreds of burial mounds at Dhahran attest, the shifting of the centre of gravity from the mainland to Bahrain in no way signalled a depopulation of the Eastern Province. Nor did it spell the end of connections with the outside world, particularly with the Oman peninsula, Iran and Bahrain. Carved softstone vessels from the Oman peninsula, characteristic of the late Umm an-Nar culture there (c. 2300–2000 BC), have been found on Tarut (cat. nos 65 and 67), and in graves in a large cemetery at Dhahran (cat. no. 66). Black-on-grey ceramic vessels with delicately painted, long-horned caprids (cat. no. 68) found on Tarut were imported from Kerman or Baluchistan.

One unusual ceramic beaker with black/brown painted decoration on a buff ware (cat. no. 69) has, in the past, been considered an important vessel from the Harappan civilization in the Indus Valley because of the vegetal decoration resembling pipal leaves, but the shape,

as well as the wavy-line decoration just below the rim, are closely paralleled in the so-called Kaftari assemblage (c. 2200–1800 BC) from sites in Fars such as Tal-e Malyan, Tol-e Spid and Tol-e Nurabad. Another vessel that seems to display both a Kaftari shape and Harappan vegetal motifs was found in a grave at Dar Kulayb on Bahrain dated to c. 2000–1800 BC.[8] Given the paste and the shape, it is unlikely that these vessels are Harappan, and more likely that they were made in south-western Iran. On the other hand, the vegetal decoration suggests the influence of a Harappan model.

One of the earliest illustrations of Bahrain's continued ties with the mainland is provided by a stamp seal (cat. no. 77) of the sort that was typical for the earliest Dilmun period (c. 2200–2000 BC) on Bahrain. Seals of this period typically show no human figures, only animals. Later, in the period c. 2000–1700 BC, the design repertoire of stamp seals in Dilmun became much more varied. Hundreds of seals have been found on Bahrain and on the island of Failaka, in the bay of Kuwait, where a satellite settlement of Dilmunites was founded sometime after 2000 BC. Three examples of Dilmun-style stamp seals are known to be from Saudi Arabia (cat. no. 78) and while it is to be expected that such seals would appear in the Eastern Province, as is the case with one of the seals from a grave at Dhahran, it is certainly surprising to find one at the much later site of Qaryat al-Faw. Without question, this seal must have been ancient, perhaps a valued curiosity, by the time it was brought to Qaryat al-Faw, so far away from its place of origin.

Ceramics also attest to close ties between Bahrain and the Saudi Arabian mainland in the late 3rd and early 2nd millennia BC. One painted jar (cat. no. 74) with pendant, hatched triangles and zigzag bands around the neck and body of the vessel, has two very close parallels in a complete jar from a grave at Madinat Hamad on Bahrain, and a sherd from a context dated to c. 2100 BC at Tell Abraq in the UAE. Given the unique decoration on these vessels, it is easy to suggest that all three come from the same source. Specifying whether that source was the Eastern Province, Bahrain or the UAE is, however, less easy. Considering that there are a number of similar vessels from the Dhahran cemetery, it is quite possible that they all came from this area.

Other ceramic vessels found in the Eastern Province, however, are so similar to finds from Bahrain that it is very probable they are imports. This is true of a typical, "red-ridged" storage jar, made of perhaps the most diagnostic type of pottery used on Bahrain in domestic contexts during the early 2nd millennium BC. Other vessels, with a very distinctive, plum-red slip (cat. nos 70 and 71), are more commonly found in tombs on Bahrain and might even be specifically funerary in character. The cup from a hollow-footed goblet (cat. no. 72) has parallels on Bahrain, but there are enough examples from the Dhahran cemetery to suggest that this might have been a local product. Still other vessels, like a shallow cup with zigzag decoration, belong to the so-called Wadi Suq tradition (c. 2000–1500 BC) in the UAE and Oman. At least one vessel is almost certainly a Mesopotamian import dating to the Akkadian or Ur III period (c. 2350–2000 BC). In paste it is completely unlike the local ceramics of the Eastern Province or Bahrain, where a few comparable examples of such imported Mesopotamian wares have also been found in graves. Finally, softstone-vessel production in south-eastern Arabia continued to be prodigious during the 2nd millennium BC, and examples of these so-called *série tardive* vessels certainly reached Bahrain, Tarut and Dhahran (cat. no. 66).

8. Petrie *et al.* 2005.

View of Tarut

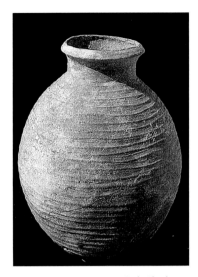

Red-ridged ware

All of this material can be seen as confirmation of the existence of a web of maritime ties between the Eastern Province, southern Mesopotamia, Bahrain, the coast of the UAE, south-eastern Iran and the Indus Valley during the late 3rd and early 2nd millennia BC. Even if the centre of Dilmun shifted from the mainland to Bahrain, sites such as Tarut and Dhahran were still able to access foreign goods – ceramics, stone vessels, seals and probably timber and copper, too – from points east. Mesopotamian cuneiform sources, while they do not directly refer to our area after the mid-3rd millennium BC, nonetheless speak of a number of regions to the south with which commercial ties existed. Certainly merchants from the Indus Valley sailed westward to Dilmun (Bahrain) and Mesopotamia. But they also stopped in south-eastern Arabia, where the modern UAE and Sultanate of Oman occupy the territory of the ancient land of Magan. As we have seen, ceramic and softstone evidence confirms the existence of ties between Magan and the Eastern Province, and it is important to remember that the early 2nd millennium BC was a period in which merchants in Dilmun were particularly active as traders in copper, supplying southern Mesopotamian cities like Ur with copper ingots. The copper in question originated in the Oman Mountains, and thus came by sea to Dilmun, before being transshipped to southern Mesopotamia. Undoubtedly, the distribution of foreign goods that we see at sites in the Eastern Province is a clear indication that this region, too, profited from such long-distance trade and was not excluded from it.

Culturally, one could even suggest that the Eastern Province, while perhaps no longer the centre of Dilmun, was nonetheless still a constituent part of it. So many settlement sites visited during the surveys of 1976 and 1977 had typical Bahraini red-ridged pottery, and the grave inventories at Dhahran share so many similarities with those of Bahrain itself, that we may justifiably consider the two regions parts of one single culture at this time.

# CHLORITE VESSELS FROM TARUT

*Marianne Cotty*

The construction in the 1960s of a road between the Tarut Island and the Arabian Peninsula led to the discovery of tombs containing vessels carved in soft stone with elaborate decorations. In the years that followed, in the process of expanding their croplands, the inhabitants of the island unearthed a great quantity of such artefacts. Part of this archaeological treasure was acquired by M. Golding and G. Burkholder from the ARAMCO, who published a study on the finds[1] and donated them to the National Museum in Riyadh. Later, the excavations led by G. Bibby in 1968[2] and the soundings by A. H. Masry in 1975[3] confirmed that the island had been inhabited from the 3rd millennium BC to the Hellenistic period. A catalogue of the six hundred or so fragments consigned to the National Museum was then compiled by J. Zarins.[4] Most of these vases are undecorated (cat. nos 40 and 41) or adorned with simple dotted circles (cat. nos 64, 65 and 67). The rest are decorated in a style known as *intercultural style*[5] – also called the *série ancienne,*[6] or the *figurative style*.[7] This style comprises a wide range of representations, from complex compositions of geometrical patterns to scenes depicting human figures and/or animals. Numerous vessels of this type have been found in Tarut as well as in many regions of the Middle East. Tepe Yahya and Jiroft in south-eastern Iran have yielded the highest concentration and therefore must have been the biggest production centres. The great popularity of intercultural style vessels in regions as widespread as Mesopotamia, Central Asia, Iran and the small island of Tarut suggests that all of these populations understood the meaning of this iconography. The motifs used are highly standardized

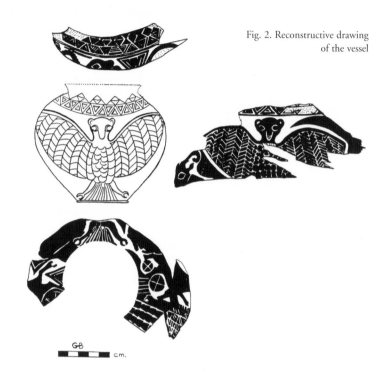

Fig. 2. Reconstructive drawing of the vessel

and originate from various spheres of influence, from Iran to Mesopotamia.

The sherd decorated with an image of the bearded hero Lahmu (cat. no. 47) with a triple waistband, the torso shown facing forward and the legs in profile, dominating a bull, is a known motif on Mesopotamian stone vessels as soon as early 3rd millennium.[8] In Mesopotamian mythology, Lahmu is often associated with water and incarnates the protector of the herds. The lion-headed eagle IMDUGUD/Anzu (cat. no. 46 and fig. 2) is shown, following Mesopotamian convention, caprine grabbing in his claws. This is a theme widely used in the Mesopotamian world on perforated plaques and silver vessels, as well as a soft stone vessel discovered in Mari.[9] However, the eagle is sometimes treated in a more naturalistic style, as on the box lid (cat. no. 48). This is a frequent theme on vessels found in Tarut[10] and Jiroft, but also on handled weights and appliques,[11] on which the eagle is often associated with snakes, illustrating the struggle between chthonian and celestial powers.

The most common animal on the Tarut vessels is a pair of entwined fighting snakes (cat. nos 51 and 60, figs 1 and 3), depicted face to face with open mouths. Their scales are represented by almond-shaped holes that were, like the eyes, inlaid with added materials, and all of them have "ears" in the shape of two interlocking

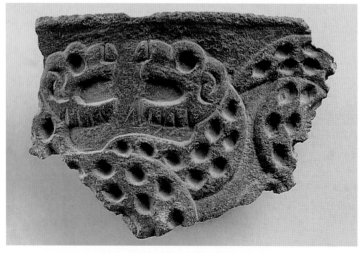

Fig. 1. Vessel fragment from Tarut decorated with entwined snakes, National Museum, Riyadh, 2662

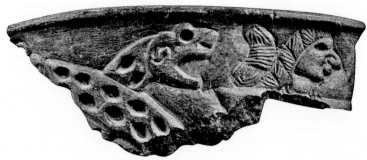

Fig. 3. Vessel fragment from Tarut decorated with a snake and a man's
head emerging from a vessel, National Museum, Riyadh, 2660

commas. The motif of entwined snakes is well known on vessels and handled weights found in south-eastern Iran,[12] and on a specimen discovered in the Ferghana Valley in Central Asia.[13] The reptiles are sometimes represented being held by men with long hair and prominent noses, similar to the "Master of the Beasts" (cat. no. 51). Such scenes are frequently found on the soft stone vessels of south-eastern Iran and Mesopotamia,[14] depicting a kneeling or standing male figure dominating zebus or felines.[15]

The image of a man's head with bunched hair emerging from a vessel and framed by snakes (fig. 3) is perhaps an illustration of a myth related to bathing or purification. This same bunched-hair figure is represented on a sherd discovered in Uruk.[16] On the other hand, the person on vessels in cat. nos 49 and 50 is treated in a different style to that in fig. 3, reminiscent of the style found in Failaka.[17] It appears with a lion whose coat is depicted by whorl-like, imbricated motifs, which also diverges from the usual feline representations found in Tarut.[18] Architectonic, mat-weave and imbricated patterns are omnipresent in the iconography of chlorite vessels. The "hut" architectural motif (cat. no. 58) found on vessels in Tarut, Bahrain,[19] Mesopotamia, Syria and Iran[20] evokes the light constructions made of palm wood that were probably the most common type of dwellings at the time. The imbricated motifs sometimes associated with architectonic elements imitate various types of wattling and imitate domestic

basketwork (cat. nos 52–54 and 56–59, fig. 33). Among the geometrical decorations are guilloche motifs symbolizing waves of water (cat. no. 63) and inlaid rosette motifs (cat. no. 55 and fig. 36).

These inlays of coloured stones or artificial materials contrast with the colour of the chloritite or chlorite, which varies from greenish grey to greenish black. Analyses have shown that the stones used in Tarut[21] came from different sources, probably transported in rough and/or semi-finished form. The island must therefore have been a transshipment and production centre with craftsmen who came there from south-eastern Iran or at least had close contacts with that region. Over several centuries, throughout the 3rd millennium, they worked in Tarut, fashioning vessels for affluent city dwellers and Mesopotamian temples, perhaps as part of the gifts exchanged between kings and local potentates.[22]

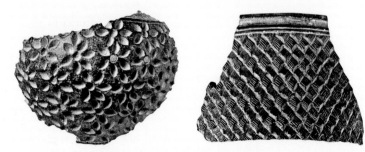

(*left*) Fig. 4. Vessel fragment from Tarut decorated with rosettes
National Museum, Riyadh, 2648
(*right*) Vessel fragment from Tarut decorated with a woven pattern
National Museum, Riyadh, 2639

1. Burkholder 1971.
2. Bibby 1973.
3. Masry 1997, pp. 97–103.
4. Zarins 1978, pp. 65–93.
5. Kohl 1974.
6. Miroschedji 1973.
7. David 1996.
8. New York 2003, no. 16a, b and Iraq Museum Baghdad, no. 66071.
9. Margueron 2004, p. 289, fig. 276.
10. Zarins 1978, nos 140 and 159.
11. Madjidzadeh 2003, cat. nos 92, 96, 97, 126, 130–33.
12. Lamberg-Karlovsky 1988, p. 79, D and E; Miroschedji 1973, p. 12, fig. I, f–g; Madjidzadeh 2003, pp. 98–107, p. 123 and Louvre, AO 29142.
13. Exhibition in New York 2003, no. 236.
14. Exhibition in New York 2003, nos 227 and 235; Amiet 1986, fig. 73; Porada 1962, fig. 12; Woolley 1955, pl. 36.
15. For example Madjidzadeh 2003, pp. 13, 15 and 45.
16. Lindemeyer and Martin 1993, no. 690.
17. David 1990, fig. 5.
18. Zarins 1978, nos 13, 22, 69 and 134.
19. Crawford and Al-Sindi 1996, fig. 1.
20. Exhibition in New York 2003, p. 341, note 2.
21. Pure chlorite, talc or steatite, amalgam of talc–chlorite, chlorite–quartz, chlorite–andradite, phlogopite and muscovite–schist (cat. no. 60); Kohl *et al.* 1979.
22. Kohl 2004, p. 287.

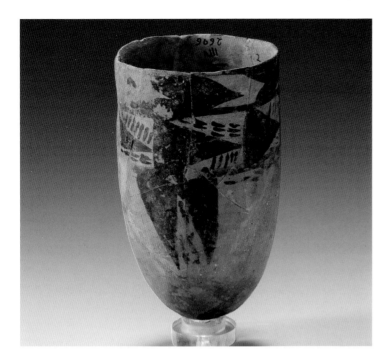

**30. Beaker**
c. 5300–4700 BC (Ubaid III)
Painted pottery
Diam. 4 cm; H. 10; Th. 0.3 cm
Khursaniyah
National Museum, Riyadh, 1137

Bibliography: Masry 1997, pl. XXX, no. 3; Potts 1990, fig. 4/k; Riyadh 2009, p. 164.

This small beaker and these sherds of painted pottery bear witness to the presence of so-called Ubaid pottery[1] on the shores of the Arabian Gulf. Hundreds of fragments of this type have been found on the surface on sixty sites, mainly concentrated in the coastal regions of Saudi Arabia, Bahrain and Qatar. This pottery is characteristic of the Neolithic Ubaid civilization that arose in the Mesopotamian plain in the middle of the 7th millennium BC and continued for over three thousand years. Around 5300–4700 BC (Ubaid, Stage III), this active, dynamic culture expanded widely to the north, but the Ubaid people also ventured southward and established contact with the Neolithic communities settled on the shores of the Arabian Gulf. The Ubaid pottery, made of fine, greenish beige clay and coarsely painted with dark brown motifs, was more elaborate than the local pottery (cat. no. 33). Were these vessels offered as goodwill gifts by Mesopotamian fishermen who wanted to ply the coastal waters, or were they a medium of exchange, bartered for goods that could find a market in Mesopotamia?[2] In any case, they were most likely considered exotic objects, symbols of luxury and prestige, by the local populations. **F. D.**

1. Named after the Mesopotamian site where it was first found.
2. Oates *et al.*, 1977.

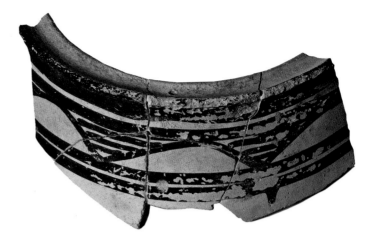

**31. Vessel fragment**
c. 5300–4700 BC (Ubaid III)
Painted pottery
about 25 cm
Abqaiq (site 23)
National Museum, Riyadh, 1943

Bibliography: Masry 1997, pl. XIX, no. 3; Riyadh 2009, p. 164.

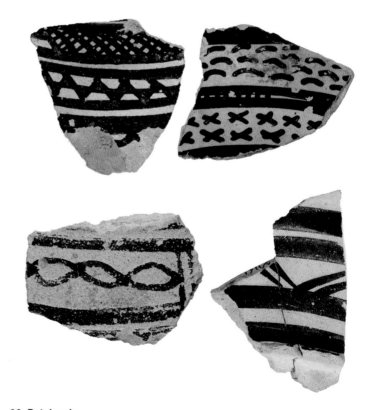

**32. Potsherds**
c. 5300–4700 BC (Ubaid III)
Painted pottery
about 5 cm each
Dosariyah and Ayn Qannas
National Museum, Riyadh, 13/1141, 8/1141, 3/1141 and 8/1144

Bibliography: Al-Rashid 1975; p. 141 top; Riyadh 2009, p. 164.

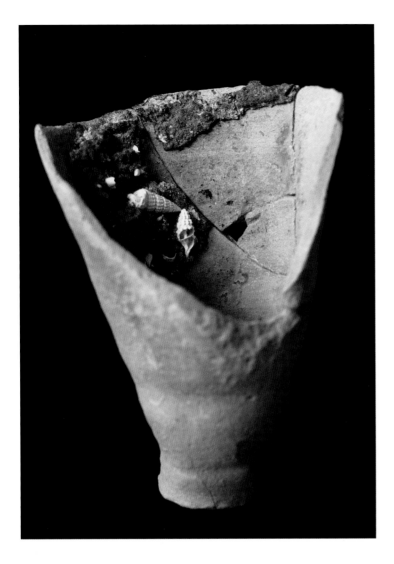

**33. Conical vessel**
5th millennium BC
Pottery, bitumen, barnacles
Ayn as-Sayh
Diam. 9 cm; H. 12 cm
Dammam Museum, 4648

Bibliography: McClure and Al Shaikh 1993, p. 107, fig. 13.

This vessel, crafted from coarse clay with straw-temper, is an example of the local pottery production. The presence of barnacles on the inner surface is an indication of higher water levels in the Arabian Gulf during the second half of the 5th millennium BC.[1] The bitumen on which they are agglomerated was imported from southern Iraq, just like the Ubaid painted pottery (cat. nos 30, 31 and 32). The development of maritime navigation starting in the 6th millennium BC enabled the transport of such products and foods.[2] **M. C.**

**34. Blade**
5th millennium BC
Obsidian
L. max. 5 cm
Dosariyah area
National Museum, Riyadh, 2/1182/2

During the 6th millennium BC, trade between the Arabian Peninsula and other regions intensified. Pottery and bitumen were imported from Mesopotamia, as well as obsidian from Turkey and the Transcaucasian region. This natural volcanic glass was especially prized for making blades, which were mounted on handles to make sickles. Although very few traces of agriculture have been found in the region, the discovery of sickle blades, hoes and grindstones confirms the existence of a marginal agricultural activity. The populations of eastern Arabia subsisted mainly by fishing, gathering shellfish, hunting, and also goat and cattle husbandry. **M. C.**

1. McClure and Al Shaikh 1993, p. 107–25.
2. Carter 2006.

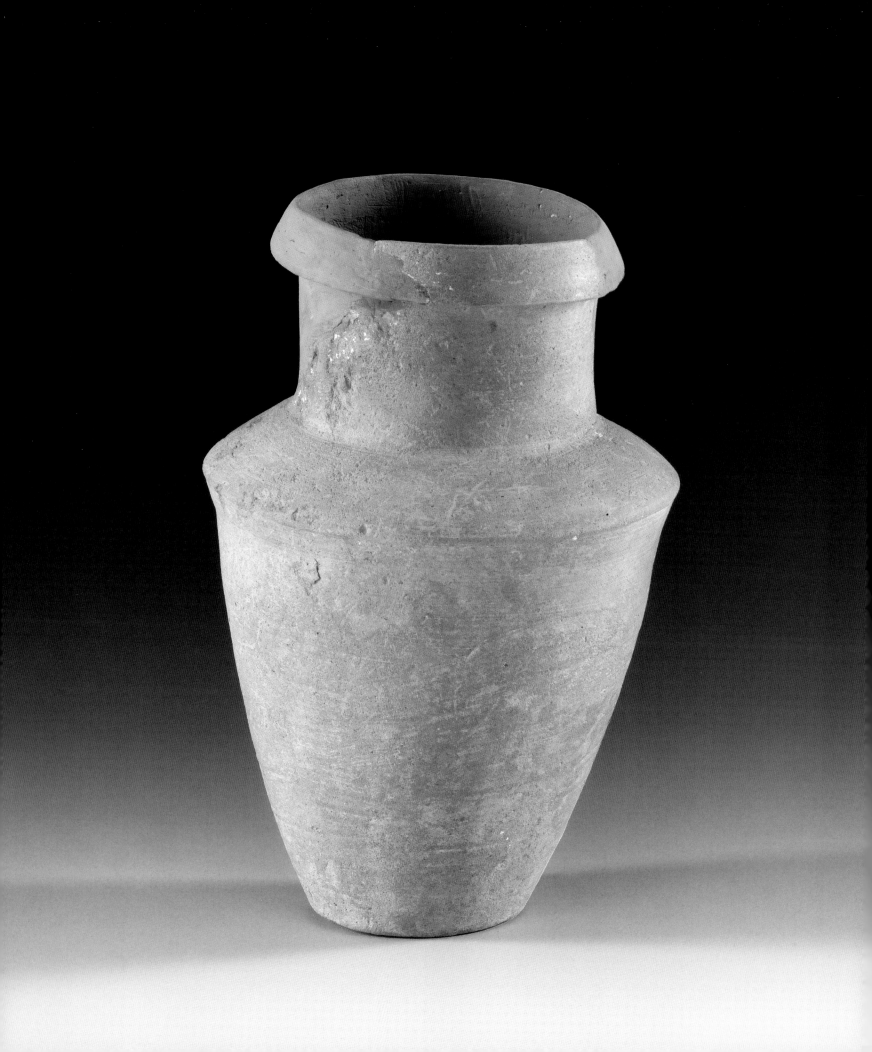

**35. Jar** (opposite)
First half of the 3rd millennium BC
Pottery
H. 21 cm; Max. diam. 14 cm
Tarut, al-Rufayah
National Museum, Riyadh, 1144

Bibliography: Burkholder 1984, fig. 17A and p. 190; Zarins 1989, fig. 6/9.

Eastern Arabia has practically no archaeological remains from the 4th millennium BC, and pottery did not appear until the early part of the 3rd millennium BC.[1] Once again, the pieces that have been found are Mesopotamian vessels that were used to transport food products like oil and grain. Soundings at al-Rufayah on the Tarut Island have yielded two jars from this period: a carinated jar with a bevelled lip and a biconical jar (below), both characteristic of the Jemdet Nasr–Early Dynastic I period in Mesopotamia.

**M. C.**

1. Concerning the controversy on the presence of Uruk material in eastern Arabia, see Cleuziou 1988, pp. 31–32.

Biconical jar from al-Rufayah, Tarut

**36. Jar** (above, left)
First half of the 3rd millennium BC (Early Dynastic I/II)
Pottery
H. 37 cm; Max. diam. 27 cm
Abqaiq, Sabkha Hammam
Dammam Museum, 1190

Bibliography: Al-Rashid 1975, p. 150 left; Riyadh 2009, p. 166.

**37. Jar** (above, right)
First half of the 3rd millennium BC (Early Dynastic I/II)
Pottery
H. 36; Max. diam. 27.5 cm
Abqaiq, Sabkha Hammam
Dammam Museum, 1192

Bibliography: Al-Rashid 1975, p. 150 right.

Many Mesopotamian ceramic vessels were unearthed from the tombs in Abqaiq and in the area around Hofuf. These large storage jars are similar to those found in Mesopotamia, in the cemetery of Ur[1] and Khafaje.[2]

**M. C.**

1. Wooley 1956, pl. 57 and 64.
2. Delougaz 1952, pl. 180 and 195.

**38. Man statue**
c. middle of the 3rd millennium BC
Limestone
H. 94 cm
Tarut
National Museum, Riyadh, 1000

Bibliography: New York 2003, no. 222; Al-Rashid 1970; Ippolitoni-Strika 1986, pp. 311–24; Potts 1990a, pp. 67–8.

This striking statue is one of the objects discovered in 1966 at al-Rufayah in the south-eastern part of Tarut Island during earthworks that exposed an ancient burial field (see, in this catalogue, Potts, p. 177). The archaeological context of this find offers no indication for precise dating, but this large male nude figure has many points in common with the early 3rd millennium Mesopotamian statuary.

His pose, standing with hands clasped on his chest, recalls the orant statues placed in temples by Mesopotamian worshippers to perpetuate their homage to the deity. The way the hands are crossed, with the right covering the left, replicates the exact gesture of the orant statues.

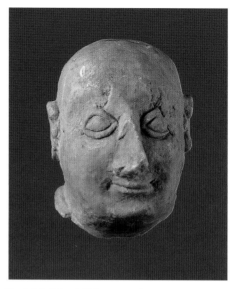

Fig. 2. Man's head, Tello, Musée du Louvre, Paris, AO 4111

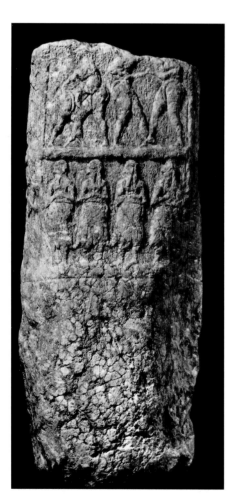

Fig. 1. Liturgical stele, Der, Baghdad, Iraq Museum, IM 75208

The figure's only clothing is a triple waistband, like those worn by the nude heroes depicted on Mesopotamian seals. The short torso in comparison with the legs, fleshy buttocks, full thighs and clearly delineated kneecaps are all characteristics of the offering bearers, wrestlers associated with religious ceremonies and priests leading rituals depicted on many reliefs (fig. 1), although imitated rather coarsely in this statue from Tarut. His shaved round head with a beardless face and globular eyes underscored by a roll of skin, full lips and large stylized ears also find parallels in Mesopotamian statuary, like the small, rather crude male head discovered in Tello, ancient Girsu (fig. 2).

All of these features reflect a strong influence of Mesopotamian sculpture from the Early Dynastic period (late Early Dynastic II to early Early Dynastic III), c. 2600–2500 BC, a time when exchanges with Mesopotamia were increasing. Some researchers also identify features characteristic of the Indus Valley Civilization, but this statue, no doubt the result of multiple influences, remains highly original. It was most likely produced locally, and bears witness to the skill and daring of its sculptor, who was able to carve an enormous block of limestone into a statue slightly more than one metre in height (including the missing ankles and feet) – much taller than any possible Mesopotamian or Harappan models. This is the only piece of its kind found so far, but future excavations may reveal other works of the same type, indicating the existence of a genuine local school of sculpture.

**F. D.**

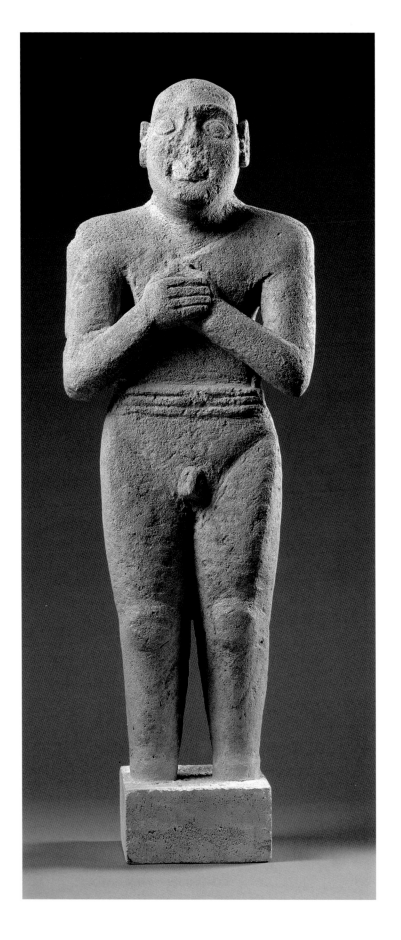
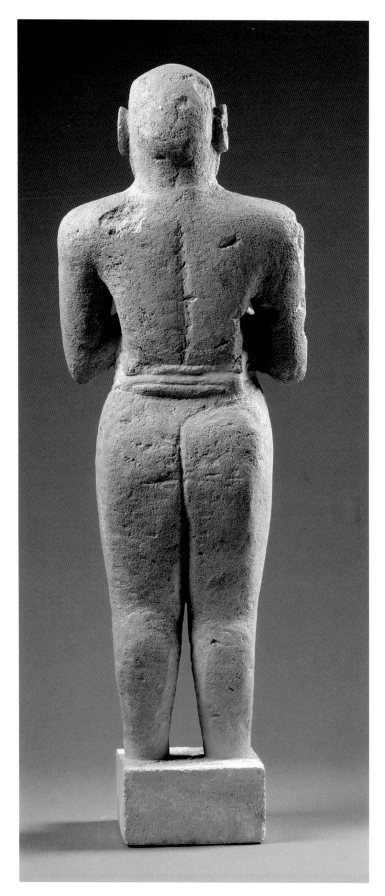

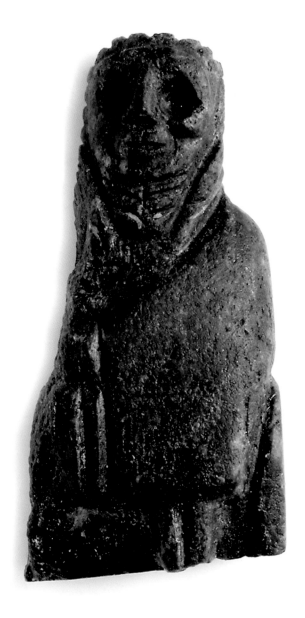

**39. Male figurine**
Second half of the 3rd millennium BC
Lapis lazuli
H. 5 cm
Tarut
National Museum, Riyadh, 1177

Bibliography: New York 2003, no. 223; Potts 1990, pp. 66–67; Al-Rashid 1970, p. 160; Rice, London 1994, p. 221, figs. 8–6.

This small figurine was discovered by chance during earthworks, along with a serie of objects including a large male statue (cat. no. 38). It could be a component from one side of a larger artefact: its left side is well finished and carefully polished, whereas the right side looks as though it had been broken off. The figure it represents is depicted seated and wrapped in a large cloak, with the head and chest facing forward but the rest of the body turned toward the left. The man is bearded and has long hair in a style that has been compared to the earliest Mesopotamian worshipper statues from the Early Dynastic period. He might have been facing a second figure, perhaps a woman: such depictions of couples were common in the 3rd millennium BC. The figurine is carved in lapis lazuli, a fine, highly-prized stone widely used by stone carvers, imported from the faraway province of Badakhshan in modern-day Afghanistan. Its presence here shows that the island of Tarut was part of a wide-ranging trade network. No stylistically similar pieces could serve as a comparison, therefore it is difficult to attribute a precise origin to this figurine.

F. D.

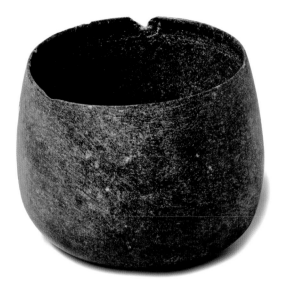

**40. Vessel**
c. 2650–2550 BC (Early Dynastic II)
Chlorite
H. 10.4 cm; Diam. 8.2–12 cm
Tarut, al-Rufayah
National Museum, Riyadh, 1220

Bibliography: Golding 1974, fig. 4 3–6, 9, 10; Al-Rashid 1975, p. 148; Zarins 1978, nos 76 and 21. pl. 72B; Potts 1986, pl. 2b; Potts 1989, p. 15 (top).

These dark chlorite containers, undecorated and finely polished, have simple shapes inspired by basketry. They are comparable to vessels of the same type found in the tombs of the Jemdet Nasr cemetery of Ur in southern Mesopotamia.[1]                    **M. C.**

1. Wooley 1956, pl. 66.

**41. Vessel**
c. 2650–2550 BC (Early Dynastic II)
Chlorite
H. 9 cm; Diam. 9.1 cm
Tarut
National Museum, Riyadh, 1168

**42. Cylindrical vessel**
4th–3rd millennium BC (?)
Diatomaceous limestone
H. 8.7 cm
Tarut
National Museum, Riyadh, 1180

This type of cylindrical vessel is carved from a rare material: limestone formed by fossilized coral, the nearest deposits of which are found along the coast of Oman. Similar containers have been found in the second half of the 4th millennium BC levels at Tepe Yahya in south-eastern Iran.[1]                    **M. C.**

1. Lamberg-Karlovsky and Beale 1986, figs 7–19–c.

**43. Bowl**
c. 2550–2350 BC (Early Dynastic III)
Chlorite
H. about 6 cm; Diam. about 13 cm
Tarut, al-Rufayah
National Museum, Riyadh, 2010

Bibliography: Zarins 1978, no. 587; Riyadh 2009, p. 167.

The island of Tarut has yielded eight bell-shaped vessels, made of very dark chlorite.[1] They have also been found in the Emirates in tombs of the Umm an-Nar period,[2] and in the Royal Cemetery at Ur, where they were associated, as in Tarut, with vessels decorated with figurative motifs.[3] A few vases have also been found in south-eastern Iran (Tepe Yahya and Shahdad), where these bowls were probably produced.[4]                                         M. C.

1. Zarins 1978, nos 5, 91, 334, 417, 497, 585 and 593.
2. Al Sufouh: Benton 1996, p. 163; Hili: Cleuziou and Vogt 1985, fig. 4 no. 2.
3. Wooley 1934, pl. 245.51, type 49–51.
4. Hakemi 1997, figs 1–4.

**44. Bowl**
3rd millennium BC
Alabaster
H. 5.5 cm; Diam. 14 cm
Tarut
National Museum, Riyadh, 1288

Bibliography: Potts 1989, p. 21 (top left).

Prestigious objects carved in alabaster were highly prized by the urban elite as symbols of their social status. However, the stone was not known for its functional qualities – alabaster is too porous to be used for storing liquids. This type of bowl was found throughout the Near and Middle East in the 3rd and 2nd millennia BC.

M. C.

**45. Bowl**
3rd millennium BC
Veined alabaster
about 10 x 10 cm
Tarut
National Museum, Riyadh, 1997

Bibliography: Riyadh 2009, p. 166.

Holes left by rivets show that this vessel was repaired in Antiquity, giving us an indication of the value attached to this prestigious possession. Bowls of this shape were common in Mesopotamia and Iran (Ur, Kish, Tepe-Moussian and Shahr-i Sokhta).[1]                M. C.

1. See Casanova 1991, series XII, p. 36.

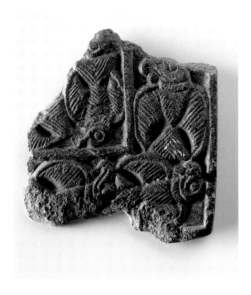

**46. Vessel fragment**
Second half of the 3rd millennium BC
Chlorite
H. about 4 cm
Tarut
National Museum, Riyadh, 1242

Bibliography: Zarins 1978, no. 69; Burkholder
1971, pl. V, no. 13 a–b–c, and p. 311, figs 2a–c.

**47. Vessel fragment**
Second half of the 3rd millennium BC
Chlorite
H. about 6 cm
Tarut
National Museum, Riyadh, 1224

Bibliography: Zarins 1978, no. 42, 2637; Golding
1974, figs 4 and 13.

**48. Lid fragment**
Second half of the 3rd millennium BC
Chlorite
6.5 x 7 x 0.5 cm
Tarut, al-Rufayah
National Museum, Riyadh, 1227

Bibliography: Burkholder 1971, pl. IV no. 12;
Zarins 1978, no. 2645 and 699–13–5; no. 62.

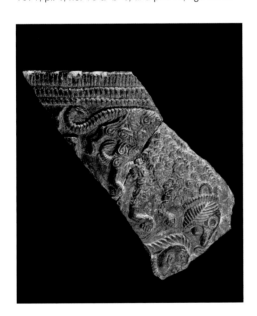

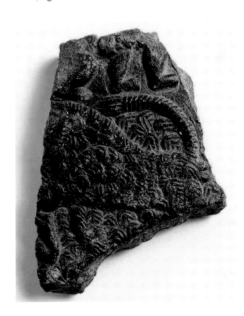

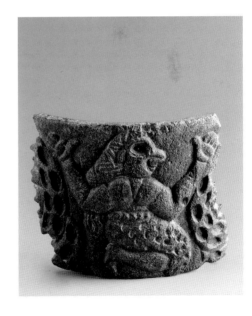

**49. Vessel fragment**
Second half of the 3rd millennium BC
Chlorite
9 x 4.8 x 0.9 cm
Tarut, al-Rufayah
National Museum, Riyadh, 1240

Bibliography: Burkholder 1971, pl. VI, no. 15a;
Zarins 1978, 2652 and 69–12 A; no. 47;
Al-Rashid 1975, p. 148.

**50. Vessel fragment**
Second half of the 3rd millennium BC
Chlorite
H. about 7 cm
Tarut
National Museum, Riyadh, 1254/2

Bibliography: Burkholder 1971, pl. VI, no. 16;
Zarins 1978, no. 2647 and 70–6 A; no. 48.

**51. Vessel fragment**
Second half of the 3rd millennium BC
Chlorite
7.5 x 10.8 cm
Tarut, al-Rufayah
National Museum, Riyadh, 1234

Bibliography: Zarins 1978, 2632 and 71–7 B;
no. 546.

**52. Vessel fragment**
Second half of the 3rd millennium BC
Chlorite
13 x 8 cm
Tarut
National Museum, Riyadh, 1248/2

**53. Vessel fragment**
Second half of the 3rd millennium BC
Chlorite
11 x 2 cm
Tarut
National Museum, Riyadh, 1255/2

Bibliography: Burkholder 1971, pl. III, no. 2.

**54. Vessel fragment**
Second half of the 3rd millennium BC
Chlorite
about 5 x 4 cm
Tarut
National Museum, Riyadh, 3134

Bibliography: Zarins 1978, no. 569.

**55. Vessel fragment**
Second half of the 3rd millennium BC
Chlorite
H. about 4 cm
Tarut
National Museum, Riyadh, 1250

Bibliography: Burkholder 1971, pl. IV, no. 10.

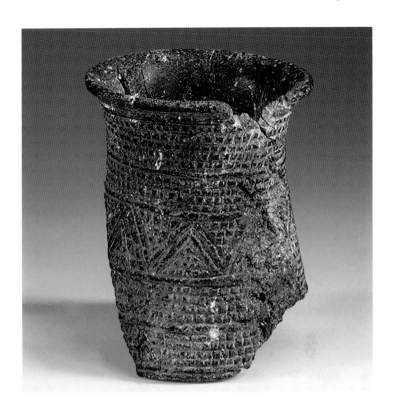

**56. Vessel fragment**
Second half of the 3rd millennium BC
Chlorite
H. about 11 cm
Tarut
National Museum, Riyadh, 1253/1

Bibliography: Burkholder 1971, pl. III, no. 5; Zarins 1978, no. 64.

**57. Vessel**
Second half of the 3rd millennium BC
Chlorite
H. about 9.5 cm
Tarut
National Museum, Riyadh, 1246

Bibliography: Burkholder 1971, pl. II, no.4; Zarins 1978; no. 57; Riyadh 2009, p. 166.

**58. Vessel fragment**
Second half of the 3rd millennium BC
Chlorite
6 x 5 cm
Tarut
National Museum, Riyadh, 3134/4

**59. Vessel fragment**
Second half of the 3rd millennium BC
Chlorite
5 x 4 cm
Tarut
National Museum, Riyadh, 3135/1

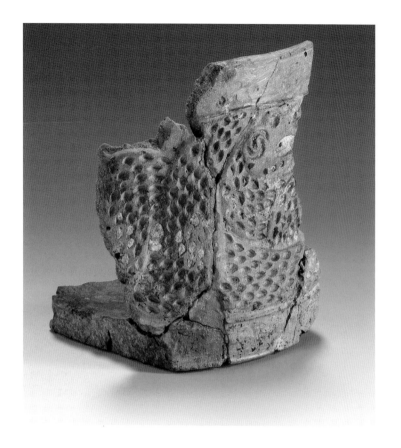

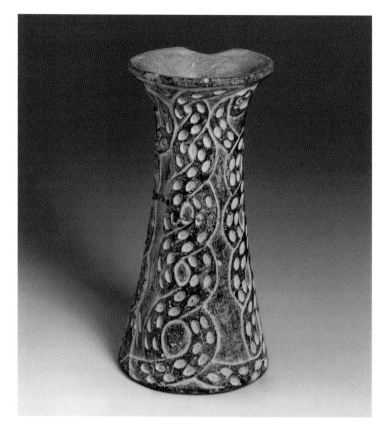

**60. Vessel fragment**
Second half of the 3rd millennium BC
Muscovite schist
H. 15.5 cm
Tarut, al-Rufayah
National Museum, Riyadh, 1173

Bibliography: Zarins 1978, 2657–2 and 70–2–A; no. 545.

**61. Conical vase with entwined snakes**
Late 3rd millennium BC
Chlorite
H.: 19.5 cm; D.: 9 cm
Tarut ?
National Museum, Riyadh, 3170

**62. Cylindrical vessel with palm tree**
Late 3rd millennium BC
Chlorite
H.: 11.5 cm; D.: 7.5 cm
Tarut?
National Museum, Riyadh, 3171

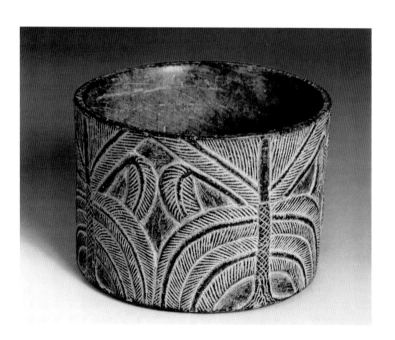

**63. Vessel**
Second half of the 3rd millennium BC
Chlorite
H. 7.7 cm
Tarut, al-Rufayah
National Museum, Riyadh, 1247

Bibliography: New York 2003, cat. no. 224f.

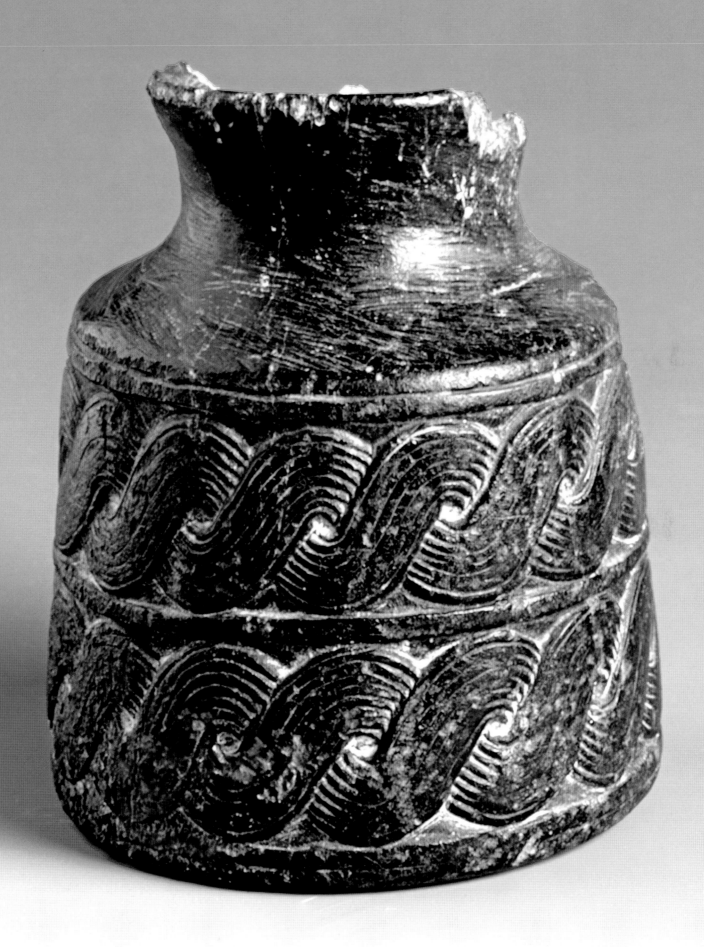

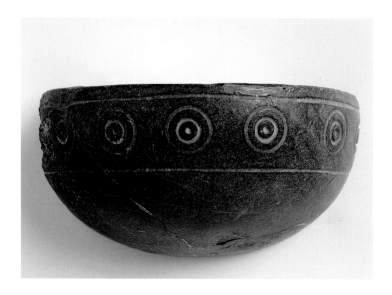

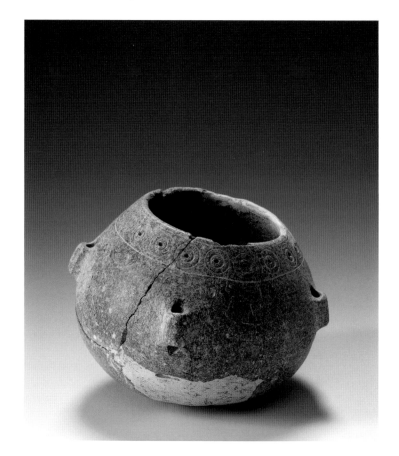

**64. Hemispherical bowl**
Late 3rd millennium BC
Chlorite
H. 5 cm; Diam. 11 cm
Tarut
National Museum, Riyadh, 1231

**65. Suspended globular vessel**
Late 3rd millennium BC
Chlorite
H. 9.5 cm; Max. diam. 11.5 cm; Th. 0.5 cm
Tarut, "Fariq al-Akrach"
National Museum, Riyadh, 1226

Bibliography: Bibby 1973, p. 37, fig. 33; Al-Rashid 1975, p. 148; Zarins 1978, no. 40, pl. 70.

Chlorite vessels decorated with dotted concentric circles were imported from the Oman Peninsula during the Umm an-Nar period. Containers of this kind were very common throughout the late 3rd millennium in southern Mesopotamia, Iran (Tepe Yahya,[1] Shahdad and Suse[2]), Central Asia, the Indus Valley and all along the coasts of the Arabian Gulf. Various soundings and excavations in Tarut have yielded some sixty fragments of this type of vessel.[3] The forms vary from bowls to cylindrical vessels to compartmented vessels, some with lids.

These chlorite vessels were found in tombs, where they were left as offerings, containing food or high-value cosmetic products. **M. C.**

1. Lamberg-Karlovsky 1988, figs 4/CC and DD.
2. Miroschedji 1973, figs 8 and 9.
3. Potts 1990a, p. 180, footnote no. 133.

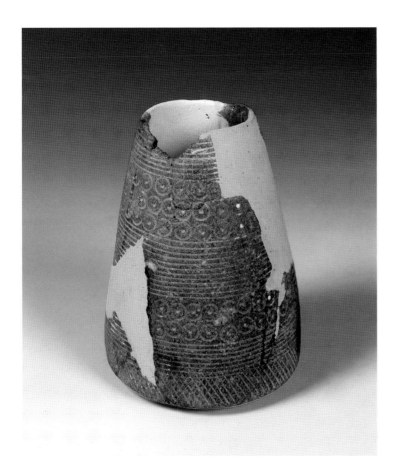

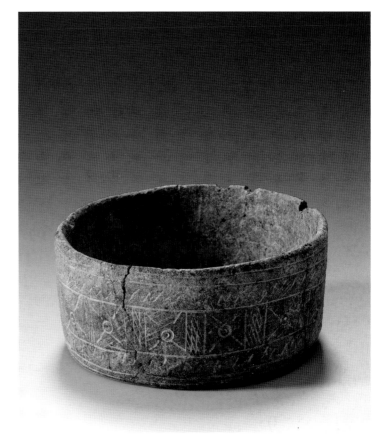

**66. Conical vessel**
c. 1600–1250 BC
Chlorite
H. 12 cm; Diam. 4.4–8.2 cm
Dhahran, tomb A6
National Museum, Riyadh, 1969

Bibliography: Riyadh 2009, p. 167.

This large conical vessel is elaborately decorated with bands of hatching, horizontal lines and dotted circles. It was imported from Oman Peninsula, in the late Bronze Age (Wadi Suq period), where stone vessels were produced from material that was often of poor quality and with decorations less skilfully executed than in previous periods.

**M. C.**

**67. Cylindrical vessel**
c. 1300–1000 BC
Chlorite
H. 6 cm; Diam. 12.5 cm
Tarut
National Museum, Riyadh, 175

This flat-bottomed cylindrical vessel was probably produced in Oman during the transition between the Wadi Suq period and the Iron Age. It is crudely decorated with a band of dotted circles surrounded by radiating lines, hatching and zigzags. The form and layout of the patterns evoke certain vessels discovered in the Emirates and Oman.[1]

**M. C.**

1. Zutterman 2004, p. 109, and Huckle 2003, p. 60, fig. 7.

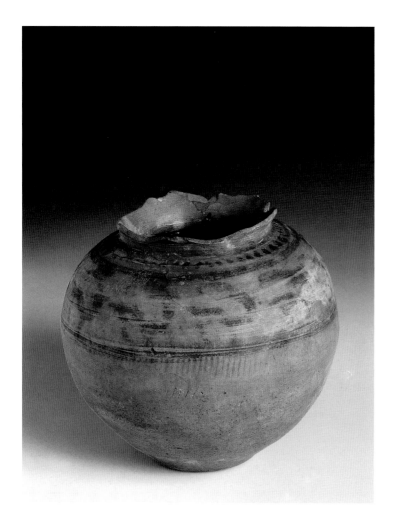

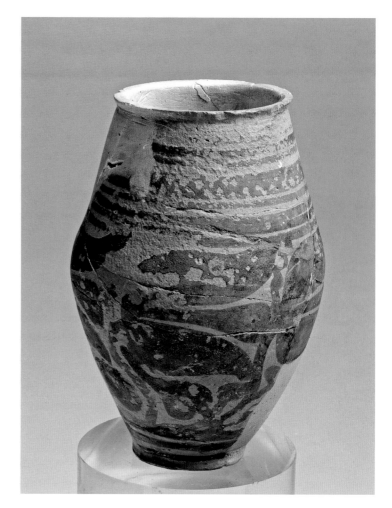

**68. Globular jar**
c. 3000–2250 BC
Painted pottery
H. 10 cm; Diam. 4.5–11.5 cm
Abqaiq, tomb AGM13
National Museum, Riyadh, 1199

Bibliography: Piesinger 1983, fig. 61; Zarins 1989, fig. 11, no. 6.

This pottery, decorated with a painted band of stylized goats, was imported from south-eastern Iran. Many similar vessels have been unearthed at Bampur, Damin, Khurab, Miri Qalat, Tepe Yahya and other sites in Baluchistan. This type of delicately painted pottery was highly prized in eastern Arabia, where numerous examples have been found. The discovery of an identical jar in the fort on Tarut Island (see

opposite) suggests that certain models were produced in series. **M. C**

Globular jar decorated with ibexes, Tarut,
Dammam Museum, 1162

**69. Vessel**
2200–1800 BC
Painted pottery
H. 15.6 cm; Diam. 7.4–12 cm
Tarut, al-Rufayah
National Museum, Riyadh, 1164

Bibliography: Zarins 1989, fig. 6, no. 20; Burkholder 1984, fig. 30 and p. 197.

**70. Cylindrical jar**
2000–1800 BC
Pottery with red slip
H. 22.5 cm; Diam. 14 cm (rim diam. 10.5 cm)
Dhahran, tomb B 28
National Museum, Riyadh, 196

Bibliography: Riyadh 2009, p. 172; Al-Mughannam and Warwick 1986, p. 24, pl. 20.

Several jars of this type have been found on other sites of the Saudi coast and in the Dilmun period graves on Bahrain. It is thought that these large containers held a liquid used in funeral rites. Such vessels were exported to the Oman Peninsula; they have been found at Shimal, Sur, al-Munayi, Tell Abraq and Kalba,[1] and even to southern Mesopotamia (Ur and Larsa[2]).                                     **M. C.**

1. Mery *et al.* 1998, p. 169 and 178.
2. Wooley *et al.* 1974, pl. 52. XII.

**71. Ovoid vessel**
2000–1800 BC
Pottery with red slip
H. 24 cm; Max. diam. 17 cm
Dhahran
National Museum, Riyadh, 181

Bibliography: Riyadh 2009, p. 104.

This type of vessel is very common in Dilmun graves but almost never in dwellings, which suggests an exclusively funerary function.[1] The red slip characteristic of this production would continue to be used through the Kassite period (middle of the 2nd millennium BC.)                                     **M. C.**

1. Paris 1999, cat. no. 13, p. 59.

**72. Hollow-footed chalice**
2200–1800 BC
Painted pottery
H. 7.8 cm; Diam. 8 cm
Dhahran, tomb DGM 3
National Museum, Riyadh, 1210

Bibliography: Riyadh 2009, p. 165; Piesinger 1983, fig. 139/3; Zarins 1989, fig. 13, no. 12; During Caspers 1994, fig. 4.

This beaker decorated with vertical lines and short horizontal strokes had originally a hollow foot. Chalices of this type are frequently found in Dhahran[1] and around the Arabian Gulf; they are common in south-eastern Iran, for example at Mehrgarh and Tepe Yahya. These stemmed goblets might have come from Central Asia, where the form is well attested.[2] They were most likely imported undecorated to Dilmun and then painted in the local style. **M. C.**

1. Zarins 1989, fig. 13.6, 13.12 and 13.18.
2. Potts 2001, p. 81–2.

**73. Bowl**
3rd millennium BC
Painted pottery
H. 6 cm
Dhahran
National Museum, Riyadh, 182

This small globular bowl with a tapering rim is rudimentarily decorated with a zigzag line that evokes the decoration of Omani pottery from the Wadi Suq period. However, it seems to have been produced locally, because other very similar bowls have been discovered in the graves of the Dhahran region.[1]

**M. C.**

1. Frohlich *et al.* 1985, pl. 25a and 28a.

**74. Globular jar**
c. 2100 BC
Fine orange pottery, black paint
H. 27 cm; Diam. 26 cm
Dhahran, tomb B25
National Museum, Riyadh, 1946

Bibliography: Frohlich and Mughannum 1985, pl. 29 A; Riyadh 2009, p. 169.

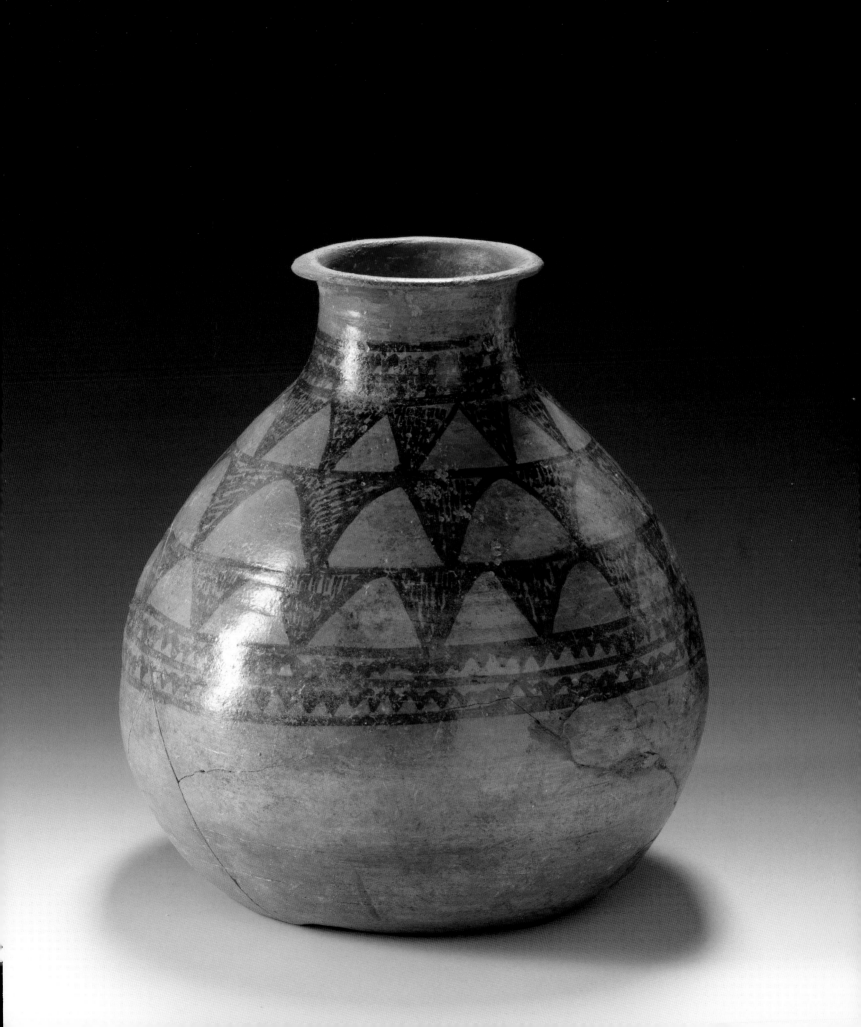

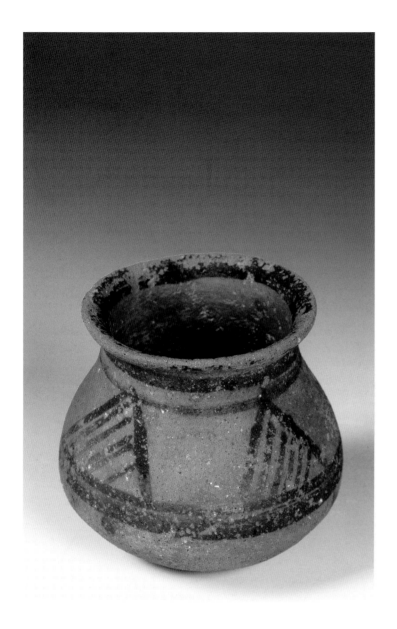

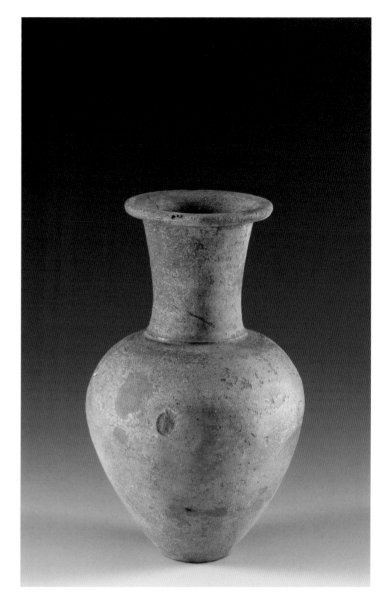

**75. Miniature funerary vase**
2000–1800 BC
Painted pottery
H. 8 cm; Diam. 9 cm
Dhahran, tomb B29
National Museum, Riyadh, 3109

Bibliography: Riyadh 2009, p. 166; Mughannam and Warwick 1986, no. 7 B29, p. 24, pl. 20.

**76. Jar**
6th century BC
Pottery
H. 20.5 cm; Max. diam. 12.5 cm
Tarut, purchased in Qatif
National Museum, Riyadh, 1165

Bibliography: Riyadh 2009, p. 165.

"Pseudo-Barbar" jars like this one are part of the characteristic funerary material of the Bahraini bathtub-coffin of the end of the late Dilmun period. A similar jar found at Qalat al-Bahrain was used to conceal a treasure containing more than 350 fragments of jewellery and silver scraps.[1]

M. C.

1. Paris 1999, cat. no. 212.

**77. Gulf seal**
c. 2200–2000 BC
Chlorite
Diam. about 1.5 cm
Tarut, al-Rufayah
National Museum, Riyadh, 2669/2

Bibliography: Zarins 1978, no. 583.

This seal, bearing the figures of a bovine and a bird, is a "Gulf seal", the oldest type produced in Dilmun. These seals are usually small, with a high back knob or boss marked by a single groove. The decoration is often limited to figures of bulls, gazelles or goats, sometimes combined with birds or scorpions; the human foot motif is often used to fill empty spaces. **M. C.**

**78. Dilmun seal**
c. 2000–1800 BC
Heated stearite
Diam. about 2.8 cm; Th. 1.5 cm
Dhahran, tomb A/10
Dammam Museum, 4614

Bibliography: Al-Mughannam et al., 1986, pl. 18a; Riyadh 2009, p. 181.

The shape of the so-called "Dilmun seals" gradually became more standardized, with a low boss decorated with four dotted circles on both sides of incised lines. On the other hand, their iconographic range expanded to include scenes of worship, eroticism, the "Master of the Beasts" figure, compositions of animal figures, etc. This seal, decorated with eight animal protomal (goat, gazelle or antelope) with ringed necks and stylized heads, corresponds to the iconographic conventions of the "Dilmun seals". **M. C.**

**80. Scarab**
2nd millennium BC (?)
Limestone
1.4 x 1.2 cm
Dhahran, tomb B2
Dammam Museum, 4614

The discovery of this scarab bears witness to exchanges and contacts with the Mediterranean region. The highly stylized image and the smooth plain reverse are characteristic of productions from the Syro-Palestinian zone. It is proof that Levantine imagery reached the shores of the Arabian Gulf, where it could have, as some experts maintain,[1] exerted a strong influence on the iconography of the "Dilmun seals".

1. Kjaerum 1986.

**79. Seal**
Second half of the 3rd millennium BC
Terracotta or heated steatite (?)
Diam. about 1.5 cm
Tarut
National Museum, Riyadh, 2669/3

Worn at the belt or around the neck, seals expressed the owner's individuality and had great apotropaic value. They were used to leave an impression on documents or sealing materials, thus guaranteeing their authenticity. Interestingly, the archaeological sites on the eastern coast of Saudi Arabia have yielded very few seals and no imprints of seals compared with the neighbouring island of Bahrain.[1] It is difficult to identify the decoration of this seal, whose undecorated boss is pierced for suspension. It could be a seal that was later converted into a pendant. **M. C.**

1. See Golding 1974, fig. 5, 4–5–6; Barger 1969, p. 139; Piesinger 1983, fig. 186.11; Riyadh 2009, p. 181. A seal from Qaryat al-Faw decorated with a figure surrounded by five antelopes is kept at the museum of King Saud University, Riyadh.

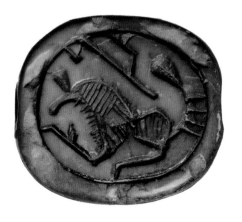

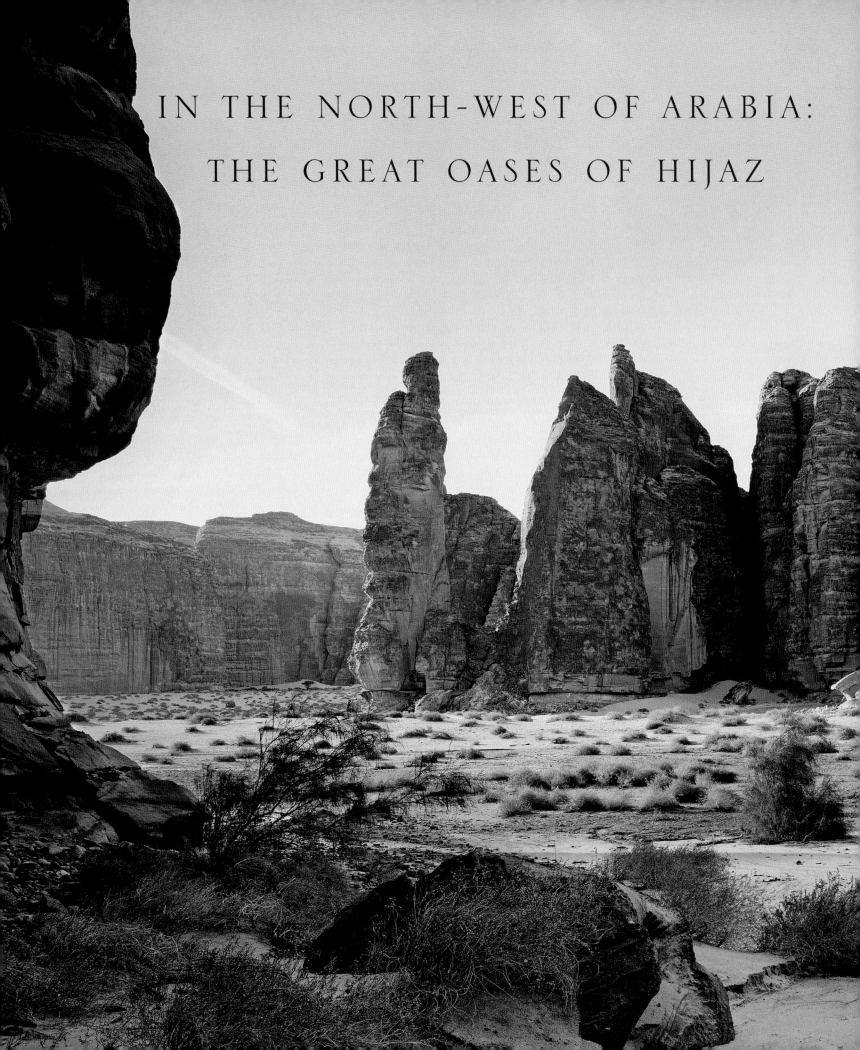

IN THE NORTH-WEST OF ARABIA:

THE GREAT OASES OF HIJAZ

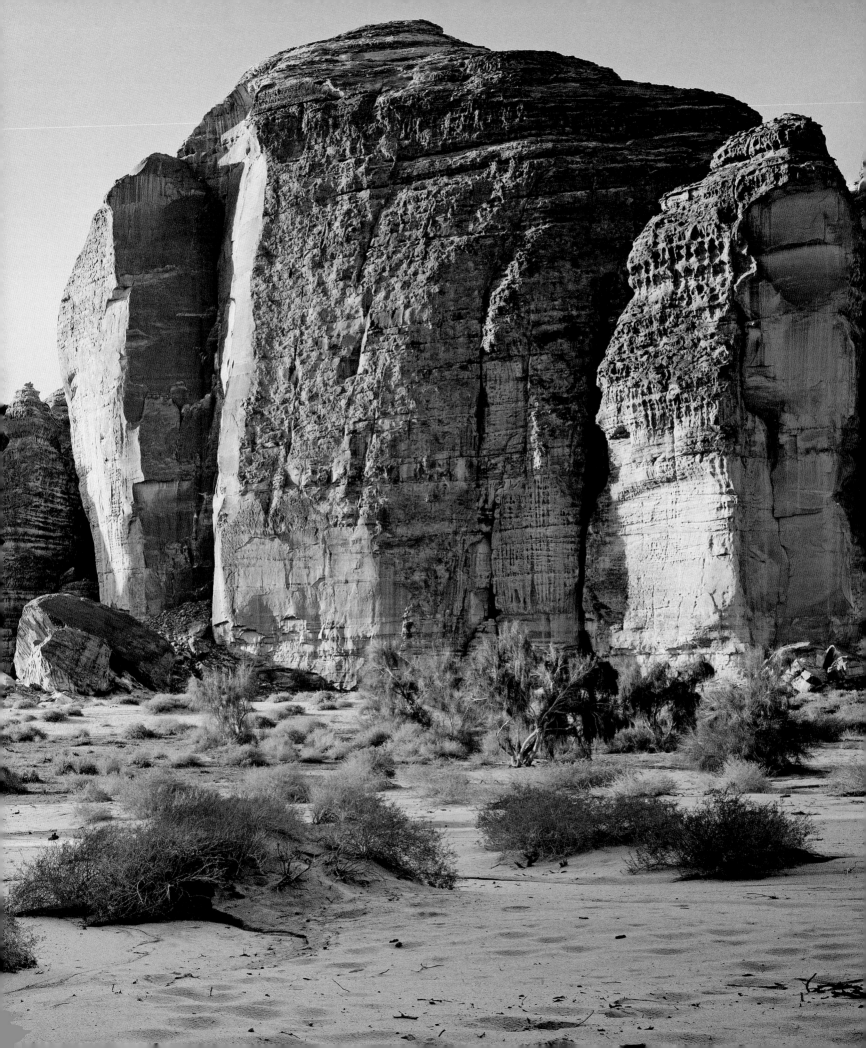

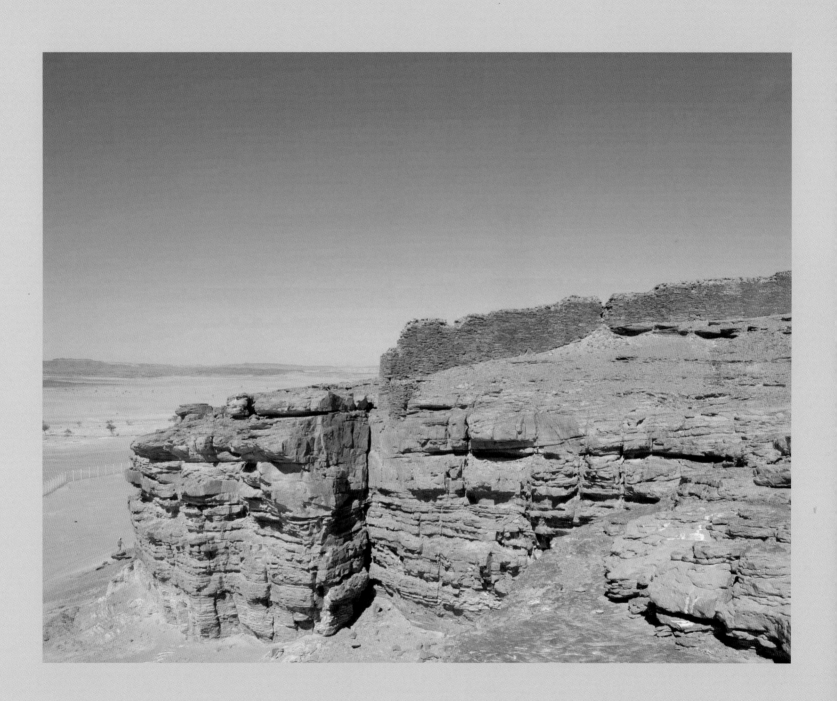

# THE KINGDOM OF MIDIAN

*Abdulaziz Saud Al-Ghazzi*

When studying the history and civilization of the Midianites, there are two sources to which we can refer: the sacred books, such as the Quran, the Torah and their exegetical texts, and the archaeological research in the field. The work conducted on the Midian site has unquestionably helped to elucidate the history of this community, and in particular, the work on the site of Qurayyah in the region of Tabuk, which is believed to have been the Midianite capital.

## The history of the Midianites

"He said: 'O my people! Let not my dissent from you cause you to sin, lest ye suffer a fate similar to that of the people of Noah or of Hud or of Saleh, nor are the people of Lut far off from you!'" ("Hud", Surat 11:89).[1]

"He said: 'O my people! Give just measure and weight, nor withhold from the people the things that are their due: commit not evil in the land with intent to do mischief.'" ("Hud", Surat 11:85).[2]

"Hath not the story reached them of those before them? The People of Noah, and 'Ad, and Thamud; the People of Abraham, the men of Midian, and the cities overthrown." ("Repentence", Surat 9:70).[3]

"If they treat thy mission as false, so did the peoples before them (with their prophets), the People of Noah, and 'Ad and Thamud; those of Abraham and Lut; and the Companions of the Madyan People; and Moses was rejected (in the same way). But I granted respite to the Unbelievers, and (only) after that did I punish them: but how (terrible) was my rejection (of them)! ("The Pilgrimage", Surat 22:42–44).[4]

Historically, in the Quran, the Midianites and the prophet Shu'aib come after the peoples of Abraham and of Lot, and before the people of Moses, in other words, sometime between 1700 and 1200 BC. The first date corresponds to the end of the age of the peoples of Abraham and of Lot, and the second date to the age of the people of Moses. In archaeological terms, this

(*preceding pages*)
Hijaz landscape, photograph by Humberto da Silveira

(*opposite*)
Wall on the site of Qurayyah

1.  Quran, 11:89, in Quran 1980.
2.  Quran, 11:85, *ibid.*
3.  Quran, 9:70, *ibid.*
4.  Quran, 22:42–44, *ibid.*

Palm groves at the site of Dedan

Overlooking the site of Dedan

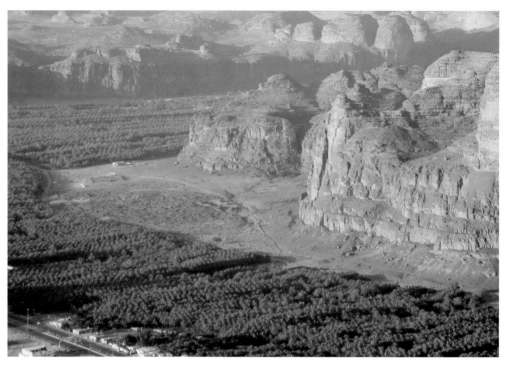

corresponds to the Late Bronze Age. The Quran tells the successive stories of these peoples and we learn that the Midianites, after the peoples of Abraham and of Lot, also strayed from the law of God. The prophet Shu'aib was thus sent to persuade them to follow the principles of the true faith.

It should be noted that the people of Shu'aib (Midian) came after the people of Lot, and that Lot was a contemporary of Abraham. Abraham came after Saleh and lived during the time of Hammurabi, who reigned Babylon in the 18th century BC. Secondly, the people of Shu'aib came before the people of Moses. According to historians, the children of Israel, led by Moses, journeyed through the lands inhabited by the Midianites at the end of the 13th century and the beginning of the 12th century BC. Therefore, the history of the people of Midian ranges from 1700 to 1200 BC, at which time they begin their decline.

### The size of the kingdom of Midian

Based on the historiography and according to Ibn Kathir, the Midianites were an Arab people living in Midian, a village in the land of Ma'an near the borders of Syria on the way to Hejaz. Archaeological evidence has shown that the Midianite civilization developed in the region of Tabuk and spread as far as southern Jordan and the Sinai.

Some of the biggest towns in the land of Midian were Dedan, Qurayyah, Timna in the Wadi 'Araba, Tayma, Al-Bid'. The people of Thamud lived on the land of the Midianites. The Dedanites, and then the Lihyanites and the Nabataeans took over after the Midianites.

### The activities of the Midianites

In the Quran, the city of Midian is mentioned in thirteen verses, along with its prophet, its inhabitants, its land, its sources of water. The Quran describes the excessive wealth of the Dedanites who were swindlers, dishonest tradesmen and who committed crimes on earth.

The passages in the Quran make it clear that brigandage was rampant, that corruption reigned: there were markets where buyers were cheated and sellers were abused.

In the Torah, Midian was known for its abundance of mineral deposits. Gold, silver, copper, lead, tin and iron were mined there. It was also famed for its precious stones – turquoise, quartz, flint – and above all for its pottery decorated with animal motifs (peacocks, geese, mouflons, camels) and the sophisticated geometric designs on the outside and the inside of the vases.

## *The war between the Hebrews and the Midianites*
According to historical accounts, Midian was a small nation-state ruled by a monarch.[5] The history books indicate that in the time of the prophet Moses it was governed by kings such as Evi, Rekem, Tsur, Hur, Reba, Zebah and Zalmunna; the names of princes are also mentioned, such as Oreb and Zeeb.

The sites once inhabited by the people of Midian are located in north-western Saudi Arabia and they date from the time of Jacob, the grandson of Abraham. Their former inhabitants maintained commercial ties with Egypt, and their trade routes crossed the lands that had once been inhabited by the Hebrews before their arrival in Egypt. In fact, the caravans that delivered Joseph from the well into which his brothers had thrown him to get rid of him were Midianite caravans, and they took him to Egypt. Later, in the 12th century BC, Moses led the exodus of the Hebrew people out Egypt. The Hebrews had to fight many wars before they were able to settle in the promised land. Midian was one of the most powerful nations at the time of the Exodus. The Hebrews fought the Midianites several times because they had to cross the Midianite territory. And in one of these wars, as the Torah tells us, the Hebrews were victorious.

Around 1150 BC, according to historians, the Midianites reigned over the Hebrews for a few years as a result of their estrangement from the divine religion. The writer al-Tabari and the historian Ibn Khalun state that they were ruled over by the kings 'Urayb, Rabib, Barsuna, Dari', Sulna.

## The archaeological aspect
According to archaeological research, the site of Qurayyah, which has been identified as the capital of Midian, is the only site in Saudi Arabia associated with the Midianites. Yet archaeological surveys also show that Tayma, Dedan, Al-Bid' and other sites date from the same period. Since the question is still up in the air, I will confine myself to presenting the findings from the work conducted at Qurayyah. This is the only site in Saudi Arabia where Midianite remains, and in particular the painted ware, have been studied.

Harry St John Bridger Philby wrote that the site of Qurayyah was mentioned for the first time by a Swedish explorer, G. A. Wallin, in 1848. Without a guide, however, Wallin was unable to visit the site himself.

The second European to mention the site was Charles Doughty in November 1878. While he was travelling by train from Madaba to Hasmi – north of Tabuk – his guide helped him locate Qurayyah, which was 10 miles off to the west. In 1878, Richard F. Burton travelled through the area and in 1884 two famous western explorers, the Frenchman Charles Huber and the German Julius Euting, visited Tabuk without mentioning Qurayyah.

Douglas Croth went to Tabuk in 1910, and in his report, published in 1935, he described Qurayyah as an abandoned spot in the hills of Hasmi, north of Tabuk. That same year, two French Dominican priests, Antonin Jaussen and Raphaël Savignac, visited Tabuk, but they did not mention the site of Qurayyah in their travel writings. Again that year, an Austrian explorer, Mosel, journeyed to Tabuk though al-Saq and discovered the temple at Rawwafah. However, he furnished no information on the site, and it remained unexplored until Philby showed interest in it in February 1951.

5. Its political structure can be compared to that of the Sumerian cities in Mesopotamia in the 3rd millennium BC or of the small states in Syria during the 3rd and 2nd millennia BC. The continuation of this type of regime led to the emergence of the small nation-states in Syria during the Islamic period and in Andalusia during the medieval Islamic centuries. The same type of regime existed in the southern Arabian Peninsula before the arrival of Islam and was prevalent even before the modern era when each city in the peninsula was ruled by one family.

Archaeological studies on the kingdom of Midian began with the work at Qurayyah, which may have once been the Midianite capital. The first excavations were conducted in 1968 by a British archaeological team who presented the remains they found to researchers and connected the site to the Midianites by studying its pottery. This team was made up of Peter Parr, W. Harding and John Dayton.[6]

An archaeological team from the Department of Antiquities and Museums conducted fieldwork in 1980 and published a report in 1981. After that, no research was done on the site until 2008 when a member of the Department of Archaeology in the Faculty of Tourism at King Saud University set up the first excavation expedition in the site's residential zone.

### The site

The site of Qurayyah is spread out over a large area. The ruins of the buildings form widely spaced groups in what appears to be an urban centre: a residential zone, a citadel on the mountain, an agricultural zone in the north, buildings outside of the area north of the reservoir and in the south-west castle, walls, dams, cemeteries and ovens.

### The residential zone

This zone occupies a large area that is marked by the outlines of its walls. Philby states that the surface area of this vast walled section is approximately 50,000 square metres. It is thus an enormous complex and its remains date back to ancient times. The zone is surrounded by three stone walls. An outer wall that is over 15 kilometres long is connected to the plateau in the west. This wall is 6 metres high in some places. It is constructed of regularly laid stones and reinforced in certain places with buttresses, some of which were used as watchtowers. The second wall is made of irregular stones. Finally, the wall around the residential zone itself surrounds the mounds that were made by the buildings and dwellings when they collapsed.

Each of these walls is outfitted with gates and watchtowers. This type of architecture incorporating several rows of walls is commonly found in Arabia and it was still used until quite recently. For example, the ancient city of Tayma was surrounded by three walls, as was Dumat al-Jandal; in terms of modern cities, we might mention Qifar in the Ha'il region and Zalfi in the Riyadh region.

### The castle

The castle and the buildings connected to it are located outside of the city. Its walls have been preserved at a height of 4.5 metres, and they measure 24 metres in length. It may have contained a small hall and two or three rooms. The passageway running between it and the city walls is 10 metres wide. Half a dozen little tells can be found on the north-eastern side: this area was probably used by servants and animals.

### The walls

The biggest of the three walls is the one that surrounds the site and the adjacent hills. The second wall is smaller; it surrounds the residential zone as well as the buildings around it. The third wall is that of the residential zone itself. All of these walls are built of blocks of various kinds of cut stones. The mortar consists of clay and stone.

### The dams

There are several dams on and around the site. One of them connects the two slopes of the *wadi* at the south-western and south-eastern corners of the city. It is made of stones and rubble.

6. A report on the site was published in 1970: see Parr, Harding and Dayton 1970.

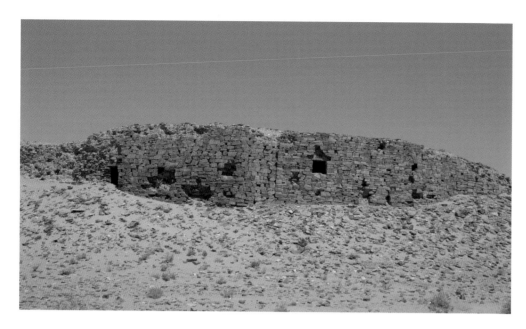

Outer wall at Tayma (south-eastern side)

The one on the eastern side is 715 metres long, while the western dam measures less than 200 metres. There is another dam that is 940 metres in length.

Many wells have been identified on the site, as well as a canal system that supplied water to the city. The external canals made of stone are still visible today, even when they have been covered up with earth. Water from the wells irrigated the fields via these channels.

On the northern side of the site are the remains of some robust foundations belonging to a castle or a temple, along with numerous secondary constructions that are probably vestiges of the local water tank. The size of the main building is 21 by 27 metres. It contains three or four rooms of varying lengths, and a 2-metre corridor leading to a large hall on the western side that is about 18 square metres in size.

There are remains of the real temple on the north-eastern side. Its perimeter is 4 metres by 23 metres. There is a two-room structure on the northern axis. The first room measures 6 by 15 metres and the second, 12 by 15 metres. In the southern corner is another structure that measures 16 by 13 metres. Only the foundations of these structures remain today.

## The cemeteries

What little excavation work has been done on the site has not been able to uncover the cemeteries in the residential zone. However, the existence of a hundred or so graves was mentioned by Philby, who compared them to Sabaean graves. On the plateau that overlooks and is an integral part of the site, there are graves in the form of *tumuli*, and they bear similarities with the burial mounds of the 2nd and 3rd millennia BC.

## The ovens

The report published in 1970 by the archaeological mission from the University of London observed that a number of ovens were found at Qurayyah. In 1980, an oven was excavated by a team from Saudi Arabia's Department of Antiquities and Museums: it contained numerous pottery fragments and a huge amount of ashes. In 2007, an archaeologist found several ovens that had been damaged by modern activity, along with a lot of ceramic shards.

Agricultural installations have been found on the site: wells, irrigation channels, ponds and dams in the surrounding valleys. The remains of a few individual structures have also been discovered

View of the residential zone at Qurayyah

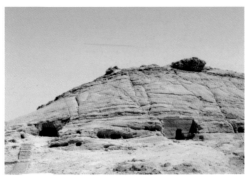

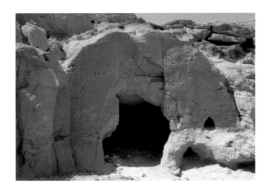

The caves of Shu'aib

7. Ingraham *et al.*; Gilmore *et al.*; Parr 1969; Parr, Harding and Dayton 1970; Dayton 1972; Rothenberg 1972; Parr 1979; Bawden, Edens and Miller 1980; Parr 1982; Bawden 1983; Rothenberg and Glass 1983; Muhly 1984; Parr 1984; Mazar 1985; Kalsbeek and London 1987; Parr 1987; Bawden and Edens 1988; Knauf 1988; Parr 1988; Edens and Bawden 1989; Abu Duruk 1990; Al-Ghazi 1992; Parr 1992; Al-Ghazi 1995; Philby 1995; Al-Ghazi 2000; Al-Ghazi 2005a; Al-Ghazi 2005b; Al-Ghazi 2007.

and they may date back to the Midianite era. According to Philby, there is evidence of rock engravings, graffiti and traces of inscriptions with short vertical lines on the rocks around the site.

### The archaeological data

The archaeological artefacts that have been studied the most since 1969 are the pottery sherds. Many articles about this period have been published.[7]

1. The articles written by the first explorers described the location of the site and this, in turn, aroused the interest of researchers.

2. The first articles, by Peter Parr, described the corpus of ceramic artefacts found on the site of Qurayyah and compared them with other artefacts from several sites in Palestine.

3. The articles that followed, by G. Bawden and J. Muhly, provided a critical analysis of Parr's theories, focusing on the criteria he used to identify and date the pottery – considered an important factor when studying sites from the Midianite period.

4. The articles by Rothenberg, Glass, London and Parr examined pottery resembling the Midianite ware in order to determine the area of distribution and its frequency in archaeological sites; potsherds were found on several sites in Palestine, but only in small amounts, which indicates that the pottery was imported. Qurayyah is considered one of the most important sites for the quantity of pottery that has been unearthed there. The researchers believe that it was a centre for making and exporting pottery. This is substantiated by the presence of manufacturing waste and the large number of ovens both inside and outside of the walls, as well as by the abundance and variety of potsherds found on the surface.

5. The articles by Abdel Aziz ibn Saoud al-Ghazi made comparisons with pottery from sites outside of Palestine and looked for relationships with Hili and the Ubaid period in order to analyse its historical origins. These articles also reviewed all of the recent fieldwork.

6. The other articles examined the results of the fieldwork conducted on the ancient Tayma sites and graves in al-Sina'iyya. A large quantity of pottery in good condition was found inside of these tombs. Carbon-14 was used to date organic matter excavated from the tombs: the oldest date obtained was 1400 BC and the most recent 750 BC.

7. The comparative studies done by Rothenberg and Glass, as well as the analyses made by the

Saudi Department of Antiquities and Museums using the carbon-14 dating method, show that the bones and pottery found in the al-Sina'iyya graves in Tayma date from the Bronze Age and, according to Parr, should be linked to the Midianites.

8. It has been shown that this distinctive style of pottery was indeed manufactured at Qurayyah, and that Qurayyah was one of the biggest centres for pottery production. The analysis of the mineral composition of the clay, as reported by Rothenberg and Glass in their article published in 1983, and the analysis made by a British researcher, cited by Parr in his 1987 article, as well as the findings of the second and third excavation campaigns at al-Sina'iyya in Tayma all proved the existence of kilns and a pottery-making industry. In addition, a type of pottery was discovered that could not have come from anywhere else since it was clearly too delicate to transport. A number of ovens were also found at Qurayyah.

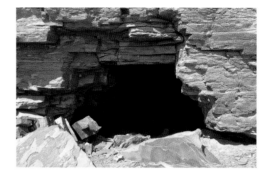

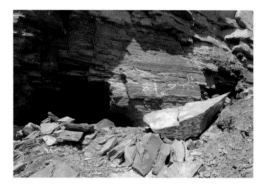

Cave at Qurayyah

## The demise of the people of Midian

Several verses in the Quran tell us that some of the inhabitants of Midian did not heed the words of the prophet Shu'aib and did not follow him. God's wrath thus descended upon them and they suffered divine punishment. Shu'aib was saved and the believers were saved with him.

"When Our decree issued, We saved Shu'aib and those who believed with him, by (special) mercy from Ourselves: But the (mighty) blast did seize the wrong-doers, and they lay prostrate in their homes by the morning." ("Hud", verse 94)[8]

"As if they had never dwelt and flourished there! Ah! Behold! How the Madyan were removed (from sight) as were removed the Thamud!" ("Hud", verse 95)[9]

"And O my people! Do whatever ye can: I will do (my part): Soon will ye know who it is on whom descends the penalty of ignominy; and who is a liar! And watch ye! For I too am watching with you!" ("Hud", verse 93)[10]

The ruins that are observed are probably the ruins of the main cities of Midian. First and foremost among them is Qurayyah where the remains of the residential quarter lie scattered across the ground. Beneath the earth, there is a row of walls that are 3 metres high in places. The second city is Tayma where recent discoveries have revealed vestiges similar to those found in Qurayyah. Piles of rocks cover the surface of the site, burying the remains of walls that stand 4 metres deep. The third site is al-Khurayba at Dedan. On the surface of the site can be seen masses of fallen rocks. They cover the remnants of walls that remain well preserved except in the inner areas that are filled with fallen rubble, rocks and dirt.

All of this proves that, at one time, the region was struck by earthquakes that completely destroyed all of the dwellings. According to Peter Parr, the cataclysmic demise of the people of Midian occurred around 1050 BC. Afterwards, people returned to a nomadic way of life for a couple of centuries before sedentary settlements were once again established in the north-western realms of the kingdom of Saudi Arabia.

8. Quran, 11, 94, Quran, 1980.
9. Quran, 11, 95, *ibid.*
10. Quran, 11, 93, *ibid.*

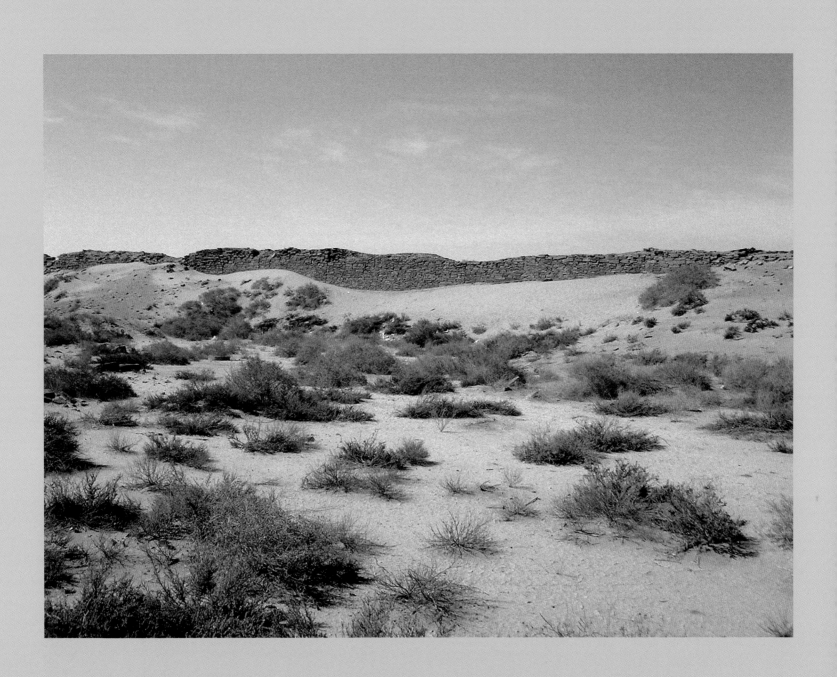

# THE OASIS
# OF TAYMA

*Arnulf Hausleiter*

> "In Tayma, it [the flood] does not leave a palm tree,
> nor a castle if not built on a rock."
> Imru' al-Qays, *Mul'allaqat*, v. 85.

## Introduction

Located inland in the north-western part of the Arabian Peninsula, at the same latitude as the southern tip of the Sinai – between the foothills of the Hijaz and the great Nafud Desert – the oasis of Tayma is one of the largest archaeological sites in the region and in the modern-day kingdom of Saudi Arabia. Tayma stood on a segment of the legendary "Frankincense Route", one of the main trade routes of the Arabian Peninsula, linking southern Arabia with the eastern Mediterranean region. As confirmed first by written sources from the 1st millennium BC, and by the latest archaeological discoveries, the site maintained close economic, political and religious ties with all the regions of the Middle East before the Islamic era. Geographically speaking, Tayma is located at the crossroads of southern Arabia, Mesopotamia, the Levant and Egypt. Although the main branch of the Frankincense Route passed to the west of Tayma, a constant supply of artesian water made the oasis an attractive stopover and settlement site. Its natural assets made it equally attractive to foreign powers, whose aggressions it was not always able to resist, at least from the 1st millennium BC onward. Recent archaeological and scientific discoveries indicate that Tayma was first settled by sedentary populations in the 3rd millennium BC. Its history spans more than four and a half millennia, during which itinerant groups always played a significant role. Judging from the many rock carvings found in the region, the earliest visitors were nomadic shepherds whose herd included cattle. Starting at the latest toward the end of the 2nd millennium BC, camel shepherds began to give the oasis a prominent socio-economic role, perhaps as part of a political-religious confederation.[1]

A text found nearly twenty-five years ago at Sur Jar'a in the Iraqi Middle Euphrates region provides not only the oldest mention in cuneiform of the Tayma oasis, but also gives detailed information on the caravan trade between Mesopotamia and the Arabian Peninsula in the

Outer wall of Tayma (eastern section)

1. Edens and Bawden 1989, p. 66.

1st millennium BC.[2] In the early 8th century BC, Ninurta-kudurri-usur, "Governor of Suhu and Mari", launched a surprise attack on a caravan that included people from "Tēma and Saba" who were attempting to avoid paying a tax. The lavish spoils of the raid included two hundred camels, wool, iron (?) and precious stones – in short, "all that one could desire". A hundred members of the caravan were taken as prisoners. The goods mentioned here are similar to the riches that several northern Arabian cities, including Tayma, were obliged to surrender as tribute to the Assyrian King Tiglath-Pileser III (744–27 BC) a few decades later. Assyria controlled the region for a time during this period, but without annexing it.[3] Starting in the 9th century BC, the territory around Hindanu on the Middle Euphrates seems to have been a trading hub for the redistribution of goods from the Arabian Peninsula,[4] which had probably arrived via the north-eastern al-Jawf route.

Toward the end of the 2nd millennium BC, the domestication of the dromedary (*Camelus dromedarius*), which proved to be a productive and easily tended beast of burden, was a key condition for the development of international trade. In the view of A. De Maigret, commercial caravan traffic could not have developed on any large scale before the 8th century BC. It is, however, possible that the origins of this form of trade date back a little earlier, to the second half of the 10th century BC.[5] The Assyrians also seem to have recognized the economic value of the dromedary (and of camel herders), considering that Tiglath-Pileser III took 30,000 of the animals from the Arab queen Samsi, and several of his successors (Sennacherib, Assurbanipal) also gained possession of thousands of dromedaries.

Starting in the 9th century BC, the term "Arabs" (*aribi*) was used in Assyrian sources to designate members of a coalition of Syrian cities that rose up against the Assyrian King Shalmaneser III (858–24 BC). Later Assyrian kings, such as Tiglath-Pileser III, Sargon II (721–05 BC), Sennacherib (705–681 BC) and Assurbanipal (681–27 BC), also engaged in struggles against Arab groups. Arab warriors mounted on dromedaries are depicted on the orthostates of the North Palace of Assurbanipal at Nineveh. However, there is also an earlier representation of Arabs paying tribute to Assyria under the reign of Tiglath-Pileser III, a depiction that might, according to A. M. Bagg, include Queen Samsi offering proof of her submission. In any case, the relations between Tayma and Samsi, as well as the other Arab queens mentioned as adversaries by the Assyrians, have yet to be clarified. Perhaps more significantly, the reference made by the Assyrian ruler Sennacherib on one of the gates of Nineveh ("The gifts of the people of *Sumu'il* and *Tēma* enter here") emphasizes the economic aspect of the relations between Assyria and north-western Arabia.

In another sign of the close links between Tayma and Mesopotamia, the last Babylonian king, Nabonidus (556–39 BC) made the oasis his residence during his campaign against northwestern Arabia, most likely during the third year of his reign. Tayma became the base from which he "came and went" between the main oases of the region.[6] As suggested by the texts, Nabonidus probably arrived in Arabia from the north-west. A rock carving relief of the king at Sel'a (in today's Jordan) could be a further indication, but only a few characters of its inscription have survived. His decision to leave the capital, Babylon, forsaking his religious and social duties and leaving his son Belshazzar to act as regent, has generally been explained by his worship of the moon-god Sin rather than Marduk, the patron deity of Babylon. Nabonidus's mother, Hadad-happe (Adad-guppi), was active in Harran, one of the main centres of the Sin cult in northern Mesopotamia. Still, economic factors must have been just as determinant, since the control of the oases mentioned in the texts, in the Hijaz all the way to Yathrib (pres-

2. Cavineaux and Khalil Ismail 1990, text no. 2, col. IV, l. 26–40; see also Dossin 1970.
3. See Tadmor 1994, pp. 142–43, "Summary Inscription" 4, 27'–33, pp. 168–69, "Summary Inscription" 7, rev. 3'5'; for the motifs, see Edens and Bawden 1989, pp. 80–81.
4. Edens and Bawden 1989, p. 91.
5. Liverani 1992, pp. 113–14; De Maigret 1999.
6. Schaudig 2001, pp. 497–98, text 3.1, col. I, l. 22–27 (Harran Stele).

ent-day Medina), would have allowed the king to profit from the commercial traffic between southern Arabia and the Levant, Syria and Mesopotamia. This hypothesis is confirmed by accounts found in Uruk of merchandise deliveries from Tayma during the reign of Nabonidus.[7] On the other hand, it is not possible to confirm whether the sickness mentioned by the king was the actual reason for his stay in north-western Arabia, which was often described as an "exile".

It should, however, be noted that the excerpts from the literary composition *Verse Account of Nabonidus* that are often cited as evidence of his activities as a builder in Tayma come from a pamphleteer's text denouncing the king and written after his reign. Consequently, they cannot be considered direct proof. In addition to the cuneiform texts recently unearthed in Tayma, there are a number of Taymanites / Thamudic rock inscriptions found in the area around the oasis that refer to the "king of Babylon" and constitute displays of solidarity addressed to the king.[8] Near one of these inscriptions is a carved representation of a mounted horse, offering parallels with the reliefs in the Assyrian palaces of the late Neo-Assyrian period. However, this figure dates from after the reign of Nabonidus.[9]

After the fall of the Babylonian Empire, the Achaemenid rulers obtained power and influence over vast regions of the Middle East. Given the information available today, it is difficult to assess the actual influence of this domination on the political administration of Tayma under the reigns of Cyrus and Cambyses,[10] although the majority of the stelae inscribed at least partly in Aramaic come from temples of that period. These include the Tayma Stele (cat. no. 311) whose inscription mentions twenty-two years of reign, which can only be attributed to Darius I, Artaxerxes I or Artaxerxes II[11] in the early Persian period. To this artefact must be added the al-Hamra Cube (cat. no. 102) and a religious stele with an Aramaic inscription from Qasr al-Hamra (cat. no. 103), which, like the Tayma Stele, both refer to Ṣalm ("ṢLM"), the main deity of Tayma. During the Achaemenid period, Tayma found itself for the last time within the sphere of influence of a great empire. The oasis continued to be a political focal point in the region, first for the Lihyanite dynasty in Dedan (during the Hellenistic period) and later for the Nabataeans. Although in the Roman inscriptions recently discovered in the region (see cat. no. 121),[12] Tayma plays no role it nonetheless retained its importance into late Antiquity before integrating into the Islamic world.

Were it not for the Biblical tradition, the ancient name of the oasis might well have been lost to history. Tayma is mentioned several times in the Old Testament (Job 6:19, Isaiah 21:14, Jeremiah 25:23, Genesis 25:15, I Chronicles 1:30), along with other names of places and tribes in the region, such as Dumah, Massa, Qedar, Saba, etc., that are also mentioned in other Pre-Christian sources.

The Pre-Islamic poet Imru' al-Qays (c. 540) is considered the first Arabic-speaking author to mention the site.[13] Up to this point, the inhabitation of Tayma at this period was mainly linked to the name of the Judaeo-Arab poet Samaw'al ibn 'Adiya, famous for having sacrificed his son's life in order to fulfil a promise, and who (according to the poet al-Aacha) lived at al-Ablaq al-Fark. The exact location of this place in Tayma, also known as "Qasr al-Ablaq", continues to be the subject of speculation today. On the other hand, Judaic proper names of Tayma residents are in evidence starting in the early 3rd century, as shown by the recent discovery of a grave slab with a Nabataean inscription giving the name of a governor of Tayma.[14] Although they had tried to negotiate authorization to stay, the last Jews were obliged to leave Tayma during the caliphate of Umar.

7. Edens and Bawden 1989, p. 77.
8. Müller and al-Said 2002.
9. Al-Ghabban 2008; Jacobs and Macdonald 2009; al-Said 2009.
10. Graf 1990; see also Knauf 1990.
11. Briquel-Chatonnet and Robin 1997, pp. 261–63; Stein, forthcoming.
12. Al-Talhi and al-Daire 2005.
13. On this subject and what follows, see Buhl and Bosworth 1999.
14. Najem and Macdonald 2009.

During the Islamic period, historiographic and geographic texts in Arabic built up a rich tradition regarding the oasis, perpetuating the memory of the site in the Arab world. The information provided by this corpus highlights the importance of the site in the early years of the Islamic period. According to these sources, Tayma was a four-day journey from Dumat al-Jandal. Al-Muqaddasi mentions a journey of three days between Tayma and al-Hijr/Hegra and four days between Tayma and Tabuk. According to Ibn Hawqal, in the 4th century of the Hegira the city had a larger population than Tabuk and was an important trading place for the Bedouins in the area. By the 5th century of the Islamic era, the prosperity and importance of Tayma had become a constant in the tradition. Al-Muqaddasi mentions its water supply coming from a spring and several wells, as well as lush palm groves yielding excellent dates. The site's prosperity was also described a little later by al-Bakri, who mentions the city walls. Still visible today, they give the ruin its characteristic profile. The walls were also mentioned by Yaqut as possible vestiges of Qasr al-Ablaq. In later years, the Tayma oasis became a rest stop on the pilgrimage route between Syria and the holy cities.

## History of reasearch

In the middle of the 19th century European explorers began to take an interest in the site.[15] After short visits by G. A. Wallin (1848) and C. Guarmini (1864), the British explorer Charles Doughty (1876) came to Tayma for an extended stay, publishing a map of the site and describing some of its inscriptions and pottery sherds. Charles Huber and Julius Euting visited Tayma in the 1880s, first separately and later together. Their expedition led to the discovery of the Tayma Stele, an important artefact now exhibited at the Louvre (cat. no. 311), although it also resulted in Huber's tragic death.

Antonin Jaussen and Raphaël Savignac visited Tayma in 1909 but did not stay long. Their publication includes a few noteworthy photographs of the site, and also of the palm grove (fig. 1), whose surface has more than quadrupled since then.

Fig. 1. The caravan of Antonin Jaussen and Raphaël Savignac arriving in Tayma, 1909

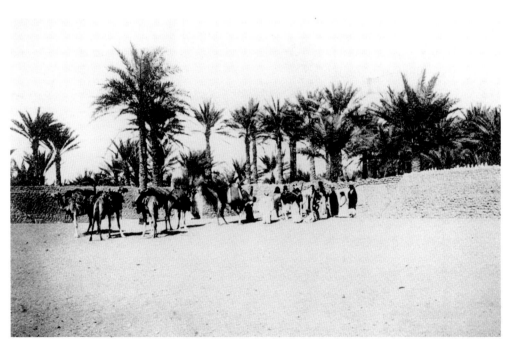

15. See Bawden, Edens and Miller 1980, pp. 73–74.

Half a century later, in 1951, Harry St John Philby travelled to Tayma and became the first to offer a detailed description of the oasis, its environment and its ancient ruins. Shortly thereafter, in 1962, F. V. Winnett and W. L. Reed led investigations in Tayma as part of their epigraphic survey of north-western Arabia. Their work focused primarily on the Taymanite / Thamudic and Nabataean inscriptions of Jabal Ghunaim. They were the first to illustrate characteristic sherds of the painted and unpainted pottery of Tayma.

However, the systematic study of the site did not begin until the survey missions sponsored by the Department of Antiquities and Museums of the Saudi Commission for Tourism and Antiquities, which were initiated throughout the entire kingdom in the mid-1970s. This led in 1979 to the first scientific excavations in Tayma, supervised by G. Bawden, C. Edens and R. Miller on behalf of the Department of Antiquities.[16] Shortly before, P. J. Parr, G. L. Harding and J. Dayton had explored the Mintar bani Attiya Tower located to the north-west of Tayma and identified it as part of a vast network of fortifications surrounding the oasis.[17] For more than twenty years a team of Saudi researchers, initially headed by H. I. Abu Duruk, carried out excavations at Qasr al-Hamra, Qasr al-Radm and around the city wall.[18] The expansion of the modern city into the archaeological zones led to new excavations on the "Industrial Site" (Sana'iye), which yielded many grave complexes with multiple tombs.[19] The results of the excavations in the necropolis of Rujum Sa'sa', south-west of the oasis, were recently published.[20]

## Recent research

Since 2004 the Tayma oasis has been the focus of a new joint research project by the Saudi Commission for Tourism and Antiquities (SCTA) and the German Archaeological Institute (DAI), financed primarily by the Deutsche Forschungsgemeinschaft (German Research Foundation, DFG). The project comprises systematic archaeological, epigraphical, bioarchaeological, geoarchaeological and hydrological studies for the purpose of describing the evolution of living conditions at the Tayma oasis and their impact on the site's development.[21]

Even before this project was launched, the constant expansion of the modern city of Tayma made it necessary to protect the ruins against the encroachment of modern civilization. The Department of Antiquities has so far designated twenty-eight archaeological zones and surrounded them with protective enclosures. The close links between the ancient and modern cities provide an ideal opportunity to bring the ancient history of north-western Arabia to life for Tayma's inhabitants and visitors, with the local museum serving as the starting point. A concept of sustainable conservation, based on the principle of reversibility and using local materials with no chemical additives, has been developed to showcase the architectural heritage revealed by recent excavations.

## Climate, landscape and vegetation

With less than 50 millimetres of annual rainfall, the climate of Tayma and its surrounding area is hyperarid today. But between 30,000 and 20,000 years BP, and again between 9,000 and 6,000 years BP, the region of present-day Saudi Arabia had many freshwater lakes formed in the Quaternary and Pleistocene periods in connection with a northward extension of the monsoon climate. In addition, the evidence indicates that the eastern Sahara and the Arabian Peninsula had a much more humid climate in the 5th and 4th millennia BC. This is consistent with the analyses carried out in the *sabkha* of Tayma, a highly saline depression covering several square kilometres near the oasis.

16. Bawden, Edens and Miller 1980.
17. Parr, Harding and Dayton 1972.
18. Abu Duruk 1986; Abu Duruk and Murad 1985 and 1988.
19. Abu Duruk 1989, 1990 and 1996.
20. Al-Hajiri *et al.* 2002, 2005 and 2006; al-Taima'i 2006.
21. Eichmann, Hausleiter, al-Said and al-Najem 2006; see also www.dainst.org/index_3258_html.

Today there are five distinct ecosystems in the region: rock and scree deserts, sand deserts and sand expanses with rock outcrops, dunes, salt flats (*sabkha* vegetation) and wadi systems.[22]

Initial pollinic analyses of sediments in the *sabkha* of Tayma, combined with a palaeobotanical analysis of plant macroremains and analyses of the current vegetation, are being used to reconstruct the site's ancient flora and retrace its development, in the process offering a better understanding of the palaeoclimatic conditions in the region.[23]

The pollinic analysis of the *sabkha* sediments has revealed a vegetation typical of deserts/steppes and wadis throughout the period in question. Carbon dating (C14) indicates that this type of ecosystem first appeared here in the 6th millennium BC. Although sclerophyll forest growth is no longer present in the region of Tayma, analyses show the presence of pistachio trees, hackberry (*Celtis*) and plants of the *Dodonaea* genus. These species were also present in the central zones of the Arabian Peninsula, which was affected by monsoon rains. Since these species can only develop under much more humid conditions than those found in present-day Tayma, the limit of the monsoon climate must have extended much further north during the ancient and middle Holocene era. The analyses have also revealed the presence of cultivated plants, such as olive (*Olea*), grapevine (*Vitis*) and fig (*Ficus*). If they were indigenous to Tayma, this also indicates a wetter climate in Antiquity. The existence of grapevines in Tayma starting in the 3rd millennium BC has been proven by carbon 14 dating of macroremains, and is perfectly in keeping with the archaeological reconstitution of the city's development. The study of botanical macroremains also indicates the presence of several grains (barley, common wheat, oats, millet) and pulses (lentils), as well as a large number of fruits and hard-shelled fruits, including dates, almonds, blackberries and pomegranates, plus the above-mentioned cultivated plants: grapes, olives and figs.

The palaeobotanical data leads to the conclusion that the vegetation in Tayma and its surrounding area was once much denser, characterized by a higher percentage of trees that still thrived in the many wadi systems. Other clues are provided by rock carvings depicting animals typical of the savannah, like lions, leopards and ostriches. Consequently, the few protected wadis in the region offer an idea of the landscape as it must have been in ancient times.

### Hydrology of the oasis

One of the most important aspects of this new project is the study of water control, water usage and flood protection methods in the oasis, which could not have survived without planned water management. The role of water as a resource for Tayma is illustrated to this day by Bir Haddaj, a well with a diameter of nearly 20 metres whose construction probably dates back to Antiquity and whose water was distributed throughout the oasis for irrigation purposes via a complex mechanism pulled by camels. This well is considered one of the largest reservoirs in the entire Arabian Peninsula (fig. 2). The oasis has many other wells, but none nearly as large as Bir Haddaj.

The areas that are hydrologically significant for a reconstitution of the water control in Antiquity are the *sabkha*, a highly saline depression north of the oasis, the palm grove and the ancient habitation zones.[24] Today the *sabkha* fills with water only after heavy rainfalls, but the presence of fossil deposits several metres thick formed by partially halophilic lacustrine fauna shows that this was once an inland lake whose surface rose to more than 10 metres above the

22. Kürschner 2009.
23. Dinies and Neef 2009.
24. Wellbrock and Grottker 2009.

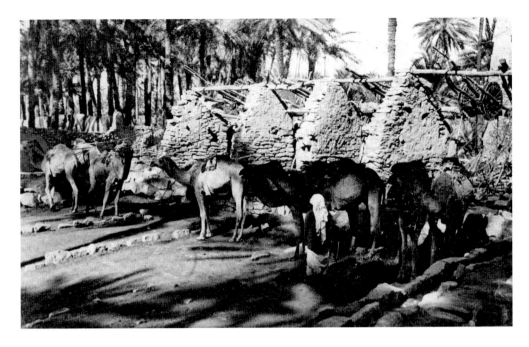

Fig. 2. Bir Haddaj at H. St J. Philby's time, 1951

current level. Radiocarbon dating (C14) correlated with the reconstitution of the palaeoclimate of the Arabian Peninsula indicates that this lake – just like the other freshwater lakes – probably dried up about six thousand years ago, in other words before the permanent settlement by sedentary populations. The lake's disappearance may even have been a triggering factor in the settlement of the oasis once the usable surface water was gone.

The ancient site of Tayma is located on high ground south-west of the *sabkha*, in the direction of the flow of surface waters toward the *sabkha* (fig. 3). Most of the inhabitants' water was supplied by wells, whose installation was facilitated by a geological formation, the Tayma trough fault, which made it easier to raise artesian underground water to the surface. All of the wells in the ancient settlement, plus the only spring detected within the site so far, were fed by these waters.

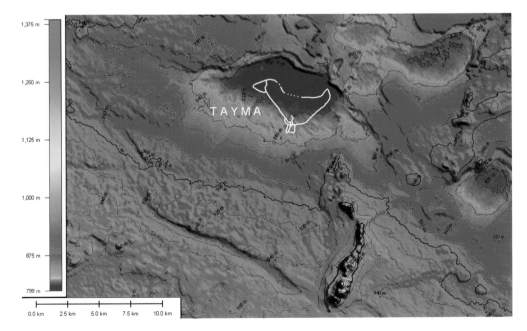

Fig. 3. Digital representation of the topography of Tayma and the surrounding area

The remains of a well to the south-west of the site indicate that draught animals were used to transport the water, as in Bir Haddaj (Qasr al-Radm, which also dates from late Antiquity, has a well of the same type.) Another well was located further to the east. The existence of these two wells was perhaps the reason for the layout of compounds connected to the main habitation zone by defensive walls. Canals for the irrigation of cultivated land have been preserved in the eastern sector.

Despite these installations, after a heavy rainfall the accumulated surface water could pose a danger to the population. Massive deposits of silt found inside the inner wall could be evidence of flooding. According to the carbon dating of organic remains found under this layer of silt, the catastrophe must have occurred in the late Nabataean period. Even though the exact sequence of events has yet to be reconstructed, the most recent part of the inner wall seems to have been built in reaction to this flood. However, this analysis would postulate that the wall is more recent than the sediments, which has not yet been confirmed from a stratigraphic point of view. A trench 12 metres wide and several metres deep dug into the sandstone outside the wall could have accommodated large quantities of water. A geophysical survey has shown that this trench, parts of which were also unearthed in the excavations, stretches to a length of about 500 metres. The stone removed during its digging was used as backfill to reinforce the most recent double wall, which was built over a previous construction, indicating that the wall and trench must be contemporary.

## Excavation results

As far as is currently known, the ancient constructions of Tayma occupy about 80 hectares south of the palm grove, in an area known as Qraya (or Qrayan). This is a name that harks back to the old village centre, the remains of whose mud-brick houses are still visible near the ruin. However, since the 1950s the ever-faster expansion of the modern city of Tayma has led to construction on formerly open land, rendering these areas inaccessible for archaeological research.

The Qraya zone (fig. 4) and the palm grove are surrounded on the west, south and east by a system of defensive walls about 12 kilometres long. These walls could have been quite high in ancient times, in contrast to a low retaining wall about 6 kilometres long that linked the outer extremities of the north-western and north-eastern defensive walls between the palm grove and the *sabkha* (fig. 4). This wall was built to prevent the erosion of the cultivated land toward the *sabkha*. Core samples have shown that the sediments found inside this wall contain no salt, unlike those found to the north of the wall. The palm grove and the town centre of Tayma were thus surrounded by defensive walls 128 kilometres in length and enclosing a surface of more than 950 hectares. Within this enclosure smaller sectors surrounded by other walls were identified.

The archaeologists who excavated the site in 1979 referred to these walled sub-units as "compounds". The various excavation zones were first identified by their traditional toponyms – Qasr al-Hamra, Qasr al-Radm, al-Bujidi, Rujum Sa'sa' – or by modern names like Sana'iye / Industrial Site. The name "Qasr al-Ablaq" used to refer to the central part of Qraya, made up of a sandstone rise and several metres of different archaeological layers. The German–Saudi excavation sites have been designated by letters (A–Z). All are located within the perimeter of Qraya except for the site of the defensive wall (W) and the soundings conducted in the *sabkha* (SE).

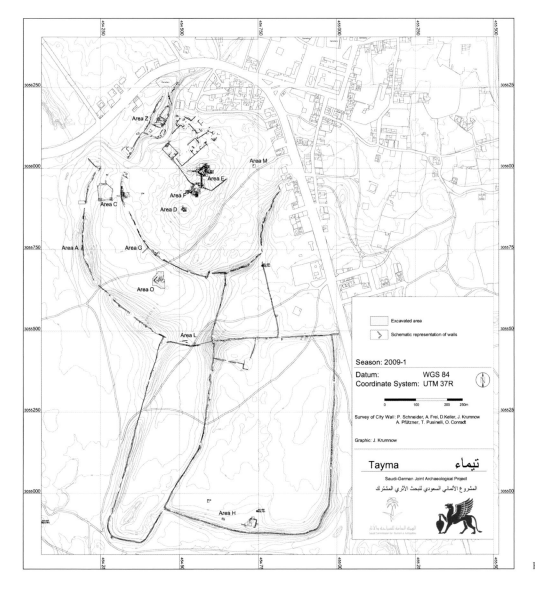

Fig. 4. Map of the central zone of the Tayma ruins (Qraya)

Six different periods of occupation by sedentary populations have been identified on the site, distinguished by their architectural remains (buildings, defensive walls, funerary constructions) and stratigraphic succession:

1: The modern period,

2: The Islamic period,

3: The Late Iron Age / Late Antiquity / Pre-Islamic period,

4: The Early Iron Age,

5: The Middle and Late Bronze Age,

6: From the Neolithic to the Early Bronze Age.

Epigraphical, archaeological and scientific dating techniques have been used to obtain a definitive chronology, making it possible to encompass a period from the Neolithic Age to the modern era.

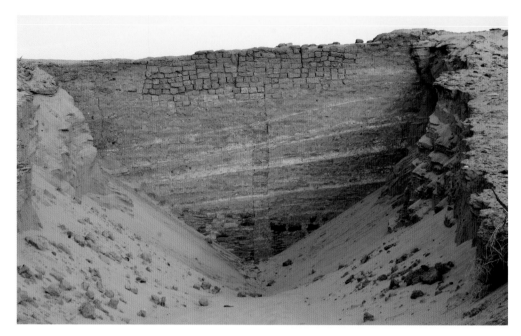

Fig. 5. The outer wall of Tayma

## From the Neolithic to the Bronze Age

The archaeological evidence of occupation from the sixth period (from the Neolithic to the Early Bronze Age) includes arrowheads found on the surface and crafted according to the "Arabian Bifacial Tradition".[25] A more precise location can be given for the remains of cornelian beads, workshop-made with flint tools similar to other tools from Chalcolithic sites in the Middle East. This production must predate the 2nd millennium BC, since worn-out drills have been found in the bricks of the outer city wall – the drills must have been brought to Qraya along with clay from the *sabkha*. The location of these ancient production sites near the *sabkha* is indicated by concentrations of drills and fragments of cornelian beads.

The numerous rock carvings in north-western Arabia attributed to this period shed light on the means of subsistence during the Neolithic Age. They include representations of shepherds with their animals, including cattle. Extending a hypothesis of development often proposed for the Sahara, it is easy to imagine – although it remains pure supposition – that these nomadic groups watered their herds in the freshwater lakes of what is now the Arabian Desert, before the region's desertification.

Based on the timeline for the reconstitution of the environment described above, it seems determinant that the construction of the main outer wall of Tayma can be dated, at least for certain sections, to the 3rd millennium BC, the Early Bronze Age. This estimate seems likely considering the results of physical dating methods (optically stimulated luminescence, OSL) applied to the aeolian sediments that have accumulated against this wall, as well as carbon dating (C14) of the organic remains contained in these sediments.[26] At the time, the defensive walls were built of mud bricks on sandstone slab foundations. This type of wall probably surrounded certain parts of the palm grove and the central habitation zone. The walls from this early occupation period were at least 6 metres tall (fig. 5).

The chronological differentiation of these walls is based for the moment on the construction materials (mud bricks/stone), independently from the discoveries made within the perimeter of this defensive wall. The sections built of stone are characterized by a type of

25. On this subject see Uerpmann, Potts and Uerpmann 2009, pp. 212–14.
26. Klasen *et al.*, forthcoming.

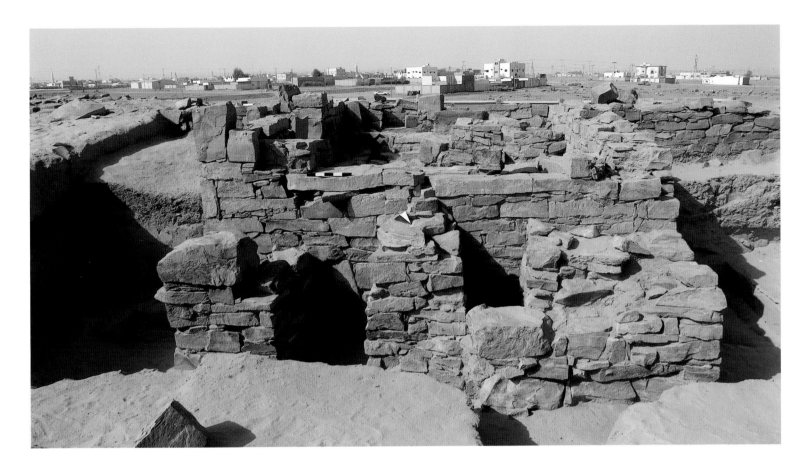

modular construction that probably reflects the organization of labour, as well as by high nar-
row niches (or sometimes openings) at regular intervals, whose function remains unknown.[27]
Unlike the remains of the outer wall, no remains of any settlement from the 3rd millennium
BC have been identified in Tayma. On the other hand, in 2003 a team of archaeologists led
by M. al-Hajiri unearthed bronze weapons in the "Industrial Site" zone. These weapons cor-
respond precisely to the fenestrated axes and ribbed daggers found under similar circum-
stances in so-called "warrior tombs" and that appeared in Syria and the Levant at the end of
the Early and beginning of the Middle Bronze Age.[28] Although these weapons were found in
a clearly secondary context and provide no further information on the significance of their
presence in Tayma, the oasis is the southernmost discovery site of such objects, which could
attest to a history of contact between the oasis and the Early and Middle Bronze Age popu-
lation centres of the Levant and Syria.

For the period between the early and late 2nd millennium BC, the archaeological dis-
coveries have not been able to clearly determine the configuration of the settlement of
Tayma. This period corresponds to the fifth occupation period. By this time the neighbour-
ing regions (Egypt, Syria, Mesopotamia) had already developed a palatial civilization of
which no trace has yet been found in Tayma. During or after the first half of the 2nd millen-
nium BC, the outer wall of Tayma was enhanced with superstructures and annexes built on
the sand parallel to the wall, as indicated by the carbon dating of organic remains found in
the unfired mud bricks. Recent carbon dating of materials from a tower inside the north-
western section of the wall (W41) also indicate that it could have been in use starting in the
Late Bronze Age (fig. 6).

27. Schneider, forthcoming.
28. Nigro 2003.

## The Iron Age

The earliest archaeological remains discovered in Qraya that served purposes other than fortification or protection against the sand date from the Late Bronze Age and early Iron Age (12th–10th/9th centuries BC, occupation period 4). In the south-western periphery of the walled northern part of Qraya (site O) there once stood at least one public building, facing a large paved area and protected by a massive wall 2 metres thick. It was a long rectangular building (12 x 19 metres) surrounded by at least one row of pilasters. However, it does not closely

Fig. 7. Map of the building and the tombs found in Area O

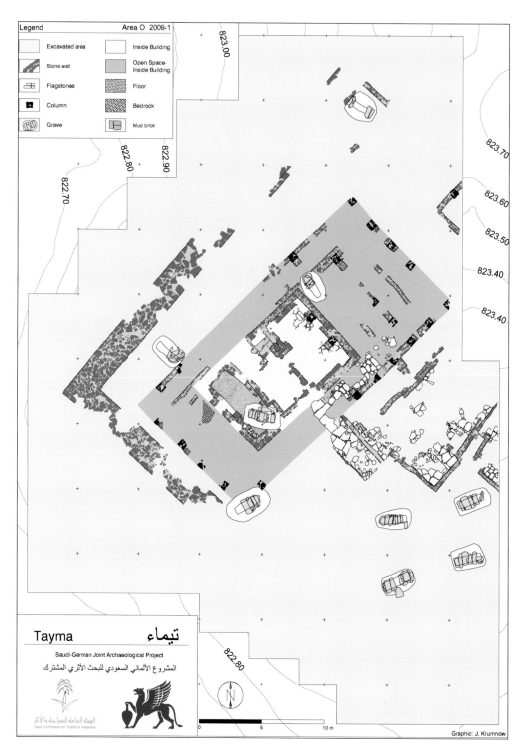

resemble the temples built during the same period in the neighbouring regions (from the Aegean Sea to Egypt) (fig. 7).

Numerous fragments of small unpainted pottery drinking vessels indicate the frequent use of liquids on the site, perhaps in conjunction with ritual meals. Pottery bowls and cups with dichromatic painted decorations in black and red, essentially characterized by a combination of depictions of birds and geometric patterns (cat. no. 82), have also been found here. These vessels echo certain motifs associated with the so-called "Qurayyah" pottery, whose earliest production has been dated, based on comparison with similar pieces from Timna' (Palestine), to the late 13th or 12th century BC. However, the pottery found in Area O differs from the Qurayyah pottery and may well be a more recent local variant. Sherds of Qurayyah pottery have been found in Tayma, but so far only in other sectors and not in significant quantities.

In addition to the pottery, the edifice in Area O has yielded a large number of sophisticated objects made of ivory, wood, bone and faience, discovered among the charred debris. These include tokens (perhaps for a game) that share characteristics with those from the Neo-Assyrian period found at Nimrud,[29] amulets, as well as fragments of glazed containers similar to objects that have been dated to the Early Iron Age. In addition, the discovery of scarab (fig. 8) and a series of figurines of Egyptian deities would indicate close relations between Tayma and Egypt at this period.

Sections of decorative borders of containers have been found, many inlaid with bone and wood and some also adorned with carved motifs (guilloches) typical of the eastern Mediterranean.

The size, layout and protective wall of this structure would indicate that it was an important building, probably public, but its exact function has yet to be determined. Similarly, it is not possible to confirm whether the ritual ingestion of liquids was associated with religious activities, although the design of the building is comparable to places of worship built later in other regions.

From this same period there dates a narrow annex built on a dune several metres high that had formed against the outer wall (Area A), which evidently would no longer have served its original defensive function. Like the upper part of the wall, this annex was built of sandstone slabs. The pottery repertoire found here corresponds closely to the one from Area O. The extensive deposits of bird bones in the annex dating from the two main phases points to a function related to food preparation.

Today it seems sure that Tayma was inhabited continuously through the Late Iron Age (occupation period 3), even though none of the more recent deposits of the centre of the site can be stratigraphically linked to the Early Iron Age deposits. For the most part, the only remains in Tayma and its surrounding area that have been dated to the early and mid-1st millennium BC are cemeteries (Tal'a, Sana'iye). Like the pottery (cat. nos 83–91), some Early Iron Age decorative elements endured, which was not as consistently the case of the techniques used, making the hypothesis of continuous inhabitation more plausible than the interruption considered by P. J. Parr.[30] This decorative continuity had been noted as early as 1979, and was what led G. Bawden and C. Edens to use the term "Tayma Painted Ware"[31] to designate all painted pottery from Tayma, even if it meant not considering certain disparities, including functional, among the different pottery groups and the contexts in which they were found.

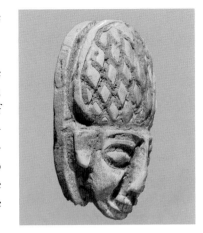

Fig. 8. Egyptian scarab in glazed stone, 1.8 cm. Tayma Museum, TA 7536

29. See Herrmann and Laidlaw 2009, p. 212, no. 321a-c, pl. 101; Initilia 2009.
30. Parr 1988.
31. Bawden and Edens 1988.

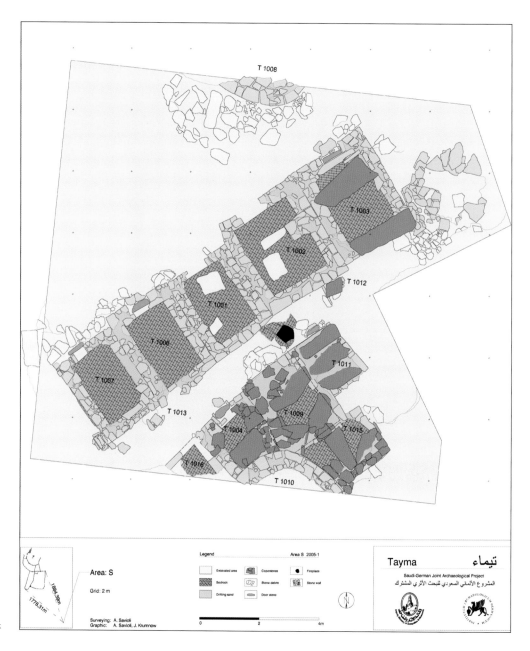

Fig. 9. The Tal'a funerary complex

The graves of this period consist of a cluster of adjoining compartmented rooms made of rectangular stones used for collective burials (fig. 9).

Many round funerary constructions with rectangular annexes have also been found in Sana'iye, and more recently further to the south in Tal'a.[32] In addition to pottery, the discovery of a painted terracotta figurine of a dromedary with an incised brand mark (*wasm*) and a small funerary stele decorated with a face offer a better understanding of the social differentiations visible through the furnishings of the tombs. Several radiocarbon analyses have dated the Tal'a burial sites to the 9th to 5th centuries BC.

In the central part of Qraya, pottery comparable to the ones from the Sana'iye and Tal'a cemeteries has been found only in debris and in backfilling material. It can therefore be presumed that, except for a few rare vestiges, the structures from this period were all demolished

32. Beuger, forthcoming; Lora, Petiti and Hausleiter, forthcoming.

during subsequent construction works. The only remains in the centre of Qraya (Area F) that could date from this period are a few sizeable sections of a wall built on the rocky substrate and covered by a structure from Late Antiquity. So far no remains of any public or private buildings have been dated to the period of contact between Tayma and Assyria – only tombs, whose fittings offer no parallels with Assyrian material culture, being characterized, on the contrary, by local or regional features. Sherds of pottery from Sana'iye found at Tell al-Kathib, north of al-Khuraybah (ancient Dedan), and at Tell Kadesh Barnea (in the Sinai) reveal a regional dimension of this production that was previously ignored.[33] Furthermore, a number of individuals from Tayma are mentioned in Babylonian texts.[34] Like the period of contact with Assyria, the ten-year stay (556–39 BC) in Tayma of the Babylonian king Nabonidus left little or no discernible trace in the architectural remains, although several texts in Babylonian cuneiform that are clearly attributable to him have been found in the centre of the site. Examples include a Mesopotamian-style arched stele (cat. no. 100) as well as two fragments of a disk that might have formed its pedestal (cat. no. 101). Unlike the inscription on the stele, which recalls the decoration of Babylonian temples and makes reference to the city's principal god Marduk and his consort Zarpanitu, the inscription on the discoid base explicitly designates Nabonidus by name, the earliest such mention in cuneiform characters found in Tayma. The stele depicts the king turned toward the astral symbols of the Babylonian gods: Sin (the disc and crescent moon), Shamash (the sun) and Ishtar (the star).[35] The fact that these text fragments were discovered in the immediate vicinity of a public building that was used as a temple under the Liyhanite dynasty (Area E) suggests that these artefacts are related to an earlier structure that could also have served as a temple.

The use of the site for religious purposes seems to have continued into the Achaemenid period, since the ruins of the building in Area E have yielded a bucranium comparable to the one depicted on the edge of the Tayma Stele. This could provide a clue to the original location of this stele relating the introduction of the god Ṣalm HGM to Tayma.[36] On the other hand, an example of a sanctuary from this period is known: Qasr al-Hamra, built on a rocky spur that rises above the western part of the *sabkha* about 2 kilometres from Qraya (fig. 10).

This is where the al-Hamra Cube and Stele were found, in primary context (cat. nos 102 and 103). These two monuments, along with other *paraphernalia*, provide a starting point for the reconstitution of this complex, associated with the worship of the god Ṣalm R/DB. The depictions on the al-Hamra cube (cat. no. 102) of a bucranium and a bull in the style of the Apis Bull integrate certain Egyptian representational forms. Another similar representation of a bull, but without the sun disc, has been found in the Qraya temple. This underscores the consistency of the iconography associated with the god Ṣalm in Tayma, while at the same time revealing a differentiation in the distribution of bull representations, with a sun disc (Qasr al-Hamra) or without (the Qraya temple). The "Aramean pantheon" worshipped in Tayma, centring around the gods Ṣalm (MHRM, HGM and R/DB), Ashima and Shengalla, no doubt originated in Syria.[37]

At the latest under the Lihyanite dynasty of Dedan (c. 4th to 2nd centuries BC), whose centre was located in the al-Khuraybah oasis (modern-day al-Ula[38]), Tayma lost its independance. Dedan was already an important power in the region during the Neo-Assyrian and Neo-Babylonian periods. Several rock inscriptions near Tayma mention "wars" between Tayma and Dedan, Massa and Nabayat.[39] In addition, during his forty-four-year reign, the Lihyanite king Tulmay (TLMY) regularly left inscriptions in the Qraya temple every ten years, to commemo-

33. Bernick-Greenberg 2007, 140, fig. 11.24, pl. 11.14, 11.6; Zahrani 2007, pp. 224–25.
34. See Edens and Bawden 1989, pp. 77–78.
35. Eichmann, Schaudig and Hausleiter 2006.
36. Hausleiter, forthcoming.
37. Maraqten 1996.
38. See Farès-Drappeau, 2005.
39. On the importance of the trade in central Arabia via Gerrha at the time, see Edens and Bawden 1989, pp. 92–93.

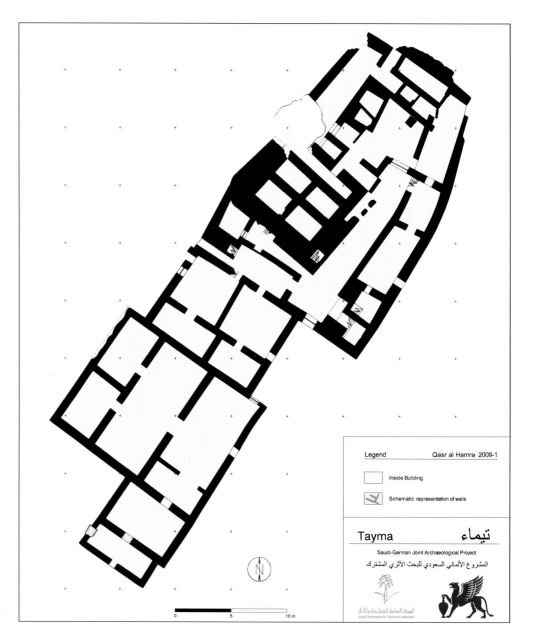

Fig. 10. Map of Qasr al-Hamra'

rate his twentieth, thirtieth and fortieth years on the throne. It was most likely during this time that several larger-than-life statues of male figures were erected in al-Khuraybah and Tayma (cat. no. 107). Given that one of the statues in al-Khuraybah bears a royal inscription, one may deduce that the statues found in Tayma are also royal representations that, like the ones in Dedan, stood next to the temple. However, the pedestal found in the Qraya temple whose inscription mentions a Lihyanite king named 'Ulaym Shahru (P. Stein) probably served another purpose, considering its smaller size.

Under the reign of King Lawdhan of Lihyan, a certain Natir-It served as governor of Tayma, as indicated by an Aramaic inscription found in the fill in the ditch that runs along the inner wall. This inscription is also the earliest sign of political and administrative organization at the oasis. If the "breach" it mentions refers to the remains of a passage under the Nabataean inner wall, this would indicate that the wall dates to earlier in the Lihyanite dynasty or shortly

before. At the time, the outer wall had already been covered by dunes for a long time and could no longer fulfil its defensive function. In this context, the reduced size of the site could reflect a loss of political importance attached to the oasis.[40] The space on the other side of the inner wall, which during the early Iron Age was still occupied by public buildings housing sophisticated objects (Area O), was at this point only used as a burial site, in which a number of funerary stelae bearing a simple depiction of a face and sometimes an Aramaic inscription of a name were reused to cover the tombs (cat. no. 105). The names recorded on these stelae have provided a basis for Aramaic onomastics, but do not give enough information to draw any conclusions about the social makeup or prosopographical nature of Tayma'nite society. Moreover, this is the only category of objects that show southern Arabian influences in Tayma, in terms of style and morphology.

The last architectural level of the public building in Area E that served as a temple, and that had a special importance for the Lihyanite kings (fig. 11), shows various stages of construction, each one divided into several phases. At first the building consisted of a single large hall with three naves separated by pilasters. Later, most likely under the Lihyanite dynasty or during the Nabataean period, the southern part of the building was transformed into a portico, while its northern part was divided into five rooms, which could indicate that the building was no longer being used as a temple.

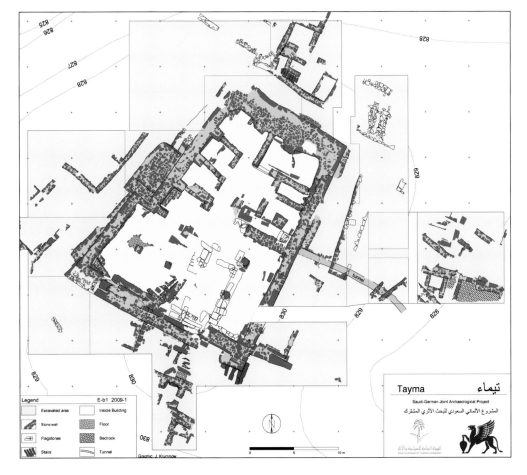

Fig. 11. Map of the E-b1 temple (Area E)

40. Hausleiter 2009.

The fill beneath one of the floors installed during this period has yielded an imitation of a coin depicting Athena dating from the late 4th or early 3rd century BC, thus providing a *terminus post quem* for the more recent construction phases.[41] The building underwent other transformations in late Antiquity, in particular when the columned hall, which had survived unaltered until then, was divided into several smaller rooms. The initial use of the building as a temple can be deduced from its configuration and decoration (plastered and painted walls) as well as its raised position and the presence of a double staircase near the most recent main entrance, where several sphinxes probably once stood. Pools and ditches, oriented from the inside of the temple outward, indicate the use of water. This aspect presents similarities to Qasr al-Hamra, as does the design of the pilasters and floors. One distinctive feature of the Qraya temple is a narrow underground tunnel, also of the Lihyanite architectural level, connecting it to a well located to the south-east. One of the stone slabs lining the tunnel is inscribed in Aramaic with the Babylonian-sounding name Nabu-nadin-ahhi (P. Stein).

## From the Nabataeans to Islam

Several Nabataean construction elements have been found in the ruins of the Qraya temple, including a column capital (fig. 12), an in-the-round vase, and decorative plinths and triglyphs that recall the architectural style of Nabataean temples and tombs. These, plus an inscription by King Aretas IV, seem to indicate that the ties between Tayma and the Nabataean city of Mada'in Saleh/Hegra were closer than previous archaeological discoveries in Tayma would have implied.[42]

Many objects from the Nabataean period, such as coins, many incense burners with inscriptions and of various shapes (cat. nos 110, 109), pottery sherds (also inscribed) and a sculpture of an eagle have been unearthed in the inhabitation zone south of the temple, although it should perhaps be added that these artefacts were found in the backfill.

Fig. 12. Nabataean capital found in Tayma, TA 975

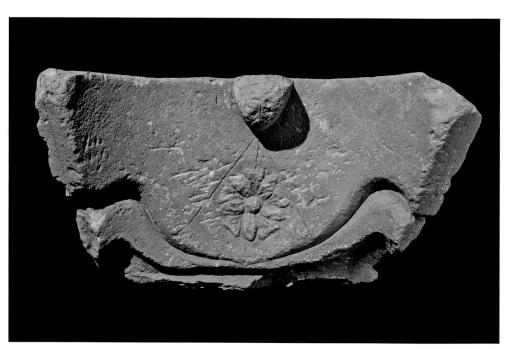

**41.** On a similar coin found in Qasr al-Hamra, see Abu Duruk and Murad 1988, pl. 27.
**42.** Regarding the two Nabataean inscriptions-*strategoi* in Tayma, see Nehmé 2009.

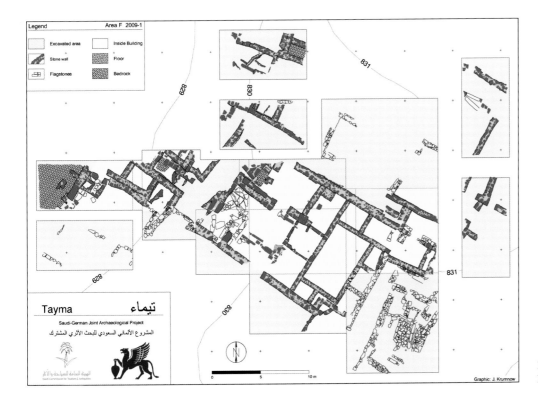

Fig. 13. Map of the habitation zone dating from Late Antiquity (Area F)

Remains from the subsequent period, Late Antiquity, cover a considerably larger surface in Qraya.[43] To the south of the temple was an inhabitation zone where several square houses have been excavated, each with a surface of about 100 square metres and richly supplied with cooking utensils and utilitarian pottery for the preparation of food products (fig. 13).

During this period the entire area around the Qraya temple was subjected to an architectonic reorganization. After the erection of a temenos wall immediately around the temple, another protective wall was built, extending all the way to the wadi that crosses Qraya to the north (fig. 4). Most probably, the temple permanently lost its original function in the 3rd century. Fragments of Lihyanite statues as well as pillars inscribed with the name of Tulmay of Lihyan were recycled as construction materials and used to seal the remaining openings of the portico. The representative and administrative centre of the site was moved to the north, to an elegant complex with palatial dimensions spanning nearly 2 hectares. This complex, from which no decorative elements have survived, was divided by spacious courtyards. The carbon dating of materials from under the foundation level as well as the stratigraphic relations established with the structures south of the Qraya temple indicate that this complex could not have been built earlier than the 2nd century (132–325 Cal AD[44]). The only written source from this period found in Tayma so far is a grave slab in the form of a *tabula ansata* from the year 203, mentioning a *s'yh*, or chief, of Tayma, plus a series of other Judaic names.[45] Although there is no stratigraphic relation between this inscription and the complex or the south-western inhabitation zone, these architectonic remains provide a very clear image of the size and importance of the site, in particular the scale of the official buildings in this zone dating from Late Antiquity, which exceeds that of all previous constructions. It is possible that Qasr al-Radm also dates from this period. A rectangular complex that was first documented by Euting in the late 19th century, it is located inside the north-western wall and is reinforced with defensive towers (fig. 14).

43. Eichmann 2008.
44. Calibrated date Anno Domini (AD).
45. Al-Najem and Macdonald 2009.

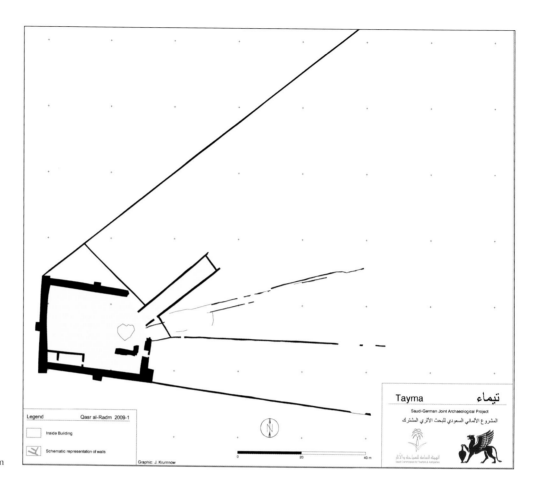

Fig. 14. Map of Qasr al-Radm

Between the Pre-Islamic and Islamic periods (the latter being designated as occupation period 2), it must be assumed that Tayma was continuously inhabited. Within Qraya, the centre of activity shifted to the north and north-west, and the earlier structures around the Qraya temple were not reoccupied. The constructions from this period, more or less contemporary with the early Abbasid period, were built on sand and had a different type of interior configuration from the Pre-Islamic buildings. Although the findings of the excavations cannot easily be correlated with the rich Arabic tradition concerning Tayma, mentioned above, an immense square complex spanning 2,500 square metres (fig. 4) reflects the importance of the oasis. This complex, which includes two corner rooms and a row of rooms on its north side – no doubt used for the distribution of merchandise – plus several other complexes built around a central courtyard, also with a series of halls behind a row of rooms and a forecourt, must have been erected in the 8th or 9th century or shortly thereafter. Another vast complex from this same period was built on a narrow strip of land between the wadi in Qraya and the more northern section of the extension of the outer wall. Its dimensions, with multiple courtyards and rows of rooms, are consistent with a public building, but its function has yet to be more precisely established. The design of these buildings, preceded by a courtyard and dating from the early Islamic period, recalls certain structures unearthed in Tell Mabiyat, south of al-Ula. The al-Bujidi complex north of Qasr al-Radm has the characteristics of a fortification (fig. 15). Based on preliminary observations, the pottery found there offers similarities to Ayyubid or Fatimid pottery.

Given the information available today, it is not possible to date when the occupation period of the early Islamic period came to an end and Qraya was abandoned. According to Arabic inscriptions, the ancient structures were damaged extensively in the 9th and 10th centuries.

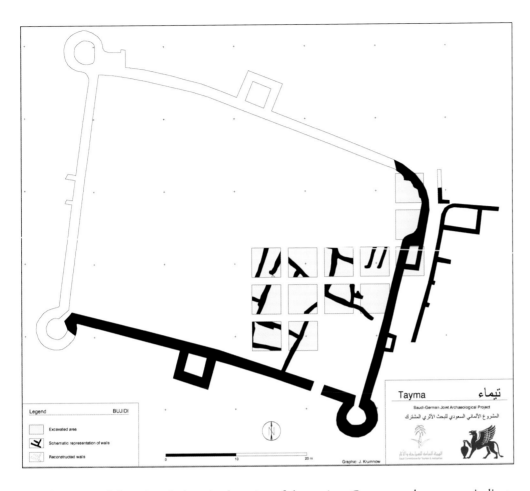

Fig. 15. Map of the fortified complex of al-Bujidi

The discovery of these inscriptions in the ruins of the ancient Qraya temple seems to indicate that the early constructions were purposefully destroyed, perhaps to recuperate the construction materials. It is likely that the site was moved at this time to the current location of the old city near the palm grove, once again experiencing a loss of greatness and importance. Consequently, the Qasr ibn Rumman complex east of Bir Haddaj must date from no earlier than the medieval Islamic period. This complex was the seat of the governor of Tayma before King Abdulaziz Al Saud (also known under the name of Ibn Saud) united the kingdom. By then the ancient ruins of Tayma, which were already subjected to extreme climatic conditions in the time of Imru' al-Qays, were long abandoned and buried under sand. The imposing city walls still bear witness to the former importance of the oasis of Tayma, centuries after its final decline.

## Perspectives

The environmental, archaeological and epigraphical data show that the Tayma oasis was a prominent local and regional centre, but also played a key role in the network of international, cultural and economic relations in the Middle East. The formerly accepted belief that the oasis was only a peripheral site has proven to be unfounded. The substantial documentation from the 1st millennium BC notwithstanding, recent research has shown that, beyond the expansion of our chronological horizon, the inhabitation of this region, most likely dating from the 3rd millennium BC, sheds new light on the importance of this oasis in the fundamental processes of civilization in the Arabian Peninsula.[46]

46. See Robin 2008, p. 244: "From Tayma, the alphabet spread to the Hijaz (Dedan), Yemen (Saba') and, more marginally, to lower Mesopotamia and eastern Arabia."

## EARLY IRON AGE POTTERY

At Tayma the painted ware found in Early Iron Age levels (12th–9th centuries BC) features representations of birds and geometric patterns. It was largely unearthed in a public building (Area O) together with a wealth of small red beakers, mass produced by wheel and for the most part not painted. Associated artefacts as well as radiocarbon analysis allow the dating of the pottery with certainty. The most recurrent shape is the large bowl made on the lathe with a medium fine chaff-tempered clay (cat. no. 82). Other isolated forms (chalice-shaped cup) are also attested. The surface, coated with a light slip, is enhanced with a polychrome painted décor (brown-black and red) on the inner and outer walls. The motifs of this décor are already known by the Qurayyah Painted Ware which was identified and defined by P. J. Parr[1] in the Qurayyah oasis (north-west of Tabuk). This pottery is characterized, though not exclusively, by a décor of a wide circular red band framed by narrow black bands encircling the vessel. Above this motif juxtaposed vertical bands are painted. Qurayyah Painted Ware is found at Timna,[2] but subsequently spread to Palestine and even Jordan. It has been dated to the end of the Late Bronze Age (13th–12th centuries BC) but is also found in more recent archaeological levels. It was formerly known as "Midianite pottery". In Northwest Arabia it is found south of Qurayyah, in the region of al-Bad' and at al-Ula/Tell al-Kathib and Tayma.[3]

The characteristics shared by the Tayma's bird decoration ware and Qurayyah Painted Ware, but also the differences in forms, painted décor and dating, lead to believe that it might be a local perpetuance of the Qurayyah Painted Ware tradition. Sherds belonging to the latter were also found at Tayma. The same is true of the painted ware of al-Ula/Tell-al Kathib north of al-Khuraybah/Dedan where several Qurayyah Painted Ware sherds were found.[4]

**A. H.**

1. Parr 1970, p. 238.
2. Rothenberg 1988.
3. See in this book the article by Hausleiter, p. 219.
4. Al-Zahrani 2007, p. 184, nos. 77–79, and p. 186, no. 82.

**81. Bowl**
First half 1st millennium BC
Painted ceramic
H. 6.6 cm; Diam. 20 cm
Tayma, Sana'iye
National Museum, Riyadh, 981

**82. Large, painted bowl**
12th–9th century BC (Early Iron Age)
Ceramic
H. 11.5 cm; Diam. 14 cm
Tayma, Saudi–German Excavations, Area O
Tayma Museum / Saudi–German Excavations TA 4300

Bibliography: Hausleiter 2006, p. 162 and fig. 4; *DAI* 2007, p. 312 and fig. 10 p. 313

Large pottery bowl with a bi-chromatic décor on both sides. Several fragments of the lip are missing; the vessel is incomplete. The lip is decorated with a red band and red and black cross-hatching on a cream-coloured ground. The cross-hatching is bordered on each side with two black lines, parallel and horizontal, separated by a red line. A second set of three similar lines, two black and one red, is painted at the bottom of each side, on each side of the central part. On the outside of the bowl groups of black and red vertical lines divide the area thus circumscribed into a series of near identical squares, all filled with black and red diagonals. Inside the bowl the space is divided into eight compartments by similar groups of vertical lines. The four smallest ones are entirely filled with black and red cross-hatching, whereas each of the larger compartments is occupied by a single bird facing left. The birds are stylized: their drop-shaped body is filled with red paint, their long neck and round head, wings and curved feet are rendered with a few black dashes. Details such as the eyes, beaks and décor of the wings consist of red dots and dashes. A series of black and red lines represent the birds' tails.     **A. I.**

## LATE IRON AGE POTTERY

Another group of painted pottery was found at Tayma, more recent it differs from the Early Iron Age ware because of the clay, the manufacturing technique, forms and the painted motifs. The repertory is wider: conical dishes of different sizes, open-shaped beakers, cup-shaped beakers called "incense burners", pitchers with handles, etc. In addition to its medium fine well-fired clay, this group is remarkable for its friable fabric, white to pinkish-white on the fracture and fired at a low temperature. The décor is mainly painted in brown (sometimes also red) and offers a large variety of geometric motifs, both simple and complex, as well as occasionally vegetal and more rarely animal motifs painted on a light slip, its colour ranging from white to orangey-brown. Because of the place where it was discovered at Tayma, the name Sana'iye Pottery was recently created;[1] although these vessels belong to Tayma Painted Ware as defined by C. Edens and G. Bawden in the 1980s. Its dating is less certain than Tayma pottery considered as a local variant of the Qurayyah Ware. Radiocarbon data from the necropolis of Tal'a, south of Tayma, where great quantities of this ware was found suggest a period between the 9th and 5th centuries BC. However the analysed organic remains do not come from a funerary context of the graves, which had been looted. Nonetheless this data might explain the presence of several motifs of the local variant of Qurayyah Ware in the Sana'iye pottery such as the series of crossed bands on the outer wall of tall beakers (cat. no. 84). A fragment bearing this same type of decoration was also found in the graves of Rujum Sa'sa' south-west of Tayma.[2] The eventual interruption of human occupation at Tayma, expounded by P. J. Parr between on the one hand the Late Bronze Age and the Early Iron Age and on the other hand the end of the Iron Age is based on the dating of the pottery. This question appears settled according to the opinion of G. Bawden and C. Edens[4] in favour of continuity, as regards the material culture as well. Sana'iye pottery comes mainly from tombs but is now also found in deep level of backfill at the centre of the site of Tayma (Qraya). However no trace of tombs has yet been found in this area. It must be secondary fills, whose origins are still undetermined. **A. H.**

1. Al-Hashim 2007.
2. Al-Hajiri *et al.* 2002, pl. 3–14B.
3. Parr 1988.
4. Bawden-Edens 1988.

**83. Large, painted bowl**
First half to mid-1st millennium BC
Ceramic
H. 22 cm; Max. diam. 34 cm
Tayma, Sana'iye, tomb no. 4
National Museum, Riyadh, 151

Bibliography: Abu Duruk 1989, p. 16 and pl. 6a and 10a; Hashim 2007, p. 154 and fig. 5T37, p. 159.

Large ceramic bowl found in a corner of Tomb no. 4 at Sana'iye. The conical flat-based vessel is exceptional by its dimensions. Made of a flaky white material, it has rather thin walls. The exterior of the bowl bears a rich painted décor of various geometric motifs arranged in fifteen horizontal registers on a white ground. The lip is enhanced with a painted band. **A. I.**

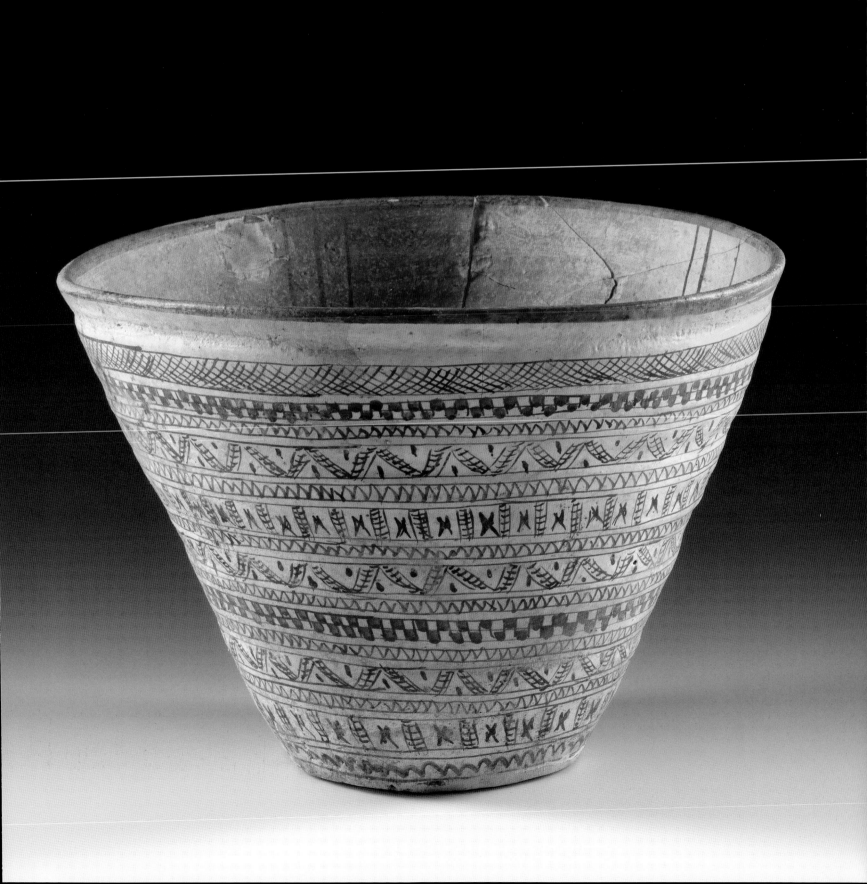

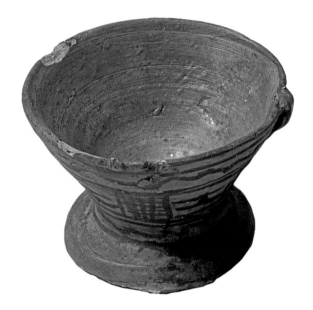

**84. Deep, painted bowl**
First half to mid-1st millennium BC
H. 13.5 cm; Diam. 18 cm
Ceramic
Tayma, Sana'iye
National Museum, Riyadh, 530

Bibliography: Hashim 2007, p. 154 and fig. 5T:31 p. 156.

Deep, roughly cylindrical, painted pottery bowl made of a coarse material with grooves originating from the turning-process on the pottery-wheel. On the exterior a band of loosely rendered X-shaped motifs is set inside two horizontal, parallel lines, all on orange-brownish background. The interior is decorated with four triangles made of parallel lines, also on white background, set directly below the painted rim of the vessel. This bowl is similar in shape to cat. no. 86.  **A. H./A. I.**

**85. Small, painted cup ("incense burner")**
First half to mid-1st millennium BC
Ceramic
H. 8 cm; Diam. 11 cm
Tayma, Sana'iye
National Museum, Riyadh, 501

Small pottery cup, so-called incense burner, made of a medium to coarse material with a conical body set on a rather large, flat, circular foot. A very small handle has been set near the rim. The painted design consists of a frieze of geometric patterns in the lower part of the exterior. Above it, there is a wavy line running between two horizontal lines. The rim is also painted. This vessel is very similar in shape to another pottery vessel from Tayma, cat. no. 87.

**A. H./A. I.**

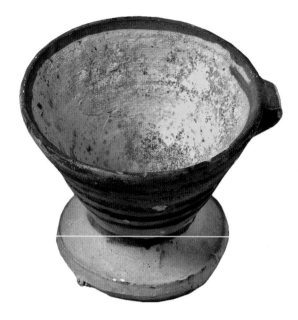

**86. Deep, painted bowl**
First half to mid-1st millennium BC
Ceramic
H. 5.5 cm; Diam. 7 cm
Tayma, Sana'iye
National Museum, Riyadh, 509

Bibliography: Hashim 2007, p. 149 and fig. 5T:29 p. 155.

Deep, cylindrical pottery bowl made of medium to coarse material. A criss-cross pattern inscribed between two parallel, horizontal lines has been painted on white background onthe exterior of the vessel. A continuous band decorates the rim. This vessel is similar in shape to cat. no. 84.                    **A. I.**

**87. Small, painted cup ("incense burner")**
First half to mid-1st millennium BC
Ceramic
H. 8 cm; Diam. 9 cm
Tayma, Sana'iye
National Museum, Riyadh, 3103

Small pottery cup ("incense burner") with painted decoration. This conical vessel has been made of a medium fine clay and is similar in shape to cat. no. 85, including the flat base and the small handle near the rim. The exterior of this vessel has been decorated with a series of horizontal lines on white background; the rim and the handle are also painted.                    **A. I.**

**88. Small, painted deep bowl**
First half to mid-1st millennium BC
Ceramic
H. 6.5 cm; Diam. 8.5 cm
Tayma, Sana'iye
National Museum, Riyadh, 511

Deep bowl with slightly conical shape. This vessel is thin walled and made of a fine to medium fine clay. On the exterior there is a painted decoration of reddish-brown colour on a whitish ground. In the lower part, above a double horizontal line, there are double-axe and hatched geometric patterns framed by an irregular horizontal line above. In the upper part there are further hatched patterns and horizontal lines. The rim is also painted.                    **A. H./A. I.**

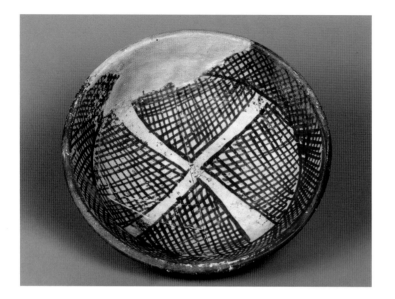

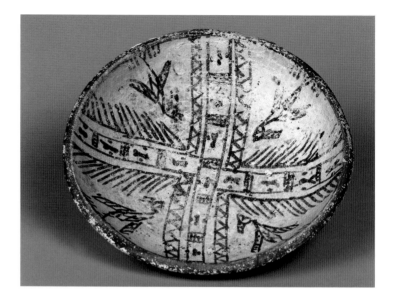

**89. Flat painted bowl**
First half to mid-1st millennium BC
Ceramic
Diam. 19.5 cm
Tayma, Sana'iye
National Museum Riyadh, 524

Ceramic dish made of medium to fine clay with a painted decoration. The inside of the lip is decorated with dark red cross-hatching on a white ground, bounded at the bottom by a horizontal line. Below this line on the bottom of the bowl four triangles filled with cross-hatching are separated by the four arms of a white cross which extend to the painted band adorning the lip of the vessel.          A. I.

**90. Flat, painted bowl**
First half to mid-1st millennium BC
Ceramic
Diam. 14 cm
Tayma, Sana'iye
National Museum Riyadh, 521

Bibliography: Hashim 2007, p. 160 and fig. 5T:40 p. 161.

Flat pottery bowl with convex body and painted decoration. The vessel is made of a medium to fine clay. On the interior a central cross, painted in brown on a white background and filled with geometric motifs, divides the vessel into four sectors. Each of these sectors is enclosed by a further frame, consisting of a series of parallel, oblique lines on one side and two parallel lines filled with triangles on the other. Inside this second frame, a highly stylized bird, quite different from those represented on the Early Iron Age vessels, is represented standing on the rim of the bowl, its head towards the centre. The rim is decorated with a painted band, with a series of very small, oblique lines set immediately below each bird. The shape of this bowl is similar to that of cat. no. 91.          A. I.

**91. Flat, painted bowl**
First half to mid-1st millennium BC
Ceramic
Diam. 14 cm
Tayma, Sana'iye
National Museum, Riyadh, 521

Flat pottery bowl made of a medium to fine clay with painted decoration. The interior of the vessel is divided into four sectors by a central cross painted in brown on a white background and filled with geometric motifs. A painted band decorates the rim of the vessel; four small triangles pointing towards the centre of the bowl have been painted immediately below the rim, at the centre of each sector. The shape of this bowl is similar to that of cat. no. 90.          A. I.

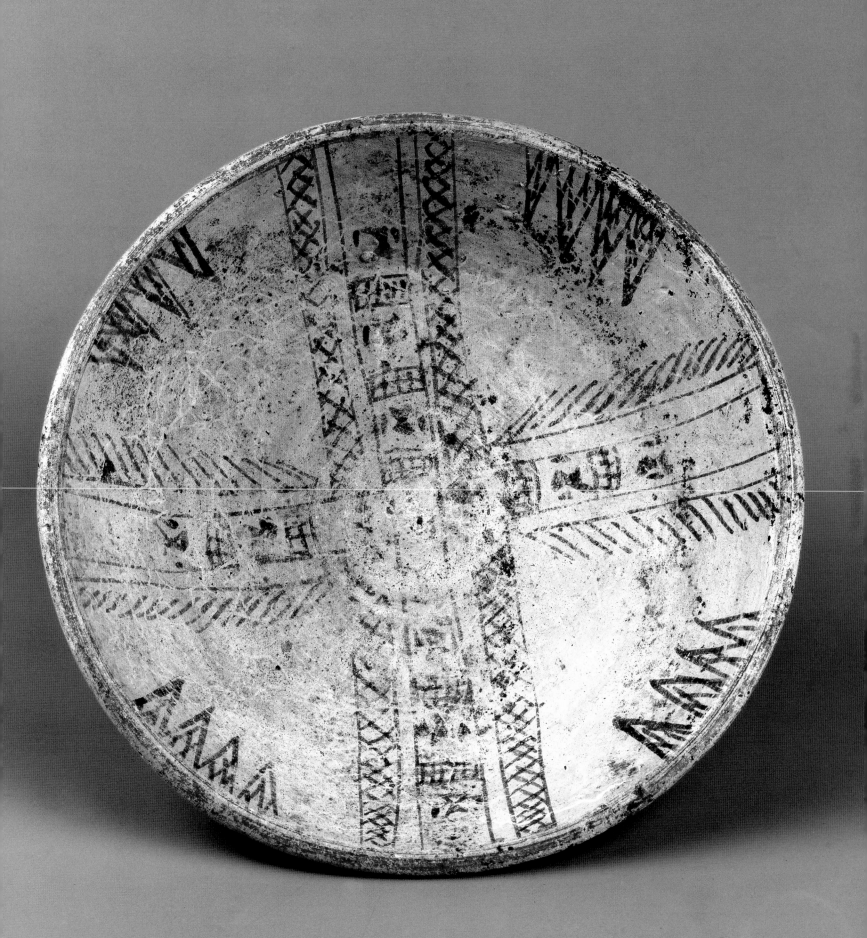

## SLIP-TRAILING POTTERY

Some vessels made of medium to coarse reddish clay and with a polished surface often bear an applied décor made of a calcareous white material, poured in the lines, usually horizontal or wavy, incised on the surface of the pottery. Over this "Barbotine" decoration, small circles 1 to 2 millimetres in diameter were successively stamped at more or less regular intervals. In some cases the thicker extremities of these lines resemble serpent heads. The forms of these slip-trailing pottery vessels are closed forms, bottles or small pots. Just like Sana'iye pottery (or Tayma Painted Ware), slip-trailing pottery was found in the cemeteries of Sana'iye and Tal'a, whereby a dating between the first half and the middle of the 1st millennium BC is possible. Isolated sherds of this type were also found in the graves of Rujum Sa'sa.[1]

**A. H.**

1. Al-Taima'i 2006, p. 131, no.3.

## PLAIN POTTERY

Specialists tended to neglect unpainted ceramic, favouring painted ware. And yet unpainted pottery vessels are attested at Tayma for every period, either the Early or Late Iron Age. After the disappearance of Sana'iye ware (Tayma Painted Ware), that is, probably after the mid-1st millennium BC the tradition of painted pottery was lost and utilitarian pottery of the late 1st millennium BC up to the Pre-Islamic period offers only surface treatments without painted decoration. The décor consists merely of a limited number of incised motifs. In their publication Winnett and Reed[1] already reproduced several of these typical coarsely made, mineral-tempered sherds formerly called "Granite Ware".

**A. H.**

1. Winnett and Reed 1970, pp. 175–76, fig. 85.

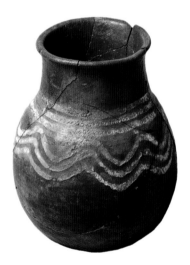

**92. Small jar**
First half to mid-1st millennium BC
Ceramic
H. 19.5 cm; Max. diam. 11.5 cm
Tayma, Sana'iye
National Museum, Riyadh, 533

Small pottery jar with a globular body and wide neck made of a medium to coarse reddish clay. The surface has been burnished and is decorated with white material: three parallel, horizontal bands have been set at the base of the neck, while three wavy ones are located directly below them, on the upper part of the body. Small circles have been impressed on the white lines.

**A. I.**

**93. Small jar**
First half to mid-1st millennium BC
Ceramic
H. 11 cm; Diam. 7 cm
Tayma, Sana'iye
National Museum, Riyadh, 544

Bibliography: Hashim 2007, p. 149 and fig. 5T:26 p. 152.

Small jar, made of a coarse material, with a globular body, flat base and short neck. Its exterior is smoothed, but the vessel is otherwise undecorated.

**A. I.**

# GLAZED POTTERY

Closed forms, made of medium to coarse reddish clay, mineral-tempered and fired at a low temperature have been unearthed in different contexts of the end of the Iron Age during the recent excavations at Tayma. However, their distribution does not allow their dating with assurance. The two bottles displayed here (cat. nos 94 and 95) only share with these vessels the surface treatment. The form of the first has been rightly compared – by S. Rashid[1] who also established parallels with Mesopotamia – to the Iron Age pottery tradition of the Levant. The exact place in Tayma where these bottles were found is not known, so an approximate dating to the 7th century BC can only be established by comparison. They could possibly be imported pieces.                      **A. H.**

1. Al-Rashid 1974.

**94. Jar with red slip**
c. 7th century BC
H. 34.5 cm; Max. diam. 16.5 cm
Ceramic
Tayma
National Museum, Riyadh, 21386

Bibliography: Al-Rashid 1974, pp. 160–62 and pl. 19.3.

Pottery jar with an oval body and long, cylindrical neck. This vessel is covered by a red slip.                      **A. I.**

**95. Jar with red slip**
c. 7th century BC
Ceramic
Tayma
H. 26.5 cm; Max. diam. 15 cm
National Museum, Riyadh, 4791

Pottery jar with a globular body and large neck.            **A. I.**

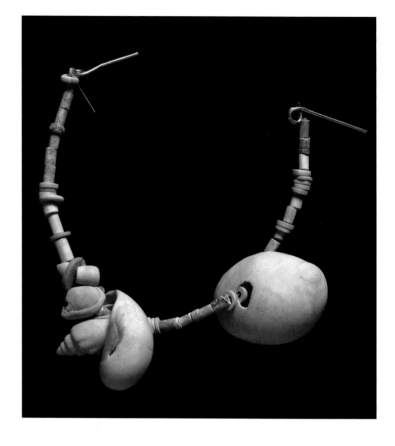

**96. Shell bracelets**
First half to mid-1st millennium BC
Shell
Diam. 6–9 cm
Tayma, Sana'iye
National Museum, Riyadh, 21386

Bibliography: Abu Duruk 1996, p. 21 and pl. 1a and 12a.

The third excavation season at Sana'iye yielded an ensemble of eight identical shell bracelets. Each bracelet was made by cutting a large shell cross-wise, then the inside of the shell was removed and the cut edges carefully smoothed. **A. I.**

**97. Necklace/bracelet 1**
First half to mid-1st millennium BC
Shell, vitreous material and/or stone
Tayma, Sana'iye
National Museum, Riyadh, 1472

Small necklace or bracelet made of beads and pierced shells. The largest elements of this composition are four shells of different types and various sizes. They have all been pierced in order to string them. The rest of the necklace/bracelet consists of small beads, either elongated and cylindrical in shape, or round and flat discs. Cylindrical beads are greenish in colour and are made of vitreous materials or stone, while the round elements are reddish and made of shell. **A. I.**

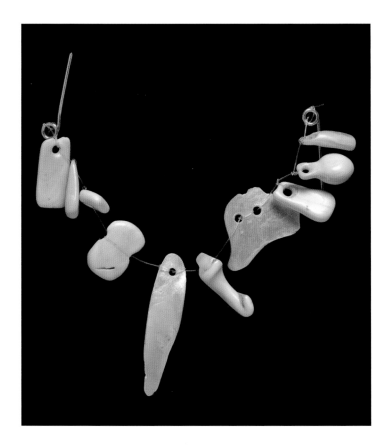

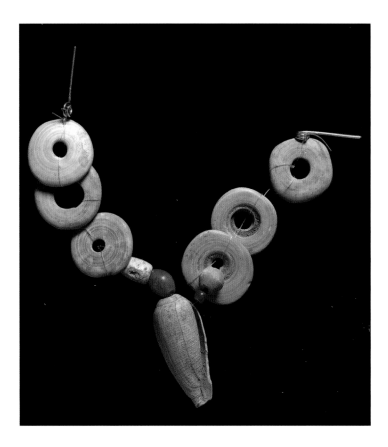

**98. Necklace/bracelet 2**
First half to mid-1st millennium BC
Shell and mother-of-pearl
Tayma, Sana'iye
National Museum, Riyadh, 1514

Bibliography: Abu Duruk 1996, p. 21 and pl. 1a and 12b.

Ten pendants of different shapes, sizes and materials found during the third excavation campaign at Sana'iye. The two largest specimens, in mother-of-pearl, are both very thin but their shapes differ. One is a flat elongated oval, slightly curved, pierced with a suspension hole at one end. The other mother-of-pearl pendant is also flat, but its form is more elaborate: a semicircle with two projecting tips, one of which, near the base, initially longer, is now broken. Two suspension holes are near the rounded edge of the item. Five of the eight shell pendants are rectangular, but one of them is very short and pierced with a suspension hole at one end. Another specimen is a rather uneven, slightly curved cylinder, bearing a suspension hole at one extremity. One shell pendant is a small oval with a rectangle attached with a loop hole and another is shaped like an eight with a central suspension hole at the joining of the two small juxtaposed circles forming the object. **A. I.**

**99. Necklace/bracelet 3**
First half to mid-1st millennium BC
Shell, cornelian and vitreous material or stone
Tayma, Sana'iye
National Museum, Riyadh, 1508

Bibliography: Abu Duruk 1996, p. 21 and pl. 1a and 13b.

Small necklace or bracelet made of beads of various materials and shapes and a single, pierced shell. The six largest beads are flat discs with a central passing hole created by cutting the apex of large, conical shells. The original, inner structure of the shell is still partially visible on one of the sides. Of the other beads, two are made of red cornelian, one biconical, the other a small sphere, while the other two are of greenish vitreous material or stone and rather irregular in shape. A rather large shell takes up the centre of the composition, one small passing hole pierced near one extremity. **A. I.**

## STONE

**100. Stele of Nabonidus, king of Babylon**
Mid-6th century BC (reign of Nabonidus, king of Babylon)
Sandstone
51 x 59 x 10–12 cm
Tayma, Saudi–German archaeological mission, Yard E,
debris east of Temple E-b1
Saudi–German archaeological mission, Tayma Museum, TA 488
Bibliography: al-Taima'i 2006, p. 87; Eichmann-Schaudig-Hausleiter 2006;
Hausleiter 2008a-b.

Only the top part of this arched stele is preserved. Originally probably 1.4 metres high, its base was doubtless fixed to a pedestal by a tenon. The obverse displays a royal figure facing symbols of deities and a text in cuneiform script which probably covered the entire surface. The inscription is within a slightly raised panel and continues above the figured representation, which is rather unusual for this type of stele.

The king, turned to the right, faces divine symbols in keeping with a manner of representing rulers introduced in the Assyrian period. He wears a long robe and a tiara; only the hair line and beginning of the beard are visible. The long sceptre he holds is largely erased. The astral symbols of the moon (disc and crescent), the sun (winged sun) and the star represent the Mesopotamian (Babylonian) gods Sin (moon-god), Shamas (sun-god) and Ishtar (goddess of love and war). The cuneiform text is written in the usual Neo-Babylonian cuneiform characters. It is the typical Babylonian dedication in one part describing the decoration of temples with precious materials, such as a gold incense burner. The deities cited relate to Babylon where the "seat of Marduk and zarpanitu" is located in the Esagil temple complex. The gods Nabu, Tashmetu and Nanaia are also named. At the present time this text is unique, but it presents stylistic similarities with the stele of Nabonidus also called the Babylon Stele (London, British Museum).

Although the king's name is not preserved, the form, iconography and inscription of this stele allow to unquestionably attribute it to the king of Babylon Nabonidus (556–39 BC). He set up his residence at Tayma during a ten-year reign, against a background of

**101. Disc-shaped object with an inscription of King Nabonidus**
Mid-6th century BC (reign of Nabonidus, king of Babylon)
Sandstone
40 x 16 x 7.5 cm; Diam. reconstituted: c. 80 cm
Tayma, Saudi–German archaeological mission, Yard E, debris south of Temple E-b1
Saudi–German archaeological mission, Tayma Museum, TA 9208 and TA 3656
(right)

Bibliography: Schaudig 2001, p. 535 Text 3.6 Uruk Stela (with bibliography).

These two fragments bearing the remains of a text in cuneiform belong to an object originally disc-shaped. A series of small notches on the upper part may have held a metal facing. The text on the rim is written in a non-archaizing Neo-Babylonian cuneiform script and means "image/Stele of Nabonidus, king of Babylon, mighty king . . .". It is the first attestation in Babylonian cuneiform of the name of the Babylonian ruler at Tayma (for the names of the king in the local idiom, see cat. no. 100). The text was likely drawn before being incised, suggested by traces of the drawing on the character *lugal* (king). This supplies interesting data on the making of a monumental inscription of this type.

The mention of the "image/stele" concept gives an idea of the possible role of this item. The hole pierced in the centre of this disc may have held the tenon of the king's stele (cat. no. 100) forming its base. A stele of King Nabonidus from Uruk/Warka in Iraq shows us what an integrally preserved stele would look like. Measuring 80 centimetres in diameter, the disc is slightly wider than the stele (approximately 60 centimetres), which would leave a 10-centimetre space on each side. A stone of a similar form may have been placed under the disc to firmly anchor the tenon.

**A. H./H. S.**

political-religious conflicts with the clergy of Marduk provoked by his intention to profit by the caravan trade in Arabia. Moreover this attribution allows the reconstitution of the rest of the text which probably relates the sovereigns' undertakings in Babylonia, Syria-Cilicia, Northern Arabia and Tayma, as well as in the temple of Ehulhul at Harran. When it was discovered in 2004 this text was the first in Babylonian cuneiform script to be unearthed at Tayma. Since then four other fragments of cuneiform texts were found on other supports (cat. no. 101). The name "Nabonidus, king of Babylonia" also appears in several Taymanite-Thamudean rock inscriptions in the vicinity of Tayma. But unlike the presentation of the Babylonian sovereign by himself, the latter attest to the reception of his presence in the local idiom, thereby expressing social distinctions. Originally this stele was probably in the centre of the city of Tayma, in a building older than the temple which dates to the Late Iron Age (4th–2nd century BC). The following item (cat. no. 101) could be a fragment of the base of the stele.

**A. H./H. S.**

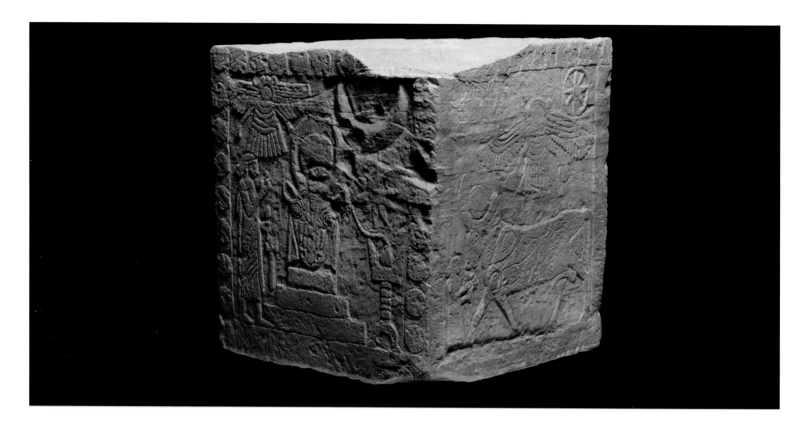

**102. Pedestal/altar with ritual scenes ("al-Hamra cube")**
5th–4th century BC
Sandstone
38 x 39 x 41 cm
Tayma, Qasr al-Hamra, Room 1
National Museum, Riyadh, 1021

Bibliography: Bawden *et al.* 1980, pp. 83–84; Abu Duruk 1986, pp. 57–61 and pl. 50.; Dalley 1986, pp. 86–88.

Sandstone cube with two adjacent sides decorated with religious scenes carved in low relief. The upper edge where these sides meet is now lost, but the carved faces are well preserved, with only some minor flaws. The centre of the left side is occupied by the representation of a bull's head set on a stepped altar or platform. The bull's head is seen *en face*, with a solar disc between its horns. A priest dressed in a long tunic stands to its left, while a piece of furniture occupies the other side. Three astral symbols fill the rest of the space: an elaborated, winged solar disc is located above the priest, to the left of the bull's head, while a moon crescent and a ten-pointed star have been carved to its right, above the furniture. Small discs decorate the upper and lateral sides of the risen frame which surrounds this scene. A similar frame surrounds the second scene, but in this case only its upper side has been decorated with a series of stylized flowers and buds. Inside this frame, a standing bull is represented facing left, in front of a human figure who holds an offering towards its mouth. The bull also has a solar disc between its horns. A large winged disc

is located above its back, while an eight-pointed star has been carved in the upper right corner of the scene. In the upper left corner there is the representation of a scorpion. The al-Hamra cube has been interpreted as symbol for syncretistic religious tendencies at Tayma although the use of symbols from different parts of the (Near Eastern) world during the 1st millennium BC is not uncommon. The representations on both sides of the cube centre around the bull with a sun-disc thus most resembling the Egyptian Apis bull. The occurrence of bull representations with sun-disc at Qasr al-Hamra (contrary to representations of bulls without sun-discs at the temple building of Qraya) has to be noted. Although the god Valm has been associated with the winged (sun)-disc by Dalley[1] the frequent occurrence of inscriptions mentioning Valm (VLM) together with representations of the bull should be stressed and may be connected to one or more "aspects" (R/DB, HGM) of this god.[2] The rendering of the uncarved edges of the cube resembles a relief with the representation of a human figure in front of a bull from the temple E-b1 in the central part of Tayma (Qraya) and a fragmentary relief from Tayma with a more complex scene – presently in the Louvre.[3]

A. H./A. I.

1. Dalley 1986.
2. Hausleiter, forthcoming.
3. See Briquel and Chatonnet-Robin 1997.

**103. al-Hamra stele**
c. 4th century BC
Sandstone
45 x 16 x 102 cm
Tayma, Qasr al-Hamra, Room 1
National Museum, Riyadh, 1020

Bibliography: Livingstone *et al.* 1983, pp. 108–11 and 113 and pl. 96; Aggoula 1985, pp. 66–68; Abu Duruk 1986, pp. 61–66 and pl. 50; Cross 1986; Beyer–Livingstone 1987, pp. 286–88; Knauf 1990, pp. 210–11; Kottsieper 2001, pp. 187–89; Schwiderski 2004, p. 412.

Rectangular sandstone stele, lower part now lost. On the upper side two steps leave a central, risen rectangle. One of its larger sides bears an Aramaic inscription in relief, set below several astral and religious symbols, also rendered in relief. The symbols were originally in three rows, but those belonging to the lower one as well as those which occupy the left of the decorated face are badly damaged. An elaborate winged sun and an Udjat-eye are still visible above an eight-pointed star and a moon crescent in the upper right half of the face. According to G. Sperveslage, on the lower row there was a standing bull facing the left where remains of an incense burner are still visible, similar to those depicted on the al-Hamra cube (cat. no. 102). Below these symbols, ten lines of Aramaic text are still preserved, most of them incomplete. Like the lower part of the stele, the end of the inscription is also lost. Lacunae and several dubious readings notwithstanding, it is however clear that the text is a votive inscription composed on the occasion of some offerings and dedications made by an individual named PVGW SHRW to the god Valm (here VLM R/DB) (Kottsieper 2001), the chief deity of Tayma. As on the Tayma-Stone (Musée du Louvre, AO 1505), the goddesses Shingalla (SNGL) and Asima ('SM) are also mentioned; both are of Syrian origin. The name of the dedicant has a connection to the royal sphere of the dynasty of Lihyan which is also evident by the element Shahru (SHRW) in his name. The latter occurs also in a king's name on a pedestal from the temple building E-b1 at Qraya (see p. 234). Some Thamudic signs have been carved at a later stage on one edge of the stele.                                                                    **A. H./A. I.**

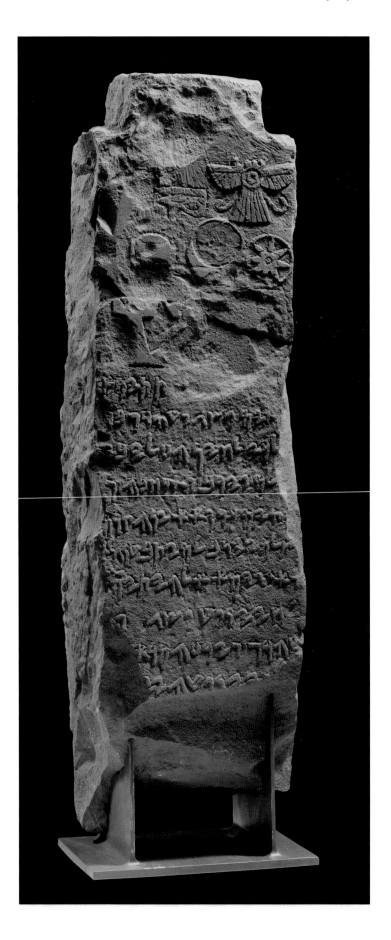

**104. Stone table or altar**
5th–4th century BC
Sandstone
40 x 30 x 18 cm
Tayma, Qasr al-Hamra, Room 1
Tayma Museum, T/M/115

Bibliography: Abu Duruk 1986, p. 56.

A rectangular reddish sandstone table with four thick legs. Albeit eroded, the upper part of the object shows traces of different levels. On the longer sides the feet are connected. The item probably was used as a table, an altar or a base, perhaps in a ritual context.

A. H./A. I.

**105. Funerary stele with the schematic representation of a human face and an Aramaic inscription ("eye-stele")**
5th–4th centuries BC
Sandstone
26 x 15 x 72 cm
Tayma, stray find
Tayma Museum, T/M/119

Bibliography: Livingstone *et al.* 1983, p. 107 and pl. 94c; Beyer–Livingstone 1987, p. 289; Schwiderski 2004, p. 413.

A rectangular stele adorned with a stylized face and an Aramaic inscription on one of the long sides. The face is treated in low relief within a shallow square panel above the inscription. It consists of a highly stylized nose represented by a vertical rectangle from which two thinner, slightly curved lines featuring the eyebrows rise. Under these lines two ovals represent the eyes; two lines incised inside each oval separate the eyelid from the interior of the eye. Below this face an Aramaic inscription is engraved on two lines: "In memory of Taym, son of Zayd". We know of many stelae of this type from Tayma. Up to now only two were found during the methodical archaeological excavations in graves where they had been used as lid slabs. These graves can be dated to the 3rd or 2nd century BC when the Lihyanite dynasty appears to have exerted a certain influence on Tayma. Named "Eye stelae", presently these stelae are the only evidence of cultural contacts between Tayma, Northwest Arabia and the south of the Arabian Peninsula where tombs of this type are very common.

A. H./A. I.

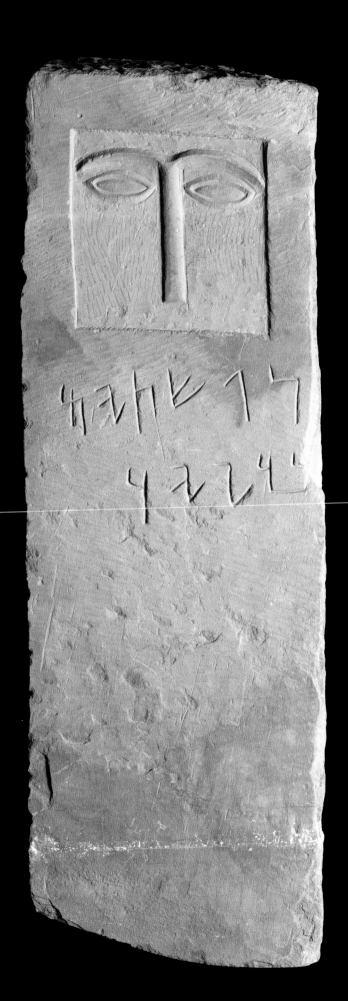

**106. Head of a royal statue of the Lihyanite dynasty**
4th–2nd century BC
Sandstone (restored)
47 x 40 x 51 cm
Tayma, Saudi–German archaeological mission, Yard E, deposit of the ancient Temple E-b1
Saudi–German archaeological mission, Tayma Museum, TA 489

Bibliography: *DAI* 2005, 148, ill. 13; Hausleiter 2006, p. 179, fig. 9; Eichmann, Hausleiter, al-Najem and al-Said, forthcoming.

This head of a bearded man belongs to a huge statue carved from a single block about 4 metres high. The eyebrows, eyes, nose and mouth, powerful and realistic, are extremely expressive, as are the ears and hairstyle held by a band. The eyeballs have kept the trace of the modelling of the pupils. As the preserved fragments indicate, the statues were dressed in a loincloth wound about the waist, with a slanted trimming and without folds, ending above the knee and held by a double belt with a hanging tie. The over-garment had short sleeves. Arms, forearms and fingers were enhanced with carved bracelets and rings. As evidenced by the traces of paint on a fragment of a belt found at Tayma (cat. no. 107), these statues were entirely or partly painted. The smooth aspect of several fragments of the lower part of the body show they were backed up to the wall and therefore invisible on this side.

Comparison with sculptures from al-Khuraybah/Dedan in the present-day oasis of al-Ula (cat. nos 112 and 113) allows identification this head as the royal representation of a member of the Lihyanite dynasty, one of the al-Khuraybah statues bearing the inscription "king of Lihyan". This type of statue was first discovered by Jaussen and Savignac at al-Khuraybah (statues A and B); since then other statues, usually raised near the temple, have been unearthed there (also in at Umm Daraj) during the King Saud University excavations. Similarly at Tayma statues of this type were probably in the vicinity of Temple E-b1 at Qrara, the centre of the site. However they should not be directly linked with the above-mentioned Lihyanite kings (TLMY, 'Ulaym Shahru) who left their inscriptions here. At the end of the Lihyanite dynasty these statues and these inscriptions were destroyed or taken apart, probably in Late Antiquity. The head was doubtless intentionally deposited in the temple when it lost its role. The lower portion of these statues was re-utilized as building material. Most of the hands and fragments of arms and legs of statues were also discovered in the same room of the former temple.

In addition to realistic representations of the body and face, there were also schematic representations as attested by another fragment from Tayma which should be compared to one from al-Khurayah/Dedan (cat. no. 113). No South Arabian style head statue have yet been found in Tayma. However, another fragment of statue was discovered there in which the hands present similarities with the royal statues of the Lihyanite dynasty; although its garment, featuring very marked folds distinguish it from the smooth garb of the other statues.

While there are several similarities with heads of Egyptian statues of the late period as well as with classical statues, the execution of these pieces from Northwest Arabia differs in the details. Compared to the latter, even the heads from Tayma and al-Ula believed to have been modelled appear rather sketchily executed. So we can assume that they are loans from a wide language of forms, locally borrowed in an independent manner. Albeit smaller, a head from Amrit, in Syria, in fact features a comparable treatment of the ears and hairstyle.[1] In addition to these colossal statues, smaller versions of these figures, not over 40 centimetres high, are known at Tayma.          **A. H.**

1. Lembke 2004, pl. 18d, no. 145

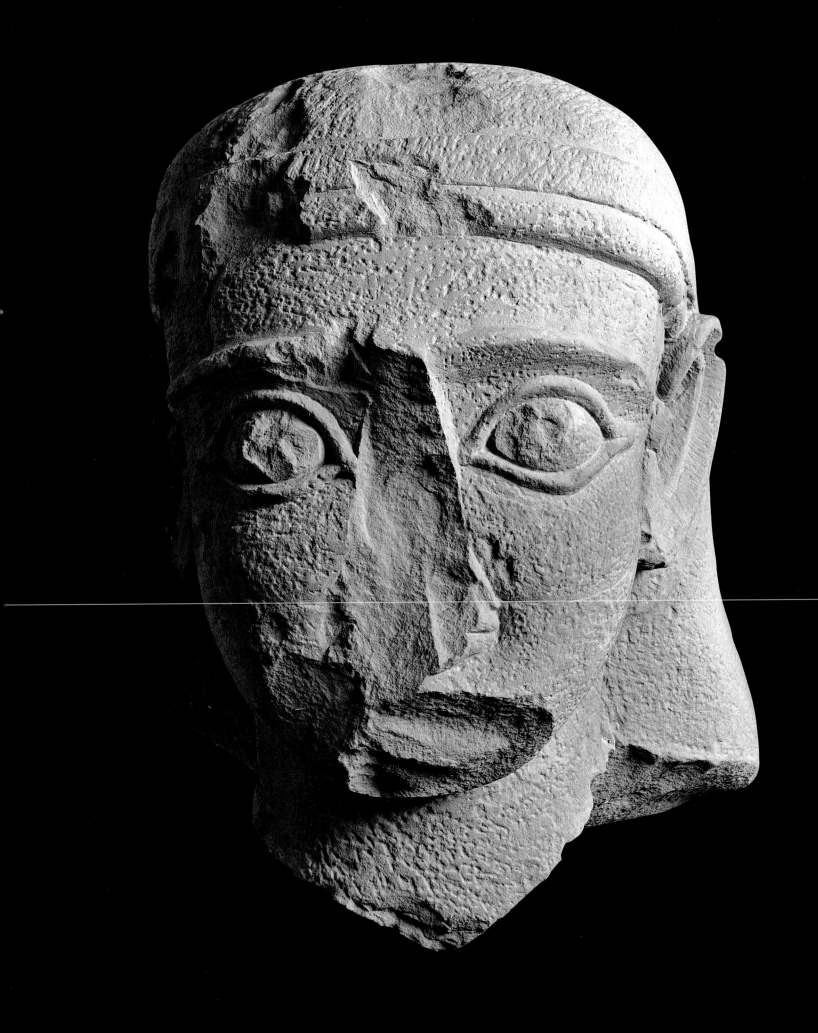

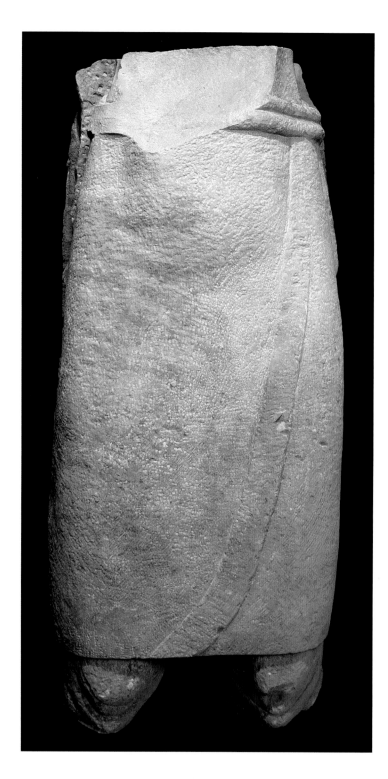

This fragment of a royal statue belongs to the same typology as the head presented previously (cat. no. 106). The figure wears a simple twisted loincloth ending above the knee. The garment was held by a double belt; the part hanging on the right side bears traces of red colour. The smooth back of the statue shows that originally the figures were backed up to vertical constructions, walls or pillars. An identical fragment was identified at Tayma in 1968,[1] preserved today in the local museum. A recently discovered fragment of a statue of the same size has no precedent at the present time. It wears a pleated robe, proving the presence of different types of human representations at Tayma under the Lihyanite dynasty of Dedan. **A. H.**

1. Altheim, F., Stiehl, R. 1973, p. 251 and fig. 11.

**108. Basin with Nabataean inscription**
c. 1st century BC
Sandstone
31.5 x 54 x 15.5 cm
Tayma, stray find
Tayma Museum, T/M/115

Bibliography: Livingstone *et al.* 1983, pp. 105–06 and pl. 93b; Aggoula 1985, pp. 65–66; Beyer–Livingstone 1987, 290–92.

This basin has been carved from a block of greenish sandstone. The central depression is 10 centimetres deep, the walls 2.25 centimetres thick; traces of tools are still visible on every surface. Since the basin is a stray find, its original function remains unclear, but the Nabataean inscription carved on one of its sides states that it was dedicated to the goddess Manwah by an individual named Ahab. The text is arranged in two and a half lines with words written continuously, without separators. The inscription reads: "Enclosure (= basin?) which Ahab . . . dedicated to Manwah, the goddess of goddesses, for the life of his soul and the souls of his posterity . . .". **A. I.**

**107. Fragment of a statue**
4th–2nd century BC
Sandstone
120 x 57 x 46 cm
Tayma, Saudi–German archaeological mission, Yard E, re-utilized in a Late Antiquity wall of the ancient Temple E-b1
Tayma Museum, TA 200

Bibliography: Eichmann, Hausleiter, al-Najem, al-Said 2006, pp. 110–11, pl. 9.14b and 9.15.

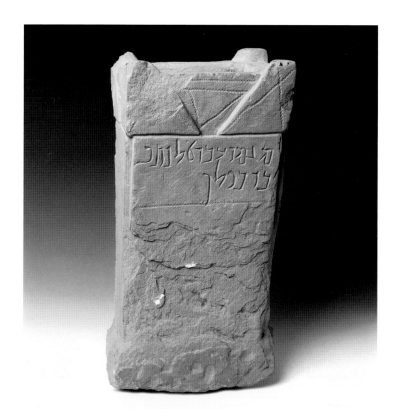

**109. Incense burner with Nabataean inscription**
1st century BC
Sandstone
20 x 13 x 44 cm
Tayma, stray find
Tayma Museum, 3415

Bibliography: Livingstone *et al.* 1983, pp. 111–12 and pl. 97a;
Beyer–Livingstone 1987, p. 292.

Almost integral incense burner despite the loss of several portions of the original surface due to the sandstone's crumbling. The item is rectangular, with a slightly wider base which is one of the most damaged parts. The body of the incense burner is relatively straight but the upper part is wider. The top of the object features on the edges two projecting triangles beside a hollow central area shaped like an upside-down triangle. The summit of each rising triangle is higher than the top of the incense burner which is decorated with several incised lines. A Nabataean inscription is engraved on one of the larger sides, directly below the two projecting triangles adorning the top. The text, laid out on two lines, says: "Tomb of Abdel-Katab, son of Bolan". By its overall structure, this item is very similar to several Tayma incense burners with the top engraved in low relief rather than sculpted like other incense burners (cat. no. 110).

A. I.

**110. Incense burner**
Nabataean period (1st century BC–1st century AD)
H. 40 cm; Diam. 15.5 cm
Sandstone
Tayma, domestic quarter south of the temple, burnt ruins of a room
Saudi–German Expedition, TA 3415

Bibliography: Hausleiter 2006, p. 166 and fig. 12 (inscribed exemplar); *DAI* 2007, p. 312 and abb. 9 (three better preserved examples).

Four identical incense burners, one bearing a Nabataean inscription, were unearthed in the debris of a room of the post-Nabataean period (mid or late 2nd century). Cylinder-shaped, they consist of a base, a body and an upper part. The base is separated from the body by two incised lines. Rather tall, it is formed of two distinct sections, separated by two incised lines. The foot of the incense burner is connected by the tapering upper section to the body of the object, narrower than the foot. The body is a straight cylinder enhanced in the middle with a decorated band.

This décor, framed by two parallel horizontal lines, consists of small plain rectangles separated by series of parallel vertical lines. The incense burner's form seems to reproduce the architectural features of a column (its overall form) and an architrave (the decorative motif in the centre). The top of this item is square with a flat centre surmounted by four summits. Incised lines enhance this upper part, distinguishing it from the body of the object.

A. I.

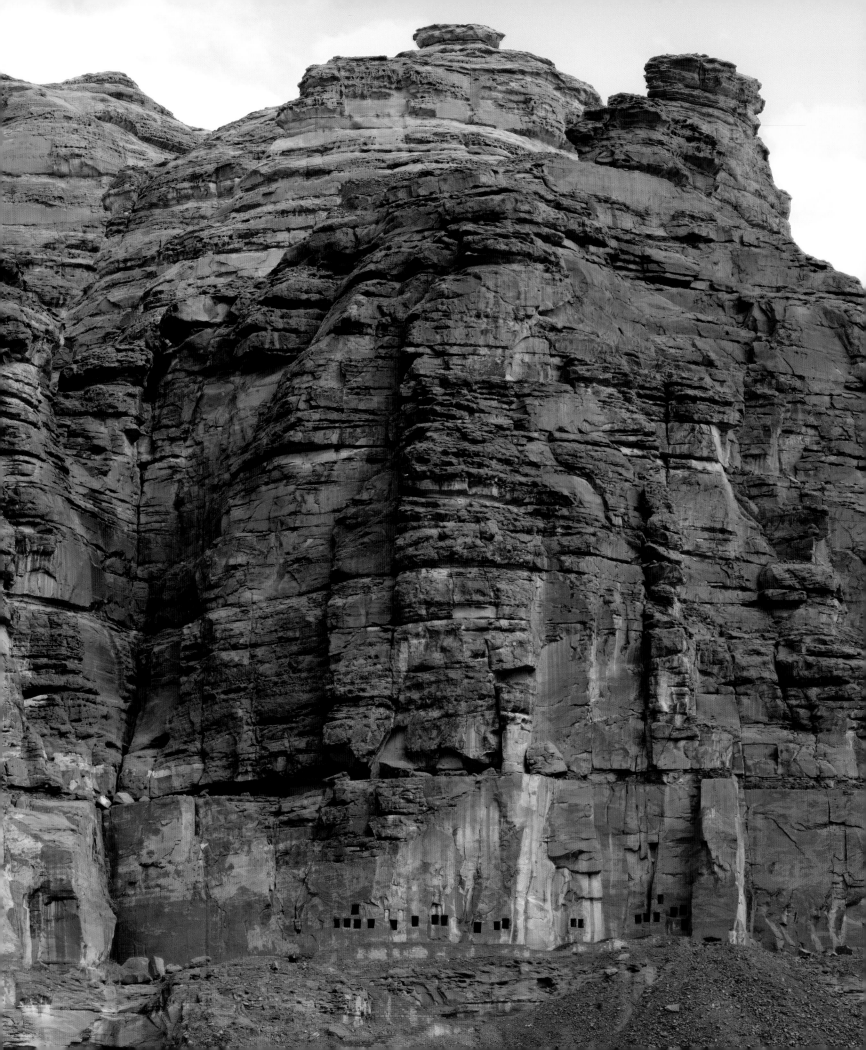

# DEDAN

## (AL-ULA)

*Said F. Al-Said*

Dedan, in the north-west of the kingdom of Saudi Arabia,[1] is set in the middle of a wide valley surrounded by mountains to the east and the west. Arabian geographers called it Wadi al-Qura.

The first Arabian sources mention the presence in the region of fertile soils and abundant water, two crucial elements for attracting people to the oasis. In time the importance of the city grew, Dedan being one of the stages along the old trade road (the incense road) adopted by the caravans carrying wares from the far south of Arabia to the north of the peninsula and the countries of the Mediterranean Basin.

The site of Dedan is known by written historical sources: the inscriptions discovered at Tayma dated to the 7th–early 6th centuries BC are the oldest. Apparently a war broke out between Tayma and Dedan at that time. The second indication is provided by the inscription of the Harran stela, from the mid-6th century BC, on which Nabonidus, king of Babylon, mentions the king of Dedan. Between c. 553 and 543 BC Dedan was under the influence of Nabonidus.

In the Old Testament, in several books of Pentateuch, we find a third mention of Dedan (the place and the tribe). In Genesis there are indications on the origin of the Dedanites: sometimes they are Semites descendants of Abraham and sometimes Hams descendants of Cush, but they are always designated as belonging to a well-organized state which plays a role in the political and economic life in the East. The Book of Ezekiel mentions that they were active in transporting and selling merchandise in the Mediterranean regions. In the same book they are associated with the Sabaeans who, according to the sources, in the first half of the 1st millennium BC transported wares from their territories in the southern Arabian Peninsula towards different regions of the ancient world.

The South Arabian inscriptions are some of the most important ones regarding the Dedanites. Several passages of these inscriptions refer to Dedan and its inhabitants. In this way the texts incised on the stone stelae erected on the square of the temple of Rasafem, at

Rock-cut tombs, Jabal Dedan (al-Ula), photograph by Humberto da Silveira

1. By 26° 36' 29" latitude north and 37° 55' 58" longitude east.

263

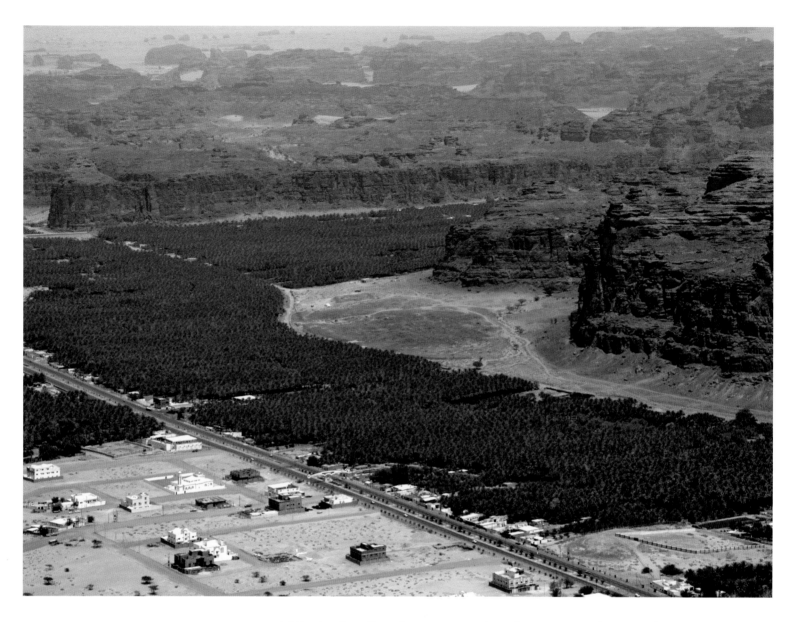

The historic site of Dedan

Ma'in (ancient Qarna), mention Dedan, the country and its people. These inscriptions record marriages between a group of individuals belonging to the tribes of Ma'in and Dedanite women. These texts are a part of long lists which record the alliances by marriage between men of the Ma'in tribe, in the Yemeni Jawf, and foreigners belonging to various populations of Eastern countries. This proves that Dedan was an independent entity bound by marriages to tribes and kingdoms of the southern Arabian Peninsula.

On the other hand the Arabian sources merely name the place. Yaqut, for example, says: "Dedan, on the road of Balqa, near Hijaz, was a beautiful city in ruins". Ibn Shuja refers to Dedan as a large valley located south of al-Ula.

The sources therefore clearly indicate the existence of an Arabian kingdom called "kingdom of Dedan", located at Dedan, and of its population, outstanding for a remarkable political and social organization which enabled it to establish relations with the nations and peoples within and outside the Arabian Peninsula. Hence the effective role it played in the economy of the region, contributing with other tribes in dispatching merchandise towards the markets of the ancient East.

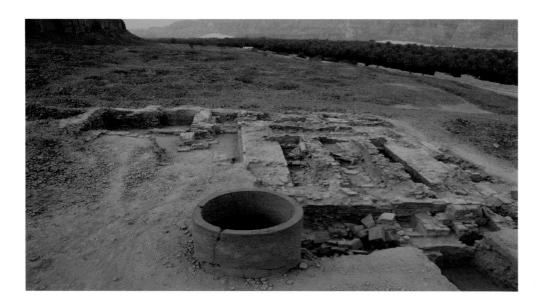

The basin of Dedan

These historical facts have aroused the interest of Western and Arab scholars and travellers since the mid-19th century. Visits on the site and surveys were carried out; however most of the vestiges in Dedan have not yet been the object of scientific studies. The ruins of the antique city, save the well-known basin, have not been systematically excavated. Nonetheless King Saud University and the Department of Antiquities sought to acquire further knowledge of the historical and cultural background of the site where scientific excavations, supervised by the Historic Monuments Department of the University, started in 2004. Fieldwork was carried out during five successive campaigns, leading to the discovery of vestiges spread over a large area (300 metres long by 200 metres wide) in the centre of which stood a temple.

The historical importance of the site goes back to the early 2nd millennium BC,[2] despite the fact that we have no information about the political history of this period nor of the early 1st millennium BC. It probably coincided with the existence of the very active kingdom of Dedan which played a vital cultural and commercial role in the north-west region of the Arabian Peninsula.

The kingdom's influence spread to many neighbouring regions, including al-Hajar (Mada'in Saleh) some 22 kilometres north of al-Ula. But the growing importance of the Lihyanite tribes in the late 6th century BC contributed to the decline of the historical role of the kingdom of Dedan and to its population's submission to the new power. Pliny, who lived in the 1st century BC, reports that the Gulf of Aqaba was called "Gulf of Lihyan", unquestionable proof of the Lihyanites' influence which extended, southwards, to the antique Yathrib. Similarly a stone stela found in Tayma bearing the name of a Lihyanite king (Talmi) testifies that in the 3rd century BC their power was exerted all the way to Tayma. The population of Dedan included, in particular, tribes from Ma'in who inhabited the region under the Dedanite and then the Lihyanite rule. Subsequently they formed a community of active and powerful tradesmen at the Lihyanite court.

The Lihyanites governed Dedan for approximately five centuries, up to the 1st century AD, as indicated by several royal architectural vestiges which attest to the sudden abandon of the site after the decline of the kingdom of Lihyan in the early part of the 1st century AD, which apparently coincided with a violent earthquake causing the collapse of buildings.

2. In keeping with the results of the scientific discoveries produced by the excavations by King Saud University (see below the passage relative to pottery).

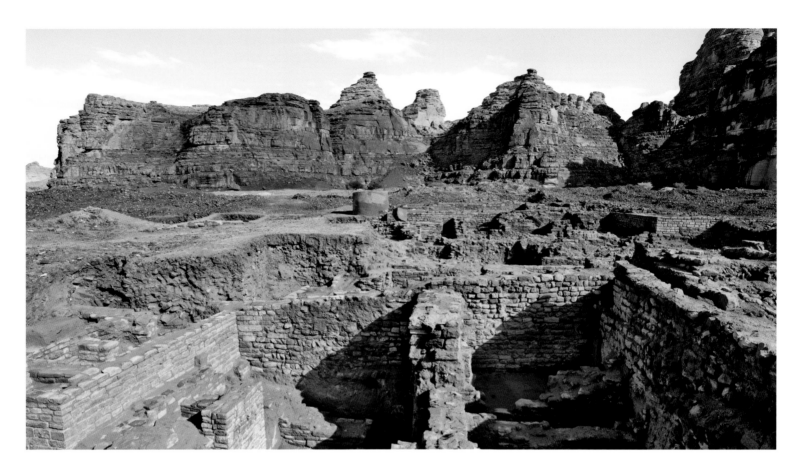

The religious centre of Dedan

Fragment of a perfume burner or an altar
in its archaeological context (see cat. no. 117)

3. Traditionally known under the name *mahlab al-naqa*, "female-camels' milking place" and, locally, *al-halawiyya*.

## Architectural remains of Dedan

Before the excavations carried out by King Saud University began, the vast basin at the centre of the site ruins was certainly the major vestige.[3] Cut in the rock it forms a perfect circle, 3.75 metres in diameter, almost 2.15 metres deep, with a capacity of 6,000 gallons, that is almost 27,000 litres. Inside, three steps carved in the rock make it easier to descend. Its perfectly cylindrical form makes it an admirable architectural work in which symmetry vies with harmony. This basin was doubtless used for ritual ablutions linked to the principal temple of Dedan, probably consecrated to the Lihyanite deity dhu Ghabat.

In addition to the foundations and house walls of the Dedan site ruins – foundations and walls of houses – on Jabal Umm Daraj at the south entrance to Wadi Saq north-west of Dedan, across from Jabal Dedan (al-Khurayba), were discovered the remains of three religious architectural structures, built with the local red sandstone and consolidated with sun-dried mud. One of these constructions was approximately 15 metres long by 11 metres wide. Two circular reservoirs as well as niches for holding statuettes were carved in the rock and coated with plaster. The first five excavation campaigns led to the discovery of the architectural remains of the principal religious centre of Dedan under the Lihyanite rule, built of sandstone brought from the nearby mountain. This centre, with numerous annexes, features a basin and terraces.

The large rectangular temple is 16 metres long and 13.2 metres wide. On its north side, a terrace supported by four rectangular stone pillars leads into the centre of the sanctuary. There, statues of certain kings of Lihyan were probably displayed, enabling the monarchs to be part of the religious ceremonies and ritual offerings. Another central stone terrace, 3 metres long and 1.5 metres wide, was also linked to the temple on its north-west side.

It is likely that this was another place where statues were exhibited. An exceptional series of such statues, as high as 4 metres, was discovered lying on the terrace or nearby. Their stone-pedestals have also been found.

On the north side, a large courtyard is connected with the temple and includes the famous above-mentioned basin as well as a certain number of stone terraces where apparently the ceremonies were held and the faithful pronounced vows.

To the east, south and west, a series of chapels separated by corridors surrounds the temple; the discovery of fragments of statues, tables and cultic items leads to suppose that they contained the statues of some secondary deities and of several kings of Lihyan. Amidst the ruins of the religious centre the excavations brought to light remains of cylindrical shafts on which are carved mouflons, this animal representing a deity in Pre-Islamic times. A fragment of a fluted column, a piece of a capital and other polished stones adorned with a wavy serpent were discovered as well. There is no doubt that the presence of the serpent in the decoration of the walls and stones attests the importance of this symbol in the Dedanites' culture. It may also be the emblem of one of their deities.

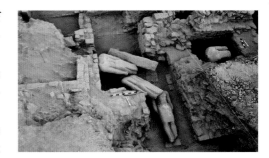

Dedan statues in its excavation context
(see cat. nos 111, 112 and 113)

## The art of sculpture in Dedan

Remains of several Lihyanite statues and other vestiges were found on the Umm Daraj mountain. This allows to assume the existence of a sculpture workshop going back to the period when the Lihyanite ruled over the region, from the late 6th century up to the early 1st century BC. Jaussen and Savignac discovered near the large basin two life-size stone statues of men, typical of the art of Lihyanite sculpture. This sculpture reflects influences, even indirect, of ancient Egypt, according to some scholars. It is well known that 7th- and 6th-century BC Greek statuary reintroduced the traditions and styles of ancient Egypt: full-length statues, hieratic, with grave expressions and arms tensed along each side of the body, closed fists, left foot forward, wearing a loincloth. This style subsequently spread to Syria and other regions under the influence of Greek art, and beyond, to the north of the Arabian Peninsula.

The style of the two Lihyanite statues, studied by the scholars H. al-Mazroo and A. Nasif, conforms to the norms of this school; but they identified "the style of a local school" characterized by the outline of the silhouette and details such as the rectangular form of the loincloth. A third statue reveals more accentuated local details, whether it be the form of the loincloth or the presence of a Lihyanite inscription. Jaussen and Savignac had previously discovered another almost complete statue on the site of Dedan, presenting most of the details already mentioned with variants in the features of the face, notably the eyes and eyebrows inspired by Mesopotamian art. This confirms the role of the al-Ula region as a crossroads of civilizations of the ancient East. These different statues are preserved in the Riyadh National Museum or the Museum of Popular Arts and Traditions in al-Ula. Another collection of Lihyanite statues was transferred to Istanbul and Damascus at the time of the project to create the Hijaz railroad. The excavations of the King Saud University Archaeological Department during the first five campaigns largely contributed to our knowledge of Lihyanite sculpture, both of the manner or places for raising the statues and of their style. This ensemble of discoveries and observations relative to the statuary and architectural elements of the temple is the result of the first five excavation campaigns of this university. Highly important feature of the statues include the short loincloth, lateral drapery, musculature and details of the bracelets, or other distinctive details such as the veil

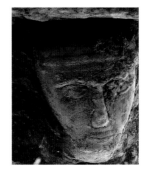

Head of a Lihyanite statue
(see cat. no. 114)

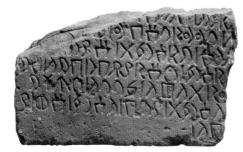

Lihyanite inscription found in al-Ula

and the cord holding it, the dagger (*janbiyya*) slipped in the belt of the loincloth. Several of these statues are of the sovereigns of Lihyan, as the inscription on the base of one of them shows, but others represent local deities, the principal one being dhu Ghabat.

These details of a local character prove that there was a sculpture school in the north-west of the Arabian Peninsula. A statue comparable by the loincloth and the dagger and another one wearing an ornamented veil held by a band were both found by the Saudi–German mission at Tayma during their second and third excavation campaigns.

## Dedan script and ancient Arabic script

Various inscriptions incised in stone were found in almost a hundred places in the province of al-Ula: Thamudic, Dedanite, Lihyanite, Ma'inic, Nabataean inscriptions. Jabal Ikma, located 3 kilometres north-west of al-Ula, is where the Lihyanite inscriptions were the most plentiful: 196 texts, published by Abu al-Hasan, relate to the economic and religious life of Lihyan and provide numerous indications on its geographic frontiers but also on what is commonly called the yearly "tithe" owed by the faithful of dhu Ghabat. Moreover these inscriptions prove the existence of rituals performed on the occasion of pilgrimages, with details relative to cultic practices. During the recent King Saud University excavation on the site of Dedan, the many inscriptions discovered, which date to the period between the 6th and the 2nd centuries BC, reveal different aspects of the cultural history of the last period of the Dedanite kingdom and the rule of the Lihyanite kingdom. They equally attest the existence of a Dedanite script, unique among the other ancient Arabic scripts, and of an important ensemble of royal inscriptions in the name of the Dedanite sovereign (Asi) dated to the 6th century BC, as well as votive inscriptions dedicated to the deities of the temple of Dedan. Other texts record laws in force at Dedan. Generally speaking their detailed study will demonstrate the cultural importance of ancient Dedan during the first half of the 1st millennium B.C.

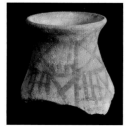

Pottery fragment    Fragment of a ribbed column

## The tombs of Jabal Dedan (al-Ula)

Jabal Dedan, which overlooks the site on the east, features an important ensemble of sculptures. Most of them, cut at different heights out of the side of the mountain, are cavities about 2 metres deep. They are approximately dated to the 5th century BC, the period of the Lihyanite rule over the region. Only two of them are decorated with two carved lions probably allowing the identification of their owners, governors or personalities. An inscription on one of these two tombs indicates that it belonged to a member of the Minean community in Dedan. The other goes back to the late Lihyanite period. Some of these tombs featured interior installations: hollows were carved in the walls or the ground. There are also ordinary individual graves, cut in the base of the Jabal, whereas others bear inscriptions giving their owners' identities; on the slope of the Jabal, some areas were marked out to prepare for future tombs. Remains of bones, shrouds and pieces of wood from the coffins were found in these graves.

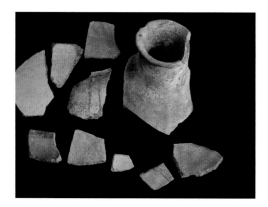

Types of Dedan pottery

## Pottery

The first studies of the pottery of Dedan (al-Ula) were performed by Winnett and Reed then continued by Peter Parr and Bawden.[4] Al-Ghazi also published research on Dedan pottery and al-Zahrani studied that of Tell al-Kathib. These studies showed that this pottery is

4.  He published a study on the pottery of the site of Khayf al-Zahra and the Wadi al-Mutadil, which are part of the Dedan site.

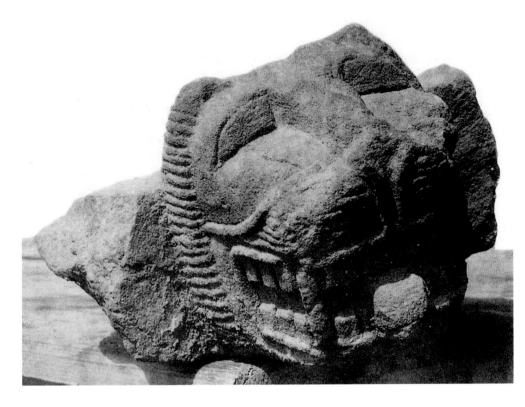

Stone lion found in al-Ula by French priests Antonin Jaussen and Raphaël Savignac, 1914. *Atlas*, pl. XXXVI, 1

very similar to the one from the sites of Tayma and Qurayyah, both in form and decoration, but that the material and craftsmanship are of an inferior quality. Comparative study revealed that Dedan pottery dates to the early 2nd century BC. This is attested by the utensils and articles discovered in the principal temple of Dedan during the five prospecting campaigns. Other utensils date to the 1st century BC and samples of Roman, Nabataean and Byzantine pottery were found as well.

Dedan ceramic was hastily made. It often has a décor painted black, brown and red on the outside and the rims but these decorative motifs, evocative of nature – plants and animals – are less frequent than at Tayma and Qurayyah. There are occasionally some decorative elements in relief representing serpents, wavy lines, incised segments and circles, symbols of the spiritual life of the time.

## The other discoveries

The French scholars Jaussen and Savignac already discovered in the vestiges of the religious centre of Dedan the sculpture of a lion on a stone base. The stylisation of the animal, the details of its jaws and fangs show the influence of Hittite and Assyrian sculpture.

Beads

Further excavations in the temple itself and the adjoining constructions led to the discovery of many archaeological items relating to daily life and religious rites, such as stone perfume burners in various forms and volumes, sacrifice tables, remains of basins, kitchen utensils, cooking pots, scales, and a collection of bronze articles for various uses, tools for crushing, precious items including a collection of beads, some made of stone, others of amber, glass paste or shells.

Also a certain number of lamps in different shapes were found as well as remains of clay figurines representing a camel with neither head nor legs. Other figurines are outstanding for their coloured ornamentation; their thick red paste mixed with lime or basalt is striking.

Boat-shaped oil lamp

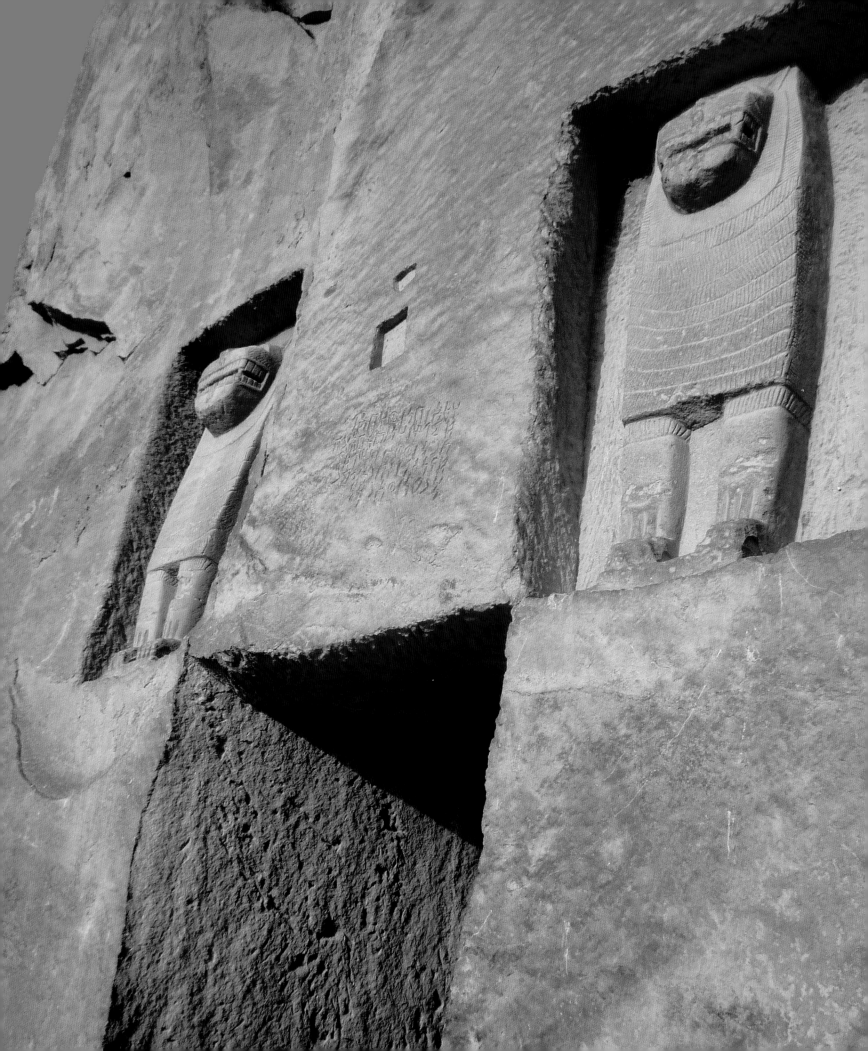

# THE KINGDOM OF LIHYAN

*Hussein bin Ali Abu Al-Hasan*

## Geographic position

Dedan, capital of the Lihyanites, known as al-Ula, is situated in the north-west of the Arabian Peninsula in the valley of al-Qura[1] on the old trade route connecting the south of the peninsula to the lands of the Fertile Crescent, Mesopotamia and Egypt. The choice of this location largely contributed to its blossoming in the Pre-Islamic period.[2]

The numerous archaeological sites of the al-Ula province (al-Khurayba, Tell al-Nathla, Khayf al-Zahra, Jabal Umm Daraj, Danan and al-Ruzayka) are proof that the capital of the Lihyan kingdom was in the valley of al-Ula, spread over a territory placed between a mountain in the east cited in the Lihyanite inscriptions under the name of "mountain of Dedan" and the mountain of al-Ruzayka in the west. The Roman writer Pliny the Elder called the Gulf of Aqaba the "Lihyan Gulf", a name still used up to the 2nd century AD. The Lihyanite inscriptions discovered in several centres such as Tayma and Qaryat al-Faw and all along the trade routes attest to the relations the Lithyanites had with the neighbouring kingdoms.

## History

The inscriptions found in the region are the principal source studied by historians. As early as the 6th century BC they mention the "kingdom of Dadan" or "Dedan". Another kingdom is also cited in the inscriptions: Lihyan. The frequency of the expression "kingdom of Lihyan" in the texts has it go back to some time between the 5th and the 4th centuries BC, the date of the fall of the State of Lihyan still being a moot point among historians.

Thus the origins of the Lihyanite kingdom date to the 6th century BC, coinciding with the rise of the reign of the city of Dedan and then of the tribe of Lihyan. We believe that it was at this time that Lihyanite script was formed. Rudimentary during the first Lihyanite period (Dedan), it was subsequently perfected. The Banu Lihyan (or subjects of the Lihyanite kingdom) were one of the most ancient Arab tribes settled in the north of Hijaz and are mentioned by Arab historians. After the fall of the Lihyan kingdom subsequent to the arrival of the

Rock-cut tomb of al-Aswad
(al-Khurayba sandstone cliffs)

1. South-east of Hira Uwayrid in the valley of Diq, between the mountain chain rising to the east and the west on the 36° 37' parallel and the 20° 27' longitudinal line.
2. Al-Hasan 1997, p. 32.

List of the Lihyanite kings cited in
the inscriptions discovered at al-Ula
and Tayma, in chronological order
(Abu al-Hasan 2002, p. 329)

1.  Hana'us ibn Chahr
2.  Shahr ibn Hana'us
3.  Takhmi ibn Loudhan
4.  Jachim ibn Loudhan
5.  Jalt Qaws
6.  Loudhan ibn Hana'us
7.  Talmy ibn Loudhan
8.  Mas'ud
9.  Hana'us ibn Talmi
10. Talmy ibn Hana'us
11. Abdan ibn Hana'us
12. Salhan
13. Fadj
14. Mita'al

Nabataeans in the second half of the 2nd century BC, the Lihyanites took over other areas of Hijaz, such as Rajih located between the holy city of Mecca and the enlightened city of Medina. But they were the object of an attack by the Prophet, known as the "conquest of Banu Lihyan". The name of the tribe of Lihyan still exists and today there are still some Lihyanites living south-east of Mecca.

## Lihyanite kingship

The Lihyanites adopted a hereditary succession system within a same family, but royalty could be passed on from one family to another. The king was assisted by an advisory council (the *Hajbal*) which played an important role. Lihyanite inscriptions discovered in al-Ula as well as Nabataean (Jaussen and Savignac no. 33) or Aramaic inscriptions, like that engraved on the stela of Qasr al-Hamra at Tayma (cat. no. 103), mention kings' names.[3] In the Lihyan kingdom events were dated according to the years of the reign. This clearly shows the importance given to the king, who sometimes had a nickname: *Dhi Aslan*, king of the mountains, *Dhi Manen*, the robust king. The king levied taxes and controlled the economy, having at his disposal the agricultural and commercial resources.

## Trade and agriculture

The situation of al-Ula at the crossroads of trade routes was one of the sources of its prosperity. Taxes and rights of way were levied on each caravan in exchange for protection and supplies. The Lihyanites contributed to the development of trade between the south of the peninsula, the other cities of Arabia and neighbouring countries like Mesopotamia and the Levant. The Lihyanite traders consecrated their camels to the deity dhu Ghabat.

The Lihyanites were farmers as well, thanks to the plentiful water and fertile soil, agricultural produce actually being the main source of the kingdom's wealth.[4] The geographer Eratosthenes, referring to the north-east of the Arabian peninsula, described the country as a region growing palms, prickly bushes and tamarisk.

The inscriptions feature many terms relative to agriculture: *kharaf*, autumn fruits, *datha*, those of spring, or again *thabart*, qualifying a cultivated piece of land, and *mou*, water. Their frequency proves there was a well-organized agriculture, involving the purchase of land, its cultivation and irrigation, then the harvest of the crops, a part of which was offered to the deity. Orchards and pastures surrounded the city. Agriculture seems to have been one of the mainstays of the economy.[5]

## Religion

Religion played a significant role. The construction of temples, considered the houses of the gods, allowed the kings and the population to approach the deities. At al-Ula several cultic places were found, notably at al-Khurayba, Jabal Umm Daraj and Danan, all consecrated to the god dhu Ghabat. A temple dedicated to the god al-Kutba was also discovered at Tell al-Kathib. The inscriptions mention the names of the deities and also provide information on the rites, in particular the offerings, of vital concern to the Lihyanites. In this way the *tahal*, a share of the taxes equal to one tenth of the produce of the soil and the other riches,

3.  Al-Ansari *et al.* 2008, p. 93.
4.  Al-Hasan 1997, p. 399.
5.  Al-Hasan 1997, p. 401.

Altar at Jabal Umm Daraj,
photograph by Humberto da Silveira

was dedicated to the deities. The inscriptions show that they were very careful to express their piety and firmly believed that their offerings would be rewarded by divine benevolence towards them. At the end of the votive inscriptions, expressions of redemption such as "[...] offered to [...]. So he was satisfied with him". Pilgrimages as well were very important: the inscriptions at the base of the mountains of Ikma and Jabal Umm Daraj indicate that a pilgrimage was dedicated to the deity dhu Ghabat.[6]

## Lihyanite script

The Lihyanite alphabet consists of twenty-seven letters which all match the letters of the present Arabic alphabet, save the letter *dh* which was utilized in none of the inscriptions found up to now. This script is derived from South Arabic, several letters of which have been altered. In Lihyanite the vertical line or the semicolon were used to separate the words from one another, but this rule was not always applied. Most of the inscriptions were written from right to left, on almost parallel lines, sometimes separated by a horizontal line. As in South Arabic the same letter could appear in a variety of forms.[7]

6. *Ibid.*, pp. 383–91.
7. A few of the principal sites of the province of al-Ula where inscriptions in Lihyanite were discovered: al-Khurayba, the mountain of Ikma, the valley al-Mutadil, Danan, Abu Wadd and al-Ruzayka, as well as the area surrounding the caravan route.

## The Fall of the Lihyan kingdom

For most historians the kingdom of Lihyan disappeared at the end of the 2nd century BC. Some texts indicate that a king named Mas'ud claimed he was king of the Lihyanites. He left inscriptions in Nabataean, but nothing else proves that he or his name was Nabataean.[8] So Mas'ud was not a Nabataean king of Dedan (al-Ula) but instead the first to take advantage of the Nabataean expansion southwards. Indeed the Nabataeans invaded the territory between Hegra (Mada'in Saleh) and Dedan (al-Ula) at the end of the 2nd or the 1st century BC, making Hegra their second capital after Petra, and ruled the region until the fall of their kingdom under the Roman Empire in 106 AD.

## The principal Lihyanite sites
### Al-Khurayba

North of al-Ula, al-Khurayba (a district of Dedan, former capital of the kingdom of Dedan) is one of the principal and most ancient sites of the Lihyanite civilization. The excavations performed by King Saud University in the area close to a rock-cut cylindrical basin led to the discovery of a religious building as well as an important collection of human statues, inscriptions, perfume-burners, sherds of pottery or stone vases.

Rock-cut tombs carved in the mountain of Dedan (al-Khurayba mountain) were found as well. They present a chamber cut in the cliff containing a group of rectangular graves hollowed in the ground or the walls; these rock tombs are similar to those discovered in Hegra (Madain Saleh) but their architectural ornamentation and interior arrangement are less elaborate. The excavations also brought to light other tombs of a different type cut in the mountain outcrop, aligned one next to another, each containing a single body.[9] Other individual graves were a simple trench dug out of the side of the hills. Several of these graves bear an inscription giving the name of the deceased. The most well-known are the two tombs of al-Aswad, both marked by two lions carved on the façade.

### Ikma

Several inscriptions were found in the massif of Ikma north of al-Ula. This site is a great source of information for the history of Dedan and Lihyan and in particular for their religion. Most of the inscriptions are distinguished by a lovely script with letters in relief or incised. Some date to the first years of the reign of the Lihyanite kings. Their study provided new data on trade, taxes and in particular the system of the *zakat* (offering). The faithful of the deity dhu Ghabat thronged to the site, coming from the most distant lands, such as Oman in the south and Badr in the north, to dedicate offerings to their god: the *zakat*, consisting of camels, sheep, fruits and grains from their countries. These inscriptions revealed information about hitherto unknown functions and activities, such as the tours undertaken by some of the deity's faithful to levy the *zakat*. The men practising this activity were called "*salha*" and the women "*salhat*". Last, the Ikma inscriptions brought to light different Arabic dialects and terms. They also revealed incisions representing humans, animals and musical instruments (*semsem*) belonging to an even older period.

### Tell al-Kathib (or the hill of the dunes)

Tell al-Kathib, between al-Khurayba and Ikma, is a hill of sand where potsherds were found, some of which are decorated with coloured geometric motifs. The excavations uncovered the foundations of a religious building consecrated to the Lihyanite deity al-Kutba and houses of

8. The Nabataean kings had names like Haritha, Rab Il, Abada or Malek.

9. The doors, between 60 to 80 centimetres wide and 70 centimetres to 1 metre high, are separated by 2 to 2.5 metres.

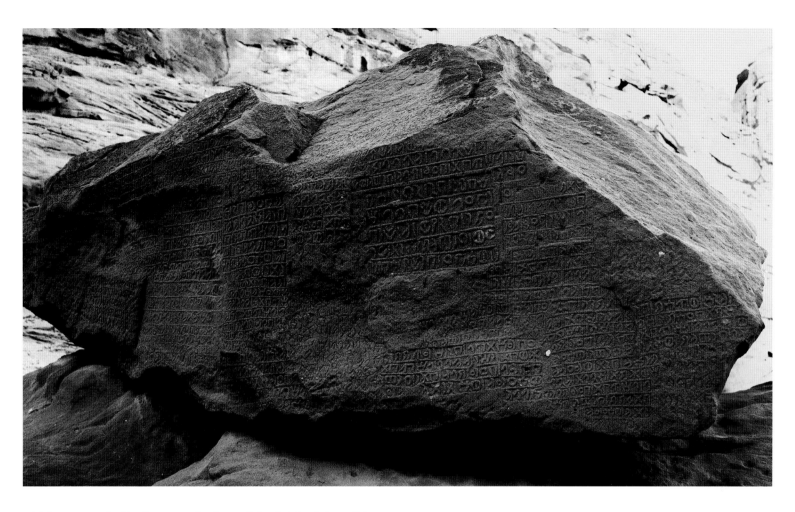

Inscription at Ikma, photograph by Humberto da Silveira

which some are built of stone and others of clay bricks. Most of the pavements were cut stone. A rich collection of statuettes was discovered, as well as pottery vases, inscriptions and decorative patterns carved on some stones used for building.

## Hegra

Not far from the presumed border between the Nabataean kingdom and what was left of the kingdom of Dedan at the beginning of our era, Hegra is built in a wide alluvial valley, dotted with sandstone outcrops less impressive than those of Petra. Geophysical prospecting brought to light countless indications attesting the existence of an authentic urbanization since Antiquity. In fact cultivated lands and an efficient irrigation system based on a considerable network of wells caused the ancient nomadic shepherds to become sedentary and settle in Hegra, at the crossroads of the trade routes connecting the Arabian peninsula with Syria, Jordan and Mesopotamia. This city is mentioned on several occasions in the Quran thirteen centuries before its rediscovery. Surat 15 is entitled: "al-Hijr". Equally mentioned are the populations who lived there, the Thamuds and the Lihyanites who arrived there in the mid-1st millennium BC. Several inscriptions of Lihyanite texts were discovered in different spots in the city.[10] They attest the presence of a Lihyanite garrison that controlled the traffic of the trade caravans coming from the north and the east. Hegra was certainly a border post. But the Nabataeans took over from the Lihyanites and made Hegra their second southern capital, after Petra, in the early 1st century BC.[11]

10. Notably in a quiet, remote spot in Jabal Ithlib.
11. Al-Ansari 2005, pp. 56–7.

Bibliography:
Abdallah 1975; Kamal 1984; Al-Hasan 1997; Al-Hasan 2002; Jawad 1980; Al-Ansari 1966; Al-Ansari 1970; Al-Ansari 1975; Al-Ansari 1990; Bafqih *et al.* 1985; Bastoun *et al.* 1982; Cantineau 1978; Caskel 1954; *CIH; CIS V; Quran;* Al-Dhabib 1998; Harding 1971; Ibn Darid 1958; Jaussen and Savignac 1914–1922; Al-Khraysheh 1986; Al-Maani 1999; Nasif 1988; Nassif 1413 H.; *RES;* Al-Roussan 1978; Al-Said 1995; Sayed Abdul Monem Abdul Halim 1993; Winnett 1937; Winnett 1939; Winnett and Reed 1970; Zaza 1984.

## STONE SCULPTURE

These three colossal statues, discovered very recently, belong to an important ensemble of male statues unearthed in the Kuraybah sanctuary. The French fathers Jaussen and Savignac had already found the first four statues, two of which were very fragmentary, during their first mission in 1909. Since then, excavations carried out by the King Saud University Archaeology Department teams led to the discovery of over ten of these sculptures, some of them colossal. These statues, placed on terraces, under porticoes, were backed up to the wall; on one of them the name of a Lihyanite king was inscribed and the three giants shown here were probably Lihyanite sovereigns as well. All are standing full-face, arms hanging down, closed fists, legs on the same line and are consolidated by a dorsal pillar to below the waist. While one of the statues (cat. no. 111) is very bulky and quite roughly hewn, the treatment of the other two (cat. nos 112 and 113) is very naturalistic and attests to the sculptor's remarkable skill. Albeit extremely original, the style of these colossi appears to have been deeply influenced by coeval Egyptian sculpture: this is underscored by the remaining traces of colour which the restorations at the Musée du Louvre have highlighted. All the nude parts of the two statues (cat. nos 112 and 113) were accentuated with dark red paint whereas the loincloths were coated with white plaster. One statue (cat. no. 111) appears to have been entirely covered with a bitumen-based coat colouring it black; the two heads (cat. nos 114 and 115) were also treated with a bituminous coating which now forms a sort of thick crackled crust. The layers of coatings indicate that these sculptures were periodically repainted.

The restoration at the Musée du Louvre also provided the opportunity of returning the head to one statue (cat. no. 112) and to another its sandalled feet (cat. no. 111).

**111. Statue of a man**
4th–3rd centuries BC
Red sandstone
256 x 80 cm
Al-Ula
Department of Archaeology Museum, King Saud University, Riyadh, 134D2

A sandstone human figure, larger than life and headless. The torso and feet were coated with fine particles of grey tar, colouring it pitch-black. The figure wears a waist-to-knee tunic, covered with a white coating and held at the waist by a double belt. The arms are gathered close to the body, the fists closed. The artist created a three-dimensional work, carefully highlighting the anatomical details of the muscles of the torso, abdomen, arms and legs. He carved a deep hollow in the back representing the spinal column. The legs are parallel and slightly parted. They are connected by a fully visible pillar in the back part of the statue to give it a solid support and protect it from eventual breakage due to the space between the legs. The feet of the statue were found separated from the legs.

The artistic characteristics of this statue lead to believe it belongs to the Lihyanite school of sculpture with influences from Syria and Ancient Egypt.

**S. S.**

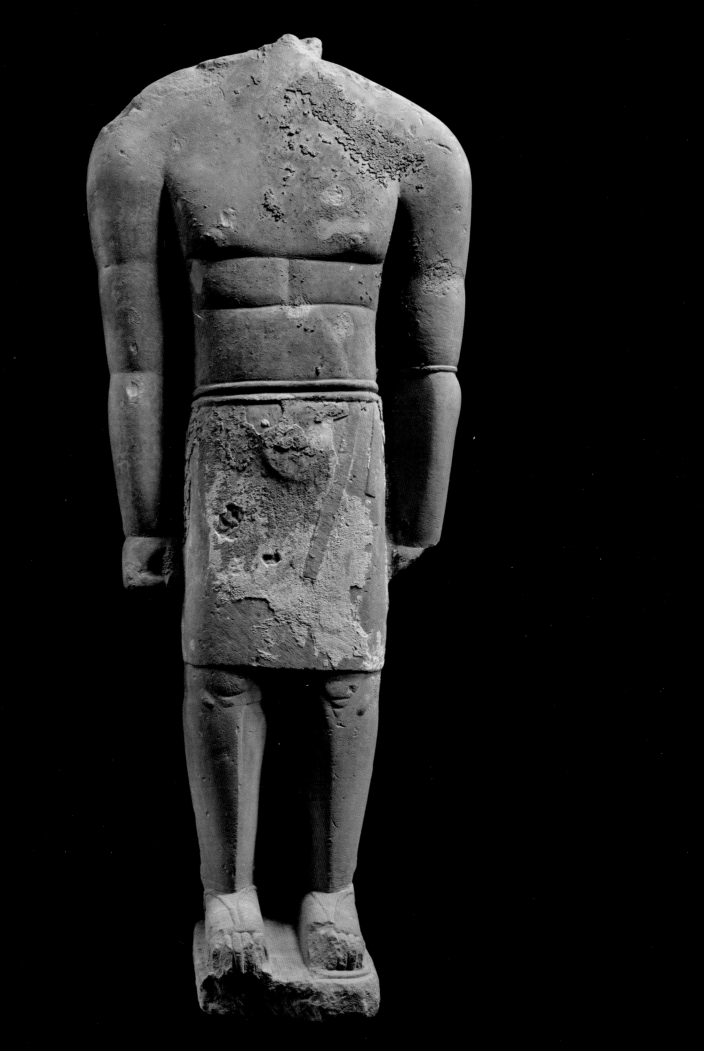

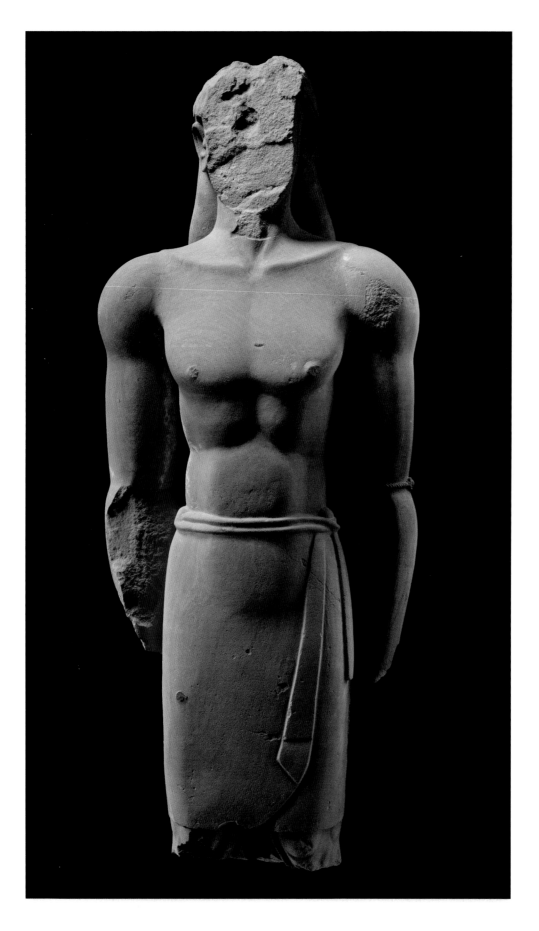

**112. Statue of a man, broken at knee height**
4th–3rd centuries BC
Red sandstone
230 x 83 cm
Al-Ula
Department of Archaeology Museum, King Saud
University, Riyadh, 137D4 and 136D4

Fragmentary sandstone statue, larger than life, probably representing a king of Lihyan, standing straight-legged. The face is missing and the lower part of the legs is lost. The arms are gathered close to the body and are joined to it. The left hand is closed and the right hand is broken off above the wrist. A jewel with a round-shaped bead adorns the left arm. A deep hollow in the back recalls the spinal column. The figure is wearing a short tunic. The garment is held at the top by a double belt around the waist. The surface of the statue is smooth. The artist accentuated the muscles of the arms, the knees, the torso and the abdomen. The head of the statue was found separated from the body. The face was hammered and all that remains is the ears and part of the turban covering the head.

The sculpture style is similar to that of a series of large and small statues also found in the temple of Dedan. It belongs to the Lihyanite sculpture school, with a very distinct local character but having received early artistic influences from Ancient Egypt or Syria.                                    S. S.

**113. Statue of a man**
4th–3rd centuries BC
Red sandstone
230 x 80 cm
Al-Ula
Department of Archaeology Museum, King Saud
University, Riyadh, 140D4

A standing statue, larger than life, probably
representing a Lihyanite king. Carved out
of sandstone it no longer has its head,
neck, hands, or feet. The arms are close to
each side. A striped jewel with a sort of
rounded bead adorns the left arm. The fig-
ure wears a short tunic. The garment is held
at the waist by a double belt with two knots
on the sides. The end of one of them pro-
trudes showing the extremity of the knot.
Under the foot, part of the sole is still visi-
ble. The surface of the statue is smooth.
The artist was able to highlight the anatom-
ical details, clearly visible in the muscles of
the torso, the abdomen and what remains
of the muscles of the arms and legs. A layer
of plaster covers the garment. All these fea-
tures lead to the belief that this statue
belongs to the Lihyanite sculpture school
which has a very distinct local character but
received early artistic influences from
Ancient Egypt or Syria.               **S. S.**

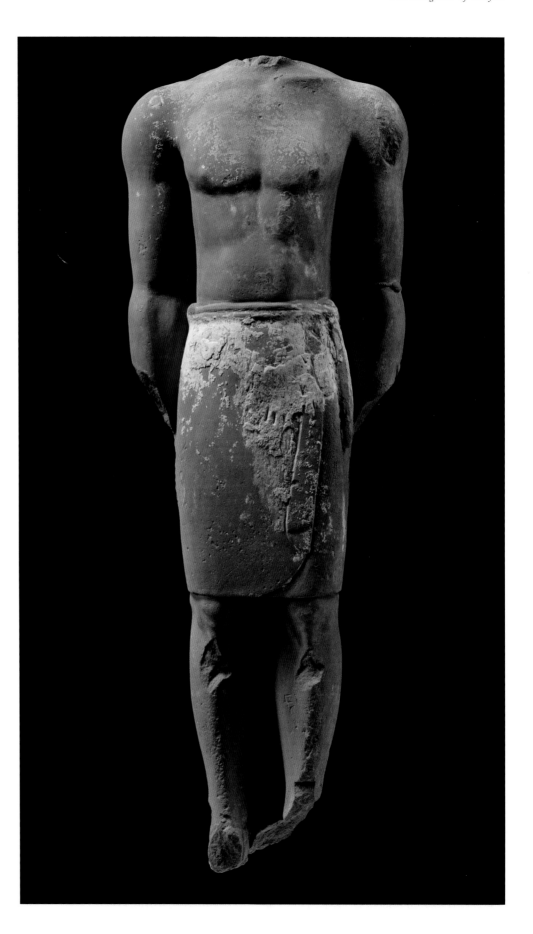

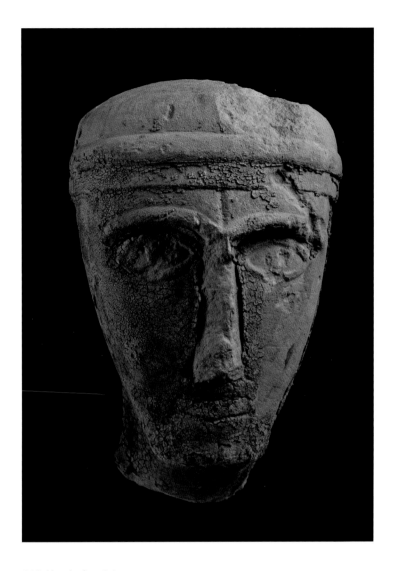

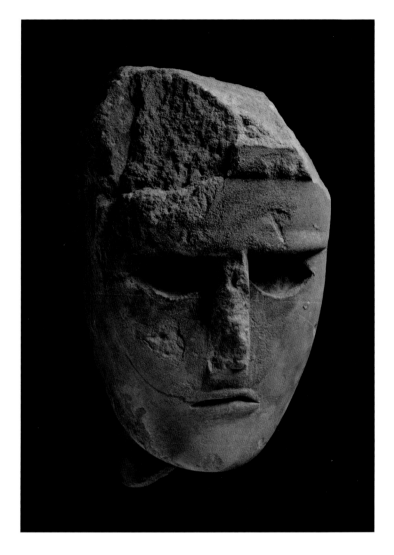

**114. Head of a statue**
4th–3rd centuries BC
Red sandstone
50 x 32 cm
Al-Ula
Department of Archaeology Museum, King Saud University, Riyadh, 285D2

**115. Head of a statue**
4th–3rd centuries BC
Red sandstone
55 x 30 x 28 cm
Al-Ula
Department of Archaeology Museum, King Saud University, Riyadh, 275D2

A man's head carved out of sandstone. The head has kept the remains of a veil, a band surrounds the brow with a clearly visible line; the lower part of the veil resembles a braid. The forehead is wide, the arched well-outlined eyebrows meet. A vertical incision marks the forehead, its lower end perpendicular to the point where the eyebrows meet; the chin is wide and straight and cleft in the middle. The neck bulges at the throat. The back part of the head is broken, the face is coated with a layer of tar which has crumbled in various places.                                                        S.S.

Sandstone head of a man, larger than life. We notice the remains of a veil, the lower part of which forms two clearly visible parallel lines in the form of a band. The brow is wide, eyebrows well delineated, the almond-shaped eyes are hollow, the tip of the nose is broken. The cheeks are round, the mouth small, the lips full, the chin jutting and rounded; the right ear sticks out and its auricle is long and arched, a fragment of the left ear and a small fragment of the neck are preserved. The back part of the head is broken. The face is coated with a layer of black tar which has crumbled in several places. It is worthwhile pointing out that this head was re-utilized in the construction of a wall.

S.S.

**116. Fragment of a statue**
5th–2nd centuries BC
Sandstone
47 x 25 x 13 cm
Al-Ula
National Museum, Riyadh, 999

Sandstone statue with neither head nor legs; part of the right shoulder is lost. The rest of the statue shows that the figure is standing, legs joined. The arms are close to the body. A clearly visible jewel surrounds the left arm. The fists are closed. The figure wears a short tunic, a double belt around the waist. The upper part of the body is nude, giving the artist the opportunity to carve the muscles of the torso, abdomen and arms, as well as a deep hollow in the back representing the spinal column. All these features lead to the belief that it belongs to the Lihyanite sculpture school, which has a very distinct local character but received early artistic influences from Ancient Egypt or Syria. **S. S.**

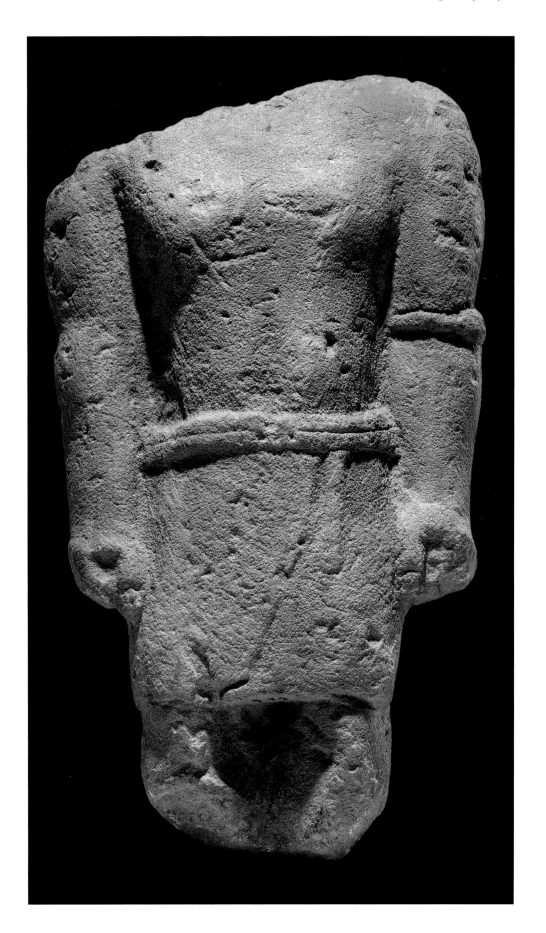

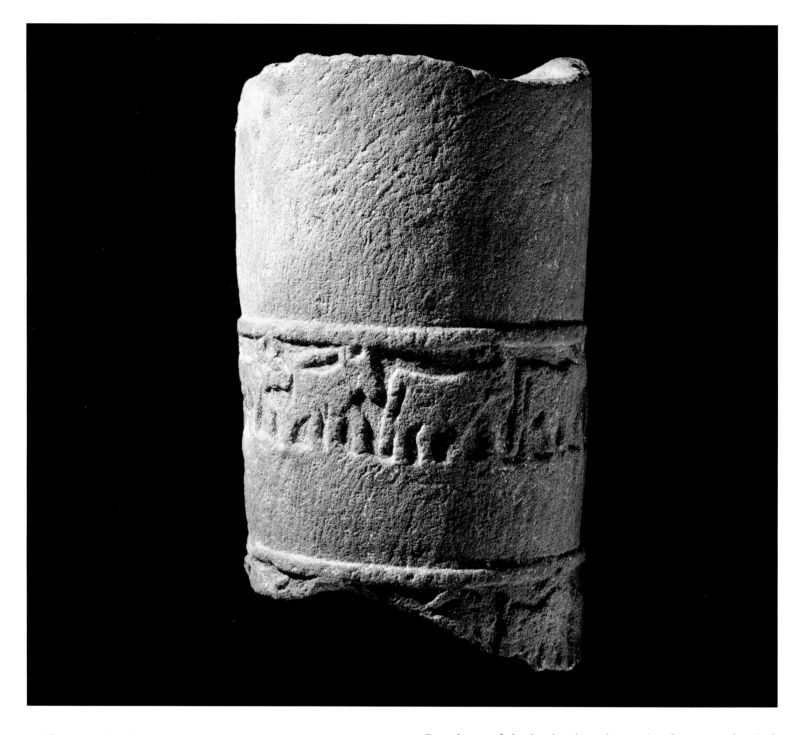

**117. Fragment of an altar or incense burner**
4th–3rd century BC
Red sandstone
H. 48 cm; Diam. 28 cm
Al-Ula
Department of Archaeology Museum, King Saud University, Riyadh, 180 D2

Carved out of the local red sandstone this fragment of a shaft adorned with two bands in low relief displaying processions of goats formed the base of an altar or incense burner. This type of monument was probably between 80 centimetres and 1 metre high: a complete exemplar is still preserved *in situ* in the sanctuary located at the summit of Jabal Umm Daraj. It consists of a cylindrical base surmounted by a parallelpipe-shaped block slightly hollowed on the top surface: the hollow thus carved doubtless received the offerings.                                                F. D.

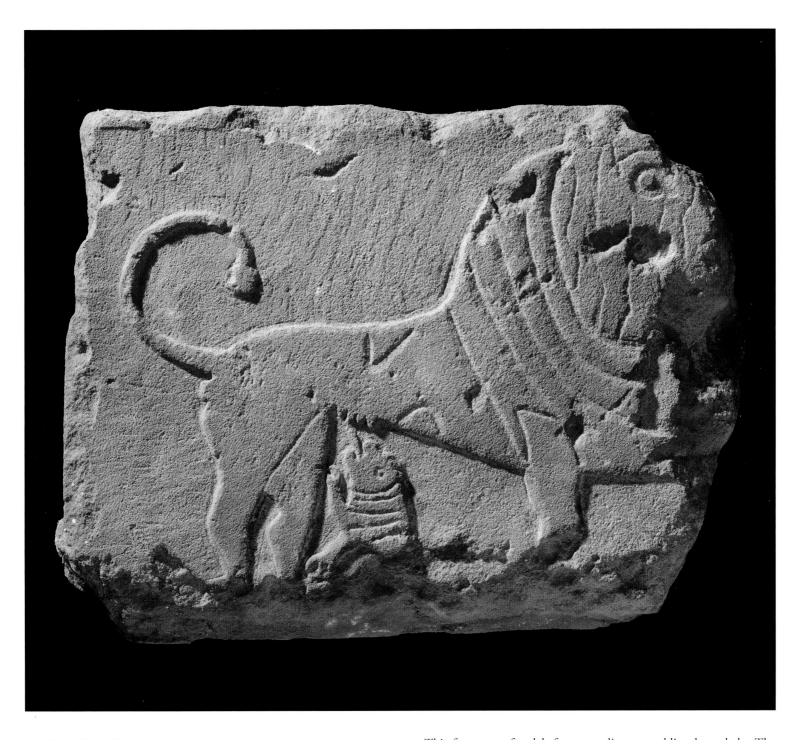

**118. Low relief with a lion**
6th–4th centuries BC
Red sandstone
33 x 46 x 15 cm
Al-Ula
Department of Archaeology Museum, King Saud University, Riyadh, 15D2

This fragment of a slab features a lioness suckling her whelp. The motif which stands out on a perfectly smooth polished ground is very graphically carved in flat relief with a rather crude stylization. A strong symbolism is associated with the image of the lion: it was a dangerous animal and therefore considered a formidable guardian. It is found throughout the Near East, represented on the doors of temples and palaces protecting their entries. At al-Ula two pairs of lions watch over two rock tombs carved out of the Kuraybah cliff.

F. D.

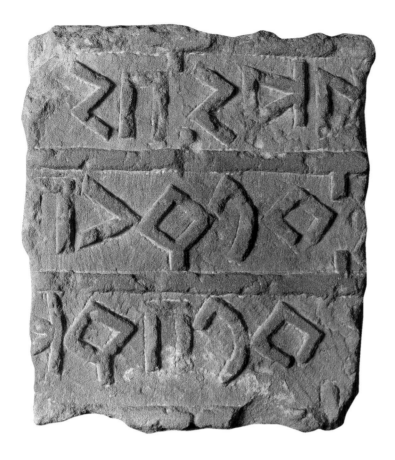

**119. Lihyanite inscription**
5th–2nd centuries BC
Red sandstone
23 x 14 cm
Al-Ula
Department of Archaeology Museum, King Saud University, Riyadh, 169 D1

> ...]Ddn b-N...
> ...] f-lyrb...
> ...]f-lbyd

Excepting the first word *Ddn* all the rest is difficult to interpret. *Ddn* is the name of a mountain, either the one now known as Jabal al-Khurayba with the major site of the oasis at its foot or else Jabal Umm Daraj with a sanctuary and important archaeological vestiges at its summit.

The inscriptions tend to suggest a high place where a certain cultic act was performed.

**S. F.**

**120. Lihyanite inscription**
5th–2nd centuries BC
Red sandstone
86 x 37 x 30 cm
Al-Ula
Department of Archaeology Museum, King Saud University, Riyadh, 338 D 5

| | | |
|---|---|---|
| *h-Ṣyġ h-* | = | the craftsman (jeweller, arrow-maker) |
| *wdq h-m* | = | offered this |
| *mt̲lt l-d̲-* | = | statuette to |
| *Ġbt f-[r]* | = | dhu-Ghabat |
| *[d̲ yhm]* | | for Him to be satisfied with them |

The provenance of this inscription is not known but its script is the same as several texts found in the village of al-Ula and at Khirbat al-Khurayba,[1] where the script features stiff angular letters unlike those of ʿIkma which tend to be rounded, cursive. The texts D42 et D45 come from Khirbat al-Khurayba where vestiges of a sanctuary and the wall of the ancient city were found. The text D42 follows the same structure as this text:

*ʾltṣr bn ʿmr ḥṣnʿ ʿbd l-mrʾ-h f-rḍy-h* – *ʾltṣr* son of *ʿmr* the craftsman did for his Lord for Him to be satisfied with him. In D45 it refers to the offering of a statuette.

**S. F.**

1. Farès-Drappeau 2005, D5, 12, 17, 42 and 64.

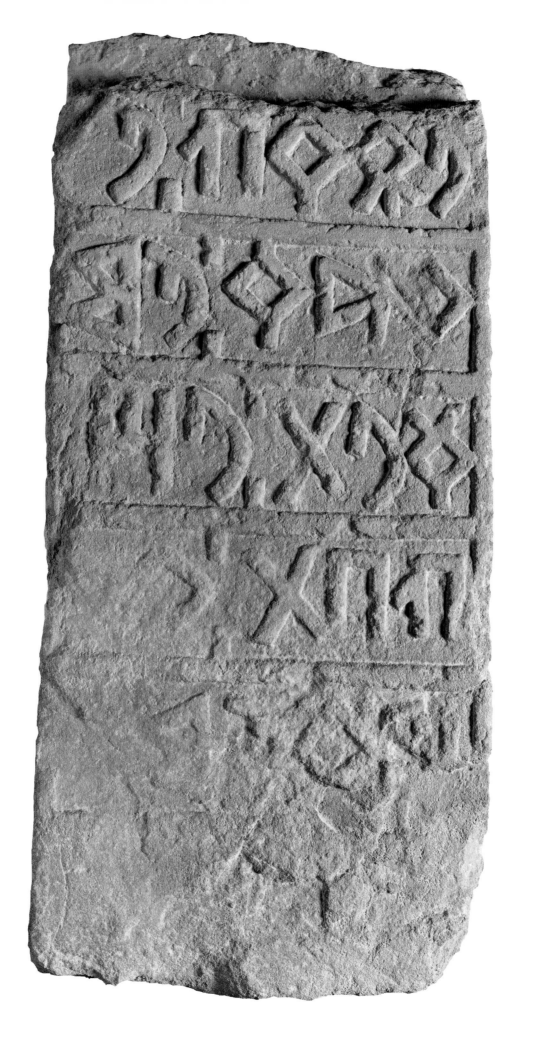

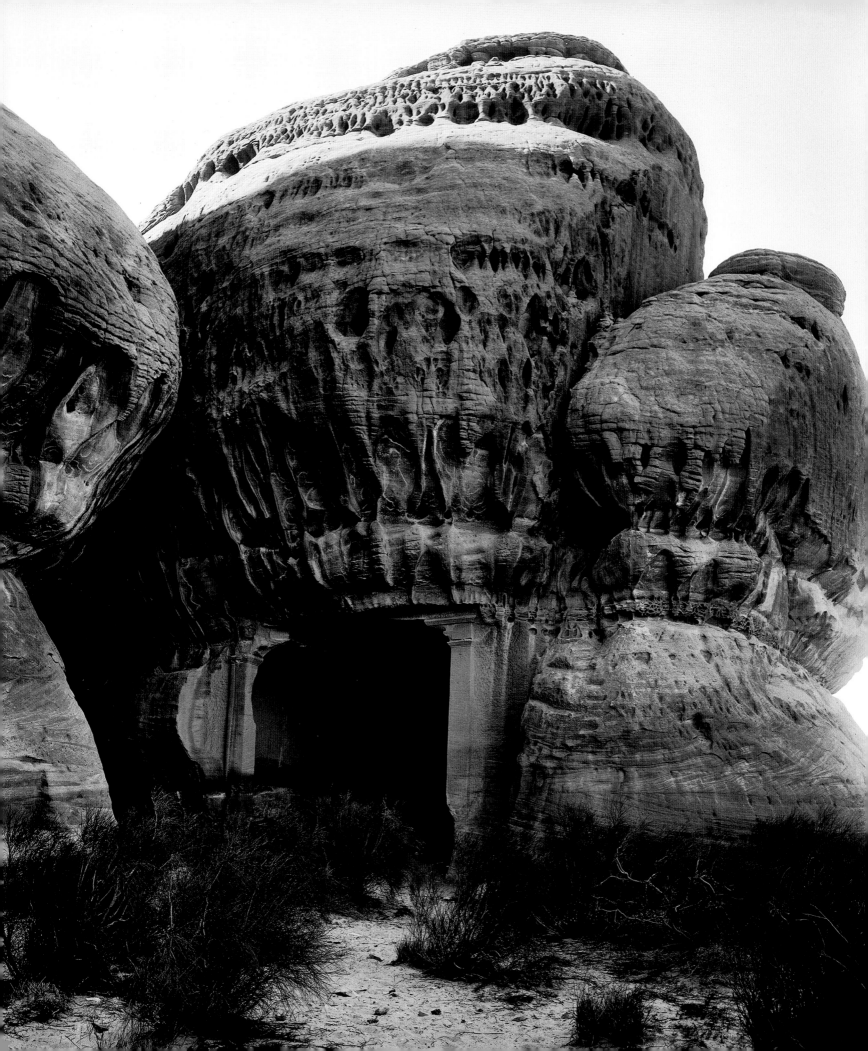

# HEGRA

## OF *ARABIA FELIX*

*Laïla Nehmé, Daifallah Al-Talhi and François Villeneuve*

On Ptolemy's map, Hegra, the city on the southern border of Nabataea, is located in *Arabia Felix* as are Yemen and Central Arabia. However, we would expect to find it in *Arabia Petraea* where it belongs by its history and material culture. It depends on the perspective: should it be considered the farthest point of a northern geographic space facing Jordan, Syria and the Levant? Or the farthest point of a southern geographic space, the world of incense and of the South Arabian kingdoms of the last centuries before the Christian era: Saba, Main, Qataban, etc.? For historians and archaeologists of Nabataea and the eastern Roman provinces, Hegra belongs to the same geographic ensemble as Petra, Humayma and Wadi Ramm, the three principal Nabataean sites in southern Jordan. On the other hand, for specialists of South Arabia, Hegra does not belong to the same geographic ensemble as Yemen and its kingdoms. Probably, as is often the case, the most appropriate viewpoint for comprehending the site is to consider it a pivotal influence at the crossroads of North Arabia and Central Arabia. Hegra – today often called Mada'in Saleh – far less known than Petra, the Nabataean capital in Jordan, is gradually coming to the fore thanks to the systematic research undertaken since 2001 by an archaeological mission (French up to 2006, Franco–Saudi since 2008[1]) and to the promotion of tourism encouraged by the Saudi authorities over the past few years. In 2008, the inscription of the site on the UNESCO World Heritage list has also contributed to its recent recognition. But not to be forgotten is the memorable description of the site, its rock monument façades and inscriptions, as well as that of its older neighbour Dedan – al-Ula of today – by the Dominicans Antonin Jaussen and Raphaël Savignac in the early 20th century.[2]

For some time this city belonged to the Nabataean kingdom whose first ruler, around 168 BC, was a certain Aretas, tyrant of the Arabs. In 106 AD, it became part of the Roman province of Arabia, its territory closely following the boundaries of the annexed kingdom. The rather uncertain southern border of these two successive entities could be located somewhere between Hegra and Dedan, the ancient capital of the kingdom of Lihyan in the second half of the 1st millennium BC, which is 20 kilometres south of Hegra. In fact, although

Photograph by fathers Jaussen and Savignac of the Diwan, the banquet hall at the entry of Jabal Ithlib

1. Mission under the direction of the Saudi Commission for Tourism and Antiquities, the other partners being the UMR (Unité Mixte de Recherche) "Orient et Méditerranée" and "Archéologie et sciences de l'Antiquité", the CNRS, the University Paris I and the Institut français du Proche-Orient. The French Ministry of Foreign Affairs and the French Embassy in Riyadh provide most of the public financial support, but the mission also benefits from the patronage of the French Senate as well as OTV Île-de-France and Total. In 2008 it won the grand prize for archaeology from the Simone and Cino Del Duca Foundation.
2. Jaussen and Savignac, 1909–22.

the notion of frontier scarcely applies here because it implies a line of demarcation which certainly did not exist in the desert, epigraphic finds tend to show that the Nabataean inscriptions as well as the Greek and Latin graffiti almost entirely disappear from the landscape south of this buffer zone. The site was left almost unexplored for a long time after it was rediscovered in 1876 by the English traveller Charles Doughty, who in 1876 had joined up with a caravan of pilgrims on their way from Damascus to Mecca. He stopped over at Hegra and wrote a description which he published in his *Travels in Arabia Deserta*.[3] The book contains information appearing nowhere else, in particular on the discovery, in the tombs, of incense and traces of spices and of strips probably from leather shrouds. The other 19th-century travellers concentrated more on epigraphs. It was in the early 20th century that the site's first major exploration was undertaken by Antonin Jaussen and Raphaël Savignac, the Dominican fathers of the Ecole biblique et archéologique in Jerusalem. To do so they took advantage of the opening of the Hijaz railway connecting Damascus to Medina, and of the inauguration of the Mada'in Saleh station in 1907. Up until the recent Franco–Saudi works, the *Mission archéologique en Arabie* by Jaussen and Savignac, of which the first two volumes, devoted to Hegra, were published between 1909 and 1914, remained the principal documentary source. Explorations after World War I produced hardly any more information about the site, barring a few ensembles of inscriptions[4] and the data obtained by gathering surface sherds.[5] The first excavations were carried out between 1986 and 1990, and then in 2003 by the Saudi Department of Antiquities and Museums, but have not yet produced full reports.

The site is known under several names: Hegra, al-Hijr, Mada'in Saleh. The first is the antique name as it appears in the Greek and Latin sources, notably Pliny[6] and Stephen of Byzantinum.[7] "Haegra" or "Egra" directly derive from the Nabataean "Hijra". These forms are found in the Nabataean or Latin inscriptions of the city. Al-Hijr is the present Arab name which already appeared in the surat of the Quran, bearing this name. It is the exact equivalent of the Nabataean toponym, the prefixed Arabic article *al-* being the translation of the suffixed Nabataean article *-a* that ends the name "Hijra". Its etymology is not clear. Indeed the semitic root *hjr*[8] can have several meanings: "surround, encompass" in Aramaic, whereas *hujr* or *hijr* in Arabic means "what is defended, prohibited and illicit" or simply, "wall, high wall". One of the hypotheses advanced recently to explain this toponym is the following: in the desert where population centres are sometimes as far as several hundred kilometres apart, an element as remarkable as the ramparts that surrounded this city as of the 1st century AD could have inspired a place name suggesting the idea of protection, enclosure. However, this hypothesis implies that the locality was not founded and named earlier, or else that it was re-founded in the 1st century and its former name lost. The name "Mada'in Saleh" appeared later, probably not before the Ottoman period. It means "the cities of Saleh", referring to the tradition according to which Saleh, a Pre-Islamic prophet, unsuccessfully attempted to convert the local polytheist inhabitants, the Thamudean, to the worship of the unique god. The Thamudean's refusal, expressed by the assassination of the she-camel sent by this prophet as a divine sign, is recorded in the Quran. The consequence was the sudden, overnight extermination of the entire population of the city (Surat "al-'a'raf", 7, 71–73, and Surat "al-Hijr", 15, 80–84).

Still on toponymy, we can point out as a matter of interest that from the 17th to the early 19th centuries the sites of Petra and Hegra were mistaken one for another. In fact the

3.  Doughty 1888, p. 125–78.
4.  In particular Milik and Starcky 1970.
5.  Parr, Harding and Dayton 1972.
6.  Pliny the Elder, *Natural History*, 157.
7.  Stephen of Byzantium, *Ethnica, s. v.*
8.  The exact transcription of the Semitic root requires an *h* with a diacritical point, corresponding to the letter *heth*.

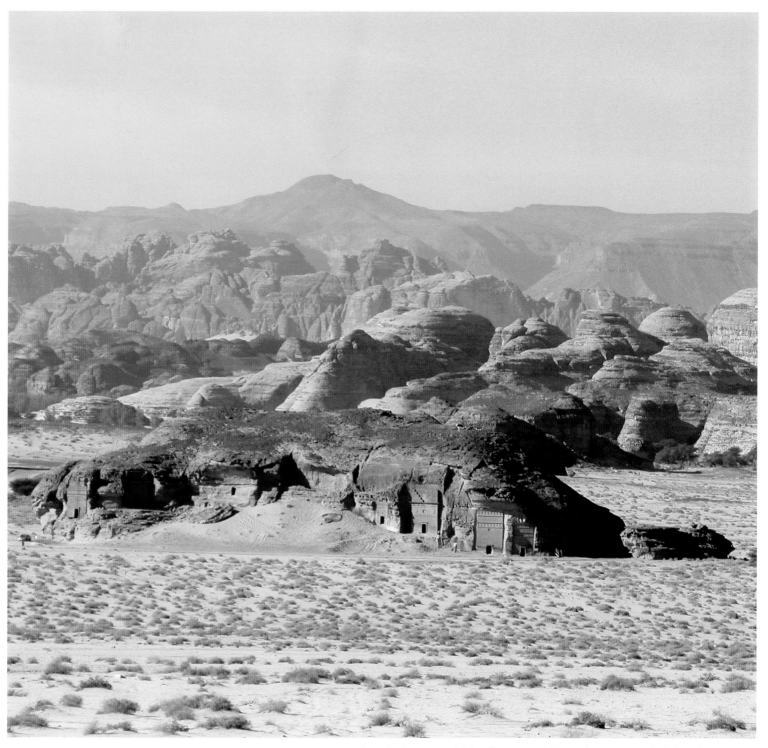

Fig. 1. In the foreground, Jabal al-Ahmar, one of the sandstone crags in which the Nabataean tombs
of Hegra are cut. In the background, Jabal (or Harrat) al-Uwayrid

Fig. 2. A Nabataean well dug partly into the rock and partly into the sediment

translators of Al-Idrisi's geography (12th century) of which the first Latin edition, *Geographia Nubiensis*, dates to 1619, did not know the toponym "al-Hijr" cited by this geographer. So they vocalized it Hajar, a word which in Arabic means "stone". To translate this word they preferred the Latin *petra* rather than *saxum* or *rupes*. Thereafter it seemed obvious to later authors that the site described by Al-Idrisi was Petra, in Jordan, whereas it actually was al-Hijr/Hegra in Arabia. This confusion lasted at least until 1830, since Léon de Laborde in his *Voyage de l'Arabie Pétrée* indicated (mistakenly) that the Muslims called Petra "Hadjar", because, he said, it was surrounded by a rocky mass.

Hegra is about 300 kilometres as the bird flies, halfway between the cities of Medina (Yathrib before Islam) and Tabuk. The site lies in an inland plain at the foot of Jabal/al-Uwayrid, a basalt plateau of the eastern spurs of the Hijaz (fig. 1).[9] This plain is dotted with unevenly high sandstone crags from the Palaeozoic age, carved by the intense erosion which affected the region at the end of the Miocene (13–5 million years BC). It is crossed by a north-east-south-west wadi along which vegetation is more plentiful. The colour of the Mada'in Saleh sandstone is either reddish brown for the oldest Cambrian sandstone, or whitish, for the more recent Ordovician sandstone. Their very fine grain makes them suitable for rock carving, but unevenly resistant to erosion. Some layers of sandstone suffered enormously both from wind erosion and, in contact with the ground, from capillary risings of salt-laden water.

The climate at Mada'in Saleh is extremely arid, with average yearly rainfalls not exceeding 50 millimetres. Nonetheless the plain, from the point of view of hydraulic resources, enjoys a privileged situation. In fact it is in a natural gully that drains the runoff water from the massifs surrounding it, the impressive Jabal al-Uwayrid to the west and a group of lower sandstone hills to the east.[10] These runoffs feed the ground water, now some 20 metres deep but in the Antiquity certainly less than 10 metres from the surface. Thus at Hegra, the Nabataeans set up an entirely different system to exploit the hydraulic resources than the one found in Petra where the water supply system was based on tapping perennial sources and collecting runoff water. In Hegra there is only one tank fed by a rock-cut canal located in the area of the extramural religious monuments and reserved for their sole use. Elsewhere, in the parts of the site not buried under dunes, especially in the west, north and north-west, the Nabataeans dug close to one hundred and thirty wells 4 to 7 metres wide and 20 metres deep (fig. 2). These wells are dug in varying depths of sediment, but their lower part is usually cut out of the sandstone, widening towards the bottom in order to increase the surface of contact between the well and the ground water. These wells allowed the development of an irrigated oasis with enough food supplies for the local population and perhaps even people passing through. The quality of these lands, acknowledged until the 10th century by the Arab geographers, permitted their cultivation.

The vegetal remains found in the excavations[11] attest to the region's agricultural potential. They include cereals (hulled barley and naked wheat), leguminous plants (lentils and field peas) and many fruits (especially dates but also figs, olives, pomegranates, grapes and a fruit taxon of the jujube family growing red berries). Most of the fruit species are typically Mediterranean and were probably imported. Whereas the dates, present in large quantities, were local. The discovery of by-products of cereal crops, meaning what is left of the different stages of cleaning to separate the grain from these by-products, allows the confirma-

**9.** For a geographic description of the site, see Rigot 2006, in Nehmé, Arnoux, Bessac *et al.* 2006, pp. 54–73.
**10.** On the hydraulic resources and the wells of Mada'in Saleh, see Courbon 2008.
**11.** The study of plant macro residues is performed by Charles Bouchaud; see Bouchaud, in Nehmé, Al-Talhi and Villeneuve 2009 [2010], pp. 299–311.

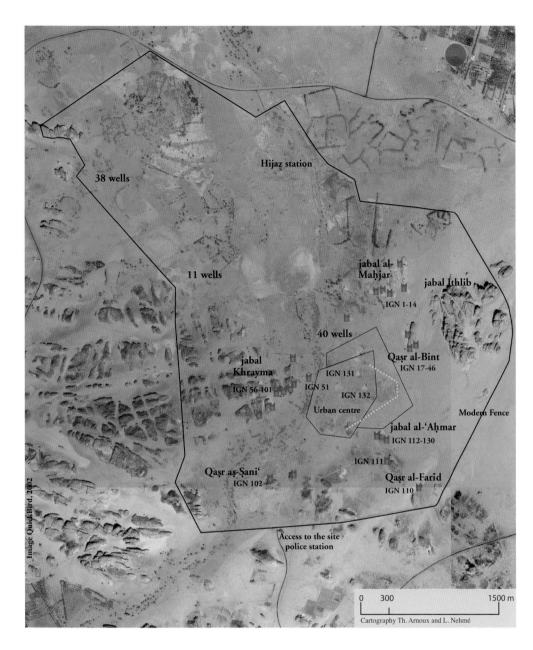

Fig. 3. Identification of the types of remains on a satellite image of the site.

⩗     Tomb or group of tombs

▲     Cult monument outside Jabal Ithlib

▦     The most visible section of the rampart

⬭     Jabal Ithlib and its borders

⬮     Area with wells

tion that cereals were grown on the spot. As far as the leguminous plants are concerned, nothing proves that they were cultivated locally, but we can assume that some plots were devoted to them. Lastly, it is probable that pomegranate and olive trees were grown, as evidenced by the discovery of wood charcoal and seeds belonging to these species.

In conclusion, despite unfavourable climactic conditions, the access to fairly abundant hydraulic resources, the existence of enough agricultural land and the mastery of techniques for tapping water facilitated the development of a city, where we identify sectors with clearly differentiated functions (fig. 3).

The most obvious function, characterized by the monumentality of the remains, is funerary. As in Petra, the tombs are the most instantly visible vestiges, and they are often better preserved than the tombs in the Nabataean capital. There are several types: monumental

Fig. 4. Aerial view of the tower-tomb
at the top of the Jabal Khraymat

12. Directed by W. Abu Azizeh; see Abu Azizeh, in Nehmé, Al-Talhi and Villeneuve 2009 [2010], pp. 189–203.

rock-cut tombs with or without façades crowned with merlons; tombs with a rectangular trench, simply dug out in the rocky substratum; and *tumuli* consisting of stone mounds 1.5 to 3 metres in diameter, whose preserved height can reach 1 metre. The distribution of these different types of monuments is simple: the monumental tombs are carved out on the sides of the sandstone mounts surrounding the central part of the plain where the *intra-muros* city is located. Whenever possible their façade faces the city so as to be seen by the greatest number and thereby contribute to the glorification of the family who commissioned it. Thus several necropolises and a few isolated tombs occupy the sandstone outcrops surrounding the urban centre. The trench-tombs are on the summit of these crags, some in groups of several hundred. Reserved for ordinary mortals they were not made to be seen, and the two thousand trenches found during the exploration of the site since 2001 represent a minimum for this type of tomb. Lastly, the *tumuli* are mostly found on the summit of the very uneven outcrops lying west of the site beyond the monumental tombs. One of them, appearing on the surface like a mound 10 metres in diameter and 1 metre high was excavated in 2008 on the plateau overlooking the IGN 81–90 tombs in the area of Jabal Khraymat. The excavation[12] showed that it was a monument 7.3 metres in diameter, consisting of two imbricated towers separated by a space filled with big uncut stones (fig. 4). The interior tower, 3.9 metres in diameter, was built with blocks of dark-coloured sandstone, while the exterior tower was made of whitish sandstone blocks. Only the exterior facing of the towers was regular. The grave proper was at the centre of the inner tower: an almost rectangular 0.75 x 1.9 metre-trench, surrounded by large stones arranged in a rather disorderly manner. It had been completely looted in the past. The dating of this tower–tomb raises problems. It belongs to a category of monuments whose architecture seems distinctly older than the Nabataean tombs, but the three lots of bones that survived the looting and were tested with carbon-14 dating provided dates between the 1st century BC and the early 3rd century AD. However this pre-Nabataean tomb may well have been emptied of its contents and re-utilized in the Roman–Nabataean period before the looting.

The monumental tombs do not all present a decorated rock façade. Some are mere funerary rooms with a door, the frame of which is occasionally, but not always, levelled. However Hegra counts eighty-six façade tombs – versus over six hundred at Petra – pertaining to a well-defined typology that presents a variety of forms:
– an arch tomb, crowned by a round arch;
– twelve tombs with one row of merlons, crowned by a row of whole merlons;
– fourteen tombs with two rows of merlons, crowned by two rows of whole merlons (fig. 5);
– eight tombs with half-merlons, crowned by two symmetrical half-merlons and resting on an Egyptian cornice (fig. 6);
– twenty-four tombs of the proto-Hegra 1 type, the façade flanked by pilasters, crowned by two symmetrical half-merlons, the entablature being an architrave and an Egyptian cornice (fig. 7);
– twelve tombs of the proto-Hegra 2 type, the façade flanked with pilasters, crowned by two symmetrical half-merlons, the entablature being an architrave, a frieze and an Egyptian cornice. They differ from the preceding ones by the presence of the frieze;
– fourteen tombs of the Hegra type, the façade flanked with pilasters, crowned by two symmetrical half-merlons and possessing two entablatures separated by an attic (fig. 8); this last aspect distinguishes the Hegra type from the proto-Hegra types;
– a tomb without a crowning, the façade flanked with pilasters.

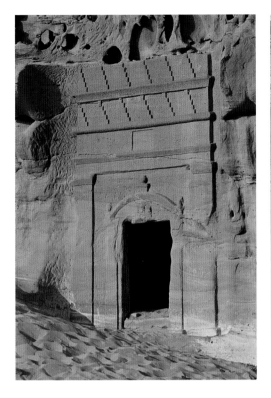
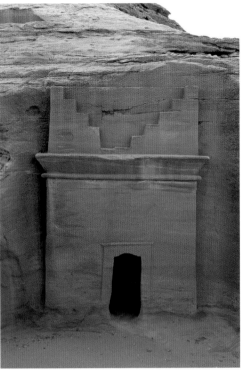
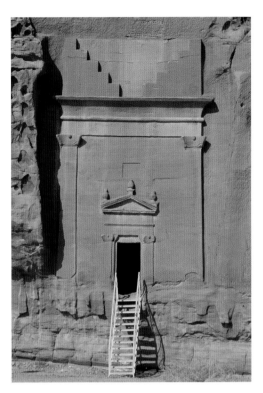

*Above, from left to right:*
Fig. 5. Nabataean tomb with two rows
of superimposed merlons, IGN 117.
Fig. 6. Tomb with symmetrical
half-merlons, IGN 122.
Fig. 7. Proto-Hegra 1 tomb, IGN 112.

The Hegra tombs were already quite accurately described by Jaussen and Savignac. In addition, systematic sketches[13] of the façades, layouts and sections were made in the context of the Mada'in Saleh archaeological mission. In the old bibliography they are identified by the number given them – per necropolis – by Jaussen and Savignac. Presently, on both the site and in the latest publications they are identified by the number ascribed to them by the National Geographic Institute (IGN) which was commissioned in 1978 by the Saudi Department of Antiquities and Museums to make a series of studies including a map of the site and the photogrammetric renderings of most of the façades of the tombs. The surveys of the façades drawn by the mission are largely based on these renderings. The numbers ascribed by the IGN are now the only ones used and are affixed to the monuments themselves.

The dimensions of the tombs vary considerably: ranging from 2.7 metres high and 1.65 metres wide for the smallest façade (IGN 3) to 21.5 metres high and 13.8 metres wide for the largest *completed* façade (IGN 110, al-Farid). Another tomb would have been even much larger had it been finished. This is tomb IGN 46, cut in the highest part of the mounts known as Qasr Al-Bint where the principal necropolis lies: both the closest to the urban centre and the one presenting the most monumental ensemble of tombs (fig. 9). This monument, of which only the crowning was sculpted, would have been almost 28 metres high. It should pointed out that Nabataean tombs are always carved out from top to bottom without scaffolding, each descending portion, determined by the working height of a standing man, being entirely completed before beginning the next portion. A Nabataean inscription engraved beneath the carved part of IGN 46, almost at ground level, tells us that it was commissioned by a "strategist", meaning a Nabataean province governor. This strategist specifies that he "took possession of this place", that is, where the text is. So it is clear – and this is proved by other inscriptions with the same content – that the tomb commissioners, before engaging the services of a team of stonecutters, had to first purchase a burial plot, probably from the municipal services of the city.

13. By Jean-Pierre Braun, from 2001 to 2003.

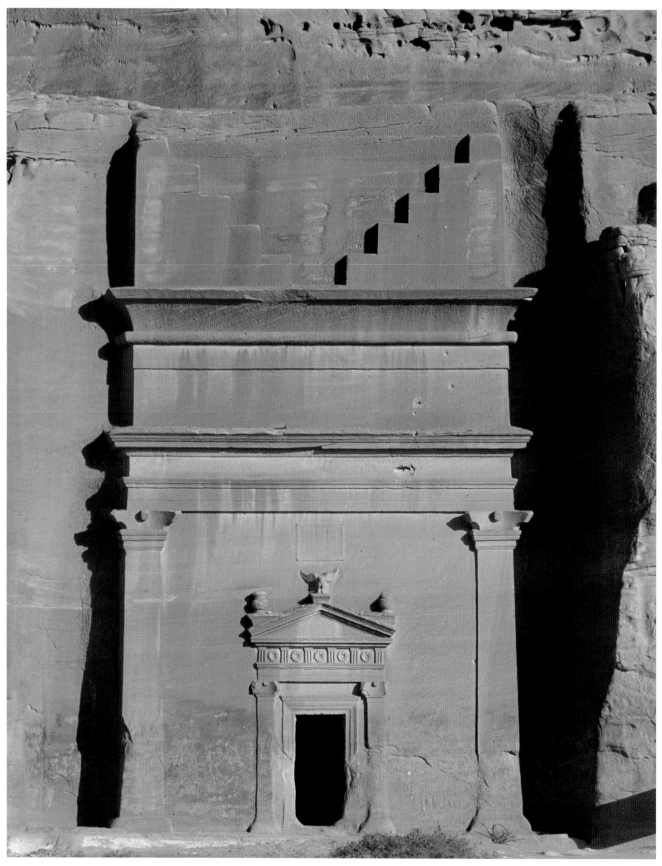

Fig. 8. Hegra-type tomb IGN 21

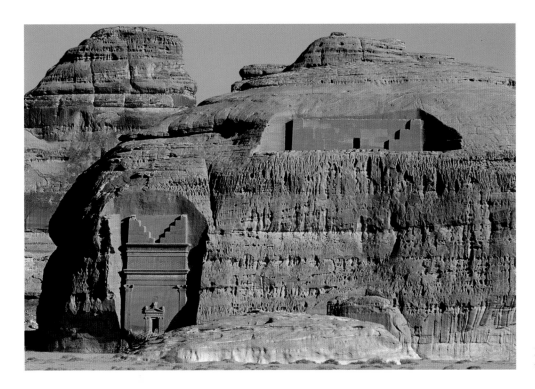

Fig. 9. Tombs IGN 17 on the left, and IGN 46 on the right, were partially carved and left unfinished

Contrary to the Petra tombs which are almost all anepigraphic, those of Hegra are of great interest, almost a third of them having a Nabataean inscription engraved in a more or less elaborate cartouche sculpted above the door (fig. 10). These inscriptions are juridical documents giving the name of the owner or owners, naming or identifying the persons who had the right to be buried in the burial chamber and listing the prohibitions. Some of the most frequent texts tell about selling, pledging or renting the tomb. Moreover the inscriptions include a curse against tomb looters and date the tomb by the year of a Nabataean king's reign. Some feature the signature of one or several stonecutters who worked on the tomb, allowing to reconstitute families or even schools of stonecutters. The texts engraved on the façade, scarcely legible from ground level, were not the original juridical document. In fact one of them indicates that a copy, written on another support, was preserved in a temple of the city. The dates mentioned in the texts are all between 1 and 75 AD.

The tomb owners are men, women or couples.[14] They belonged to the families of the city notables. Among them there were military men or civilian administrators: a centurion, three eparchs, two strategists and members of the families of three strategists. Another owner is a physician and a last one a fortune-teller. The interior installation of the burial chamber testifies to the collective character of the tombs. Only exceptionally, they contain a single grave for the inhumation of a defunct: the average number of graves per chamber was between six and seven. There were three types: funerary niches which are deeper than wide and lengthwise perpendicular to the wall in which they are carved; caissons, wider than deep and lengthwise parallel to the wall in which they are carved; rectangular trenches directly cut out of the rock substratum forming the floor of the room (fig. 11). All these graves were probably closed with slabs sealed with mortar. Barring a few exceptions the burial chambers are never full and there was room left on the walls and in the ground for hollowing other graves. Their layout is never geometric and they are not perfectly perpendicular to the axis of the façade. Similarly, their walls do not intersect at right angles. Except for a few fittings, carved out with particular care at the back of

14. Respectively twenty-one, seven and three, to which are added a group of men and women.

Fig. 10. Nabataean inscription (Jaussen and Savignac no. 12) engraved inside a cartouche with double dovetails on the façade of tomb IGN 29

"This is the tomb which Wushuh, daughter of Bagrat, and Qaynu and Nashkuyah, her daughters, Taymanites, made for themselves, for each one of them, and for 'Amirat and 'Usra'nat and 'Al-alat, their sisters, daughters of this Wushuh, and for everyone under their protection, male or female, in order for Wushuh and her daughters mentioned above, and all of their protégés to be buried in this tomb. And it behoves Wushuh and her daughters and all of their protégés, male or female, not to sell and not to pawn and not to alter anything in this tomb for anyone. And whoever alters the above shall owe one hundred Aretas drachmae to Ta{dha}y and the same amount to our lord Aretas. In the month of Iyyar, year 43 of Aretas, king of the Nabataeans, who loves his people. Done by Halp'allahi, the stonecutter."

15. Directed by I. Sachet, archaeologist, and N. Delhopital, anthropologist; see Delhopital and Sachet, in Nehmé, Al-Talhi and Villeneuve 2009 [2010], pp. 205–58.

several chambers, which may have been executed within the same architectural programme of the tomb façade and chamber, most of the graves were executed according to need. Therefore in principle for each burial the tomb had to be reopened and a grave cut to the dimensions of the defunct.

The systematic sketches of all the tombs have highlighted two stages of occupation of the Hegra massifs. A first ancient stage features burial chambers vertically cut out in the rock walls, their interior entirely filled with pit-graves. The second stage features the Nabataean façade tombs described above. The excavations in 2008 in one of the tombs probably belonging to the first stage, IGN 125 (Jaussen and Savignac no. C4) unfortunately did not enable dating. The excavations begun in 2008 and continued in 2009 inside one of the rare Nabataean tombs that had not been entirely cleaned produced more results.[15] This small tomb, IGN 117 (Jaussen and Savignac no. C14), with two rows of merlons (fig. 5) is dated to 61 AD by the inscription engraved on its façade. The excavation, not yet completed, yielded a great amount of wood (probably elements of coffins), as well as leather and fabrics that wrapped the deceased. Several periods of occupation were revealed, all Pre-Islamic; the oldest being that of the tomb owner. Above all, the anthropological study of the bones indicated the presence of a minimum of sixty-four individuals, including thirty-eight adults (thirteen men, thirteen women, twelve of undetermined gender), their stature varying between 1.45 metre to 1.71 metres and twenty-six juveniles aged between zero and nineteen years. Young children, up to four years old, are less represented: this demographic category may have been given a separate burial treatment. In addition, the study of discrete characters – non-pathological anatomical variations directly observable on the skeleton – revealed the existence of blood ties between the individuals buried in the tomb. Several pathologies, in particular on the vertebrae but also fractures, were also observed.

Of course religion was present in Hegra. Contrary to Petra however, where the space devoted to religious practices is organized in a markedly hierarchical manner and religious monuments (temples, holy places, banquet halls, small rock sanctuaries) are found in all the sectors of the antique site, the cultic space of Hegra, as far as we now know it, is mostly concentrated in an area of the site named Jabal Ithlib. This crag rising in the north-east of the site is the highest and the most uneven, presenting the sharpest summits. Vestiges of monumental architecture, notably elements of columns, have actually been found *intra-muros* and on the edge of the city on the slopes descending gradually towards it from the east. But the monuments to which these elements belong have not been identified and the city temple where the city archives were kept, as some inscriptions on the tombs indicate, has yet to be found. Aside from Jabal Ithlib and its southern outskirts, Hegra yielded very few religious monuments. At the most a few baetyls (sacred stones) associated with tombs, several baetyl niches cut out in the outcrops rising inside the city, and also a few niches carved in different places of the site and which do not seem related to any other vestige.

The interior of Jabal Ithlib, accessible by a narrow gorge which recalls in miniature the famous Siq in Petra, is cut in two by a wadi hemmed in by two rocky banks, the slopes of which are sometimes broken by projecting ledges (fig. 12). The most well-known monument of this sector, hewn at the entrance of the gorge, is a large banquet hall with three benches, a *triclinium*, called the Diwan (fig. 13), where the Nabataean religious confraternities gathered in groups of thirteen persons, including two musicians. A large number of

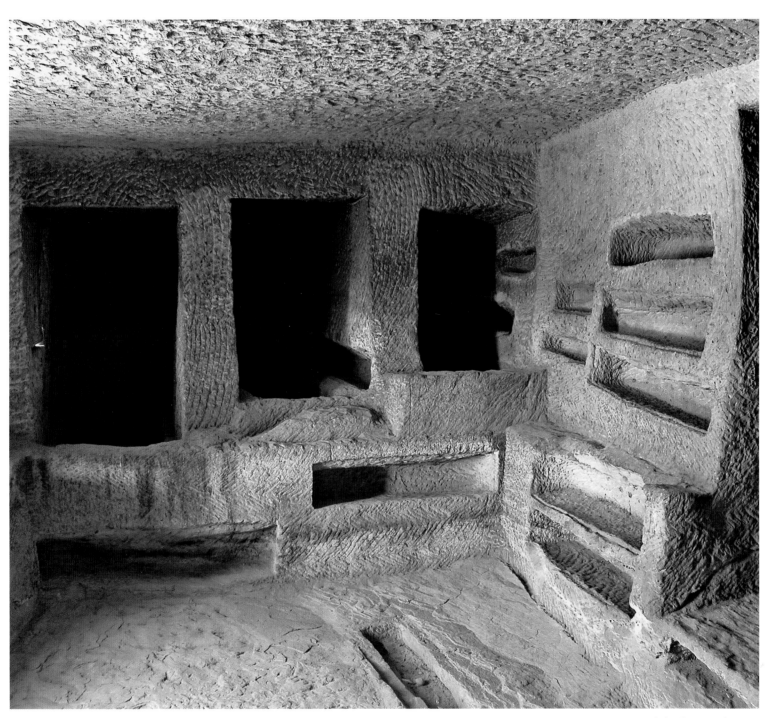

Fig. 11. Burial chamber in tomb IGN 9

It contains the three types of burial structures found in the Hegra tombs:
numerous niches and caissons, as well as a trench
in the floor of the chamber (in the centre of the photo)

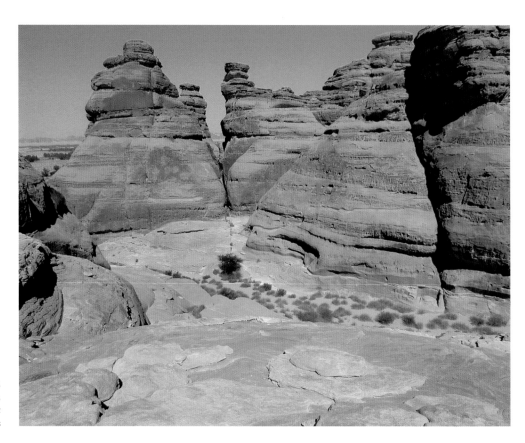

Fig. 12. General view of the wadi running through Jabal Ithlib. On the right, in the red sandstone outcrop, can be seen the groove of the canal cut into the rock to collect the runoff waters

baetyl niches featuring inscriptions occupy the walls of the gorge. One of them is the Jaussen and Savignac inscription no. 39, a religious dedication carved with great attention over a baetyl that the dedicator consecrated to the deity "'A'ra who is in Bosra god of Rabbel" in the year 1 of a king Malichos (fig. 14). Because this baetyl is consecrated to a deity whose main sanctuary was at Bosra (in the south of present-day Syria) it is assumed that the dedicator, a native of that city, was passing through Hegra. Other deities are mentioned in the inscriptions of Jabal Ithlib: Shay''alqawm, "the companion of the tribe", dhu Shara', the principal god of the Nabataeans, and especially Mar Bayta, the "Lord of the Temple", doubtless another name for dhu Shara'.

The excavations carried out in 2008 in Jabal Ithlib[16] have revealed three new banquet halls: one completely cut in the rock, one entirely blocked up and a third one probably combining the two. Other banquet halls may be buried under the sand while temporary installations might also have been set in several spots.

The religious installations of Jabal Ithlib were supplied water from a tank: an underground chamber cut out of the rock wall. It was fed by two rock canalizations: one collected rainwater, the other came from a water reservoir on a dam installed higher up.

After the recent works in this jabal, two remarkable points should be underscored. The first is the importance of the banquet halls and their related installations: baetyl niches and basins. In several cases the signatures of the Nabataeans who frequented the installation are incised on the rock walls bordering it. The absence of religious dedications reveals that these installations are not real sanctuaries: we can doubtless consider Jabal Ithlib as a quarter

**16.** By L. Nehmé; see Nehmé, in Nehmé, Al-Talhi and Villeneuve 2009 [2010], pp. 259–82.

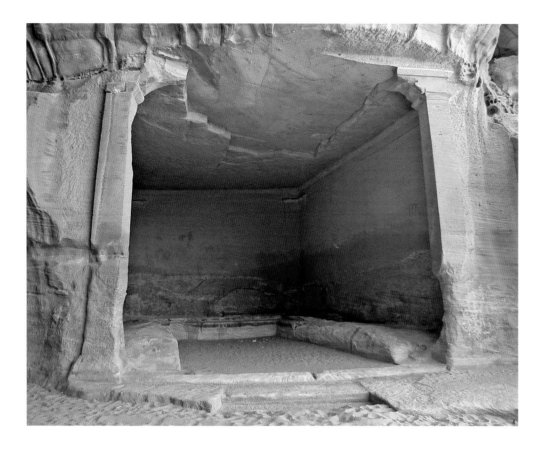

Fig. 13. The large rock-hewn banquet hall at the entrance of Jabal Ithlib, known as the Diwan

reserved for confraternity assemblies, the equivalent of which can be found in Petra as well. The second point: the elements of dating revealed by the excavation – the sounding in the tank as well as the clearing of new banquet halls – show that these meeting places were no longer used after the beginning of the 2nd century AD, that is, far before the rest of the site. Perhaps this desertion should be connected with the annexation of Nabataea and the creation of the Roman province of Arabia. As expression of social cohesion and probably a place of political debate, the confraternities may have been forbidden by Rome, perhaps in the context of a more general prohibition promulgated by Trajan and not specific to this region.

Roman occupation of Hegra is documented in several ways. The first is the presence of at least one inscription dated to the eparchy, that is, the era of the Roman province of Arabia. The second is the attestation in several points of the city outskirts of Greek inscriptions whose authors belonged to the auxiliary corps of the Roman army, notably the *ala Getulorum,* the North-Saharians, and the *ala dromedariorum,* a squad of camel riders. Third, a Greek inscription and a Latin one, which mention elements of the III Cyrenaic legion, are testimony of its activity at Hegra. The Greek inscription, discovered in the 1960s in a Hegra well, mentions a painter from the legion. The second, in Latin, was unearthed in 2003 in the course of the excavations carried out in the city by D. Al-Talhi. The text of ten lines, overall well preserved, is dated between 175 and 177 AD[17] (cat no.121). It indicates that the *vallum* or rampart of the city, had to be restored because of its great age and that the works were paid for by the *civitas* of the people of Hegra. Therefore the city, in the Roman period, was surrounded by a rampart. Was it already there in the Nabataean period? It was: the excavations in 2008 and 2009 on three sections of this wall[18] showed that it was built during

Fig. 14. Baetyl crowned with an inscription (Jaussen and Savignac no. 39) consecrating it to the deity "'A'ra who is in Bosra, god of Rabbel"

**17.** Al-Talhi and Al-Daire 2005.
**18.** Executed by F. Villeneuve; see Villeneuve, in Nehmé, Al-Talhi and Villeneuve 2009 [2010], pp. 151–188.

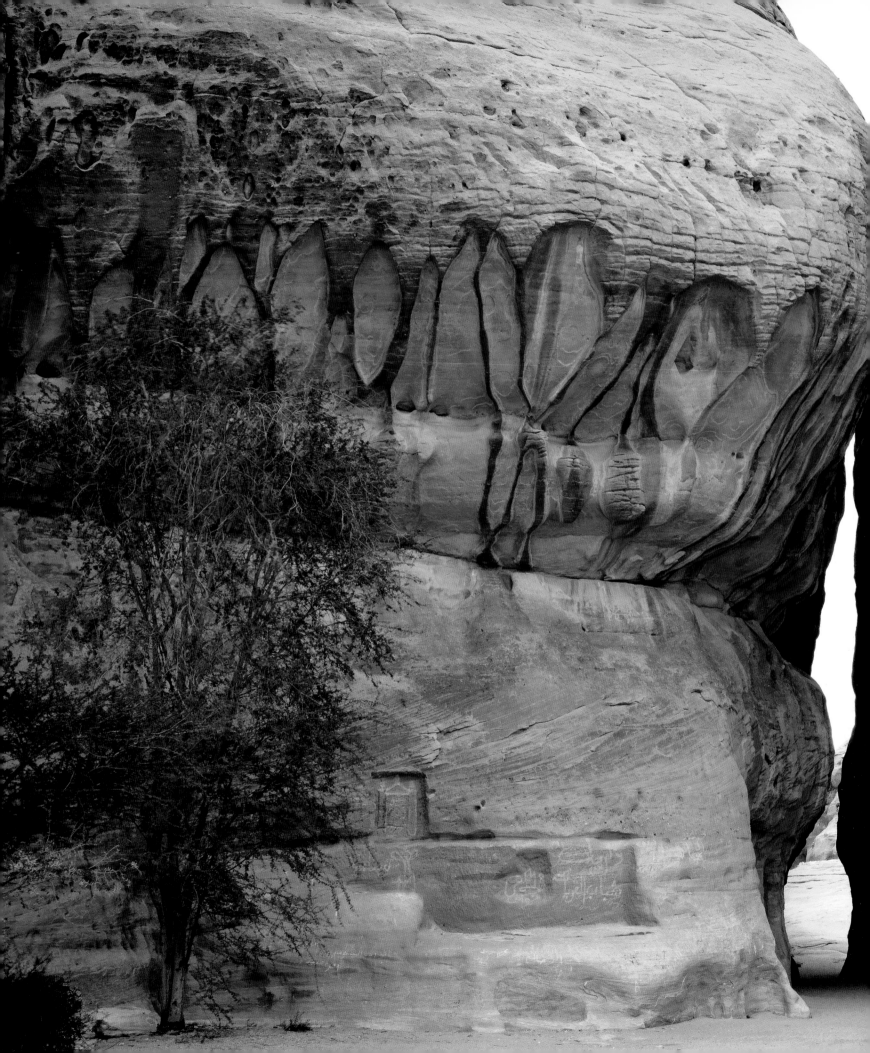

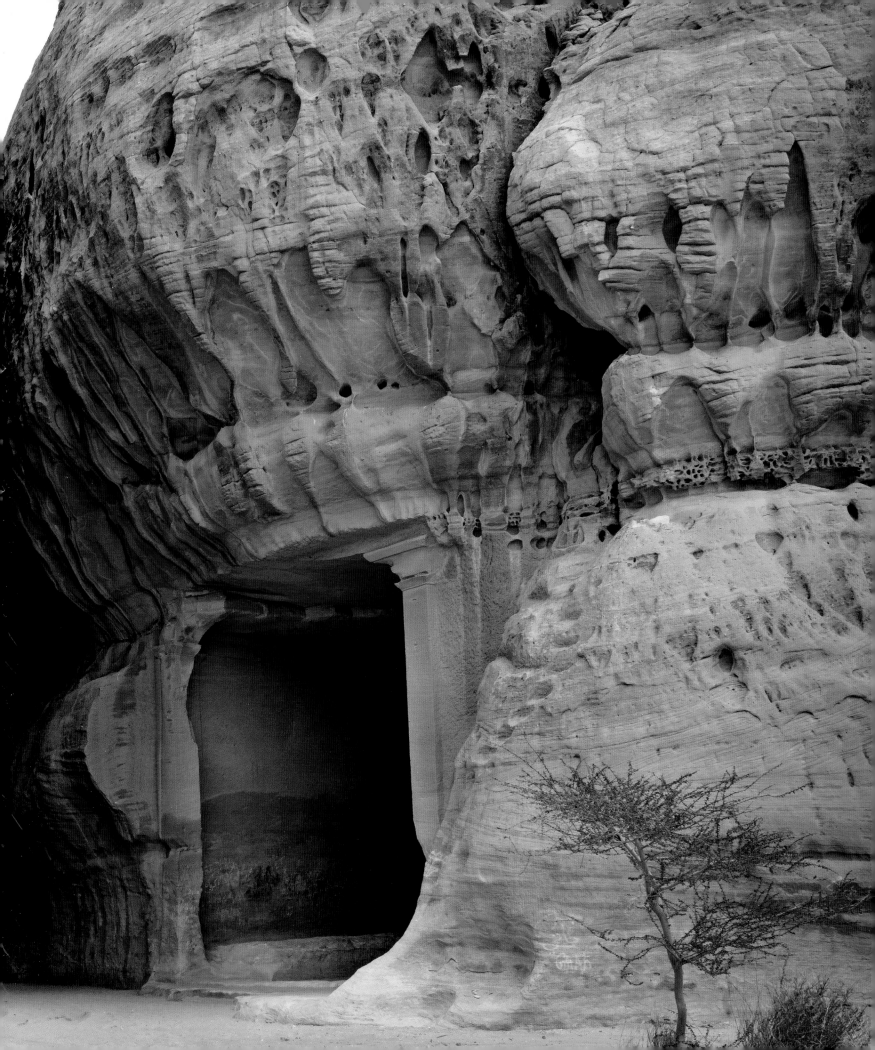

*(preceding pages)*
Banquet hall (the Diwan),
at the entrance to the Jabal Ithlib gorge,
photograph by Humberto da Silveira

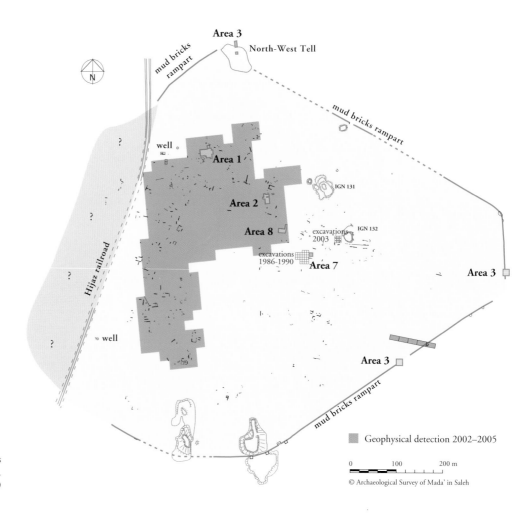

Fig. 15. Plan of the city of Hegra showing its ramparts
and the location of the different excavation zones.
Zones 1 to 8 were excavated in 2008 and 2009

19. Executed under the direction of G. Charloux in
zone 1 (see Charloux *et al.*, in Nehmé, Al-Talhi and
Villeneuve 2009 [2010], pp. 47–82) and by Z. T.
Fiema, J. Rohmer and M. Al-Hajiri in zone 2 (see, in
the same book, their respective reports).

the 1st century AD. This rampart is in mud brick; its thickness varies from 1.50 to 3.8
metres and it does not have foundations. It was obviously built rapidly without much concern for homogeneity and on land which was not entirely bare, as revealed by the small potsherds and charcoals present in the underlying layers of sand. The area it encloses, sixty or
so hectares, was probably never entirely built up. It underwent several repairs and reinforcements but it does not seem to have been of very much use; it became useless after the 2nd
century AD.

The city inside this rampart occupies the central part of the site and forms a vast plain
dotted with scattered sandstone outcrops (fig. 15). It is crossed by the large wadi which traverses the site diagonally, and two *intra-muros* wells supply its water. In addition to the excavations along the rampart and operations started in 2009, three excavations inside the city
have begun to yield results regarding the forms and chronology of its occupation.[19]
Apparently there were two major phases of occupation. A first one in the 1st century BC
has, for the time being, left very faint traces, except in the southern part of zone 2 where
there is an important raw brick construction. A second one begins in the 1st century AD
after the construction of large housing units which underwent successive renovations up to
the 5th century in zone 2, or even the 6th century in zone 1 (fig. 16). Presently the early
Islamic period is represented only by a few sherds and Arabic inscriptions of the first centuries of the Hegira.

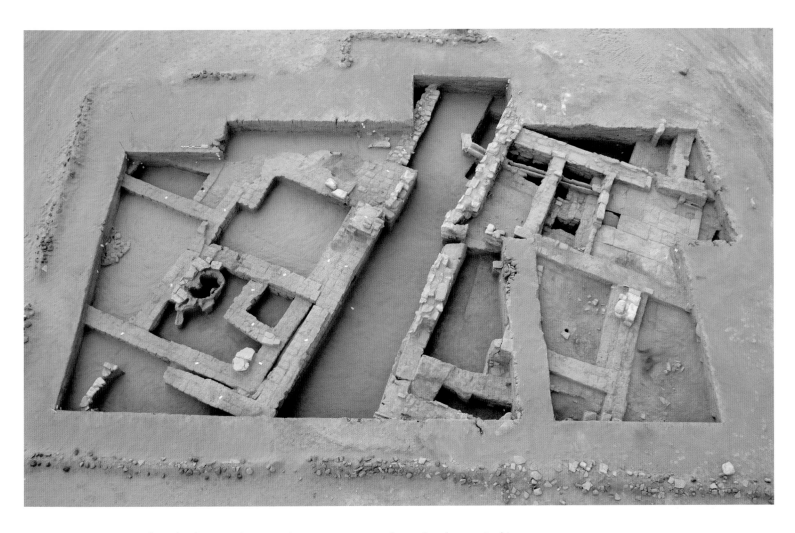

Hegra was certainly a leading station on the caravan route from Southwest Arabia towards Petra and the Mediterranean. Its hydraulic resources and agricultural potential enabled its population, estimated at several thousand inhabitants, to survive in an environment otherwise largely dominated by the desert. The presence of numerous Nabataean officers and perhaps of an epitrope (an administrator) during th Roman period, and the monumentality of the rock vestiges, attest to the importance of Hegra in the Nabataean era and the Nabataean dynasty's interest in it, notably after the reign of Aretas IV (9 BC–40 AD). The vestiges brought to light and the furnishings associated with them are evidence of the contacts which existed with Petra and southern Jordan, naturally, but with South Arabia and southern Mesopotamia as well. The continuity of the occupation, from the 1st century BC to the 6th century AD, as revealed not only in the excavations but also in the inscriptions, notably those written in transition characters between Nabataean and Arabic, makes Hegra a choice site for the study, in this region, of the late antique period, from the 4th to the 7th centuries) – the period of the *Jahiliyya*, the religious ignorance, in the Islamic historiography, about which almost nothing is known.

Fig. 16. Zone 2 after the 2009 excavation campaign. The diagonal street running down the middle separates the buildings constructed in raw brick during the 1st century BC and abandoned in the 1st century AD (on the left) from the structure that developed from the 1st to the 4th century (on the right)

**Bibliography:**
Courbon 2008, pp. 48–70; Dentzer 2009, pp. 143–92 (pp. 156–75 on Hegra); Doughty 1888; Jaussen and Savignac 1909–22; Milik and Starcky 1970, pp. 139–63; Al-Najem and Macdonald 2009, pp. 208–17; Nehmé, Arnoux, Bessac *et al.* 2006, pp. 41–124; Nehmé, Al-Talhi and Villeneuve 2009; Parr, Harding and Dayton 1972, pp. 23–61; Al-Talhi and Al-Daire 2005, pp. 205–17.

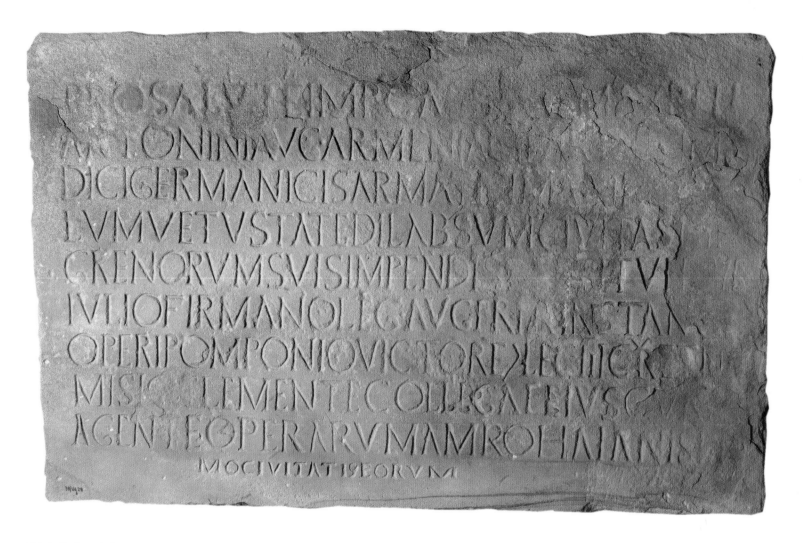

**121. Latin inscription**
175–177 AD
Sandstone
110.5 x 60 x 12 cm
Mada'in Saleh, found by D. Al-Talhi 2003
Mada'in Saleh, 38/W28

Bibliography: Al-Talhi and Al-Daire 2005; Speidel 2007.

( ) expansion of abbreviations or acronyms, { } uncertain but highly probable letters, [ ] restored letters.

*Pro salute Imp(eratoris) Ca{esaris M. Au}reli*
*Antonini Aug(usti) Armeniaci Parth[ic]i Me-*
*dici Germanici Sarmitici Ma{xim}[i] {v}[al(?)]-*
*lum vetustate dilabsum civitas {He}-*
*grenorum suis impendi[s res]{ti}tuit {sub}*
*Iulio Firmano leg(ato) Au(gusti) pr(o) {pr}(aetore) instan[tib(us)]*
*operi Pomponio Victore (centurione) leg(ionis) III Cyr(enaicae) et {N}[u]-*
*misio Clemente collegae eius cu{r}[am]*
*agente operarum Amro Haianis {pri}-*
*mo civitatis eorum.*

("In honour of Emperor Caesar Marcus Aurelius Antoninus Augustus, most great conqueror of the Armenians, Parthians, Medes, Germans, Sarmatians, the city of the Hegrans has restored at its own expense the {rampart?} that collapsed from dilapidation under Julius Firmanus, legate of Augustus propraetor. These works were undertaken by Pomponius Victor, centurion of the Third Cyrenaic Legion, and his fellow Numisius Clemens, responsibility for the construction being assumed by Amru son of Haian, first citizen of their city.")

This stone was discovered during excavations at Hegra, within the city walls at the foot of sandstone hill IGN 132, approximately 200 metres south of the north-eastern section of the ramparts. The slab was not found in its original location, but lying face down in a sector where it must have been reused as masonry material, perhaps several times, in what seems most likely to have been a dwelling of Late Antiquity. The fineness of the stone, a thin rectangular plaque, points to the possibility that the building in which it was originally placed, for which it served as a dedicatory inscription, was built of mud brick, although this is by no means certain. The text is in Latin, making it unique and indeed surprising in Hegra, a city in which the vast majority of texts are in Nabataean and the others are in Lihyanite or, rarely, in Greek. But the involvement of the Roman

army in the construction work mentioned in the inscription explains the use of Latin. The letters are carefully engraved, even though the text was not laid out with any great precision: the last line had to be carved in smaller characters. The Latin is correct but for two errors: *dilabsum* instead of *dilapsum*, and the genitive *collegae* instead of the ablative *collega*. This is not the only Latin inscription found in the Arabian Peninsula nor, by far, the one found furthest south. In particular, two Latin inscriptions from the first half of the 2nd century AD were recently discovered in the Farasan Islands, a Saudi archipelago in the southern Red Sea,[1] and a fragment of an undated bilingual Latin and Greek inscription has been known in Baraqish, in northern Yemen, since the 1970s.[2]

The Hegra document can be accurately dated. Marcus Aurelius was Emperor of Rome. His title already includes Sarmaticus, a distinction that he acquired in early 175. His son Commodus, whose name became associated with the empire during the year 177, is not cited here. Therefore the date must be between 175 and 177. This invites a comparison between this text and a bilingual Nabataean and Greek inscription discovered several decades ago in Ruwwafa, a small locality 200 kilometres north-west of Hegra, indicating that in c. 165, already under Marcus Aurelius, a small temple of the imperial cult was erected by a local confederation, the Thamudeans, a group that might have been an auxiliary unit of the Roman army.[3] Thus it seems that under Marcus Aurelius Rome extended, or re-extended, its military control to the northern Hijaz region, south of the Roman province of Arabia.

This action seems to have followed a period of negligence. In fact, the dedicatory inscription of Hegra testifies to the restoration of a structure that was *vestutate dilapsum* – it had "collapsed" or perhaps even "vanished" due to dilapidation. But what was this structure? This is the only irresolvable question posed by the text. The determinant word begins with three or four nearly illegible letters, at the end of line 3, and ends with *-lum* at the beginning of line 4. The most plausible interpretation is *vallum*, or "defensive structure", which would mean a rampart. However, sounding carried out in 2008 and 2009 in several locations of the rampart built in the 1st century showed no sign of reconstruction in the 2nd century. In addition, the stone was not found on or even near the rampart, but very near the suspected location of a partially rupestrian and partially constructed sanctuary. Consequently, there subsists the doubt that the word actually should read *templum,* or "temple". The involvement in the project of a military corps gives no further clue: in the Roman provinces it was common for the army to engage in the construction of not only military installations but also civil – possibly religious – structures.

This military corps working on the construction under the command of two centurions belonged to the IIIrd Cyrenaic Legion, the legion occupying the Roman province of Arabia. It had its main camp in Bostra, the provincial capital 900 kilometres north of Hegra. Soldiers from this legion had already been present in Hegra, according to sporadic and undated mentions, but this inscription is the first document to indicate any substantial activity on their part in the area. This establishes beyond doubt that Hegra was still part of the Roman Empire in the late 170s, which had not previously been accepted as fact. It is fully confirmed by the dating of the text "under Julius Firmanus, legate of Augustus propraetor", in other words the governor (by implication, of the Arabian province).

Lastly, this document provides information about the institutions of the 2nd century at Hegra. The construction work was carried out by a detachment of the Roman legion, but was financed (possibly under orders from the provincial governor if the structure being restored was indeed the rampart) by *civitas Hegrenorum,* which should be translated literally as "the city of the Hegrans", rather than the vague designation "the community" proposed by the initial publishers of the text. "City" here does not necessarily imply the idea of an entity organized like a Greek *polis* or a Roman town. As the excavations have shown, this was not at all the case of Hegra in terms of its urban characteristics or monuments, nor, as indicated by the end of the inscription, in institutional terms. There were no magistrates here, no administrative presence like the two-man *duumviri,* but a single leader, the *primus civitatis.* This title, which is Latinized here, seems to be a direct translation of the equivalent title in Nabataean, *rash* or *rysh* – "chief", held by the principal leader of the city of Tayma (100 kilometres north-east of Hegra) in 203 AD, according to a recently published inscription,[4] and by the chiefs of Hegra and Tayma in 356.[5] As for the name of the "first citizen" of Hegra in 175–77, Amrus Haianis, it is perfectly local and Nabataean: ʿAmru son of Hayyân. The onomastics of Hegra already indicated extremely weak Romanization and Hellenization. Thus we now know that as late as the end of the 2nd century, fully three-quarters of a century after the Roman annexation of the Nabataean kingdom, even the highest-ranking leader of the city had yet to adopt any kind of Greek, Latin or mixed name.

F. V.

1. Villeneuve 2007, pp. 13–27.
2. Costa 1977, pp. 69–72.
3. Milik 1971, pp. 93–101; Macdonald 1995c.
4. Najem and Macdonald 2009, pp. 208–17.
5. Stiehl 1970, pp. 87–90.

**122. Fabric fragment**
1st–2nd century AD
Fabric
15 x 20 cm
Mada'in Saleh
Al-Ula Museum of Archaeology
and Ethnography, 10U

Piece of fabric folded into several layers, fringed, from one of the tombs of Hegra. It is decorated with a square tapestry medallion in polychrome wool representing a human figure, probably a bearded man, within a frame decorated with volutes. The upper layer of the fabric seems to be plain weave.                P. D. P.

**123. Amphora**
2nd–4th century AD
Ceramic
H. 33 cm; Max. diam. 24 cm
Mada'in Saleh
Al-Ula Museum of Archaeology
and Ethnography, 55

The discovery context of this piece is unknown. It is an amphora with a ribbed globular body. It has a rounded base, a short neck and a lip that flares outward to become nearly flat on top. The ribbed ovoid handles are attached at the top of the body. The neck and lip were warped during firing, leaving the mouth more oval than circular. The clay is grey at the core and orangish near the surface, under a pale green slip. Used for transporting liquids, this container is an example of the utilitarian production of the potters' workshops of Hegra, probably during the Roman or post-Roman period.     F. V.

**124. Nabataean jar**
Early 1st century AD (?)
Ceramic
H. 49 cm; Diam. (rim): 21 cm
Mada'in Saleh, found by the French–Saudi archaeological mission 2008
Al-Ula Museum of Archaeology and Ethnography, MS10067_P01

Bibliography: C. Durand and Y. Gerber in Nehmé, Al-Talhi, Villeneuve 2009 [2010], p. 286 and fig. 3 p. 293.

This small jar for storing foodstuffs (grain?) was discovered during the excavation of a large dwelling. It was found buried under the partially paved floor of a room and covered by a flat stone flush with the floor. Another, larger jar was found buried nearby.

The crude egg-shaped body, which was not turned on a potter's wheel, is irregular. The base is flat with an edge that turns slightly inward. The lip is flat to fit smoothly against the cover, and the rim is underscored by a concave groove. Originally there were three handles attached to the upper half of the body, indicating that this container was initially used for transport. These handles have disappeared, probably broken off when the container was reused as a buried storage jar.

The clay is porous and light brown in colour, with large inclusions of calcite and a few black inclusions. The jar is covered with a light green slip inside and out. It is decorated with three roughly parallel wavy lines of incised dots on the upper part of the body, and a fourth line of the same type on the top of the lip. In addition, between the marks left by the removal of the handles are three relief appliqués of fired clay, which in turn are decorated with small dots. All of the jar's decorative elements, which obviously would not have been visible while it was buried, were conceived for its original purpose as a transport container. This jar is an example of local utilitarian production in Hegra during the Nabataean period.     F. V.

**125. Bowl decorated with a lion**
Post-Roman era (?) (6th century AD?)
Ceramic
Diam. 29 cm
Mada'in Saleh
National Museum, Riyadh, 2246

The discovery context of this piece is unknown. It is a bowl with a broad horizontal rim tapering toward the outside or small deep plate, fashioned from orangish clay and coated with a red slip. The inside of the bowl, a shallow concave section of a hemisphere, is decorated with a painted motif in light pink of a walking lion, its contour highlighted in red. The animal faces left, with one front paw raised and its tail arched above its body. A second motif, barely discernible, seems to appear above the lion to the right. The rim, clay and slip are indicative of the semi-luxury ceramics of the Roman Orient from the 3rd century AD. However, the decoration technique points to much later productions typical of the Byzantine period (or early Umayyad) in the more northern regions of the Middle East, like the Jerash Bowls, found mainly in the north of present-day Jordan and produced mainly in Gerasa (Jerash) in the 6th and 7th centuries. The lion motif has been found on a partially conserved bowl also found in Jerash.[1] It would be interesting to know if this object, conserved in the National Museum, Riyadh, but not found as part of either the scientific Saudi or Franco–Saudi excavations, was actually found in Mada'in Saleh. If that is the case, it would be the only evidence of activity in Mada'in Saleh during the sixth or seventh centuries and also a very interesting testimony to long-distance trading. **F. V.**

**126. Nabataean capital**
Smooth ionic capital of a half-column
1st century AD?
Sandstone
H. 29 cm; L. 41 cm; Th. 20 cm
Mada'in Saleh
Al-Ula Museum of Archaeology and Ethnography, 37/U129

Bibliography: On ionic Nabataean capitals, see Schmidt-Colinet 1983, pp. 307–12, pl. 66–67, with bibliography; McKenzie 1990, p. 117; Gärtner 2003, pp. 156–79 (p. 159, fig. 222,3 and p. 160).

This block was not discovered in position, but in the same excavations as the Latin inscription (cat. no. 121), near sandstone massif IGN 132 within the city of Hegra. It is an appliqué: the rear surface is cut flat. The lower part of the block is a half-column and the upper part is the capital. Given its reduced dimensions, it might have been an ornament for a door or gate. **J. D.-F.**

1. A. Uscatescu, *La cerámica del macellum de Gerasa*, Madrid, 1996, p. 333, fig. 63 no. 272, p. 81, motivo 31 d; also rather than Rasson & Seigne, "Une citerne byzantino-omeyyade sur le sanctuaire de Zeus", *Syria* 66, 1989 (117–51), fig. 8, where the lion is off-centre.

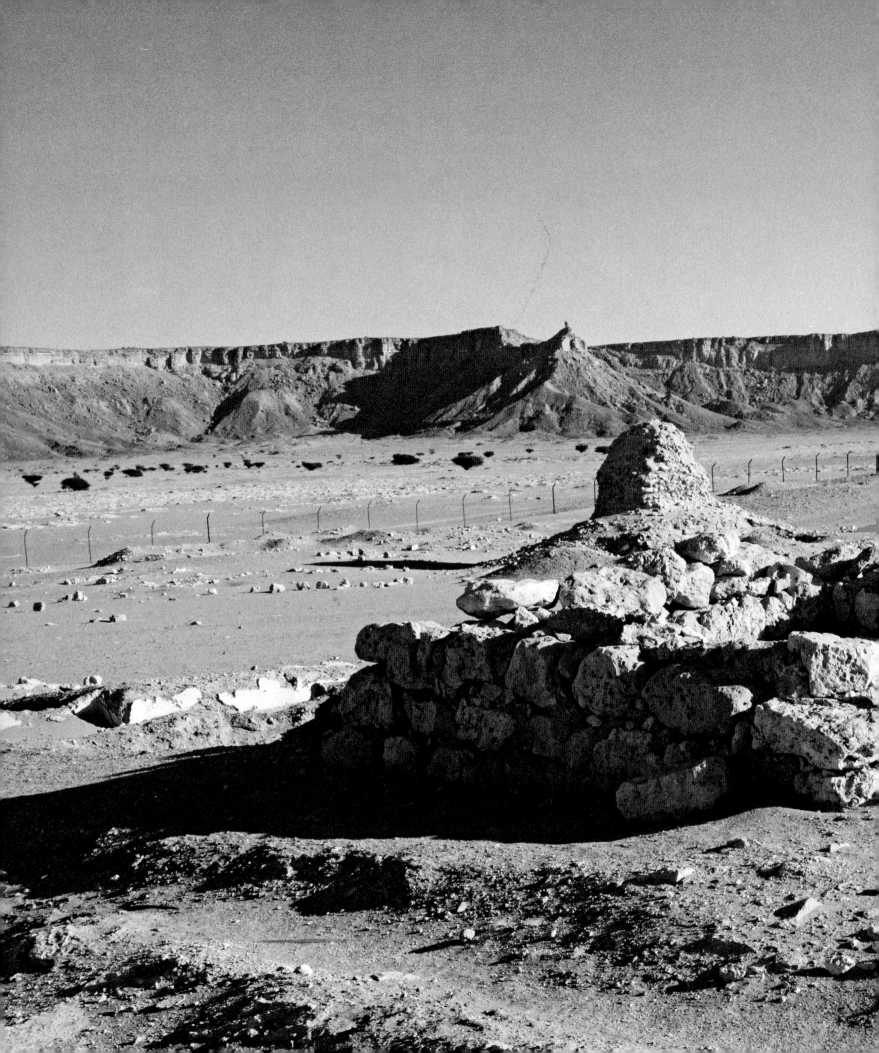

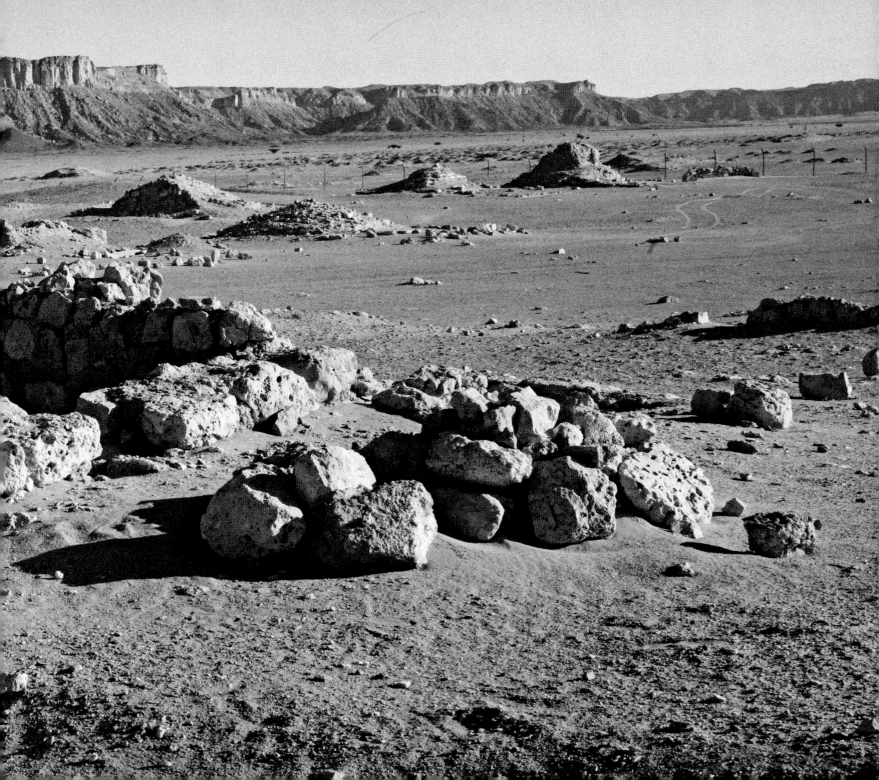

# THE ANCIENT TRADING CITIES
## AT THE HEART OF ARABIA

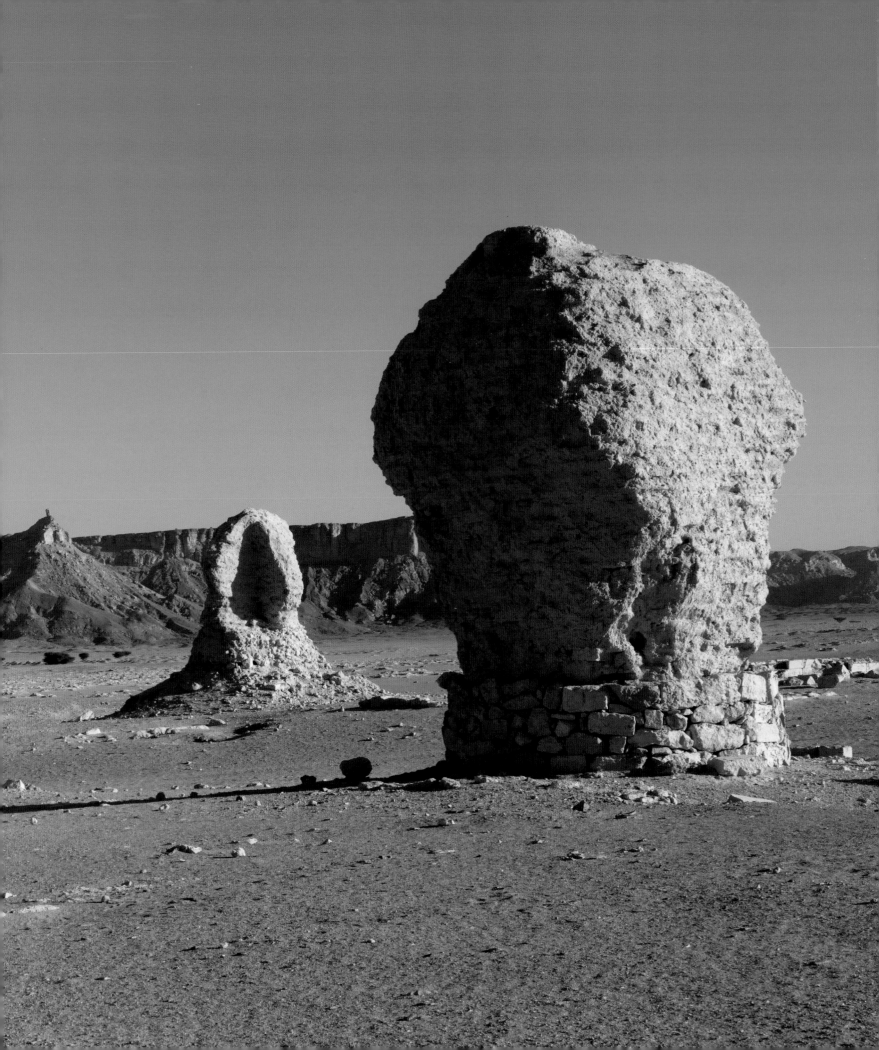

# QARYAT AL-FAW

*Abdulrahman Muhammad Tayeb Al-Ansari*

Qaryat al-Faw lies on the edge of the desert of the Rub' al-Khali, or "Empty Quarter", approximately 700 kilometres south-west of Riyadh. The region is crossed by the Wadi al-Dawasir, which in this place runs between the cliffs of Jabal Tuwaiq through a narrow gorge named "al-Faw".

The first people who became interested in this site were employees of Aramco in the 1940s. Beginning in 1951, Jacques Ryckmans, Gonzague Ryckmans and Philippe Lippens visited Qaryat al-Faw, followed, in 1969, by Albert Jamme. Jamme had been asked by the Department of Antiquities to examine a set of inscriptions discovered at the foot of Jabal Tuwaiq.

In 1967, King Saud University also became interested in Qaryat al-Faw and sent a team from the History and Archaeology Association of its History Department, which began to explore in the region in 1971, with the aim of localizing the site accurately. Digging began in 1972 and lasted three years. The Department of Antiquities then took over and continued the excavation until 2002.[1]

In the South Arabian inscriptions, Qaryat al-Faw is referred to as "Qaryat dhat Kahl". Kahl was the name of the town's god. They also indicate that the kingdom of Saba and dhu Raydan had conquered the town several times; other texts also make reference to these events.[2] These different sources illustrate the importance of Qaryat al-Faw between the end of the 4th century BC and the beginning of the 4th century AD. Its inhabitants described the town as the City of Paradise (in reference to Dhat al-Jnan) or the Red City (Qaryat Talu or Qaryat al-Hamra'). But Qaryat al-Faw had fallen into oblivion until the archaeologists of King Saud University took an interest in the site in 1972.[3]

During the Islamic period, the name of the town was not mentioned except by al-Hamdani.[4] As for Jorge Zaydan, he simply alluded to the people who lived in the Najd as the Qaryanites. Who were the Qaryanites?

The inscriptions (F15-87086) indicate that the al-Sabi, al-Baai, al-Naten and al-Jabal tribes all lived in Qaryat al-Faw. They dug a well and built an altar as an offering to the god

(*preceding pages*)
The site of Qaryat al-Faw,
photograph by Humberto da Silveira

(*opposite*)
Brick towers around the site connected
with the excavation, Qaryat al-Faw,
photograph by Humberto da Silveira.

1. As a whole, the excavation work undertaken at Qaryat al-Faw was directed up until 1995 by Professor Abdulrahman Tayeb Al-Ansari.
2. Such as Jamme pp. 576, 635, 660, 665, or Ryckmans p. 509.
3. They assembled a body of information and wrote different articles on the subject. John Philby published an outstanding article on Qaryat al-Faw in *The Geographical Journal* after visiting the site with Ryckmans and Lippens. Henry Field also published a number of studies on Qaryat al-Faw in the context of the expedition sent by Aramco to make a study of the prehistory of the kingdom of Saudi Arabia.
4. A few lines in his work *Geography of the Arabian Peninsula*.

Aabit. This god was probably the first divinity worshipped at Qaryat al-Faw. The altar, the first cult building in the residential quarter (and the whole of the site) was constructed in the late 4th century BC. The remains of the homes in the residential area and the temple dedicated to the god Shams offer an idea of what the town was like before this period.

Were the al-Sabi tribe and all the other tribes who seem to have been present in Qaryat al-Faw from its origin the first to settle in this region? That hypothesis seems to be confirmed by the excavations, which reveal that the population settled on the site at the start of the 3rd century BC. Their names do not indicate they originated in South Arabia; if that had been the case, rather than call themselves Qaryanites, they would have claimed kinship to better known tribes.

Then where did the Qaryanites originate?

They may have come from a region known as al-Jarha (Gerrha) in eastern Arabia where they controlled the trade route that linked the east and south of the peninsula. If we accept that the name al-Jarha is an altered version of the word "Qaryat", which would have been typical of the period, it would denote that the east of the peninsula was involved in the region's trading activities. The prosperity of Qaryat al-Faw would indicate the economic and peaceful links that existed between the east and centre of Arabia.

Around the middle of the 3rd century BC, the Mineans, who were heavily engaged in the caravan trade, settled in Qaryat al-Faw. One of the members of the Minean tribe of al-Muleyh built a sanctuary as an offering to Athtar Wadd (F8-299), and an inscription made by a man of the al-Maren lineage gives the list of offerings made at Bayt Wadd (F8-271). Another inscription tells us of the offerings made to gods like Athtar dhu Qabd, Wadam Shahr, Nakrah Shiman, Athtar dhu Yuhariq and Athtar Baal Hadath, as well as to Maan and Kahl.[5]

The other names given to Qaryat al-Faw – the City of Paradise and the Red City (Qaryat Talu) – were coined by the Mineans. At that time the palms and greenery must have made the scenery a paradise in the middle of the desert as Qaryat al-Faw, with its red clay palaces, stood at the centre of the oasis. The Mineans were not the only ones to enjoy the exceptional surroundings: the al-Sabi tribe, followers of the god Aabit, and their Lihyanite allies, originally from Dedan, were also present. This fact is confirmed by the discovery of a lintel and funerary stelae with inscriptions in Lihyanite.

This was a new situation in the Arabian Peninsula: the existence of a common trading organization controlled by the Mineans and Lihyanites. The former held the reins of economic power at Qaryat Talu, while the latter contributed to activities that generated economic growth in the region.

Another tribe, the Hanikain Amirain, made its appearance in Qaryanite society. Different versions of the name of this tribe are known.[6] Arguments can be made to associate it with the Ameer tribe that was very influential to the south-east of Rub' al-Khali, or with the Minean tribe of Maren. Was the Hanikain Amirain tribe representative of an alliance between Hanikain and Ameer or between Hanikain and Maren? The first supposition seems more probable as the letter 'n' at the end of the word "Amirain" is simply a conjugation ending.

The Hanikain played a decisive role in the region's development, in particular in the spheres of the economy and architecture. Several palaces were constructed during this period and the organization of the houses and shops was altered to adapt to the commercial development taking place in the town. The Hanikain were also present in Dedan during the first years of the reign of the state of Lihyan.

Discovery of characteristic shards of pottery indicates the presence at Qaryat al-Faw of another Arab population, the Nabataeans, between the 1st century BC and 2nd century AD.

5. Kahl is mentioned for the first time in a text found at Qaryat al-Faw.
6. One version was declined differently in the feminine and masculine forms, in the first part of the name only.

Inscriptions in two different scripts (South Arabian and Nabataean) and funerary stelae provide confirmation, but the poor quality of the Nabataean writing suggests that the Nabataean community at Qaryat al-Faw had no great writing skills.

In the mid-2nd century AD, another constituent of Qaryanite society made its appearance: the Ghalwan, whose name is mentioned on several funerary stelae. Ijil ibn Hofi 'amm of the Ghalwan lineage (cat. no. 130) and another individual buried with a camel were among the most influential members of this clan. It is also supposed that there was a connection between the Ghalwan and king Mu'awiya bin Rabi'a.

The funerary inscription of Mu'awiya, son of Rabi'a, king of Qahtan, of the lineage of Maytha, raises many questions as it is the only one that mentions a king in Qaryat al-Faw (see fig. p. 94). Other texts instead cite the kings of Hadramawt and Hamir or king Abdi of Saba. Mu'awiya did not bear the title of king of Qaryat al-Faw but that of king of Qahtan and Madhhij, and to this day this is the only mention made of these countries at Qaryat al-Faw. This may signify that Mu'awiya died in Qaryat al-Faw while he was passing through, and was buried there. His tomb is crowned by a Nabataean- and Palmyrean-style monument that features a few lines of inscription and a headless statue carved in the upper section, which probably represents a Roman king. These elements argue that Mu'awiya was a king of the tribes of Qahtan and Madhhij at Qaryat al-Faw. Though the rest of the text gives no indication of the place he ruled over, it confirms his relationship with Maytha and Qahtan, his tribe of origin.

As the Ghalwanites represent the second period the site was occupied, it can be assumed that Mu'awiya and his descendants belonged to the same period, which began in the 2nd century AD.

The South Arabian texts that record the invasion, destruction and pillage of the town attest the existence of a new political system in Qaryat al-Faw. The inscriptions of Sha'r Awtar describe the defeat of Rabi'a of the line of Thawr, king of Kinda and Qahtan, who had his base at Qaryat dhat Kahl. We note, not without surprise, that this last expression is a different name for Qaryat al-Faw from the one given to the town by the Mineans, and that it associates the town with its god Kahl.

Its king, referred to as the "king of Qahtan and Madhhij", had moreover called his son Rabi'a bin Mu'awiya of the lineage of Thawr, king of Kinda and Qahtan.

How can this link with the lineage of Thawr be explained? These two texts recording the Sabean campaigns date from the first quarter of the 3rd century AD, and both allude to the kingdom of Kinda as coming before the kingdom of Qahtan. It is not known, however, why the texts disregard Madhhij.

Another text from the mid-3rd century refers to "Malik ibn Budd" as king of Kinda and Madhhij, thus ignoring Qahtan completely. And then a text from the time of Ilisharah Yadub and his brother Yazil, kings of Saba and dhu Raydan, refers to Malik as being king of Kinda only. Kinda's dominant political position at that time might have given it the chance to reign over Qaryat dhat Kahl.

Arab genealogists make no distinction between Kinda and Madhhij, and do not associate Qahtan with them. In fact, the kingdom of Kinda had been formed by a number of tribes who had come from the south of the peninsula. During the 3rd century AD it managed little by little to monopolize power in Qaryat al-Faw and the surrounding area. However, an inscription has been found belonging to Imru' al-Qays al-Mandhiri that enumerates the tribes that he knew and describes his flight from Madhhij. Did he pass through this town close to "Qaryat dhat Kahl" or another region close to Najran? Whatever the answer, the inscription demonstrates that the town had declined by the start of the 4th century AD.

The power of the kings of Kinda became progressively weaker before they joined up with the troops of Himyar. Kinda is mentioned much later, in the 5th and 6th centuries AD, in inscriptions discovered in Wadi Ma'sal[7] and in one of the inscriptions engraved for Abraha[8] (Abyssinian king of Yemen in the first quarter of the 6th century). The latter document records the critical role played by the Kindites in various expeditions and military attacks.

Arab sources refer to the presence of a kingdom of Kinda at the centre of the Arabian Peninsula but without specifying all the towns and cities that belonged to it, such as Ghamr Dhi Kinda near Taif and other places mentioned in the poems of Imru' al-Qays. Lastly, these texts signal the presence of Kinda in Persia and at Dumat al-Jandal, as well as the relationship it maintained with the Byzantines.

With the advent of Islam, Kinda was a member of the delegations that visited the enlightened city of Medina to recognize the Prophet, even though Qahtan seems to have fallen into oblivion in the 3rd century AD.

Qaryat al-Faw owed its importance to its strategic location on the caravan routes that linked South Arabia to the north-east of the peninsula, the shores of the Arabian Gulf and Mesopotamia, and also to the north-east, towards the Hijaz and countries of the Levant. An economic, religious, political and cultural centre at the heart of the peninsula, Qaryat al-Faw was an influential city, particularly during the early years of the powerful kingdom of Kinda.

Plan of the market at Qaryat al-Faw

## The site

More than one hundred and twenty wells have been discovered. They were made easier to dig given the position of the town on the edge of a wadi that flooded periodically. The large number of pits reveals that the inhabitants were farmers and sedentary stock breeders. Channels allowed them to direct the water to the heart of the oasis where palms, vines and various cereals were grown. The trunks of palms and other trees were used to make the roofs of the houses, while planks made of local or imported wood were used for doors and windows and household tools, such as combs. Animal breeding was an important activity: the inhabitants owned herds of cattle, sheep, goats and camels, and used their manure to fertilize the fields.

Qaryat al-Faw was an unprotected town: no wall or fortress has been discovered. It was an easily accessible trading town and a staging point for travellers, merchants and pilgrims from the different kingdoms of Arabia. To the east of the town Tuwaiq cliff provided a natural defence. The residents constructed several large gateways on the north, south and west sides of the town.

During the wars that they fought, the inhabitants of Qaryat al-Faw made use of horses, as is attested by wall paintings and bronze figurines. Their weapons were swords, spears, longbows and crossbows.

The building walls were constructed with sun-baked brick but the foundations, tombs and funerary towers were all made of cut stone. The filler used was made from a mixture of plaster, sand and ash.

### The market

The market lay to the east of the residential district, on the west bank of the wadi that separates Tuwaiq cliff from the edge of the town. With a length of 30.75 metres running east-west and a width of 25.2 metres north-south, the massive enclosure wall was composed of three parts: the central section built from limestone blocks, and the internal and external facings

7. Ryckmans 509–10.
8. Ryckmans 506.

made from sun-baked brick. This sturdy three-storied construction was equipped with seven towers. The only entrance, on the west side, was a small door that opened onto the central court where a very deep stone well had been dug. This courtyard was traversed by a water channel and lined by rooms, stores and shops.

### The temples

Three temples and an altar have been found at Qaryat al-Faw. Two are situated to the west of the market. South Arabian inscriptions have revealed that the earliest was dedicated to several divinities, of which one was al-Ahwar.

The remains of the second temple attest the religious nature of this part. This large temple probably knew two major periods. In the first it was dedicated to the god Sin, in the second to Shams. South Arabian inscriptions refer to the building of a sanctuary dedicated to the gods Shams and Athtar.

The third temple, consecrated to the god Athtar Wadd, was discovered in the residential quarter of Qaryat al-Faw. Unlike the first two, this temple is very well preserved and differs from other sanctuaries in the region by its better-balanced plan. Its architecture, internal decoration and inscriptions carved on the walls make reference to the god dhu Ghabat of the kingdom of Lihyan.

A limestone altar dedicated to the god Aabit stood to the west of the residential district, close to a large courtyard where a well was consecrated to Aabit and Kahl.

### The necropolises

Qaryat al-Faw stands out for the diversity of its types of tombs, which correspond to the different periods during which the site was occupied. Family and collective tombs were reserved for the town's most important residents, who were members of the upper classes or of high political ranks; for instance, the tombs of king Mu'awiya bin Rabi'a and Ijil ibn Hofi 'amm, both of which lay on the west side of the town. Another tomb, that of Ma'sad ibn 'Arsch, was built in the tower section. Its discovery near a tower has revealed some of the characteristics that distinguished graves and funerary stelae, which were prevalently dug out of the rock at the back of family cemeteries. The public cemeteries to the north-east of the city were the burial grounds for the less fortunate citizens of the town. They are similar to Muslim cemeteries, consisting of an irregularly shaped terrain between one and five metres in depth, which has remained practically unchanged nor been covered with lime. A mausoleum stood at the highest point of the cemetery.

### The residential quarter

This is one of the largest districts in Qaryat al-Faw. Excavation of this zone has enabled us to know more about the daily life of the inhabitants of the kingdom of Kinda. The site knew three major periods of occupation.

The huge houses[9] in the residential district were served by many streets and lanes. All the buildings were characterized by the care with which they were constructed and the thickness of their walls. These could be up to 1.8 metres in width and were made of stone blocks. South Arabian inscriptions on the blocks demonstrate that they were brought from another site. The doors and house frames were made of wood. Almost all the houses had a floor reached by stairs (the shell of the stairway was used as a storage place and for grinding grain). They were equipped with a system of water supply and outdoor pits for waste. We can also suppose that latrines existed on the upper floor.

The market

The market reconstructed in 3D

9. The largest measure 10 x 3 metres.

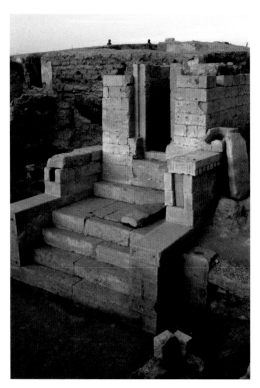

The Wadd temple, Qaryat al-Faw

## The inscriptions

Inscriptions discovered on the rock walls at the foot of the mountains near Qaryat al-Faw, on the market walls, in the temples and on paintings have helped to shed light on the world of the Qaryanites. Many have been found in the residential quarter and burial zone. Ceramic objects were also used as a writing surface. All the inscriptions were engraved in an Arab script identified as the South Arabian style that took a different form in Qaryat al-Faw from other regions in the south of the peninsula.

The spoken language in this region was a blend of the languages of the North and South. The writings dealt with such subjects as religion, trade and the relations between the inhabitants. There are also the names of gods and tribes, and family names that indicate the links that existed between Qaryat al-Faw and certain kingdoms in the Arabian Peninsula namely the Nabataeans and the Lihyanites. Inscriptions in two different scripts (South Arabian and Nabataean) have also been found, and, in the residential quarter, in Nabataean only. There are also texts in North Arabic mentioning the Lihyanite god dhu Ghabat, which are indicative of the existence of a Lihyanite community in Qaryat al-Faw.

## Wall paintings

A large number of wall paintings that differ greatly from one another have been found in Qaryat al-Faw. This form of figurative art knew four principal periods.

In the first, the artists initially engraved images featuring camels, horses, humans, war scenes, parties, ceremonies and types of vegetation, especially palms, on the rock walls at the foot of the mountains. Later, designs were incised in the mortar of walls inside homes.

Then the inhabitants asked the artists to portray scenes of daily life in black and red so as to bring out the details of the pictures. Coloured frescoes are caracteristic of the fourth period.

## Statues

Fragments have been found of high-quality statues made from a variety of materials: bronze, stone, clay and ceramic. The bronzes represent human figures or the limbs of humans or animals, while the statues of clay seem to be human figurines that were probably used as children's toys. Statuettes made of ceramic are few in number: an engraving on ceramic has been found depicting the face of a man with a long beard, wearing a sort of bonnet with two plaits that hide his ears.

## The materials used to make everyday objects
### Wood

Wood was used in the construction of houses and the fences around the market, and also in tombs. Because it is a perishable material, only a few wooden objects have been found: combs, a small pot used for grinding grain, and a rectangular piece of wood bearing two trays that may have been used as a scale.

### Bone and ivory

Camel bones were used as a surface on which South Arabian texts were written in black and red ink. Ivory was used to make bracelets, rings, buckles and other ornaments and jewels.

### Textiles

Fabrics have been found in Qaryat al-Faw made from linen, sheep's wool and camel hair, some

were clothes and others saddle rugs for the camels. Paintings of figures in loose-fitting, richly adorned clothes (cat. nos 161 and 162), and the presence in the houses of tools for making textiles attest widespread weaving skills (cat. nos 209 to 216).

## Metals

Excavations have unearthed metal vases (cat. no. 174), inscribed plaques (cat. nos 135 and 136) and fragments of statues of human and animal figures (cat. nos 147, 150 to 158, 170). There are also knives, needles, dagger sheaths, keys, saddle trees, kohl spatulas, bracelets, weights and lamps.

## Coins

The many silver and bronze coins found, in particular in houses, are evidence of the town's wealth. They are of different size and bear the name of the Kinda god, Kahl, on the obverse. The reverse shows either a standing or sitting figure surrounded by South Arabian letters (cat. no. 220).

## Jewellery

Jewels are relatively rare in Qaryat al-Faw (cat. nos 177 to 182). Most of them are bracelets – metal, glass, ivory or bone – decorated with elegant motifs. A few silver, copper or iron rings have been found, as well as many glass beads, and decorative objects like bronze hairpins, small and large bronze needles, copper kohl spatulas and settings for rings.

## Glass

Glass was used in the manufacture of vases, small bottles to hold perfumes or other cosmetic products[10] (cat. nos 189 to 198), bracelets, decorative objects, rings and beads.

## Stone

The stone ware was made of local stone but also of imported ones, such as basalt and soapstone. Grindstones, offering tables, perfume burners (cat. nos 137 to 145), basins and funerary stelae (cat. nos 127 to 130, 133 and 134) are the principal stone objects made that have been discovered.

## Pottery

Ceramic ware is abundant on the site. Some of the vases were thrown on a wheel, others without. Some shards bear inscriptions, usually invoking Kahl, the god of Qaryat al-Faw. There are three types of ceramic: coarse, fine and enamelled.

Containers for daily use were made from coarse clay; this has also been found in temples, tombs, houses and the market. Cooking pots, jars, vases, colanders and lids were made from coarse ceramic as well.

Fine ceramic was made with a smooth clay that allowed decorative motifs to be incised. A large number of red-clay Nabataean plate shards, painted with black and orange motifs, has been found on the site (cat. no. 206).

Several enamelled ceramics have also been uncovered such as plates and carafes decorated in different ways: for example, vertical lines and plant motifs in either high or low relief. The paste, the porosity of which varied depending on the ceramics, was probably yellowish; the glaze was mostly green and blue (cat. nos 199 to 202 and 204).

10. The vases and bottles are often very fragmentary.

**Bibliography**
Al-Hamdani 1977; Al-Ansari 1982; Al-Ansari *et al.* 2003.

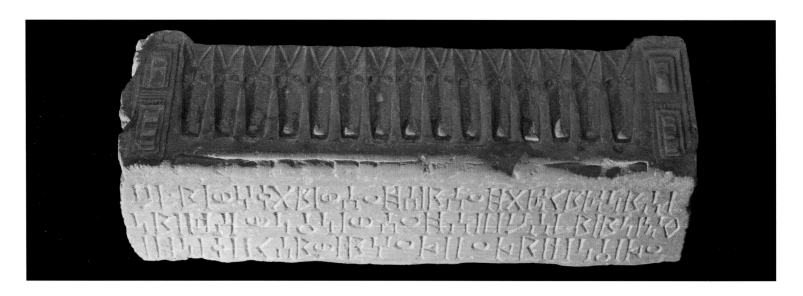

## 127. Architectural element

1st century BC
Limestone
59 x 17 cm
Qaryat al-Faw
Department of Archaeology Museum, King Saud University, Riyadh, 3 F 12

1    ...n qbr-hmw Ms¹'d G'dᵐ bny D'=
2    nm ..wnyn w-h'ḏ-h b-Khlᵐ mn 'f=
3    klᵐ w-s¹qtᵐ w-h'ḏ-h m-h'ḏt ...

1    ... their grave Mas'u–d Ga'dᵘᵐ son of
2    Da'nᵘᵐ ... They entrusted it to Kahlᵘᵐ against every priest
3    and minister of the cult and they entrusted it...

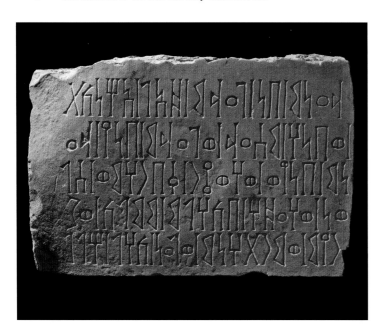

The inscription in Sabaic is dated to the 1st century BC; it was commissioned by inhabitants of Qaryat and not by Minaeans, as their name and deity's name indicate (cat. no. 128). The inscription is engraved on a re-utilized architectural component of a temple.

**C. R.**

## 128. Inscribed slab

c. 1st century BC
Limestone
67 x 44 x 12 cm
Qaryat al-Faw
Department of Archaeology Museum, King Saud University, Riyadh, 2 F 12

1    D'nᵐ bn G'dᵐ ḏ-'l 'hnkt
2    /w-bn-h Ms¹'d w-G'dᵐ bny D'=
3    nᵐ bnyw w-hwṭr qbr-hmw S¹l=
4    wⁿ w-h'ḏ-h b-Khlᵐ m-mlk w-s²=
5    rym w-mrthnm w-l'n Khl ḥll

1    Da'nᵘᵐ son of Ga'dᵘᵐ, of the Aḥnikat clan
2    and his sons Mas'u–d and Ga'dᵘᵐ, son of Da'nᵘᵐ
3    built from the foundations their Sil-
4    wān tomb and they entrusted it to Kahlᵘᵐ against every owner, purchaser
5    and moneylender. May Kahl curse whoever would appropriate it

The inscription is in Sabaic with a few distinctive local features. Its authors belong to the leading clan of the oasis, the Aḥnikat. The deity involved, Kahl(um), is the major god of the oasis.

**C. R.**

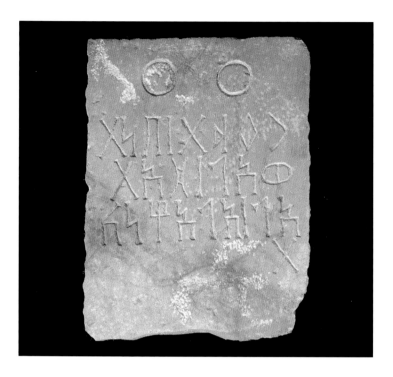

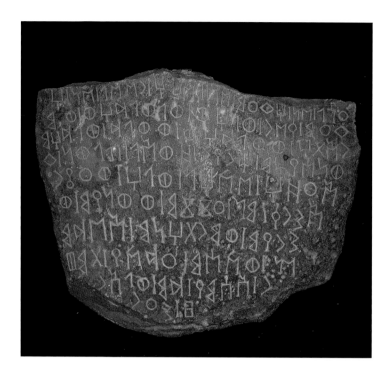

**129. Eye-stele**
5th–4th century BC (?)
Limestone
37 x 36 x 16 cm
Qaryat al-Faw
National Museum, Riyadh, 3 F 23

| | | |
|---|---|---|
| 1 | *R(t)dt bnt* | Rathidat daughter of |
| 2 | *W'l (d)'t* | Wâ'il, of |
| 3 | *'l 'l-'ḥnk* | clan of al-Ahnikat |
| 4 | *(t)* | |

(transcription C. R.)

This funerary stele citing the name of a female deceased of the tribe of the Hanikat is surmounted by two incised round eyes. The connection with Nabataean eye-stelae, which are posterior, is probably owed to a common cultural strain belonging to all of Arabia rather than any kind of influence of the North-Arabian populations in South Arabia.                                          **M. C.**

**130. Funerary inscription**
Late 1st millennium BC
Limestone
60 x 48 x 13 cm
Qaryat al-Faw
National Museum, Riyadh, 887

Bibliography: Ghoneim, 1980, ill. 11 ; Al-Ansari, 1982, p. 146 ; Robin, 1991b, p. 116.

| | | | | |
|---|---|---|---|---|
| 1 | *'gl bn Hf'm bn l-'h-h Rbbl bn H=* | | 6 | *'-s²rq mn 'zz^m w-wny^m w-* |
| 2 | *f'm qbr w-l-hw w-l-wld-hw w-m=* | | 7 | *s²ry^m w-mrthn^m 'bd^m* |
| 3 | *r't-h w-wld-hw w-wld wld-hm* | | 8 | *bn wks^{1m} 'd-ky tmt=* |
| 4 | *w-ns¹y-hm ḥryr ḏw-'l Ḡlwn f-* | | 9 | *r '-s¹my dm w-l-r=* |
| 5 | *"ḏ-h b-Khl w-Lh w-'ṭr* | | 10 | *ḍ s²'r* |

"'Ijl son of Hofi'amm built for his brother Rabib<'>il son of Ho- ² fiamm <this> tomb, as for him, for his children, for his wife ³ for her children (hers), for their grandchildren ⁴ and for their wives, nobles of the lineage of Ghalwan. Then, ⁵ he entrusted it to Kahl, to <Al>lah, to 'Aththar ⁶ to <sh>-Shariq against anyone mighty or weak, ⁷ purchaser and money lender, everlastingly, ⁸ against every damage, as long as ⁹ Heaven shall give rain and the Earth ¹⁰ be covered with grass."

This inscription warning whomever would come and damage the family grave is the oldest attestation of the use of Arabic, but the script is South Arabian. Two other Qaryat al-Faw texts, more lacunar, are also written in Old-Arabic,[1] the rest of the corpus transcribes an idiom combining South Arabian and Arabic.                          **M. C.**

1. Robin 1991b, pp. 114–15.

319

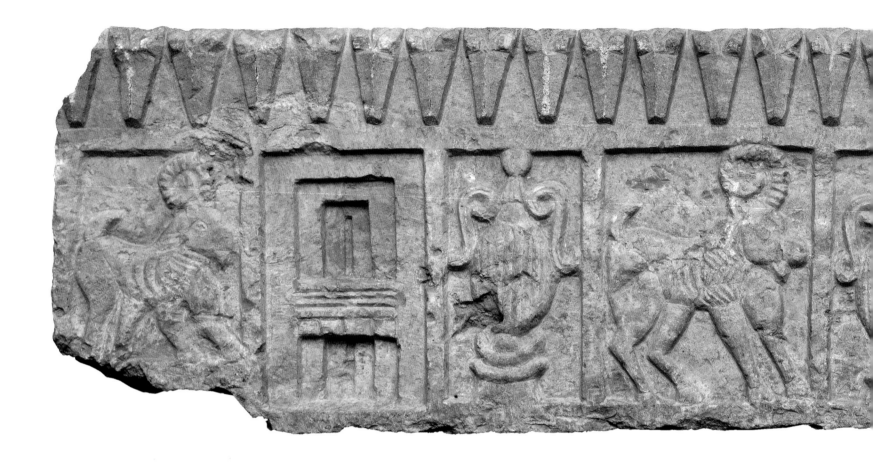

**131. Lintel fragment**
3rd century BC–3rd century AD
Limestone
21 x 90.5 x 18 cm
Qaryat al-Faw
Department of Archaeology Museum, King Saud University, Riyadh, 15 F 12

This architectural element is carved in low relief with motifs of ibexes, canthari, blind windows, topped by a frieze of stylized ibex heads. The cantharus is a motif already illustrated on a capital of the palace of Shabwa where it is associated with Palmyran and Parthian iconographic styles.[1] This décor is an astonishing combination of local traditions and Graeco-Roman and Eastern traditions. **M. C.**

1. Paris 1997, p. 114

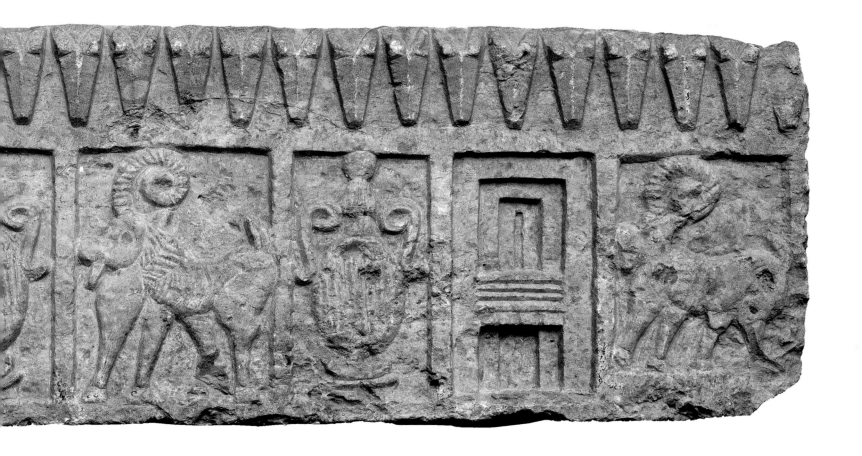

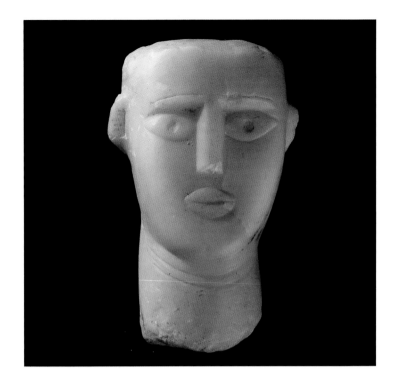

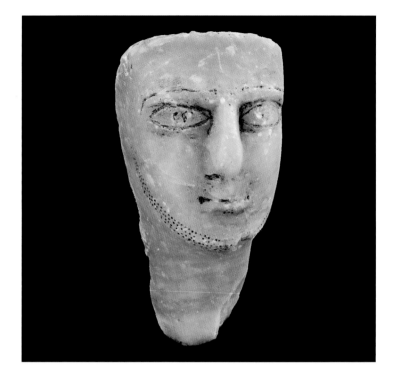

**132. Head of a Woman (?)**
3rd century BC–3rd century AD
Calcite-alabaster
21 x 13 cm
Qaryat al-Faw
Department of Archaeology Museum, King Saud University, Riyadh, 50 F 11

This round head is erect on a long neck, the folds of flesh marked by incised lines. The details of the face are sketchy: big eyes with deeply emphasized pupils, a quadrangular nose and curved lips. The top of the skull is missing because as was very often the case, the hair was probably inlaid.

The stone most frequently used for sculpture is a calcite-alabaster appreciated for the delicacy of its grain and its translucent blonde colour. According to the information provided by the *Periplus Maris Erythrea*, a 1st-century AD Greek navigation handbook, this stone known under the name of *mwglm*[1] was exported from the port of Mouza on the Red Sea.           **M. C.**

1. Garbini 1974, p. 296.

**133. Head of a Man**
3rd century BC–3rd century AD
Calcite-alabaster
23 x 12 cm
Qaryat al-Faw
Department of Archaeology Museum, King Saud University, Riyadh, 1 F 10

Alabaster heads of the dead are very common in South Arabia; it is assumed they were set in small cubic bases or in niches hollowed in the funerary stelae bearing the name of the deceased. The jawline beard, eyes and eyebrows of this masculine face are highlighted with black paint. The top of the skull is missing because the hair was probably made of a different material.           **M. C.**

**134. Stele representing a man with a dagger**
1st–3rd century AD
Calcite-alabaster
57 x 30 cm
Qaryat al-Faw
Department of Archaeology Museum, King Saud University, Riyadh, 70 F 15

The effigy, treated in the round, stands out against a smooth background; the man has short hair, a thin moustache and a beard. He wears a long tunic with vertical stripes held by two straps and carries a short grooved sword at his belt. It can be compared to early AD stelae from Jawf which display men in warlike attitudes wearing the same garb.[1]           **M. C.**

1. Arbach and Audouin 2007, no. 62, p. 95 and no. 59, p. 92; Paris 1997, p. 208.

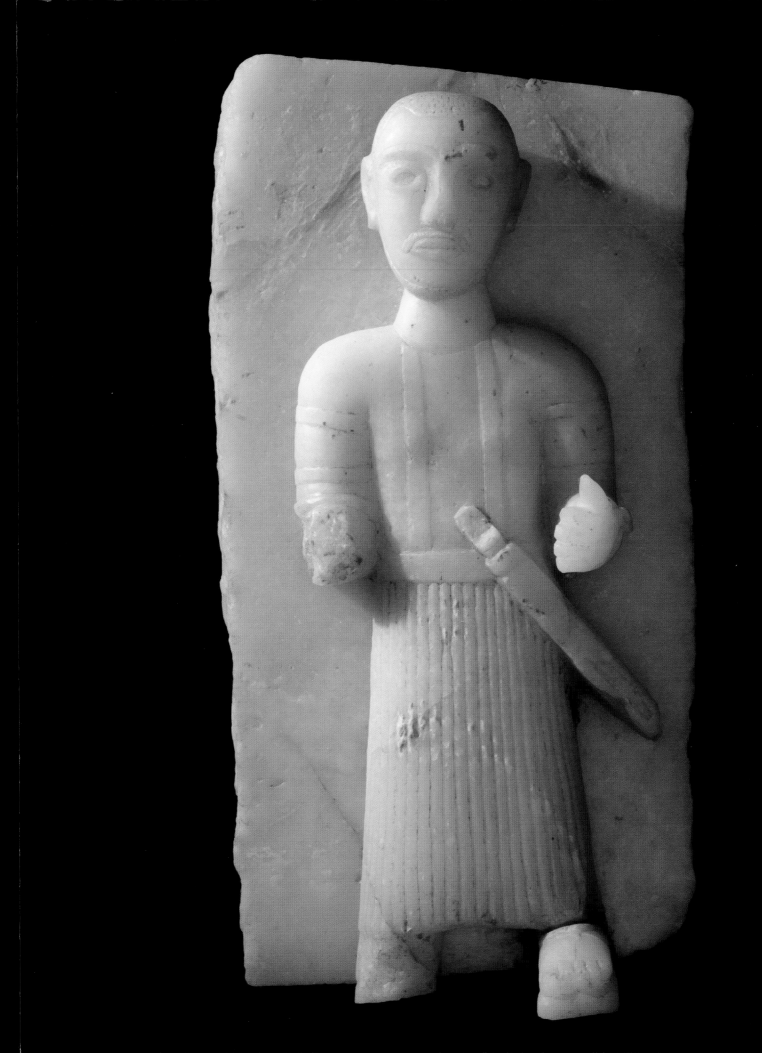

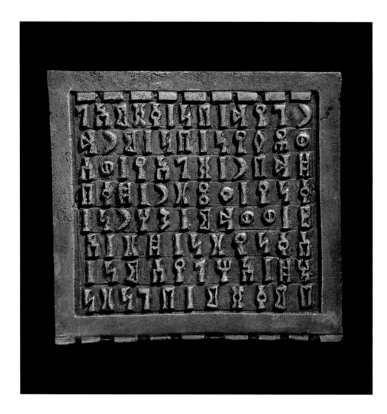

**135. Inscription in Ma'inic**

c. 3rd–2nd century AD
Bronze
17.5 x 15.5 cm
Qaryat al-Faw
Department of Archaeology Museum, King Saud University, Riyadh, 262 F 8

| | | |
|---|---|---|
| 1 | Rgyd bn Qs³m'l | Rugayd son of Qasama'il |
| 2 | w-Sfyⁿ bn Mrd | and Sufiyān son of Murād |
| 3 | d-Dbr s³l'y w-s¹= | dhu-Dabr dedicated and of- |
| 4 | qny 'ttr d-Qb= | ferred to 'Athtar dhu-Qabd |
| 5 | d w-Wdᵐ S²hrⁿ/ | and Waddᵘᵐ Shahrān |
| 6 | s¹qnytⁿ dt '= | this offering taken |
| 7 | hd 'hly-s¹mn/ | off their wares |
| 8 | b-mqs³m b-Gntn | at the market in the Oasis |

The plaque commemorates an offering to the two principal deities of Ma'in. The authors are Minaeans, as indicated by the name of their clan, Dabr, found at Baraqish (Yemen). **C. R.**

**136. Inscribed plaque adorned with ibex**

c. 1st century BC or 1st century AD
Bronze
62 x 34 cm
Qaryat al-Faw, Temple of Wadd
Department of Archaeology Museum, King Saud University, Riyadh, 302 F 8

[One line missing]
1  ny Wd't d-Mrn 'dm Wdᵐ
2  S²hrn s³l' w-s'qny 'ttr
3  d-Qbd w-Wd S²hr(ⁿ) w-Nkrh S²=
4  ymⁿ w-'ttr d-Yhrq w-'tt=
5  r b'l Hdt w-kl 'l'lt M=
6  'n s¹qnyt dhbⁿ b-Gntⁿ/
7  b-Qryt Tlw b-hdyht w-'k=
8  rb 'hd 'hly-s¹m ns²'-h k-
9  Nhr 'd S¹lky w-gb'-h 'd
10  Qryt w-Qrnw f-l t's¹m 'dn
11  d-Qbdᵐ w-'l'ltⁿ k-d-yktrb-s¹m
12  w-rtd 'hl Mrⁿ d-Qbd w-'l=
13  'ltⁿ 'nfs¹-s¹m w-'hh-s¹m w-w=
14  ld-s¹m w-qny-s¹m f-l ys¹m'-s¹m

[One line missing]
1  [s]ons of Wa– di'at dhu-Marrān, servants of Waddᵘᵐ
2  Shahrān, dedicated and offered to 'Athtar
3  dhu-Qabd, Wadd Shahrān, Nakrah the Pa-
4  tron, 'Athtar dhu-Yuhāriq and 'Athtar
5  master of Hadath and all the deities of Ma-
6  'i-n the bronze offering in the Oasis
7  at Qaryat Talaw, with the gifts and the taxes
8  taken off their wares, which they carried away for
9  (the Land of) Nahar (?) to Seleucia and brought back to
10  Qaryat and Ma'īn. May the protection of
11  dhu-Qabdᵘᵐ and the deities for whom they pay taxes be oft repeated.
12  the Marrān clan entrusted to dhu-Qabd. and the deities
13  their persons, their brothers, their children
14  and their possessions. May they answer this prayer

The authors, who belong to the Marran clan, are Minaeans. This clan is named "servants of the (god) Waddum" and doubtless had special obligations in the cult of this Minaean god. In good logic the dedication is addressed to the four deities of the Minaean pantheon, and to a fifth "Athtar master of Hadath" (probably the Athtar worshipped by the Minaeans at Qayat al-Faw). This text offers a wealth of new data. It is the first to cite a Minaean trade expedition towards the Arabian Gulf and Lower Mesopotamia (here called Nahar?), more precisely towards Seleucia on the Tigris (35 kilometres south-east of Baghdad). It indicates how the population called the site in Antiquity: Gannatan, "the Oasis". This "Oasis" apparently was the centre of a country named Qaryat Talaw. **C. R.**

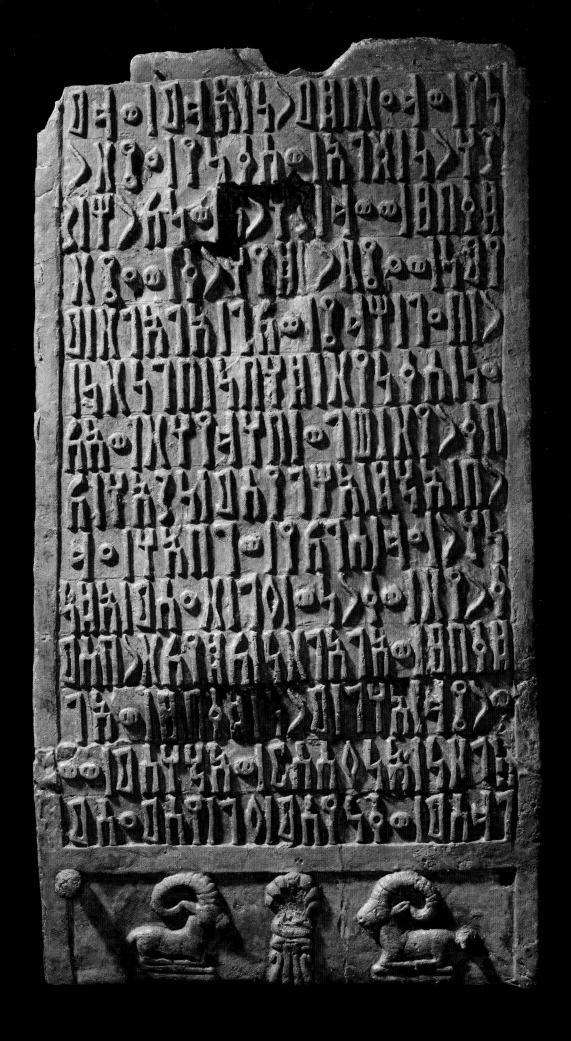

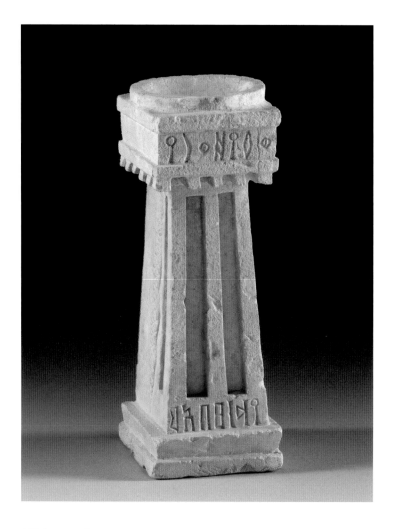

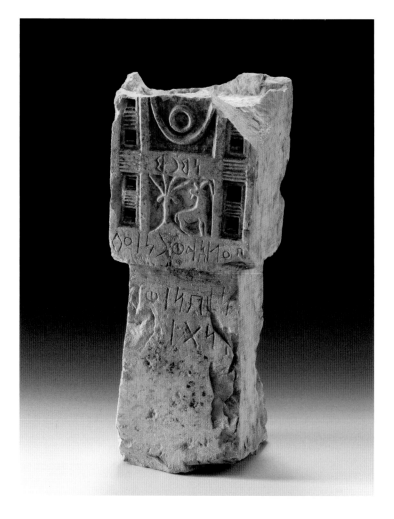

**137. Incense burner**
4th–1st century BC (?)
Limestone
25 x 9 cm
Qaryat al-Faw
National Museum, Riyadh, 2184

1    ]w f-yd'ry
2    [?]yd Ḏb᷂ᵗᵐ

**(transcription C. R.)**

The pedestal of the altar rests on a two-stepped base, the surfaces are decorated with deep grooves, a serpent rising over the entire height of the shaft and a rectangle in high relief. The upper part is enhanced with a denticulated frieze topped by an inscription.    **M. C.**

**138. Altar**
4th–1st century BC (?)
Limestone
42 x 16 cm
Qaryat al-Faw
Department of Archaeology Museum, King Saud University, Riyadh, 24 F 10

On the burner, above the ibex and the palm:
1    Nmrᵐ            Nimrᵘᵐ

On the burner, below the ibex and the palm:
1    (b)'l 'dwrn 'f=        The master of Adwaran 'Affan

On the pedestal:
2    n bn W[.]=        son of W[..]nt
3    .nt/

I believe the original inscription is the upper one (Nmrᵐ). The lower text (its meaning is not certain) seems to me to have been added subsequently.
**(transcription C. R.)**

This stone altar is decorated on the front with blind windows framing astral symbols in the upper register and an ibex with a date palm in the lower register.    **M. C.**

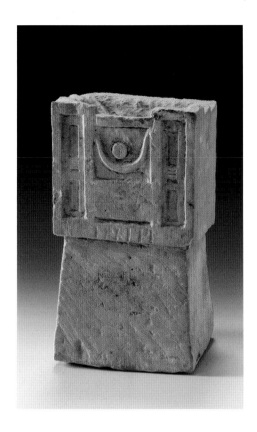

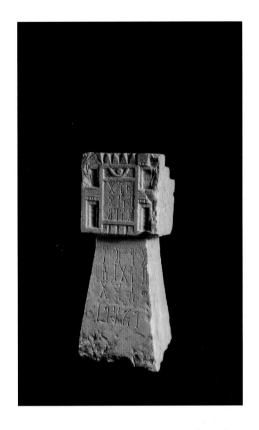

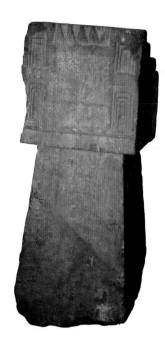

**139. Altar**
c. 1st century AD
Limestone
22.5 x 10.5 x 12 cm
Qaryat al-Faw
Department of Archaeology Museum, King Saud
University, Riyadh, 255 F 8

Only the front of the altar is decorated, with blind windows framing the motif of the disc and the crescent. This type of altar with an astral decoration appeared in the 5th century BC and had a long succession in South Arabia and even Ethiopia.　**M. C.**

**140. Incense burner**
1st century AD (?)
Limestone
64 x 26 x 25 cm
Qaryat al-Faw
Department of Archaeology Museum, King Saud
University, Riyadh, 45 F 13

In the shallow square adorning the burner panel:

| | | |
|---|---|---|
| 1 | *Dyt* | Diyyat |
| 2 | *bn Ṯ=* | son of Thu- |
| 3 | *mylᵐ* | may\|ᵘᵐ |

On the pedestal:

| | | |
|---|---|---|
| 1 | *Thmy* | Tahma |
| 2 | *bnt '=* | daughter of Aws- |
| 3 | *ws¹lt* | allat |
| 4 | *l-Khll* | for Kahl |

The shallow square which was carved to contain the dedication text probably gives the name of the person who offered the incense burner. The inscription on the pedestal possibly commemorates a re-utilization. However, given that the script of the two inscriptions is comparable, they could be of the same date: in this case, Diyyat and Tahma may have joined to make the offering.
**(transcription C. R.)**

This large incense burner with a pyramidal base is decorated in its upper part with architectural motifs, astral symbols and fluting.

**C. R.**

**141. Altar**
1st century AD (?)
Limestone
73 x 28 x 28 cm
Qaryat al-Faw
Department of Archaeology Museum, King Saud
University, Riyadh, 3 F 13

| | |
|---|---|
| 1 | *W'l .* |
| 2 | *.(h)'z.* |
| 3 | ??? |

Eroded text of uncertain reading. It seems to continue on the plinth.　**C. R.**

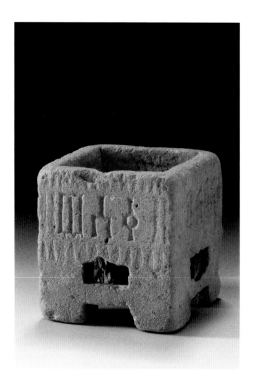

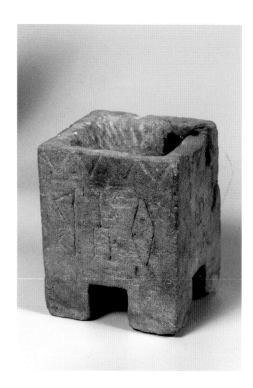

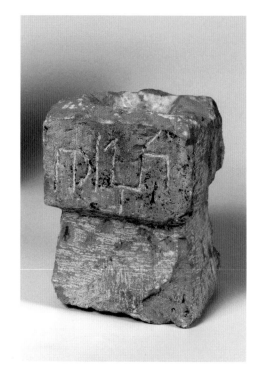

**142. Incense burner**
4th century BC (?)
Limestone
10 x 10 x 10 cm
Qaryat al-Faw
Department of Archaeology Museum, King Saud
University, Riyadh, 5 F 13

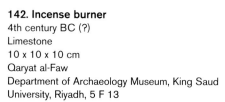

$qs^1t$   costus

*(name of a perfume)*
**(transcription C. R.)**

**143. Incense burner inscribed
with the name of the dedicator**
3rd century BC
Limestone
13.5 x 11 x 11 cm
Qaryat al-Faw
Department of Archaeology Museum, King Saud
University, Riyadh, 3 F 7

$fs^1l$

**(transcription C. R.)**

**144. Incense burner**
Limestone
16 x 12 x 12 cm
Qaryat al-Faw
Department of Archaeology Museum, King Saud
University, Riyadh, 56 F 2

– on the right: monogram of Kahl, consisting of the
letters *k, h* and *l*;
– on the left: *rb* (?).

This cubic incense burner with four feet, adorned with bands of triangles, bears the names of spices on each side. *Libnay* is the incense of the resin of the *boswellia*, a rare tree that grows in southern Yemen, on the island of Socotra, in the Horn of Africa and India. *Kamkam* is the gum of the Mastic tree that grows in Yemen and whose leaves are still used in perfume-making and medicine. *Qust* or *costus* is a spice made out of the root of an Indian plant; Greek and Roman authors also mention an Arabian variety of costus of far finer quality.

**M. C.**

Small cubic incense burners were very widely diffused in the Near East, they were utilized during funeral rituals but also in household shrines. This one is inscribed with the name of the dedicator *fs¹l*, which is unusual because they generally bear names of spices (cat. no. 142).   **M. C.**

This roughly carved incense burner stands on a pyramid-shaped base.   **C. R.**

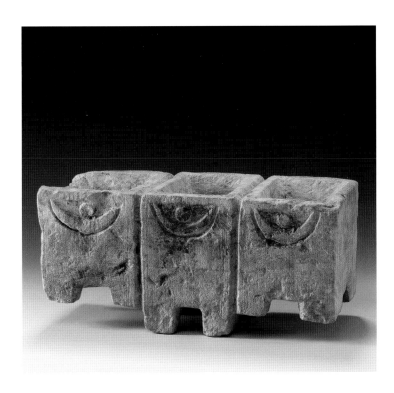

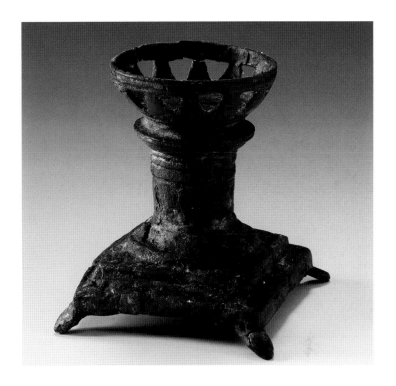

**145. Incense burner**
3rd century BC–3rd century AD
Limestone
13 x 29 x 11.5 cm
Qaryat al-Faw
Department of Archaeology Museum, King Saud University, Riyadh, 10 F 22

**146. Incense burner**
3rd century BC–3rd century AD
Bronze
10 x 8.5 x 8 cm
Qaryat al-Faw
Department of Archaeology Museum, King Saud University, Riyadh, 216 F 7

This triple incense burner, probably unfinished, is enhanced with moon crescents and stars (doubtless the planet Venus), a very frequent decoration in South Arabian iconography (cat. nos 138, 139 and 140). These astral symbols did not designate a particular deity, because they are found on the altars and sculptures of the temples dedicated to Wadd, Almaqah, but also on dedications to the sun goddess Shams. **M. C.**

Metal incense burners were the most prized but are relatively rare because once out of use they were surely cast down. This incense burner is composed of a square base with four feet and a cassolette perforated with triangles. It can possibly be compared to lidded perforated incense burners like those of Wadi Dura.[1] **M. C.**

1. 'Aqil and Antonini 2007, no. II B b2.

Domestication of the dromedary, achieved in the early 1st millennium BC, brought about changes in the economy, allowing to convey incenses and spices towards the Mediterranean shores. Perfectly adapted to the desert climate, the dromedary can travel long distances from one oasis to another. In spite of its foremost position in society, this animal did not have a special relationship with one of the deities of the South Arabian pantheon, but statuettes were frequently offered to the gods for the prosperity of the herd and its owner.

**M. C.**

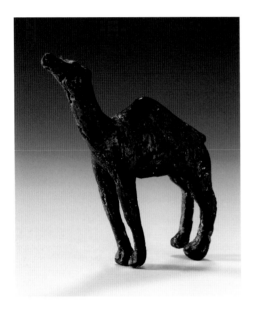

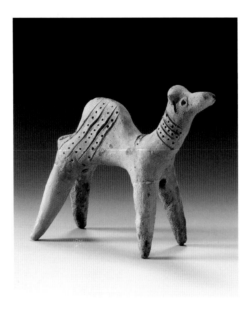

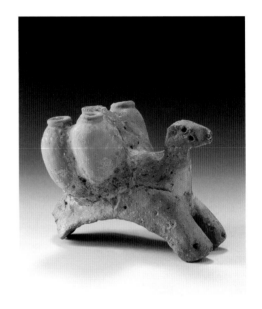

**147. Inscribed statuette of a dromedary**
2nd century BC–2nd century AD
Bronze
H. 8.9 cm
Qaryat al-Faw, Temple 401 A
Department of Archaeology Museum, King Saud University, Riyadh, 249 F 6

Bibliography: Al-Ansari 1982, p. 106.1 (left).

| 1 | ...]'d h(qny)-d- | ... (dedicated to) dhu- |
| 2 | S¹mw[y ...]'lh | Samaw[i ...]... |
| | | **(transcription C. R.)** |

This statuette has two holes under the belly, which suggests the presence of a support for fixing it to a base. It bears a dedication to dhu Samawi, a deity particularly worshipped by the Amir tribe and, generally speaking, by camel breeders and caravaneers. An inscription (Musée du Louvre, AO 4694)[1] mentioning the offering of a bronze camel to the god dhu Samawi attests this devotion.

**M. C.**

**148. Statuette of a dromedary**
3rd century BC–3rd century AD
Clay
H. 15.3 cm
Qaryat al-Faw
Department of Archaeology Museum, King Saud University, Riyadh, 11 F 26

The incisions of lines and dots on the neck and the hindquarters of the figurine could possibly correspond to harnesses or else paintings of a ritual nature as is still the case today in ceremonies in Yemen.[1]

**M. C.**

1. Daum *et al.* 2000, p. 119, abb. 12.

**149. Figurine of a dromedary carrying jars**
3rd century BC–3rd century AD
Clay
15 x 21 x 13 cm
Qaryat al-Faw
Department of Archaeology Museum, King Saud University, Riyadh, 36 F 11

This type of modelled earthenware figurine is one of the most common forms of votive offerings.

**M. C.**

1. Calvet and Robin 1997, cat. no. 91.

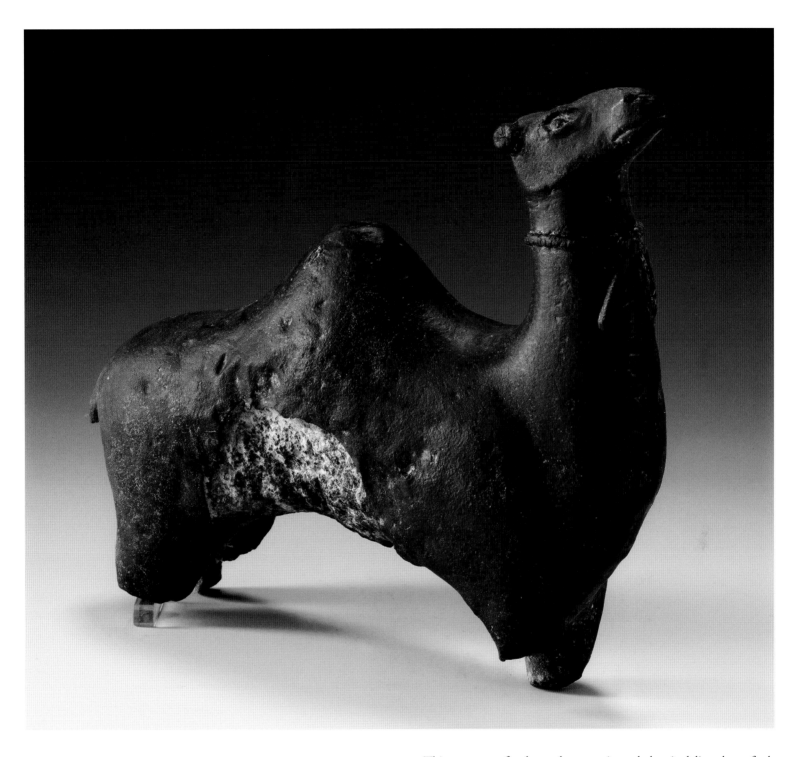

**150. Statuette of a dromedary**
2nd century BC–2nd century AD
Bronze
17 x 21 cm
Qaryat al-Faw
Department of Archaeology Museum, King Saud University, Riyadh, 36 F 11

This statuette of a dromedary wearing a halter is delicately crafted. This type of harness is also known on a statuette of a she-camel[1] and on one of the wall paintings of Qaryat al-Faw. Several other dromedary statuettes also evidence this practice.[2]          **M. C.**

1. Al-Ansari 1982, p. 106, 2.
2. For example British Museum, 1907-10-12.5=102480; Musée du Louvre, AO 4608; and Munich Staatlisches Museum für Völkerkunde, inv. nos 93-316 969/972, 975, 977, 979, 980, 985, 990, 991, 993, 994, 304, 308.

**151. Fragment of a statue: a fist**
3rd century BC–3rd century AD (?)
Cast bronze
24 x 13 x 13 cm
Qaryat al-Faw
Department of Archaeology Museum, King Saud
University, Riyadh, 240/149-84 F 5

Bibliography: Al-Ansari 1982, p. 110.

These numerous fragments of statues, like the fist, from very large works, indicate that it is likely there were bronze workshops at Qaryat. Throughout the cultural sphere of South Arabia an important number of large bronze sculptures have been found. Though often very fragmentary, they are evidence of the expertise of the local bronze founders who several centuries before the Christian era perfected a very special casting technique, one of its main characteristics being preserving the core inside the pieces. These workshops were receptive to influences from the Hellenistic world, and itinerant artists from the Graeco-Roman world occasionally worked with local founders, as attested, for example, by the double signature on two large bronzes featuring kings of Saba' and dhu Raydan (c. 2nd–3rd century AD) in the San'a National Museum: the sculptor's name is Greek, whereas the founder's is South Arabian.          **F. D.**

**152. Fragment of a statue: fur of an animal (lion's mane?)**
3rd century BC–3rd century AD
Cast bronze
18 x 10 x 5.5 cm
Qaryat al-Faw
Department of Archaeology Museum, King Saud
University, Riyadh, 102-157 F 5

**153. Head of a Man**
1st century BC–2nd century AD
Cast bronze
H. 40 cm
Qaryat al-Faw
Department of Archaeology Museum, King Saud
University, Riyadh, 119 F 13

The dimensions of this head, probably of a man, indicate that it belonged to a statue which must have been approximately life size. Despite the awful cavity deforming the face, we can identify full cheeks, a small mouth with full lips, eyes with carved-out pupils, a style comparable to Hellenistic-Roman sculptures. The hair, with curls simulated by long twists evenly arranged on the front of the skull and spread out in longer rolls on the nape of the neck, suggests rather a female hairstyle, that of Roman women around the 1st century BC. This type of hairstyle also recalls that of the Graeco-Egyptian statues of the Ptolemaic period, but the original treatment of the curls reveals the production of a local workshop influenced by Graeco-Roman models. A very similar head found at Ghayman, in Yemen, is preserved at the British Museum (inv. no. BM136359) and several heads of the same type, unfortunately fragmentary or very corroded, are held in the museum of San'a, and attest the existence in this period of a South Arabian school of sculpture drawing its inspiration from Western models.

**F. D.**

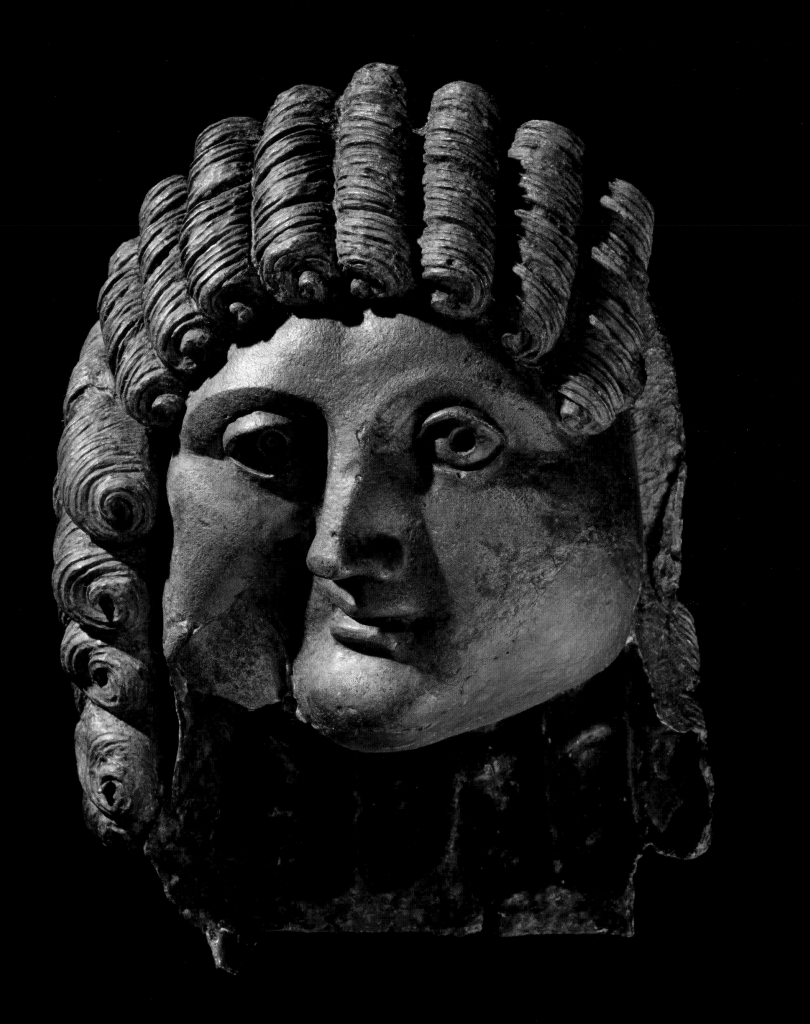

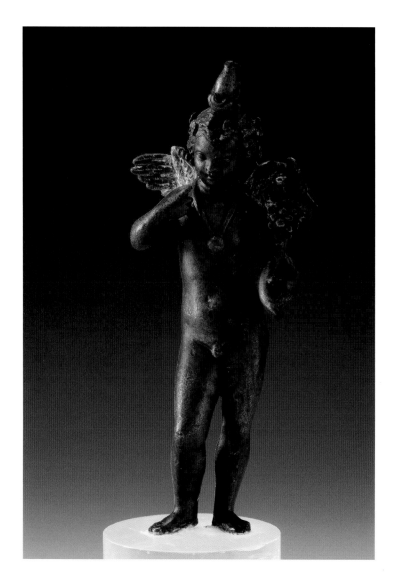

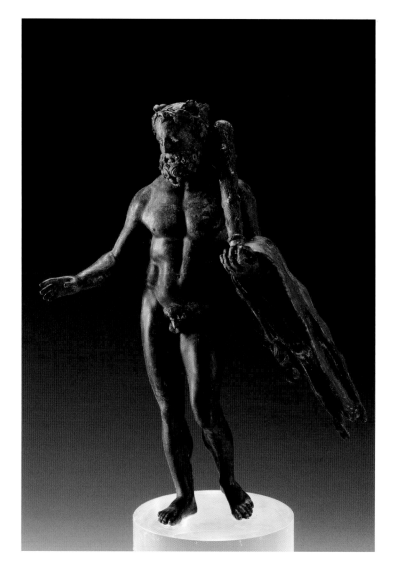

**154. Statuette of Harpocrates**
2nd–3rd century AD
Bronze
12.4 x 6.1 cm
Qaryat al-Faw
Department of Archaeology Museum, King Saud University, Riyadh, 248 F 6

Bibliography: Al-Ansari 1982, p. 104; Parlasca 1989, pl. 11; 'Aqil and Antonini 2007, p. 150, no. I Ac4/.

Harpocrates or "Horus the Child" is an Egyptian deity already adopted by the Greeks in the Ptolemaic period, then popularized and widely diffused in Roman times. At this time he was generally represented as a naked child with his finger at his mouth, wearing a vegetal crown and an Egyptian *pschent* (the double Egyptian crown), which are reminiscences of his Egyptian iconography. In addition to all these traditional attributes, the al-Faw statuette features a cornucopia, a pair of wings and a bulla around his neck, characteristic of Roman children. **M. C.**

**155. Statuette of Heracles**
1st–3rd century AD
Bronze
H. 25.3 cm
Qaryat al-Faw
Department of Archaeology Museum, King Saud University, Riyadh, 214 F 7

The hero Heracles is identified by the lion skin and the club resting on his left arm. The expression of his face is accentuated by the inlays of his eyes and his partly open mouth. Initially, he held in his right hand a drinking vessel, presently lost. This image of Heracles nude, bearded and holding the drinking vessel won him the name Hercules-Bibax, "the Drinker"; an iconography associating him with Dionysus and also illustrating his participation in the banquets of the gods and therefore his immortality. This type of Heracles, fashioned after the canons established by the Greek sculptor Polykleitos, was highly popular in Hellenistic and Roman times and the diffusion of his cult transcended the boundaries of the Greek world. **M. C.**

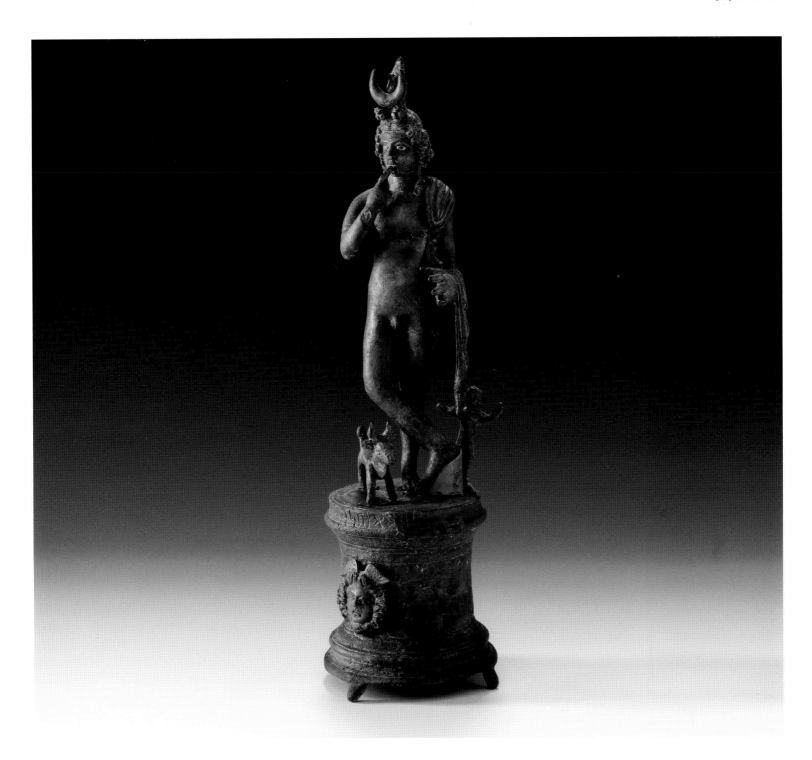

**156. Statuette of Harpocrates**
1st–3rd century AD
H. 32 cm; Max. w. 9.2 cm
Bronze
Qaryat al-Faw
Department of Archaeology Museum, King Saud University, Riyadh, 209 F 7

On the plinth of this statuette probably representing a deity (lunar?), we can make
out the name of person. Only a few letters can be deciphered in the visible part:

 *Hḏrt bn (Z)ʿ[*     *Hidhdhārat son of (Z)ʿ...*

            **(transcription C. R.)**

This figurine differs from the traditional iconography of Harpocrates
(cat. no. 154) by the number of attributes. The Egyptian Child-God
is associated with a small horned bovine and a small figure with raised
arms wearing a loincloth. The scene is set on an inscribed cylindrical
base on which a winged gorgon's face is applied. Hidhdharat, the
dedicator, may have had himself represented in the guise of the little
figure with uplifted arms ready to perform a sacrifice in the context
of a Graeco-Roman pagan cult.         **M. C.**

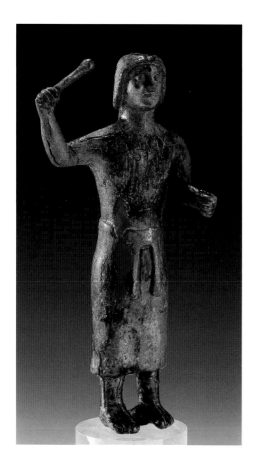

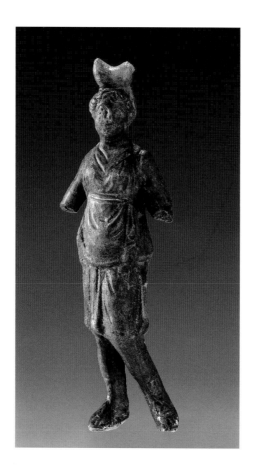

**157. Male statuette**
c. 3rd century BC
H. 15.5 cm
Bronze
Qaryat al-Faw
Department of Archaeology Museum, King Saud
University, Riyadh, 287 F 8

| | | |
|---|---|---|
| 1 | Tn... | |
| 2 | hqny . | has dedicated |
| 3 | (m')..m. | |
| 4 | (wy).. | |

The text on the breast of this figurine apparently
features four lines. It is not easy to read. The only
relatively sure word is *hqny* on the second line.
**(transcription C. R.)**

This statuette represents a man wielding a
stick and probably holding an object in his
other hand. His face and thick cap-shaped
hairstyle are delicately crafted; he is wearing
a long loincloth closed by a belt knotted at
the waist. **M. C.**

**158. Statuette of Artemis**
3rd century BC–3rd century AD
Bronze
H. 7.5 cm
Qaryat al-Faw
Department of Archaeology Museum, King Saud
University, Riyadh, 37 F 10

This statuette of Artemis, with a moon
crescent on her head, wears the traditional
garb of the Greek huntress: the short *chiton*
draped on the hips, belted under the
breasts, and open leather boots. The slightly
bent left leg also attests to a Graeco-Roman
model. **M. C.**

**159. Statuette of Isis-Tyche**
1st century BC–3rd century AD
Blue and green glazed terracotta
H. 25 cm; Diam. 8 cm
Qaryat al-Faw, residential district
Department of Archaeology Museum, King Saud
University, Riyadh, 241 F 8

Bibliography: Al-Ansari 1982, p. 124/4.

This unusual-sized figurine represents a
woman with a tall crown and a cornucopia,
the traditional attributes of Isis-Tyche, the
Egyptian goddess of Fortune. This imported
item of the Imperial period was probably
intended for a household cult and does not
necessarily mean that the worship of Isis was
officially celebrated at Qaryat al-Faw. **M. C.**

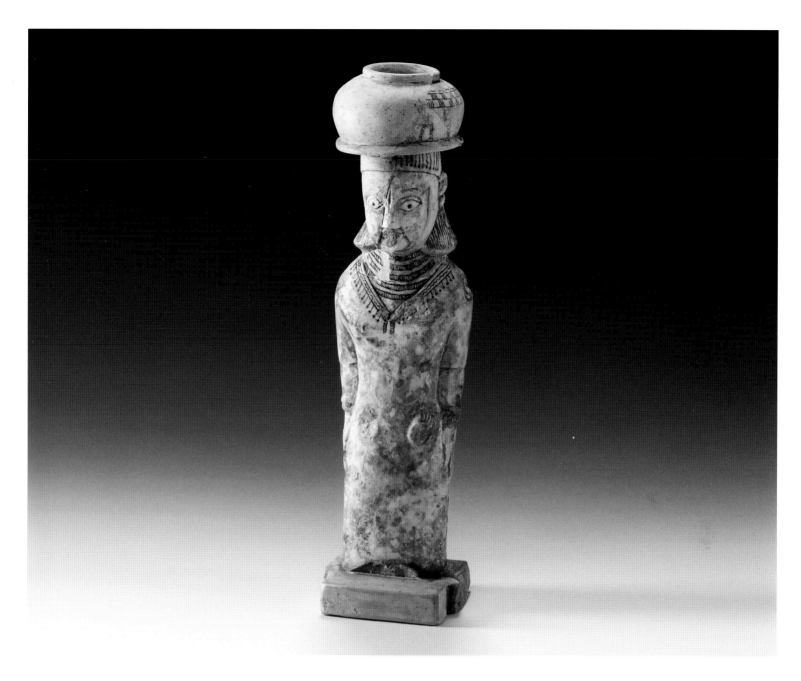

**160. Female statuette**
1st century BC (?)
Painted limestone
27 x 7 cm
Qaryat al-Faw
Department of Archaeology Museum, King Saud University, Riyadh, 1 F 23/155 F 9

This female statuette wearing a circular altar on her head is adorned with many jewels: pendants around her headdress, a necklace with five rows of beads and several pairs of bracelets. Her long robe is trimmed with braids on the breast. Level with the hips we can make out hands belonging to other figures now lost. The bridge of the nose and the cheekbones are marked with deep incisions, perhaps corresponding to scarifications. In another Qaryat al-Faw tomb a head of the same type was found, this time crowned with a square altar.[1] The jewels of the limestone statuette of al-Faw are identical to those worn by a bronze statuette of a woman also with an altar headdress.[2] But the most intriguing parallel comes from a grave of Shuka, in Yemen, where the famous "Lady of Ad-Dali"[3] was discovered. The identity of this richly adorned woman, bearing an altar on the top of her head, remains a mystery. Was she a high-ranking dedicator, a priestess or a deity?

**M. C.**

1. Al-Ansari 1982, p. 120, no. 2.
2. 'Aqil and Antonini 2007, no. IAa1, p. 127.
3. Paris 1997, p. 168.

## WALL PAINTINGS

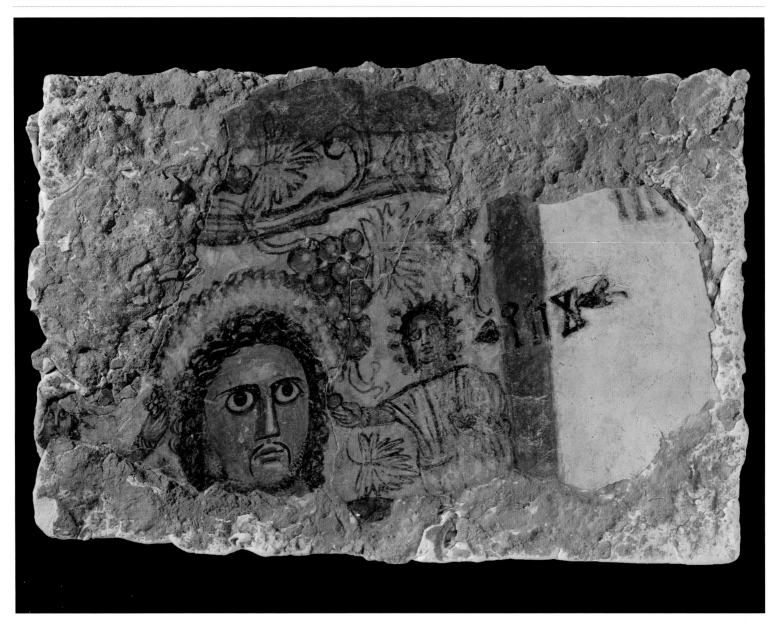

**161. Fragment of a wall painting with a man's head**
1st–2nd century AD
Black, red and yellow paint on white plaster
53 x 36 cm
Qaryat al-Faw, residential district (palace)
National Museum, Riyadh, 2182

Bibliography: Al Ansari 1981, pp. 26–27, ill. 135, 136, 137.

This head of a man with thick curly hair stands out on a yellow ground strewn with vine tendrils. A thin drooping moustache frames his mouth, in keeping with a fashion in the first centuries AD in South Arabia.

This same type of moustache appears for example on the bronze statues of two kings of Saba and dhu Raydan (San'a, National Museum). Above his head two much smaller figures, probably servants, hold aloft a diadem of bunches of grapes. While the figure on the left is almost erased, the one on the right, clearly visible, is identified by an inscription : Zky (*Zaki*). This fragment, which may have belonged to a panel featuring a banquet scene, shows the influence of Dionysiac iconography, diffused throughout the East in the 1st–2nd centuries AD. But it also reveals to us the countenance of a notable of the élite of this Qaryat society which adopted the fashions of the Hellenized Near East without losing its local identity.

F. D. (transcription C. R.)

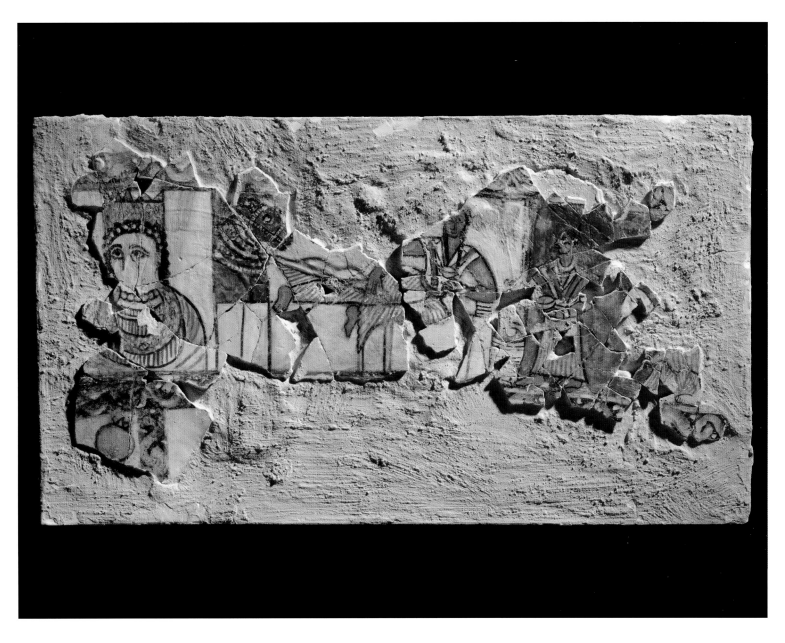

**162. Fragment of a wall painting with a banquet scene**
1st–2nd century AD
Black and red paint on white plaster
58 x 32 cm
Qaryat al-Faw (residential district, sector B 17, 1987 excavations)
Department of Archaeology Museum, King Saud University, Riyadh, 103 F 12

Bibliography: Stierlin 1987, pl.137, 138; Alexander 1996B, p. 43.

The painted fragment shows that wall decorations were laid out in panels; here, bands enhanced with grisaille scrollwork define several areas. At the centre a richly garbed man is lying on a banquet couch, a laurel crown placed on his long hair. He holds a cup in his left hand and, oddly, in his other hand he grasps the reins of a gor- geously harnessed horse of which the head alone is visible; on the right a servant approaches with a pitcher. Rather than a mere genre scene, this motif instead seems to represent a funerary banquet, the horse doubtless evoking the high rank of the deceased. On the left we make out the bust of a woman wearing a draped garment in the Graeco-Roman style and many necklaces. Because of the crown and the pomegranate, symbol of fertility, featured directly below her, it has been suggested identifying her with a goddess, but she might simply be the wife of the deceased. If an accurate interpretation of this fragmentary scene hardly seems possible, its iconography attests to the adoption of Western fashions by the population of Qaryat.

F. D.

**163. Fragment of a mural painting with zodiacal motif**
1st–3rd century AD
Black, red and yellow paint on white plaster
50 x 29 cm
Qaryat al-Faw
Department of Archaeology Museum, King Saud University, Riyadh, 238 F 9

On the right:
> ]yn..lṭ  w
> ]d....lḥy

The text, perhaps incomplete, does not provide anything we can understand.
No certain reading is possible.

(transcription C. R.)

This enigmatic painting features an axis topped by a semicircle, from which rise clusters; around it various figures gravitate: a spotted feline, a lion, a scorpion, a centaur, a hydra; on the right, we make out the horns of a ram. These animals represent constellations arrayed around the welkin. Mesopotamians, Egyptians, Greeks and Romans were already familiar with the zodiac since Antiquity and it is probably contact with the Romans that led the South Arabians to adopt this repertory of zodiacal motifs. However, we do not know if this is the foundation horoscope of a building or the enthronement of a high-ranking personality or if these motifs had an entirely different meaning. This zodiacal representation differs from the few rare known exemplars in the Arabian Peninsula, as at Zafar and Khirbat al-Tannur.[1]

M. C.

1. Laffitte 2003, pp. 77–87, pl. 9, 10 and 11.

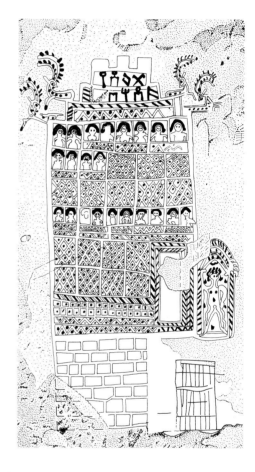

### 164. Fragment of a wall painting depicting a tower house

3rd century BC–3rd century AD
Black, red and yellow paint on white plaster
59 x 64 cm
Qaryat al-Faw
Department of Archaeology Museum, King Saud University, Riyadh, 29 F 22

On the right, from top to bottom:

*Tym*
*Mnt*

Read probably *Tym|mnt*, "Taymmanāt", a man's name.
Manāt is an Arabian goddess, found in many regions of West Arabia

**(transcription C. R.)**

The tower house is built on a stone foundation; on the ground floor two doors are open, one of them framing a nude figure. The storeys are built with beams forming regular frames, filled with raw bricks or earth and painted with red and black geometric motifs. At the windows of the two storeys busts of identical figures appear. The building is crowned by a crenellated décor, bearing an inscription; it is surrounded by four bounding ibexes. One of the roles of these tower houses may have been defensive; in fact the very narrow openings eventually allowed to use a bow and the terrace could serve as a lookout post. This tradition of tower houses has lasted up to today in the south of Arabia.

**M. C.**

### 165. Reconstitution of a funerary bed
Early 1st century AD
Qaryat al-Faw, tomb of Sa'd ibn Malik (Tomb K6)

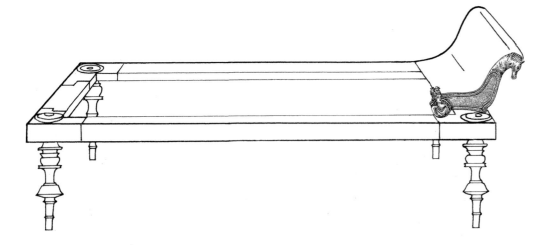

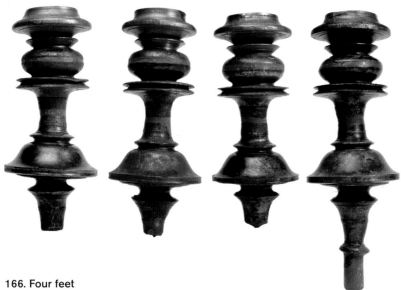

### 166. Four feet
Cast bronze
L. 30 cm; Max. diam. 12.5 cm (Tenon L. 3.6 cm)
Department of Archaeology Museum, King Saud University, Riyadh, 49 F 16

### 167. Four round ornamental pieces
Cast bronze
Diam. 9.2 cm
Department of Archaeology Museum, King Saud University, Riyadh, 51 F 16

### 168. Four corner elements
Cast bronze
20 x 11.5 x 3 cm
Department of Archaeology Museum, King Saud University, Riyadh, 50 F 16

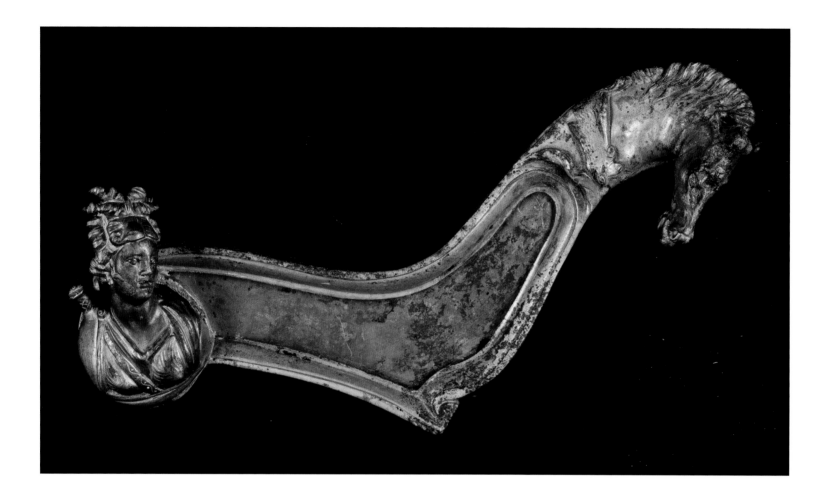

**169. Gilt bronze appliqué adorning the bed head (*fulcrum*)**

*The exhibition presents a reproduction.*
29 x 3 cm
Original: Department of Archaeology Museum, King Saud University, Riyadh,
38/48/F 16

Bibliography: Alexander 1996a, p. 65, ill. II; Alexander 1993.

In one of the burial chambers discovered at Qaryat the deceased was lying on a magnificent formal Graeco-Roman-style bronze bed. In addition to traditional grave furnishings (pottery, stone vessels . . .), almost all the items forming this funerary bed of outstanding quality were preserved. The four feet are made of various separately cast elements, finely smoothed, then soldered together; their shape emulates the turned wooden feet of the first *klinai* prototypes. The bed frame, probably made of wood, was assembled by four solid bronze corner pieces, which allowed its attachment to the feet. The four large convex discs were placed above it, imitating the element which originally topped the turned wooden feet of the bed. The most stunning part is the *fulcrum*, that is, the bronze appliqué enhancing the edge of the arm rest; often, as here, there is but one, because only the visible side of the bed was adorned. This *fulcrum* was cast in several elements first soldered together, then gilded. A small bust of Artemis slightly facing the right adorns the base while the hollow part in between was doubtless overlaid, perhaps with ivory which is now lost; the top ends with a horse's head, that of a quivering stallion, treated with intense feeling. This iconography is traditional in the highly codified ornamentation of this type of object: the horse's neck is wrapped in a panther hide, and based on this detail it has been suggested to recognize in this décor a Dionysiac motif. Artemis, goddess of hunting, would then be identified with a Maenad.

The *fulcrum* discovered at Qaryat enriches the corpus of these ornaments with an outstandingly fine piece, probably produced by one of the workshops specialized solely in making the *klinai* that existed in Greece and Rome. This formal bed is evidence of the fondness for luxury of a refined clientele who in the depths of Arabia had adopted Graeco-Roman fashions. It also proves the extent and vitality of exchanges with the West Mediterranean world.                    F. D.

**170. Chair leg**
c. 1st century AD
Bronze
10 x 8.5 x 4 cm
National Museum, Riyadh, 2235

Bibliography: Al-Ansari 1982, p. 112.

This type of chair leg is well known in the Roman world[1] and the site of Sidon, in Syria, provided many exemplars comparable to that of Qaryat al-Faw (Musée du Louvre, AGER, Br 2579, Br 2580). The two holes in the upper part were for inserting rivets.　**M. C.**

1. Boube-Piccot 1975, pl. 177, p. 243.

**171. Door knockers**
3rd century BC
Bronze
Diam. (head): 8.8 cm; Diam (ring): 4.5 cm
Qaryat al-Faw
Department of Archaeology Museum, King Saud University, Riyadh, 346/347 F 1

Bibliography: Al-Rachid 1975, p. 173; Ghoneim 1980, fig. 13; Al-Ansari 1982, p. 93.

These lion-head knockers were probably placed on doors. This type of object, already appreciated in Eastern Greece by the 5th century BC, was also very popular in the Roman world.　**M. C.**

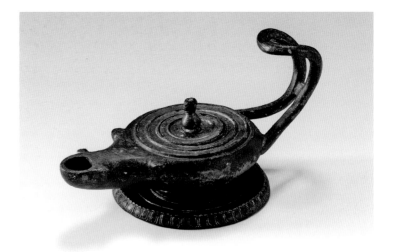

**172. Pear-shaped lamp**
c. 3rd century BC–3rd century AD
Bronze
3.5 x 9.5 cm
Qaryat al-Faw
National Museum, Riyadh, 2237

Bibliography: Al-Ansari 1982, p. 92, figs 1–2.

**173. Lamp**
c. 3rd century BC–3rd century AD
Bronze
2.5 x 14 cm
Qaryat al-Faw
Department of Archaeology Museum, King Saud University, Riyadh, 15 F 13

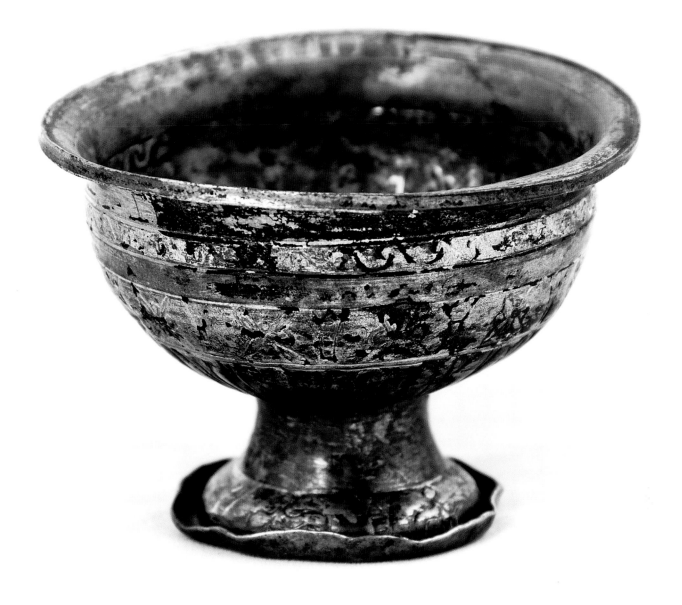

**174. Chalice**
3rd century AD
Silver, partly gilded
H. 5 cm; Diam. 7.7 cm
Qaryat al-Faw
Department of Archaeology Museum, King Saud University, Riyadh, 34 F 16

(Qs³)m bn Mlk s²ym     (Qasim) son of Malik had made
**(transcription C. R.)**

This small chalice can be compared to a series of slightly larger standing cups widely diffused throughout the Near East from the 3rd and 4th centuries, but on a model introduced by Western workshops. The bottom of the bowl, on the outside, is adorned with a motif of petals in relief and two bands highlighted by mercury gilding: the first is engraved with a motif of tiny waves, the second with a sequence of rosettes. This décor is inspired by Graeco-Roman models, but the rigid design of the rosettes, in particular, illustrates the South Arabian tendency to geometricize forms and reveals a local goldsmith's touch. This same type of rosette is found on some capitals discovered in the Himyarite capital of Zafar dated approximately to the 4th century. As on many goldsmith's artefacts, an inscription, here in South Arabic, gives the name of the commissioner.     **F. D.**

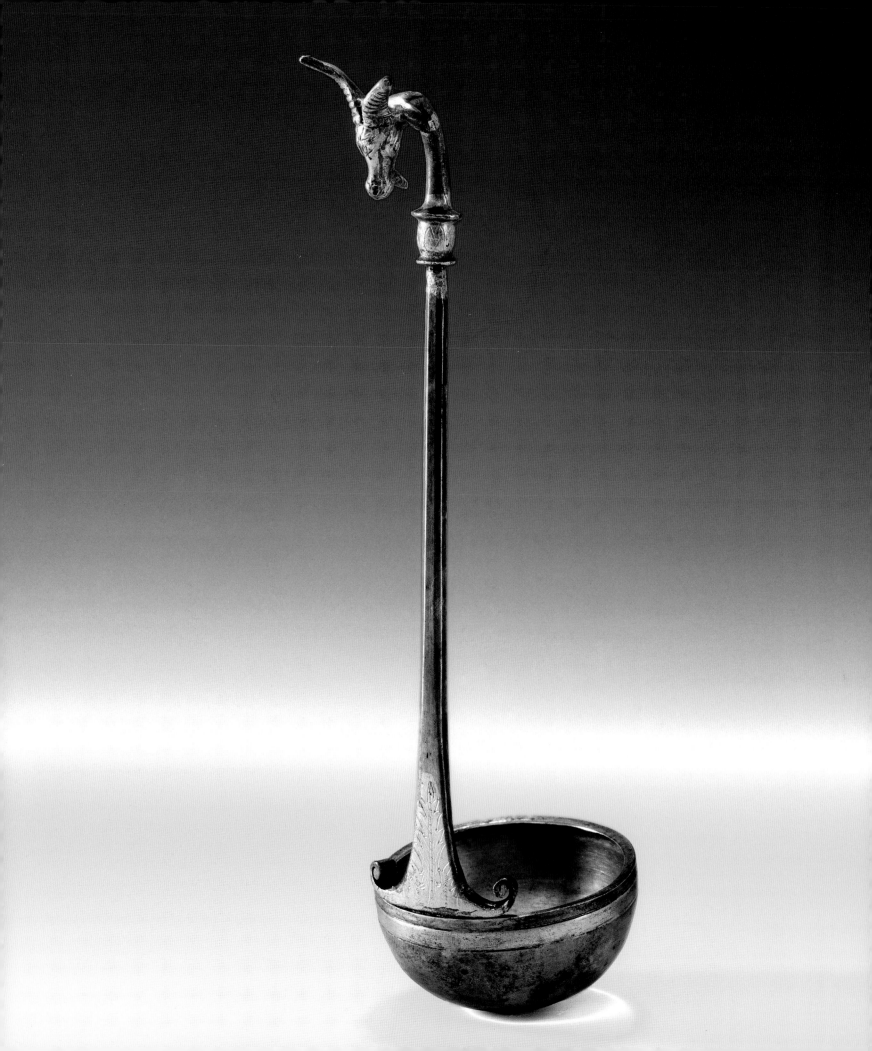

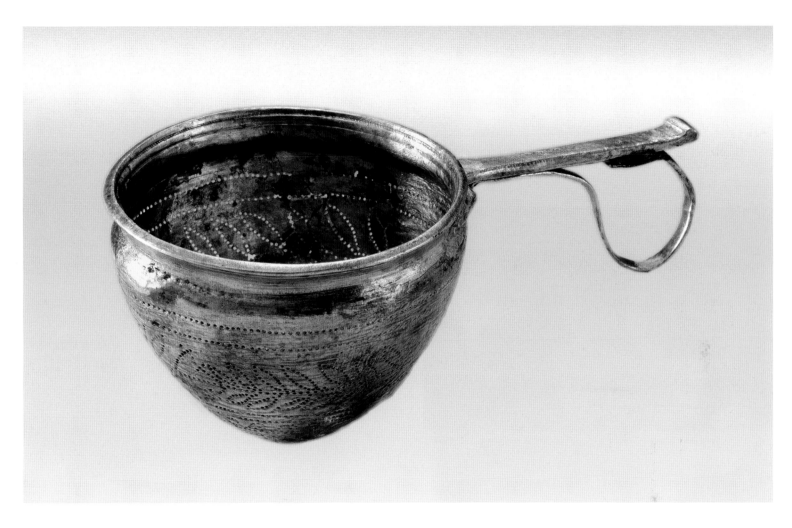

**175. Ladle (*simpulum*)**
1st–2nd century AD
Silver, partly gilded
L. about 30 cm
Qaryat al-Faw
Department of Archaeology Museum, King Saud University, Riyadh, 39 F 16

**176. Strainer.**
1st–2nd century AD
Silver
H. 5.5 cm; W. 7 cm
Qaryat al-Faw
Department of Archaeology Museum, King Saud University, Riyadh, 54 F 13

The relatively deep bowl of the ladle is adorned with a plain gilt band, but the décor of its long handle ending in a delicate ibex head with tall ringed horns makes it a particularly refined piece of goldsmith's art. A large number of these ladles, the most precious in silver, or in bronze, was discovered in archaeological sites in Arabia, both in the north-east (Bahrain, Failaka, Hofuf) and the south-east, specially at ed-Dur, or in Wadi Dura in Yemen. They are usually associated with drinking cups and a strainer.

Actually the ladles were one of the pieces of the "drinking-services" which arose in the East but whose use spread to the Graeco-Roman world by the mid-1st millennium and whose popularity continued to expand in the Hellenized Orient. The archaeological finds show they were utilized in Arabia as well. They were used during banquets, the ladle allowed to draw the beverage from a large container: because the drinks – perhaps wine or also a fermented beverage obtained from dates – often contained impurities, they had to be filtered before they could be drank. The strainer shown here is also a well-crafted article, the perforations design an elegant foliage motif. Like the ladle, it is probably the production of a local workshop. The context of the finding of these two objects is not known; however in Arabia most of these drinking services were found in graves and may have been used during funeral banquets. **F. D.**

## JEWELLERY

The Queen of Sheba supposedly brought many gifts and great quantities of gold to King Solomon (*Kings*, 10). Indeed, geological surveys between Medina and Yemenite Jawf revealed the existence of goldmines.[1] Its deposits and the import of precious or semi-precious stones from the Indian sub-continent allowed the development of high-level gold work. Some jewels, like the beads used as separators, were mass produced (cat. nos 178 and 179).[2] The Hellenistic jewels imported from the Near East largely influenced the forms and ornementation of South Arabian jewellery (cat. no. 180).

**M. C.**

1. London 2002, p. 120.
2. 'Aqil 1993, p. 189.

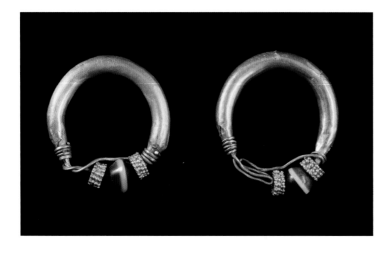

**177. Loop earrings with an agate bead and granulated beads**
c. 1st–3rd century AD
Gold and agate
Diam. 2.5 cm
Qaryat al-Faw
Department of Archaeology Museum, King Saud University, Riyadh, 16 F 14

**179. Disc-shaped beads with a cloisonné décor of rosette motifs, for separating various elements of a necklace**
c. 1st–3rd century AD
Gold, glass paste
Diam. about 1 cm
Qaryat al-Faw
Department of Archaeology Museum, King Saud University, Riyadh, 63 F 10

**178. Beads for separating various elements of a necklace**
c. 1st–3rd century AD
Gold
H. about 0.5 cm
Qaryat al-Faw
Department of Archaeology Museum, King Saud University, Riyadh, 82 F 12

**180. Bell-shaped earrings (opposite page)**
c. 1st–3rd century AD
Gold
H. 3.4 cm; Diam. about 2 cm
Qaryat al-Faw
Department of Archaeology Museum, King Saud University, Riyadh, 79 F 12

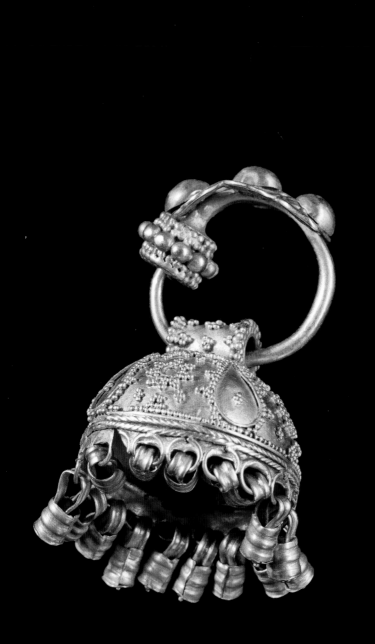
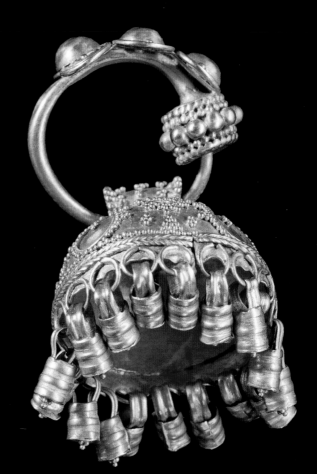

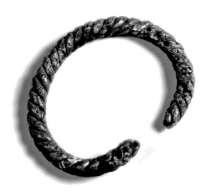

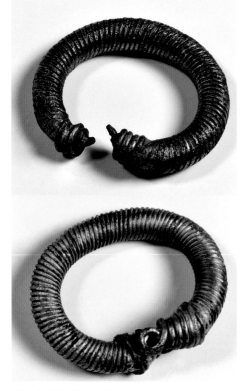

**182. Twisted bracelets**
c. 1st–3rd century AD
Diam. 8.2–9.5 cm
Silver
Qaryat al-Faw
Department of Archaeology Museum, King Saud
University, Riyadh, 118 F 13

**183. Tubular bracelet**
c. 1st–3rd century AD
Diam. 4.2–5.2 cm
Silver
Qaryat al-Faw
Department of Archaeology Museum, King Saud
University, Riyadh, 24 F 11

**181. Twisted bracelets**
c. 1st–3rd century AD
Diam. 6–7.4 cm
Silver
Qaryat al-Faw
Department of Archaeology Museum, King Saud
University, Riyadh, 21 F 16 and 72 F 12

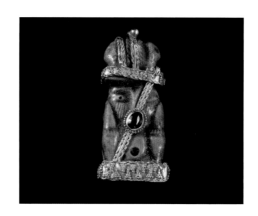

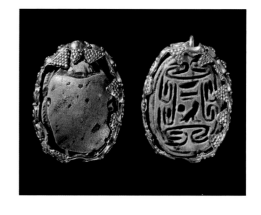

**184. Amulet**
1st millennium BC
3.8 x 1.5 cm
Faience, gold, stone (ruby)
Qaryat al-Faw
Department of Archaeology Museum, King Saud
University, Riyadh, 35 F 8

Bes amulets were widely diffused through-
out the Syria-Palestine area in the Late
Bronze Age and Iron Age. This Egyptian-
style artefact arrived at Qaryat al-Faw and
was preciously preserved there. The magic
and apotropaic virtues of this amulet,
prized as an antique, were amplified by its
gold and ruby setting.          **M.C.**

**185. Scarab**
1st millennium BC
Faience and gold
H. 1.5 cm
Qaryat al-Faw
National Museum, Riyadh, 2227

Egyptian-style scarabs, particularly popular
in the Levant during the Bronze Age, repro-
duced Egyptian hieroglyphs and enhanced
them with friezes. This exotic item was cer-
tainly brought to Qaryat al-Faw by a trades-
man returning from a journey.          **M.C.**

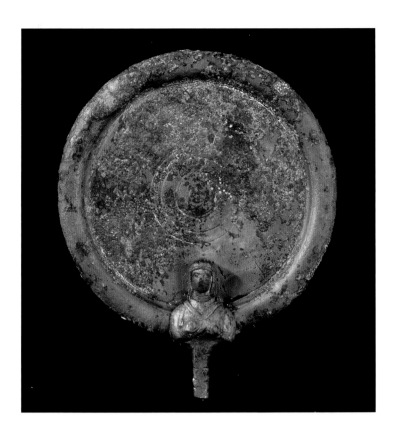

**186. Mirror with an anthropomorphic handle**
c. 1st century AD
Bronze
Diam. 16.5 cm
Qaryat al-Faw
Department of Archaeology Museum, King Saud University, Riyadh, 19 F 13

After being polished, the disc decorated with concentric circles reflected the light; it is supported by a figurine of a woman holding her breasts, a particularly fitting subject for a toilet article. It can be compared to several mirrors discovered in the south of the peninsula[1] and East Arabia, for example from Ayn Jawan or ed-Dur.[2]      **M. C.**

1. 'Aqil and Antonini 2007, pp. 69–70.
2. Mouton 2008, fig. 92. 6.

**187. Female figurine**
1st–2nd century AD
Bone
H. 8 cm
Qaryat al-Faw
Department of Archaeology Museum, King Saud University, Riyadh, 3 F 18

Bone figurines of this type first appeared in the Hellenistic and Parthian Orient and then were widely diffused in Egypt, Arabia and even the Occident. These tiny statuettes, sometimes called "dolls", may be protective amulets, fertility symbols as suggested by the prominent belly and emphasized pubic triangle. The arms joined to the shoulders were mobile.      **M. C.**

**188. Box**
3rd century BC–3rd century AD
Bone
4.7 x 9 x 5.2 cm
Qaryat al-Faw
Department of Archaeology Museum, King Saud University, Riyadh, 34 F 17

The plates of this box, decorated with dotted circles and lines, were joined by pegs.      **M. C.**

## GLASS

The excellent state of conservation of most of these flasks and cups leads to assume that they were discovered in graves where they had been placed as offerings near the deceased, but vessels of this type were also utilized in everyday life. These luxury items are all pieces imported from the main manufacturing centres located in the countries of the Levant or Egypt, particularly in Alexandria, production being diffused throughout the East, as far as Bagram in Afghanistan. The archaeological sites of East Arabia (Bahrain, Mleiha, Dibba or ed-Dur) yielded many exemplars of this precious glassware that arrived in the ports of the Gulf. The trade city of Gerrha maintained close trade relations with Qaryat and probably played a major role in the redistribution of these wares.
F. D.

**189. Ribbed cup**
Late 1st century BC–1st century AD
Moulded glass
H. 4.7 cm; Diam. 17 cm
Qaryat al-Faw
Department of Archaeology Museum, King Saud University, Riyadh, 90 F 11

This type of cup, relatively common in the Augustan era in all the provinces of the Roman Empire, was a tableware item. Fragments from similar pieces, the same deep blue enhanced with white threads, were found at Dibba on the east coast of the Oman Gulf.
F. D.

**190. Bowl**
1st century BC
Moulded glass
H. 5.8 cm; Diam. 12.5 cm
Qaryat al-Faw
Department of Archaeology Museum, King Saud University, Riyadh, 105 F 13

**191. Cup**
1st century BC
Moulded glass (?)
H. 8 cm; Diam. 21 cm
Qaryat al-Faw
National Museum, Riyadh, 2242

This spectacular transparent glass cup is adorned with two sets of incised lines.

F. D.

**192. Beaker**
1st century AD
Blown glass
H. 10.3 cm; Diam. 8.5 cm
Qaryat al-Faw
National Museum, Riyadh, 2243

**193. Thin-ribbed bowl**
1st century AD
Blown glass
H. 6.5 cm; Diam. 9 cm
Qaryat al-Faw
Department of Archaeology Museum, King Saud University, Riyadh, 45 F1 6

These two containers were drinking vessels and may have been imported from Italy. The small thin-ribbed bowl is a particularly common type in the West. The rather unusual opaque white colour was obtained by adding antimony to the glass paste; the décor consists of blue threads applied in festoons and rolled on the marver.

F. D.

**194. Aryballos**
1st century AD
Blown glass
H. 4.6 cm; Diam. 3.8 cm
Qaryat al-Faw
Department of Archaeology Museum, King Saud
University, Riyadh, 85 F 7

This aryballos, the body of which was probably colourless or slightly blue glass, only preserved one of its elegant small dark-blue ribbed glass handles. This type of bottle was usually intended to contain scented oils.

F. D.

**195. Balsam bottle**
1st century AD
Blown glass
H. 3.3 cm; Diam. 5.9 cm
Qaryat al-Faw
Department of Archaeology Museum, King Saud
University, Riyadh, 27 F 13

This miniature blue-green thick glass flask probably contained an unguent or a particularly rare and precious scented oil.

F. D.

**196. Small flask with a globular body**
1st century BC–1st century AD (?)
Blown glass
H. 5 cm; Diam. 4.5 cm
Qaryat al-Faw
National Museum, Riyadh, 2239

This tapered-neck flask has a marble décor arranged in festoons.

F. D.

**197. Balsam bottle**
1st century AD
Blown glass
H. 12.2 cm; Diam. 5.9 cm
Qaryat al-Faw
Department of Archaeology Museum, King Saud
University, Riyadh, 25 F 11

These elegant small flasks were to contain unguents or perfumes that their long neck allowed to pour drop by drop. This precious balsam bottle preserved its stopper. It may come from Egypt; with its brown-green colour, enhanced with white threads applied in a spiral design and then rolled on the marver, it emulated agate.

F. D.

**198. Date-shaped flask**
Late 1st century–early 2nd century AD
Glass blown in a mould
H. 6.5 cm; Diam. 3.5 cm
Qaryat al-Faw
National Museum, Riyadh, 2240

Crafted like balsam bottles to contain precious unguents or scents, these small amber-coloured flasks, imitating the form of a dried date, are a typical production of the Syrian-Palestinian region in the late 1st century and early 2nd century AD. They were widely diffused throughout the Near East: several were found in the countries of the Levant, but also in Mesopotamia and the Gulf region, at Bahrain for example.

F. D.

## POTTERY

Ordinary pottery for everyday use forms the most part of the pottery corpus of Qaryat al-Faw.[1] The rest is glazed pottery, often preferred for offerings in shrines and funerary furnishings (cat. nos 199 to 202 and 204). This type of pottery is imported from the Mesopotamian sphere where it was made during the Parthian era (140 BC–220 AD); this type of pottery was also found on the island of Failaka, at Bahrain, in the Oman Peninsula where it abounded by the end of the 3rd century

BC and in South Arabia. In the early Christian era glazed pottery was even exported to the coasts of Eastern Africa, in Somalia. The site of Qaryat al-Faw also yielded several sherds related to Nabataean thin painted ceramic (cat. no. 206) as well as a small painted bowl of Taymanite origin or inspiration (cat. no. 208). **M. C.**

1. See Al-Ansari 1982, pp. 61, 66 and 67.

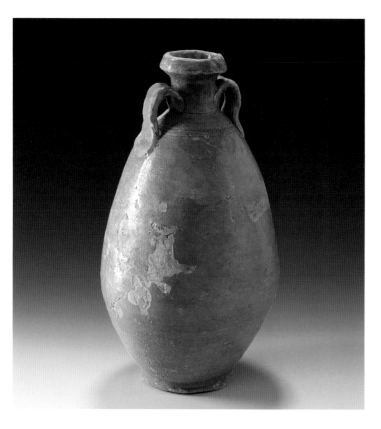

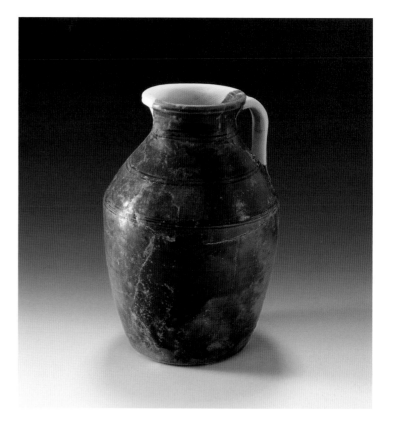

**199. Two-handled pyriform amphora**
1st century BC–1st century AD
Brown-green glazed pottery
H. 39 cm
Qaryat al-Faw
Department of Archaeology Museum, King Saud University, Riyadh, 172 F 2

**200. One-handled jug with keel-shaped body**
1st century BC–1st century AD
Dark-green glazed pottery
H. 31.5 cm; Diam. 20 cm
Qaryat al-Faw
Department of Archaeology Museum, King Saud University, Riyadh, 173 F 2

Bibliography: Al-Ansari 1982, p. 64–1.

**201. Two-handled ovoid jug**
1st century BC–1st century AD
Dark-green glazed pottery
H. about 25 cm; W. 15 cm
Qaryat al-Faw
Department of Archaeology Museum, King Saud University, Riyadh, 26 F 17

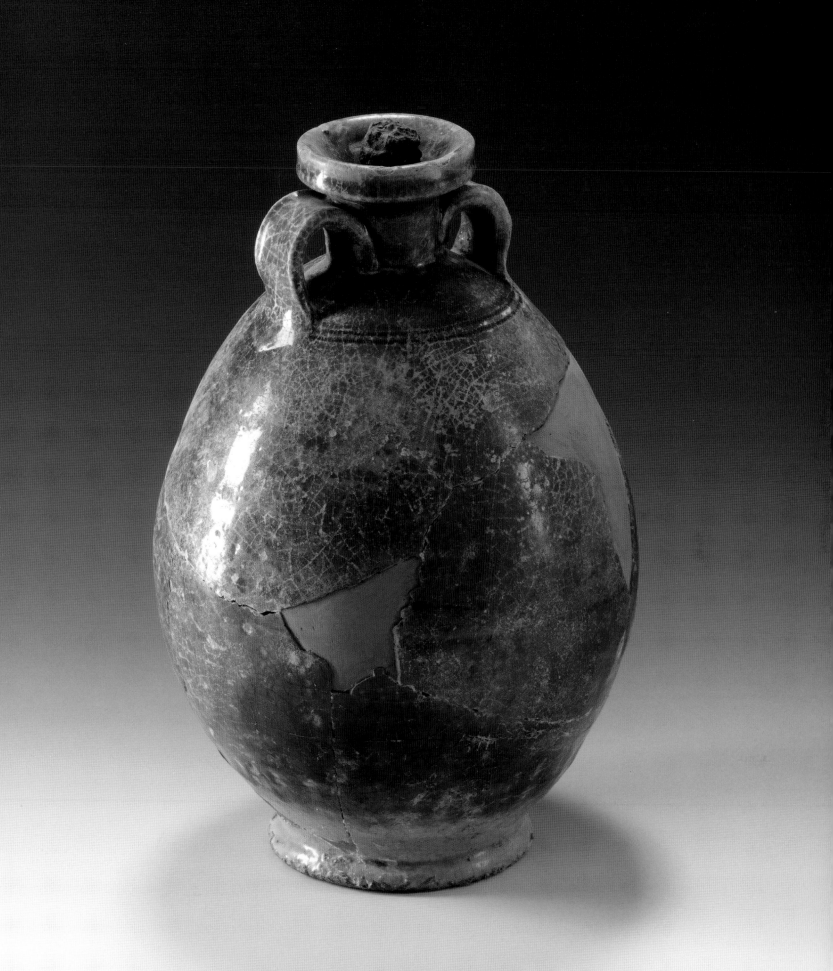

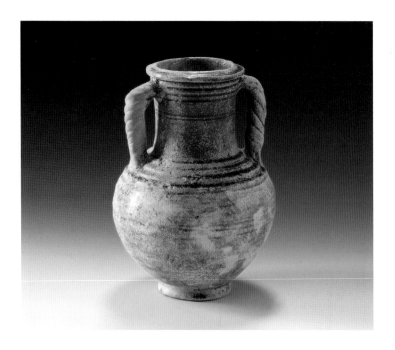

**202. Amphora**
1st century BC–1st century AD
Turquoise glazed pottery
H. 23.3 cm; W. about 18 cm
Qaryat al-Faw
Department of Archaeology Museum, King Saud University, Riyadh, 13 F 28

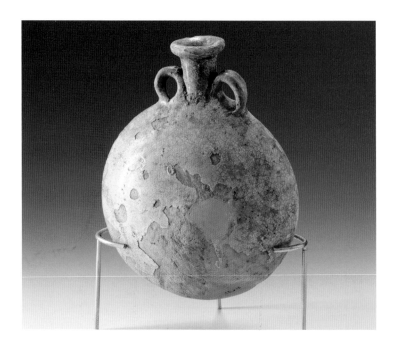

**203. Two-handled lenticular gourd**
2nd century BC–2nd century AD
Brown and blue glazed pottery
H. 26 cm; Diam. 20 cm
Qaryat al-Faw
Department of Archaeology Museum, King Saud University, Riyadh, 14 F 22

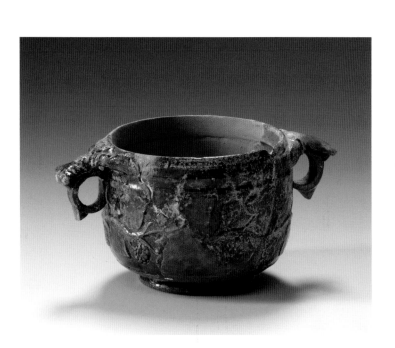

**204. Skyphos with loop handles and thumb rests with vine-foliage décor**
1st century BC–1st century AD
Dark green glazed pottery
H. 6 cm; Diam. 8 cm
Qaryat al-Faw
National Museum, Riyadh, 2253

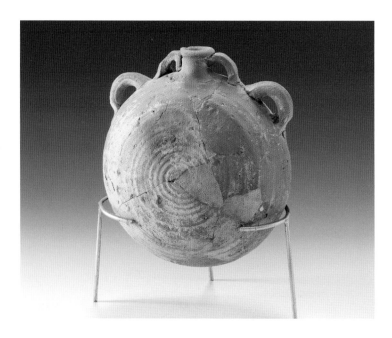

**205. Two-handled lenticular gourd**
2nd century BC–2nd century AD
Pottery
Diam. 20.4 cm
Qaryat al-Faw
Department of Archaeology Museum, King Saud University, Riyadh, 5 F 16

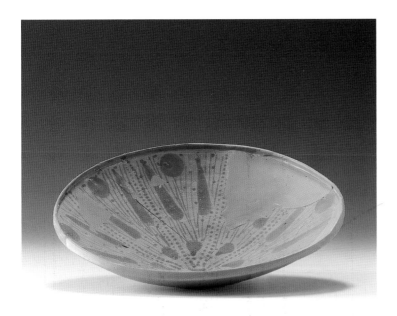

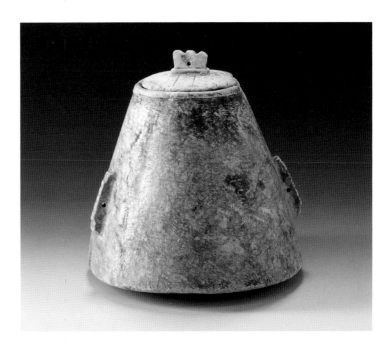

**206. Platter**
2nd century BC–2nd century AD
Painted ware
H. 5 cm; Diam. 19 cm
Qaryat al-Faw
Department of Archaeology Museum, King Saud University, Riyadh, 52 F 20

**207. Truncated cone-shaped vessel**
2nd–1st century BC
Limestone
H. 18.5 cm; Diam. 9 to 22.5 cm
Qaryat al-Faw
Department of Archaeology Museum, King Saud University, Riyadh, 75 F 2

Bibliography: Al-Ansari 1982, p. 62; Ghoneim 1980, fig. 7; Hassell 1997, p. 263, fig. 12, T1.

From the 2nd and 1st centuries BC stone vessels with zoomorphic handles were widely diffused throughout South Arabia (Shabwa, Qataban, Hadramawt, Najran . . .) and even East Arabia (Mleiha, ed-Dur, Dhahran . . .). They could be used to store food products, dates as here, cosmetics or coin hoards. Many lids belonging to this type of vessel were found at Qaryat al-Faw.[1]          **M. C.**

1. Al-Ansari 1982, p. 73 no. 4; p. 74, no. 2 ; p. 75, no. 4.

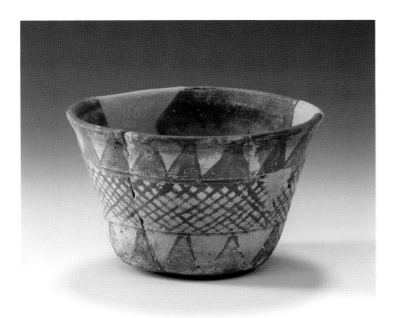

**208. Bowl**
1st–2nd century AD
Painted ware
H. 5 cm; Diam. 11.5 cm
Qaryat al-Faw
Department of Archaeology Museum, King Saud University, Riyadh, 9 F 18

## TEXTILE

The site yielded a large quantity of fragments of fabrics in camel-hair, sheep's wool and linen; the wall paintings (cat. nos 161, 162 and 164) also give a glimpse of the wealth and variety of the fabrics used at Qaryat al-Faw. Excavations in the residential district revealed the existence of a textile workshop where both the raw materials (balls of wool) and an ensemble of tools (spindle whorls, needles and textile combs in different materials) were found.

M. C.

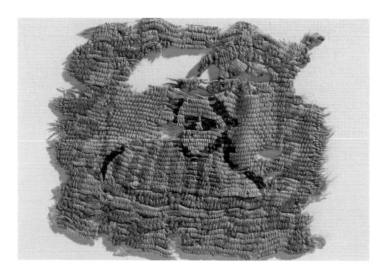

**209. Fragment of fabric with a bust of a man**
3rd century BC–3rd century AD
Tapestry, orange and green wool (?) warp
9 x 10.5 cm
Qaryat al-Faw
Department of Archaeology Museum, King Saud University, Riyadh, 182 F 8

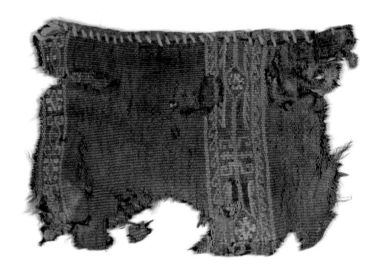

**210. Fragment of fabric adorned with bands of ornamental motifs**
3rd century BC–3rd century AD
Wool (?)
10.5 x 8.5 cm
Qaryat al-Faw
Department of Archaeology Museum, King Saud University, Riyadh, 295 F 7

**211. Fragment of fabric with a chequer-work motif**
3rd century BC–3rd century AD
Green and beige linen
9 x 7 cm
Qaryat al-Faw
Department of Archaeology Museum, King Saud University, Riyadh, 179 F 8

**212. Spindle-whorl**
3rd century BC–3rd century AD
Stone
Diam. 2.7 cm
Qaryat al-Faw
Department of Archaeology Museum, King Saud
University, Riyadh, 251 F 7

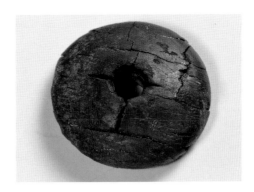

**213. Spindle-whorl**
3rd century BC–3rd century AD
Wood
Diam. about 3 cm
Qaryat al-Faw
Department of Archaeology Museum, King Saud
University, Riyadh, 101 F 9

**214. Ball of wool and needle**
3rd century BC–3rd century AD
Wool, bronze
Diam. about 5.5 cm
Qaryat al-Faw
Department of Archaeology Museum, King Saud
University, Riyadh, 6 F 10

**215.          216.**

**215. Needle with eye**
3rd century BC–3rd century AD
Bone
L. about 8 cm
Qaryat al-Faw
Department of Archaeology Museum, King Saud
University, Riyadh, 48 F 10

**216. Needle with eye**
3rd century BC–3rd century AD
Bronze
L. about 12.5 cm
Qaryat al-Faw
Department of Archaeology Museum, King Saud
University, Riyadh, 69 F 2

### 217. Zoomorphic weight

c. 1st century AD
Bronze
12 x 14.9 x 6.5 cm; weight: 4 kg
Qaryat al-Faw
Department of Archaeology Museum, King Saud University, Riyadh, 294 F 6

Bibliography: Al-Ansari 1982, pp. 88–89; 'Aqil and Antonini 2007, p. 212, no. II E a 2.

A        *Ḡwt̠ (b)= Ghawth son*
B        *n Qs²mᵐ  of Qashamᵘᵐ*

On side A, a second text (posterior) is incised:
*(monogram of Kahal, composed of the letters K, h and l)*
*'f'm-bn-'l(w)        Af'am son of 'Ala*

The transcription is not certain.

**(transcription C. R.)**

The rectangular lion-shaped weight rests on four feet. On the short sides the head and tail of a lion are applied. It is inscribed in the name of its owner and bears the symbol of the national deity Khal. A similar weight inscribed with the letter *k* was found at al-Gwaf in Yemen.[1]        **M. C.**

1. Paris 1997, p. 102.

**218.**          **219.**

### 218. Zoomorphic weight

c. 1st century AD
Bronze
3 x 4 x 1.9 cm
Qaryat al-Faw
Department of Archaeology Museum, King Saud University, Riyadh, 285 F 5

This lion-shaped weight is a reduced and schematized version of the inscribed weight above (cat. no. 217).        **M. C.**

### 219. Weight

c. 1st century AD
Bronze
3.6 x 4 x 3.5 cm
Qaryat al-Faw
Department of Archaeology Museum, King Saud University, Riyadh, 465 F 1

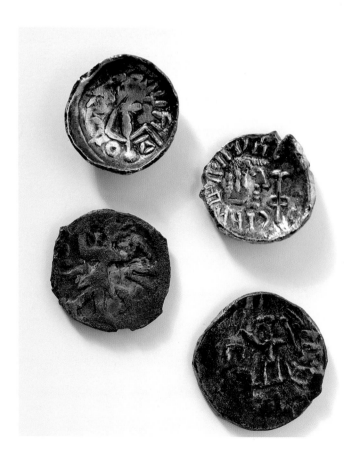

### 220. Coins

1st–4th century AD
Silver
Diam. 1–1.5 cm
Qaryat al-Faw
National Museum, Riyadh, 4946, 4947, 4941 and 4948

Upper left: Qaryat coin. Around the central motif – apparently a figure with long folded arms – we make out a few Sabaean letters:
*S¹'d and Kh[l]. Kahl is the great god of Qaryat*

Upper right: Himyarite coin in the name of *Tha'rān Ya'ūb* (c. 200–220)

Lower left: Qaryat (?) coin with a striding figure with raised arms

Lower right: Qaryat (?) coin with a standing figure with raised arms

**(transcription C. R.)**

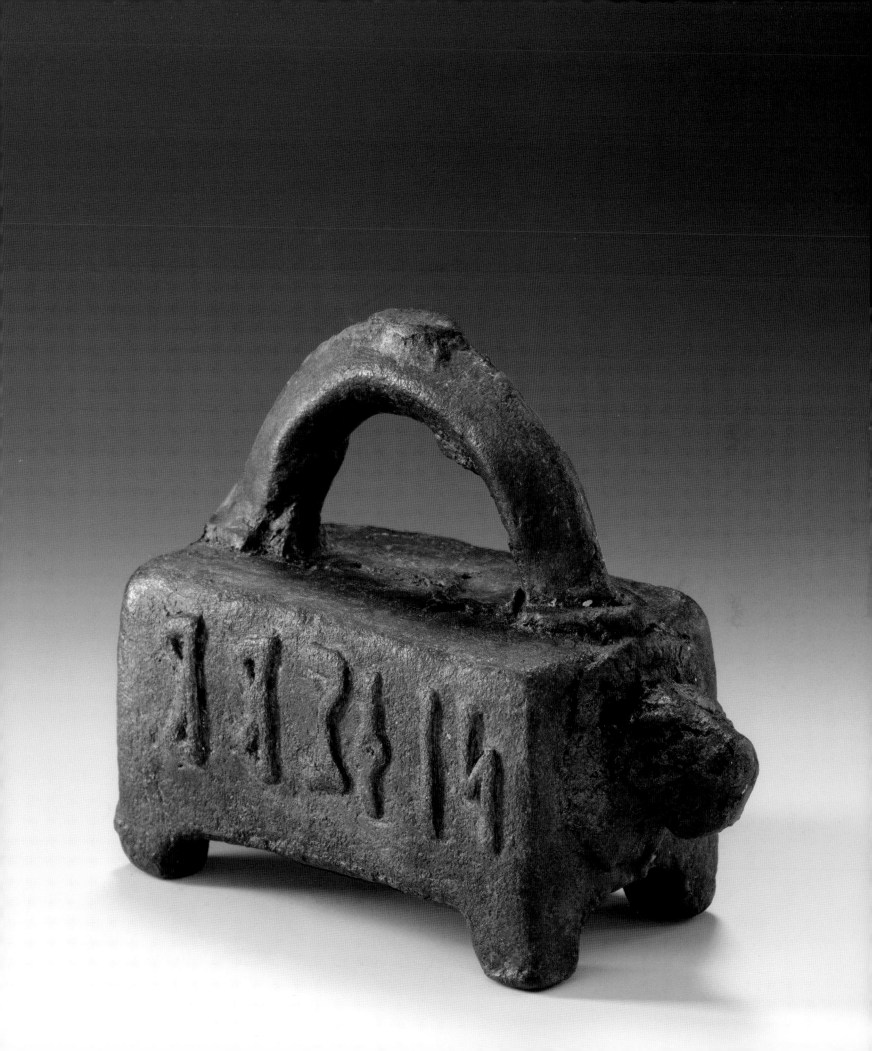

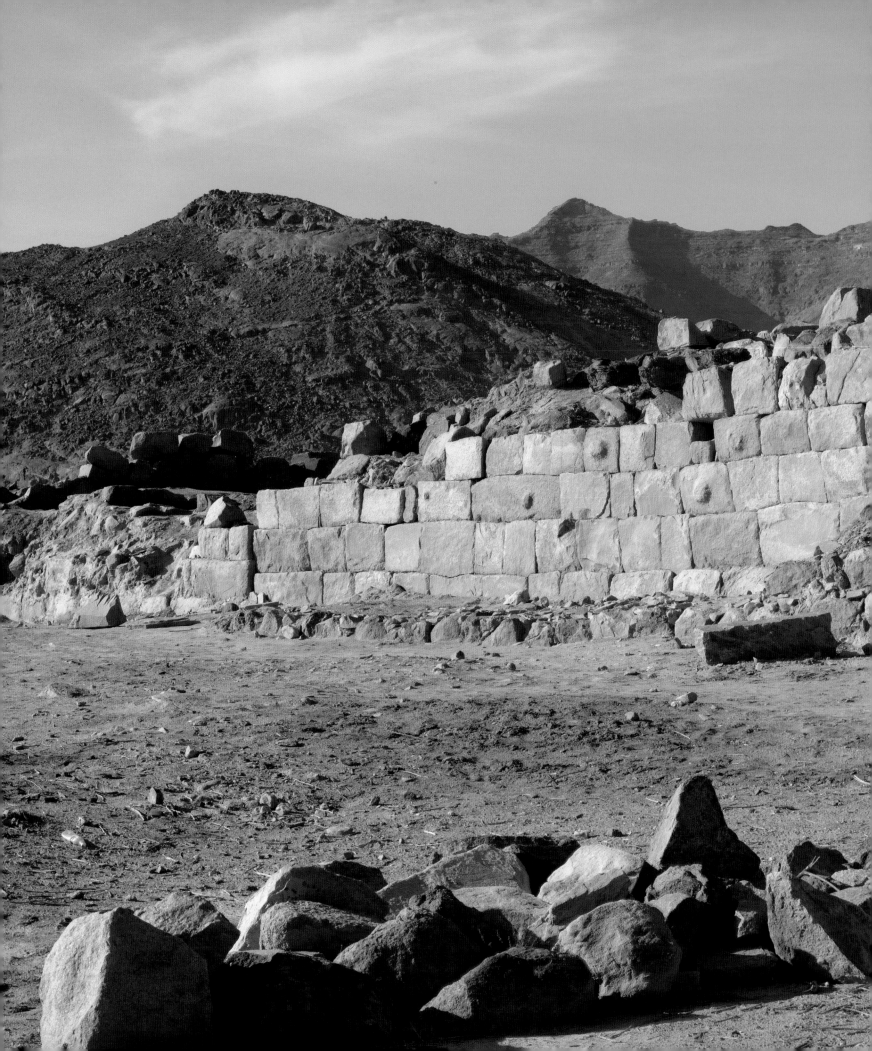

# NAJRAN

*Saleh Al-Marih*

Najran is located in south-western Saudi Arabia, on the edge of the Rubʻ al-Khali desert. The city is considered one of the oldest urban centres of the Arabian Peninsula. According to recent archaeological discoveries, the first human settlements here date from the Palaeolithic Age. Researchers have found evidence of organized inhabitation dating back more than a million years, as well as indications of ancient lakes that have since disappeared. This is a region of great historical importance, having played a crucial role in the power struggles between the various Arab kingdoms that sought to dominate this luxuriant oasis, whose location made it an obligatory point of passage on one of the most important trade routes.

Najran has been inhabited continuously throughout its history, which has been marked by many significant events. Due to its proximity to the southern Arabian kingdoms it was caught up in nearly all of their conflicts, as evidenced by inscriptions. The most famous of these is a text by King Karibʼil Watar recounting a battle waged by his son (Yathaʻʼamar Bin) against enemy tribes in the Najran oasis and in its main town Ragmat. Another inscription, dating from the period between 35 and 15 BC, describes a military expedition against Najran and is attributed to King Ilisharah Yadub and his brother Yazil.[1]

## Toponymy

The name Najran is mentioned in numerous historical sources and in accounts by Arab and foreign travellers. The term itself could denote the bolt of a gate. Other sources suggest that it was derived from the name of its founder: Najran ibn Zaydan ibn Sabaʼ ibn Yashjib ibn Yuʼrub ibn Qahtan.

Najran is the name of both the valley and the city. It seems that the site now called ʻal-Ukhdud' designates the ancient city, whose name is transcribed as *ngrn*. It was a place of growth and prosperity during the 1st millennium, between 500 and 250 BC.

1. Jamme 577.

## The tribes

Before Islam, the main tribe in Najran was the Bani al-Harith ibn Ka'b tribe, who later shared the region with the Hamadan tribe. Ultimately, the Banu Yam tribe of Hamadan ibn Zayd dominated the area between the valley of Najran and Habuna, and joined up with the tribes of al-'Ajamane and al-Murra. Another local tribe, the al-Harith, declined in importance over time, although many of its members still live in Najran.

## Prehistory

A great deal of archaeological evidence attests to human presence in the region. Blades, scrapers, hammers and bifaces found at Shu'ayb Dahdha have been dated to between 1.2 and 1.8 million years ago, before the Palaeolithic period. The best-known Middle Palaeolithic sites are Bir Hima and 'Irq al-Bir in the Rub' al-Khali. Both are situated on high ground overlooking the valleys. The tools discovered at these sites, including drills, arrowheads and scrapers with sharp ridges, are carefully and precisely hewn.

The Bir Hima region was inhabited for a long time, as indicated by the remains of hearths and rectangular or semicircular dwellings from the Neolithic Age. Numerous rock carvings provide information on the clothing worn at the time, the jewellery, weapons, incense burners and bowls.

## The al-Ukhdud archaeological site

The most remarkable feature of the ancient city of Najran (*ngrn*) is its 'citadel', a zone that was inhabited between 500 BC and the early 1st millennium AD. Rectangular in shape, the citadel is surrounded by a wall 235 metres long and characterized by the irregularly spaced overhangs and recesses typical of southern Arabian city walls. The fortification system integrates bunkers abutting the rampart. Their reinforced walls can be as thick as 150 centimetres, compared with 80 to 110 centimetres for the walls of the houses within the enclosure.

Many buildings inside the city wall have foundations made of rectangular or square stone blocks.[2] Their walls, none of which survive today, were made of mud brick. Excavations of the citadel sponsored by the Saudi Commission for Tourism and Antiquities have led to the discovery of a mosque that dates from the 1st century of the Hegira (7th–8th centuries AD), making it one of the oldest in the region. Archaeological research at the site is still underway.

## Early archaeological projects at al-Ukhdud

Najran and al-Ukhdud are mentioned by a number of Arab historians and travellers. At the time of Ibn Al-Mujawir, the city and people of Najran had already been cited, although in his work Tarikh al-Mustabsir, that author specifies that the region of al-Ukhdud was no longer inhabited. Al-Bakri's dictionary describes the city as being in ruins, with only the mosque built by 'Umar ibn al-Khattab remaining. Carsten Niebuhr was no doubt the first Western traveller to mention Najran, but Halevy was the first to visit the site and the oasis, in 1870. He gives a description of the ruins, repeating what al-Bakri had written about the mosque of 'Umar.

No actual research was undertaken at al-Ukhdud until Philby visited the site in 1936. He recorded a precise and detailed description, but his work was not published until 1952. He

2. The blocks could be as large as 35 centimetres.

describes the fortified zone as a 'citadel' covering a surface of 8 hectares, and notes structures bearing witness to the splendour of the site's architecture, as well as the remains of canals, artificial lakes and dams on the outskirts of the city. Al-Ukhdud was surrounded by trenches or moats supplied with water from a nearby river. Philby believed that these moats separated the citadel geographically from the rest of the city.

In December 1951 the Philby-Ryckmans-Lippens expedition, led by Philby, produced an accurate map of the citadel, although omitting certain interior details. Ryckmans and Dayton undertook a brief study of the site's pottery, but did not know the exact origins of this material and therefore could not interpret it correctly.

During the summer of 1968, Van Beek conducted a prospecting survey of the main site and noticed similarities with the sites of the Hadramawt. He also identified other ruins south of al-Ukhdud. In the early spring of 1980, a prospecting survey collected pottery in the citadel and the surrounding area. Carbon 14 dating of samples selected from a probe carried out in the citadel revealed that the site had been inhabited from about 500 BC to 250 AD. The other sites that had been identified were also mapped and documented.

Decorated stone blocks, Najran, photograph by Humberto da Silveira

## Artefacts discovered
### Terracotta jars

Pottery sherds discovered at al-Ukhdud have made it possible to reconstitute a series of jars originally used for storage. Their pear-shaped bodies are made of a light brown clay tempered with small pebbles and straw. They were thrown on a wheel and fired with sufficient heat. Potters' fingerprints are visible on both the inside and outside of the jars. These fragments were found in a room near several grindstones, indicating that the jars were used to store agricultural products such as wheat, barley, etc.

### Bowls

A number of pottery bowls covering a range of shapes, materials and production methods have been found. Some are large, made of brown clay tempered with bits of stone and have a circular base, a globular body and a straight rim. Traces of dark brown slip are visible on the inner surface and around the outer rim.

There are also smaller bowls with a concave base and a straight or slightly inward curving rim. Some have a coarse surface. All have a broad base and some an ovoid body. These bowls were thrown on a wheel, and marks from the turning process are sometimes visible inside and out. They were fired with sufficient heat.

### Undulating rim vessels

Many vessels with scalloped rims have been found nearly intact. They were thrown on a wheel using light brown clay and well fired. They have a concave base and a piriform body ranging in thickness from 3 to 6 millimetres. Some bear traces of slip on the outside or, in certain cases, the inside surface.

### Cups

A relatively large number of incomplete cups made from a light brown clay containing impurities and mixed with sand have been found. They have a flat or concave base and a body that tapers toward the rim, which is turned slightly outward. They were thrown on a wheel and well fired.

### Clay baking moulds

The discoveries at al-Ukhdud also include a number of clay moulds with a shape indicating that they were used to bake bread. They were thrown on a wheel using a dark brown ceramic clay mixed with small and medium-sized pebbles.

### Glazed jars

Sherds of glazed pottery have been found at the site and have been identified as fragments of medium-sized jars. These jars were made of relatively pure yellow clay and are glazed on the outside. The glaze has turned green as a result of corrosive agents.

### Chlorite vessels

Large fragments of a variety of stone containers have been discovered: pots, drinking vessels, cups and bowls that were carved from chlorite, possibly with handles. Some have green oxidized metal attachments, and one has an inscription in South Arabic on its inner surface. Certain of the vessels are very well polished. Their outer surfaces show evidence of exposure to fire, which is consistent with their function.

### Metal artefacts

The excavations have yielded metal rivets used to repair stone vessels as well as components of metal vessels. The discoveries also include fine, delicate metal objects like needles, awls, knives and daggers, plus a silver tube 9 centimetres long and 1 centimetre in diameter that was in the process of being crafted.

### Coins

Circular bronze coins have been found with diameters ranging from 1 to 2 centimetres. However, after cleaning it was noted that corrosion had destroyed the motifs on both the obverse and reverse sides. In addition, many silver coins of Sabaean, Himyarite and Qatabani origin have been unearthed.

### Beads

A number of coloured beads have been found. Some are spherical, and made of black glass with white circles. Others are made of shell, and still others are yellow ceramic with traces of vitrification.

### Wooden objects

The wooden artefacts from the site are fragments of combs decorated with deep crosshatching.

### Glass

The excavations have yielded many fragments from the bodies and bases of vessels made of dark blue and light green glass. Some are decorated with parallel lines on the outer surface.

### Incense burners

Small cubic incense burners made of grey stone and standing on four square feet have been found intact. Traces have been noted of a South Arabic inscription reading 'fruit of the mastic tree', which corresponds to the name of a perfume. Fragments of incense burners made of siliceous stone and decorated with triangular motifs have also been uncovered. Other incense burners found on the site are made of ceramic. The clay contains impurities and the surfaces

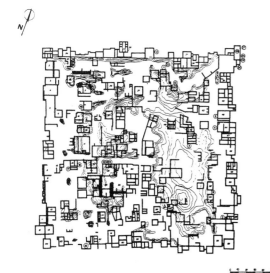

Map of Najran

show the potters' fingerprints, as well as traces of slip and in one case a South Arabic inscription, still legible, of the name of another perfume: 'aloe wood'.

## Mortars
A number of mortars of various shapes and colours have been discovered. Some are round, with a central hole and spout, while others are rectangular and have feet.

## Grindstones
The excavations have yielded the upper and lower grindstones of a number of mills, plus a few isolated fragments. They are made of grey stone and some are coarsely hewn. Their diameters range from about 40 to 50 centimetres.

## Stone basins
Two basins have been found, one grey and the other made of yellowish stone. They are hewn from siliceous stone and equipped with a spout at the base.

## Marble vessels
Fragments of marble vessels have been unearthed, as well as a fragment of a marble frieze carved with regularly-spaced parallel grooves.

## Carvings and inscriptions
The discoveries include inscriptions, both complete and unfinished. Some appeared on the walls of buildings. A stone from a wall has been found bearing an inscription that probably gives the name of the house's owner. Other carvings depict animals and reptiles, including a horse and a snake, whose head is clearly visible along with most of the body. The site has also yielded two stelae covered with inscriptions in South Arabic, which are currently being analysed.

## Efforts undertaken to preserve the al-Ukhdud ruins
The Saudi Commission for Tourism and Antiquities has initiated a number of actions for the preservation of the ruins of al-Ukhdud. The main priorities are: geophysical surveys, excavations and installations of the site; surveillance; scientific publication of the geophysical and archaeological findings; expansion of the Najran Archaeological Museum to add seven new rooms; improvement of public access to the site; and the installation of a new protective fence around the ruins.

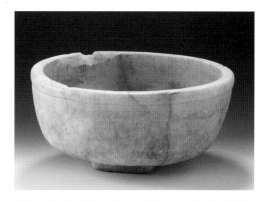

Alabaster basin, Najran. National Museum, Riyadh, 1320

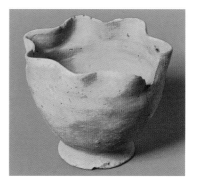

Bowl with undulating rim, Najran

# NAJRAN

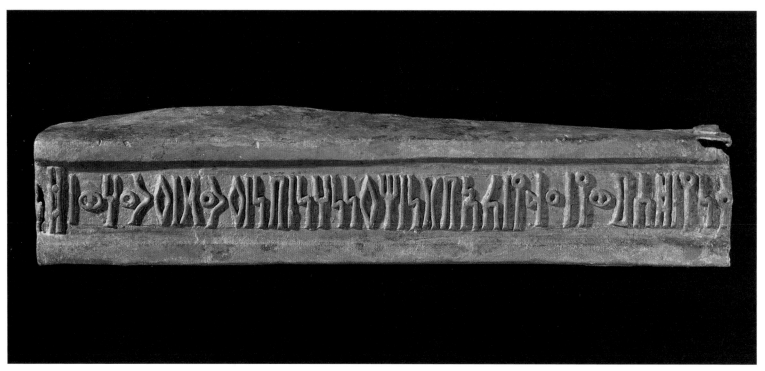

221.

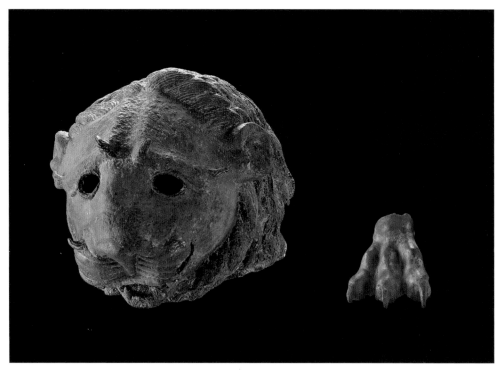

222.

**221. "Gutter" with inscription**
c. 2nd century AD
Bronze
9.5 x 53 x 7.5 cm (H. of the letters: 5 cm)
Najran
National Museum, Riyadh, 1327

Inscription :
*…]qny ḏ-S¹mwy 'dy K'btⁿ ḥfnnhn bn fr't fr'-hw* Symbol
… ..de]dicated to dhu-l-Samawi at Ka'batan the two (gutters) with the first fruits
he offered Him     **(transcription C. R.)**

Bibliography: RES 4930, Smith 1937, p. 155, pl. XLII.

**222. Head and tip of a lion's paw**
c. 2nd century AD
Bronze
32 x 25 x 23 cm
Najran
National Museum, Riyadh, 1328

Bibliography: Smith 1937, pl. XLII; Philby 1938, pp. 4, 17; 'Azza 'Ali 'Aqil and
Sabina Antonini 2007, p. 168, no. IBa1.

This head of a roaring lion is very similar to 1st- and 2nd-century
AD Graeco-Roman models but several elements of style and tech-
nique provide unquestionable proof that it was produced by a local
workshop. The inlaid eyes, the mane treated in graphic style, the
astonishing moustache and eyebrows in high relief as well as the two
roughly sketched small tubes featuring the round ears recall the styl-
ization of lion heads discovered in South Arabia; in addition the
presence of the clay core inside the work is typical of the technique
of South Arabian founders. This head was probably soldered to a
body in the round or in high relief as the asymmetry of the mane
suggests. It is not surprising that no other parts were found, due to
the South Arabian bronze-casters' technique of preserving the clay
core inside their sculptures: while it did spare material it also made
the walls of bronze sculptures very thin and therefore particularly
fragile. This item was a stray find in the early 20th century, so we
can imagine that thin fragments of bronze, doubtless corroded, did
not attract the attention of the prospectors and that the remains of
the sculpture were totally overlooked and simply left on the spot.
This small lion head was supposedly found with the fragment of
the tip of a paw and the inscription, so we may assume that these
objects were part of the same monument and suggest that the "gut-
ter" might simply be the pedestal of the lion sculpture.     **F. D.**

**223. Flat stone adorned with a snake**
Orangey-red sandstone
Diam. 21 cm; D. 7 cm
Najran
National Museum, Riyadh, 3168

This flat stone featuring the coils of a wound-up snake may have
been made to be placed as an offering in a temple. The snake had a
strong symbolic importance: at Ma'in it was the symbol of the god
Wadd, one of the principal deities invoked by the caravaneers.     **F. D.**

THE EASTERN PROVINCE

AND THE GRAECO-ROMAN WORLD

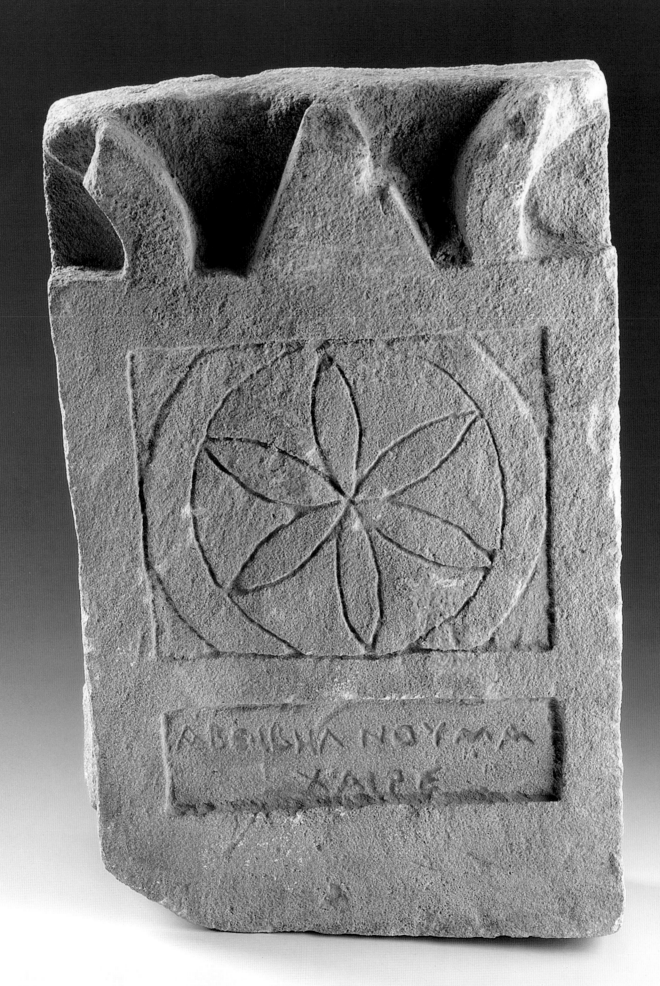

# THE RENAISSANCE
# OF NORTH-EAST
# ARABIA

## IN THE HELLENISTIC PERIOD

*D. T. Potts*

Because it can be difficult if not impossible to date archaeological sites and finds specifically to the Seleucid or Parthian period, to speak in political terms, many scholars prefer the term "Hellenistic" for the entire period from the 4th century BC to the arrival of the Sasanians in the 3rd century AD in north-eastern Arabia. Unquestionably, this period has yielded a stunning series of finds (cat. nos 229 to 242). Yet anyone viewing these for the first time is surely justified in asking, where did the culture that produced such extraordinary material originate? The answer to a question of this sort is usually sought in the preceding period where we would expect to find the roots of such a cultural florescence. In the present case, however, we are confronted by an obvious difficulty for following the 3rd and early 2nd millennium BC, with its impressive evidence from Tarut and Dhahran on the coast and Sabkha Hammam, Umm an-Nussi and Umm ar-Ramadh in the interior, we can point to very little evidence of late 2nd millennium or Iron Age date anywhere in the Eastern Province, apart from a few finds from the surface of Jabal Kenzan and the Salt Mine site near Hofuf oasis and Dhahran.[1] Thus, in contrast to north-western Arabia, where Tayma and al-Khuraybah show signs of an evolution of local material culture as a result of both internal development and external, Egyptian stimuli, eastern Saudi Arabia currently exhibits too little evidence of continuity in occupation from the 3rd through the 2nd to the 1st millennium to permit us to speak of evolution.

In fact, based on current data it is difficult to find evidence in the centuries immediately prior to the Hellenistic period of the population needed to account for the developments we see at this time. Demographically, therefore, it is likely that the Eastern Province received an influx of new settlers early in the Hellenistic period. Whether unfavourable environmental and climatic conditions were responsible for the apparent drop in population after the early 2nd millennium BC, followed by an amelioration in the 4th century BC, we do not know, but it is certainly possible that factors such as these may have induced new colonists to move into what must have been a sparsely populated area at the time. The possibilities

(*preceding pages*)
View of an oasis, photograph by Humberto da Silveira

(*opposite*)
Funerary stele, Greek inscription,
National Museum, Riyad (cat. no. 227)

1. Potts 1989.

Nephesh-type stele of al-Hajjar necropolis in Bahrain

Earthenware from Thaj

of where that population might have originated are limited. When one looks at the most ubiquitous cultural marker of the period, namely ceramics, then it becomes clear that similarities between the ceramic traditions of Bahrain, Failaka (Kuwait) and the Eastern Province are striking. Viewed from this perspective, one could certainly hypothesize an infiltration of the north-east Arabian mainland from Bahrain and/or Failaka. Indeed, there are clear similarities in some of the ceramic shapes characteristic of the Hellenistic period and those of the earlier 2nd millennium BC "Barbar" tradition on Bahrain suggesting that Dilmun is the parent culture of the settlers who emigrated to the Eastern Province around the 4th century BC.

Shared funerary practices at this time on Bahrain and in the Eastern Province also strongly suggest a common culture. The two funerary stelae (cat. nos 225 and 226) on display came from a series of cist graves dug into a mound on Tarut that was being mined for sand around 1966. Made of beach rock (Arabic *farush*), these consist of a stylized head and torso with a peg at the base which was set into a stone plinth. Exactly the same sort of stelae have been found on Bahrain in the cemeteries at Karranah, al-Hajjar and Shakhoura suggesting shared traditions. In one case, Danish archaeologists discovered three stelae of this type, evenly spaced around a burial mound of the Hellenistic period on Bahrain which had pottery exactly like that found in the Eastern Province.

It is also interesting to note that at least two of the stelae from Bahrain of the sort known also from Tarut bear funerary inscriptions in Greek commemorating individuals with non-Greek, Semitic names. One of these, marking the grave of Auidisaros, son of Auidisaros, of Alexandria, may have been a native of Alexandria-on-the-Erythraean Sea, a foundation of Alexander the Great's that was better known, from the late 2nd century BC onwards, as Spasinou Charax, and was probably located near Mohammareh or Basra. The second marked the grave of Abidistaras, son of Abdaios, a pilot or sea captain. Clearly, therefore, even though Greek was the language used to inscribe these stelae, the deceased whose graves they marked were probably not ethnic Greeks.

Over thirty years ago a survey conducted between Abqayq and the border of Kuwait discovered sixty-five sites with evidence of occupation dating to the Hellenistic period but it is likely that the real number is much higher, particularly in view of the fact that the area around Hofuf, the largest oasis in eastern Saudi Arabia, was not systematically surveyed. For the most part, occupation was indicated by a very consistent ceramic assemblage dominated by red wares ranging from fine examples used for cups and bowls to coarser ones for cooking pots. Sites with this sort of pottery were found all along the coast, from Kuwait to Dhahran, and in the interior around Fuda, Yaqrub, Ayn Dar, Salasil and Thaj. Excavations at Thaj by a Danish expedition in 1968 recovered such ceramics in stratigraphic context, along with other, chronologically diagnostic finds, making it clear that this assemblage of red wares is typical of the Hellenistic era in the Eastern Province.

Thaj is by far the most important and, at over 80 hectares, the largest site of the Hellenistic period in eastern Arabia.[2] Located about 90 kilometres inland from the port of al-Jubayl in the Eastern Province, Thaj is in the Wadi al-Miyah on a caravan route linking Basra in southern Iraq with Hofuf. References to Thaj in Pre-Islamic Arabic poetry show that it was still a noted watering place with wells, even if its stone ruins, thought to have been quarried

2. See Potts 1990 and 1993 a.

by Iram, son of 'Ad, the legendary Pre-Islamic Arabian tribe, were of such antiquity as to have semi-mythical origins. Over five hundred burial mounds in the southern part of the site border an area of rolling topography and a *sabkha* or seasonally flooded salt flat further north. The central part of the site, where occupation was most dense, is delimited by a monumental city wall. With a uniform thickness of 4.5 metres (± 10 centimetres), the city wall is built entirely of cut limestone blocks and over 2.5 kilometres long (the walls measure individually 725 metres [N], 685 metres [S], 535 metres [E] and 590 metres [W]), enclosing an irregular parallelogram of ground. Semicircular turrets at 40 metre intervals are clearly visible all along the southern city wall, each of which is about 4.5 metres wide and 5 – 7 metres thick. Smaller buttresses, 1 x 2 metres, are also visible in between the turrets and each corner has a massive, diamond-shaped tower. Although aerial photos suggest breaks in the city wall at several points, no obvious gateways have been identified.

Within the central part of Thaj various areas of clearly visible stone architecture can be seen. Test excavations suggest that most of the area inside the city wall is residential. Significantly, the earliest occupational layers at Thaj pre-date the construction of the city wall. Thus, a settlement of unknown size clearly existed on the site before the massive project to build the city wall was begun, and the need to enclose a pre-existing, sprawling, irregularly shaped settlement might help explain the rather eccentric shape of the city wall, none of the angles of which is built at 90°.

With its semi-circular turrets and diamond-shaped corner towers, the city wall of Thaj certainly had no antecedents in eastern Arabia. As noted already, the repopulation of north-eastern Arabia may have been launched from Bahrain and/or Failaka, but it is difficult to attribute the design or masonry style of the city wall at Thaj to either of these areas. Indeed, the small fortification on Failaka, certainly established by Greeks, is nowhere near as monumental, and Bahrain has nothing like the Thaj city wall. Nevertheless, two aspects of the structure at Thaj, pointing in two very different directions – towards the Greek world and towards South Arabia – should be considered as potentially relevant.[3] Let us consider the Greek evidence first.

The Macedonian conquest of Western Asia by Alexander the Great and his armies is commonly seen as a major watershed in the history of the region. Indeed, were it not for this, we would not speak of a "Hellenistic" period or of "Hellenism" in the East at all. In the broadest sense, Greek language, material culture (ceramics, theatres, temples, etc.), intellectual traditions (philosophy, religion, drama, literature), coinage and much more were diffused widely from the Mediterranean to Central Asia, India and Arabia. But like the British Empire, whether in India or in her colonies in Africa, the Macedonian empire and its Seleucid successor in the Near East was not brought about by a massive transplantation of ethnic Greeks and Macedonians from the European mainland and Aegean islands into foreign realms.

Much has been made of Alexander's famous "last plans" and of his projected conquest of Arabia. Certainly Alexander had heard of the richness of Arabia – meaning the frankincense- and myrrh-growing regions of Hadramawt and Dhofar – and Pliny knew, as Herodotus had before him, that before the fall of the Achaemenid empire the Arabians had sent 1,000 talents (c. 25.5 tons) of incense each year to the Persian king. Like Nabonidus, Alexander may well have had a plan to seize control of this resource, and quite possibly the

3. Breton 1994.

three naval expeditions sent out from Babylonia to explore the coasts of Arabia under Archais, Androsthenes and Hieron may have had an attack on South Arabia as a goal, but although these expeditions succeeded as intelligence-gathering missions, no subsequent military campaign was ever launched.

From a demographic point of view, it seems clear that only relatively small numbers of Greeks or Macedonians ever settled east of the Euphrates, and even when Alexander and his successors established colonies by giving land to ex-soldiers, or enlarged those colonies with the addition of new colonists from "mother" cities, like Magnesia-ad-Maeandrum in Asia Minor, the absolute numbers of ethnic Greeks in these regions remained small, and intermarriage with the local population undoubtedly diluted their "Greekness". Both Arrian (*Anabasis* 7.21.7) and Quintus Curtius (*Histories* 10.4.3) refer to Alexander's settlement of veterans of his wars in "Arabia" but all indications are that these sites were located on the edge of southern Babylonia, not in the Arabian Peninsula itself. Nevertheless, according to several commentators, including Eduard Glaser and W. W. Tarn, three Greek foundations mentioned by Pliny (*Natural History* 6.32.159) – Arethusa, Larisa and Chalcis – were established by Alexander or his Seleucid successors somewhere between the mouth of the Euphrates and the Arabian emporium of Gerrha, identified by some scholars with Thaj and certainly located in the Eastern Province.

In evaluating the evidence of Greek influence at Thaj and more generally in the Eastern Province, it is clear that the bulk of the ceramics, domestic architecture and burial customs documented in no way suggests the presence of a large Greek contingent amongst the population. Most of the pottery from this period belongs to the local, north-east Arabian tradition of redwares, and only a few shapes reflect Hellenistic influence. The same is true of the steatopygic female figurines (cat. no. 229) that are clearly not Greek in inspiration. There are some sherds of imported Greek black-glazed pottery (and even a single Nabataean sherd) from Thaj but only a small number of typically Hellenistic "fishplates", carinated bowls or bowls with incurving rim recall Hellenistic material found elsewhere in the Near East. By far the greater proportion of the imported pottery, with green or white glaze, is almost certainly from southern Mesopotamia or south-western Iran, as is to be expected given the ease of trade by boat to ports there. Similarly, although a small stele from Tarut (cat. no. 227) has a Greek inscription, the personal name in the text – Habib'il Nawmat – is Semitic, just as the names are on the funerary stelae from Bahrain. In 1988–89, Greek numismatic evidence from the Hellenistic era was found at al-'Ayun, in the al-Aflaj region of central Saudi Arabia, a small settlement with mudbrick architecture excavated by Abdullah Saud Al-Saud.[4] A coin hoard found there contained thirteen silver tetradrachms of Alexander type including four that were minted in Macedonia around 323–20 BC, one that was minted at Babylon c. 315 BC and four that were minted at Amphipolis c. 300 BC. One can only speculate that this hoard ended up at al-'Ayun because of the site's location on a main caravan route through the heart of Arabia.

Nevertheless, Greek influence in north-eastern Arabia may have been operating at an entirely different level than ceramics, coins or other small objects might reveal. From a fortification-theoretical perspective, the city wall at Thaj suggests some knowledge of Hellenistic or Greek theories of fortification, as recommended by Philo of Byzantium (c. 240 BC) in his *Poliorcetica* (*Siegecraft*).[5] Given the presence of Greek commanders and veterans in southern

Incense burner, terracotta, Thaj

4. Al-Saud 1997.
5. Winter 1971.

Babylonia, and of several likely colonies in the area, it is certainly possible that Greek theoretical knowledge, specifically of engineering, geometry and fortification construction, may have played a role in the design and construction of the great fortified enclosure at Thaj.

A second source of possible influence upon the construction techniques and design of the city wall at Thaj is South Arabia. Unlike Mesopotamia, where the building tradition was founded upon the use of baked brick and sun-dried mudbrick, South Arabia had a tradition of cut stone architecture extending back many centuries. The earliest examples of large-scale, monumental Sabaean fortifications in cut stone at Yala, Marib and Sirwah (7th–6th centuries BC) pre-date the foundation of the city wall at Thaj by several centuries. Interestingly, of some three dozen South Arabian sites with monumental enclosure walls for which measurements are available, only Marib's 4.2 kilometre long wall surpasses Thaj's city wall in length. The possibility certainly exists that at Thaj we have a fusion of northern, Greek fortification theory, and southern, South Arabian stone masonry techniques. Nor is this the only domain in which South Arabian influence is evident in north-eastern Arabia during the Hellenistic period.

The small beehive-shaped unguent vessel made of alabaster from Tarut (see G. Burckholder 1984, pl. 136) with a lid topped by a crouching lion, for example, is a well-known South Arabian type. More importantly, however, over thirty inscriptions written in monumental South Arabian letters have been found at Thaj, Ayn Jawan, Qatif, Abqaiq and al-Hinna. Typically, these inscriptions are funerary in character, appearing on grave stelae. Most of them follow the formula "memorial/monument and tomb (*nfs wqbr*) of PN1, son of PN2, of the group A, of the group B". Called Hasaean or Hasaitic after al-Hasa, a traditional Arabic term for the Eastern Province, the inscriptions employ a script developed from the South Arabian Sabaic script with some peculiar letter forms. Their language, however, is not a South Arabian one but rather a dialect of Ancient North Arabian. The names in these texts are Semitic. Although most of the Hasaitic inscriptions have been found out of context, one example of this type, found interestingly enough at Uruk in southern Iraq, shows us how they were originally placed. Discovered in 1857 by William Kennet Loftus, the Uruk exemplar (*CIH 699*) stood at one end of a small burial chamber, the inscription facing inward.

As noted above, over five hundred burial mounds ring the southern portion of the site and while some of these are modest stone cists in the ground, others consist of massive accumulations of soil on top of a burial chamber built of unworked or only semi-worked stone. Some of these have produced remarkable gold death masks and jewellery that shows clear Hellenistic influence (cat. nos 236 and 238–42). Although most of these tombs are unexcavated, it is probable that some of them contain inscribed stelae, placed at the end of the burial chamber, as seen at Uruk.

The language of the Hasaitic inscriptions may appear obliquely in another ancient source. In describing the visit of the Seleucid king Antiochus III to Gerrha in the Eastern Province (possibly Thaj) in 205 BC, the Greek historian Polybius (c. 203–120 BC) referred to a letter addressed to the king by the Gerrhaeans in which they begged for perpetual peace and freedom (*Histories* 13.9.4–5). Polybius says that Antiochus granted their request "when the letter had been interpreted to him" and one can probably assume that the Ancient North Arabian Hasaitic texts described above preserve for us the language in which the Gerrhaeans's letter to the Seleucid king was written.[6]

6. On Seleucid policy in the region, see Capdetrey 2007.

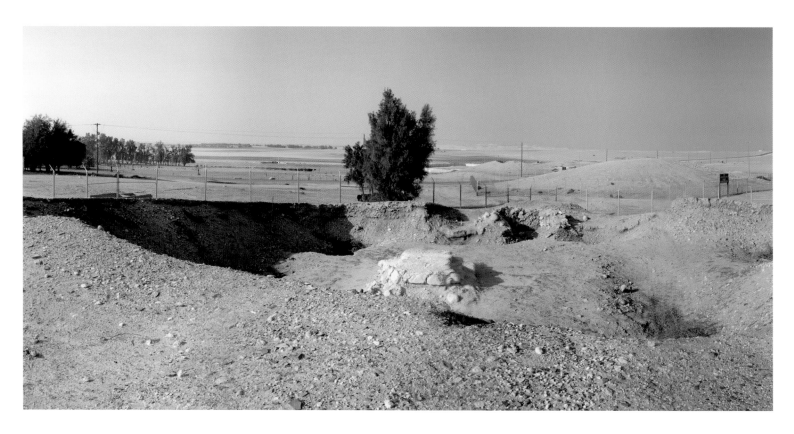

Tomb of Thaj, photograph by Humberto da Silveira

Coin from Abyatha

Polybius also says that the Gerrhaeans honoured Antiochus with a "gift" – or more probably tribute – consisting of 500 talents of silver, 1,000 talents of frankincense and 200 talents of a superior kind of myrrh known as *stacte*. The references to aromatics clearly show, as other ancient authors confirm, that north-eastern Arabia at this time profited from its position astride the caravan route leading from the producers of aromatics in Southern Arabia to the markets in Babylonia. Yet equally important is the reference to silver. At Thaj and other sites, such as the Salt Mine Site, Jabal Kenzan and ash-Sha'ba near Hofuf, thousands of coins have been picked up on the surface by amateur collectors. While only a portion of these are silver, they nonetheless make it reasonable to suggest that the silver paid by the Gerrhaeans to Antiochus was in coin, not bullion.

The indigenous coinage of north-eastern Arabia (cat. no. 228) provides yet further evidence of the simultaneous influence of both South Arabia and the Greek world on north-eastern Arabia. Like many Hellenistic issues elsewhere in the Near East, the earliest coinage from the Eastern Province was modelled on that of Alexander the Great, perhaps because his coinage had a reputation for being pure and true to weight and hence completely trustworthy wherever it circulated. Coinage inspired by Alexander's own issues typically has the head of Heracles, or a modified portrait of Alexander himself, on the obverse, usually wearing the pelt of the Nemean lion. The reverse shows us a figure that resembles the seated Zeus. In some cases, the name ALEXANDROU written in Greek letters runs vertically down the side of reverse, behind the seated figure of Zeus. In other cases Alexander's name has been replaced by that of the local king who minted the coinage written in South Arabian or Aramaic letters.

This is the case on the issues of Abyatha (*'byt̲*), whose name is written in South Arabian letters. On numismatic grounds, Abyatha is thought to have reigned around 230–20 BC.

Outside of eastern Arabia, small numbers of his coins have been found on Failaka (Kuwait) and, most intriguingly, in Syria and at Gordion and Mektepini in Turkey. Whereas some scholars have suggested in a very general way that the distribution of these coins highlights the overland trade routes in operation from eastern Arabia to the Mediterranean, another, far more precise explanation may be suggested. Recalling Polybius's account of the silver paid to Antiochus III in 205 BC, it is interesting to note that after leaving Gerrha, the Seleucid king went to Tylos (Bahrain)[7] and northern Syria before reconquering Asia Minor in the aftermath of his Arabian sojourn. It seems highly plausible that, rather than reflecting trade routes in general, the distribution of Abyatha's coinage follows the path of Antiochus III's army from Arabia into Asia Minor.[8]

Scholars have long wondered whether the seated deity on the reverse of the east Arabian coinage is in fact Zeus. The reasons for doubt is clear. Some coins of this type have the name of the Arabian solar deity, Shams, written in South Arabian letters in front of Zeus's knees, or in other cases simply the first letter of his name, *shin*. This has led some authorities to suggest that, while modelled on the scene of Zeus, the deity was meant to be understood, in the Arabian context, not as the Greek god but as the local sun god Shams.

Because very few coins have been found in stratigraphic excavations at Thaj and the vast majority are surface finds, we have only a very approximate understanding of their chronology. It is clear, however, that they probably span several centuries. Many hundreds are so stylized that their connection with the earliest, much more Greek-looking issues, can only barely be recognized. In such cases, the obverse has become blank, while the reverse appears like a maze of vertical and horizontal lines with dots filling in some of the blank spaces. In fact, these lines are the stylized representation of the seated figure of Zeus/Shams with his throne and staff behind him, and some vestige of the legend, either the name of the king or that of Shams. Coins such as these come in many denominations ranging from large tetradrachms to small obols and demi-obols. Their very existence, however, is a mystery. Coins of this sort circulated very little. A few have been found elsewhere in Saudi Arabia at Qaryat al-Faw, for example, on Bahrain and Failaka, and in Yemen and the UAE (e.g. at ed-Dur). For the most part, however, they seem to have been used locally. Whether they functioned in the marketplace – the majority of them are not silver, or even silver billon but copper – or were used to pay members of the military, as in other parts of the ancient world, we do not know.

The end of the Hellenistic period is difficult to define with any degree of precision. As in Mesopotamia and south-western Iran, where the material culture of the region changed only slightly from the Seleucid to the Parthian period, so too in eastern Arabia can we see continuity into the 1st century BC and perhaps even slightly later.[9] Some of the tombs, such as the one at Ayn Jawan[10] (cat. nos 238 to 242) and others in the cemetery at Dhahran, have glass and jewellery that is either Roman or Roman-inspired, while much of the glazed pottery was probably manufactured in southern Mesopotamia and Khuzestan and shows a similar range of types.

7. On the Greek inscriptions found in Bahrain, see Gatier, Lombard and Al-Sindi 2002.
8. Huth and Potts 2002.
9. On a general perspective on the history of human habitation in the region, see Mouton 2009.
10. See, in general, Potts 1993 b.

# NORTH-EAST ARABIA IN THE HELLENISTIC PERIOD

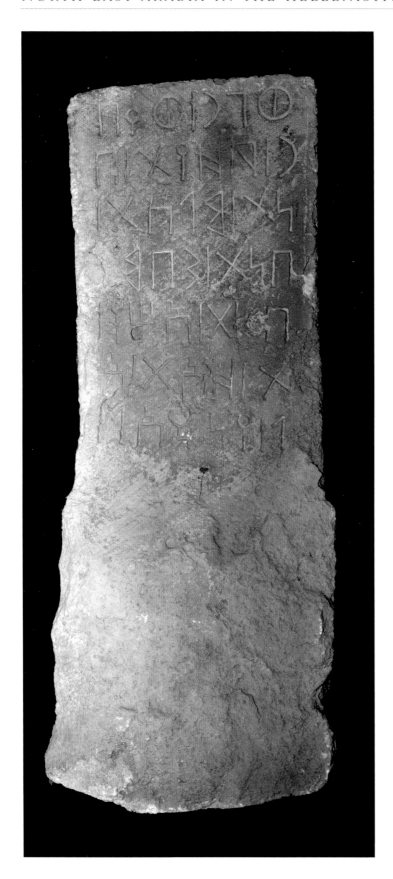

**224. Funerary stele**
c. 3rd–1st century BC
Limestone
128 x 54 x 21 cm
Thaj
Dammam Museum, 82

Bibliography: Anonymous 1982, pl. 124A, p. 139; Ryckmans 1986, pp. 407–18; Robin 1991, p. 119, fig. 26.

| | | |
|---|---|---|
| 1 | wgr w-qb | monument and tomb |
| 2 | r Gdyt b | of Ghadhiyyat, daughter |
| 3 | nt Mlkt | of Malikat, |
| 4 | bnt S²bm | daughter of Shibam |
| 5 | bnt 'hd | daughter of Ahdhat, |
| 6 | t d't' | of the lineage |
| 7 | l Ynh'l | of Yanakh'il |

(after Robin 1991)

Among the few Hagaric (or Hasaean) inscriptions known today we have observed that their authors were often women. Here the deceased's ancestry is given up to the third generation going back to her great-grandmother. Therefore some lineages of the region must have adopted a matrilinear filiation. The populations of the central zone of the Arabian Gulf recorded their language with South Arabic alphabet but with a few particularities in the shape of the letters.

M. C.

**225. Nephesh-type stele**
2nd–1st century BC
Limestone
37 x 14 x 13 cm
Tarut
National Museum, Riyadh, 1015

Bibliography: Potts 1989, figs 56–57, p. 48.

**226. Nephesh-type stele**
2nd–1st century BC
Limestone
50.5 x 18.5 x 8.5 cm
Tarut
National Museum, Riyadh, 1016

Bibliography: Potts 1989, fig. 58, p. 49.

These stelae were discovered on a "funerary mound", associated with partially destroyed cist tombs.[1] They marked the location of the graves and perpetuated the memory of the deceased. "Nephesh" stelae of the same type were found at Bahrain.[2]                         **M. C.**

1. For the description see Potts 1989, p. 47.
2. Paris 1999, cat. nos 347–51.

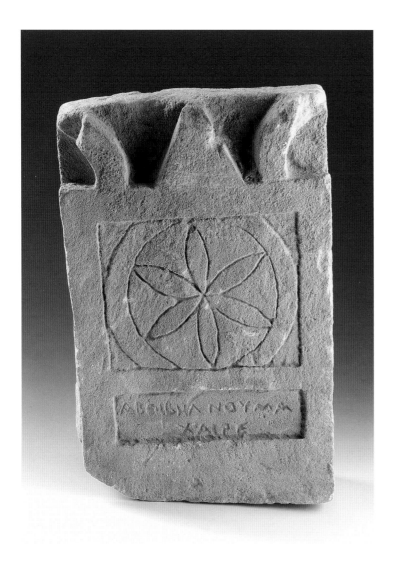

**227. Stele with a Greek inscription**
3rd–2nd century BC
Limestone
29 x 42 x 9 cm
Tarut, al-Rufayah
National Museum, Riyadh, 1289

Bibliography: Jamme 1970, p. 132 and p. 139, no. 6; Potts 1990b, pl. III;
*"Habib'il Salutation"*.

This stele adorned with a rose bears one of the few Greek inscriptions known today in East Arabia (the others come from the island of Bahrain[1]). Nonetheless these finds do not mean that the central coasts of the Arabian Gulf were, like Failaka, ruled by the Graeco-seleucids. Bahrain and the coasts of East Arabia were more likely used as ports of call for the Seleucid ships which controlled the major sea trade routes.

**M. C.**

1. Marcillet Jaubert 1990, pp. 665–73, fig. 1.

**228. Coins**
1st century BC–1st century AD (?)
Bronze
Diam. between 1 and 2.5 cm
Thaj
National Museum, 4880, 4881, 4876, 4868 and 4184

These six very worn bronze coins awkwardly copy the silver coins struck by Hagar/Gerrha, which themselves imitated the Alexander coins of the Hellenistic world. In the left margin of the coin in the right column, at centre, we recognize the letter *shin*, perhaps the initial of Shams, the sun-god.

**C. R.**

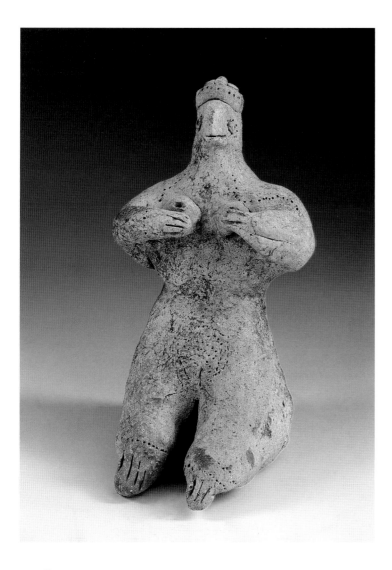

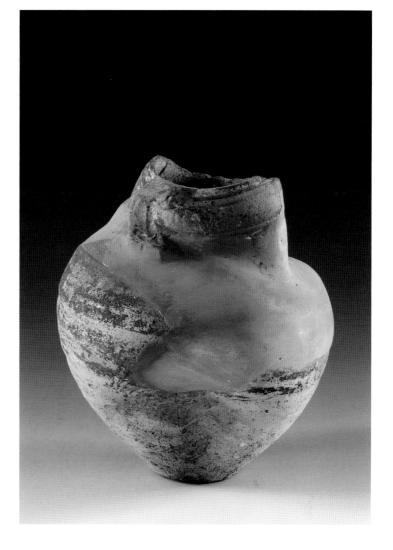

**229. Figurine**
3rd–1st century BC
Painted terracotta
H. 15 cm; Th. 10 cm
Thaj
National Museum, Riyadh, 3107

Bibliography: Riyadh 2009, p. 179.

Thaj was one of the main centres producing figurines of this type which were exported throughout East Arabia, i.e. to ed-Dur,[1] Mleiha, Qal'at al-Bahreïn and even Najran.[2] However we know nothing about the religious significance of these figurines characterized by thick thighs and a rough-hewn head. **M. C.**

1. Daems 2004, p. 94, fig. 2.
2. Zarins *et al.* 1983, pl. 27-18, 19.

**230. Jug**
3rd–1st century BC (Seleucid period)
Earthenware
H. 18 cm; Max. diam. 19 cm
Thaj
National Museum, Riyadh, 781

This coarse pottery jug took on a whitish colouring from an ineffectual firing, as proved by the sunken form. Locally made bowls, jars and cooking pots were plentiful on the site; they were associated with fine ware imported from Seleucia, Seleuco-Parthian glazed ware or Greek black-burnished ware. A Rhodian amphora handle bearing a stamp dated between 250 and 225 BC was found as well. **M. C.**

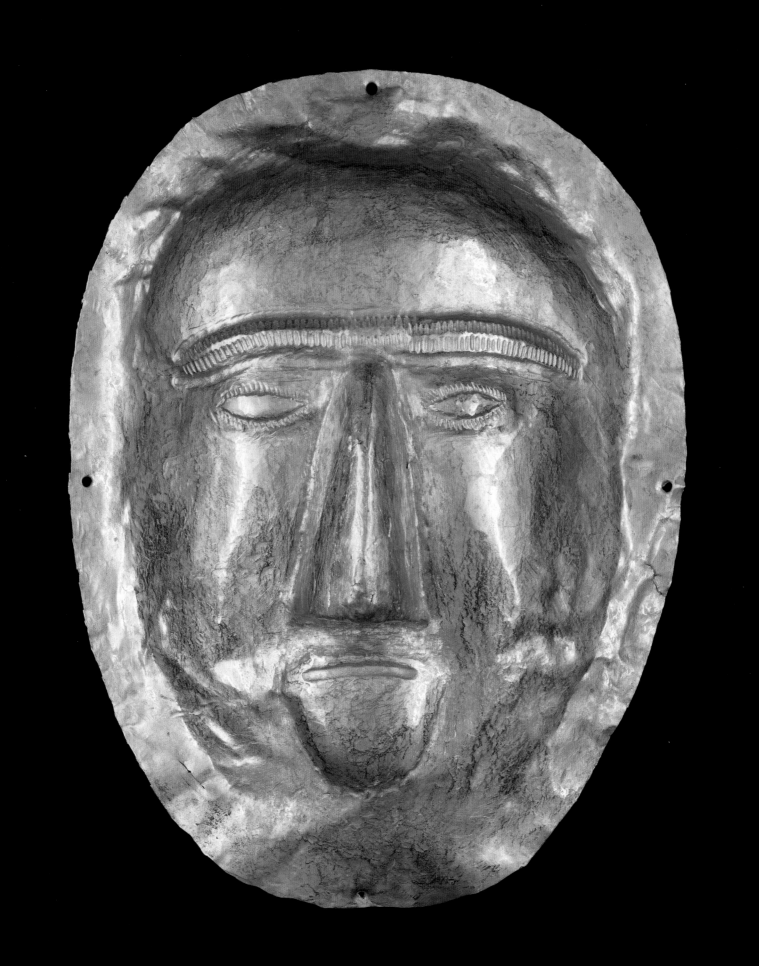

# THAJ
# AND THE KINGDOM
# OF GERRHA

*'Awad bin Ali Al-Sibali Al-Zahrani*

## Introduction

During the first millennium BC and the first centuries AD, the Arabian Peninsula witnessed the emergence of urban civilizations that developed due to their privileged geographic position in the ancient world. During this period, known as the "intermediate period of the Arab kingdoms", numerous kingdoms developed rapidly, including the kingdom of Gerrha in north-east Arabia.

Archaeologists have tried to find out more about this kingdom by focusing their research on its capital, frequently mentioned in ancient texts. They have not yet been able to agree on a precise site but have established that most sites which could correspond to the city of Gerrha are in the north-east region of the kingdom of Saudi Arabia, along the Arabian Gulf coast or further inland.

On the remains of the Dilmun civilization, a new and brilliant civilization flourished at Gerrha, a city known throughout the ancient world. Ancient authors recount that its inhabitants lived in luxury, not on the proceeds of petrol, obviously, but on the basis of their entrepreneurial spirit, mastery of commerce, navigation and the transport of goods over land.

## The importance of the city of Gerrha

Gerrha is one of the cities of which we have lost all trace, like Iram dhat al-'Imad and Ubar, but the many mentions made of it in texts by the classical authors have spurred archaeologists and historians to search for it.

These texts tell us that the kingdom of Gerrha secured its dominance from the 3rd century BC in the Arabian Gulf region, between Shati' Nisf al-Qamar and the port of al-'Uqair in the south. The city had major strategic importance because it was the port through which goods bound for Mesopotamia and the cities of Asia Minor transited. It was renowned for its trade in incense and luxury goods. Its merchants travelled as far as Babylonia, Petra and the incense

Gold mask, Thaj (cat. no. 231)

country in the south of the peninsula. Its wealth rivalled that of the Sabaeans. According to historians' descriptions, the inhabitants of Gerrha acted as commercial intermediaries between the Sabaeans, India, Mesopotamia and western Greece. Their city, the main market in the eastern Arabian Peninsula, dominated trade in resin (gum arabic), myrrh, perfumes, dates, incense and medicinal plants from Oman and Hadramawt. It was also the port for re-exporting commodities from India such as spices, ivory, perfumes and Chinese silk.

Caravans left Gerrha for Syria laden with luxury goods. They went from Jubayl all the way to Mesopotamia, or, via the west route, from al-Samane to Mada'in Saleh, Basra, Petra, Palestine and then on to the European cities.

The people of Gerrha were masters of overland and sea transport due to their skill in shipbuilding and knowledge of the seasonal winds. They also reaped the benefits of the rich pearl harvests in this region of the Arabian Gulf and levied customs duties on goods transiting through their country. In exchange they protected caravans and provided them with information enabling them to reach their destination safely. This important role in organizing land and sea trade enabled them to accumulate great wealth.

## The site of the city of Gerrha

Researchers and archaeologist still disagree on Gerrha's exact location. Major R. E. Cheesman, for whom the search for the city's remains was a passion, notes[1] that the site of the ruins of Abi Zahmoul, in the port of al-'Uqair, would seem to correspond exactly to the site indicated by Ptolemy.

Strabo's *Geography*, the richest source of information on the city, locates it at some 2,400 stades[2] from Teredon. Strabo relates that exiled Chaldaeans lived there, that the houses were built of "salt stones" and that the city was 200 stades from the sea. According to him, the Gerrhaeans, who traded by sea and by caravan overland, were very rich and decorated their houses with precious stones. He cites Artemidorus (190–276 BC), according to whom the exchanges between the Sabaeans and Gerrhaeans proved that their lands were among the richest. Many of their utensils and objects such as beds, tripods and cups were in gold and silver. Their houses were extremely luxurious, with ceilings decorated with ivory and silver. All these reports seem to point to Thaj and not al-'Uqair as the historic site of the city of Gerrha.

## Texts cited by historians concerning the description of the city of Gerrha

The first topographic description of the city, in another paragraph of Strabo's dictionary, after Eratosthenes (c. 275–195 BC), notes: "When one has sailed along the coast of Arabia for 2,400 stades, one reaches, within a gulf reaching deep inland, a city called Gerrha, whose inhabitants, descendants of an ancient colony of Chaldaeans banished from Babylon, [live, one could say, in salt]. The surrounding land is completely impregnated with salt, the houses themselves are built with big lumps of salt and, as if due to the effect of the sun's rays, constantly shed flakes, so that the only means the inhabitants have of consolidating the walls of their houses is to continually douse them with water. The city of Gerrha is 200 stades from the sea. The main industry of the Gerrhaeans consists in transporting spices and other goods overland from Arabia."[3] The historian Pliny the Elder (23–79 AD) notes: "the Gerraic Gulf; the city of Gerra, which is 5,000 paces broad, with towers made from cubic lumps of salt; at 50,000 paces from the coast, the land of Attene; opposite, the isle of Tylos, at 50,000 paces from the shore, very famous for its abundance of pearls, with a town of the same name."[4]

1. R. E. Cheesman, *In Unknown Arabia* (London, Macmillan and Co., 1926).
2. Approximately 276 miles, 444 kilometres.
3. Strabo, *Geography*, XVI, 3, 3, translated by A. Tardieu.
4. Pliny the Elder, *Naturalis Historia*, VI, 32, 6, translated by E. Littré.

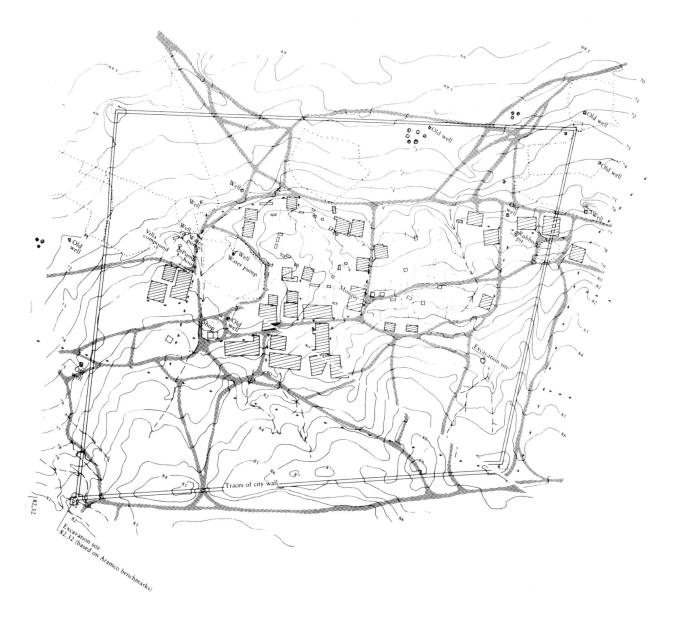

Map of Thaj

Strabo, citing Artemidorus, gives the following information: "The city of Gerrha is situated on the coast of the Arabian Gulf, some 60 miles west of the isle of Dilmun, generally agreed to be the isle of Bahrain. Tribes of Chaldaean Arabs and exiles from Babylon live there. There are salt marshes inland. The inhabitants live in houses whose walls are made of salt, on which water is poured to maintain their consistency. It is called the City of White Walls." He also recounts that the inhabitants are very rich, buy the most luxurious furniture and live opulently, as shown by their gold and silver utensils, fine furniture and the walls of houses decorated with gold, ivory, pearls and precious stones. Pliny cites the same indications.

Thaj, in the north-east of the kingdom of Saudi Arabia, 95 kilometres from the Arabian Gulf coast, is on the edge of the Wadi al-Miyah region, an area of abundant water and wells. Thaj was a vital staging post on the important al-Kanhari and al-Jamal caravan routes between the south of the peninsula and southern Babylonia, linking Najran and the city of al-Faw then al-Yamama and Hajar. It was also a gateway to the Arabian Gulf, at al-Dafi, north of Jubayl, from where it transported merchandise to Tylos, or to Acaros then Babylon and the upper Euphrates in Mesopotamia.

4600

Jewellery found in a tomb at Thaj

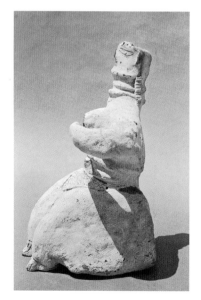

Female figurine, Thaj

5. These studies did not, however, clearly establish this dating.
6. Bibby 1973, pp. 10–28.
7. Department of Antiquities, 1982, unpublished.
8. Gazdar *et al.* 1984, pp. 49–95.

The imposing size of the fortified city, its many tombs, its bronze currency and the rich archaeological remains discovered there attest that it was one of the most important cities in the region.

The first historical and archaeological traces of settlements at Thaj date from Neolithic times.[5] Later Thaj had permanent trading links with the Neo-Assyrian and Neo-Babylonian dynasties. During the Achaemenid period, from the fall of the second Babylonian dynasty to the advent of Alexander the Great in the Orient around 332 BC, there is evidence that populations settled at Thaj and, more generally, in the Gulf region and the Arabian Peninsula.

Although these inhabited areas in the east and south of the Arabian Peninsula were prosperous, they clearly sought to establish relations with one another. There are archaeological signs that these contacts took place by land, since Thaj was the main city to the east of the peninsula.

The Hellenistic period was particularly brilliant there. Excavations attest to the existence of contacts with the centres of civilization which appeared and prospered at that time, relations which continued and developed during the late Parthian and Sassanian periods, from the 1st century AD until the destruction of the Sassanian dynasty in 640 AD. During the modern period, Thaj was explored by a number of researchers convinced of its importance.

Although excavations have shown the site's historic importance and its principal periods of settlement, complementary research and scientific study of the discoveries made there are necessary to refine these initial results.

Archaeological searches located the city's walls. The most important remains are visible on the surface; they are 335 metres long and between 4 and 4.95 metres thick. Dwellings were built against these walls, which were reinforced with towers. One can clearly make out the north-east and north-west towers, in stone and linked to the outer wall. No gateway or entrance on any of the four sides has been identified. The north part of the walls is visible today in part of the salt marshes. Inside the walls one can distinguish the upper parts of the walls of houses and alleyways – the city's streets – between five and six metres wide.

To the east and west there are remains of the foundations of houses, probably palaces and public buildings.

To the south and east, one kilometre from Thaj, there are mounds scattered over a wide area, comparable to the *tumuli* of the tombs of Dhahran and Bahrain.

It seems that one of the activities at Thaj was pottery making. The heaps of debris and the large amount of ashes found outside the city walls on the south-west and east sides, suggest pottery discarded before drying in the sun or during firing.

The city's wells, inside and outside the walls, were built in the same stone as the houses.

## Fieldwork

The aim of the Danish mission which undertook the first fieldwork in 1968 was to precisely date the settlements at Thaj. Excavations there and the comparative study of pottery fragments established that there were at least two periods of settlement on the site between 300 BC and 100 AD.[6]

In 1982, a team from the Saudi Department of Antiquities investigated the surface remains and formulated several recommendations, including the necessity to explore the *tumuli* inside and outside the walls.[7] An initial exploration of the site carried out in 1983 with the aid of a German team led by D. T. Potts from the Freie Universität in Berlin, identified five periods of settlement.[8]

The Department of Antiquities field research in 1984 yielded no further results. The site has been dated from the 5th century AD. Carbon-14 analyses have fixed these dates between

565 BC and at the most 150 BC for the most ancient period, and between 160 and 105 BC for the more recent,[9] but these dates apply only to the samples dated.

In 1993–1994, 'Awad al-Zahrani conducted excavations in several areas of the site.[10] The existence of two periods of settlement was established, the first from the 6th to the 1st century BC, the second from the 1st to the 5th century AD.

In 1998–1999, a team from the Department of Antiquities carried out excavations which unearthed the tomb of a young girl and statuettes, pottery and jewellery dating from the 1st to the 2nd century AD.[11]

The area excavated comprised dwellings inside and outside the walls and also a larger area occupied by tombs and numerous wells, proving the existence of a dense concentration of population. Apart from trading, the city's inhabitants made pottery, in which there was a flourishing trade at the time, and farmed well-irrigated and fertile land. The wells outside the residential area, particularly to the south and east, show that large areas of land were cultivated.

Discoveries have shown exchanges between Thaj and its trading partners, influences from the south, centre, north-west and south-east of the Arabian Peninsula and also Sassanian and Seljoukid influences. As a city of far-reaching commercial renown, Thaj would certainly have had an extremely diverse population.

Currency, ceramic figurines and incense burners excavated there prove that deities – a sun god and probably a moon god – were worshipped by the city's population. Offerings were made to them and incense was burned, clear evidence of the existence of temples yet to be discovered.

## Conclusion

Gerrha was an important city benefiting from its remarkable strategic location. As the staging point and destination of caravans, and as the transfer point between overland transport and sea convoys, around 300 BC it was the economic hub of the Arabian Gulf region. The city's experience in seafaring and particularly its knowledge of the region's seasonal winds, ensured its control of maritime trade between India and Mesopotamia. These characteristics correspond to the site of Thaj, which was probably the ancient city of Gerrha.

9. Eskoubi and Al-Aila 1985, pp. 37–53.
10. To obtain a diploma from Historic Monuments and Museums section of the Faculty of Letters.
11. The Department pursued its fieldwork and published its results in the periodical *Atlal*, nos 16 and 19; Al-Hashash *et al.*, 2002–06.

# THE TOMB OF THAJ

*Claire Reeler and Nabiel Al-Shaikh*

In the summer of 1998, a group of Saudi archaeologists from Dammam Regional Museum started excavating a large mound of ashes and pottery wasters, on the edge of the modern village of Thaj, outside the walls of the ancient city. Suddenly an opening appeared in one side of the trench. Investigation revealed a burial chamber with broken capstones. The team were disappointed, assuming that this burial, like most others, had been robbed. However, once the broken pieces of capstone were removed, astonishingly, a shiny gold mask (cat. no 231) appeared in the dirt, followed by necklaces (cat. nos 234 and 235), golden beads, gold foils and other exquisite funerary goods.

A little girl (possibly about six years old), had been buried in a royal manner (fig. 1). She was lying on a funerary bed made of wood covered with lead and bronze and decorated with Mediterranean motifs. The legs of the bed were in the form of statues of a young woman in the Classical style (cat. no 236). The girl was lying on her back surrounded by round gold foils (cat. no 237), some impressed with the figure of the god Zeus. Two gold rings were found, set with engraved rubies, one possibly the goddess Artemis and one, the profile of an unknown male wearing a helmet. A gold mask covered her face, depicting simple facial features. Across the top of her head lay three gold bands. On her neck lay two gold necklaces with rubies, pearls and turquoise (one with a cameo face pendant) and a third necklace of eighteen gold beads. Two gold earrings lay either side of her head. Two solid gold bracelets (cat. no 232) lay on her left side, a golden glove (cat. no 233) on her chest and a gold belt across her waist. More than two hundred convex gold buttons of two sizes, some smaller than the others, lay around her body. Beneath her body lay three large metal vessels, compressed into a single corroded mass and to the right of her head was a small open metal goblet.

The depictions of Zeus and Artemis and other motifs show that this burial dates to the Hellenistic period in Arabia about two thousand years ago. At this time, Arabia was linked into extensive trade routes with the Mediterranean world. Incense from South Arabia was traded along these routes, one of which passed through Thaj. It is this lucrative trade which would have provided the wealth that furnished this grave with such luxurious objects.

The burial chamber was constructed of cut limestone ashlars, with seven capstones and floored with white plaster. The length of the chamber was 2.1 metres, the width 1 metre and the depth of the chamber itself 1.25 metres. The orientation of the chamber was north-south, with the girl's head in the south and her feet in the north. The mound, within which the chamber lay, was 5.7 metres high and 55 metres in diameter. It was made of ashes, pottery wasters, incense burners and terracotta figurines, all damaged. The mound therefore seemed to be composed of waste from a pottery kiln, which was confirmed by later excavation.

The site was named Tel Al Zayer in remembrance of the late Director of Dammam Regional Museum, Walid Al Zayer, director of the excavation, who was tragically killed in a car accident during the excavation.

This remarkable discovery demonstrates the loving care with which the wealthy family of this child buried her according to their customs. These customs were themselves strongly influenced by the beliefs and symbols of the Classical world, extending even into the Arabian Desert.

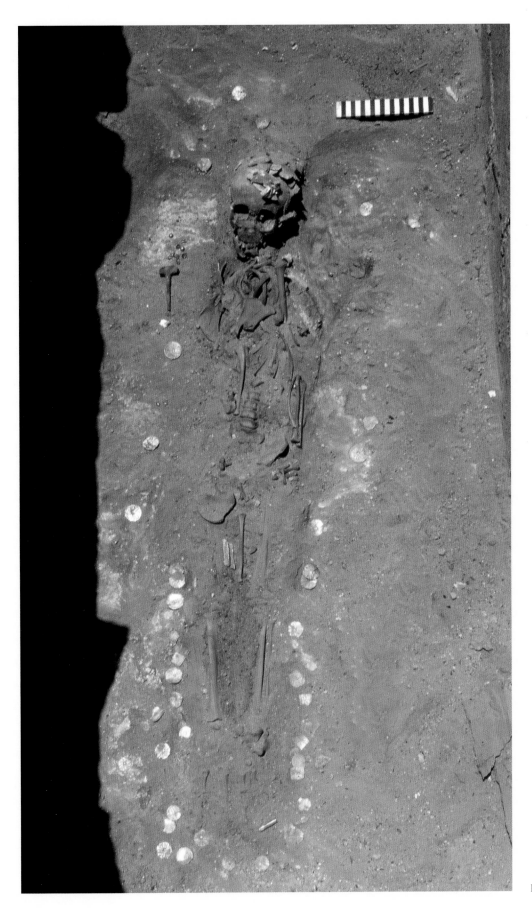

Fig. 1. The tomb of Thaj during its excavation

## THE TOMB OF THAJ

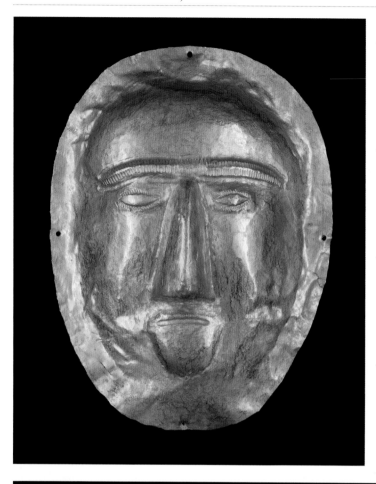

**231. Funerary Mask**
1st century AD
Gold
H. 17.5 cm; W. 13 cm
Thaj, Tell al-Zayer
National Museum, Riyadh, 2061

**232. Two Bracelets**
1st century AD
Gold
Diam. min. 4 cm; Max. diam. max. 5.5 cm
Thaj, Tell al-Zayer
National Museum, Riyadh, 2067

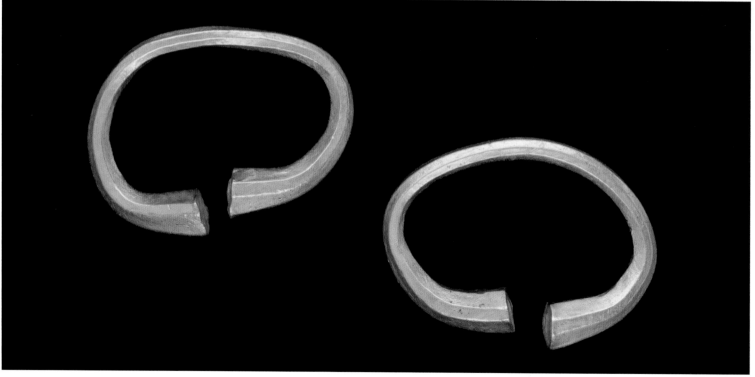

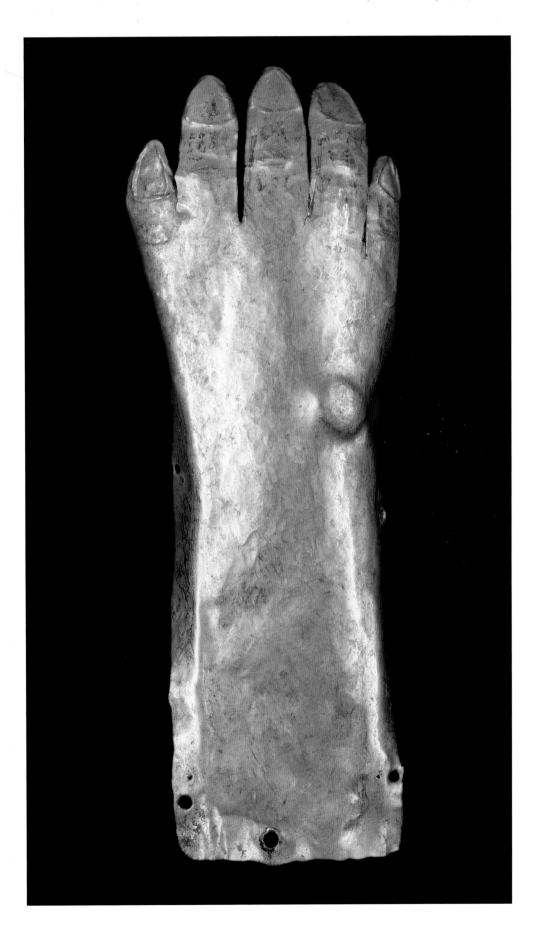

**233. Glove**
1st century AD
Gold
L. 15 cm; W. 4.5 cm
Thaj, Tell al-Zayer
National Museum, Riyadh, 2063

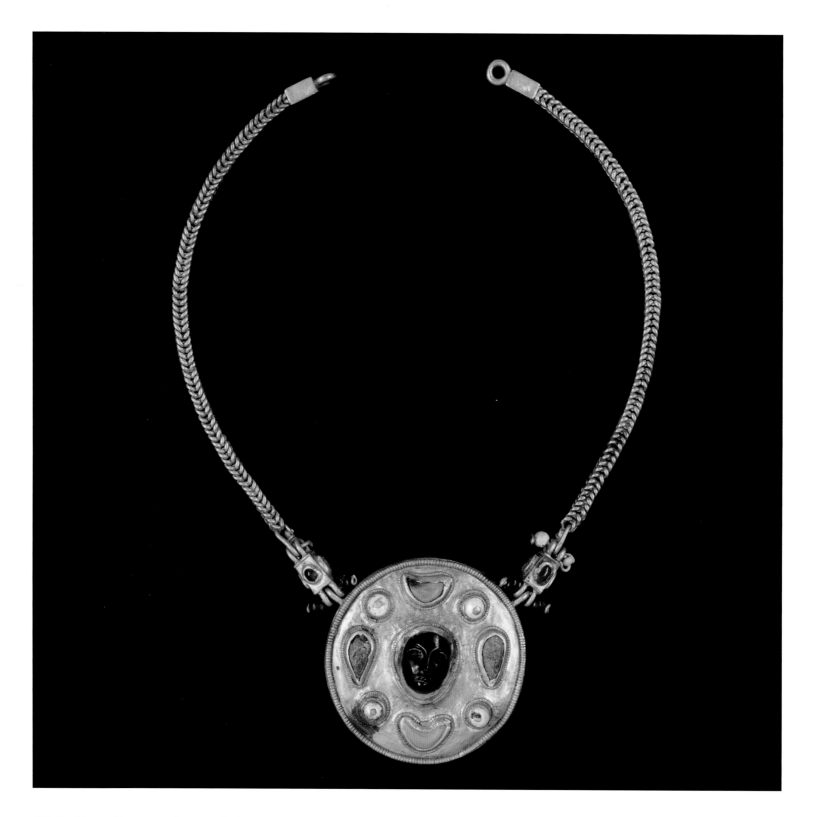

**234. Necklace with a cameo face pendant**
1st century AD
Gold, pearls, turquoise, ruby
L. 38.5 cm; Diam. disc: 5 cm
Thaj, Tell al-Zayer
National Museum, Riyadh, 2059

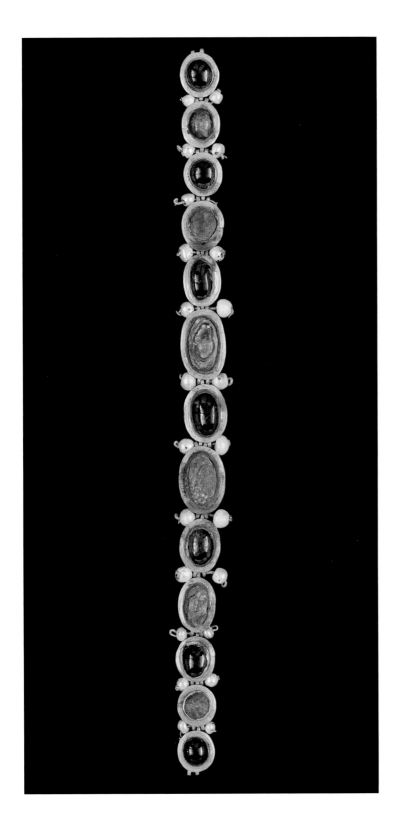

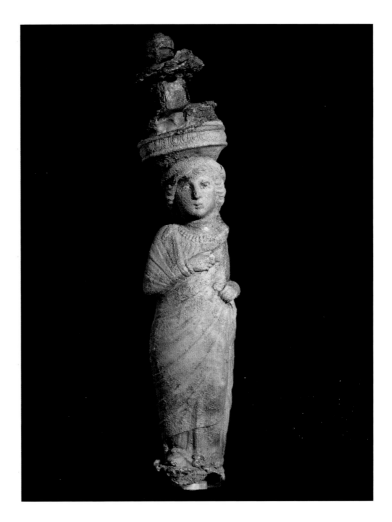

**236. Anthropomorphic leg of bed**
1st century AD
Iron, bitumen, lead
H. 46 cm
Thaj, Tell al-Zayer
National Museum, Riyadh, 2088

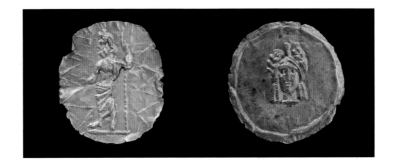

**235. Necklace**
1st century AD
Gold, pearls, turquoise, ruby
L. 22.5 cm
Thaj, Tell al-Zayer
National Museum, Riyadh, 2062

**237. Gold Foils**
1st century AD
Gold
Diam. c. 3.5 cm
Thaj, Tell al-Zayer
National Museum, Riyadh, 7/2534 and 2/2534

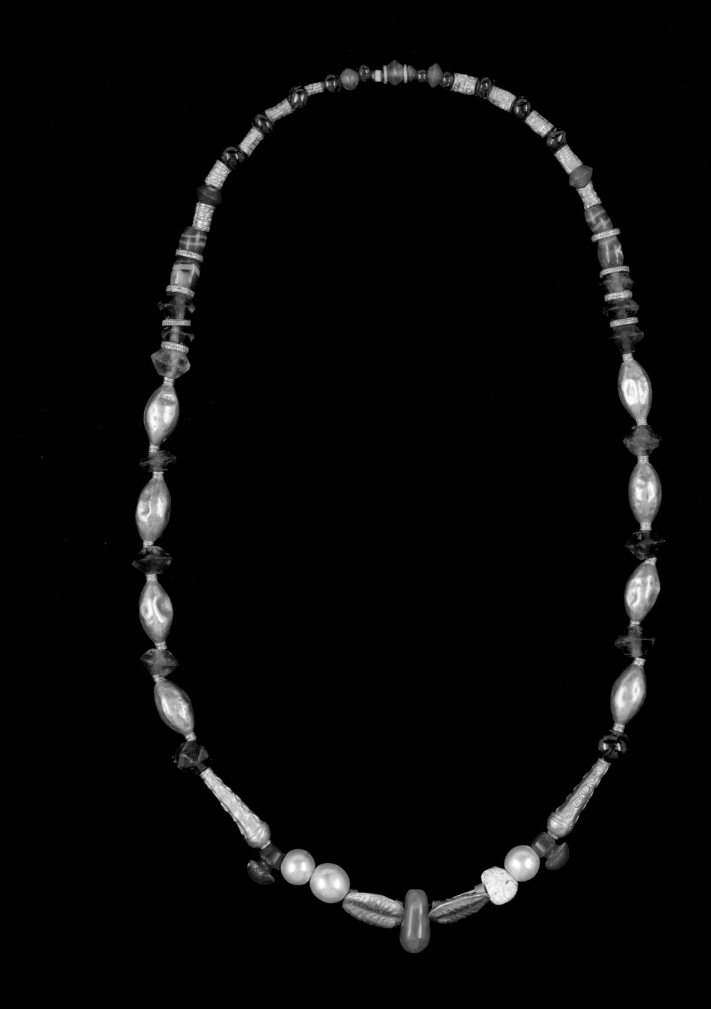

# AYN
# JAWAN

*Abdullah S. Al-Saud*

Ayn Jawan,[1] north-west of the Gulf of Tarut, doubtless owes its importance to its proximity to the coast. It is one of the most extensive archaeological sites in the kingdom; in an area of about 200 hectares, dotted with rocky outcrops and edged with *shabka*, there remain many vestiges of walls built with coated limestone blocks joined with mortar as well as small cist tombs.[2] We probably can identify Ayn Jawan with Ptolemy's Bilbana. Arab sources mention it under the name "al-Jounin" or "al-Jounan".

The site was discovered in 1943 before the end of the Second World War when the Saudi Aramco company decided to convert the land next to the port of Ras Tanura into a quarry. In the course of the operation the Aramco workmen found mysterious constructions buried under mounds of sand. In 1945 a fragment of an inscription in South Arabic was unearthed, revealing the presence of the tomb of a woman named Ghatham bint Oumrat ibn Tahiou, of the family of [...], a member of the Chadab tribe. In 1950 Richard LeBaron Bowen Jr[3] published a first study devoted to the pottery of the site[4] and assembled documentation, hitherto unpublished, on the Ayn Jawan graves. In 1952 Aramco put the archaeologist F. S. Vidal in charge of the survey and excavations; he worked for twenty-two months and unearthed a monumental tomb.

This cist tomb is built of blocks of limestone and mortar; its door was closed with blocks of limestone and mortar. It is organized around a central chamber reached via a long corridor on the west side. Five other chambers open onto this central space: one to the east, two to the south and two others to the north (see layout on the next page). The north and south chambers each contained one body whereas the larger east chamber held two. Four other chambers adjoin the edifice. Unfortunately the central tomb was already looted in Antiquity and again between the archaeologists' various visits, thus hastening the destruction of the east chamber. In spite of these successive lootings, the excavations made it possible to assemble the bones of several individuals, shards of pottery and glass, a bronze spatula and carnelian beads. The tomb's set-up indicates it was planned for nine persons, then was looted and reutilized to deposit the bones of more recent deceased. Some remains were burned but we do not know whether this was due to a religious ritual or voluntary acts.

Necklace, 2nd century AD, tomb at Ayn Jawan (cat. no. 238)

1. At 3 kilometres north of Qatif, west of Ras Tanura; at 26° 42' 46" latitude north and 49° 57' 53" longitude east.
2. Unlike those of al-Zahran and Ayn al-Sih in the eastern province.
3. LeBaron Bowen 1950.
4. Frederick R. Matson, in LeBaron Bowen 1950; Florence E. Day, in LeBaron Bowen 1950.

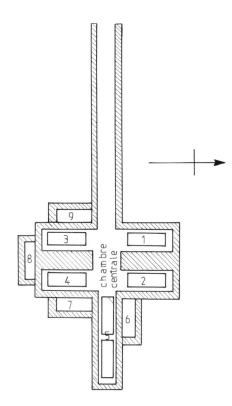

Layout of the tomb at Ayn Jawan

Considering the location of the tomb, very close to the sea, the construction and the grave contents were permeated with moisture which delayed the excavation; some items took a very long time to dry. The trench dug around the tomb permitted light in to the four outlying chambers which had remained intact. The graves were then examined, measured and photographed. The four chambers are contemporary with the looted chamber.

The three south chambers (7, 8 and 9) were cut out of the limestone as was one of the walls of the north chamber. In the latter was buried the body of a little girl, about six years old, richly adorned. The three other chambers (7, 8 and 9) were the graves of three adult men placed in wooden coffins closed with nails.

In the south-west chamber (9) the body faced south; although the sides of the wooden coffin were still there the bones were poorly preserved and the grave contents featured only a small gold hair clasp.

In the south room (8) the body faced west; the lid of the coffin was vaulted. Two small gold hair clasps and a poorly preserved iron sword with an ivory pommel were found.

In the south-east chamber (7), the body faced north. The skeleton was very fragmentary, crushed by the fall of one of the slabs of the lid. The deceased was buried with a long iron sword of which the pommel and the sheath were wood lined with leather.

In the north chamber the skeleton faced west. The grave contained three female statuettes approximately 20 centimetres high. One of them bore traces of red pigment; her right arm was folded over her breast and the drapery suggested a tunic. Another statuette, of which only the torso, the top of the legs, a hand and a fragment of drapery remained, presented traces of blue paint. She is an Aphrodite of a type widespread in the Hellenistic Near East. A third statuette, in ivory, was found in a poor state of conservation.

The chamber also contained a bronze bowl and a mirror with an ivory handle, both very damaged unfortunately, along with two pins and four gold hair clasps. The deceased woman was bedecked with a gold torque from which dangled a pendant inlaid with agate (cat. nos 239, 241 and 242), and she wore a necklace of gold, carnelian, amethyst beads and natural pearls (cat. no. 238). A frontal jewel was also found, consisting of a small chain linking two cabochon ornaments from which hung models of amphorae in natural pearl and a bird-shaped fastener (cat. no. 240); there were also a pin made of bone and small pieces of extremely corroded metal probably belonging to rings.

The dating of the tomb is still very uncertain as it was looted several times and, above all, because we have no *terminus ante quem* for proposing an accurate date. Nevertheless, considering the grave contents, we can assume that it goes back to the 1st century AD. This must have been the tomb of a family of local notables enriched by trade (very active with the west and the north, the Greek world and the Parthian Empire as well as India), pearl fishing or agriculture. In addition to the discovery of the tomb, many glazed and unglazed ceramics and stone vessels were found. Many coins were found as well (some coined on the spot, others of foreign provenance)[5] and several Hasaean inscriptions[6] which probably marked the location of the graves. One of them commemorated the deceased woman:

"Nephesh and tomb of Ghatham daughter of Oumrat son of Tahiou of the family of [. . .], of the clan of 'Uwayr, of the Chadab tribe. We miss her".[7]

In 1977 a team of archaeologists from the Department of Antiquities, in collaboration with scholars from Harvard University, undertook a topographical survey throughout the eastern province to which Ayn Jawan belongs.[8] In 1984 Marny Golding published an article in the journal *Atlal*[9] in which she mentions Ayn Jawan and the discoveries made there.

5. Potts 1990b.
6. LeBaron Bowen 1950, p. 23.
7. Winnett 1946, p. 2.
8. Potts *et al.* 1978.
9. Golding 1984, pp. 159–64, pl. 156.

Bibliography:
Golding 1984; Al-Jasser 1979; LeBaron Bowen 1950; Potts 1990b; Potts *et al.* 1978; Winnett 1946.

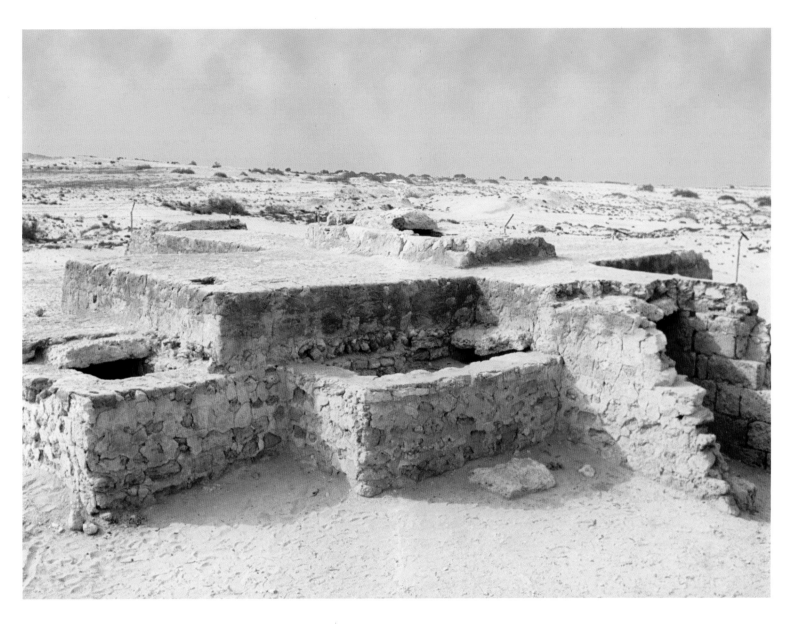

Tomb at Ayn Jawan

## TOMB OF AYN JAWAN

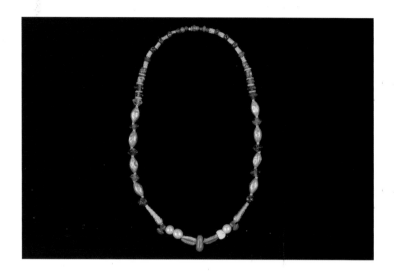

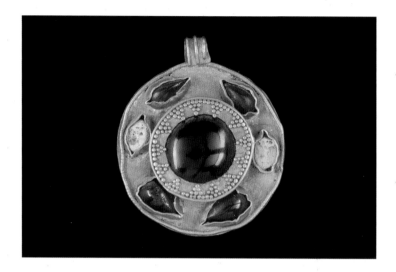

**238. Necklace**
2nd century AD
Gold, agate, amethyst, carnelian, pearl
Diam. 9–15 cm
Tomb of Ayn Jawan
National Museum, Riyadh, 1309

Bibliography: Al-Rashid 1975, p. 143; Potts 1984, pp. 21–30, p. 28; fig. 10.

**239. Circular pendant, garnet teardrop cabochon and fine pearl**
2nd century AD
Gold and stone
Diam. 2.2 cm
Tomb of Ayn Jawan
National Museum, Riyadh, 1312

Bibliography: Al-Rashid 1975, p. 143; Potts 1984, pp. 21–30, p. 28, fig. 10.

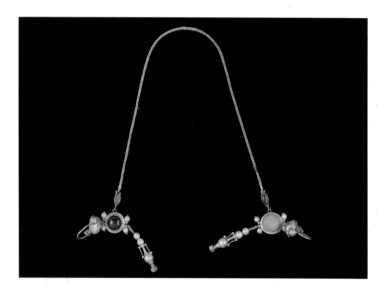

**240. Frontal jewel**
2nd century AD
Gold, fine stone and pearl
L. 41.5 cm
Tomb of Ayn Jawan
National Museum, Riyadh, 1311

Bibliography: Al-Rashid 1975, p. 143; Potts 1984, p. 28, fig. 10.

**241. Torque**
2nd century AD
Gold
Diam. about 12 cm
Tomb of Ayn Jawan
National Museum, Riyadh, 1312

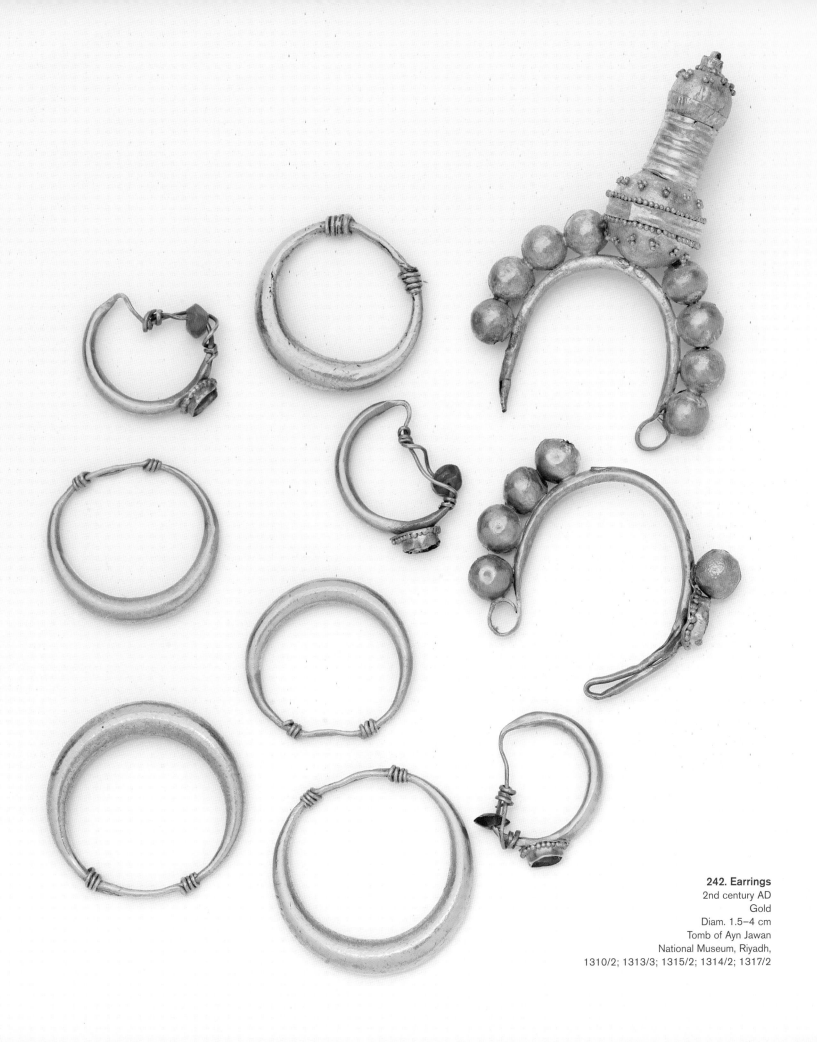

**242. Earrings**
2nd century AD
Gold
Diam. 1.5–4 cm
Tomb of Ayn Jawan
National Museum, Riyadh,
1310/2; 1313/3; 1315/2; 1314/2; 1317/2

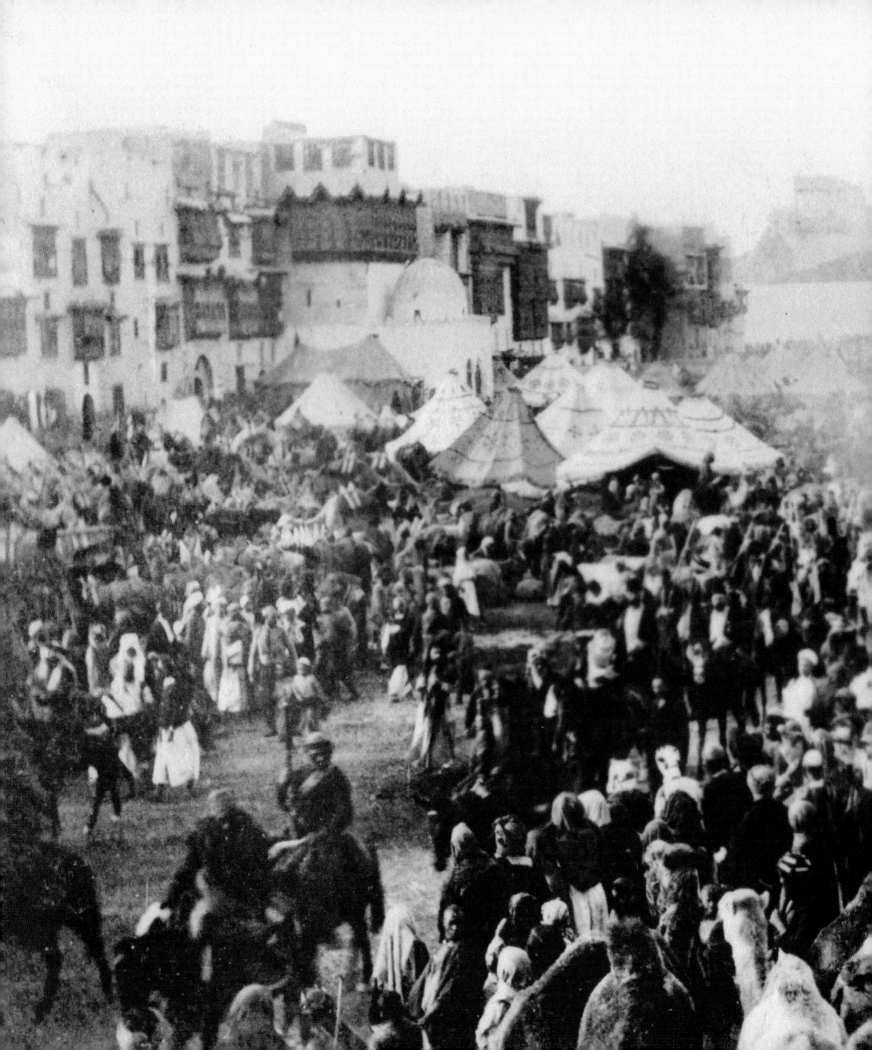

# INTRODUCTION
# TO THE ISLAMIC PERIOD

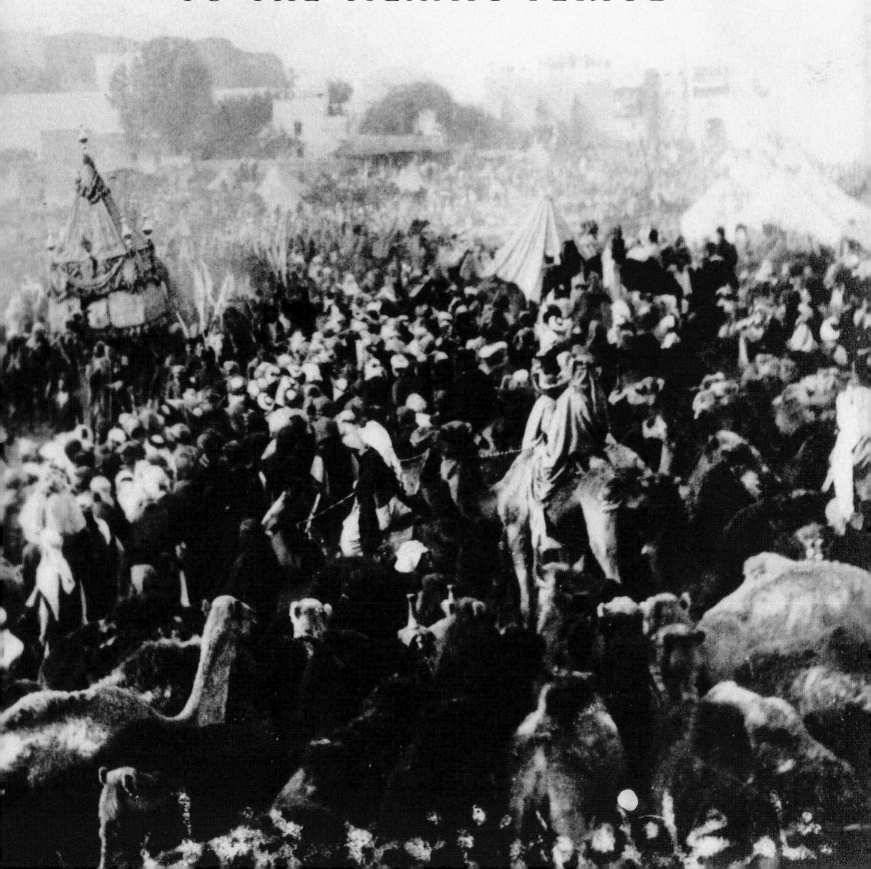

# ARABIA AND THE HOLY CITIES

## IN THE MIDDLE AGES

*Julien Loiseau*

*Jazirat al-Arab*, island of the Arabs. In the 9th- and 10th-century imperial geography, compiled in the chambers of Baghdad or drawn up along the roads permeating and sustaining the Islamic world, this was the name of the vast peninsula which everyone recognizes as the cradle of Islam. "I begin with Arabia", wrote the Persian Ibn Hawqal at the opening of his *The Configuration of the Earth* (completed c. 988), "because it is the land of the *qibla* (the direction of prayer), of Mecca, the mother of cities, because that is the native region of the Arabs where they have their homes and whose habitat they share with no other people". Indeed an island, sea and desert separating it from the rest of the world without forbidding its access, provided the exacting itineraries to reach it have been carefully marked out. Island of the Arabs, they alone were able to settle there lastingly and had the honour of receiving in their midst the Messenger of God. Thus defined, Arabia does not include Yemen, a high land of an old sedentary civilization facing the ocean. But it extends its territory far northwards, and westwards, even touching the rich lands of Syria, eastwards the Euphrates valley where the black soil of Iraq begins, far beyond the borders drawn by default in 1916 by the Sykes-Picot agreement.

## The ways across

The isolation of the Arabian Peninsula in the Middle Ages, surprising in a world as intensely travelled as that of Islam, was not as absolute as might appear. The sea surrounding it on three sides, and which on the geographers' maps has the familiar shape of a bird, firmly connected it to the pulse of the world.

In the Arabian Gulf, where the rise of the great maritime trade matched the huge demand created when Baghdad became the imperial capital in 762, the bleak coasts of the peninsula could not compete with the ports of Persia: Siraf, then Qays in the 11th century and Ormuz three centuries later, which then extended their control over the coasts of Oman and the port of Suhar. Conversely, in the Red Sea, the harbours of the west coast of Arabia

*(pages 404–05)*
The mahmal arriving at Mecca, photograph by Halldjian (Royal Geographical Society, London), 1908

*(opposite)*
Map of Arabia, Ibn Hawqal, *Surat al-Ard*, 15th century, Bibliothèque nationale de France, Paris, Arabe 2214, fol 4 v°

(Hijaz) benefited from the considerable Indian Ocean trade relayed from Aden by the Yemeni merchants: from south to north, Jedda, Mecca's port, beyond which large vessels could not pass without risking shipwreck, and al-Jar, Medina's port, with more modest moorings connected coastal navigation to the gulfs of Aqaba and Qulzum (Suez). Relations were lively on both sides of the Red Sea: with Ethiopia which as Islam progressed there provided a good number of slaves but converts as well; with Egypt above all, reached by the port of 'Aydhab, which supplied Mecca and Medina with the utterly vital grain from the upper valley of the Nile. In spite of the dangers of navigation – on embarking at 'Aydhab for Jedda the pilgrims recited the "Litany of the Sea" by the North African Sufi al-Shadhili (d. 1260) to assure themselves a not overly perilous crossing – it was faster and safer to travel by sea from Hijaz to Oman than follow the tracks criss-crossing the peninsula.

There were not many of these tracks but they were well identified. Their stages, duly documented to preserve travellers from the fate of those who got lost in the desert, scarcely changed between the 9th century, when the treatise *Book of Roads and Kingdoms* (*al-Masalik wa'l-mamalik*) was compiled for the civil administrators of the Empire, and the 14th century when the North African traveller Ibn Battuta followed them.

From Iraq the main overland route left the Euphrates valley at Kufa and reached Medina in a march of about twenty days after almost thirty stages: the most important way station was midway between Baghdad and Mecca, at Fayd, the principal locality of Najd – the high plateau at the centre of the peninsula, with its proverbial mild climate – with a fortress where, in the 9th century, the "road supervisors" resided. But you could also travel from Basra to Medina by a shorter route. From Syria the major route departing from Damascus entered the desert after the fortress of Kerak and led to Medina in twenty or so stages, more dangerous than the Iraq route especially between Tabuk and al-Ula where graffiti on the rocks reminded travellers that here others had endured thirst. A second route left Syria at Raqqa on the Euphrates but apparently was frequented only intermittently. From Egypt the one and only route for those who wished to be spared the risks of crossing the Red Sea led directly to Mecca, after leaving Cairo, cutting across the Sinai and hugging the coast from 'Aqaba. The trip took about thirty stages, particularly gruelling between Azlam and al-Hawra where often the wells were dry, travelled in thirty-five days, or if you like, a march of almost four hundred and fifty hours. But it took the horse-rider courier less than twenty days. Impracticable after the early 12th century when the Latin crusaders secured themselves in 'Aqaba, it was definitively reopened after the re-conquests achieved by the Sultan of Egypt, Zahir Baybars (1260–77). Last, from Yemen, two roads led to Mecca: the first took about thirty days, following from Aden the large coastal plain of Tihama; the second, shorter, skirted the mountains.

In this way these principal itineraries converged towards Medina and Mecca, about a ten-day journey apart. Regularly travelled, equipped with well-maintained watering places, they were the roads followed by the pilgrimage (*darb al-hajj*), safer despite their dangers than the few other regular tracks, like between Oman and Bahrain or between Bahrain and Iraq. On the maps of the geographers, who saw the mountains as the skeleton of the Earth and "the evident sign of God's design" (A. Miquel), the powerful geography of Hijaz anchored Mecca to the very centre of the peninsula like a knot holding it together. The Arabia of the mountains was indeed the first created land, as preserved for posterity at Jedda by the tomb of the Grandmother (*al-Jadda*), Eve, and of Adam at the summit of Mount Abu Qubays overlooking Mecca.

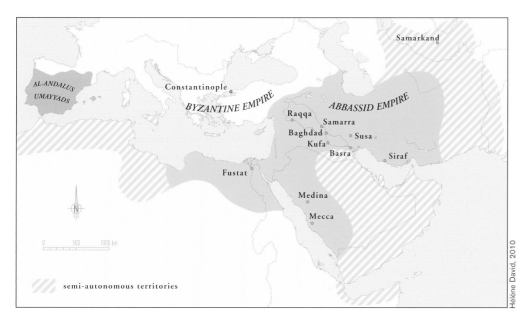

Hélène David, 2010

The Abbasid Empire in the 9th century

## On the fringes of the Empire

The birthplace of Islam and the Arab conquests, the peninsula was soon pushed back to the margins of the history to which it had given birth. Medina, the first capital, was already deserted by the sovereigns under the caliphate of 'Ali (656–61), all it retained of its short-lived ascendancy being the prestige of its law school. Mecca, inflamed once again by the uprising of Ibn al-Zubayr, had only one *raison d'être* left: its pilgrimage. But Hijaz was still an integral part of the empire and until the early 9th century the caliphs performed the duties of their charge by personally leading the pilgrimage: the Abbasid al-Mansur (754–75) went five times and had the good fortune to die and be buried there; his grandson Harun al-Rashid (786–809) donned the pilgrim's garb nine times. Governed by trustworthy men – the presumptive heir or one of the caliph's brothers – Hijaz enjoyed regular relations with Iraq. The influential wife of the caliph al-Rashid, Zubayda, watched over it personally, devoting considerable funds to the route from Kufa to Medina: the many tanks for collecting rain water which lined the stages, like that of al-Shuquq which was so large the pilgrims could bathe in it, kept her memory alive throughout the Middle Ages.

But Arabia was conducive to all rebellions against the caliph of Baghdad, offering a near impregnable asylum in the shelter of the desert and by its remoteness. In Oman, the Kharijites, already dissident in 657 in the name of a strict and egalitarian Islam, became independent in spite of the Abbasid expedition in 752, remaining so for four centuries. Shia above all was present almost everywhere, always ready to restore the rights of one or another of the numerous descendants of the Prophet by 'Ali and Fatima who had scattered throughout the peninsula. At the end of the 9th century Arabia became a mission land for the Ismaili Shia, partisans of a lineage of imams which soon won over North Africa and Egypt: the Fatimids. In Bahrain the Ismaili "Qarmatian" rebels took hold on the Arabian Gulf coast, ransoming the pilgrims' caravan from Iraq when not denying it passage. In 930 the Qarmatians dealt a masterstroke by assaulting Mecca at the height of the pilgrimage season: the shrine was desecrated by the dead and the Ka'ba amputated of the Black Stone, which the rebels did not return until 951. For ten years no pilgrimage could be held in the holy city.

The tragic events of Hijaz point to more sweeping disruptions. The Abbasid Empire broke up and the caliph of Baghdad, most often deprived of any actual power, had to delegate his authority in the provinces to governors anxious to establish their own dynasty. In 935 the caliph al-Radi charged the governor of Egypt Muhammad ibn Tughj with the task of protecting Mecca and Medina. The decision – justified by the strategic importance of the Egyptian breadbasket in supplying the holy cities unable to meet the pilgrims' needs on their own – had major consequences. In fact it established for six centuries the primordial role of Egypt in the protection of the pilgrimage and the Cairo master's hegemonic claims on Hijaz, which in turn the Ottomans took over in 1517. For the time being the conquest of Egypt by the Fatimid armies in 969 offered the Ismaili caliph, rival of the Baghdad Abbasid, the opportunity to assert his claims before the universal nation of Muslims: the *kiswa*, the great brocade veil adorned with the caliph's name which is draped over the Ka'ba during the pilgrimage ceremonies, was no longer black, the Abbasids' colour, but white, the colour of 'Ali's champions.

## Isolation and political autonomy

The victories won by the Shia caliphate of the Fatimids created new political conditions in Arabia, more favourable to the claims of 'Ali's successors without which they lacked the means for restoring a central authority there. These troubled years saw the concomitant rise in Mecca (968), Medina (c. 970) and other localities in Hijaz such as Yanbu', of small principalities, or emirates, governed by dynasties of sharifs or descendants of the Prophet. In Mecca the emirs descended from the lineage of Hasan, 'Ali and Fatima's older son, and professed a Zaydi Shia Islam in which we can see an obvious influence of nearby Yemen. In Medina they descended from the lineage of Husayn, Hasan's younger brother, and professed an Imami Shia Islam, which distinguished them also from the partisans of the Cairo Fatimids. Actually, in spite of Egypt's authority the emirs of the two holy cities remained independent sovereigns and every Friday during the sermon their name was uttered, associated with that of the protector of the moment. The decline of Fatimid strength and the renewal of Sunni powers throughout the East in the second half of the 11th century did not affect the official presence of Shia in Mecca and Medina, even heard in the call to prayer. For over a millennium, until the annexation of Hijaz by Ibn Saud in 1927, the upheavals in the world affected only the fringes of this regime of local autonomy which expressed the holy cities' isolation in political and religious terms.

In the Middle Ages the continuity of the Hijaz principalities withstood the great internal instability caused by the permanent conflicts opposing the numerous pretenders to the emirate (in Medina thirty-six sharifs followed one after another between 1249 and 1495, many of them reigning several times) as well as by the unrelenting rivalry between Mecca and Medina. In the 13th century Medina was most often backed by the sovereign of Egypt against Mecca's hegemonic aspirations sustained by the sultan of Yemen. But the Medina emir's authority was scarcely acknowledged beyond the city walls, whereas that of his rival extended to the neighbouring cities of Yanbu' and Ta'if, the rich port of Jedda and part of the Tihama coastal plain. The significant income enjoyed by the two emirs explains both the clashes of the factions dividing their city and the concern to preserve their autonomy. In 1076 the emir of Medina began levying a tax on the pilgrims who chose to come to the shrine of his city for a devout visit (*ziyara*) to the Prophet's tomb, an increasingly popular supererogatory religious devotion in the Middle Ages. His Meccan homologue levied a far

more lucrative tax on the pilgrims from North Africa and Egypt. According to al-Idrisi (c. 1157) on embarking in the Egyptian port of 'Aydhab the pilgrims departing for Jedda had to prove their solvability. Since the mid-12th century the issue of the abolition of this tax and its compensation was central to the negotiations renewed each year between the emir of Mecca and the sovereign – from Egypt, Syria, Iraq or Yemen – who wished to protect the pilgrims. We know that Saladin in 1177, like the Fatimid vizier Ibn Ruzzik several years before, gained great fame by redeeming the tax of the pilgrims from Egypt: as we can easily imagine it was soon re-established.

But the fiscal income of the Meccan emir had other resources. Arriving in Jedda in 1297, al-Tujibi reported that each pilgrim had to hand over to the authorities one-fourth of his supply of grains, pay a tax on the merchandises he may have brought with him, and again another tax to hire a mount to convey him to Mecca. The pilgrimage season was a time of intense commercial transactions which climaxed during the ritual halt of Mina outside the holy city, as good a way as another for the pilgrims to finance their journey by taking advantage of the presence of men and women from all over the Islamic world. But the Meccan emir especially levied his share on the great spice trade transiting through Jedda, through the intermediary of the merchants of the Karim, the seafaring season between Aden and Egypt lasting from June to October. In the 14th century the increase of this extremely lucrative traffic, which steered clear of the Gulf while Iraq was sinking into chaos under Mongol rule, did not only make the fortune of the Hasanid sharifs. It revived the attention of the main regional powers, leading to a tighter grip on Hijaz, and contributed to making Mecca once again the object of a symbolic competition for the leadership of the universal nation of Muslims.

## The two holy sanctuaries, ornaments of Islam

Mecca and Medina cannot be disassociated from their status as pilgrimage cities. A sacred territory (*haram*), carefully marked off and defended by taboos, separated them from the secular world: it took a day's walk to go round the Meccan *haram*; that of Medina began about 5 kilometres from the city walls. Only two other sites shared this privilege in the Middle Ages, albeit on far smaller areas: Jerusalem and Hebron in Palestine. By metonymy the sanctuary occupying the heart of the two cities was also called *haram*: the Meccan shrine contained the House of God (*Bayt Allah*, the Ka'ba); that of Medina the Prophet's burial chamber (the *hujra*). In the 8th century the two sanctuaries acquired their appearance which was only altered in a few details before they were rebuilt in the 1950s.

The Prophet's mosque in Medina, built between 707 and 709, was the work of the Umayyad Caliph al-Walid: the Syrian and Egyptian craftsmen, for the most part Christians, faced it with gorgeous mosaics, comparable to those still adorning the great Damascus mosque built on the orders of the same sovereign; they did not survive the two fires which ravaged the shrine in 1256 and 1481, and had to be rebuilt exactly as they had been. The Prophet's burial chamber (*hujra*), an entirely closed aedicule which also preserved the tombs of the first two caliphs, exclusively served by Ethiopian eunuchs, occupied one of the corners of the prayer hall; the pilgrims came to worship the holy remains, facing the silver nail that showed on the wall the place where the Prophet's head rested. Vizier of the sovereign of Mossul and lavish administrator of the holy places in the 1150s, Jamal al-Din al-Isfahani had two posthumous privileges: performing the pilgrimage to Mecca in a coffin made of the

wood of the Ka'ba doors he had had replaced; being buried in the shrine of Medina, an opening in his grave enabling him to contemplate the Prophet's burial chamber until resurrection. Moreover the mosque sheltered the treasure of the *hujra*, enriched by the precious gifts of the faithful, looted several times in the Middle Ages by the Medinan emir himself: Islamic art collections all over the world gained thereby some of their outstanding items.

The Mecca sanctuary, a plain esplanade which at first separated the Ka'ba from the city dwellings, was converted into a mosque by adding roofed arcades on its four sides. Undertaken by the Umayyad al-Walid, pursued by the Abbasid al-Mansur, this transformation was completed by his son, the Caliph al-Mahdi, between 777 and 783, who had the holy precinct enlarged for the Ka'ba to be in the centre. Syria and Egypt (from the temple of Akhmim) provided the marble columns and the tesserae for the mosaics of which the signatures could still be read two centuries later. Located in "the hollow of Mecca" (*batn Makka*) the sanctuary was regularly flooded by the torrential rains inundating the city: it is recorded that some years the ritual tours had to be performed swimming. So the draperies of the Ka'ba had to be constantly restored and the sovereigns fought over the privilege of changing the doors, made of precious wood faced with gold or silver leaf, and supplying the keys. The cube-shaped temple however remained unchanged in its structure since 693, the devout councillors respecting the wish of the jurist Malik ibn Anas (d. 795) addressing the Caliph al-Mahdi: "Leave the House just as it is for I fear that in the future it might become a plaything for princes". Open to the pilgrims at precise hours, the Ka'ba was nonetheless highly significant in terms of politics: trophies were stored there in times of conquests, as later was the testament of the Caliph Harun al-Rashid. As of the 13th century many decrees were posted on its walls or engraved on the columns of the surrounding arcades in the name of the suzerain of Hijaz, most of the time in an attempt to abolish the taxes levied in Mecca by the local authorities. In 1400 a fire devastated the sanctuary; it was modestly restored with the scarce building materials available in Hijaz (see cat. no. 244).

Without ever being a big city – the Bolognese traveller Ludovico di Varthema who visited it in 1503 claimed it counted six thousand houses (perhaps thirty thousand inhabitants?) – Mecca was gradually endowed with a large number of facilities and institutions created to deal with the specific needs of the pilgrimage season, enhance the particular dignity of the venerated city (*al-Makka al-mukarrama*) and underscore the piety of its generous benefactors. At least two hospitals (*maristan*) were created for care of the sick, one by the Abbasid Caliph al-Mustansir in 1231, the other by Sha'ban, the Cairo sultan, a century and a half later. Since the beginning of the 11th century there was an ever greater number of *ribats*, humbler institutions for lodging needy pilgrims, especially those who came to reside at length in the vicinity of the sanctuary (the *mujawirun*): at the end of the 15th century almost sixty of them were registered. Founded by wealthy individuals more often than by sovereigns, frequently by women, the Mecca *ribats* preferred to welcome their founder's countrymen. The rule of Ribat al-Abarquhi, founded in 1369 in the name of the sultan of Shiraz for the sojourn of ten guests from Iran, in this way explicitly excluded pilgrims from India. In the 15th century the spectacular growth of the port of Jedda gave the great merchants of Mecca the means to contribute to welcoming pilgrims.

But the major building competition was fought in an entirely different sphere: the *madrasa*, the place where law and its auxiliary disciplines were taught, a crucial institution of the Sunni restoration movement permeating the Islamic world since the second half of the 11th century. Founding a *madrasa* in Mecca, preferably set against the very wall of the sanctuary, was the surest way to assert oneself as a champion of Sunnism. In this respect the

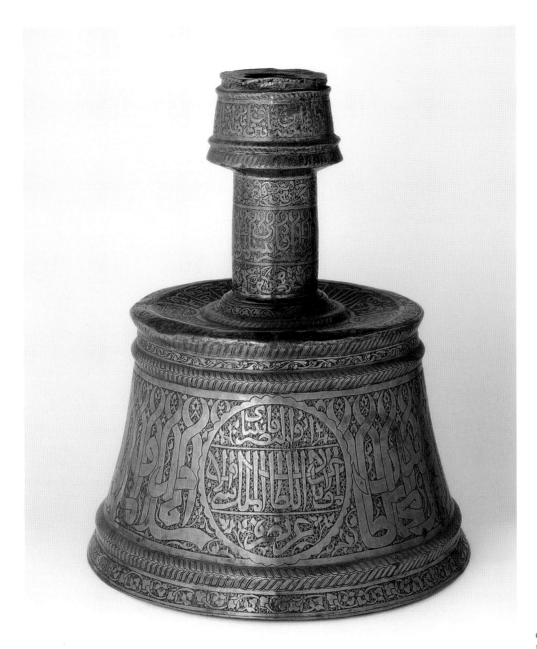

Candlestick given by Qa'itbay to the sanctuary of Medina,
Benaki Museum, Athens, BE 13040

Rassulid sultans of Yemen were the most brilliant builders in the 13th and 14th centuries when seeking to establish their suzerainty over Hijaz. From al-Mansur 'Umar in 1243 to al-Afdal 'Abbas in 1367, four of the first six sovereigns of the dynasty had a *madrasa* bearing their name built in the symbolic heart of Mecca. In the 15th century the escalating power of the sovereigns of Islamic India and the intensification of the spice trade led to the founding of three institutions: in the name of the sultans of Bengal in 1410, Gulbarga (in the Deccan) in 1427, Cambay (Gujarat) in 1461. Conversely, the Mamluk sultans of Cairo, lavish builders in the cities of Egypt and Syria, were notably absent until 1480 and 1484 when the Sultan al-Ashraf Qaitbay founded a *madrasa* and a *ribat* in each of the holy cities. It is true that the most powerful sovereigns of Islam had other arguments to put forward for the defence and illustration of Islam: in addition to the *jihad* against the Mongol and Latin infidels, protection of the pilgrimage and suzerainty over the holy places.

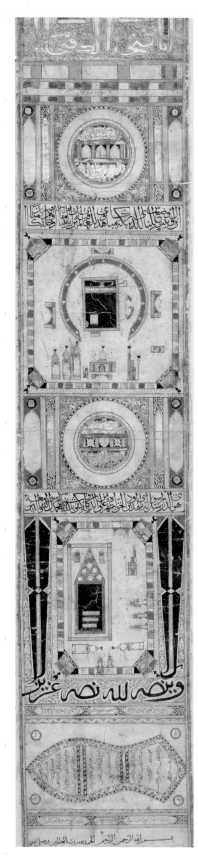

Pilgrimage certificate (scroll), 15th century.
British Library, London, Add. MS 27566

## A grand venture: the *Hajj*

In the Middle Ages an actual pilgrimage economy was set up, involving the departure countries as well as the cities of Hijaz and focusing a large part of the activity of the Bedouins of Arabia, at once hijackers and providers of mounts and supplies to the pilgrims.

The pilgrimage season lasted almost three lunar months – which according to the year could be in summer or winter – whereas the commemorative ceremonies were narrowed down to five days, between the eighth and the twelfth day of the "pilgrimage month" (*dhu'l-hijja*). To validate the performing of the *Hajj*, it was imperative to be present the ninth day of the month during the ritual station in front of the Mount of Mercy in the valley of 'Arafa, which implied respecting a strict travel calendar. The caravan from Egypt traditionally left from the Pilgrims' Pond north of Cairo on the sixteenth of the month of *shawwal*: as of 1340 the departure was postponed to the twenty-fourth so the pilgrims would arrive on the first day of the pilgrimage month, about five weeks later, to avoid having to bear the expense of an extensive stay in Mecca. However some pilgrims chose to depart three months earlier with the caravan of the month of *rajab*, staying longer near the holy sanctuary for the minor pilgrimage, or *'umra*, preferably during the fasting of the month of Ramadan, and finally getting to Medina on the Prophet's Tomb, a devotion occasionally performed after the *Hajj*, on the way home.

Four principal caravans led the pilgrims to the holy cities: the one from Yemen which the pilgrims from Ethiopia joined in Aden; the one from Iraq which assembled in Kufa the Iraqi pilgrims with those from Iran and Central Asia; the one from Syria which grouped in Damascus the Syrian pilgrims and those from Anatolia, eventually replacing the Iraqi caravan when it was prevented by the country's instability (almost one year out of three between 1330 and 1430); last, the one from Egypt which gathered in Cairo the Egyptian pilgrims, those from North Africa and Takrur (Sub-Saharan Africa), and met up with the caravan from Gaza and the pilgrims from Palestine in 'Aqaba by the Red Sea. Grouped in convoys, the pilgrims nonetheless sought to stay with their countrymen in a distinct caravan: in 1321, the year in which the pilgrimage may have had its greatest influx in the Middle Ages, thirty caravans camped on the ninth day of the month in the valley of 'Arafa. However it is difficult to know the exact number of pilgrims, save for several years deemed exceptional: thus in 1279 there were supposedly forty thousand pilgrims in the Egyptian caravan and just as many in those from Syria and Iraq put together.

The influx of pilgrims, at least doubling the usual population of Mecca, supposed a logistic capacity that far exceeded the local authorities' means. Some stages of the pilgrimage route – al-Aslam on the Egyptian itinerary, Fayd on the Iraqi itinerary – occasioned great markets supplied by the Bedouins in livestock produce. Christian Syrian merchants travelled down to al-Ula, a three-day journey from Medina, to sell their wares. But the pilgrimage was dependent on the supply, every year, of Egyptian grain unloaded in the port of Yanbu' or conveyed by the pilgrims' caravan itself, escorted by a detachment of about a hundred dromedaries. Sometimes on the return journey a caravan of fresh supplies awaited the pilgrims at 'Aqaba. These costly logistics rested on the perpetual pious foundations or *waqf* whereby since the 10th century the sovereigns of Egypt attributed to the holy cities the produce of the agricultural land of the upper valley of the Nile. Individually a good many sultans of Cairo, like al-Zahir Barquq (1382–99), founded *waqfs* to provide the poorest pilgrims with the sum needed for hiring a mount and for water throughout the journey.

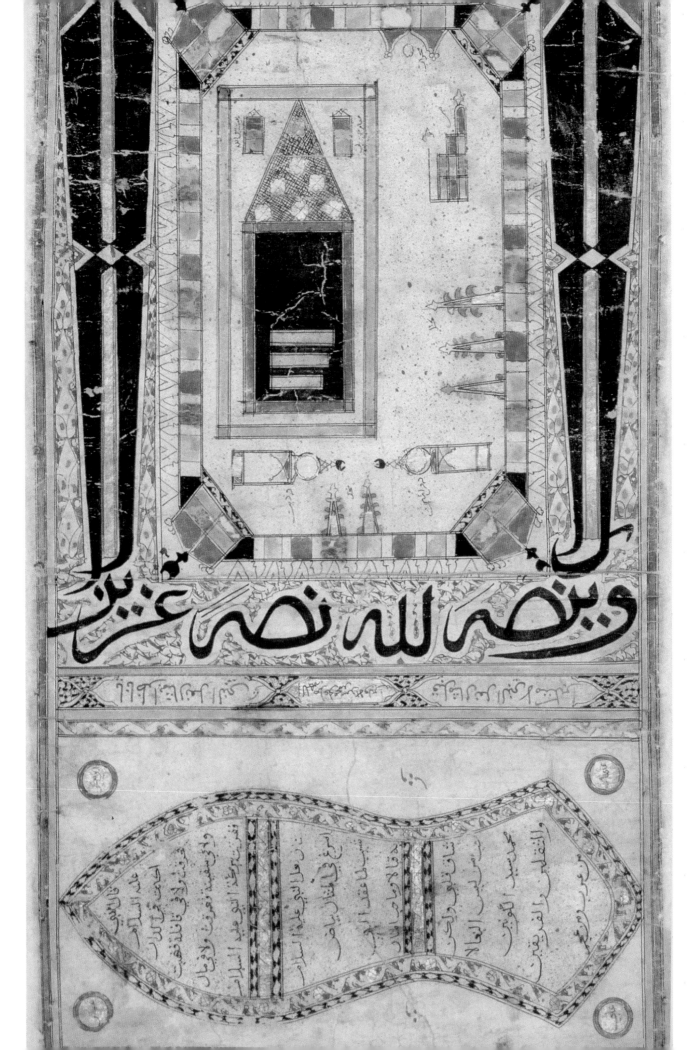

## A palanquin and spices, or how Hijaz was subjected

The Egyptian breadbasket gave the master of Cairo a major asset for intervening in the affairs of Hijaz. Saladin understood this perfectly and in the struggle for influence opposing him to the Abbasid Caliph al-Nasir he was the first to claim the title of "Servant of the two holy sanctuaries" (*khadim al-haramayn al-sharifayn*) in an inscription of 1191.

Several of his descendants, the Ayyubid sultans, even claimed they were protectors (*hami*) or lords (*sahib*) of the shrines to counter the ambitions of the Rassulids from Yemen whose armies intervened in Mecca several times between 1232 and 1254. But in just a few years the fall of the Abbasid caliphate, crushed by the Mongols in Baghdad in 1258, the defeat of the latter by the armies of Egypt in 1260 and finally the restoration of the legal and religious authority of the caliphate in Cairo in 1262 gave an unprecedented of prestige to the Mamluk sultan al-Zahir Baybars, his authority henceforth being acknowledged from the valley of the Nile to that of the Euphrates. In 1266 Baybars entrusted to the pilgrimage emir who commanded the Egyptian caravan an empty palanquin, richly embroidered, which was to head the pilgrims' procession until their arrival in Mecca: the tradition of the *mahmal* was founded and would last almost seven centuries.

Symbolizing the protection that the sultan of Cairo assured the pilgrimage, the *mahmal* was instrumental in a gradual domination of Hijaz. The Egyptian caravan, preceded by the precious palanquin, conveyed the investiture diploma, the robe of honour and the turban granting the Meccan emir and his homologue of Medina their mandate: on greeting the procession they each had to mark their submission by kissing the foot of the dromedary bearing the *mahmal*. Up to the mid-14th century the Cairo Mamluks' suzerainty continued to be challenged by the sultans of Yemen and to a lesser degree the Mongol sovereigns of Iraq who for several years sent their own *mahmal* and a new *kiswa* to drape the Ka'ba. But the sultan of Egypt al-Nasir Muhammad (1311–41) settled the quarrels of succession that bedevilled the two Hijaz emirates, not hesitating to perform personally the pilgrimage on three occasions.

The integration of Hijaz in the Mamluk sultanate gathered momentum in the 15th century. Certainly conferring on the Meccan emir the rank of "lieutenant of the sultan" (*na'ib al-saltana*) – similar to that of the Mamluk governors in the provinces of Syria – with authority over Hijaz, was ineffective. Its titular, Hasan ibn Ajlan, emir from 1395 to 1426, was even able to act as a genuine sovereign and contributed to the embellishment of his city more than any of his predecessors. But in 1424 the Egyptian caravan arrived with a detachment of Mamluks who came to set up a permanent garrison in Mecca. The same year the rerouting of the spice route – the Indian shipowners henceforth preferred to convey the precious goods from the ports of Western India directly to Jedda, avoiding the port of Aden and the Yemen sultans' exorbitant taxation – alerted Cairo. In 1425 the Mamluk sultan Barsbay sent a financial inspector to levy a tax on the merchandise unloaded in the port of Jedda. He returned every year. The inevitable arrival of the Egyptian caravan, the coming of the pilgrimage emir – the sultan's eminent representative – the presence of a regular garrison in Mecca and Medina, the huge stake of the taxes levied on the spice trade in the port of Jedda, in the 15th century got the better of the fierce five hundred-year-old autonomy of the Hijaz sharifs.

## Epilogue: Arabia threatened by the Portuguese

The hard-won *modus vivendi* established by the sultans of Cairo in Hijaz was shattered in the very first years of the 15th century after the Portuguese ships completed the circumnavigation of Africa. Anchoring in the Bab al-Mandab strait in 1500, the Portuguese threatened

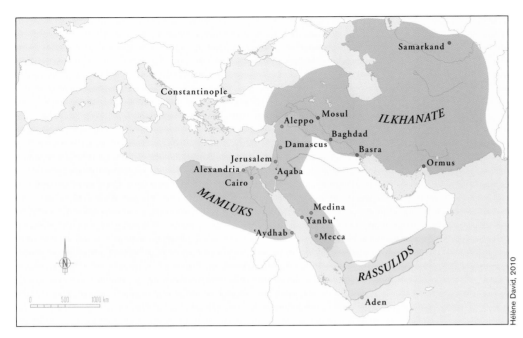

The Mamluk Sultanate and its neighbours, c. 1300

to permanently interrupt the great spice trade, recalling the ghost of Renaud de Châtillon, the crusader war captain who in 1182 had put an end to the inviolability of the Red Sea, looted the ports of Hijaz and threatened the integrity of the two holy precincts. For the first time since the advent of the Mamluks in 1250 the pilgrimage was officially prohibited by the sultan in 1506 at the departure from Cairo and Damascus because of the uprising of the emirs of Khulays, Yanbu' and the Bedouin tribes in Hijaz. The Mamluk rule was shaken.

Immediately after the defeat of the Egyptian fleet by the Portuguese ships off the Indian port of Diu in 1509, the Sultan Qansuh al-Ghawri (1501–16) undertook to reinforce the defences of the Red Sea coasts: in addition to the port of Tur in the Sinai, Jedda was protected by mighty walls; fortified caravanserais were rebuilt or built for the first time at 'Ajrud, Suez, Nakhl, 'Aqaba, al-Muwaylih and al-Azlam. In this way the entire route of the Egyptian pilgrimage was defended. But in 1513 the Portuguese failed to seize Aden. The danger was postponed for a while.

However in 1516 al-Ghawri died on the battlefield of Marj Dabiq in northern Syria, far from the Red Sea. The Mamluk domination in Hijaz with its symbols and customs, the trains of Egyptian grain and protection of the pilgrims, the sending of the palanquin and the new veil for the Ka'ba, all fell like a ripe fruit into the hands of the Ottoman sultan Selim. From then on and for four centuries Arabia and its holy cities would be one of the many ornaments of the master of Istanbul.

**Bibliography:**
Behrens-Abouseif 1999, pp. 129–48; Charles-Dominique 1995; Gaudefroy-Demombynes 1954, pp. 5–21; El-Hawary and Wiet 1985; Jomier 1953; Miquel 1967–88; Mortel 1991, pp. 63–78; Mortel 1998, pp. 29–50; Vallet 2009, pp. 325–28.

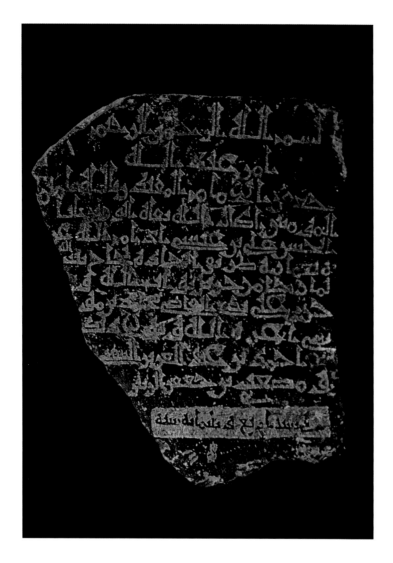

In the manner of basalt funerary tombstones this inscription was hammered on an uneven, rough block to which it was adapted. The script, although featuring several stylizations (loops of several letters, flaring bevelled endings, reverse stretching of the *ya'*, heart-shape of the *lam-alif*), is laid out rather clumsily and the base line of the script is not perfectly straight. It is nonetheless a caliphal inscription in the name of the Abbasid sovereign al-Muqtadir bi-llah and his vizier Hasan 'Ali ibn 'Isa, commemorating the construction of a pilgrimage road and specifying that it was supervised by the *qadi* (judge) Muhammad ibn Musa and built by Ahmad ibn 'Abd al-'Aziz al-[?] and Mus'ab ibn Ja'far al-Zubayr in the year 304 H./916–17. The treatment of the date, on the last line, differed from the rest of the inscription: it is carved with the inscription on reserve on a pecked cartouche. This text is a testimony of the Abbasid caliphs' interest in the development and maintenance of the roads leading to the holy precincts.

C. J.

**243. Inscription mentioning a road construction**
304 H./916–17
50 x 44 x 10 cm
Found in Mahd al-Dhahab (Hijaz)
National Museum, Riyadh, 899

Bibliography: Miles 1954, p. 477; Al-Ansari 1969, pp. 51, 59; Al-Rashid 1980, pp. 26–27; Al-Fa'r 1984, p. 236–47; El-Hawary and Wiet 1985, p. 80; Washington n.d., Kufi 9.

بسم الله الرحمن الرحيم
امر عبد الله
جعفر الامام المقتدر بالله امير
المومنين اطال الله بقاه ابو...
الحسن علي بن عيسى ادام الله عز
ه بعماره طريقي الجاده لحاج بيت الله
لما رجا من جزيل ثواب الله و
حرر؟ على يدي القاضي محمد بن مو
سى اعزه الله وتولاه بذ؟
احمد بن عبد العزيز ال...
ومصعب بن جعفر الزبير
في سنة أربع وثلاثمائه

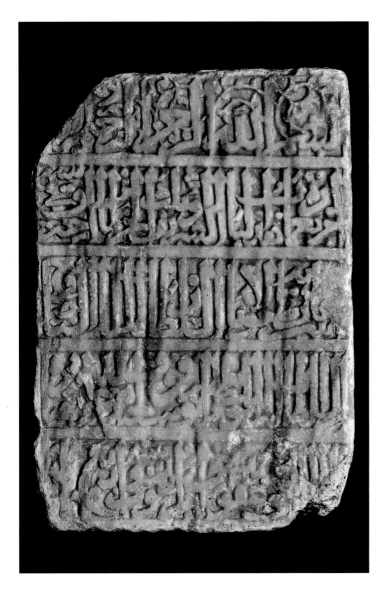

The fragments of the text in square brackets are renderings of illegible – because very worn – passages, performed in accordance with several marble inscriptions in the name of the Sultan Faraj ibn Barquq which were present in the *haram* and recorded in the early 20th century by Hasan el-Hawary[1] (their present localization is uncertain and none seem to exactly match this one). This inscription commemorates the reconstruction of part of the Meccan *haram* by order of the Mamluk Sultan Faraj (1399–1412) and supervised by the Grand Master (*amir akhur*) Baysaq. It was one of the many renovations performed in the shrine over the centuries. According to sources, in the year 802 H./1400 the sanctuary was badly damaged on two occasions: first by a severe flood, as occurred regularly owing to its location in a hollow and at the confluence of runoffs from the nearby mountains; then a few months later a fire destroyed the entire west side and part of the north side of the shrine, which coincides with the indication of one third of the *haram* mentioned in the inscription. The restoration was promptly carried out under the direction of the emir Baysaq who was about to depart as leader of the Egyptian pilgrims' caravan, and was completed in 804 H./1402, apart from the ceiling of the galleries completed three years later when the wood arrived from Asia Minor and Ta'if. The Mamluk sultans, very jealous of their prerogatives as servants of the holy precincts, went to great lengths repairing and embellishing them. But very few traces of this patronage are preserved today, save the candlestick formerly endowed as *waqf* to the Medinan shrine by the sultan Qa'itbay (held today in the Museum of Islamic Art of Cairo and the Benaki Museum in Athens) and keys for the Ka'ba, like the one preserved at the Musée du Louvre, in the name of the same Sultan Faraj ibn Barquq.[2]

C. J.

1. El-Hawary and Wiet 1985, pp. 193–96.
2. Musée du Louvre, Department of Islamic Art, no. OA 6738.

**244. Reconstruction inscription in the name of the Mamluk Sultan Faraj**
c. 804 H./1402
Carved marble
62 x 43.5 x 28.5 cm
Sanctuary of Mecca
National Museum, Riyadh, 8

Bibliography: Unpublished.

بسم الله الرحمن الرحيم
امر بعمارة هذا الباب الشريف وثلث الحرم لما احترق في سنة
[...] مولانا السلطان الملك الناصر فرج
ابن السلطان [الملك] الظاهر أبو سعيد برقوق [أعزّ الله أنصاره]
[على يد الراجى عفو ربّه] بيسق أمير اخور [...]

"In the name of God the Merciful, the Compassionate / Ordered the construction of this noble door and one third of the haram after its fire in the year / [. . .] our master the Sultan al-Malik al-Naasir Faraj / son of the Sultan [al-Malik] al-Zahir Abu Sa'id Barquq [May God glorify his victories] / [by the hand of he who trusts in the indulgence of his Lord] Baysaq Amir Akhur [. . .]."

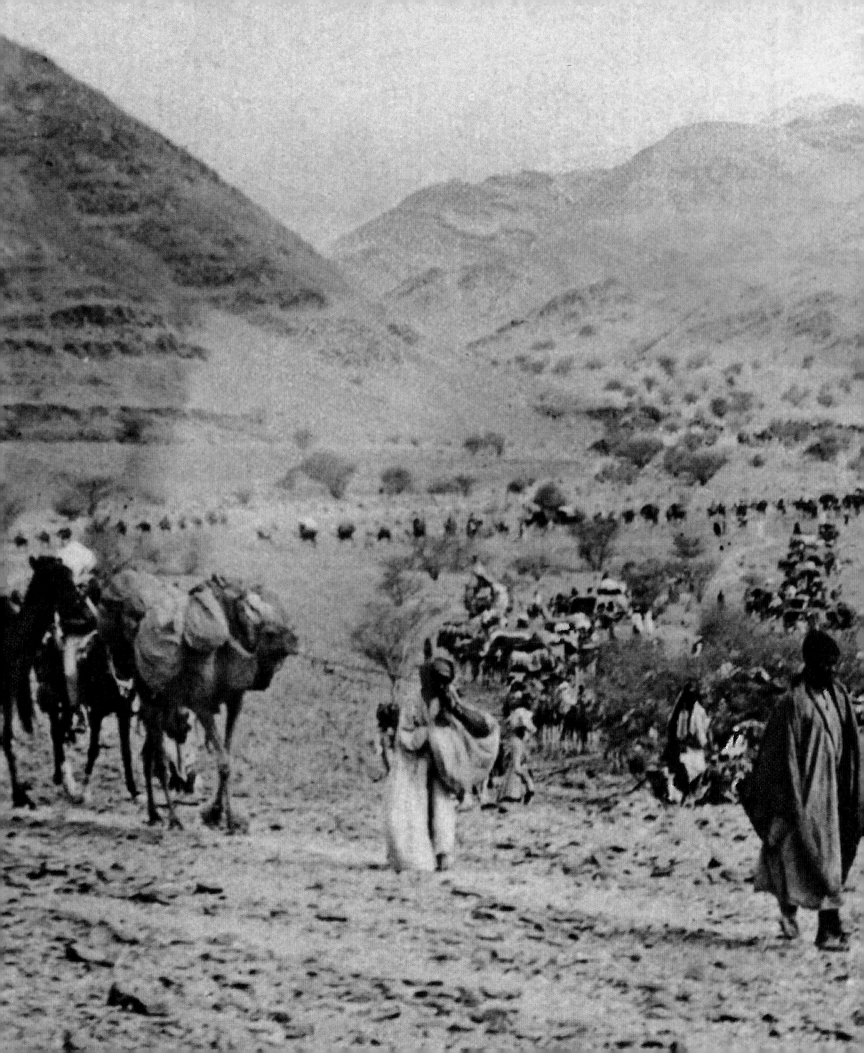

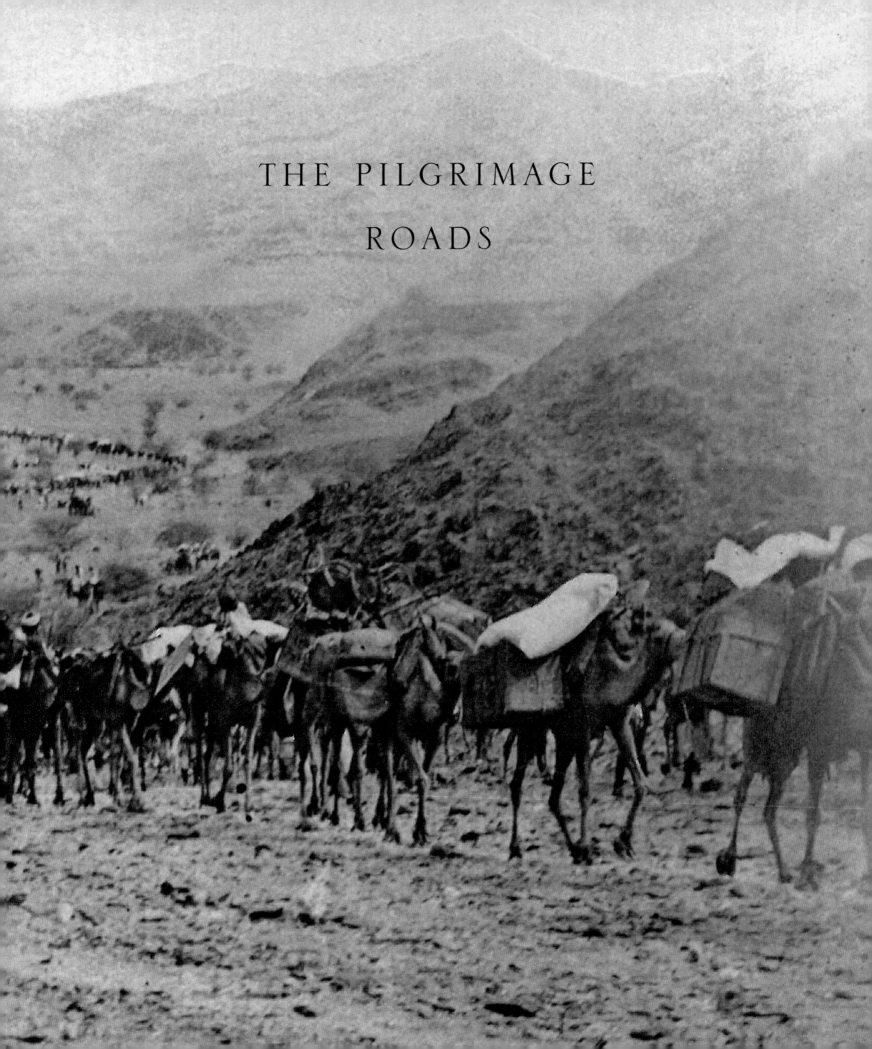

# THE PILGRIMAGE ROADS

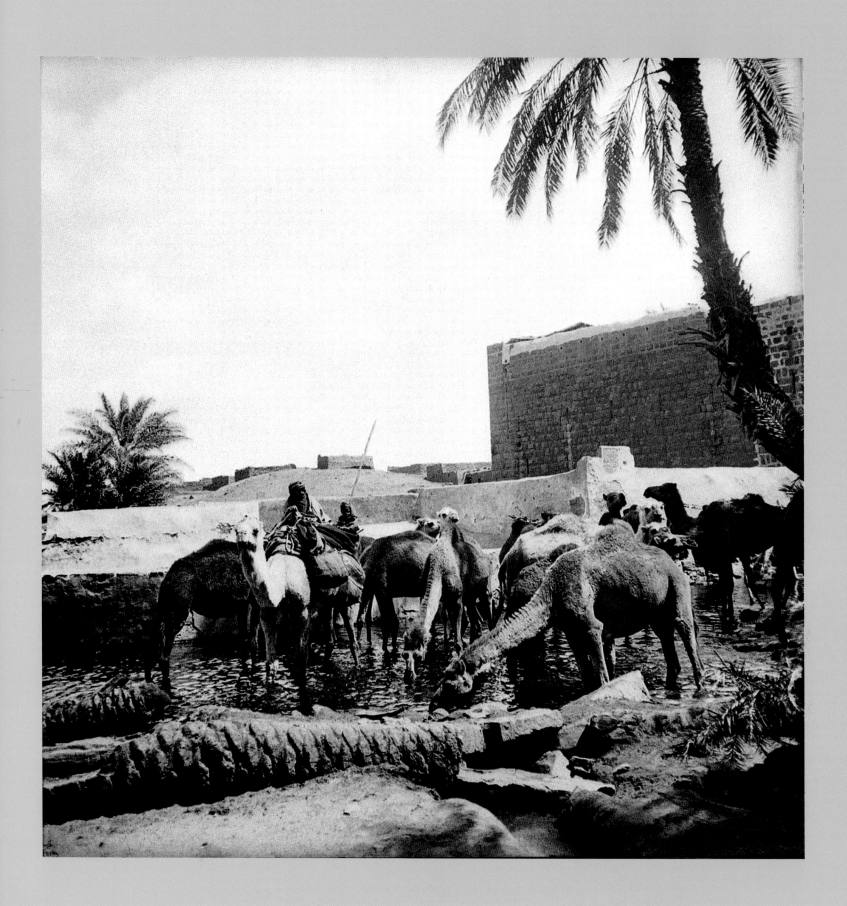

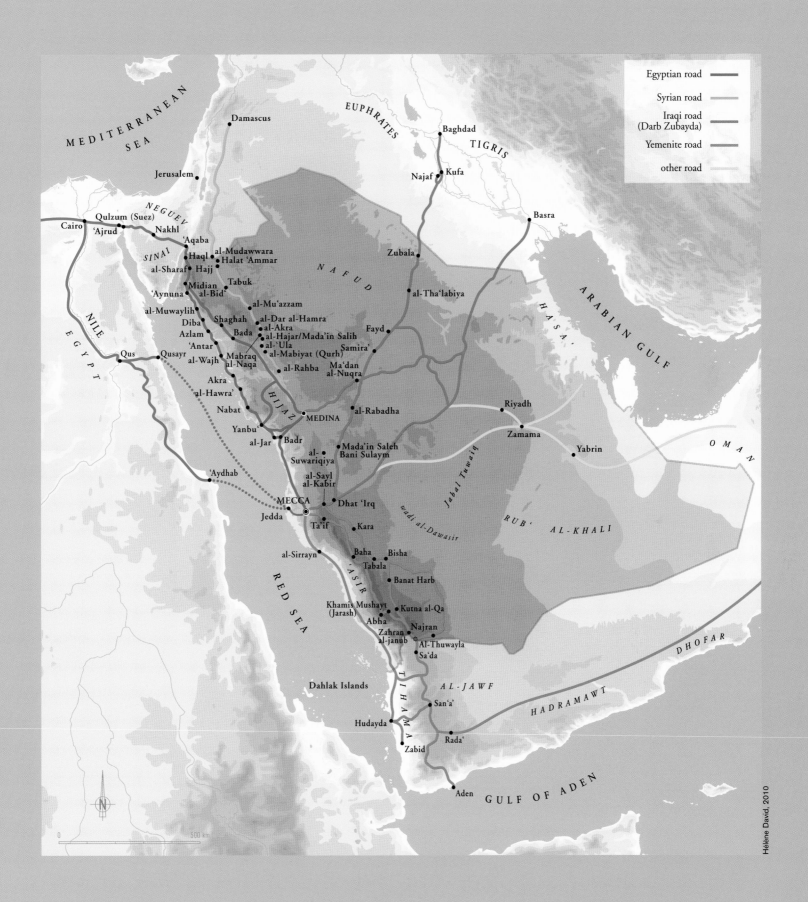

**Legend:**
- Egyptian road
- Syrian road
- Iraqi road (Darb Zubayda)
- Yemenite road
- other road

MEDITERRANEAN SEA

EUPHRATES

TIGRIS

Damascus

Baghdad

Jerusalem

Najaf  Kufa

NEGUEV

Basra

Cairo  Qulzum (Suez)
'Ajrud  Nakhl
'Aqaba

SINAI

Haql  al-Mudawwara
al-Sharaf  Halat 'Ammar
Hajj

Midian  Tabuk
'Aynuna  al-Bid'

al-Muwaylih  al-Mu'azzam
Shaghah  al-Dar al-Hamra
Diba  al-Akra
Azlam  Bada  al-Hajar/Mada'in Salih
'Antar  al-'Ula
Mabraq  al-Mabiyat (Qurh)
al-Wajh  al-Naqa  al-Rahba

Akra
'al-Hawra'

Nabat

Yanbu'
al-Jar  Badr

'Aydhab

Jedda

Qus  Qusayr

EGYPT

NILE

NAFUD

al-Tha'labiya

HASA'

ARABIAN GULF

Zubala

Fayd

Samira'

Ma'dan
al-Nuqra

al-Rabadha

Riyadh

Zamama

Yabrin

OMAN

HIJAZ

MEDINA

MECCA

al-Suwariqiya

al-Sayl
al-Kabir

Dhat 'Irq

Ta'if  Kara

Mada'in Saleh
Bani Sulaym

Jabal Tuwaiq

wadi al-Dawasir

RUB' AL-KHALI

al-Sirrayn

Baha  Bisha
Tabala

Banat Harb

'ASIR

Khamis Mushayt
(Jarash)
Abha  Kutna al-Qa
Zahran  Najran
al-janub  Al-Thuwayla
Sa'da

RED SEA

Dahlak Islands

TIHAMA

AL-JAWF

San'a'

HADRAMAWT

DHOFAR

Hudayda

Rada'

Zabid

Aden  GULF OF ADEN

0          500 km

N

Hélène David, 2010

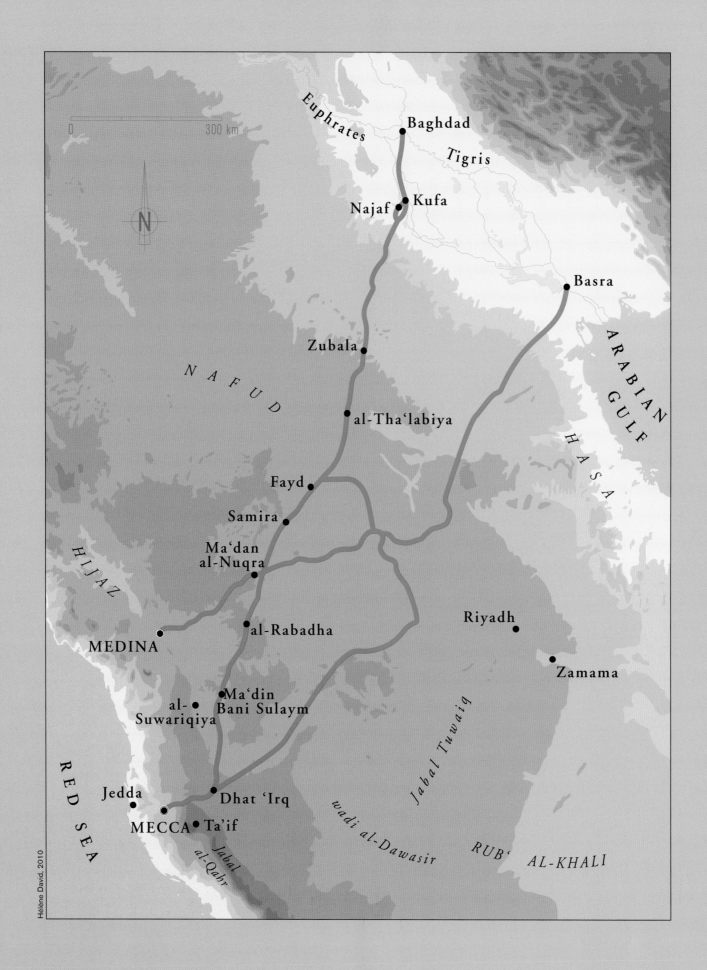

Euphrates

Tigris

Baghdad

Najaf  Kufa

Basra

ARABIAN GULF

Zubala

NAFUD

al-Tha'labiya

HASA

Fayd

Samira

Ma'dan
al-Nuqra

Riyadh

al-Rabadha

MEDINA

Zamama

HIJAZ

Ma'din
Bani Sulaym

al-
Suwariqiya

Jabal Tuwaiq

Jedda

Dhat 'Irq

MECCA  Ta'if

wadi al-Dawasir

RUB' AL-KHALI

RED SEA

Jabal
al-Qahr

0        300 km

N

Hélène David, 2010

# DARB ZUBAYDA:

## THE PILGRIMAGE ROAD
## FROM KUFA TO MECCA

*Sa'd bin Abdulaziz Al-Rashid*

## Introduction

With the advent of Islam in the holy city of Mecca and the institution of Medina as the first political and religious capital of the Muslims, the highways and byways became of vital importance in all the regions of the Arabian Peninsula. The network of trade roads connecting the peninsula to other Arab cities in Egypt, Iraq, Bilad al-Sham, Yemen and the Gulf, which had already been very developed in Antiquity, enjoyed a new bout of prosperity after a period of decline.

The expansion of the Muslim community outside the Arabian Peninsula contributed to the development of new roads and routes between the Islamic cities, and towards the two holy cities of Mecca and Medina. Many cities and regions in the peninsula – such as Jedda, Athar, San'a, Zabid, Ta'izz, Bahrain and al-Yamama – experienced remarkable urban and economic growth.

Right from the start of Islam, pilgrimage was an essential factor in the development of the roads, also used by trading caravans. Maintenance of the roads was one of the major concerns of the caliphs who, over the centuries, strove to build them, supervise them and supply them with facilities.

The first caliphs, referred to as the "Rightly Guided", were the first to develop these networks inside and outside the Arabian Peninsula. The most important of these roads, the sides of which rang with the cries of merchants and beasts of burden, was undoubtedly the one that the prophet Muhammad travelled between Mecca and Medina.

Two years after the Prophet's companion, 'Umar ibn al-Khattab (634–44), acceded to power, the Muslim army headed towards Iraq and launched an attack on al-Hira under the command of Sa'd ibn Abi Waqqas. The route followed by the army later came to be known as "Darb Zubayda". On the road leading to al-Qadisiyya, the army halted at stops and watercourses along the way, such as al-Tha'labiyya, Zarud, al-Sharaf, al-'Adhib and al-Qadisiyya. These resting places, which the conquering Muslim army had passed earlier, later became important staging posts for pilgrims coming from Iraq.

*(pages 420-421)*
Pilgrims travelling from Jedda to Mecca,
photograph by Muhammad 'Ali Effendi Sa'udi, 1907–08

*(page 422)*
The fort and spring at Tabuk, March 1907,
photograph by A. Jaussen

*(page 423)*
Map of the pilgrimage roads

*(opposite)*
Map of pilgrimage roads from Iraq

While he was undertaking the *'umra* in the year 638, Caliph 'Umar authorized water-sellers to set up rest stops along the road between Medina and Mecca. In exchange, he asked them to provide water-supply points and told them: "A traveller is the person worthiest of receiving protection". He also had a house equipped in Medina with provisions of flour, dates, raisins and other foodstuffs useful to travellers, and he ensured that numerous points were set up along the Medina–Mecca road to offer water, food and help to the needy.

Caliph 'Umar thus established the basic principles of road administration and upkeep and made it possible for travellers on their way to Mecca and Medina to receive assistance.

Under the third caliph of Islam, 'Uthman (644–56), economic conditions improved considerably; the population increased and the fabric of the cities became more closely knit. In consequence, the amount of traffic on the roads that criss-crossed the peninsula became heavier.

In 649, 'Uthman ordered wells, fountains, cisterns and infrastructures to be installed at the various stopping places on the road from Bassora to Mecca. Palms and gardens were also planted along the way. This wide road passed through Fayd, a large, ancient town where the caliph had set up several easily accessible water-points, and he appointed several companions as supervisors to oversee the works, two of whom were 'Abdallah ibn 'Amir ibn Kariz and Abu Musa al-Ash'ari.

Under the Umayyads, the Muslim empire continued to expand. New Islamic capitals and cities were created and the road network continued to grow and improve, in particular during the Caliphate of 'Abd al-Malik ibn Marwan (685–705).

Inscriptions on stone commemorating the building of these roads and their facilities in Palestine, Damascus and the Arabian Peninsula corroborate the magnitude of the investment made by 'Abd al-Malik and his successors during this period. They also provide striking confirmation of the flourishing religious and civic life, and of the construction taking place in the two holy cities as well as in the great capitals of the empire.

When he came to power, Caliph al-Walid ibn 'Abd al-Malik (705–15) sent a letter to the governor of Medina enjoining him to facilitate access to the major routes and to dig wells around the city, a request he also made to the governors of other cities in the empire.

Caliph 'Umar (717–20) continued the reforms begun by his predecessor al-Walid and developed the roads and major routes, as well as the amenities they offered to travellers. He also ordered the construction of inns offering overnight stops for travellers and rest and care for the poorest.

During the reign of Hisham ibn 'Abd al-Malik (724–43), great importance was placed on the construction of forts endowed with gardens and water in abundance. Anxious to offer travellers and pilgrims the best services possible, the caliph had cisterns built and wells and channels dug all along the pilgrimage route between Damascus and Mecca. Some of these constructions can still be seen today in Syria, Palestine and Jordan.

During the Abbasid Caliphate, the groundwork of the main trade and pilgrimage routes had already been carried out. Roads from cities and provinces across the Islamic world converged on the Arabian Peninsula and its two holy cities: roads which lead from Kufa and Bassora in Iraq, and from Yemen, Oman, Egypt and Syria, directly to the pilgrimage sites.

The roads all intersected at important junctions or were linked to one another by secondary roads. Caliphs, viziers, princes, merchants and private benefactors took personal responsibility for the upkeep of these roads. The network was dotted with rest houses, cisterns, fountains, dams and tanks, and the roads were lined by specially built inns, mosques and markets designed to make the pilgrimage an easier journey. Milestones were installed to show distances and beacons to indicate the direction of the routes and their secondary roads.

These roads were used for centuries, until new means of transport made them obsolete. Once they were abandoned by travellers, they lost their significance. The facilities installed by the roadside progressively deteriorated due to neglect and climatic, economic and political factors.

There are many historical, geographical and literary sources that provide valuable information on these roads and help researchers in their archaeological investigation of the sites and monuments that line them.

Commercial and pilgrimage routes are an important object of archaeological and historical study. Undertaken by a variety of research institutions, this scholarship has contributed to the discovery and protection of ruins and monuments on Arabia's early road network.

## The pilgrimage road from Kufa to the holy city of Mecca (Darb Zubayda)

The road from Kufa to Mecca was, for centuries, one of Islam's most important trade and pilgrimage roads. The road was known as "Darb Zubayda", in reference to Zubayda bint Ja'far, the wife of Caliph Harun al-Rashid (786–809), who had construction works carried out to ensure the provision of water to travellers. The ruins of some of these works – like Zubayda's Fountain ('Ayn Zubayda), which supplied the inhabitants of Mecca with water – are still preserved today.

The route from Kufa to Mecca was used long before the advent of Islam. The merchant caravans leaving from Mecca, Medina and the centre of the Arabian Peninsula took this route in the direction of al-Hira, a large pre-Islamic town close to Kufa. Use of the route became more organized after the conquest of Iraq and the expansion of Islam towards the cities of the Middle and Near East. Water provision points, places offering grazing and mines along the route were transformed into staging posts and rest stops for pilgrims, merchants and other travellers. During the reigns of the "Rightly Guided" caliphs and up until the Umayyad period, use of the route flourished. With the transfer of the capital of the caliphate from Damascus to Baghdad in Iraq, the road became a major communications route between the new capital, the two holy cities and the rest of the Arabian Peninsula as far as Yemen, and from there to Africa.

In consequence, the road between Kufa and Mecca became one of the major concerns of the Abbasid rulers: it can even be considered as one of their creations. Caliphs, princes, viziers and other important people contributed to its upkeep.

Geographers have retraced the course of the road that linked Baghdad, Kufa, Mecca and Medina. A number of historical, geographical and literary sources reveal that the Darb Zubayda was maintained with particular care: the directions were clear, the road tarred and cleared of sand, and stones that hindered traffic were removed in the uneven and mountainous sections. The amenities that lined the way – such as water points, dams, wells, cisterns, fountains and water channels – were set out at planned intervals. Road signs, well indicators, beacons and milestones were placed to guide travellers by day and by night.

Several caliphs had palaces and forts built along the road, which they could use for lodgings during their many journeys to Mecca and Medina to perform the *Hajj* or the *'umra*. Harun al-Rashid fulfilled his obligation of the *Hajj* nine times during his reign (786–809), even making some of the journeys on foot. A lover of art and science, Caliph al-Ma'mun (813–33) instructed his engineers to mark out the route with great precision.

Muslim geographer-travellers have registered twenty-seven main staging posts and twenty-seven secondary stations or rest stops situated between the main staging posts. In addition, other caravanserais were scattered here and there along the entire length of the route. They have

Road marker on the route from Iraq

also inventoried stations and rest houses on roads branching off the Darb Zubayda as well as secondary routes. One of the secondary routes on the Bassora road intersects the road to Kufa at Ma'dan al-Nuqra. From there it is possible to head south to Mecca or west to Medina. The main sections of the Bassora road and the Darb Zubayda meet at Mikat dhat 'Ariq, near Mecca.

Historical and geographical sources all confirm that the Darb Zubayda reached its apogee at the start of the Abbasid Caliphate. It was renowned for its safety and the series of amenities that had been placed at the service of its travellers. The historian Ibn Kathir relates that "starting from Iraq, the Hijaz road was one of the safest and most developed; but, like others, both primary and secondary, this road became increasingly hazardous, in particular by tribal raids, thus making the movement of pilgrims and travellers very risky without military protection dispatched from the caliphal capital". After Baghdad was captured by the Mongols in 1258, the Darb Zubayda was used only sporadically.

Although the condition of the staging posts progressively worsened, many of the wells are still used by the Bedouin and the majority of the hydraulic installations, most of them covered by sand today, can still be identified.

A large-scale study of the Kufa–Mecca road was made by Sa'd Al-Rashid and published under the title *Darb Zubayda*. The author has also led excavation work in some of the archaeological sites along the road. He found milestones specifying distances in *barid*, *mil* and *farsakh*, and the remains of works ordered by the Abbasid Caliphs al-Mahdi (775–85) and al-Muqtadir (908–32). Many route markers, generally circular piles of stones more than 3 metres high, still exist to indicate the direction to follow. The distance between two markers is 1 *mil* (about 2 kilometres), and this distance is reduced to a half *mil* (about 1 kilometre) close to the main staging posts where several routes intersect or where wells and cisterns were built. Dozens of roadside markers can be seen, some of which have collapsed to form enormous piles of stones. Topographical surveys and excavation work have made it possible to identify the network of forts, citadels, rest stops, places of residence and mosques that were built along the Darb Zubayda. These places were like small towns where the inhabitants, travellers, pilgrims and merchants could eat, quench their thirst, find shelter and rest their animals. Some of these rest stops developed into thriving marketplaces offering a variety of agricultural, animal and crafts products.

Some of the most important staging posts under archaeological study are: Zubala, al-Tha'labiyya, Fayd, Samira', al-Naqra, al-Rabadha and Ma'din Bani Sulaym. Archaeological research at Fayd has uncovered a highly-developed hydraulic system that included wells, fountains, water channels and cisterns, buildings such as forts, citadels, towers and mosques, and a grid of roads worthy of a large town. The site has returned coins and a quantity of objects made of ceramic, glass, metal and stone. These finds substantiate the information given in historical and geographical sources and in the accounts of Muslim travellers relating to this city, one of the oldest Islamic centres at the heart of the peninsula and one of the most important stations on the Darb Zubayda.

Excavation work has also been undertaken on the site of al-Rabadha. Twenty years of digging have unearthed a large mosque, a smaller one, residential buildings, forts, markets and mining sites. In addition, traces have been found of reservoirs, pools and water reserves. Special attention has also been paid to the many objects, coins and inscriptions discovered. All these finds provide archaeologists with a mine of information that allows them to reconstruct the environment of the town of al-Rabadha. A major town in the peninsula, it was inhabited from the start of the Islamic era until 931, when it was devastated during the Qarmat revolt and abandoned by its inhabitants.

Archaeological study of the Darb Zubayda shows that the town's architecture was typified by very thick walls and flanking towers. The houses at al-Rabadha were equipped with underground water tanks placed beneath the rooms, courtyards and corridors. Clearly water supplies were a fundamental concern. Cisterns and pools of different dimensions, and either circular, square or rectangular in shape, were dug along the length of the road, close to the staging posts or in the most remote spots. Pillars were used to support the cisterns and helped to protect them from the pressure of the water flow. The sloping walls of some of the tanks were even cut into steps. Canals and dams in the surrounding area diverted rainwater and runoff water that flowed into the valley. The entire system is an indication of the skills that had already been acquired at the time in the fields of construction and hydraulic works.

In addition, the researchers managed to retrace the course of the Darb Zubayda and its secondary roads. Most of its sections were fairly straight. It covers a length of a little over 1,276.7 kilometres, of which 227.8 are in Iraq and 1,048.9 are in Saudi Arabia. The road crossed plains, rugged terrain and very dry desert areas before entering the Hijaz hill country, where the plateaus are riven by deep, narrow valleys. However, the road was made more accessible by the re-routing of some of the sections hemmed in by mountains and the high walls constructed on its sides. Some of the stretches on mountain slopes were cut to form a flight of steps. All these adaptations reflect the know-how of the engineers of the early centuries of Islam, who carefully traced out the roads using very precise techniques.

The many ceramic, glass and metal objects, coins, inscriptions and engravings found the length of the route bear witness to its use over the centuries. A large set of Islamic engravings has been assembled from finds made in many places alongside the road and its junctions: at al-Rabadha, Ma'din Bani Sulaym, Mikat dhat 'Ariq, in the outskirts of Mecca and Medina, and around al-Hunakiya, al-Suwaydira, al-Suwariqiya, Hadha and Safina. All these engravings, some of which are dated, are from the period between the 1st and 3rd centuries of the Hegira (7th–10th centuries AD).

**Bibliography:**
Al-Harbi; Al-Hawas 2003; Ibn Battuta; Ibn Jubayr; Ibn Kathir; Ibn Khurradadhbih; Al-Istakhri; Al-Muqaddasi; Al-Rashid 1980; Al-Rashid 1406H./1986; Al-Rashid 1414H./1993; Al-Rashid 1421H./2000; Al-Tabari.

**245. Milestone**
Late 8th century?
Granite or basalt
50 x 42 x 13 cm
Darb Zubayda
National Museum, Riyadh, 1356

Bibliography: Al-Rashid 1980, no. 2, pp. 335–36; Al-Rashid 1992, pp. 138–43; Elad 1999, pp. 33–88; Bittar 2003, pp. 36–39; Washington, "Kufi 1".

ميل من
البريد
وهو على ا
ثنين وستين
بريد من
الكوفة

This milestone discovered on the famous Darb Zubayda – the pilgrimage road connecting Kufa, in Iraq, with Mecca – is another illustration of the care taken by the Abbasid sovereigns in developing and marking this road. It was also used by the postal and communications system, *al-barid*, already set up by Mu'awiya, the founder of the Umayyad dynasty. This signpost indicates a distance of 62 *barid* from the city of Kufa, the Abbasid *barid* being estimated at about 20 kilometres. It belongs to a set of five signposts of this type, more or less fragmentary, found along the Darb Zubayda: one mentions the Abbasid Caliph al-Mahdi, two indicate a distance from Kufa, another from Mecca, a last one comes from the al-Rabadha excavations. The angular script, with its distinct, deep tracing, very regular and liberally using *mashq* (the stretching of the horizontal lines of some letters) constitutes an evolved form of the Umayyad sovereign inscriptions, like those of milestones of the reign of 'Abd al-Malik discovered in Palestine marking the route from Damascus to Jerusalem.

C. J.

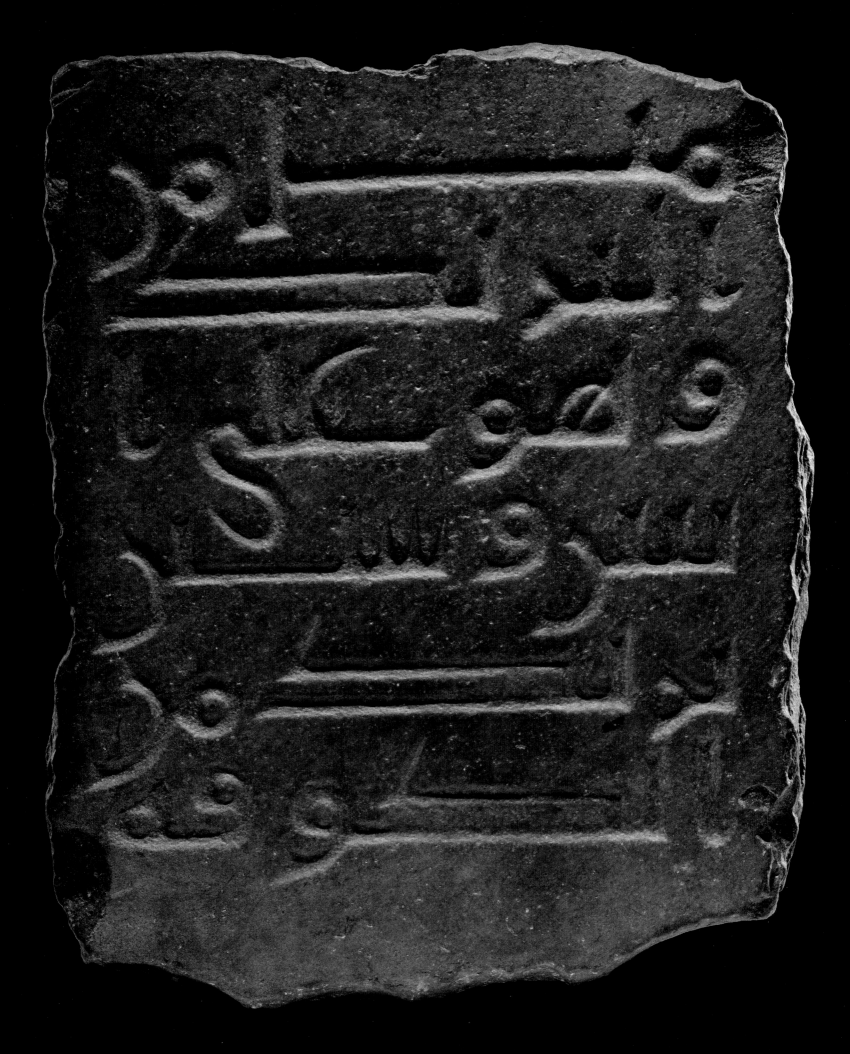

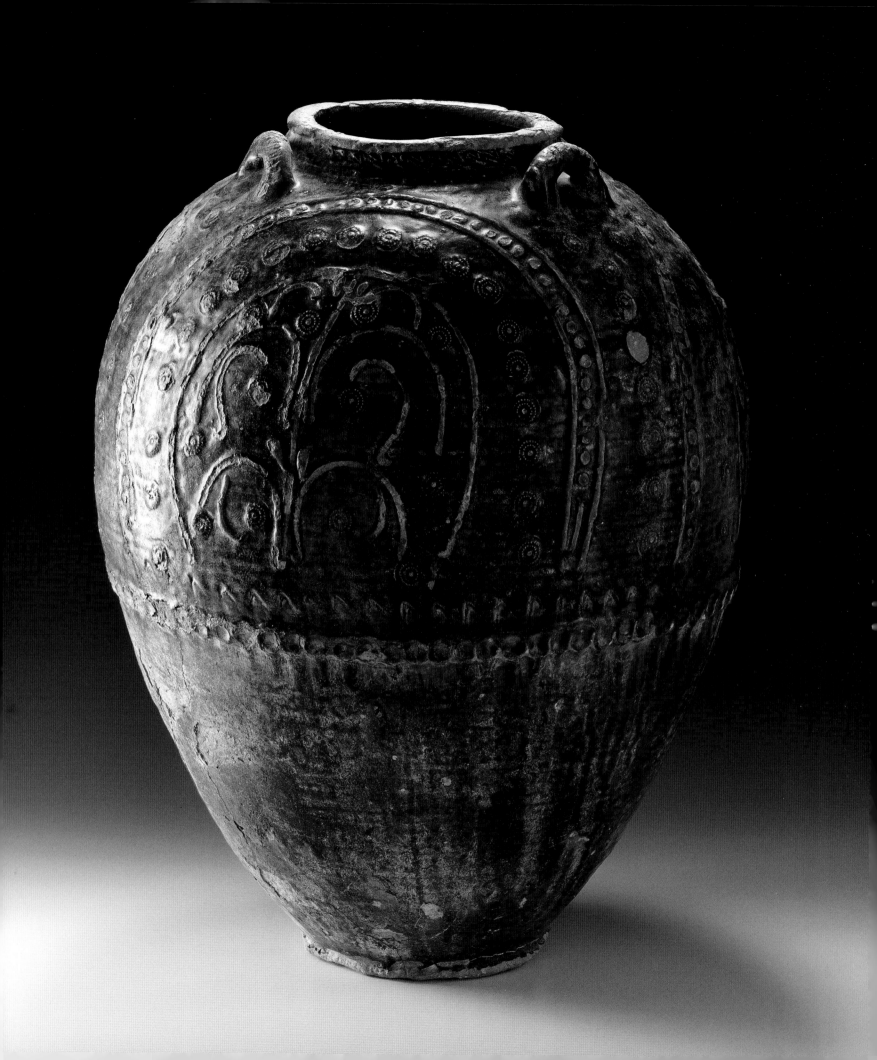

# THE DISCOVERY OF AL-RABADHA

## A CITY IN THE EARLY DAYS OF ISLAM

*Sa'd bin Abdulaziz Al-Rashid*

The site of al-Rabadha deserves our attention for a number of reasons. The site and the name al-Rabadha were widely known long before Islam. The first geographers ranked it among the most ancient villages of the *Jahiliyya*, the period before Islam.

In Islamic times al-Rabadha was considered one of the principal stages on the trade and pilgrimage road connecting Mecca and Medina to Iraq and the Muslim East.

It was known for having the best pastures for camels and horses; its fertile soil produced over fifty species of all sorts of plants and shrubs, including thorny trees, thistles and acacias, for animal fodder. Its landscape was green all year round. Already in the Prophet's day it was established as a *hima* zone, meaning a protected grazing ground for raising animals for the Muslim armies. Its state-controlled status was extended under the Caliph 'Umar (634–44). A governor was appointed to look after and preserve the *hima* and supervise the breeding of the herds and their training for military campaigns.

The importance of the site, its vast expanse and position at a crossroads brought the region prosperity under the "Rightly-Guided" caliphs, especially after the death of the Caliph 'Uthman.

The Caliph 'Ali set up a camp there for a certain time, in the year 656, regrouping his partisans and ammunition before setting off for Bassora (Basra).

The name al-Rabadha is inseparable from that of the Companion of the Prophet, Abu Dhar al-Ghifari, who settled there in the days of the Caliph 'Uthman in 651–652. He built his home and a mosque there, while going frequently to Medina at the caliph's request. When Abu Dhar died in al-Rabadha in 653, the Prophet's Companion 'Abdallah ibn Mas'ud and his retinue, who were on their way from Iraq to Mecca for the pilgrimage, undertook to bury him. Apparently the presence of Abu Dhar and other Companions drew many people to al-Rabadha, either to visit them or verify the authenticity of a *hadith* (sayings or actions of the Prophet); consequently the city had become a centre of learning.

Earthenware jar with underglaze decoration, 7th–10th century, cat. no. 247

According to several historians' chronicles we know that when Abu Dhar and his tribe, the Banu Ghifar, came to al-Rabadha it was not a coincidence. The fact of his taking up the Muslim religion shows that his tribe ruled the crossing of the trade routes to Syria. Other historical records claim that Abu Dhar, on becoming a Muslim, went to the sanctuary of Mecca and shouted his profession of faith at the top of his lungs. As a result, he was attacked and struck and al-'Abbas, the Prophet's uncle, flew to his rescue, saying to his aggressors: "Woe betide you! Do you not know that he belongs to the Ghifar tribe and is the path of your tradesmen towards Syria?", or: "Woe unto you if you kill one of the men of Ghifar when your trade caravans transit through their territory!"

These stories lead us to conclude that this Companion and his tribe were natives of the region of al-Rabadha.

The Prophet said of him: "May Allah have mercy on Abu Dhar, he walks alone, will die in loneliness and will be raised alone on the Day of Judgement". A *hadith* of the Prophet claims: "The Earth never bore nor the Heavens sheltered a man as upright and sincere as Abu Dhar".

Among the historical personalities who lived in al-Rabadha, several of whom died there, we should also name 'Utba ibn Ghazwan who marked out the city of Bassora under the Caliph 'Umar and died in al-Rabadha in 638; the Prophet's Companion Muhammad ibn Maslama ibn Khalid ibn 'Uday ibn Majda'a who lived in al-Rabadha a few years before he died in Medina 663–64; and the Companion Salama ibn al-Akwa' who married and lived there before dying in 693–94.

Many *Hadith* transmitters are associated with the city, such as Musa ibn 'Ubayda ibn Nashit and his two brothers Muhammad and 'Abdallah. Musa died and was buried there in 770. Others include Ibrahim ibn Hamza ibn Mus'ab ibn al-Zubayr ibn al-'Awam who died in 844–845, or again Yahya ibn Aktham, supreme judge (*qadi al-quda*) in the days of the Caliph al-Mutawakkil, who died in al-Rabadha in 856.

According to some sources, the celebrated grammarian Yahya ibn Ziyad, known under the name al-Farra', also died there on the way to Mecca in 822–23. His name appears on most of the inscriptions incised on the rock façade of Mount Sinam near al-Rabadha.

The Abbasid caliphs and princes liked to go to al-Rabadha to relax and reside. Al-Mansur, al-Mahdi, and Harun al-Rashid (786–809), for instance, performed works and charities on the pilgrimage route between Iraq and the holy precincts. Princes, viziers, military chiefs as well as merchants imitated them in their charitable works. The women of the Abbasid court did not wish to be outdone; first of all Zubayda, granddaughter of the Caliph al-Mansur and wife of the Caliph Harun al-Rashid who devoted huge sums to raise houses, dig wells, build basins all along the pilgrimage route. Subsequently this route was called "Darb Zubayda" (Zubayda's route). She completed these famous works by installing "Zubayda's spring" for the pilgrims and the population. Today we can still find traces of these wells with their copings and channels dug underground or built in the mountain slopes.

In light of the information provided by Muslim geographers and travellers, al-Rabadha was apparently one of the best stopping places on the pilgrimage route. Its apogee was in the early days of the Abbasid Empire when Harun al-Rashid travelled it, performing his pilgrimage nine times.

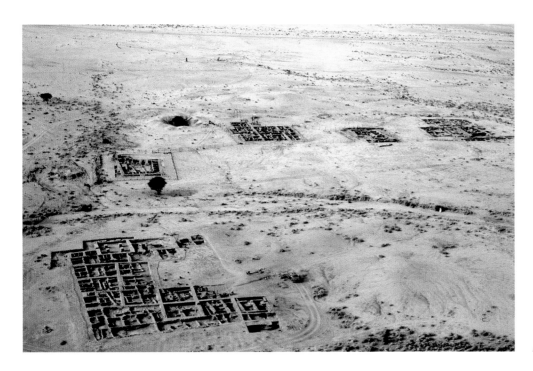

Aerial view of the site during its excavation

At the time the pilgrims' caravan from Iraq and the Muslim East could number up to twenty thousand camels, the pilgrims making their way to Mecca individually or in groups. When Harun al-Rashid went to Mecca he was escorted by his viziers, commanders of his troops, theologians, and scholars. News of the other cities reached him by messenger pigeons.

In these early days of Islam the Darb Zubayda pilgrimage route and its way-stations had a constant, heavy flow of traffic which increased during the pilgrimage. The road was a vital artery and an economic resource for the cities as well as for the villages and populations of nearby or remote hamlets. The latter came to barter with the pilgrims and merchants or sell their artisanal and agricultural produce, fodder, horses and livestock.

Al-Rabadha was one of the major stages because this protected zone, after the time of the Caliph al-Mahdi (775–785), became not only a place for pasturing the camels and horses of the Islamic State but also a grazing land open to all.

At al-Rabadha water was plentiful owing to the many wells, basins and cisterns inside the houses which the excavations brought to light.

However life in Hijaz and the centre of Arabia deteriorated because of the rebellions against the Abbasid Empire, the revolt of the religious sects against the central authority and that of several tribes which for economic and political reasons rose up in Central Arabia. These events brought about an instability that threatened the pilgrims and the population, causing the loss of livestock and the destruction of hydraulic installations.

In spite of the Abbasids' efforts to restore the authority of the state and promote stability and security in the holy precincts, the tribes' rebellions dragged on sporadically for centuries. In the early 10th century the Qarmatians almost succeeded in destroying the empire and took over extensive regions in the east and the north of the Arabian Peninsula. Their attacks against the way-stations and caravans on the pilgrimage route were directed at both men and animals and were brutal and pitiless.

The Qarmatians' influence reached its peak in 930 when they invaded Mecca, looted the Ka'ba, even removing its *kiswa* (veil) and ripping off its door. The ruin of al-Rabadha

dates to the Qarmatians who devastated and ransacked the town, forcing its population to flee. Thus ended the story, after three centuries of prosperity, of one of the most famous Muslim cities on the pilgrimage road. The geographer al-Muqaddasi, years after its destruction, was appalled to discover there nothing but "brackish water and a place of desolation".

Then the pilgrimage road deviated from al-Rabadha. Historians and geographers no longer mentioned it, as if leaving the task to archaeologists to discover its secrets, traces of its constructions and testimonies of its urbanization. This is why for centuries and up to very recently al-Rabadha was known (only by name) and ignored.

The traveller and geographer Muhammad ibn 'Abdallah ibn Bulayhid (d. 1975) was the first who sought to draw attention to it and circumscribe its location, but in vain. This failure profoundly discouraged scholars. It was only when the author of this essay undertook his doctoral thesis on the vestiges of Darb Zubayda that interest in the geographic situation of al-Rabadha was revived. Through examination of the historical, geographic and literary sources related to this route, valuable information was obtained, that proved very helpful on the first visit to the site, during which the trajectories and cross roads were followed over a distance of more than 1,400 kilometres. This inspection took from May 14 to June 11, 1973.

The data assembled concurred with that of the shaykh Hamad al-Jasir who published an essay in the review *al-'Arab* titled: "Al-Rabadha: the location of the site". A certain number of Saudi lexicologists also published useful information on the city in the wake of Shaykh al-Jasir, Muhammad ibn Nasir al-'Abudi, Sa'd ibn Junaydil and 'Atiq al-Biladi. Al-Jasir thus concluded: "In my opinion the site of al-Rabadha [he meant the city and not the protected zone] was located between the Abu Salim basin and the al-Nafazi well; I do not exclude the fact that this well may be one of the many al-Rabadha wells; it could be the one known in the past under the name Abu Dhar al-Ghifari well and which in the course of time was distorted". A scientific survey was performed on a section of the Darb Zubayda. It includes archaeological sites in the perimeter where the Abu Salim basin is situated, appearing under this name on the geographic maps of the kingdom of Saudi Arabia; similarly the natural sites and the extent of the plant covering were circumscribed. This is why the author of this essay was convinced that al-Rabadha was situated in the area containing the basin and the nearby existing archaeological vestiges.

The investigation clearly revealed that it was east of Medina, at almost 200 kilometres, at the foot of the western mountains of Hijaz.

Preliminary prospecting of the site allowed the team to prepare the excavation of this city while students of the archaeology and museology department were trained under the guidance of specialists.

The first excavation campaign took place in May 1979.

These were the grounds for selecting the localization of the site of al-Rabadha to start the excavation:

1. The connection of the place with the rise of Islam and the Prophet's Companions.

2. The pastoral character of the surrounding region and its bonds with the nascent Islamic state.

3. The gradual development of al-Rabadha, which began in the early days of Islam and continued under the Umayyad dynasty until the first Abbasid period, followed by its destruction and then its disappearance.

4. The historical and geographic sources led to the conclusion that the archaeological site could offer us useful information about the Islamic civilization; on the one hand, the urban layout and the architectural piles including houses, numerous industries such as pottery,

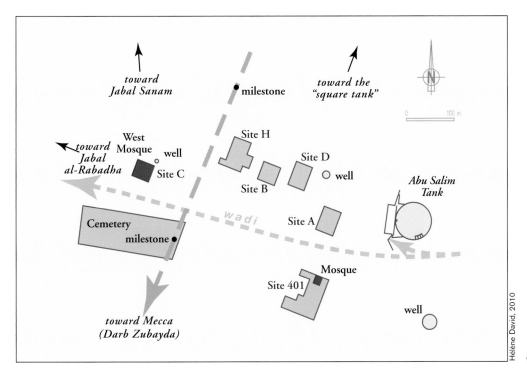

*toward*
*Jabal Sanam*

• milestone

*toward the*
*"square tank"*

N

0          100 m

West
Mosque     well

*toward*
*Jabal*
*al-Rabadha*

Site C

Site H

Site B

Site D

○ well

*Abu Salim*
*Tank*

Cemetery
milestone •

w a d i

Site A

Mosque

Site 401

*toward Mecca*
*(Darb Zubayda)*

well

Hélène David, 2010

General layout of the site

ceramic, stone and glass items, and on the other hand, metal utensils, jewellery, inscriptions, coins and other items produced locally or conveyed from the close or distant capitals of the Islamic Empire.

5. We also hoped that the results of the archaeological discoveries would provide us with coherent proof which might correct the numerous data on early Islamic architecture as well as on the many forms of craftsmanship or ancient scripts, which the rapid changes affecting the first Islamic capitals such as Bassora, Kufa, Baghdad and Samarra or even al-Hira (which belonged to the Pre-Islamic period) did not permit us to establish.

6. The archaeological excavations on Islamic sites in Iraq and Syria and resulting interpretations confronted us with many issues concerning the sources of knowledge and characteristics of the Islamic civilization.

Fortunately the results of the excavations at al-Rabadha were conclusive. In the twenty-five campaigns between 1979 and 2003 we were able to gather very significant information about the urbanism of the city, architectural elements, items in ceramic, glass, stone and metal, coins, scripts, jewellery and decorative elements.

The population of the city appears to have settled in a rectangular area going from east to west. There are no visible ruins of the city, save several archaeological mounds of which the layout is not clearly defined. One of the site's most visible vestiges is one of the Darb Zubayda tanks: a circular tank, 65 metres in diameter, 4.70 metres deep, equipped with a rectangular sedimentation basin measuring 55 x 17 metres and 3.15 metres deep. We were also able to delimit the cemetery of the old city in the south-west part. Its extension indicates that the city was quite vast and densely populated. During the first campaign the excavation brought to light three sites which we named A, B and C, to which we added two others, D and E. Last, we identified a rather large archaeological mound which we named "401". During the excavation we unearthed several architectural works comprising mosques, houses, palaces surrounded by enclosures and thick walls consolidated by circular

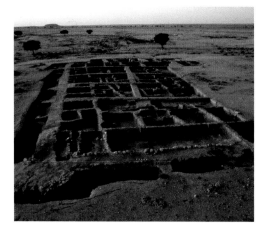

View of site 401

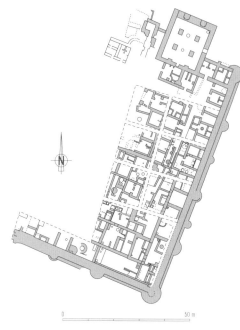

Plan of site 401

and semi-circular towers, hydraulic works dug out and built under the floors of the rooms, household ovens, as well as pottery kilns and a glass workshop, warehouses for storing grain, and draining channels.

During the excavations we were able to form a very clear idea of the urban fabric of al-Rabadha and its architectural features as well as the materials utilized in its construction.

We shall present the most important architectural discoveries, the interior organization and various archaeological finds.

## Palaces and houses

These have a specific architectural style: their shape is quadrangular and orthogonal and the foundations of the walls made of rough odd stones; sometimes the foundations rise to a little under one metre above the ground; the stone walls vary in thickness depending on the volume of the building and nature of the walls (whether exterior or interior). The walls supporting the ceilings are all made of mud brick; the masons took care to consolidate the enclosures and outer walls by adding circular and semi-circular towers near the entrances and far corners of each edifice, as well as along each wall. We noted the presence of tree trunks placed along the width of several enclosures and walls, especially those coinciding with the entrances. These wooden frames were apparently put there to avoid cracks in the walls in case of dilatation and to protect against the earthquakes which have shaken the Hijaz region, the north-west of the Arabian Peninsula and Syria since Antiquity.

The inside rooms were built as separate units connected by an inner courtyard. Within we found facilities such as kitchen ovens, water reservoirs, warehouses for storing grain and other items. The dimensions of the rooms, irrespective of whether they were in palaces or houses, were approximately 2.30 x 2.30 metres.

The interior walls were faced with a light coat of plaster; several architectural motifs and coloured drawings were found. Among the most important discoveries we should mention a painted plaster panel adorned with script, partly reproducing the *basmala* (opening verse of the Sura) and the beginning of the Throne Verse (cat. no. 246).

This opulence is reminiscent of the living units of the early Islamic period in Syria and Iraq. We were able to distinguish a certain number of castles, including edifice A, east of al-Rabadha. It had a gate looking north and was protected by a tower at the north-east corner; hexagonal, it appears to have had two storeys connected by a winding staircase. Edifice B appears to be an architectural pile formed of two overlapping quadrilaterals. The walls of the building consist of seven sides supported by seven corner towers; the edifice also contains various facilities. The two buildings D and E, by their architectural types, underscore the commercial mentality of the inhabitants of al-Rabadha. The first (D) can possibly be interpreted as the city market, because its architectural fabric comprises about ten water reservoirs, one next to another, ovens for cooking food, warehouses for storing grain and places for smelting certain types of minerals. Fragmentary objects were found as well: flasks, tubes and crucibles bearing traces of smelting. The other architectural pile (E) was interpreted as a house, quadrangular, sustained by four corner towers and connected to other architectural units extending towards the north, south and west.

The excavation brought to light extensions around the two buildings connected with the buildings and consisting of housing units and their annexes. Site 401 is the largest housing unit; it belonged to one of the southern quarters of al-Rabadha, separated from the city

by a tributary of the al-Rabadha River and flowing east to west. This part formed an extensive and complete ensemble.

It was erected inside a huge quadrangular enclosure measuring about 69 x 75 metres. The enclosure was supported by circular corner towers and semi-circular towers along the sides. The diameter of some towers attained 4.50 metres. The principal gate of the housing complex was at the middle of the north side and gave onto a central square. The rooms were units facing one another on the east and west sides, with some units back to back. The rooms measured 3 x 3 metres and their number varied from one unit to another. These units were separated by corridors, alleys and small courtyards for everyday uses and crafts. The floors were dug out to form hollows for burying waste and were then paved anew.

According to its urban fabric, this large housing unit appears to have had complete facilities, as evidenced by the cisterns, kitchen ovens and craft kilns, the presence of a well at the far south-west end of the enclosure and a mosque on the south side of the complex.

## The al-Rabadha mosques

The excavation campaigns unearthed two principal mosques.

### *The Great Mosque*

This mosque was discovered west of al-Rabadha. It is probably the mosque of Abu Dhar al-Ghifari which he himself had had built when he arrived in al-Rabadha, and which sources already mentioned, insisting on its sophisticated architecture. Its overall surface was 22.75 x 20.15 metres; it featured a prayer hall with two longitudinal naves parallel to the *qibla* wall (indicating the direction of Mecca for prayer) on the south side, with the *mihrab* (recess in the wall signalling the *qibla* wall) forming a semi-circular projection. The hall gave onto an open central courtyard 16 x 9 metres, edged by three porticoes. To the left of the *mihrab* is a structure perpendicular to the *qibla* wall, measuring 0.70 x 1.80 metres, which might be the base of a *minbar*, or the pulpit for the preacher. Twenty-one bases of stone columns supporting the ceiling of the mosque were found. The entire mosque was built of stone, and the walls faced with a coat of plaster. No trace of raw or fired bricks was found. The ground was covered with gravel, probably renewed from time to time. The overall surface of the mosque was approximately 459 square metres, while the interior surface was 380 square metres, large enough to contain about six hundred worshippers. We were not able to locate the position of the minaret and assume it was placed lower down, between the mosque and the well, and was destroyed.

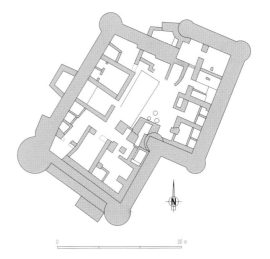

Plan of site B

This mosque is remarkable because it was built at quite a distance from the residential area, near one of the main wells of al-Rabadha which can still be seen today.

From the time it was built, the al-Rabadha mosque served as a gathering place for scholars, commentators of the *Hadith*, from different places who met there because of its strategic position on the pilgrimage route.

In a biography of Muhammad ibn Ka'b ibn al-Qarzi al-Madani (d. 735), a great master of Quranic exegesis, we notice the following: "Muhammad ibn Ka'b was surrounded by great experts of the Quranic exegesis who assembled in the al-Rabadha mosque; one day an earthquake took them by surprise, the mosque collapsed on them and they were all killed". This information, among other testimonies, enables us to define with accuracy the stages of the history of al-Rabadha and date its mosque to the early days of Islam.

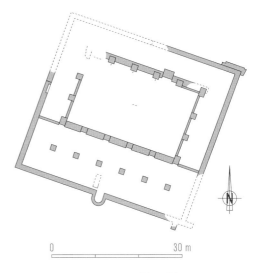

Plan of the western mosque

### The residential area mosque

Discovered in the residential area (401), this mosque differs from the preceding one by its architectural layout. Its surface is 12.30 x 10.30 metres; it has a square *mihrab* hollowed out of a cavity. In spite of its small size the mosque is remarkable for the thickness of its walls: it has four massive square pillars which once supported the ceiling. Judging by the ruins that were found, the walls of the mosque seem to have been covered with a layer of painted plaster. The mosque had four small doors; level with the west door there is an architectural pile that may have been the base of the minaret.

Given the urban layout of this housing area this mosque was probably used exclusively by the population of al-Rabadha and visitors. Given the density and variety of the habitation units we assume there were other mosques that disappeared and of which no trace has been found.

### Hydraulic structures

The city counted on rainwater and streams; the wells, over a dozen of them, were dug inside the urban perimeter. The inhabitants also took advantage of two tanks close to the city on the Darb Zubayda pilgrimage route, of those placed higher up, of wells dug in the perimeter of al-Rabadha, as well as of springs and water retained in rock crevices. However, in the housing units of al-Rabadha the most striking feature is the presence of water cisterns dug out under the floors of the rooms and inner courtyards. They all had the same architectural design: dug out of the ground, they were 2 metres deep and approximately the same length; their sides were built of stone and covered with a thick layer of plaster. They were hermetically closed with rectangular slabs of stone. Each reservoir had an opening at the top with a stone coping and lid. There were two ways to fill these cisterns: either by the ceramic canalizations used to store the rainwater which flowed into the reservoirs from the roofs (some were fitted with filters), or by direct transport of water from the tanks and wells to the cisterns when it was needed or outside the rainy season. The conception of the reservoirs guaranteed the city's water supply and is evidence of the early Muslim architects' expertise. This highly developed technique for storing water is explained by the great number of pilgrims' caravans which could include between fifteen and twenty thousand camels.

Aerial view of water tanks

### Archaeological material and other discoveries

During the excavations many items were unearthed in the area within the al-Rabadha perimeter. Countless inscribed objects and stone inscriptions are proof of the settlement process in al-Rabadha. Some were found on Mount Sinam, an important site north of al-Rabadha mentioned at the beginning of this essay when we spoke of al-Farra' who died at al-Rabadha. Rock inscriptions were found on the outcrops west of the residential area as well: prayers invoking forgiveness and mercy for the persons whose names are inscribed in these sculptures: "'Abdallah ibn Khabab, Karim ibn Hattab".

Inscriptions on the rock façade south of al-Rabadha were also found citing the name "Durayd ibn 'Abd Rabbihi", as well as inscriptions on the rock reliefs on the edge of the residential area, on the north-west side. The names Sa'd ibn Zayd, Habab ibn Zayd, Muhammad ibn Nafi' can be seen there alongside others.

Inscriptions, usually illegible, on the plaster facing of some walls and tombstones complete the epigraphic material discovered at al-Rabadha. Among them, two tombstones dedicated to a woman named "Umm 'Asim daughter of 'Abdallah". This 'Asim might be the son of the Caliph 'Umar, who died in al-Rabadha in 689–690.

Inscribed bones (*ostraca*) were also unearthed: these are commercial receipts featuring names of weights and measures (cat. no. 274). Fragments of inscribed pottery going back to the Abbasid period (cat. no. 252) were also found.

The archaeological finds were plentiful and varied: coins, common or glazed pottery, metal and stone items, wood and bone articles, glass containers, jewellery.

These finds provided information about the material culture during the three or more centuries when the city was inhabited. Some pieces were manufactured on the spot; the coins are unquestionable proof of the city's great wealth: gold dinars and copper dirhams on which were incised the names of the caliphs, the viziers and the cities of the empire where coins were minted, such as Mecca, Kufa, Baghdad, Balkh, Kirman and Nishapur. These coins date to several periods: the Umayyad era and the Abbasid golden age. The caliphs' names appearing on the coin or of which the date of striking might coincide with the periods of their reign are al-Walid ibn 'Abd al-Malik (705–715), Abu Ja'far al-Mansur (754–775), Harun al-Rashid (786–809) and al-Mu'tadid bi-llah (892–902), among others.

Dirham (silver coins) found at al-Rabadha

## Conclusion

In light of what precedes, we can state that al-Rabadha was one of the great Islamic cities in the heart of the Arabian Peninsula.

It was an important economic and cultural centre and a main stopping place on the pilgrimage route before being destroyed and deserted after 932. A period of sedition and insecurity began which coincided with the beginning of the Arab tribes' emigration from the peninsula.

Subsequently other routes than Darb Zubayda were followed, diverting the pilgrims from al-Rabadha. However the basins and wells continued to be used by the neighbouring populations.

Thus, generally speaking, the information yielded by the al-Rabadha site enlightened us on the nature of the civilization in the peninsula in the early days of Islam.

**Bibliography:**
Ibn Khurradadhbih; Ibn Rustah; Al-Jasir 1386 H./1967;
Al-Muqaddasi; Al-Rashid 1406 H./1986;
Al-Rashid 1414 H./1993; Al-Tabari.

## AL-RABADHA

All of the objects from the excavations at al-Rabadha presented here date from the early Islamic period, between the 7th and 10th centuries. Except for certain known types, more precise dating is difficult due to the lack of a well-established stratigraphy. These finds show similarities to artefacts from other major Middle Eastern sites that have served as references for characterizing the material productions of this first Islamic age, in particular Samarra, Suse and Siraf.[1] The pieces unearthed at al-Rabadha attest to the widespread presence in the Arabian Peninsula of certain types of products from Iraq, brought there by merchants and pilgrims. This is the case of the ceramics with glazed decoration. Large jars with turquoise blue glaze (cat. no. 247) were produced from the 7th century (or earlier) to the 10th century and exported with their contents throughout the Middle East and as far as India and Southeast Asia, as well as in-glazed painted vessels decorated in cobalt blue or copper green (cat. nos 252 to 254), monochrome and polychrome lustre decorations (cat. nos 248 to 251), or delicately moulded decorations under a green glaze of Chinese influence (cat. no. 256). Their presence in Samarra (imperial capital from 836 to 883) dates them from the 9th century. In terms of form and decoration, the glass objects (cat. no. 260 to 268) are also comparable to those from the above-mentioned sites (to which must be added Fustat, Nishapur and many other sites throughout the area from the Near East to Iran). However, the remains of glass kilns found in Area A at al-Rabadha indicate local production, possibly by glassmakers from Iraq. Similarly, the city might have had a small metallurgical industry, supplied by nearby mines. The rather simple metal objects (cat. nos 269 to 272) shown here can be compared to those discovered at Umm al-Walid in Jordan, datable to the 8th century. A small carved wood panel (cat. no. 275) finely decorated with a foliage scroll with small round leaves has parallels with wood and ivory pieces from the Umayyad period. The vestiges of painted decorations discovered at al-Rabadha are quite exceptional, comparable only to certain fragments with geometric motifs found at the Dar al-Khilafa Palace in Samarra. Presumably, figurative decorations were absent at al-Rabadha, unlike the Samarra site, whose royal context was much different.

The objects found here, associated with local activity and the flow of pilgrims in a place far from the centres of power, include nothing luxurious. Instead, they reflect the occupations of everyday life at this stopover on the Iraqi route, including cookware and tableware, storage vessels, personal care effects, instruments for preparing or measuring, various tools and written documents related to economic activity. Lastly, as at many other sites of the Near and Middle East, a number of soft stone lamps and incense burners have been brought to light. These are often attributed to Yemen but seem also to have been produced in other locations in the Arabian Peninsula.[2]

C. J.

1. For a report on the question of glazed pottery in the Abbasid era, see Northedge 1997, pp. 213–223.
2. In particular in the region of al-Hawra' and Ta'if, see Whitcomb 1998, p. 407, 409; Kisnawi 1982, p. 74.

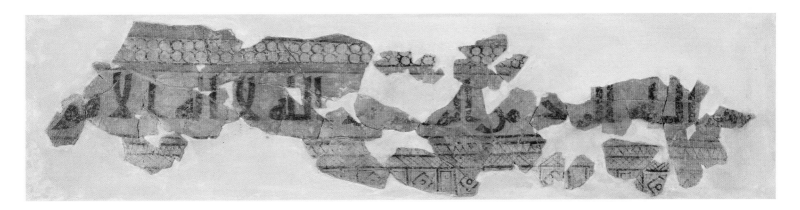

**246. Wall decoration fragment**
9th century?
Painted plaster
48 x 185 cm
Al-Rabadha
National Museum, Riyadh, 2399

Bibliography: unpublished.

Consisting of a thick layer of plaster painted in black, red and ochre yellow, it illustrates the type of wall decoration that adorned the interiors of certain civil or religious buildings in al-Rabadha. In this case, it is a frieze with an inscription in "Kufic" (angular) script between horizontal bands of chain and rope motifs that originally topped a register with a geometric pattern, a vertical arrangement of diamond shapes. The inscription is religious in nature: the *basmala* followed by the *shahada*. Its simple, clear graphic style, with straight vertical strokes, and the shape of the letters point to the early Abbasid period.

C. J.

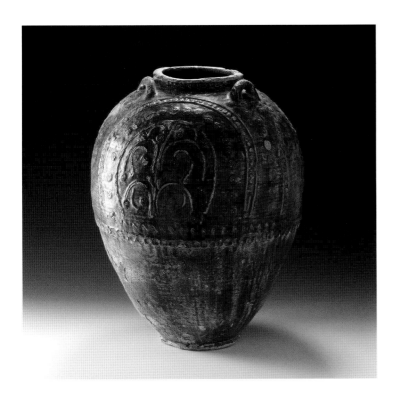

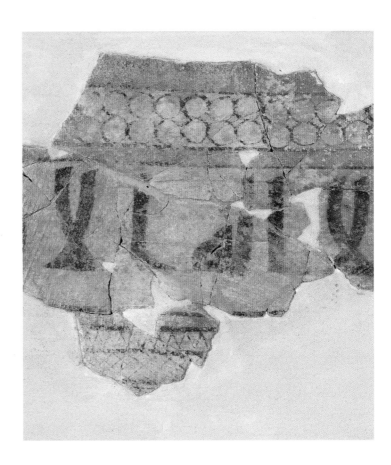

**247. Large jar**
7th–10th century
Earthenware, incised, stamped with applied decoration under the glaze
H. 66 cm; Diam. about 45 cm
Al-Rabadha
Department of Archaeology Museum, King Saud University, Riyadh

Bibliography: Al-Rashid 1986, fig. 99 and 100, p. 58.

**248. Bowl with polylobed rim**
9th century
Earthenware, painted in polychrome lustre on opaque glaze
H. 4.3 cm; Diam. 14 cm
Al-Rabadha
National Museum, Riyadh, 2294

Bibliography: unpublished.

**249. Bowl with hare design**
Late 9th–10th century
Earthenware, painted in monochrome lustre on opaque glaze
H. 4 cm; Diam. 12 cm
Al-Rabadha
Department of Archaeology Museum, King Saud University, Riyadh, R 8–123

Bibliography: unpublished.

**250. Bowl fragment**
9th century
Earthenware, painted in polychrome lustre on opaque glaze
L. 17 cm; W. 10.5 cm
Al-Rabadha
Department of Archaeology Museum, King Saud University, Riyadh, R 6–18

Bibliography: unpublished.

**251. Miniature vessel**
Late 9th–10th century
Earthenware, painted in monochrome lustre on opaque glaze
H. 1.4 cm; L: 6.3 cm; W. 4.2 cm
Al-Rabadha
Department of Archaeology Museum, King Saud University, Riyadh, R 3–55

Bibliography: Al-Rashid 1986, fig. 96, p. 58.

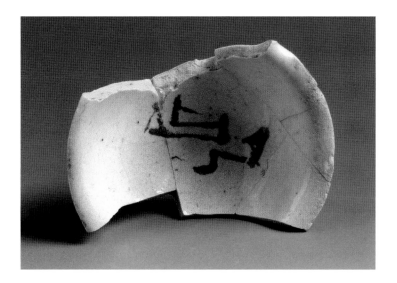

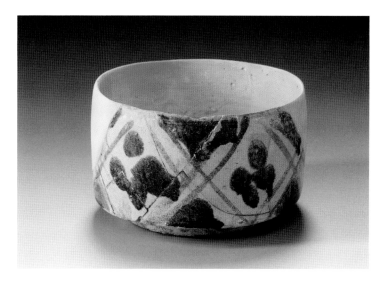

**252. Bowl with inscription**
9th century
Earthenware, painted in cobalt blue on opaque glaze
H. 3.1 cm; Diam. 8.5 cm
Inscription: *baraka* ("blessing")
Al-Rabadha
National Museum, Riyadh, 2330

Bibliography: Al-Rashid 1986, fig. 102, p. 59.

**253. Cup with cloisonné decoration**
9th century
Earthenware with painted decoration and glazed highlights
H. 7 cm; Diam. 8 cm
Al-Rabadha
National Museum, Riyadh, 349

Bibliography: unpublished.

**254. Cup**
9th century
Earthenware in-glaze green splashes
H. 13.8 cm; Max. diam. 16.7 cm
Al-Rabadha
National Museum, Riyadh, 2317

Bibliography: unpublished.

**255. Vase**
7th–9th century
Glazed earthenware
Al-Rabadha
H. 11.5 cm; Max. diam. 10 cm
Department of Archaeology Museum, King Saud University, Riyadh, R 25–1

Bibliography: unpublished.

**256. Small dish fragment**
9th century
Earthenware, moulded decoration underglaze
H. 2.9 cm; L. 6 cm
Al-Rabadha
Department of Archaeology Museum, King Saud University, Riyadh, 37R6

Bibliography: Al-Rashid 1986, fig. 89, p. 57.

**257. Small jar with three handles**
7th–10th century
Earthenware, incised decoration
H. 17.4 cm; Max. diam. 18.5 cm
Al-Rabadha
Department of Archaeology Museum, King Saud University, Riyadh, R 16–9

Bibliography: unpublished.

**258. Incense burner**
7th–10th century
Carved soapstone
H. 5.6 cm; L. 23 cm
Al-Rabadha
Department of Archaeology Museum, King Saud University, Riyadh, R 8–102

Bibliography: unpublished.

**259. Dish**
7th–10th century
Carved soapstone, engraved decoration
Diam. 16 cm
Al-Rabadha
Department of Archaeology Museum, King Saud University, Riyadh, R 8–103

Bibliography: unpublished.

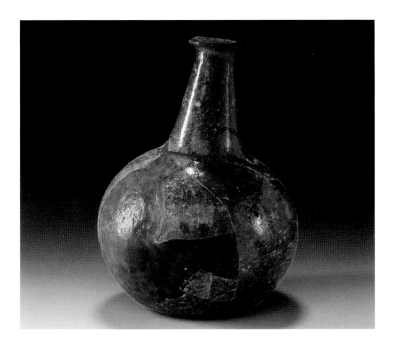

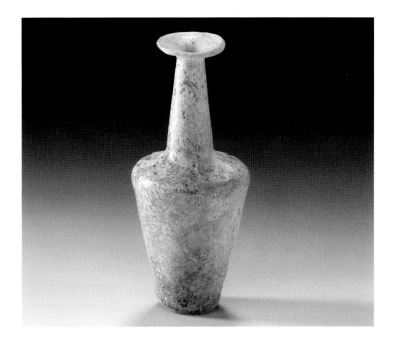

**260. Bottle**
8th–10th century
Free-blown glass
H. 22 cm
Al-Rabadha
Department of Archaeology Museum, King Saud University, Riyadh, R 7–96

Bibliography: unpublished.

**261. Bottle**
9th–10th century
Free-blown glass
H. 13 cm; Diam. (base) 3 cm
Al-Rabadha
Department of Archaeology Museum, King Saud University, Riyadh, R 4–102

Bibliography: Al-Rashid 1986, fig. 150, p. 75.

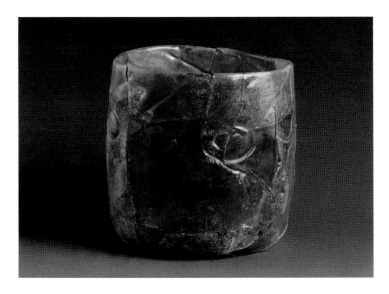

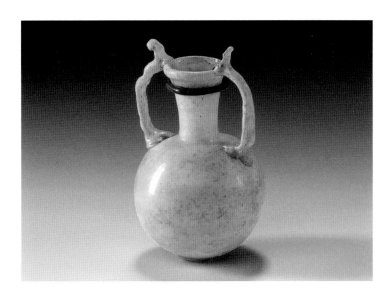

**262. Cup**
9th–10th century
Free-blown glass, decoration stamped with pincers
H. 8.5 cm; Diam. 8 cm
Al-Rabadha
National Museum, Riyadh, 2289

Bibliography: Al-Rashid 1986, fig. 143, p. 73.

**263. Flask**
8th–10th century
Free-blown glass, appliqué decoration and handles
H. 9.2 cm; Diam. 5.7 cm
Al-Rabadha
Department of Archaeology Museum, King Saud University, Riyadh, R 14–37

Bibliography: unpublished.

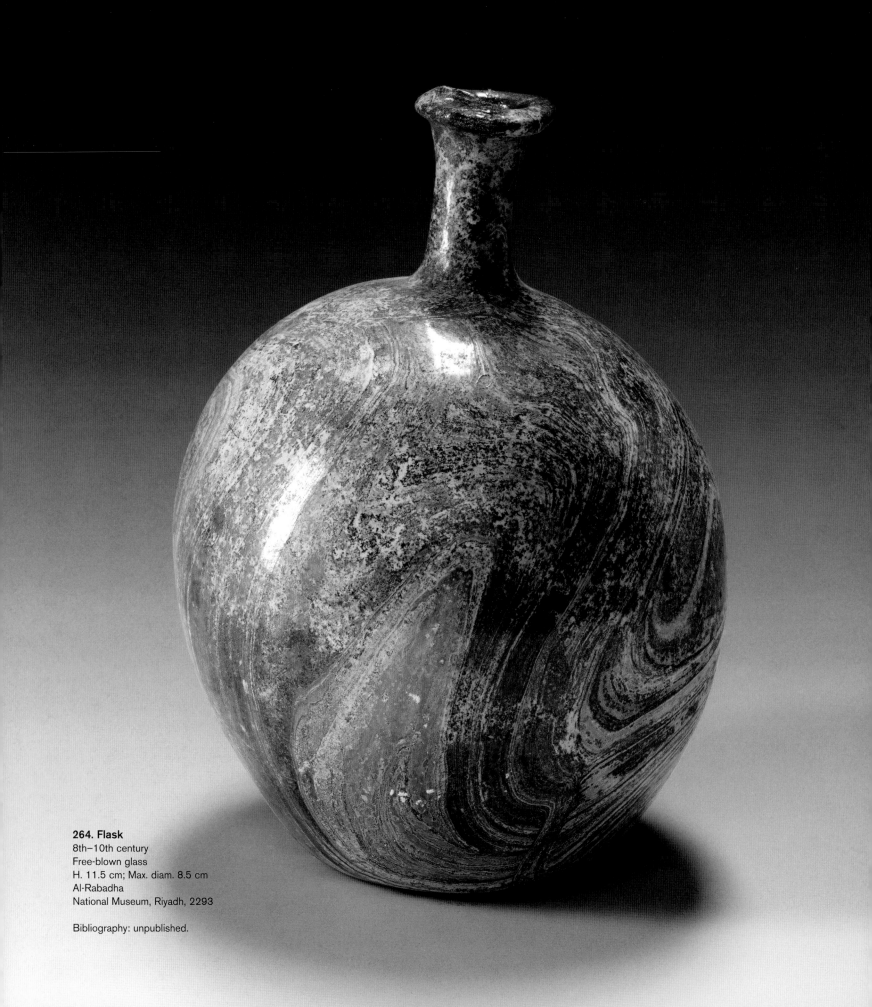

**264. Flask**
8th–10th century
Free-blown glass
H. 11.5 cm; Max. diam. 8.5 cm
Al-Rabadha
National Museum, Riyadh, 2293

Bibliography: unpublished.

**265. Flask**
8th–10th century
Free-blown glass
H. 6.5 cm
Al-Rabadha
Department of Archaeology Museum, King Saud
University, Riyadh, R 14–2

Bibliography: unpublished.

**266. Flask**
7th–10th century
Glass blown in a mould
H. 8 cm; Diam. 5 cm
Al-Rabadha
Department of Archaeology Museum, King Saud
University, Riyadh, R 18–11

Bibliography: unpublished.

**267. "Molar" flask**
9th–10th century
Glass blown in a mould
H. 6 cm
Al-Rabadha
Department of Archaeology Museum, King Saud
University, Riyadh, R 100–6

Bibliography: Al-Rashid 1986, fig. 136, p. 71.

**268. Pharmaceutical vessel**
7th–10th century
Free-blown glass
H. 5 cm; Diam. (rim) 4.5 cm
Al-Rabadha
Department of Archaeology Museum, King Saud
University, Riyadh, R 19–21

Bibliography: unpublished.

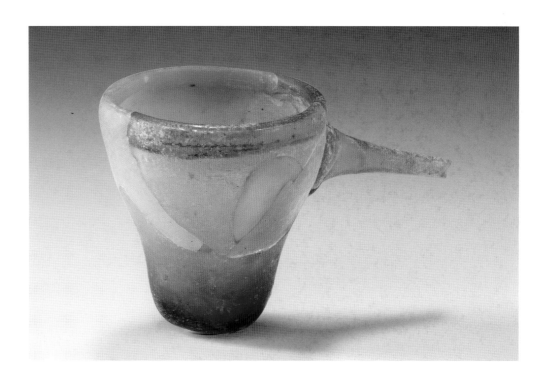

**269. Spouted vessel**
8th–10th century
Cast copper alloy
L. 11 cm
Al-Rabadha
National Museum, Riyadh, 2363

Bibliography: Al-Rashid 1986, fig. 124, p. 68.

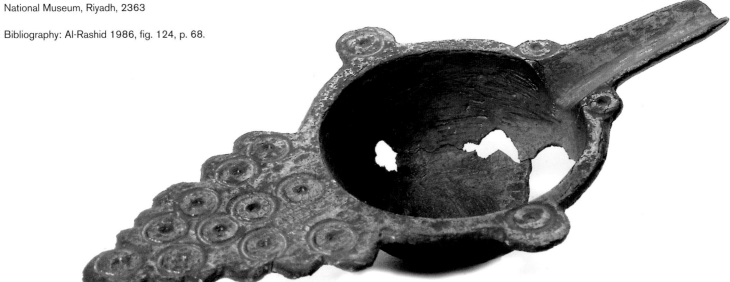

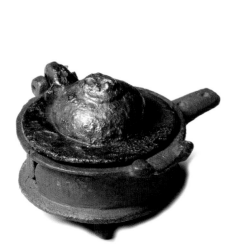

**270. Incense burner**
8th–10th century
Cast copper alloy
3 x 5.7 cm
Al-Rabadha
Department of Archaeology Museum, King Saud
University, Riyadh, R 5–132

Bibliography: unpublished.

**271. Cup**
8th–10th century
Cast copper alloy
H. 9 cm; Diam 11 cm
Al-Rabadha
Department of Archaeology Museum, King Saud
University, Riyadh, unnumbered

Bibliography: unpublished.

**272. Bottle and stirrer**
8th–10th century
Cast copper alloy
H. 2.8 cm; Diam. 3.3 cm; Stirrer L. 6 cm
Al-Rabadha
Department of Archaeology Museum, King Saud
University, Riyadh, R 5–132 and R 5–162

Bibliography: Al-Rashid 1986, fig. 127, p. 68.

### 273. Scales box
8th–10th century
Carved wood
L. 16.4 cm; W. 7.8 cm
Al-Rabadha
Department of Archaeology Museum, King Saud
University, Riyadh, R 7–116

Bibliography: unpublished.

### 274. Ostracon
8th–10th century
Bone, brown ink
H. about 30 cm
Al-Rabadha
Department of Archaeology Museum, King Saud
University, Riyadh, 5–R1

Bibliography: Al-Rashid 1986, fig. 177, p. 89.

The inscription, in common script, is a list of
quantities and measurements (*himl, makuk, mudd*)
possibly concerning grain.

### 275. Small panel (veneer)
8th–9th century
Carved wood
L. 22 cm; W. 4.6 cm; Th. 0.5 cm
Al-Rabadha
Department of Archaeology Museum, King Saud
University, Riyadh, R 2–429

Bibliography: Al-Rashid 1986, fig. 163, p. 82.

### 276. Figurine (doll's head?)
8th–9th century
Carved bone, painted decoration
H. 5.3 cm
Al-Rabadha
Department of Archaeology Museum, King Saud
University, Riyadh, R 6–64

Bibliography: Al-Rashid 1986, fig. 167, p. 82.

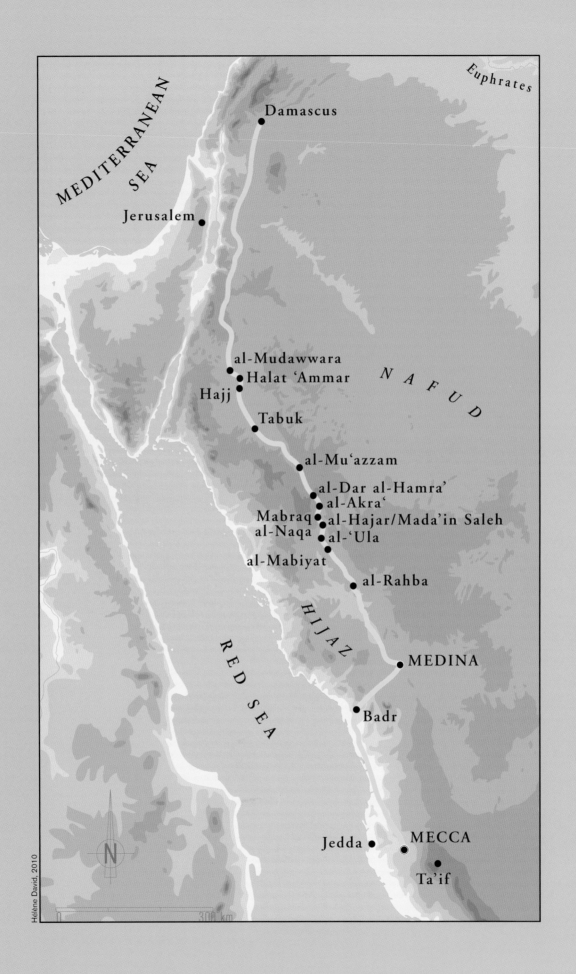

MEDITERRANEAN SEA

Euphrates

Damascus

Jerusalem

al-Mudawwara

Halat ‘Ammar

Hajj

N A F U D

Tabuk

al-Mu‘azzam

al-Dar al-Hamra’

al-Akra‘

Mabraq

al-Hajar/Mada’in Saleh

al-Naqa

al-‘Ula

al-Mabiyat

al-Rahba

HIJAZ

RED SEA

MEDINA

Badr

Jedda

MECCA

Ta’if

N

Hélène David, 2010

0                300 km

# THE PILGRIMAGE ROAD
# FROM SYRIA

*Hayat bint 'Abdullah al-Kilabi*

The Syrian pilgrimage road benefited from the attention paid to it by Muslim rulers over the centuries. The facilities it offered were developed according to the whims of dynasties and the economic and social events that marked the region. The history of the Syrian pilgrimage road can be divided into four periods.

Map of the Syrian pilgrimage road

## The Syrian road through history
### 1. The early years of Islam
This first period covers the reign of the "Rightly Guided" caliphs, the Umayyad era and the Abbasid and Fatimid dynasties. At the start, during the reign of Abu Bakr (632–34), the Muslim army took the road from Damascus, also called the Tabuk road, in the direction of Bilad al-Sham (Syria), passing through Dhu'l-Marwa and Wadi al-Qura. Caliph 'Umar, who very much wanted to take possession of Bilad al-Sham, also took the Tabuk road in the year 638 and reached Sargh, today known as al-Mudawwara, to the north of Tabuk, but on his arrival his army chiefs informed him that Bilad al-Sham was being ravaged by the plague and instructed him to turn back.

The first amenities were constructed beside the Damascus road when Caliph 'Umar ordered a spring to be built in Tabuk to protect against the build up of sand. The road then began to be used by Damascene caravans heading to Arabia on pilgrimage.

Some sources name the staging posts and rest houses along the Damascus road at the beginning of the events under caliphs 'Uthman and 'Ali. The following names are given: Dhu'l-Marwa, Dhu Khashab, Wadi al-Qura, Suqiya and Tabuk.

It was under the Umayyads that the road enjoyed its golden age, when it became the route that joined the new capital of the Islamic state – Damascus – to the two holy cities of Mecca and Medina. Mu'awiya ibn Abi Sufyan, the founder of the dynasty, took the road three times for his own pilgrimages.

Once the situation of the Umayyad dynasty had stabilized, the caliphs took an increasing interest in the Syrian route. Al-Walid ibn 'Abd al-Malik ordered the governor of the city, 'Umar ibn 'Abdulaziz, to improve the road's condition and dig a number of wells. The governor also constructed a series of mosques along the route in the places where the Prophet had prayed during his expedition to Tabuk, the most important being Tabuk mosque itself. Al-Tabari states that on account of these works and the milestones al-Walid had installed, the inhabitants of Syria considered him the best of the caliphs. Ibn al-Faqih al-Hamadhani adds that 'Abd al-Malik was the first to install water points on the Mecca–Damascus road. Later, according to al-Mas'udi, Caliph Hisham ibn 'Abd al-Malik had canals and cisterns built.

Following the fall of the Umayyad dynasty, the caliphate was transferred from Damascus to Baghdad under the Abbasids. The major concern of the first Abbasid caliphs was to improve the roads that linked Mecca and Medina to the main Iraqi cities of Kufa, Basra and Baghdad. The sources provide little information on the Abbasid constructions on the Syrian pilgrimage route, and simply allude to the thriving nature of the way stations along the route that had developed into well-populated cities. These were described by the first Muslim geographers: the *Kitab al-masalik wa'l-mamalik* by Ibn Khurradadhbih, the *Kitab al-manasik* by al-Harbi and the *Kitab al-buldan* by al-Ya'qubi were the first to describe the way stations in the 9th century. More accounts are given at the end of the 9th and at the start of the 10th centuries, such as in the *Kitab al-a'laq al-nafisa* by the Persian geographer Ibn Rustah, the *Kitab al-khiraj* by Ibn Qudama and the *Sifat Jazirat al-'arab* by al-Hamdani.

As the power and influence of the Fatimids increased, the dynasty emulated the Abbasids who were reigning in Iraq, in particular in relation to how the two holy cities were run and the state of the routes that converged on them. In the year 969 and the following year, sermons were delivered in the name of the Fatimid caliph al-Mu'izz li-din Allah, first in Mecca, then in Medina. But the tensions that permanently disrupted the situation in the Hijaz obliged the Fatimids to turn to force to impose their power and extend their influence as far as Bilad al-Sham. In 988–89 the Fatimids had to deal with the insurrection instigated by Hazim ibn Abi Hazim al-Ta'i, the governor of Wadi al-Qura, who controlled more than half the Damascus road. The Fatimid army hurried to the town and crushed the revolt. Then, hungry for more power, the Fatimids came down on the Bani'l-Jirah, the descendants of al-Ta'i at al-Ramla, to control the Syrian road and ensure the safety of its travellers, in particular in the section between Damascus and Wadi al-Qura. During this period, safety became an increasing concern on the other pilgrimage routes leaving from Iraq, a state of affairs that for several years obliged the official Iraqi pilgrimage caravan to change route and join the caravans leaving from Damascus.

During the period of the Fatimids, several geographers and travellers described the road from Damascus in their travel accounts and chronicles, such as al-Muqaddasi, the author of the *Kitab ahsan al-taqasim fi ma'rifat al-aqalim*, al-Istakhri, author of the famous *Kitab al-masalik wa'l-mamalik*, and Ibn Hawqal, author of the *Kitab surat al-ard*. All these reports provide valuable information on the many towns and way stations along the Syrian road.

## 2. The Syrian road during the Crusades

The presence of crusaders in the fortress of Karak in the south of Jordan proved a danger that the caravans of pilgrims were obliged to brave if they took the Damascus road, particularly in the early 12th century. Travellers' safety was increasingly threatened by crusader attacks and pilgrims eventually abandoned this route in favour of the Iraq road.

وكاد ينزع الجمر الشمر والنشد

ما الحج سير تأوبا وادلاجا ولا اعتيام اجمالا واجحاجا

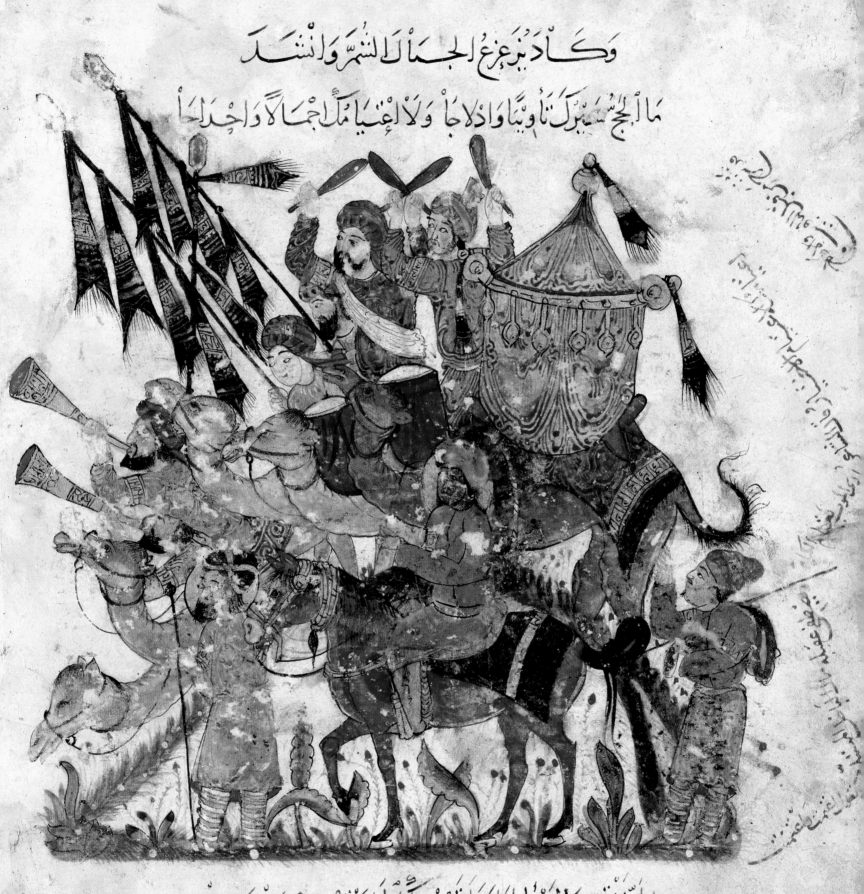

الحج ان تقصد البيت الحرام على تجريد للحج لا تبغي به حاجا

وتعطي كاهل الانصاف منحذرا ردع الهوى هاديا والخون منهاجا

The taking of power in Damascus by the Muslim chief Nur al-Din Zanki helped to re-establish order and security on the Damascus road, in particular after he had taken it to perform the *Hajj* in 1166, but the threat posed by the crusaders was not extinguished until Karak was retaken by Saladin in 1188.

### 3. The Syrian road under the Ayyubids and the Mamluks

This period lasted for more than two centuries, from the middle of the 13th century to the start of the 16th, while several modifications were made to the section of the road between al-Ula and Medina. The traffic was diverted via Zumurrud and Hadiya while several of the roadside facilities were improved. Once he became master of the Ayyubid sultanate in 1215, al-Malik al-Mu'azzam ibn al-'Adil ordered the construction of a cistern at the way station called "al-Mu'azzam", the largest on the Damascus road. Accounts made by travellers during the Mamluk period – such as those by Ibn Battuta, who performed the *Hajj* in 1325, and Ibn Tulun – abound in information and descriptions of this route.

### 4. The Syrian road during the Ottoman period

From the start of Ottoman rule the road was installed with many new facilities. Several fortresses were built along the route, such as the citadels of Dhat Hajj, Tabuk and al-Akhdar during the reign of Sulayman the Magnificent. Later, other citadels popped up among the way stations on the road, which continued to be frequented between Damascus and al-Ula, but a new route after this latter town was put in place, passing by the citadel of al-Faqir, the plain of al-Mutran, the fort of Zumurrud, Hadiya, Istabl 'Antar, al-Talhatayn, the wells of Nasif, and al-Hafira. The Hijaz railway line that connected Damascus to Medina was built by Sultan Abdulhamid along the same route.

## The geographic setting of the road from Syria

Pilgrims from Syria and neighbouring countries left Damascus and headed south across a large plain before reaching the village of al-Kaswa, the first way station on the Damascus road. This village was mentioned several times by early Muslim geographers.

Travellers gathered at al-Kaswa before continuing their way south to al-Sanamayn, a village in the Hawran, and one of the principal stations. From there, the pilgrims headed south to Bosra, the largest town in the Hawran, where a huge cistern provided the caravans with water. From here the route continued to Adhri'at, today known as Dar'a, which lies 123 kilometres from Damascus.

Late in the Islamic period, the number of stations on the Damascus route increased substantially in the Syrian section. Their order was as follows: Damascus, al-Kaswa, Khan Dunun, Ghabaghib, al-Sanamayn, Shaykh Maskin, al-Muzayrib and Dar'a, the last main way station on Syrian territory.

In the Jordanian section, the route stretched for 434 kilometres, passing first through a station called "Khan al-Mafraq". Here the caravans headed directly south towards al-Zarqa' or instead passed through Jirash and 'Amman. Al-Zarqa' was one of the most important way stations on the road. Between Damascus and this station, travellers passed through green, well-watered country-side but after al-Zarqa' the region became almost desolate. In the early Islamic period, pilgrims subsequently passed through al-Qastal, al-Hafir, a valley where the village of al-Qatrana lay, Ma'an and finally Sargh, the last way station in Jordan. Under the Ayyubids and the Mamluks, the stations between al-Zarqa' and Ma'an increased in number and sometimes changed their name. During

these two epochs, after al-Zarqa', the route passed through Zayzya', al-Qatrana and al-Karak; from there the pilgrims travelled to Ma'an, then 'Aqabat al-Suwan, and finally Sargh.

The string of way stations in Jordanian territory underwent another change under the Ottomans and became: al-Mafraq, al-Zarqa', Khan al-Zabib, al-Balqa', al-Qatrana, al-Hasa', 'Aniza, Ma'an, Batn al-Ghul and al-Mudawwara.

From al-Mudawwara, the route entered the depths of al-Shatiya, and then entered a region of high plateaux before arriving at Halat 'Ammar, the first way station on Saudi territory.

## The Syrian road in Saudi territory
### Halat 'Ammar

Although it was not a major station, Halat 'Ammar is mentioned under this name by Muslim geographers like Yaqut. Later, it was sometimes referred to as "Zalaqat 'Ammar" (the "slidings" of 'Ammar) due to the ground being covered by flaky stones on which the camels slipped. At this station there is a pillar on an oval base built to indicate the direction the route follows. According to Ali al-Ghabban, this pillar probably dates from the early Islamic era.

During later epochs, Halat 'Ammar became a way station halfway between al-Mudawwara and Dhat al-Hajj. A railway station on the Hijaz line was built there.

### Dhat Hajj

After Halat 'Ammar, the route passed through a region at the centre of al-Sha'ta', which is thought of as a part of the Hasma plateau. Next the road crosses a plain covered with sandstone rocks for about 13 kilometres before arriving at a way station set in the bottom of a valley called Dhat Hajj (the word *haj* refers to a type of plant that grows in the valley). The name is mentioned in a poem by Jamil Buthayna (during the Umayyad period), who counted it as one of the stations on the Damascus road. The name of the station became Dhat al-Hajj during the Islamic period in reference to the caravans of pilgrims (*hajj* in the singular) that halted here.

A cistern to provision pilgrims with water was built here, which was renovated and later added to with a citadel during the reign of the Ottoman Sultan Sulayman.

### Tabuk

Tabuk is the second station on the Damascus road after Dhat Hajj. It lies 80 kilometres from Halat 'Ammar in a vast valley known by any of three names: the valley of al-Basita, Wadi Baldih, and the valley of al-Saghir. Tabuk was an ancient oasis mentioned in certain Greek texts, but its name became renowned as a result of the Tabuk campaign led by the prophet Muhammad against the Byzantines in the year 630.

The Prophet made a spring flow at Tabuk and a mosque was built on the spot where he had prayed. A small village grew up around the spring as well as a mosque that al-Istakhri described in the 10th century as "a fort surrounded by a spring and palms". In the 12th century al-Idrisi mentioned "a town on the Damascus road, endowed with a fortress welcoming the inhabitants who drank from an abundant spring surrounded by palms". Pilgrims halted near the spring where they performed their ablutions and stocked up with food and water for the next stages of the journey. The spring was given its own construction under Caliph 'Umar and cisterns were built over the centuries that followed. The Ottoman Sultan Sulayman also built a citadel on the site.

### Al-Akhdar (al-Muhadatha)

The geographic sources mention al-Muhadatha as a major way station on the Damascus road located one stop after Tabuk and 68 kilometres to the south-east.

Ali al-Ghabban states that the station of al-Muhadatha was situated at Wadi al-Akhdar, where the ruins of an ancient Islamic village have been found. When journeying in the direction of Tabuk, the Prophet also passed through Wadi al-Akhdar, where a large well provided the only source of water for the caravans for several hundred years. A number of cisterns were built around the well by the Mamluks, which the Ottomans renovated whilst also building others. In 1531, Sultan Sulayman ordered the construction of a citadel here, but today only the foundations are visible.

### From al-Akhdar (al-Muhadatha) to al-Aqra'

The Muslim geographers who listed the way stations along the Damascus pilgrimage road during the Pre-Islamic era – including Ibn Khurradadhbih, al-Harbi, Ibn Rustah and Qudama – are agreed that al-Aqra' was the first station after al-Muhadatha in the direction of al-Hajar. Al-Aqra' lies 150 kilometres south of al-Muhadatha, a distance that was reckoned in the accounts of some travellers to be double the length of a standard travelling stage. Thus it was necessary for pilgrims to stop at Asfal al-Hakat, a rest place also known as al-Mu'azzam. It lay halfway between al-Akhdar (al-Muhadatha) and al-Aqra'. Under the Ottomans the number of rest places increased on this stretch of the road to six, which lay in the following order: al-Akhdar, al-Assada (situated at Wadi al-Sani), the cistern of al-Mu'azzam, al-Janib (also called Zahr al-Hamra' or al-Dar al-Hamra' and, today, al-Burayka), Qurush al-Raz and, lastly, al-Aqra'. This last station went by many names over the centuries, including al-Aqari' and al-Uqayri'. The way station of al-Mu'azzam was constructed on the route at the start of the Ayyubid age and is considered to have been the most important on the entire Syrian road. In 1214, the Ayyubid prince al-Mu'azzam ibn al-'Adil ordered a cistern to be built and named after him (al-Mu'azzam) close to Asfal al-Hakat. Later the place became the site of al-Mu'azzam, which was famous for its rectangular cistern (the largest on the Damascus pilgrimage route), its Ottoman citadel built in 1621, and for the many buildings built as part of the Hijaz railway line.

The next station, al-Janib, which is known today by the name of Umm Junayba, was a natural collection site for rainwater and thus provided an additional source of water on the route. It lies 10 kilometres north of al-Burayka and was first mentioned by Ibn Fadl Allah al-'Umari in the 14th century. Al-Dar al-Hamra', today al-Burayka, was also renowned during the Ottoman era for its cistern, which was probably built before the Turks extended their power to this region. The Ottomans added a citadel on this site in the year 1754.

With regard to al-Aqra', only the ruins of a small station on the Hijaz railway line have been found, on a site known as al-Matla'. But al-Aqra' was not a simple halt on the journey for the pilgrims: it was a vast region in which several mountains were separated by water-retaining zones that allowed the more fortunate travellers to replenish their water bags.

The changes over time to the names and order of the different stopping-off places along the road did not alter the route followed by the Damascus road, although the section between al-Akhdar and al-Aqra' was one of the most difficult due to the meagreness of the water reserves available, the quantity of which depended on the extent of the rainfall.

### From al-Aqra' to al-Hajar

The first Muslim geographers mention a single resting place situated halfway between al-Aqra' and al-Hajar, which they call "al-Janina", but this section of the Syrian route was

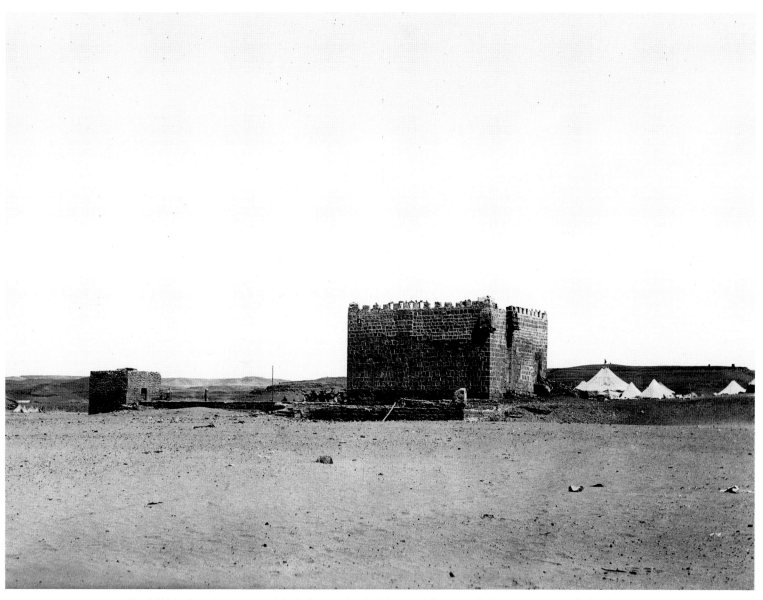

The al-Akhdar fort, 1907, photograph by R. Savignac (on the right, tents belonging to the Ottoman troops involved in the construction of the Hijaz railway)

carried out in three stages during the Ottoman era. Al-Hajar was very well known on the Damascus road. It had a well called the "Camel pit" as it was supposed to have provided the Prophet's camel Salih with water. The well lay at the centre of the oasis, away from the tombs dug out of the rocks that surround the site.

During the Ottoman period, construction was undertaken of a cistern close to the well, a citadel, and several buildings linked to the Hijaz railway, including a maintenance yard for the trains.

### The rest stops in the al-Qura valley

Today al-Qura valley is known as al-Ula valley. It stretches south from al-Hajar (Mada'in Saleh) and runs into al-Jazal valley close to Suqiya. Al-Qura valley is home to several villages through which the Syrian pilgrimage route wound for centuries, such as al-Ula and Qurh, the valley's largest city. However, the exact location of Qurh has been debated: Abdullah Nasif thought it lay at al-Mabiyat, to the south of al-Ula, where there are remains of an Islamic town. Hamad al-Jasir believed that Qurh was situated at al-Khurayba al-Qura, close to al-Ula; he has claimed that al-Mabiyat was probably al-Rahba, another city in al-Qura valley. On the other hand, Ali al-Ghabban argued in his doctoral thesis that Qurh lay at al-Mabiyat, whereas al-Rahba was located in al-Jazal valley in a place known as al-Katifa, where the ruins of an ancient village lie. Archaeological excavation has confirmed that al-Mabiyat was the ancient site of Qurh.

### From al-Hajar to al-Mabiyat

During the early Islamic centuries, this stretch of the Damascus road offered two routes. The east route was known as Darb al-Hajj or Abu Zurayba, and headed south-east through al-Hajar to al-Mu'tadil. It then entered a plain circled by mountains before reaching Qam Rum and then Qurh (al-Mabiyat). The alternative route was called the "al-Ula route": after leaving al-Hajar it headed to al-'Adhib, then al-Ula, then entered al-Ula valley before reaching Qurh (al-Mabiyat). It seems that the Darb al-Hajj was the more frequently used of the two, particularly at the beginning of the Islamic era. Several commemorative inscriptions have been found alongside the road that attest the regularity of the passage of pilgrims, while others have been discovered that nearly all date from the period between the 7th and 11th centuries. One of them, the "inscription of Zuhayr", gives the date of 24 H./644. The Darb al-Hajj was a direct road 24 kilometres long from al-Hajar to Qurh that skirted al-Ula. It was shorter than the alternative route (37 kilometres), which passed through al-Ula. This latter road was also used in the early years of Islam: it is said that on his journey to Tabuk, the Prophet prayed in the mosque of al-'Uzam at al-Ula. From the 14th century, al-Ula became the most important town in al-Qura valley and its neighbouring area. In 1226, the town was also visited by Ibn Shuja', who noted that pilgrims deposited their loads there. Ibn Battuta, who visited the town in 1326, described it as a large village where pilgrims washed, stocked up on provisions and deposited their loads and mounts there. Today the town is deserted.

### From Wadi al-Qura to Medina

Between Wadi al-Qura and Medina the road followed two routes. The first, and older of the two, was used at the start of the Islamic period, from the 7th to 13th centuries. It left Qurh (the town of Wadi al-Qura) and passed through the valley to the town of Suqiya, where it encountered the interior pilgrimage route from Egypt. The next stop was al-Rabha, which it reached in a single stage.

Otherwise, according to Ali al-Ghabban, another direction taken by Damascene pilgrims headed directly from Qurh to al-Rahba without requiring them to pass through Suqiya. This route, 40 kilometres long, joins the village of Mughayra to al-Katifa even today. This information confirms the accounts given by Ibn Khurradadhbih and Ibn Rustah, who considered al-Rahba the next station after Wadi al-Qura as one headed south towards Medina.

After al-Rahba, the route headed towards Dhu'l-Marwa, which was a celebrated town at the start of the Islamic era, and situated at the meeting point of Wadi al-Jazal and Wadi al-Hamd in the region of Umm Zarb, near Bada'i' al-Zali'a. Al-Muqaddasi described the town in the 11th century as a fortified town surrounded by palms.

Dhu Murr, the station that follows Dhu'l-Marwa, was situated, according to Ali al-Ghabban, in Wadi al-Hamd on the site of Abu Halu, 63 kilometres from Dhu'l-Marwa. Foundations exist there of a building that dates from the start of the Islamic era.

On the route described by Muslim geographers, the next stopping place was al-Suwayda', which was situated, in the opinion of Ali al-Ghabban, on the site of Istabl 'Antar, formed by black volcanic rocks, 47 kilometres from Abu Halu.

After al-Suwayda' came Dhu Khashab, the last way station before Medina. It lay about 60 kilometres north of Midian and close to al-Muwaylih. Known today by the name Wadi al-Mandasa, Dhu Khashab was home to the residences of several notables and the fort of Caliph Marwan during the Umayyad dynasty. Today the town has ruins of five forts that all date to the beginning of the Islamic period.

Pilgrims began to take the second road in the 13th century, when the state of the stations on the ancient road began to decline. The new route passed through al-Ula and al-Mabiyat before heading towards Sahr al-Mutran. From there it made its way to Dhabak in the region of Zumurrud, followed by al-Sura and Hadiya, another well known station. After Hadiya, the pilgrims could choose to take the direction of Istabl 'Antar, from where they reached Abi'l-Na'm, where the new road and ancient route joined. Between this point and Medina, travellers passed through the stations of al-Fahlatayn, Abar Nasif and al-Hafira.

The Syrian route was a high priority for the Ottomans, who endowed it with many forts, rest stops, cisterns and wells. The Hijaz railway line, which was built at the start of the 20th century, followed the second Syrian route.

**Bibliography:**
Al-Ajimi 1409 H./1988–89; Al-Ansari 1423 H./2002; Bani Yunis 2000; Doughty 1884; Al-Ghabban 1988a; Al-Ghabban 1988b; Al-Ghabban 1414 H./1993; Huber 1884; Al-Jasir 1397 H./1977; Jaussen and Savignac 1909; Al-Jaziri; Al-Kilabi 1430 H./2009; Al-Maqrizi; Al-Muqaddasi; Nasif 1988; Nasif 1416 H./1995; Al-Samhudi; Yaqut.

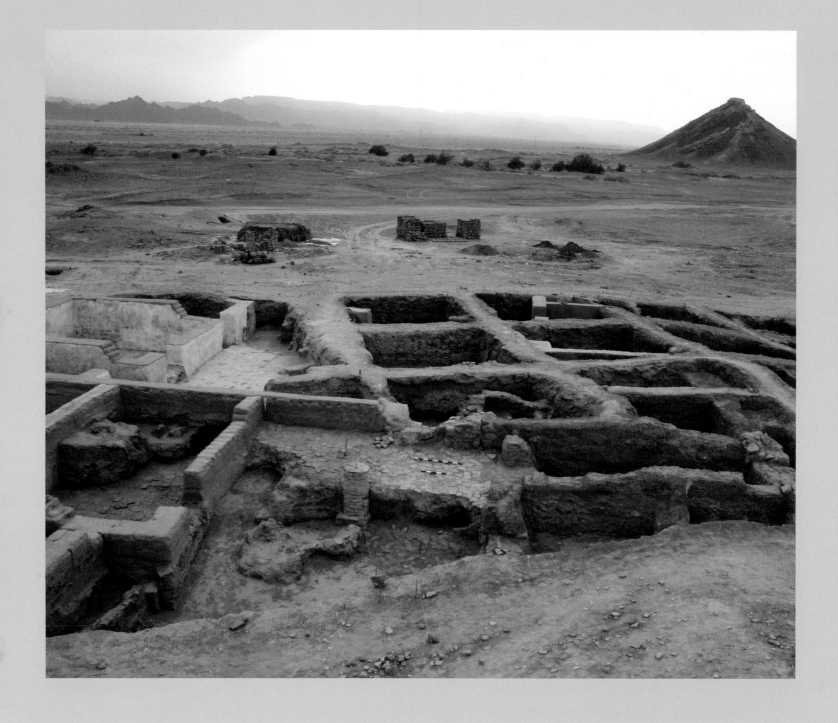

# AL-MABIYAT:

## THE ISLAMIC TOWN OF QURH
## IN THE PROVINCE OF AL-ULA

*'Abdallah bin Ibrahim al-'Umayr*

The site at al-Mabiyat lies between al-Ula to the north and al-Mutran to the south, at latitude 26° 30' north and longitude 38° 6' east, in the Medina region. The small neighbouring village of Mughayr, whose farms depend on the region's wells, is a few kilometres south of al-Mabiyat. The town of Qurh (al-Mabiyat) was known for its commercial activities before the advent of Islam. It was one of the most famous Arab markets during the Jahiliyya period.[1] During the Islamic era it grew considerably, and in the 10th century the great Arab traveller and geographer al-Muqaddasi described it as the second largest town in the Hijaz after Mecca.[2] The Persian geographer al-Istakhri – who refers to it as "Wadi al-Qura" – considered it the fourth town after Mecca, Medina and al-Yamama.[3] Qurh remained wealthy until the late 12th century AD, then, along with Wadi al-Qura sank into oblivion. A 13th-century writer, Yaqut (1178–1229), whose youth coincided with the city's decline and abandonment, mentions that its ruined houses were still recognizable, and that there was abundant water but nobody to benefit from it.[4] Today the inhabitants of al-Ula refer to the site as al-Mabiyat.

General view of the site

## Archaeological studies of the site

The excavations carried out by the Saudian Direction of National Antiquities in 1984–85 unearthed currency providing chronological clues to the site's occupation, including a coin with a monetary weight of one half-dinar in the name of the Fatimid ruler al-'Aziz bi-llah (975–96). In one of the residential structures that were cleared, a paving stone was inscribed with the name of an owner: "residence of Sulayman son of Muhammad son of Sulayman son of Muhammad".

The site extends over 640,000 square metres (each side 800 metres square). It is surrounded by the ruins of a snaking mud brick wall with three gateways, and there is an adjoining elevated area on which a small citadel was built. The area within the walls had been badly eroded and disturbed by agriculture. It was quite densely scattered with ceramic shards, and an area of kilns was identified in the middle of the site. The earth around these kilns was rich with ashes

1. Al-Afghani 1960, p. 194.
2. Al-Muqaddasi, p. 84.
3. Al-Istakhri, p. 19.
4. Yaqut, p. 338.

and terracotta fragments, some of which had a greenish vitrified coating. Vestiges of water tanks and wells were also found. The remains of a mosque built with rubble stone and mortar were visible outside the walls, 200 metres to the east. In fact this was probably a *musalla al-'id*, a place of prayer located outside the city, used only on certain occasions and comprising only a *qibla* wall marked by a *mihrab*. There was a cemetery to the north-west of the citadel, where several stelae with inscriptions were unearthed. To the south-east, beyond the remains of a water tank and installations that may have been baths, there was another settlement with a citadel. Its architectural elements and ceramic fragments enabled its attribution to the Nabataean and Byzantine periods.

Only a limited area to the south-east of the *intra muros* site was investigated during the first expedition. The following year, a number of exploratory excavations uncovered an area of houses and a section of the north-east city wall.

## The residential structures

Examination of the structures of the houses that were unearthed helped to determine the types of construction used. However, these structures can be difficult to analyse and their uses are still unclear, all the more so since the limits of the area excavated and its successive periods of occupation have not yielded a clear picture of it or an entirely satisfactory interpretation of the various elements unearthed there.

All the structures were built with mud bricks measuring 40 x 20 x 10 centimetres. The uniform colour and texture of the clay indicates that they came from the same place, probably from the river valley in which the site is located. Clay was also used in the mortar mixture binding their bricks or rubble-stone walls. Their floors, thresholds and staircases were also paved with clay and the walls were clad with a thick coating of clay.

Three sizes of terracotta tiles were used to pave the floors, to cover roofs and dress the lower parts of walls. Some of these mural tiles were decorated with geometric vegetal motifs, created using a mould (cat. nos 277 and 278). A few were found among the remains of houses. Another type of brick, an isosceles triangle with one curved side, was used to build cylindrical pillars and other architectural elements such as the retaining walls along the ring wall.

Most of the walls were built on stone foundations, usually red sandstone or black or flesh-coloured granite and occasionally volcanic rocks such as basalt, all quarried in the nearby mountains, probably to the north and north-east of the city. The same stones were also used for thresholds and lintels, interior supports, fireplaces and internal and external water evacuation installations. The stones discovered on the site were all uncut and incorporated directly into architectural structures in this state. The same practice has been observed in other towns in the region, at al-Khurayba (Dedan) and al-Ula.

As well as the layer of clay used to render brick walls, excavations also revealed widespread use of a plaster coating, especially for covering floorboards, usually between 1.5 and 2.5 centimetres thick. Plaster was also used to render the lower parts of walls inside houses. Analyses have shown that this plaster was pure and firm in texture, and that it came from the dunes to the south and south-east.

Excavations also showed the use of wood in construction, particularly for roof joists. In some houses, wood fragments were found in small circular holes, probably the remains of light-weight structures such as canopies.

A number of small domestic clay ovens were discovered. Approximately 40 centimetres high and 45 to 50 centimetres in diameter, they were turned on a potter's wheel using brown

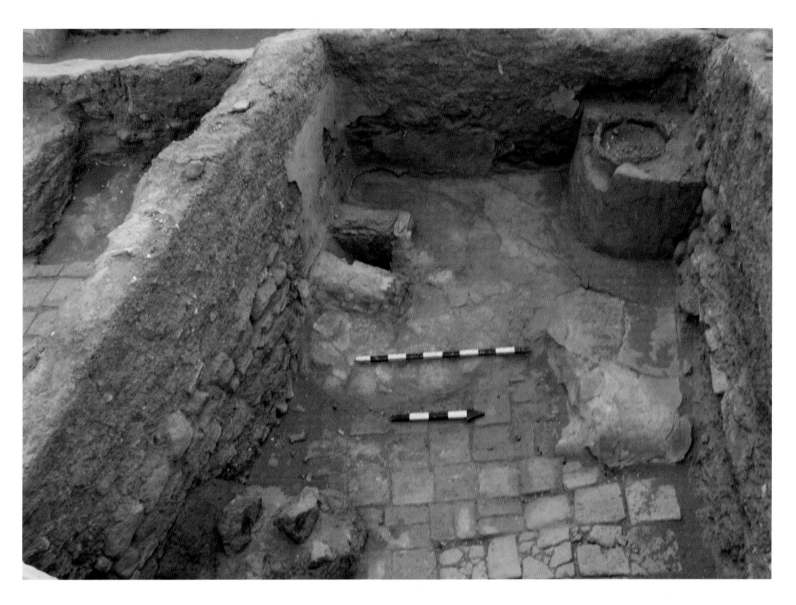

View of a residential unit

clay and their exterior was coated with the ash probably used to maintain the heat within. These ovens were always found in the corner of a room inside the house, at about 50 centimetres from the floor for easier use.

## The city wall

A 15-metre section of the city wall was unearthed on the north-east side of the city. It was built with mud bricks, similar to those used in the residential areas, and clay mortar. Outside, the wall was left unrendered, while inside it was coated with a layer of clay and the lower parts with a thin coating of plaster. The excavation descended to a depth of over 2.5 metres, as the wall was barely visible above ground in this area, whereas in other places it was still well in evidence. It was discovered that the wall did not have stone foundations and was built directly in broad bricks. It was about one and a half metres wide and had retaining walls on the inside, also built with mud bricks 90 centimetres long and 70 centimetres wide.

The length of wall unearthed during this excavation provided important information as to its form, depth and the materials used to build it. Yet there are still areas of uncertainty

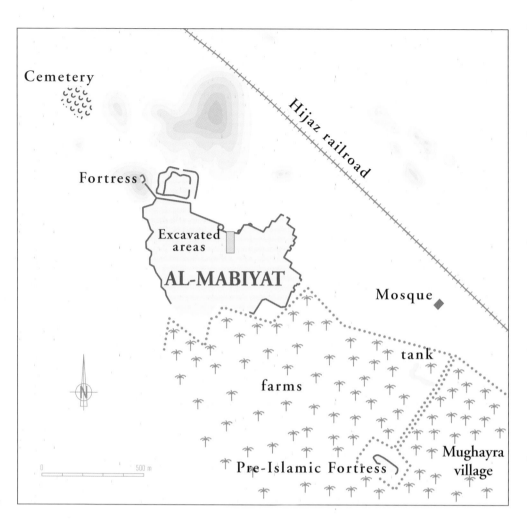

Map of the site

concerning aspects of the inner retaining walls, the absence of stone foundations, and other details needed to gain a clear and precise idea of the wall. The retaining walls were built after the wall itself and not directly against it. As mentioned above, rather curiously, the mud bricks used to build the retaining walls were triangular with one curved side, a form specifically designed for building cylindrical columns, and not the more suitable quadrangular form of brick. And why were these retaining walls relatively thin (70 x 90 centimetres) and never more than 70 centimetres high, if they were to support a wall 1.5 metres thick and 2.5 metres high (according to current data)? The discovery of other retaining walls along the city wall could eventually reveal the exact purpose of this architectural element. If one assumes that these walls were built in the same way all along the enclosure wall, then their role must have been to support it. If this is not so, then they might have been part of other architectural structures built against the enclosure wall.

## The objects found on the site
A large number of objects have been unearthed on the site.

### Unglazed and glazed ceramic objects
A great many pottery fragments were found. A preliminary study established a chronology and typology for Islamic pottery at al-Mabiyat. Its time frame, stretching from the 7th to the 12th

centuries, with a peak period between the mid-9th and 11th centuries, coinciding with the evolution of Qurh recounted by ancient sources. There were also a few surface discoveries dating from the Nabataean and Byzantine periods. Along with ordinary, unglazed pottery, some of whose types have similarities with pieces found on Syro-Jordanian sites from the Umayyad and Abassid periods, there are also several kinds of imported glazed ceramics dating from the 9th to the 12th centuries: opaque white glazes with lustre decoration, mainly from the 10th and 11th centuries (cat. no. 279); splashware and sgraffiato pieces; monochrome glazes, usually blue or green, and often datable to the latest phase (11th and 12th centuries); and a few rare examples of brown or black underglaze decoration, also from the late period. A few Chinese imports were also found, white porcelains and celadons, also linkable to the last phase of the site's occupation.

## Glass objects

A variety of vessels and small and larger bottles in transparent, clear or blue, green or light brown glass were found. There are several examples of mould-blown glass with painted or engraved decoration, and a few rare opaque glass pieces, particularly beads. There were also several fragments of lustre-painted or "stained" glass, including an exceptional lid with a vegetal and epigraphic decoration, attributable to the 10th and 11th centuries. Several glass monetary weights from the Fatimid period were unearthed.

## Metallic objects

A number of iron, bronze and even copper objects were unearthed on the site, including extremely eroded – and therefore difficult to read – coins, weights, an incense burner (cat. no. 280), a pair of pliers, pins and rings.

## Other materials

These included soft stone crockery and lamps (cat. no. 281), shell and coral beads and even fragments of fabric.

Pottery fragments with incised designs, glazed splashes and dots, 10th–11th century, found at al-Mabiyat

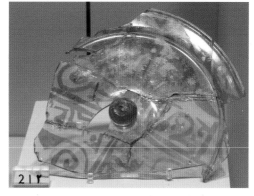

Fragment of a lustre-painted glass lid, late 10th century, found at al-Mabiyat

**Bibliography:**
Al-Afghani 1960; Al-'Umayr *et al.* 2006; Ibrahim, al-Talhi *et al.* 1985; Al-Istakhri; Al-Muqaddasi; Nassif 1416 H.; Yaqut.

## AL-MABIYAT

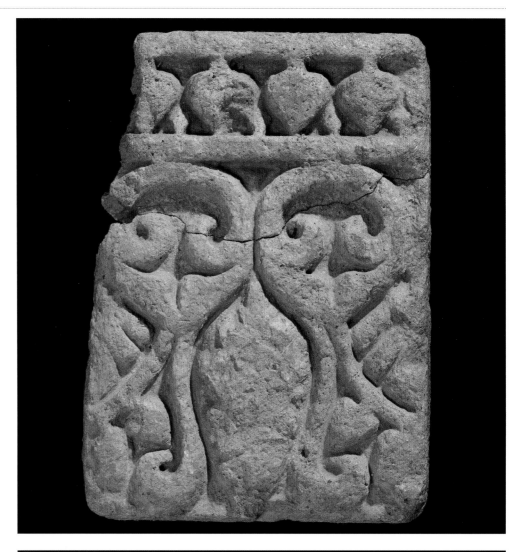

**277. Facing plaque**
9th–10th century?
Moulded earthenware
23 x 17 x 4.5 cm
Al-Mabiyat
National Museum, Riyadh, 2385

Bibliography: Ibrahim, Al-Thalhi *et al.* 1985,
pl. 108; Al-'Umayr *et al.* 2006, pl. 10–2.

**278. Fragment of facing**
9th?–10th century?
Moulded earthenware
Al-Mabiyat
National Museum, Riyadh, 852

Bibliography: unpublished.

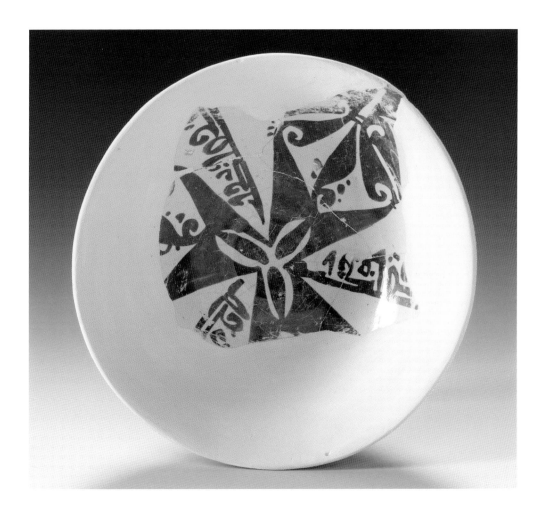

### 279. Cup with radiating decoration
10th century
Clay earthenware, lustre painted decoration on opaque glaze
Diam. (base). 8.5 cm
Al-Mabiyat
National Museum, Riyadh, 1034

Bibliography: Ibrahim, Al-Talhi *et al.* 1985, pl. 101−16 and pl. 111.

### 280. Element of an incense-burner
8th−10th century?
Cast copper alloy
H. 9 cm; Diam. 20 cm
Al-Mabiyat
Department of Archaeology Museum, King Saud University, Riyadh, 237M2

Bibliography: unpublished.

### 281. Star-shaped lamp
8th−10th century
Carved soapstone
H. 4 cm; Diam. 22 cm
Al-Mabiyat
Department of Archaeology Museum, King Saud University, Riyadh, 73M2

Bibliography: Al-'Umayr *et al.* 2006, pl. 10−19 d.

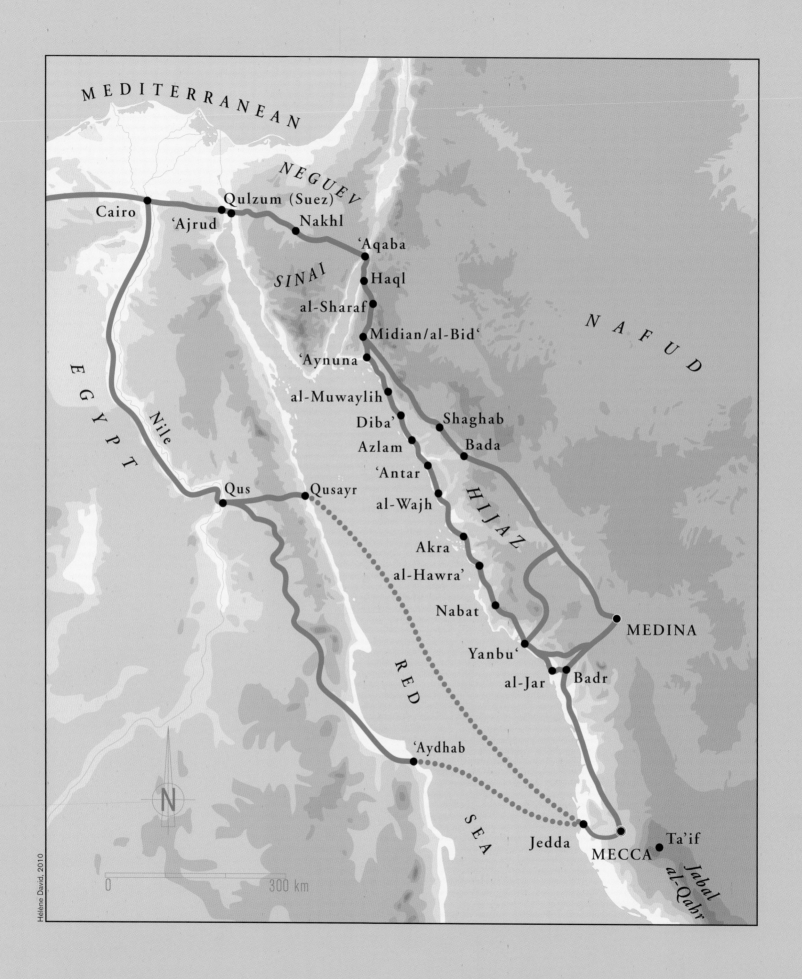

MEDITERRANEAN

NEGUEV

Cairo
'Ajrud
Qulzum (Suez)
Nakhl
'Aqaba
SINAI
Haql
al-Sharaf
Midian/al-Bid'
'Aynuna
al-Muwaylih
Diba'
Shaghab
Azlam
Bada
'Antar
al-Wajh
Akra
al-Hawra'
Nabat
Yanbu'
al-Jar
Badr
'Aydhab
Jedda
MECCA
Ta'if
Jabal al-Qahr

EGYPT
Nile
Qus
Qusayr

HIJAZ

NAFUD

MEDINA

RED

SEA

N

0          300 km

Hélène David, 2010

# THE PILGRIMAGE ROAD
# FROM EGYPT

*Ali I. Al-Ghabban*

Pilgrims from Egypt and those who joined them from al-Andalus, the Maghreb and the rest of Africa had to cross the Sinai Peninsula to reach Ayla ('Aqaba), the first way-station on the Egyptian road across the Arabian Peninsula. After Ayla, the caravans passed through Haql, al-Sharaf and Midian (the caves of Shu'ayb, al-Bid'). From Midian, there were two possible routes during the ancient Islamic period: the inland route via Shaghab and al-Bid', followed by several way-stations leading to Wadi al-Qura and joining the Damascus route near Suqiya, or the coastal route along the Red Sea, passing through 'Aynuna, al-Muwaylih, Diba', al-Uwaynad, al-Hawra', al-Hasa' (Mughayra, Nabat), Yanbu' and al-Jar, al-Jahfa, Khulays, 'Asfan, Badr and Medina before finally reaching Mecca.

The history of the Egyptian road can be divided into four major periods:

1. From the Islamic conquest of Egypt through the middle of the 11th century, the road was split into two within the Arabian Peninsula: the inland route and the coastal route. The inland route was the most popular, especially during the first two hundred years of the hegira (7th and 8th centuries). Over the next century it fell into disuse as more and more caravans took the coastal route, which eventually replaced it entirely.

2. Travellers continued to follow the coastal route until the middle of the 11th century, when the tensions plaguing Fatimid Egypt made it preferable to travel by sea, embarking from the port of 'Aydhab and sailing to Jedda. With the deteriorating political and economic situation, the Fatimids could no longer maintain the pilgrimage road. In addition, the occupation by the first crusaders of Ayla, which was the main stopover on the route and the only crossing point into the Arabian Peninsula, made the coastal land route impracticable for some two hundred years. This period had quite a negative impact on most of the installations located along the route, as well as on the settlements in the northern Hijaz region.

3. Pilgrims returned to the coastal route in 1269 under the reign of the Mamluk sultan al-Zahir Baybars, who made the region safe again. From this period onward, and throughout the Mamluk and Ottoman eras, caravans of pilgrims from Egypt converged upon a cistern near Cairo before travelling on to Suez through al-Buwayb and 'Ajrud and crossing the Sinai

Map of the Egyptian road

Peninsula between the tip of the Gulf of Suez and that of the Gulf of ʿAqaba. The caravans reached ʿAqaba/Ayla nine days after leaving Cairo, and from there followed the coastal route.

4. Pilgrims continued to follow the coast until 1883, the year the last official caravan took this route. By the turn of the 20th century, sea travel had once again become the norm among Egyptian travellers, who sailed from Suez to Jedda.

The main characteristics of the ruins found along the Egyptian road are presented below.

## Monuments from the early Islamic period

The Egyptian pilgrimage route is significant for the historic ruins found along its way. Both the inland and coastal routes were a major concern for the Muslim sovereigns of the early Islamic period. The Egyptian leaders built cisterns, dug wells, smoothed rough areas and built mosques. The historical sources mention a number of these constructions, like the clearing of boulders on the Ayla road under the reign of Khamarawayh ibn Ahmed ibn Tulun, the seven wells dug near Wadi Dibaʾ and the al-ʿAshira *khan* (caravanserai) in Yanbuʿ, unlike any other in the world according to al-Muqaddasi. Egyptian sovereigns also built mosques in Badr as well as a cistern and its canals in Khulays. Several monuments dating from this period have been found along the inland route, including the ʿAyn al-Nabiʿ cistern near Shaghab, the Bada cistern, and the Balata wells between Bada and al-Khushayba. In addition to these installations, there are hundreds of ancient Arabic inscriptions, the largest of which is carved into the rocks north of Shahiba Bada.

On the other hand, only a few monuments from the early Islamic period have been discovered on the coastal route. They are limited to a few Arabic inscriptions and cisterns, like those in Midian and al-Jar, and their relative rarity is largely due to the extensive renovations and improvements carried out under the Mamluks and Ottomans. The fact that so few ancient Arabic inscriptions are found on the coastal route can also be explained by the friable nature of the rock in the Tihama coastal plain, which makes it ill-suited for carving. Those that have been found are dispersed throughout the valleys along the route, near Naqaʿ Bani Murr, in the ʿArjaʾ pits south of al-Wajh, and in the valley of Fatima al-Jumum.

## Monuments from the late Islamic period

These monuments are all located on the coastal route in the northern Hijaz region, and all date from the Mamluk and Ottoman eras.

### *The al-Bidʿ cistern (Midian, the caves of Shuʿayb) and its installations*

In Midian, known in the time of the Mamluks and Ottomans as "the caves of Shuʿayb", a cistern and a canal from the Mamluk era have been found, as well as an older cistern dating back to the beginning of the Islamic period. The Mamluk cistern was built near the al-Saʿdani well, an ancient water source dug into the rock that is mentioned in Islamic sources under the name "Moses's well" *(Bir Musa)*. The cistern was connected to the well by a long canal leading from a pool at its western end, which in turn was fed by a brick-lined channel. Water was drawn from the well via a mechanism powered by draught animals. Al-Jaziri described the installation in the 17th century, mentioning "I also noticed several dates carved on stone slabs. Some cited the name of Sultan Qaʾitbay, who apparently was responsible for renovating the portal. Another date, carved in 800 H./1397–98, caught my attention; I tried to decipher the inscription but

it was too damaged. I could only make out the following phrase: 'built by our lord *al-maqam al-sharif al-sultan*'. Perhaps it refers to Barsbay." In fact, several constructions were undertaken at the location during the reign of the Mamluks. The oldest dates back to the time of Sultan Muhammad ibn Qalawun (first half of the 14th century), and was built under the supervision of the Great Amir Muqaddam al-Hajj al-Malik al-Jukandar. It was then renovated under Sultan Barsbay (1422–37), who sent Emir Shahin al-Tawwil to follow the Hijaz route and refurbish the watering points between Cairo and Mecca, and again under Sultan Qa'itbay (1468–96), who stopped here during his pilgrimage in 1480. The site fell into disuse during the Ottoman era and was replaced by the Bid' Helwa wells, dug into the depths of Wadi 'Afal. From then on, the site would be known under the name al-Bid'.

### The ruins of 'Aynuna

Several sites of ruins have survived in 'Aynuna, some of which date back to the Pre-Islamic era. The Islamic period is represented by two major sites: a stopover for pilgrim caravans on their way to Mecca, built on a vast highland overlooking the valley, and the ruins of al-Saghir, a small village in Majra' al-'Ayn mentioned in several sources, including Hadrat 'Uyun al-Qasab, as a way-station for travellers returning from Mecca. Under the Mamluks and Ottomans, 'Aynuna was also the site of a cemetery with mausoleums and funerary stelae.

### The ruins of Tarim

Thirty kilometres south of 'Aynuna, Tarim is the site of some very old ruins. This stopover for pilgrims was built on high ground near Majra' al-'Ayn and includes a large cistern built during the Ottoman era.

### The ruins of al-Muwaylih

Al-Muwaylih was one of the major way-stations along the Egyptian pilgrimage route under the Mamluks and Ottomans. The above-mentioned Amir al-Hajj al-Malik al-Jukandar ordered the construction of two wells north of the oasis, which were later refurbished by Sultan Qansuh al-Ghawri (1501–16). But most of the site's ruins are from the Ottoman period, in particular the fortress built under Sultan Sulayman the Magnificent and ordered by 'Ali Pasha, governor of Egypt at the time. One of its wells is inscribed with the date 967 H./1559–60, and another commemorative stone placed above the entrance to the fortress bears the date 968 H./ 1560–61. Forming a square of about 109 metres per side, this is the largest fortress on the pilgrimage routes of Saudi Arabia. Various dwellings and storage facilities as well as a mosque were arranged around the inner courtyard. At the end of the Ottoman era, the al-Muwaylih sharifs took control of the fortress.

### The Ottoman wells of Wadi al-Ghal, Wadi al-Hasha and Wadi Daba' (17th–18th centuries)

### The ruins of al-Aznam (al-Azlam)

The al-Aznam Valley was one of the main resting points along the Egyptian pilgrimage route under the Mamluks and Ottomans. Located 40 kilometres south of Daba', it harbours the ruins of the first khan built during the reign of the Mamluk Sultan Muhammad ibn Qalawun (1293–1341) and restored under Sultan Qansuh al-Ghawri in 1510–11. In certain sources the khan is referred to as Burj al-Azlam or Qual'at al-Azlam. The fortress, built of limestone and

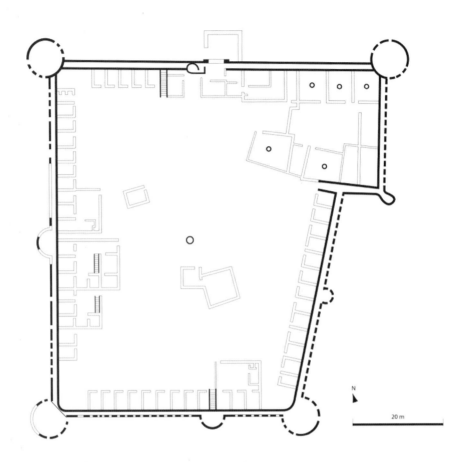

Plan of the fortress in al-Muwaylih

occupying a square about 40 metres on each side, has corner towers and high walls (about 7 metres tall) topped with barricades. The entrance was on the north-eastern side, facing the route taken by the pilgrims. A vaulted passage led to the inner courtyard, which was surrounded by barrel-arched storehouses. Staircases led to the upper level and the walkway along the top of the walls. On the south-western side was a large *iwan* (vaulted hall) that opened onto the court-yard through a row of arcades.

### The ruins of Wadi al-Zarib in al-Wajh

The al-Zarib Valley is located east of the city of al-Wajh and was a resting point for caravans of pilgrims from Egypt and others who had joined them on the way. Today the valley still has six-teen wells dating from the time of the sultans.

In 1617, during the reign of the Ottoman Sultan Ahmed I, the upper valley was the site of a large fortress built to protect the pilgrims. Its entrance portal bears an inscription indicat-ing the date of construction. The structure was rectangular, with sides 51 to 55 metres long, and had corner towers that could accommodate cannon emplacements. The entrance, facing west, led to an inner central courtyard surrounded by several halls, following the usual layout. Three cisterns were installed side by side outside the northern wall of the fortress.

### The ruins of Akra (the Akra cistern)

Located 45 kilometres south-east of the city of al-Wajh, this site houses a cistern and a well from the Ottoman era. Akra is cited in several Arabic geographic sources as a way-station for pilgrims. In 1992, excavations led by Dr Ali I. Al-Ghabban on the site of al-Qasir, 10 kilo-metres west of Akra, unearthed the ruins of a coastal settlement dating from the Nabataean

period, as well as traces of a dug-out road linking this settlement to the port of Karkama. The site is mentioned in classical sources: the port of Akra was where the Roman general Aelius Gallus embarked for Egypt upon his return from an ill-fated Arabian expedition, c. 24–25 BC.

### The ruins of al-Hawra'

Al-Hawra' was an active city during the earliest centuries of Islam. Its ruins are located 10 kilometres north of the city of Umluj. It was abandoned during the 12th century, but its name continued to be used by the Mamluks and Ottomans to indicate the way-station built on the site.

### The ruins between Nabat and Yanbu'

Numerous Ottoman ruins, including dwellings, cisterns, canals and wells, can be seen along about 90 kilometres of the pilgrimage route in this zone. These structures were apparently built by Ridwan Bey, the emir in charge of the pilgrimage for Egypt between 1628 and 1654, a period during which the route had a reputation for being safe and well-equipped.

### The ruins of Yanbu'

Qaryat al-Birka, a village within the urban zone of Yanbu', is the site of the al-'Ashira mosque, which was visited by pilgrims both on their way to and returning from Mecca, according to al-Jaziri (17th century). Also in the Yanbu' area, Kufic (angular) inscriptions have been found carved into the rocks of the mountain near the village of Suwayqa.

### The ruins of Badr

Badr is one of the best-known way-stations on the Egyptian route. Foundation inscriptions have been identified describing the works undertaken by the Muslim governors for the benefit of the pilgrims. There are also the ruins of several canals built to bring water from the ancient wellhead of Badr, as well as the remnants of a cistern built by the Mamluk sultan Qansuh al-Ghawri. The mosque in the marketplace, dating from the 16th century, is also worthy of mention.

### Ruins on the route between Badr and Mecca

There are many Mamluk and Ottoman ruins on the route between Badr and Mecca. The most important sites are: a wellhead 2 kilometres south of the al-Rays crossroads, built in the second half of the 18th century by Khanatha, daughter of the sultan of Morocco Muhammad III ibn 'Abdallah; the Muhsin wellhead, east of the paved road 5 kilometres from the al-Rays crossroads; the wells of Sharif Abu Numayy in Mastura; the ruins of a fortress in Rabigh; the wells of al-Qadima; the cisterns of Khalis; and the ruins of mosques and cisterns in al-Jumum.

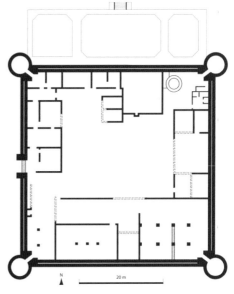

Plan of the fortress in al-Zarib

**Bibliography:**
Al-Balawi; Barbir 1980; Al-Daqan 1985; Al-Dar'i; Al-Ghabban 1414 H./1993; Ibn Battuta; Al-Idrisi; Al-Jasir 1397 H./1977; Al-Jasir 1402 H./1981–82; Al-Jasir 1404 H./1983-84; Jaussen and Savignac 1909; Al-Jaziri; Al-Khiyari; Al-Munjid 1949; Al-Muqaddasi; Al-Nabulsi; Nasif 1988; Al-Samhudi; Al-Ya'qubi.

## AL-HAWRA'

### 282. Inscribed lintel
12th century
Carved stucco
L. 120 cm
Al-Hawra'
National Museum, Riyadh, Hawra' 16

Bibliography: Thesaurus, no. 15784; Hamed 1988, p. 348; Whitcomb 1998, p. 406.

Al-Hawra' was one of the stages on the Egyptian pilgrimage route skirting the Red Sea coasts. The survey of the site revealed architectural vestiges and numerous potsherds of the Islamic period. This inscribed lintel which topped upright beams featuring stylized vegetal motifs enhanced the door of a house. The inscription is religious, precisely a short extract from the famous Throne Verse (Quran, 2, 255) frequently utilized on monuments as well as objects. Dating al-Hawra' vestiges is problematical. First an early date (Abbasid period) was proposed. The archaeologist D. Whitcomb attributed this lintel to the 12th–13th centuries, discerning in it an influence of Fatimid Egypt. However the script presents an elongation of the upper part of the letters into a sharp point which rather curiously has parallels quite to the east of Islamic territories in the early 12th century (in particular in the inscriptions of the palace of Mas'ud III at Ghazna). We know that epigraphic styles spread rather quickly and often from east to west.                                          C.J.

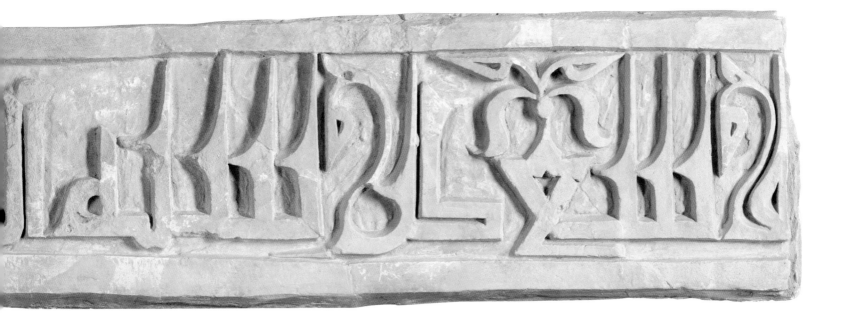

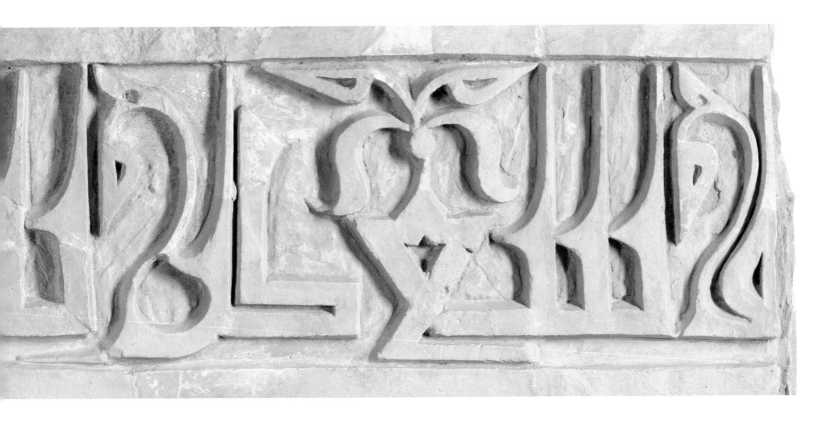

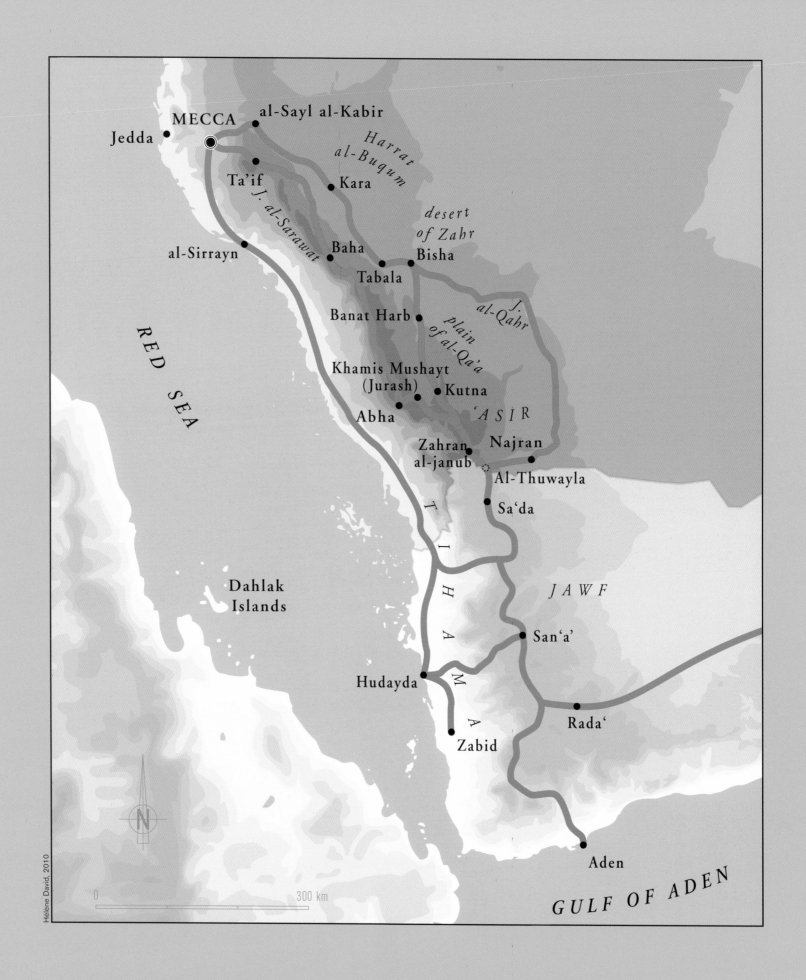

MECCA

al-Sayl al-Kabir

Jedda

*Harrat al-Buqum*

Ta'if
Kara

*J. al-Sarawat*

*desert of Zahr*

al-Sirrayn
Baha
Bisha

Tabala

*J. al-Qahr*

Banat Harb
*plain of al-Qa'a*

RED SEA

Khamis Mushayt
(Jurash)
Kutna

'ASIR

Abha

Zahran
al-janub
Najran

Al-Thuwayla

Sa'da

T
I
H
A
M
A

Dahlak
Islands

JAWF

San'a'

Hudayda
Rada'

Zabid

Aden

GULF OF ADEN

N

0          300 km

Hélène David, 2010

# THE YEMENI

## PILGRIMAGE ROAD

*Muhammad bin 'Abdulrahman Rashid Al-Thanayan*

Caravans and travellers bound from Yemen crossed the south and west of the Arabian Peninsula on their way to Mecca, and this had a positive effect on local economy, population growth and the development of urbanization. According to ancient sources, there were three principal routes to the Holy Places:

– the coastal routes, along the Tihama;
– the sea routes: from the ports of Hudayda and Aden to Jedda, via a number of ports on the Red Sea, particularly al-Sirrayn;
– the inland routes linking San'a' and Mecca (*darb al-sudur*, "*najdi*" route) and the Hadramawt and Mecca via Najran, Sa'da or Aden, the route from Aden to Mecca via San'a', and the route from Sa'da to Mecca via the al-Sarawat mountains and the town of Ta'if.

The so-called "*najdi*" route is the best documented. The Yemenin poet Ahmad ibn 'Isa al-Rada'i (first half of the 9th century) was one of the first to describe its route, stopovers and the services along the way. His poem known as *Urjuza al-hajj* or *al-Rada'iyya* describes the country along the San'a' and Sa'da caravan route between the town of Rada' and Mecca. The geographer al-Hamdani (died c. 961–70), who also mentioned this route, attached considerable importance to this "pilgrimage poem", citing it many times in his works. He regarded it as an admirable and authentic poem describing in detail, perhaps for the first time, an itinerary which then took twenty-four days to cover. Its accounts provided vital information for camel drivers, who, if they learnt the poem by heart, could use it as a complete map and guide along the route.

The writings of al-Harbi (died 898) complement the descriptions of al-Rada'i and al-Hamdani and to some extent confirm their indications. Al Harbi also provides useful details such as the names of the watering places between the main staging posts.

Other geographers, such as Ibn Khurradadhbih (died after 885), Qudama ibn Ja'far (died between 908 and 948), Ibn Hawqal (late 10th century), al-Muqaddasi (died c. 1000), al-Idrisi (died c. 1160), Ibn al-Mujawir (died after 1228), give more concise descriptions of the stages along the pilgrimage road.

Map of the Yemeni road

More recently, the expeditions of Philby, who travelled in the region in 1932 and in south-west Saudi Arabia in 1936–37, and the observations of the engineer Twitchell, who worked on the construction of a road between Abha and Najran around 1940, have provided us with sparse information on certain sections of the route.

The historic and cultural importance of the Yemeni road stems from the fact that it was already one of the ancient trading roads well before the advent of Islam, and was probably used as early as the 1st millennium BC, in conjunction with the incense road mentioned by classical sources.

With the emergence of Islam, trade decreased and these land roads began to be used by pilgrims coming from the south of the Arabian Peninsula rather than by commercial caravans. The Yemeni route had in the mean time been used by the armies of the Muslim conquest in 630–33.

Along this route, which crosses the 'Asir region, there are some seventy sites and ancient and Islamic archaeological remains, the most noteworthy being:
– the delimitation and clearing of the route over flat terrain, such as the Zahr desert, in the land of Khath'am, and the Rukba desert, near Ta'if;
– the paving and levelling of the route at impracticable points and in mountainous terrain, such as 'Aqaba Mahdha al-Ni'al, Aqawiya, al-Mandaj (al-Maslula) in the Wadi'a region, and 'Aqabat al-Shafshaf in the 'Ubayda Qahtan region, to the south-east of Khamis Mushayt;
– improvements made to watering places;
– the sites of the main and secondary staging posts;
– the mosques and places of prayer (*musalla*);
– the inscriptions and graffiti on rocks;
– the markers along the route, milestones, watchtowers, tombstones.

## The geography of the road

Geographically, the wadi of Shu'ub, to the north of the town of San'a', is regarded as the principal and official departure point of the Yemeni road. Its end, according to the first Arab geographers, is around the Jabal al-Manqib, near present-day Miqat, at the place known as al-Sayl al-Kabir (the great torrent).

The Saudi section of the route stretches between longitude 40° 30' and 40° east and latitude 21° 30' and 17° 31' north, traversing contrasting topography over an estimated total distance – as the crow flies – of some 800 kilometres. The most impracticable terrain lies in the south and south-east al-Sarawat mountains and the Harrat al-Buqum region, but the route also crosses flat terrain such as the al-Qa'a, Zahr and Rukba deserts.

## Improvements and the development of services along the road

We have no information about the constructions and improvements undertaken during the Umayyad period, probably due to Yemen's political isolation at that time.

It seems that the Abbasid Caliph al-Mahdi (775–85) was the first if not the only caliph to have contributed to the improvement of the Yemeni pilgrimage road. On his orders, a postal service was set up between the Hijaz and Yemen, due to the political unrest there. This initiative entailed the construction of a postmaster's house, milestones at precise points along the route, and watchtowers to ensure travellers' security.

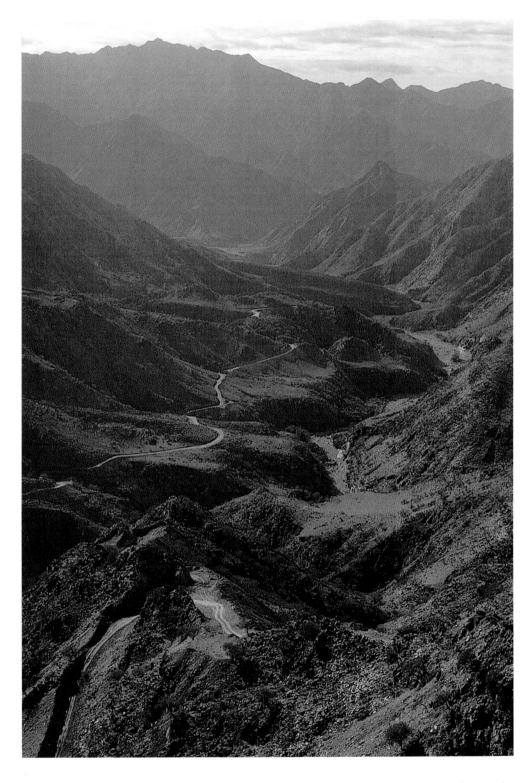

View of the 'Asir Mountains

The repairs to the road and the maintenance of water resources carried out during the relatively short reign of the Abbasid governor at San'a', Muhammad ibn Khalid al-Barmaki (799–800), are mentioned by the historian al-Razi.

The Ziyadid Emir Husayn ibn Salama (died 1011) developed the land route, building mosques with tall minarets, digging wells and installing water tanks at most of the staging posts. He ordered the erection of milestones all along the routes from Yemen to the Holy Places.

Queen Arwa, daughter of Ahmad al-Sulayhi (1099–1138), built staging posts and caravanserais such as the khan Din (Maramil), on the route between San'a' and Sa'da.

## The water reservoirs along the road

There are watering places all along the route, the best known of which are:

– the wells at al-Qa'a, a plain some 50 kilometres north-east of Khamis Mushayt, at the intersection of longitude 43° 03' 306" east and latitude 18° 29' 219" north;

– the wells at Kutna (Kutna al-Qa'), to the north-west of the present-day town of Ya'ra, at the intersection of longitude 43° 04' 935" east and latitude 18° 31' 755" north. Kutna is described by ancient geographic sources as a large village within which several wells could be used by travellers. The site and the surrounding area are dotted with rocks carved with graffiti and inscriptions, and apart from the wells, three kilns, and architectural remains, and ceramic fragments have also been found;

– the spring at al-Bardan, on the west bank of wadi Shaja', in the Zahran al-Janub region, between longitude 44° 00' and 43° 30' east and latitude 18° 00' and 17° 30' north. The poet Ahmad ibn 'Isa al-Rada'i mentioned this well in his poem, describing its abundant water and its use by pilgrims;

– the stream running through Mabrah, a mountainous region between longitude 44° east and latitude 17° 30' and 18° north, also mentioned by al-Rada'i. Along its banks, there are a numerous cave drawings of human beings and animals, and also ancient Arab inscriptions, one dating from the year 98 H./716–17. One can also see the remains of road's paving and edges;

– the spring at Jarab (or Ujrab), a locality to the east of the administrative boundaries of the Baha region, 45 kilometres to the north-east of the town of al-'Aqiq, at longitude 41° east and latitude 20° 28' north. It is mentioned by the geographer al-Hamdani and the poet al-Rada'i, and by other Arab geographers;

– the well at Runum (or Ibn Sarar), 55 kilometres south-east of the town of Bisha, between longitude 43° 00' and 42° 30' east and latitude 20° and 19° 30' north. It was described by several travellers, including al-Rada'i, al-Hamdani, and, more recently, Philby in 1936. There are undated ancient Islamic inscriptions on the volcanic rocks surrounding the site;

– the well at al-Thaja (or 'Arja'), to the south-east of al-'Arqin, 14 kilometres from Surum al-Fayd, at longitude 43° 19' 094" east and latitude 18° 12' 970" north. Al-Thaja is mentioned by the first Arab geographers as a post house and water supply point. Granite water basins were discovered by the well, and part of the ancient route, paved with local stone, is still visible nearby.

## The mosques and places of prayer

There are mosques and modest places of prayers all along the route, the most famous and probably most ancient being the mosque at Khalid, in the al-Thuwayla region, south-east of Zahran al-Janub, at longitude 44°-43° 30' east and latitude 17° 30'-17° north.

This historic mosque is on the north-east bank of wadi 'Amdan, which crosses the plain of 'Asida. Al-Hamdani and the poet al-Rada'i are the only early Muslim geographers and poets who mention it. The edifice covers a 21 by 15.5-metre rectangle, delimited by a dry-built volcanic stone wall and, as in al-Hamdani's description, has no roof.

Early Arabic inscription along the Yemeni road

## Rock inscriptions

Inscriptions and carvings on rocks, dating from the early years of Islam, have been discovered all along the route. They include:

– two milestones in the Zahr desert, some 35 kilometres north-west of the towns of Bisha and Tabala. The first, in wadi al-Qadif, bears a two-line inscription, in so-called "*hijazi* kufic" script, indicating a distance in *mil* (about 2 kilometres). The second milestone was discovered some 30 kilometres to the north-west of the first, in wadi Sha'b al-Khayl, and bears the same type of inscription;

– an inscription found in the Mabrah region, near the town of Zahran al-Janub, dated 98 H./716–17 and including the name of its carver: Thabit ibn Abi Tamim Sani' al-Jarar;

– an inscription dated 141 H./758, discovered on the Umm al-Rahi plateau, near the town of Tabala;

– an inscription dated 226 H./840 and two others dated 240 H./845, carved on the slopes of the Umm Waqr plateau, also in the Tabala region;

– a carving dated 327 H./938 discovered on the site at al-Hadiqa, in the province of Bisha;

– numerous undated rock carvings near staging posts and watering places along the route. Several of these are worth mentioning: the carvings found to the east and north-east of Zahran al-Janub: in the Qahra al-'Anz hills, at Rakiba, in wadi 'Amdan, on the slopes of al-'Arqa, al-Mandaj and Mabrah, in wadi Jawal and wadi Ithla; the inscriptions to the south of the town of Ya'ra: at al-Madabiya and Jabal Umm al-Qisas and Katna; the inscriptions to the north and south of the town of Bisha: in the village of Banat Harb (al-Ma'dan), at wadi Runum, at Tabala, in wadi Ada, wadi al-Qadif and wadi al-Khayi'. Two important inscriptions were found at al-Mandaj (al-Maslula), bearing the names of two emirs of the Yu'firid dynasty: Muhammad ibn Yu'fir ibn 'Abd al-Rahman al-Hawali (871–83) and his son Ibrahim ibn Muhammad ibn Yu'fir ibn 'Abd al-Rahman al-Hawali (883–98).

## Architectural work along the route

Precisely executed architectural works along the route, such as the clearing and paving of certain sections, especially in steep terrain, are still visible in places today, at Harrat Najd

(Harrat al-Buqum), Kara' al-Harrat al-Janubi, Kara' al-Harrat al-Shamali and al-Mandaj (al-Maslula).

## The ancient Islamic towns

Several of the towns used as camping posts by caravans played a historic and cultural role.

### Bisha

Bisha is now a large modern town in south-west Saudi Arabia. The ancient village of Nimran formed the core of the present-day town. The village gradually developed to engulf the neighbouring villages of Rushn al-Naghila and Rushn Bani Salul. Sources describe Bisha as a large, densely populated conglomeration with fertile land, palm trees and traversed by abundant streams. According to an Abbasid dirham, bearing the name of Caliph Harun al-Rashid (786–809) and a dinar bearing the name of the Abbasid Caliph al-Ta'i' (974–91), Bisha was also a centre for striking coinage.

### Tabala

The town, located some 35 kilometres north of Bisha, is mentioned by the first Muslim geographers. Its name is linked to a Pre-Islamic temple (also called the Yemeni Ka'ba). Subsequently, it was primarily associated with the Umayyad commander al-Hajjaj ibn Yusuf, appointed governor of the town by Caliph 'Abd al-Malik ibn Marwan (685–705). The first Muslim geographers stressed Tabala's importance and role as a stopover for pilgrims, at the point where the route rejoins the main Yemeni route. The historian Al-Hamdani describes it as a village of shopkeepers inhabited by members of the Quraysh tribe, and that people from the desert caused its destruction, without going into more detail. Recent research has revealed that Tabala was a mineral extraction centre: mines have been discovered nearby, at Sada', Manazil, al-Wakba and al-'Abla, and also furnaces and the remains of metallic scoria. In present-day Tabala, there are the ruins of an ancient fortress with a rectangular ground plan, surrounded by high walls with semicircular corner towers. The remains of other edifices are visible nearby, probably a mosque and its annexes.

### Banat Harb (al-Ma'dan)

The remains of this town lie 40 kilometres to the south-west of the town of Samkh. This village was mentioned by the first Muslim geographers as the main stopover point on the Yemeni pilgrimage route. It is also known for its gold-bearing deposits. There are a number of architectural remains on the site.

### Jurash

Jurash is located 25 kilometres to the south-east of the town of Khamis Mushayt and was known as one of the centres of trade and craftsmanship of the civilization in South Arabian Peninsula. Famous for its tanneries, Jurash rivalled with the towns of Ta'if and Sa'da. Apart from its industries, Jurash also seems to have been a military weapons training centre. It is recounted that Ta'if, during the siege in 628, sent 'Urwa ibn Mas'ud and Ghaylan ibn Salam to Jurash to be trained in the use of the catapult and other war machines. The fortified town of Jurash was taken in 631, without bloodshed, after a month-long siege. Its conqueror, Surad ibn 'Abdallah al-Azdi was appointed governor of the town. Jurash later became an active centre for the sciences of the *Hadith*.

Foundations of a mosque along the road, in the 'Asir

The architectural remains on the present-day site, are littered with antique and Islamic ceramic fragments, particularly from the Abbasid period. Recent exploratory excavations have revealed eight layers of occupation, the most ancient dating from the 1st century AD, and the most recent datable to the 11th century.

**Bibliography:**
Al-Athar 1420 H./2000; Al-Bakri, *Masalik*;
Al-Bakri, *Mu'jam*; Al-Baladhuri; Bunduqji
1400 H./1980; Al-Ghabban 1414 H./1993;
Al-Hamdani; Al-Harbi; Al-Harithi 1415 H./1994;
Al-Hijri; Humayd Allah 1407 H./1987;
Ibn Bulayhid 1399 H./1979; Ibn Hawqal;
Ibn Khurradadhbih; Ibn Manzur;
Ibn al-Mujawir; Ibn Sa'd; Al-Idrisi; Al-Isfahani;
Al-Jasir 1397 H./1977; Al-Kilabi 1424 H;
*Al-Mawaqi' al-athariya* 1420 H./2000;
Al-Muqaddasi; Qudama; Al-Rashid 1990;
Al-Rashid 1412 H./1991; Al-Rashid 1414 H./1993;
Al-Rashid 1416 H./1995; Al-Suluk *et al.*
1426 H./2005; Al-Tabari; Al-Thanayan 2005;
Al-Thanayan 1424 H./2004; Al-Ya'qubi; Yaqut;
Al-Zayla'i *et al.* 1423 H./2003.

# ARAB-ISLAMIC INSCRIPTIONS
# ON STONE

*Ahmad bin 'Umar Al-Zayla'i*

The great historian Ibn Khaldun describes writing in these terms: "(Writing) is the outlining and shaping of letters to indicate audible words which, in turn, indicate what is in the soul. It comes second after oral expression. It is a noble craft, since it is one of the special qualities of man by which he distinguishes himself from the animals."[1] There are also passages in the Quran that make reference to the importance of writing: "Not before this didst thou recite any Book, or inscribe it with thy right hand, for then those who follow falsehood would have doubted".[2] As for the *qalam*, a tool made of reed, used for writing and known to all, it too is mentioned in the Quran: "Nun, By the Pen, and what they inscribe . . .".[3] And Allah said to his prophet Muhammad: "And thy Lord is the Most Generous, who taught by the Pen, taught Man that he knew not",[4] in consequence of which Arabic calligraphy gained its unanimously recognized importance and became a vehicle not only of the Revelation made to Muhammad but also of the *Hadith* and treatises on Arab sciences. Even the administrative correspondence carried out on a daily basis in the chancelleries of the caliphate was carefully calligraphed from the time of their Arabization.

It is important to point out that calligraphy is one of the most refined of Islamic arts and unquestionably its most accomplished; its pure style was not influenced by the artistic forms that preceded its appearance in the world. Although some towns in the Hijaz used a certain type of Arabic script in the Pre-Islamic period, Arab–Muslim calligraphy only appeared with the arrival of Islam. Among the first calligraphic styles was that of Mecca and Medina, called "*hijazi*", cited in the sources that have come down to us, among them the *Fihrist* by Ibn al-Nadim (a complete index of Arabic books of the period), which describes it as follows: "In the calligraphies of Mecca and Medina, the letter *alif* ["a", which is transcribed with a vertical line] slopes and these calligraphies are distinguished by their slightly curved form".[5]

The Zuhayr inscription, dated 24 H./645

When the Muslims set out to conquer the neighbouring lands of Iraq, Syria and Egypt, they took with them and diffused use of the *hijazi* calligraphy. In Kufa, which was founded in 638, a new calligraphic style developed, marked by a certain rigidity and featuring right angles. This new Kufic form was exported to the various Muslim cities of the time, including Mecca, where it evolved remarkably.

Kufic calligraphy was used for inscriptions on stone and the writing of Qurans well before the appearance of scripts referred to as "cursive": *naskh, thuluth, nasta'liq* or *riqa', diwani, ijaza, tumar, maghribi,* as well as the many other appellations given to Arab–Islamic calligraphies named after places, people or functions, the type of paper used or its size, or again after the design of the letters and style of their ornaments.[6]

Let us focus our attention on the inscriptions on stone that have been discovered in the kingdom of Saudi Arabia. This vast country of strong geographical contrasts is crossed by numerous commercial and pilgrimage routes and their ramifications generated by towns, villages, water points, and stopovers where travellers rested and provisioned themselves before continuing their journey. A large number of engravings dating from the Islamic period have been found on rock walls in various parts of the country in the vicinity of these settlements and network of roads. They are engraved texts, usually very short, which seem to have been written by travellers, generally without any aim other than that of leaving a memento of their passing. The inscription of verses of the Quran, religious invocations, verses by the poets of the *Jahiliyya* or from the start of the Islamic period, may have provided their authors with a form of distraction or reassurance. In addition, sometimes a description is given of small, local events and a mention made of names known in the area of where the inscription is found.

The spontaneity of the texts may signify they were not of any importance in the eyes of their authors beyond the reasons mentioned above, but some of them are of great interest to historians as they convey local names, ancient poetry and invocations as well as the characteristics of the Arab script of the time, its styles of execution and the stages of its evolution.

Of the thousands of rock inscriptions discovered since the start of the 20th century, only some are dated, notably those from the three first centuries of the Hegira. One such important engraving is dated 24 H./645 and is the earliest inscription of the Islamic period.

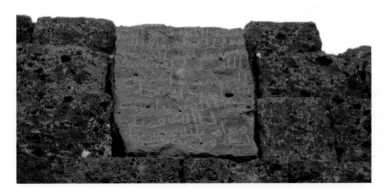

Caliph Mu'awiya's inscription on the Wadi al-Khanaq dam near Medina

This is the Zuhayr's inscription, which has been classified by UNESCO as a World Heritage site.[7] The oldest known inscription of this kind before this discovery was found in Assouan in Egypt, and bears the date 31 H./651–52.[8] Many of the rock inscriptions discovered in Saudi Arabia demonstrate a very controlled script with well-formed and easily legible letters and, with very few exceptions, with no diacritical marks (dots placed above or below certain letters to differentiate them).[9]

This type of engraving on rock is very widespread along the pilgrimage routes leading to Mecca, particularly on the roads from Syria and Iraq, and also on those of inland Yemen. A general archaeological topography of the kingdom of Saudi Arabia was undertaken with the support of the Ministry of National Education's Antiquities and Museum Office. This effort was continued when archaeology became an integral part of the Saudi Commission for Tourism and Antiquities, and when Saudi researchers discovered important rock engravings around Mecca, Medina and Ta'if, and on the large mountain chains in the regions of Baha, 'Asir and Najran.

Several sovereign or foundation inscriptions have also been discovered. These are texts engraved on constructions, generally dams and wells, but also milliary stones and decrees stipulating the length and the maintenance of roads. These types of inscription are rare as a number of these constructions have been destroyed, including by additions and extensions that have been made to the two holy mosques and several historic mosques in Mecca, Medina, Jedda, Ta'if and 'Ashm in particular.

Among the oldest examples are two inscriptions on the dams at Ta'if and Medina that date from the reign of the Umayyad Caliph Mu'awiya ibn Abi Sufyan (661–80). The National Museum in Riyadh conserves an inscription dated 304 H./916 that contains a decree promulgated by the Abbasid Caliph al-Muqtadir concerning the construction of the pilgrimage route from Iraq (Darb Zubayda) to Mecca (cat. no. 243). This was discovered by the geologist K. S. Twitchell in the region of Mahd al-Dhahab. George Miles produced a study of it in 1954 and it has been republished several times.[10]

Other foundation texts have been discovered on dams built in relatively later periods. Inscriptions have also been found on certain citadels along the Egyptian and Syrian pilgrimage routes, as well as in historic mosques and buildings in Mecca, Medina, Ta'if and 'Ashm, and in other parts of the country, but their dates are comparatively recent.

Milliary stones represent another important discovery. These were placed along the pilgrimage routes to indicate the distances to be travelled. They were expressed in *farsakh* (a league or parasang), *barid* (1 *barid* equals 4 *farsakh*) and in *mil* (approximately 2 kilometres). A small number have been found on the pilgrimage route from Iraq and upper Yemen (cat. no. 245). To these many rock inscriptions and sovereign or foundation texts can be added another important group of inscriptions for the study of Arab script: those on tombstones. These are found in various regions of the kingdom: primarily in al-Ma'la cemetery in Mecca,[11] but also in the region of 'Ashm (Mas'uda, Nasa'ib, 'Asda', al-Sirrayn, Hamdana, and others), al-Khuluf and al-Khalif in the region of Baha, and in Medina, Ta'if, Jazan, Najran, 'Asir and the east of the kingdom. Some of these are true masterpieces, in which the calligraphy and refined ornaments are of unparalleled beauty.

Taken as a whole, the rock wall inscriptions, official texts and tombstones provide an invaluable body of historical documentation, especially as regards the first centuries of Islam in Arabia, and shed exceptional light on the development of the early Arabic scripts during the Islamic age.

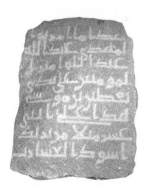

Milestone displaying the names of the Abbasid Caliph al-Mahdi (775–85) and his vizier. Jedda, King Abdulaziz Center, no. 33

1. Ibn Khaldun 1958, t. II, p. 377.
2. Quran, **29**, 48.
3. Quran, **68**, 1–2.
4. Quran, **96**, 3–4.
5. Ibn al-Nadim 1988, t. III, p. 9.
6. For greater detail, see Khatt 1406 H./1985–86, pp. 21–24, and al-Bahnasi 1999, pp. 54–59.
7. Discovered by Ali Ibrahim Al-Ghabban, then professor of Islamic archaeology at the Department of Antiquities and Museums at King Saud University.
8. Cairo, Museum of Islamic Arts, 1508/20, published in El-Hawary and Rached 1932, no. 1, p. 1, pl. I. Also see Jam'a, n.d., p. 131.
9. Al-Rashid 1423 H./2002, p. 6.
10. Al-Rashid 1993, p. 57.
11. See in this catalogue, Carine Juvin, "The Tombstones from the al-Ma'la cemetery in Mecca", p. 491.

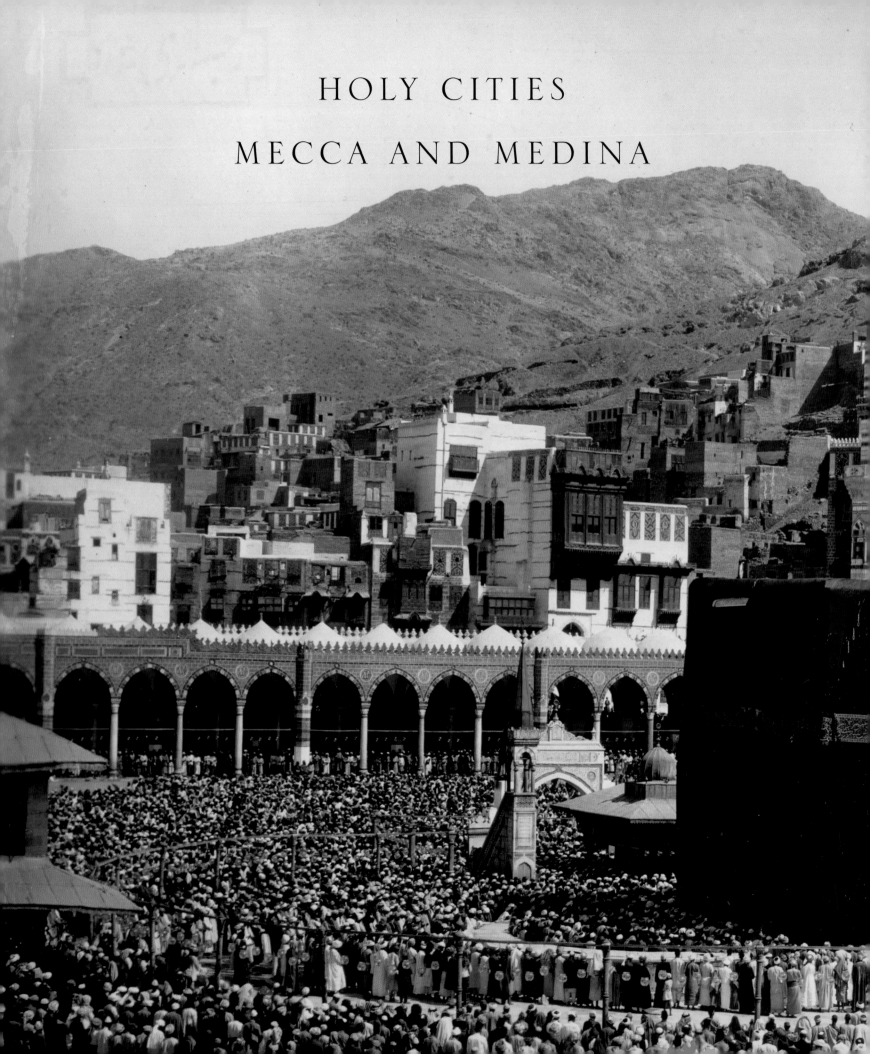

# HOLY CITIES
# MECCA AND MEDINA

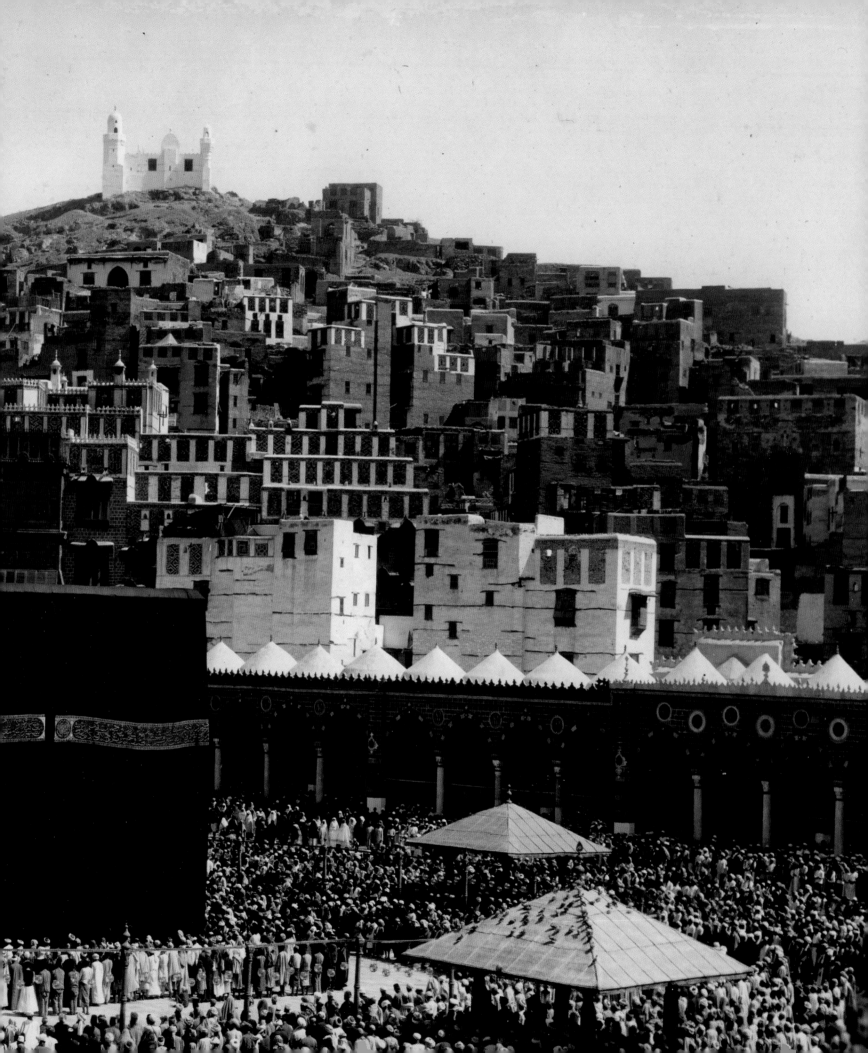

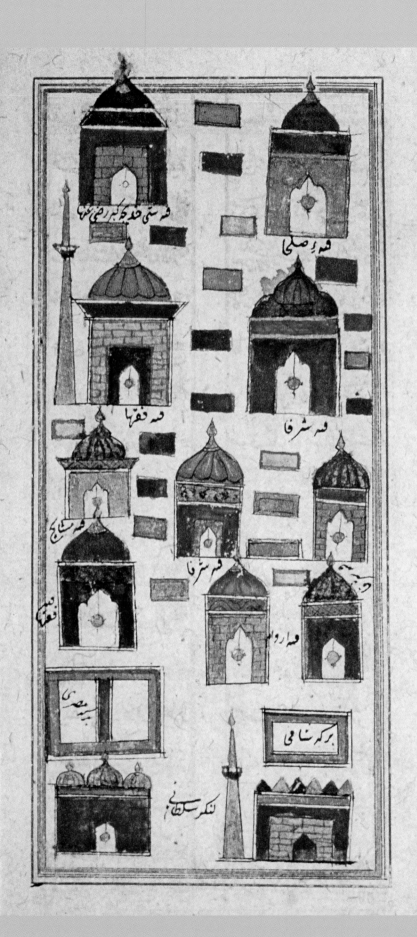

# TOMBSTONES
## OF THE AL-MA'LA CEMETERY
# IN MECCA

*Carine Juvin*

The tombstones from the al-Ma'la cemetery[1] in the little valley of al-Hujun north of Mecca are unquestionably among the most outstanding of all the treasures of Saudi Arabia's national heritage. This cemetery was the burial place of some of the leading figures of the early days of Islam. In the course of centuries it became renowned as a site for religious visits linked to the pilgrimage until it vanished in the 20th century, as a result of expanding urbanization and construction work in the holy city. Descriptions by travellers and pilgrims, along with some rare vintage photographs and a few manuscript paintings presenting a rather schematic and stereotyped view (fig. 1 and 3), provide a picture of this place of memory and devotion: plain graves with one or two stone stelae (at the head and feet of the deceased)[2] were raised next to mausoleums, small domed buildings.

*(preceding pages)*
View of the sanctuary at Mecca (the Ka'ba in the centre) by Mirza, 1890, King Abdulaziz Library, Riyadh

*(opposite)*
Fig. 1. The al-Ma'la cemetery, manuscript painting from *Futuh al-haramayn*, Istanbul, 1577, Bibliothèque nationale de France, Paris. Supplément Persan 1514, fol. 22 v°

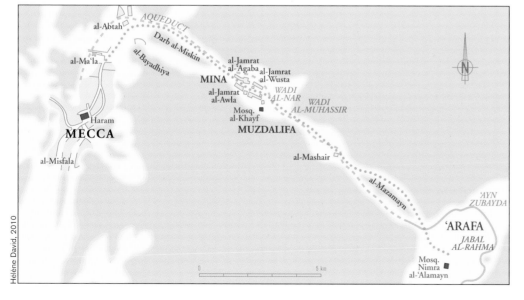

Fig. 2. Map of Mecca and the surrounding area

Helène David, 2010

1. Sometimes pronounced Mu'alla.
2. There is only one example of "twin" tombstones in the published corpus: Al-Rashid 2004, nos 394–493, dated 312 H./924.

491

## The graves: theory and practice

These monuments and stone slabs – found all over the Islamic world – contradicted the rules of the early Muslim austerity decreed in the *hadith* concerning the *taswiyat al-qabr*, "making the tomb level with the ground around it", implying that the tomb should not be marked by a sign or a structure. The domed mausoleums (*qubba*), in particular, were disliked by ulemas of all allegiances, and were sometimes even destroyed by strict doctrinarians, as happened in Mecca and the Baqi' cemetery in Medina. The mere fact of putting an inscription, naming the deceased and, even worse, of using Quranic quotations, was objected to on theoretical grounds. These constraints were rarely applied, however, and this now allows us to gather precious palaeographic, socio-anthropological and historical information, and to study these ancient testimonies of meditation in the face of death, turned towards divine mercy and the other world. If the outright marking a tomb or the naming of the deceased may have been considered futile or even reprehensible, apparently the visiting of graves was authorized and even encouraged, in accordance with a *Hadith* of the Prophet: "I had forbidden you to visit graves, but [now I tell you] whoever wishes to visit them may do so", to which some sources add: "because in them lies an example (warning)". In fact, according to the *Hadith* literature and the recommendations of the ulemas, both Sunnite and Shiite, a visit to the graves allows the believer to contemplate and meditate on the last hour while softening his heart.[3] Indeed the al-Ma'la cemetery was cited as a remarkable site to visit[4] in several accounts of travellers, geographers and historians, including Azraqi (9th century), al-Harawi (d. 1215), Ibn Jubayr (d. 1217), Yaqut (d. 1229), and Ibn Battuta (14th century). Two guidebooks on the cemetery were written in the early 15th century, when it had grown considerably, listing a certain number of epitaphs of noteworthy personalities: the first[5] was compiled by the linguist Majd al-Din al-Shirazi, known as al-Firuzabadi (1328/29–1414); the second, a selection completed by twenty-two epitaphs, recorded by Jamal al-Din al-Shaybi, a member of the illustrious Meccan family, custodian of the Ka'ba since the days of the Prophet.[6] The book is known under the title *al-Sharaf al-a'la fi dhikr qubur maqbarat al-Ma'la (The Highest Honour: Evoking the Tombs of the al-Ma'la Cemetery)*.[7] Another source of information on al-Ma'la tombstones is the history of Mecca written by Taqi al-Din al-Fasi al-Makki al-Maliki (1373–1428), titled *al-'Iqd al-thamin fi tarikh al-balad al-amin (The Precious Necklace or the History of the Faithful City)*, a sort of biographical dictionary which draws some of its information from the inscriptions in the cemetery. In a rare and particularly moving coincidence, one of the tombstones shown here (cat. no. 297) is among the epitaphs listed by al-Shaybi and al-Fasi: oddly, the date differs by a year[8] but it is clearly the same person, a renowned religious figure; in addition, al-Fasi recorded the signature of the famous stoneworker, 'Abd al-Rahman al-Harami al-Makki, which in fact features on the stele.[9]

Next to these valuable textual references, the corpus of the preserved al-Ma'la tombstones, published in length in 2004 under the direction of Sa'd Al-Rashid, groups together over six hundred inscriptions, which can be dated to between the 9th and the 16th centuries.[10] This impressive work of data recording and deciphering opens a vast field of study.

## Identities of the deceased

Barring one or two exceptions, the al-Ma'la epitaphs always name the deceased, thereby offering material for an onomastic study.[11] The Arabic name consists of the forename (*ism*), followed by the patronymic (*nasab*): "son/daughter of (*ibn/ibnat*) . . . son of . . ." usually going back at least two generations. This ancestry can be extended if the deceased belongs to a great lineage – descendants of the Prophet, a Companion of the Prophet, members of a dynasty or a lineage

3. On the questions of the legal status of the tombs and their visit see Sourdel–Thomine, *Qabr*, EI2, vol. IV, Leyde 1978, pp. 367–70, and in particular Diem and Schöller 2004, II, p. 13 and ff.
4. An al-Ma'la tombstone thus addresses the passer-by: "If you visit al-Ma'la and its graves . . .", al-Rashid 2004, no. 346B, dated 862 H./1458.
5. *Itharat al-hajun ila ziyarat al-Hujun*, manuscript preserved in Cairo, Schöller 2004, p. 304, nos 60–61.
6. Born and died in Mecca (1377–1433), after studying religious law in Baghdad, Shiraz and Zabid, he received the charge of custodian of the door of the Ka'ba, then of the entire sanctuary (*nazir al-haram*); he also served as a Shafiite judge and wrote a history of Mecca. He was buried in the al-Ma'la cemetery. See Diem and Schöller 2004, II, p. 305.
7. A manuscript is preserved in Berlin (Staatsbibliothek, Ms 6124); see Diem and Schöller 2004, II, p. 307.
8. Rabi 'II 614 H. according to al-Shaybi and al-Fasi, but dhu'l-Hijja 613 H. on the tombstone.
9. Diem and Schöller 2004, II, no. 139, pp. 483–84, where there is a confusion regarding the text recorded in the *RCEA*, no. 3808, established after al-Shaybi and not the preserved tombstone, which does not feature a poetic passage.
10. To be completed with al-Fa'r, 1984; Al-Rashid 1993; Al-Harithi 2005; *RCEA*, nos 3507, 3479, 3521, 3631, 3794, 3956.
11. On the Arabic name see Sublet 1991.

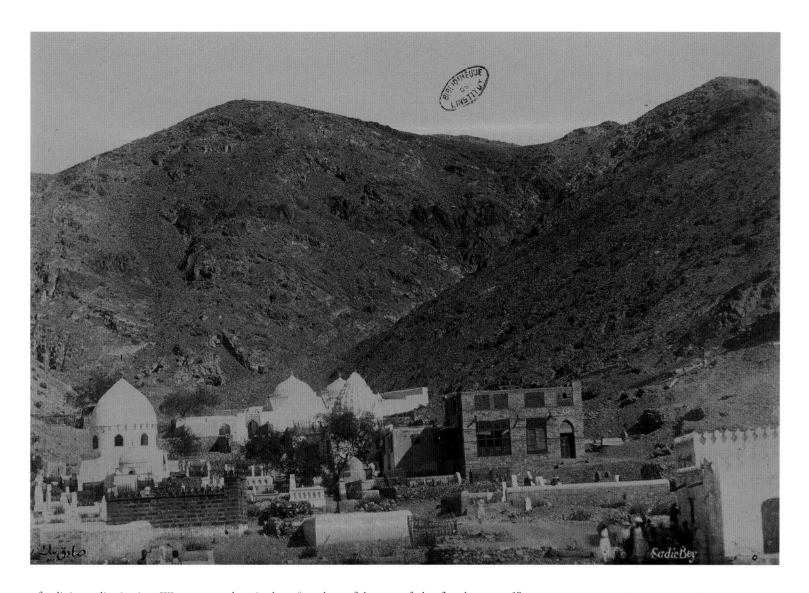

Fig. 3. An old photograph of the al-Ma'la cemetery taken by Sadiq Bey c. 1880. Institut de France Library, Paris, Schlumberger Collection

of religious dignitaries. Women can be cited as "mother of [name of the first-born son]" (*kunya*). In the 12th century the number of attributes and honorary titles escalated, making the deceased's name even longer. The names can also provide information on the geographic, ethnic and tribal origins of the individuals (*nisba*). We count at least fifty mentions of cities and regions, illustrating the steady influx in Hijaz of pilgrims and tradesmen from all over the Muslim world, from Spain to India; Iranians are particularly well represented. References to clans and tribes include: *al-Hashimi* (descendants of the Prophet, cat. no. 288), *al-Tamimi* (a great tribe of Central Arabia), *al-Shammar* (a tribal confederation from the north of the peninsula), *al-Makhzumi* (a great Meccan family), *al-Lakhmi* (a tribe settled in the north-east of the peninsula) and *al-Ghassani* (a tribe settled in the north-west).

The epitaphs occasionally contain information about the deceased's profession: the occupations of money-changer (*sarraf*/*sayrafi*) and perfumer–apothecary (*'attar*) appear several times, and must have been flourishing and lucrative activities in Mecca. Here and there we also run into craftsmen: a painter (*dahhan*), a clothes salesman (*bazzaz*), a specialist in silks (*haririya*), a "polisher" (*sayqal*), a cobbler (*kharraz*). Other occupations relate to a more intellectual activity: a bookseller (*warraq*), a master or a teacher (*mu'allim*), a secretary (*katib*). Unsurprisingly, the most frequent references concern tradesmen (*tajir, khawaja*) and especially,

as of the 12th century, functions linked to the religious sciences: *faqih* (jurist), *imam*, *mufti*, *qadi*, *qadi al-quda* (supreme judge), *shaykh al-haramayn* (religious leader of the two sanctuaries), *nazir al-haram al-sharif* (custodian of the holy sanctuary). In addition to these religious personalities, the epitaphs of persons of high lineage have also been preserved: descendants of 'Ali, the Prophet's cousin and son-in-law (cat. no. 291 and 288), 'Umar ibn al-Khattab, Companion of the Prophet and second Caliph (cat. no. 290), and al-'Abbas, the Prophet's uncle. And, among the tombstones listed by al-Fasi and al-Shaybi we should mention those of a woman connected with the Abbasid Caliph al-Mustazhir (1094–1118),[12] a Yemenite princess,[13] a Fatimid emir,[14] and a rich Iranian shipowner merchant (*nakhudha*),[15] Shaykh Abu'l-Qasim Ramisht, also known as the founder of a Sufi convent in Mecca.[16]

## Content of the epitaphs

The name of the deceased was included in a formulary way which varied over time and according to the specific requests of the commissioners. The epitaphs always begin with the *basmala*: "In the Name of God, the Merciful, the Compassionate". On the oldest tombstones it is usually followed by a prayer to the Prophet Muhammad (*tasliya*) (cat. nos 286 and 288), and sometimes by the profession of faith (*shahada*): "There is no god but God . . ." In the first centuries the following Quranic passages were frequently quoted: the short "al-Ikhlas" surat (112) – "Say: 'He is God, One, God, the Everlasting Refuge, who has not begotten, and has not been begotten, and equal to Him is not any one'." (cat. nos 287, 292 and 295); surat 33, verse 21 – "You have had a good example in God's Messenger for whosoever hopes for God and the Last Day, and remembers God often." (cat. no. 291); surat 2, verse 256 – "God there is no god but He, the Living, the Everlasting. Slumber seizes Him not, neither sleep; to Him belongs all that is in the heavens and the earth. Who is there that shall intercede with Him save by His leave? He knows what lies before them and what is after them, and they comprehend not anything of His knowledge save such as He wills. His Throne comprises the heavens and earth; the preserving of them oppresses Him not; He is the All-high, the All-glorious." (cat. nos 290, 292); surat 56, verses 49–50 – "Say: The ancients, and the later folk shall be gathered to the appointed time of a known day." (cat. nos 285, 288 and 289). Later we observe the diversification of the Quranic passages, among which figure surat 55, verses 26–27: "All that dwells upon the earth is perishing, yet still abides the Face of thy Lord, majestic, splendid." (cat. nos 294 and 299); surat 4, verse 100: "[. . .]Whoso emigrates in the way of God will find in the earth many refuges and plenty; whoso goes forth from his house an emigrant to God and His Messenger, and then death overtakes him, his wage shall have fallen on God; surely God is All-forgiving, All-compassionate." (cat. no. 297); and surat 54, verses 54–55: "Surely the godfearing shall dwell amid gardens and a river in a sure abode, in the presence of a King Omnipotent." (cat. no. 295).

The name of the deceased is introduced more specifically by several formulas: the most frequent on undated tombstones in the early centuries is: "Put (*ij'al*) [name of the deceased] among the winners/among the Companions of Muhammad in Paradise/among his relatives". Less frequently: "Forgive (*ighfir*)". Subsequently these formulas disappeared and were replaced by: "This is the grave of... (*hadha qabr*); the date was introduced by: "He died on...(*tuwuffiya*). The dated tombstones indicate, in addition to the Hegiran year, the month and day of the death, which for the most part coincide with the period of the pilgrimage. To die as a pilgrim and be buried near the *haram* was clearly an enviable fate for believers. A tombstone bears the name of a shaykh who died at 'Arafa while accomplishing the *mawqif* rite (cat. no. 297). This was also the ultimate goal of those who had chosen to retire in the vicinity of the shrine

12. *RCEA*, VIII, no. 3017, Shaybi, folio 276.
13. *Ibid.*, no. 3156, Shaybi, folio 13a.
14. Diem and Schöller 2004, II, no. 125, p. 475.
15. *RCEA*, VIII, no. 3099, Shaybi, folio 27; Diem and Schöller 2004, II, p. 474.
16. Mortel 1998, pp. 33–34.

(*mujawirun*).[17] A woman's epitaph specifies that she died at al-Husayb (Yemen) during the month of *ramadan* 546 H./1151 and that her remains were conveyed to Mecca and buried in al-Ma'la in the pilgrimage month of the following year.[18] In principle it was forbidden to reopen a grave to place a new body in it. Nonetheless at least two cases of a father buried with his child were found. One of them shows that the son died a year after his father[19]; another one gives only the date of the daughter's death (cat. no. 294).

The epitaphs of the first centuries usually end with "Amen, Lord of the Worlds", "May God extend His Mercy upon him" or formulas of prayer and blessing to the Prophet. Later the epitaph often ended more abruptly on the date of the death, and more rarely with an address to the visitor (cat. no. 299). As of the 12th century poetic excerpts on the theme of death, separation and salvation occasionally enhanced the usual formularies, reflecting the literary culture of the Meccan elites (cat. no. 295).

## Calligraphy and ornaments

The Ma'la tombstones are also remarkable for the quality and variety of their scripts. Their support is always in basalt stone from the nearby mountains, the same stone used for construction in Mecca. These very hard blocks of stone were not squared off to make them even; they were used as they were, and the script was adjusted to the surface – sometimes wavy – available to the sculptor. For the same reasons the inscriptions were executed in very slight relief: either simply engraved (which seems to be the oldest technique) or pared on a specked field. The two techniques were most certainly used at the same time, but in the 10th and 11th centuries the practice of paring prevailed.

Just like the silence of the oldest Quranic manuscripts regarding the date of their copying, the first al-Ma'la tombstones remain mute on the subject. It is tempting to assign the simplest, even the clumsiest, to the 8th and 9th centuries. However the means and social status of the deceased have to be considered. The first al-Ma'la stele featuring a date appears only in 304 H./916.[20] Several tombstones are spaced out over the 10th century. To find older reference points we have to turn to examples outside of Mecca: principally at 'Ashm, 300 kilometres south of Mecca, where three published inscriptions[21] present earlier dates: 262 H./875–76, then 285 H./898 and 289 H./902. These tombstones are remarkable in that they bear the stoneworkers' signatures. Examples of even older scripts were discovered on rock walls in various locations in Saudi Arabia, dated to the 7th and 8th centuries.[22] In-depth comparisons between these different data would probably help to refine the chronology of the earliest al-Ma'la tombstones. However, we can already attempt to define several groups of scripts according to the design of a number of letters and the ornaments associated with them. Among the undated stelae, which appear to be the oldest, some display a rather crude tracery (engraved);[23] others, conversely, are distinguished by a meticulous script, a very regular articulation and sometimes even the use of *mashq* (stretching the letters) recalling Quranic scripts.[24] A first well-defined group (cat. nos 284 to 288), quite rare in the corpus of al-Ma'la inscriptions, features a delicate script, the open form of the letter *'ayn*, curved slopes at the endings, the highly stylized form of the word "Allah" and a mannerist treatment of various *ya'* of which the beginning, forming a trifoliated bend, is prolonged by a reversed line sometimes extending as far as the preceding word. This group is also characterized by a rather exuberant but extremely elegant décor, dominated by a multifoil resembling a palmette. This type of angular script, floriated and refined, can be attributed to the second half of the 9th century, by comparison with the 'Ashm tombstones.[25] A second group (cat. nos 291 and 292) derives from the preceding

17. Al-Rashid 2004, no. 586: epitaph of a *mujawira* (female shrine custodian). See also a stele of the Musée du Louvre (MAO 1224) of a *mujawir* merchant, published in Bittar, 2003, no. 48, pp. 126–30.
18. Epitaph listed by al-Shaybi; see Diem and Schöller 2004, II, no. 126, pp. 475–76.
19. Al-Rashid 2004, no. 464.
20. *Ibid.*, no. 201. Another inscription, no. 585B, bears the date 265 H./879, but its fragmentary character, without a name and with an atypical text, is problematical.
21. Al-Zayla'i 2000, nos 2–4, pp. 247–50.
22. See in particular Grohmann, 1962; al-Rashid, 1995; Kawatoko, 2005.
23. Al-Rashid 2004, no. 177A, which does not name the deceased; it could be attributed to the 8th century.
24. *Ibid.*, nos 87, 101.
25. To which should be added two marble tombstones in the Islamic Art Museum in Cairo signed by an artisan "al-Makki" and dated 243 H./857.

Fig. 4. Pilgrimage certificate dated 594 H./1198. TIEM, Istanbul, 4752

one: it has the same characteristics but without the mannerist reverse treatment of the *ya'* and with a new curving of certain letters; furthermore, the vegetal motifs are more discreet and favour half-palmettes. A third group comprises a greater number of tombstones datable to the 10th and early 11th centuries, offering a far plainer décor: a rectilinear frame sometimes in the form known as *tabula ansata*, which matches the simplicity of the rather monotonous angular script with barely emphasized verticals (cat. nos 289 and 290). These 11th-century tombstones illustrate the evolution of the angular script – generally called Kufic or more recently "ancient Abbasid script"[26] – and often the object of new experiments. We should point out that if some scripts have parallels in the manuscripts, the al-Ma'la tombstones and lapidary inscriptions in general developed in their own particular way. As a result, they dispense entirely with the script known as "Oriental Kufic", or "new style",[27] which appears in 10th- and 11th-century manuscripts. Conversely, we find several examples of a floriated angular script with complicated outlines; on some of them, the lines of script are plaited, misleading the eye (cat. no. 293). These tombstones are chronologically well-defined, with dates between 432 H./1040 and 478 H./1085,[28] and appear to echo the latest fashion of Fatimid Egypt. In the 12th century the process of making the outline of the letters more rounded was completed: the script became "cursive". In the late 12th century, after the first tentative steps (cat. no. 294) still recalling the old manner, a delicate *naskh* script was adopted. With it came a practice found also in Quranic manuscripts, chancery documents or again in contemporary pilgrimage certificates (fig. 4),[29] that is, the enhancing of a line of script by a change in the size and body of the letters, which interrupts the monotony of the ensemble and makes the composition lighter. This embellished line introduced the name of the deceased. Last, the use of diacritic and vocalization signs, hitherto absent or almost absent became widespread. These tombstones, which belong to the late 12th and the first quarter of the 13th centuries – with a few later examples (cat. no. 298) – also adopted a new décor: a rectangular form frames a niche with a pointed arch with adorned spandrels, on which a lamp is suspended, sometimes framed by two small candlesticks. This, of course, should be interpreted as a *mihrab* and probably an allusion to the surat 24, verse 35, which begins thus: "God is the Light of the heavens and the earth; the likeness of His Light is as a niche wherein is a lamp, the lamp in a glass, the glass as it were a glittering star". This iconography is found at the same time in Iran on large ceramic tiles; it also appears on late 12th-century Egyptian tombstones.[30] On contemporary pilgrimage certificates an identical *mihrab* is represented on the summit of the Mount of Mercy at 'Arafa, the site of the essential rite of the *mawqif*, or that of the believer standing before God (fig. 5).[31] Last, among the preserved al-Ma'la tombstones there are twenty or so later epitaphs, dating from between the 14th and 16th centuries. Their relative infrequency raises some questions: does it reflect a change in the funerary practices or is their preservation the result of a choice or mere chance? The same remark is true for Egypt and the Levant. We observe at this time the development – at least for important personalities – of funerary monuments which were less resistant to time and suffered more from destructions of an ideological nature. An interesting al-Ma'la stele of the Mamluk period, dated 902 H./1497, alludes to the *qubba* (domed structure) above it.[32] The layout of the inscriptions sometimes emulates that of the preceding period, adopting an arch-shaped frame and is often organized in clearly defined registers (cat. no. 299). The scripts are more or less meticulous and closely reflect the overall evolution of epigraphy at the time: influence of the *thuluth* script, elongated vertical stems, accentuated "thickness" of the bodies of the letters. An exceptional late example (cat. no. 300) attests a superb mastery in calligraphy and a new-found freedom suddenly springing from a vein that had seemed to have run dry.

26. Déroche 1992, pp. 34–47.
27. *Ibid.*, p. 132–37.
28. See Schneider 1983, in particular nos 167, 187, 195, 198, for similar examples.
29. Aksoy and Milstein 2000, pl. 2.
30. Wiet 1939, no. 2341, v. VI, p. 201.
31. Aksoy and Milstein 2000, pls. 7–8, pp. 125–26.
32. Al-Rashid 2004, no. 308.

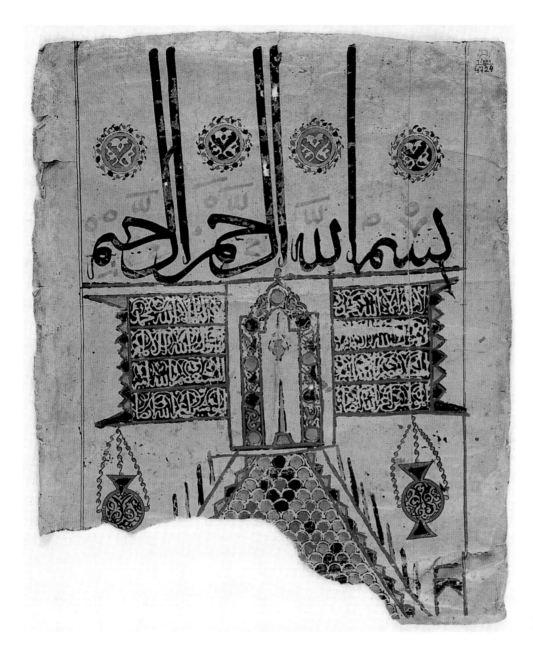

Fig. 5. Pilgrimage certificate with an image of Mount 'Arafa, mid-13th century, TIEM, Istanbul, 4724

## Making the tombstones: Meccan stoneworkers

After studying the corpus of the al-Ma'la stelae, we can venture a few remarks about how they were made. First, we note the occasional practice of reusing older tombstones to inscribe a new epitaph on the back (cat. nos 285, 294, 300); this may be due to the use of basalt stones, which are difficult to carve and probably burdensome to fetch and carry from the nearby mountains. Two cases reveal a gap of less than one century between the two utilizations.[33] Another example, which also illustrates how the stoneworker proceeded, shows that a tombstone could be installed before completion[34]: at the end of the pared text, the outline of the letters was sketchily incised but these letters were not separated from the field by pecking as was the case for the rest of the text. Furthermore two other inscriptions[35] enlighten us about a possible commission and execution procedure: the text was entirely carved – including the name of the deceased – save the date of death, which was casually added at the bottom or the top of the stele by means of a simple engraving. This indicates

33. *Ibid.*, nos 152A/B and 519A/B (with thirty-six years in between).
34. *Ibid.*, no. 151.
35. *Ibid.*, nos 365, 394.

that the stelae were commissioned before the death of the defunct, by the person himself or his close relatives, and the date hastily carved at the time of the burial.

Meccan stoneworkers probably had no lack of work given the appeal of being buried near the sanctuary, particularly during the yearly pilgrimage when a large crowd from all over the Muslim world converged there after a long and arduous journey. Signatures of craftsmen are relatively rare on Meccan tombstones: one "Ibrahim" signed an epitaph attributable to the late 9th or 10th century (cat. no. 292). For the later periods we record two mentions of a certain "Muhammad" on tombstones of the same style, one of which is dated 824 H./1421. On the other hand, in the late 12th and early 13th centuries there was an escalation of signatures, associated with the group of tombstones with the *mihrab*-shaped décor. These involved members of a same family: the uncle 'Abd al-Rahman ibn Abi Harami al-Makki[36] and his nephew Muhammad ibn Barakat. They belonged to a family of stoneworkers whom Madeleine Schneider brought to light in her study on the Dahlak Islands tombstones.[37] Indeed the names of these two workers, and those of the father of 'Abd al-Rahman, Muhammad Abi Harami, as well as the two sons of 'Abd al-Rahman, Yahya and Ahmad, feature on several Dahlak (Kebir) tombstones or attributed to Dahlak by Schneider[38] who, when the al-Ma'la stelae had scarcely been published situated their activity on this island.[39] The author pointed out that these artisans were "also" very active in Mecca, but given their *nisba*, and above all the considerable corpus of inscriptions they signed in Mecca, Schneider's assessment should obviously be revised. The account of this corpus deserves to be presented: in all, by the various publications, we know of twenty-three tombstones executed by this family, including eleven by 'Abd al-Rahman, six by his nephew Muhammad and three signed jointly.[40] These two stoneworkers were active from 563 H./1168 to 620 H./ 1220s. One[41] of the al-Ma'la tombstones signed by Muhammad ibn Barakat is the epitaph of a member of their family, a youth, "Muhammad ibn Salih ibn Abi Harami", also designated as a member of the Bani 'Attar. The stoneworker calls himself "Muhammad ibn Barakat ibn Harami al-'Attar": did they originate from a family of perfumers, one of the most flourishing activities in Mecca for the needs of the pilgrims and the shrine? The names and qualities of the deceased show that the Abi Harami family worked for the elite of the holy city or its outskirts: religious dignitaries, family of the Hassanid sharifs and members of the reigning dynasty of Dahlak.

But 'Abd al-Rahman ibn Abi Harami al-Makki did not confine his activity to tombstones; his fame – or the lack of competition in this city where, as the sources constantly remind us, there was a great shortage of artisans – brought him other types of commissions. Thus he executed in Mecca five inscriptions commemorating the construction of a basin at 'Arafa,[42] the Muzaffar al-Din madrasa[43] and two other buildings.[44] The first two works were commissioned between 1190 and 1223[45] by an eminent personality, the great emir Muzaffar al-Din Kokburi, lord (*sahib*) of Irbil in Northern Iraq, in the name of the Abbasid Caliph al-Nasir. This detail should be put in perspective with a stone slab preserved in the Iraq Museum but originally from the mosque of the *imam* Ibrahim in Mossul.[46] The stone, which was attributed to the late 11th century because of its inscription,[47] is believed to be the oldest representation of the Meccan sanctuary. But the characteristics of its script and above all its signature – 'Abd al-Rahman ibn Abi Harami al-Makki – which had not been taken into consideration,[48] lead us to attribute it to the early 13th century in Mecca. How and why did this slab arrive in Mossul? The hypothesis that the stoneworker had moved to Iraq is improbable. It is tempting to imagine that this inscription was commissioned in Mecca by the master of Irbil, Kokburi – Irbil is very close to Mossul – to a stoneworker who

36. Abi Harami al-Makki: literally, "from the Haram, the Meccan".

37. Schneider 1983.

38. Eleven in all.

39. Schneider 1983, p. 78.

40. In addition to the ones published by Schneider see Al-Rashid 2004, nos 266, 453, 507, 556; *RCEA*, nos 3479, 3521, 3631, 3956; a tombstone cited by al-Fasi (Diem and Schöller 2004, II, no. 135, pp. 480–81); a fragment of a tombstone in the Musée du Louvre (Bittar 2003, no. 50, p. 135); a tombstone in the British Museum (Bittar 2003, fig. 50, p. 137); and last an unpublished tombstone (cat. no. 296). Other unsigned tombstones might also be attributed to them by comparing styles.

41. Al-Rashid 2004, no. 556 (dated 599 H./1203), listed by Al-Fasi (Diem and Schöller 2004, II, no. 138, pp. 482–83).

42. *RCEA*, IX, nos 3507–3508; Al-Fa'r, 1984, nos 58–59, pp. 310–18 (dated 594 H./1197–1198).

43. Al-Fa'r 1984, no. 61, pp. 323–28 (dated 605 H./1208–1209).

44. *Ibid.*, no. 62, pp. 329–32 (dated 614 H./1217–18), and *RCEA*, IX, no. 4042 (dated to the years 620 H./1220s).

45. Cahen, *Begteginides*, EI2, vol. I, Leyde, 1960, p. 1195.

46. Inventory: 'Ayn 1149; the inscription mentions a mosque built by the emir Ibrahim al-Jarahi and the adjoining *turba* (mausoleum).

47. See Strika 1977 and 1979; also mentioned as such in Grabar 1985, no. 3, p. 6.

48. By Strika in any case; the *Thesaurus* (no. 26782) indicates that it had been read in an Iraqi publication: Salman 1975, p. 52.

had already worked for him: 'Abd al-Rahman. The commission included a representation of the shrine, unusual to him, but the model was at hand: he literally copied the pilgrimage certificates executed at the same time.[49] The reason for such a commission? Kokburi was renowned for his piety as his works in Mecca and his city of Irbil[50] prove; he may have responded to a request from a person linked to the Mossul mosque, or else he wished to take away with him a souvenir, – even better: a piece of the holy land of Hijaz. This brings us back to the question of the circulation of these tombstones outside of Mecca. One of them has been reported in Aden, Yemen, some are connected to Dahlak, others were found at Qus in Upper Egypt – all three important transit places for merchandise and persons on their way to the holy precincts. The "*roitelets*"[51] (little kings) of Dahlak commissioned the famous Meccan stoneworkers to carve tombstones in the latest fashion for their family, stelae of which the value was doubtless increased and sanctified by the origin of their material.

Whatever the case may be, the Abi Harami al-Makki lineage disappeared shortly after 1230. 'Abd al-Rahman's long and intense career was concomitant with a surge of pious foundations in Mecca,[52] probably in part connected with the "Sunni revival" that marked the 12th century.

This survey, inevitably incomplete, strives to emphasize the importance of the al-Ma'la tombstones and the abundant source of information their publication provides to scholars and those interested in this field. Al-Fasi[53] was right: they are a part of the memory of the holy city, a microcosm within the Islamic macrocosm. The epitaph of an Iranian merchant singularly specifies: "originating from Nishapur, resident in Balkh, he was born in Mecca on the night of the new moon of the month of *sha'ban* in the year [3]15 H./[9]27 and he left the world here below in the fourth night, twelve days before the end of *ramadan* of the year 415 H./1024". Doubtless his exceptional longevity – one hundred Hegiran years! – deserved to be mentioned. In these few lines, a summary: from the new moon to a holy night of *ramadan*, a life spent trading, along the roads all the way to Khurasan, born and dying in Mecca.

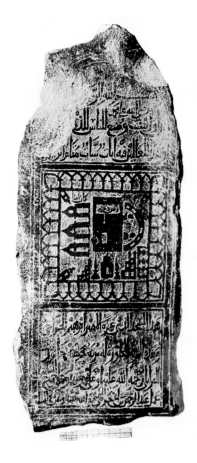

Fig. 6. Stone slab depicting the sanctuary of Mecca, signed 'Abd al-Rahman ibn Abi Harami al-Makki, Iraq Museum, Baghdad

**49.** Aksoy and Milstein 2000, fig. 3, p. 111.
**50.** Where he had notably set up commemorative celebrations of the *mawlid* (birth of the Prophet), see note 42. He was also the commissioner of the *minbar* in the mosque of the Hanbalites in Damascus.
**51.** Wiet 1952, pp. 89–95.
**52.** Mortel 1997 and 1998.
**53.** See *supra*, at the beginning of the text.

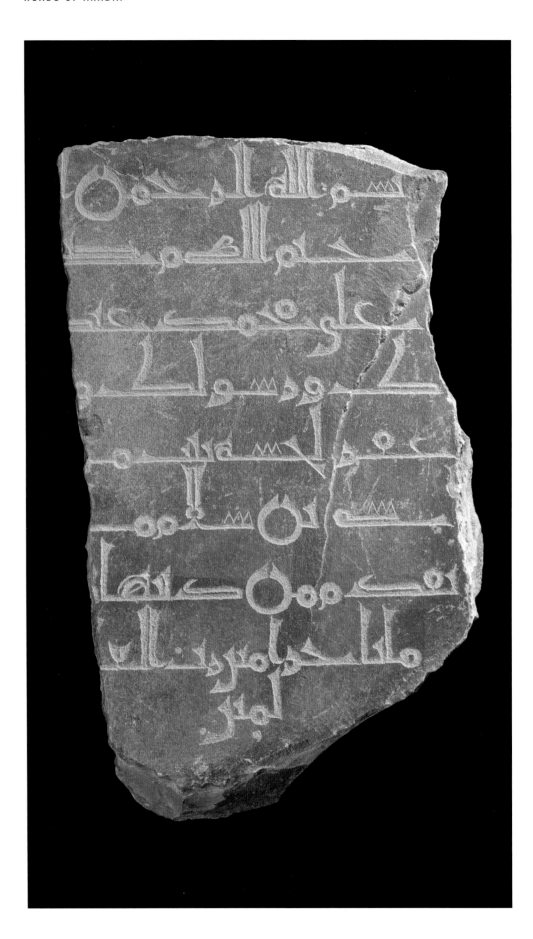

**283. Tombstone of Hasa,
daughter of Musa, son of Salam**
9th century
Basalt
40 x 18 cm
Provenance unknown
King Fahd National Library, Riyadh, 314879

Bibliography: unpublished.

بسم الله الرحمن ا
[الرحيم اللهمّ ص‍[لّى]
على محمّد عبد
ك و رسولك و
[ا]غفر لحسة بنت م[و]
سى بن سلام م ...
... من ذنبها ...
ما بأخر أمين رب ألعا
لمين

The epitaph is minimal: *basmala*, salutation on the Prophet, name of the deceased, closing exclamation ("Amen! Master of the two worlds!"). The script, at once plain and stylized, features a wide *nun* (the letter "n") forming a ring.

**C. J.**

**284. Tombstone of Umm 'Abdallah**

9th century
Basalt
69 x 31 cm
Provenance unknown
King Fahd National Library, Riyadh, 314716

Bibliography: unpublished.

بسم الله
الرحمن الرحيم
قل يا عبادى ٱلذين
أسرفوا على نفسهم لا
تقنطوا من رحمة الله إنّ الله
يغفر الذنوب جميعاً إنّه
هـو الغفور الرحيم اللهم*
أجعل أم عبد الله أم و
لد أزهر بن عبد الغفار
من...جنات النعيم

*Quran, **39**, 53

The plainness of the text is characteristic of the early centuries: *basmala*, a quote from the Quran, name of the deceased according to the formula "Place [name] in paradise". The deceased is named "Umm 'Abdallah umm walad Azhar ibn 'Abd al-Ghaffar", meaning: "Mother of 'Abdallah, mother of the child of Azhar, son of 'Abd al-Ghaffar", without specifying her first name. The expression "umm walad" indicates the servile condition of this woman who doubtless had a son by her master, Azhar, thus acquiring a new status.                    **C. J.**

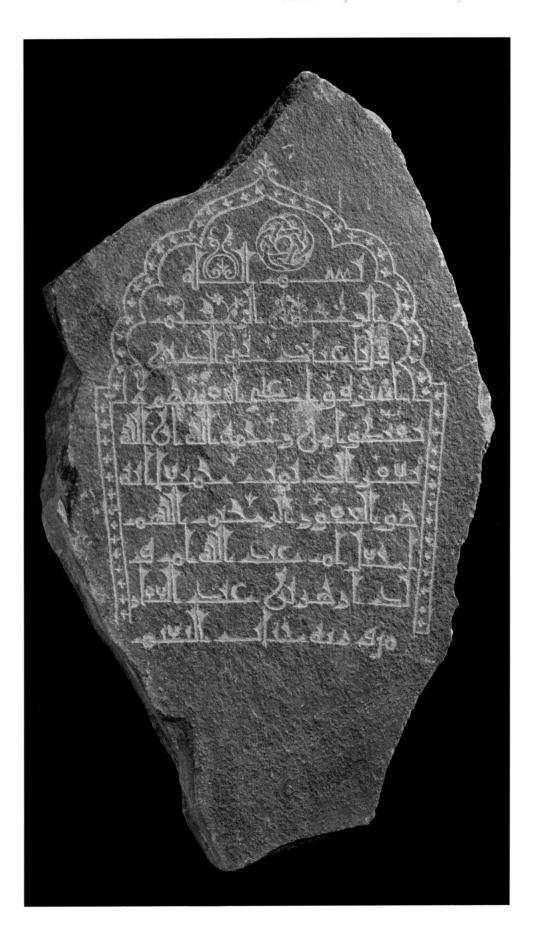

501

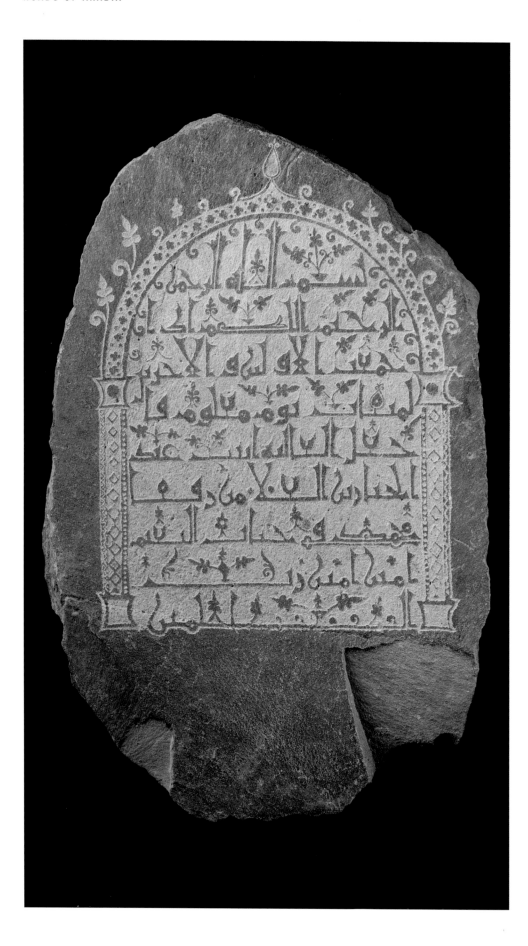

**285. Tombstone of al-Ghaliya, daughter of 'Abd al-Jabbar, son of al-'Ala**
9th century
Basalt
69 x 45 x 13 cm
al-Ma'la cemetery, Mecca
National Museum, Riyadh, 497A

Bibliography: Al-Zahrani 2003, pp. 126–30; Al-Rashid 2002, pp. 36–37; Al-Rashid 2004, no. 497A, p. 542.

بسم الله الرحمن
الرحيم اللهمّ إذا
جمعت الأوّلين و الآخرين
لميقات يوم معلوم* فأ
جعل الغالية إبنت عبد
الجبّار بن العلا من رفقاء
محمّد فى جنّات النعيم
آمين آمين ربّ
العالمين

* Quran, **56**, 49–50

The epitaph proceeds in this order: *basmala*, quote from the Quran, introduction of the name of the deceased in keeping with the formula "Place [name] among the companions of Muhammad in Paradise", closing exclamation. The exquisite floriated script and its refined frame give the stele a feminine touch. The tombstone was later re-utilized upside-down for the grave of a religious man who died in 1275.　C. J.

**286. Tombstone of 'Abbas, son of 'Abdallah, son of Muhammad, son of Nasih**

9th century
Basalt
61 x 35 x 11 cm
al-Ma'la cemetery, Mecca
National Museum, Riyadh, 451

Bibliography: Al-Zahrani 2003, pp. 344–47;
Al-Rashid 2004, no. 451, p. 496.

بسم الله الر
حمن الرحيم
اللهمّ صلّى
على محمّد النبي وا
جعل عبّاس بن عبد
الله بن محمّد بن ناصح
لوالديه ذخرا و نجاة
من النار

The elegant decoration and script attest that in Mecca delicacy was not only feminine. . . The epitaph is quite similar to the preceding one, without the Quran quote.

C. J.

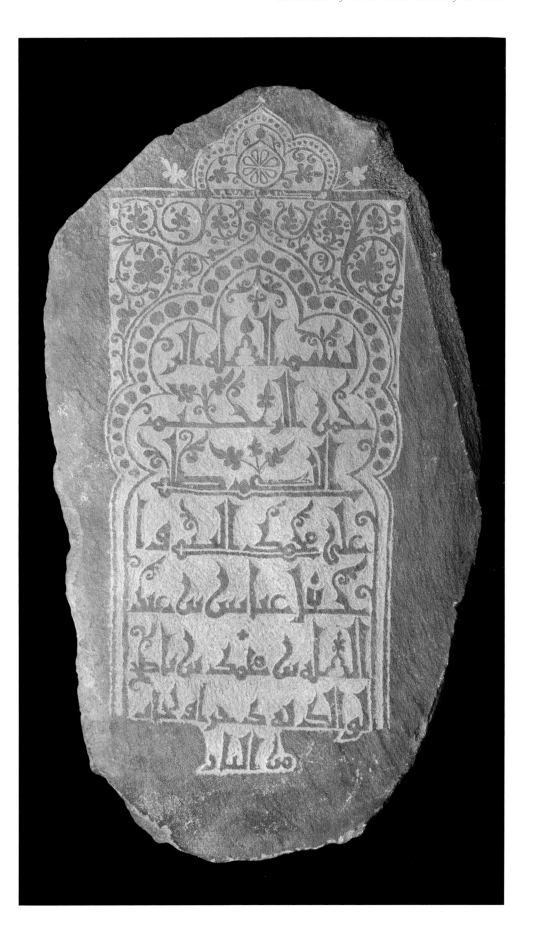

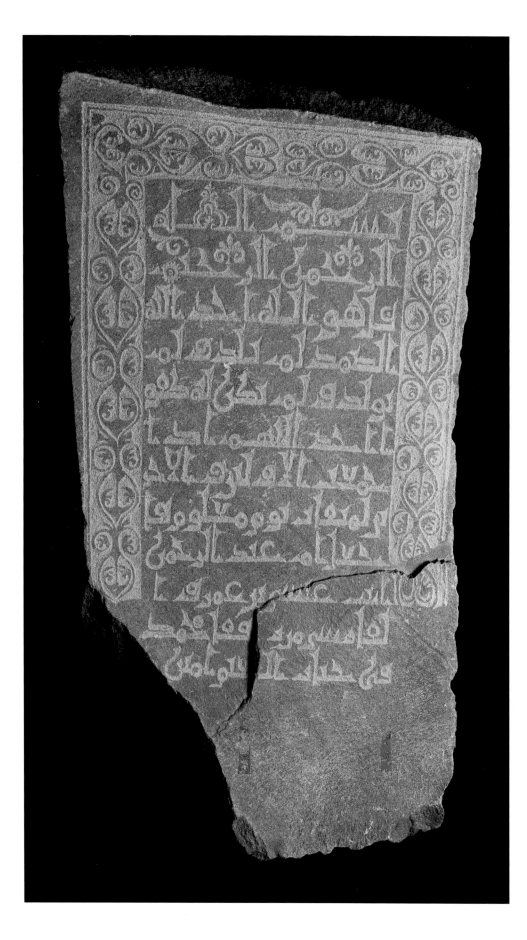

**287. Tombstone of Umm 'Abd al-Rahman, daughter of 'Isa, son of 'Amr al-Farisi**
9th century
Basalt
67 x 35 x 15 cm
al-Ma'la cemetery, Mecca
Qasr Khizam Museum, Jedda, 155

Bibliography: Al-Zahrani 2003, pp. 193–96; Al-Rashid 2004, no. 155, p. 187.

بسم الله
الرحمن الرحيم
قل هو الله أحد الله
الصمد لم يلد و لم
يولد و لم يكن له كفؤ
ا أحد* اللهمّ إذا
جمعت الأوّلين و الآخر
ين لميقات يوم معلوم** فا
جعل أمّ عبد الرحمن
إبنت عيسى بن عمروا
لفارسى من رفقاء محمّد
فى جنات النعيم آمين

\* Quran, **112**
\*\* Quran, **56**, 49–50

This tombstone features characteristic traits of the early centuries: the type of script and embellishments, unfolding of the epitaph: *basmala*, classical quotes from the Quran, introduction of the name of the deceased. Here again this woman is not identified by her first name but by her status as the mother (*umm*) of a son and by her paternal ancestry; her *nisba* (name of belonging) "al-Farisi" indicates her Iranian birth (from Fars, a region of south-west Iran).  **C. J.**

**288. Tombstone of Abu'l-Qasim Nawfal,
son of Muhammad, son of Nawfal al-Hashimi**
9th century
Basalt
88 x 48 x 20 cm
al-Ma'la cemetery, Mecca
Qasr Khizam Museum, Jedda, 457

Bibliography: Al-Zahrani 2003, pp. 174–78; Al-Rashid
2002, pp. 64–65; Al-Rashid 2004, no. 457, p. 5.

بـسم الله الر
حمن الرحيم
اللهمّ صلّى على
محمّد و على آل محمّد
و إذا جمعت الأوّلين
و الآخرين لميقات
يوم معلوم* فاجعل أبا
القاسم نوفل بن محمّد
بن نوفل الهاشمى من العا
ئذين الآمنين الذين لا خو
ف عليهم و لا هم يحزنو
ن و تفضل عليه برحمة منك
و مغفرة يا [أ]رحم الراحمين

\* Quran, **56**, 49–50

On the contour of the arch (Quran, **112**):

بسم الله الرحمن الرحيم قل هو الله أحد الله
الصمد لم يلد و لم يولد و لم يكن له كفؤا أحد

This carefully ornamented tombstone was
executed for a member of the Hashemite
lineage, that is, a descendant of the family
of the Prophet by 'Ali, his cousin and son-
in-law (the prophet Muhammad not hav-
ing a male heir) and by his son Hasan.
These descendants enjoyed special prestige
and – at least in principle – wielded power
over the Holy City from the 10th to the
early 20th centuries.                    **C. J.**

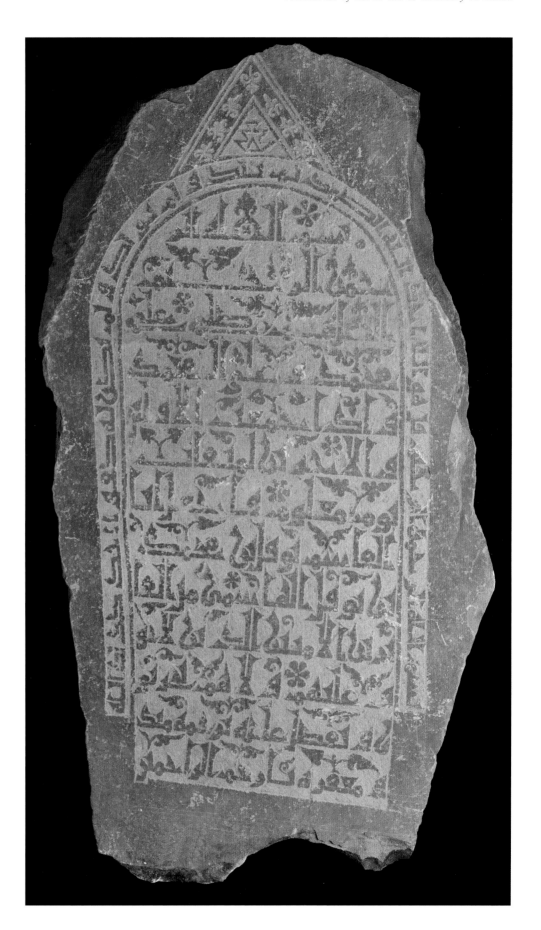

Tr

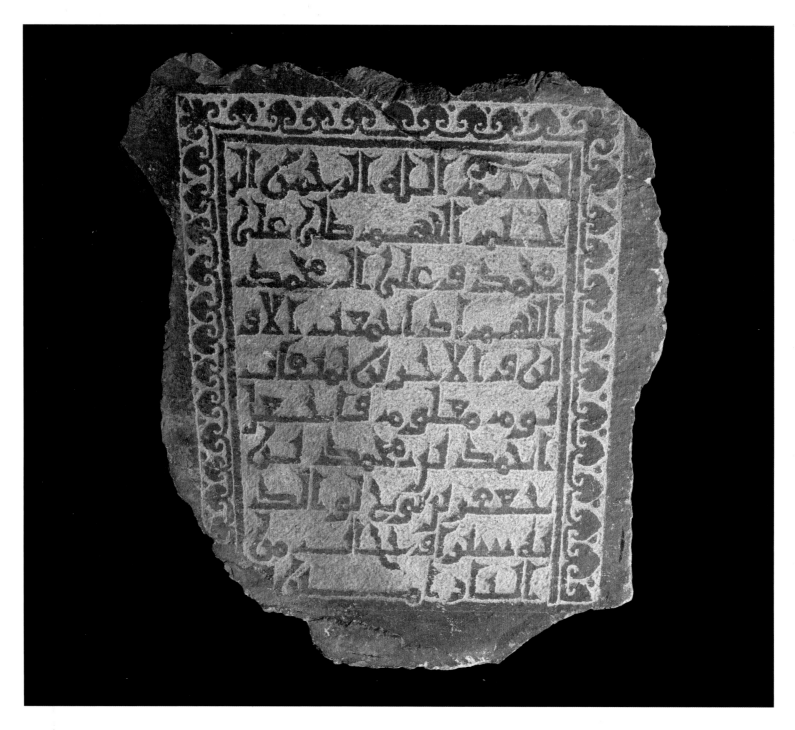

**289. Tombstone of Ahmad,
son of Muhammad, son of Ja'far, son of Nuh**

10th century
Basalt
48 x 45 x 14 cm
al-Ma'la cemetery, Mecca
Qasr Khizam Museum, Jedda, 467

Bibliography: Al-Rashid 2004, p. 512, no. 467.

بسم الله الرحمن الر
حيم اللهمّ صلّى على
محمّد و على آل محمّد
اللهمّ إذا جمعت الأوّ
لين و الآخرين لميقات
يوم معلوم* فأجعل
أحمد بن محمّد بن
جعفر بن نوح لوالد
يه سترًا و حجاب من
النار آمين

* Quran, **56**, 49–50

The simplicity of the frame and the pared script on a dotted ground date this tombstone to the 10th century. The formulation is always simple: *basmala*, salutation on the Prophet, Quran quote, introduction of the name with "Place [name] by his parents. . .".

C. J.

**290. Tombstone of Asma', daughter of Ahmad**
10th century
Basalt
81 x 52 x 9 cm
al-Ma'la cemetery, Mecca
Qasr Khizam Museum, Jedda, 260

Bibliography: Al-Zahrani 2003, p. 286–90;
Al-Rashid 2004, no. 260, p. 295.

بسم الله الرحمن الرحيم اللّه
لا إله إلا هو الحيّ القيّوم لا تأ
خذه سنة و لا نوم له ما فى السمو
ات  و ما فى الأرض من ذا الذ
ي يشفع عنده إلا بإذنه
يعلم ما بين أيديهم و ما
خلفهم و لا يحيطون بشىء
من علمه لا بما شاء وسع كر
سيه السموات و الأرض
و لا يؤده حفظهما و
هو العلى العظيم* هذا قبر
أسماء بنت أحمد بن علىّ بن
داؤد بن جعفر بن سليمان
بن علىّ بن عبد الله بن العبا
س بن عبد المطلب ر
ضى الله عنهما

\* Quran, **2**, 255

Here again we have a high-born woman: Asma', daughter of Ahmad, son of 'Ali, son of Da'ud, son of Ja'far, son of Sulayman, son of 'Ali, son of 'Abdallah, son of al-'Abbas, son of 'Abd al-Muttalib, meaning a descendant of al-'Abbas, uncle of the Prophet and ancestor of the Abbasid caliphs who ruled the Muslim Empire at the time.

C. J.

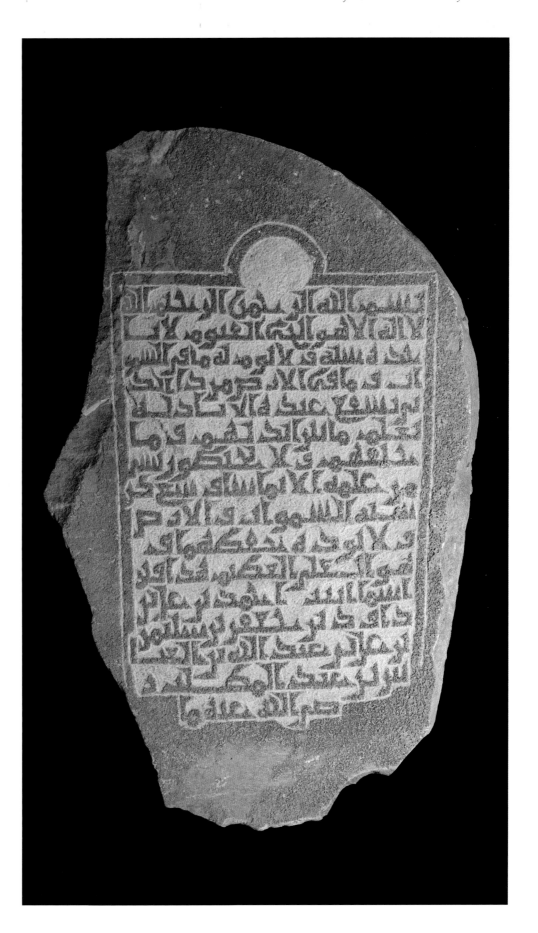

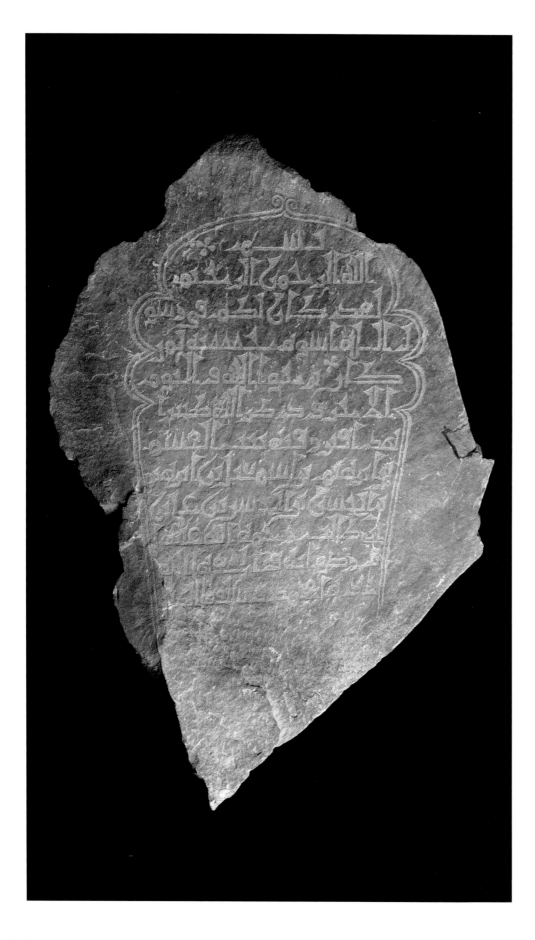

**291. Tombstone of Ruqayya, daughter of al-Qasim**
Late 9th or early 10th century
Basalt
80 x 57 x 7 cm
al-Ma'la cemetery, Mecca
Qasr Khizam Museum, Jedda, 254

Bibliography: Al-Zahrani 2003, pp. 144–46; Al-Rashid 2004, no. 254, p. 289.

بسم
الله الرحمن الرحيم
لقد كان لكم فى رسو
ل الله أسوة حسنة لمن
كان يرجوا الله و اليوم
الآخر و ذكر الله كثيرًا*
هذا قبر رقية بنت القسم
بن إبراهيم بن إسمعيل بن إبرهيم
بن الحسن بن الحسن بن علىّ بن
أبى طالب رحمة الله عليها
و رضوانه و ألحقها الله
بجدّها محمّد و سلفها آمين

* Quran, **33**, 21

With its modest appearance this epitaph spells out the prestigious genealogy of the deceased, a descendant of 'Ali, cousin and son-in-law of the Prophet, by his son Hasan. Nine generations are thus recorded: Ruqayya, daughter of al-Qasim, son of Ibrahim, son of Isma'il, son of Ibrahim, son of al-Hasan, son of al-Hasan, son of 'Ali, son of Abu Talib. Many descendants of 'Ali resided in Mecca and were buried in the al-Ma'la cemetery. Ruqayya was the name of one of the daughters of the Prophet Muhammad and his first wife Khadija. **C. J.**

**292. Tombstone of Muhammad, son of al-'Abbas, son of Muhammad, son of 'Utba, son of al-Hasan**
Late 9th–early 10th century
Basalt
75 x 31 x 33 cm
Signed: "Ibrahim wrote"
al-Ma'la cemetery, Mecca
Qasr Khizam Museum, Jedda, 194

Bibliography: Al-Zahrani 2003, pp. 165–68; Al-Rashid 2002, pp. 66–67; Al-Rashid 2004, no. 194, p. 227.

Above the arch, signature of the craftsman (calligrapher):

كتب إبراهيم

بسم الله
الرحمن الرحيم
قل هو الله أحد
الله الصمد لم يلد
و لم يولد و لم يكن
له كفؤا أحد\* اللهمّ
إذا جمعت الأوّ
لين و الآخرين لميقا
ت يوم معلوم\*\* فا
جعل محمّد بن العبّا
س بن محمّد بن
عتبة بن الحسن
من رفقاء محمّد فى
جنات النعيم يا
[أ]رحمن الراحمين آمين
ربّ العالمين

\* Quran, **112**
\*\* Quran, **56**, 49–50

This inscription lacks specific features in its formulation (*basmala*, customary quotes from the Quran, name of the deceased and closing exclamation) but is remarkable for the subtle and harmonious beauty of its calligraphy and the signature of the craftsman (calligrapher and/or stone carver), exceptional among the tombstones of the early centuries in Mecca.                                   **C. J.**

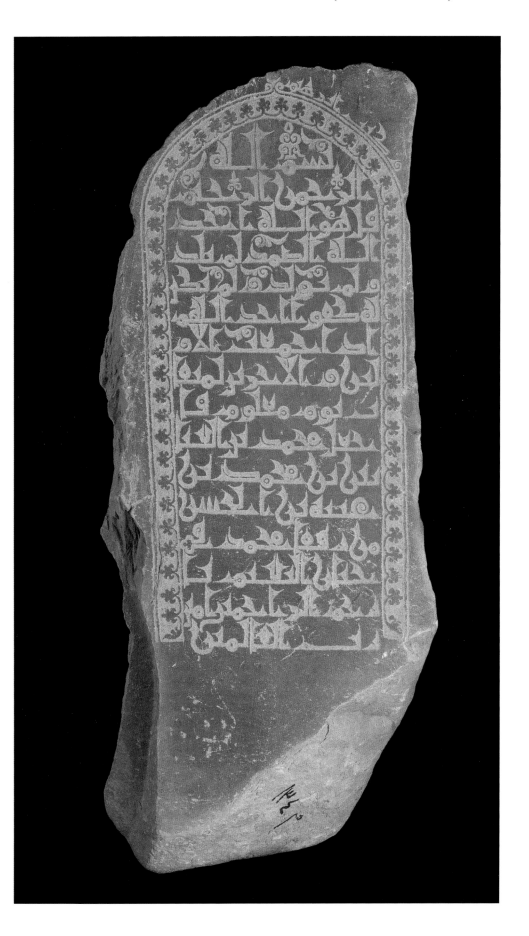

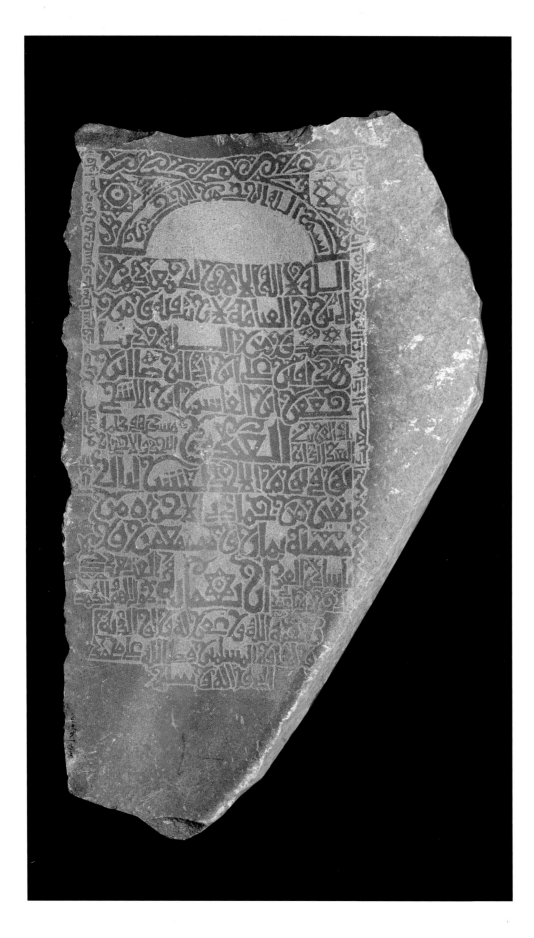

**293. Tombstone of 'Ali, son of Abu'l-Rida, son of Ja'far, son of al-Qasim, son of al-Ashaj al-'Idi**
20 *jumada* II 478 H./13 October 1085
Basalt
66 x 42 cm
al-Ma'la cemetery, Mecca
Museum of Antiquities and Heritage, Mecca, 70

Bibliography: Al-Harithi 2005, no. 70, p. 84.

بسم الله الرحمن الريم
الله لا إله إلا هو ليجمعنكم
إلى يوم القيامة لا ريب فيه و من
أصدق من الله حديثاً
هذا قبر علي ابن أبي الرضا ابن
جعفر ابن القاسم ابن الأشج
العيدي
توفي في يوم الأحد لعشر ليال
بقين من جمادى الآخرة من
سنة ثمان و سبعين و
أربعمائة
رحمه الله و غفر له و لوالديه
و لكافة المسلمين و صلى الله على محمد
النبي و آله و سلّم

This evolved angular script with its intricate forms is evidence of the new decorative experiments in the 10th century. The more fully developed text consists of: *basmala*, *shahada*, pious formula, name of the deceased introduced by "This is the tomb of . . . he died on . . .", appeal to divine mercy and salutation on the Prophet.  C. J.

**294. Tombstone of a father and his daughter**
Middle of *dhu'l-hijja* 511 H./April 1118
Basalt
66 x 45 x 6 cm
al-Ma'la cemetery, Mecca
Qasr Khizam Museum, Jedda, 251B

Bibliography: Al-Rashid 2002, pp. 82–83;
Al-Rashid 2004, no. 251B, p. 286.

بسم الله الرحمن الرحيم
كلَّ من عليها فان و يبقى وجه
ربّك ذو الجلال و الإكرام*
هذا قبر راجح بن يحيى إبن
حسن بن أحمد إبن عبد
الله السديدى (الشديدى) الحسنى
و دفنت عليه إبنته منيفة إبنت
راجح بن يحيى توفّيت يوم النصف
من شهر الحجّة في سنة إحدى
عشر و خمسمائة رحمهما الله
و ألحقهما بنبيّهما محمّد صلّى
الله عليه و آله

\* Quran, **55**, 26–27

After the *basmala* and a quote from the
Quran, the text declares: "This is the grave
of Rajih, son of Yahya, son of Hasan, son of
Ahmad, son of 'Abdallah al-Sadidi (or al-
Shadidi) al-Hasani and buried with him
was his daughter Munifa, died in the mid-
dle of the month of *dhu'l-hijja* [the pilgrim-
age month] of the year 511, may God grant
them his Mercy . . .". The script shows a
distinct evolution towards lithe lines fore-
shadowing *naskh*. The reverse features a
more ancient epitaph in the name of one
Muhammad, son of al-Harith datable to
the 10th century.                    **C J.**

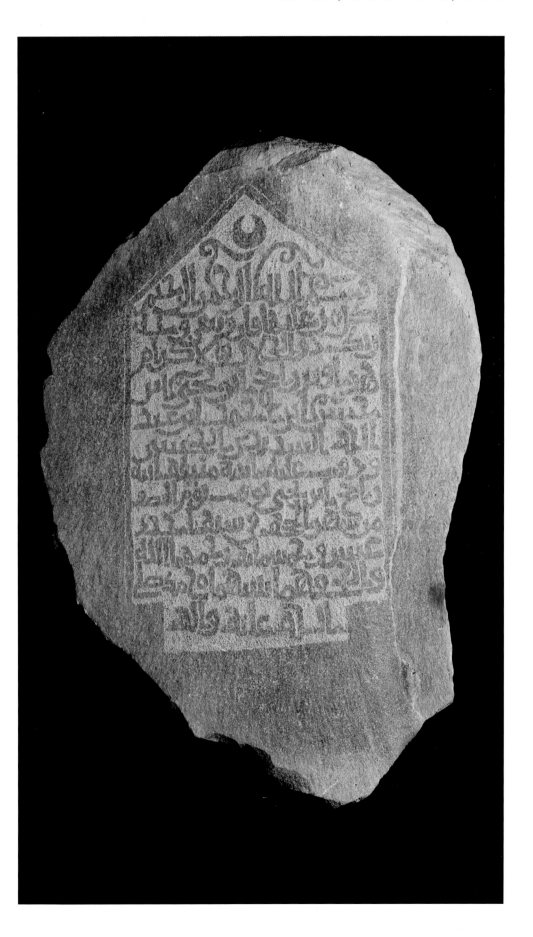

## 295. Tombstone of Yusuf, son of 'Abdallah, son of Yusuf, son of Abu'l-Fath

*5 sha'ban* 595 H./2 June 1199
Basalt
76 x 42 x 20 cm
al-Ma'la cemetery, Mecca
Qasr Khizam Museum, Jedda, 411A–B

Bibliography: Al-Rashid 2004, no. 411B, p. 451.

The tombstone is a reuse: the reverse bears an older epitaph datable to the 10th–11th centuries in the name of one 'Ali, perfume-maker by profession. Although this tombstone is not signed, the style of the script and the *mihrab* niche decoration link it to the production of the Abi Harami al-Makki. The poetic quote might suggest that the youth was of Andalusian birth unless it illustrates the diffusion of this poetry in the cultivated circles of the Hijaz.

**C.J., after J. Chabbi and A. Cheikh-Moussa[2]**

On each side of the lamp:
*Prayers and salutation on our master Muhammad, the Prophet and on his family*

Main text:
*In the name of God the Compassionate, the Merciful,*
*"Surely the godfearing shall dwell amid gardens and a river in a sure abode, in the presence of a King Omnipotent." (Quran, 54, 54–55)*

Then elegiac poem in khafif metre:
*Oh you who find fault with me, be gentle, oppress me not*
*I refuse to be blamed*
*Had Fate struck you as it did me*
*You could only have let your tears flow*
*The blows of Fate tore me apart*
*I have fallen prey to laments and grief*
*Destiny parted us from our beloveds*
*I ought have been the first to die*
*Could I enjoy life after they were gone? With whom do you think I could have found consolation*
*Death oh death you left me no companion with whom I could find consolation; not a friend is left to me*
*Death oh death, my life [. . .] my liver* [the liver is the source of affection and passion]*. . . Because of the loss of [. . .]*
*[Death] committed to the earth beauty and perfection, [. . .] man of noble birth*
*And endowed with reason*
*Let us linger near us on the tombs [. . .] [of] the one who was beauty and nobility*
*Objects of my love and affection, can you after [. . .] youth*
*[. . .] burden*
*May God keep him in His salvation and His mercy*
*May his tomb be sated by the clouds laden with rain which shall flow*
*Over him in showers*
*Here lies the youth taken from his family and his beloveds, Yusuf, son of 'Abdallah, son of Yusuf, son of Abu'l-Fath, died on Wednesday fifth day of the month of sha'ban in the year 595*

On the sides, poem by the Malikite jurist of Elvira, in Spain, Ibn Abi Zamanin:[1]
*Each day death unfurls its shroud and yet we persist heedless*
*Of what awaits us*
*Give not your trust to this world and its beauty even if the lovely one* [that is, the world] *is decked out in all its finery*
*What has become of our beloveds and what befell our nearest and dearest?*
*Where are the ones who were our comfort?*
*Death made them drink the impure cup*
*They have become captives under the heaped ground*

On the outline of the arch (Quran, **112**):

قل هو الله أحد الله الصمد لم يلد و لم يولد و لم يكن له كفؤا أحد

Main text:

بسم الله الرحمن الرحيم
إنّ المتقين في جنّات و نهر في مقعد صدق عند مليك مقتدر
أيّها العادلون بالله مهلا لا تلحوا فلست أقبل عدلا
لو أتاكم من القضاء ما أتانى لغدا الدمع منكم مستهلا
قصمتنى نوائب الدهر حتى تركنى النوح و الحزن أهلا
فرقت بيننا و بين الأحبّاء أنا بالموت منهم كنت أوّلا
فمن بعدهم ألذّ بعيش أترى من بقربهم أتسلا
موت يا موت لم تدع لي خدنا أتسلا به و لم تبق خلا
[...] موت يا موت قد عيشى كبدى من فراق
و لقد أودع التراب جمالا و كمالا طرفا و عقلا
قف بنا فى القبور كل من كان ذو جمال و نبلا
أهل ودي و صفوتي هل أطقتم بعد ... الشباب.... حملا
رحمه الله و السلام عليه و سقا قبره من المزن هطلا
هذا قبر الشابّ المفارق الأهل
و الأحباب يوسف بن عبد الله بن يوسف بن أبى الفتح
توفّى يوم الأربعاء الخامس من شعبان سنة خمس و تسعين و خمسمائة

On the sides:

الموت فى كلّ يوم ينشر الكفن و نحن فى غفلة عما يراد بنا ÷
لا تطمئن إلى الدنيا و بهجتها و لواتشحت من اثوابها الحسنا /
أين الأحبّة و الجيران ما فعلوا أين الذين هم كانوا لنا سكناً ÷
سقاهم الموت كأسا غير صافية و قصيرتهم الأطباق الثرى رهنا

1. Ibn Abi Zamanin (Abu 'Abdallah Muhammad b. 'Abdallah al-Ilbiri, born in 324 H./935–36, died in 399 H./1008, Malikite *faqih* and mystic, author of books of preaching and self-denial and tales of pious men but poet as well. These verses appear in various authors but with minor variants. See al-Dhahabi 1996, pp. 188–89.
2. My deepest gratitude goes to Gabriel Martinez-Gros, Jacqueline Chabbi and Abdallah Cheikh-Moussa who agreed to examine this inscription. The Arabic text and its translation in French were established by Jacqueline Chabbi and Abdallah Cheikh-Moussa, who also provided the information regarding the poet Ibn Abi Zamanin. This entry is entirely owed to them.

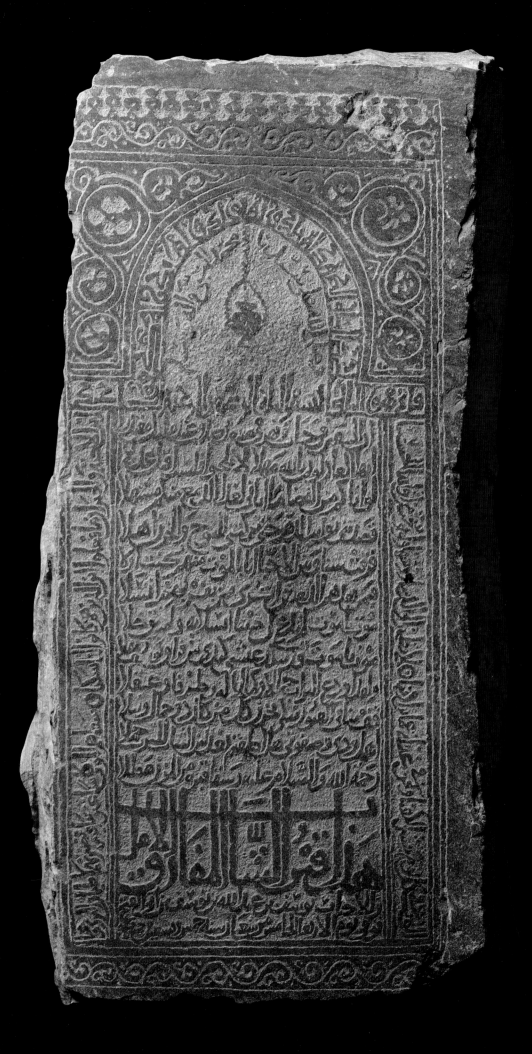

**296. Tombstone of the *faqih* Jamal al-Din Abi 'Abdallah Muhammad**
10 *jumada* I 592 H./11 April 1196
Basalt
84 x 38.5 x 22.5 cm
Signed: "'Abd al-Rahman and his nephew Muhammad"
al-Ma'la cemetery, Mecca
National Museum, Riyadh, 666

Bibliography: unpublished.

In the inner frame, from lower right: Quran, **41**, 30–32.
In the outer frame, from lower right: Quran, **39**, 72–75
On each side of the cusped arch:

<div dir="rtl">

[...]عمل عبد الرحمن و ابن اخيه محمد عفى الله عنهما و عز

</div>

At centre:

<div dir="rtl">

بسم الله الرحمن الرحيم و صلى على نبيه محمد
و ما جعلنا لبشر من قبلك الجلد
فان مت فهم الخالدون* و الذين
جاهدوا فينا لنهدينهم سبلنا
و ان الله لمع المحسنين**
هذا قبر الامام الفقيه
العالم العابد الزاهد الورع
جمال الدين ابي عبد الله محمد
بن عبد الله بن الفتوح بن محمد
المكناسي المحاصي امام المالكية بحرم الشريف توفي
يوم الخميس العاشر من جمادى الاولى من سنة اثن و تسعين و خمسمائة رحمه الله[...]

</div>

\* Quran, **21**, 34–35
\*\* Quran, **29**, 69

This unpublished tombstone joins the *corpus* of the inscriptions carved by the Abi Harami al-Makki family. Its decoration is especially elegant and well-crafted and corresponds to a sub-group of their production that adopted wide bands with three fillets for the frames and a bulbous arch. A stele held at the British Museum,[1] very similar to this one, also belongs to this group. The epitaph liberally borrows passages from the Quran, particularly appropriate for a deceased *faqih*, that is, a specialist in religious law. Following the trend which arose during the 12th century the name of the deceased is enhanced by a series of epithets and precisions regarding his function: "The imam, the *faqih*, the scholar, the worshipper [of God], the devout, Jamal al-Din Abi 'Abdallah Muhammad, son of al-Futuh, son of Muhammad, al-Maknasi [= from Meknes, Morocco], Malikite imam of the Noble Sanctuary". Therefore he was an important Meccan religious personality who led the prayer for those who followed the Malikite rite, one of the four great Sunni juridical schools, particularly observed in the Maghreb. The person's given name is Muhammad whereas "Jamal al-Din" ("Beauty of the Religion") is a sort of honorary surname (*laqab*) such as those which the religious dignitaries were beginning to adopt on the model of the military and civilian élites.

C. J.

1. Bittar 2003, fig. 50, p. 137.

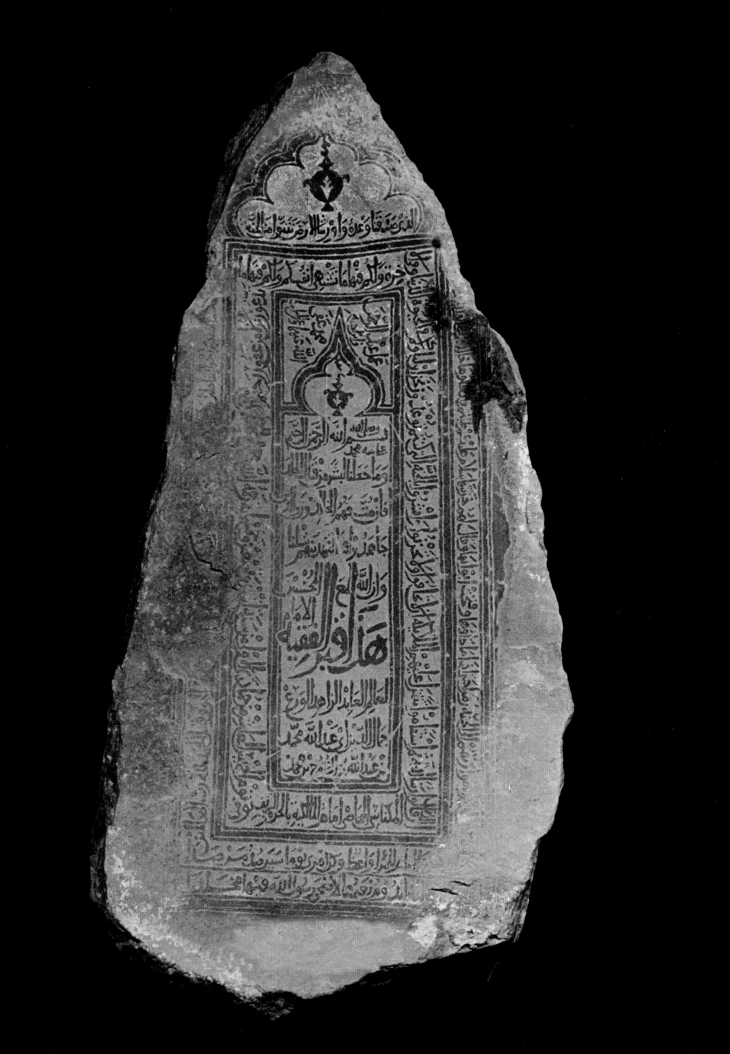

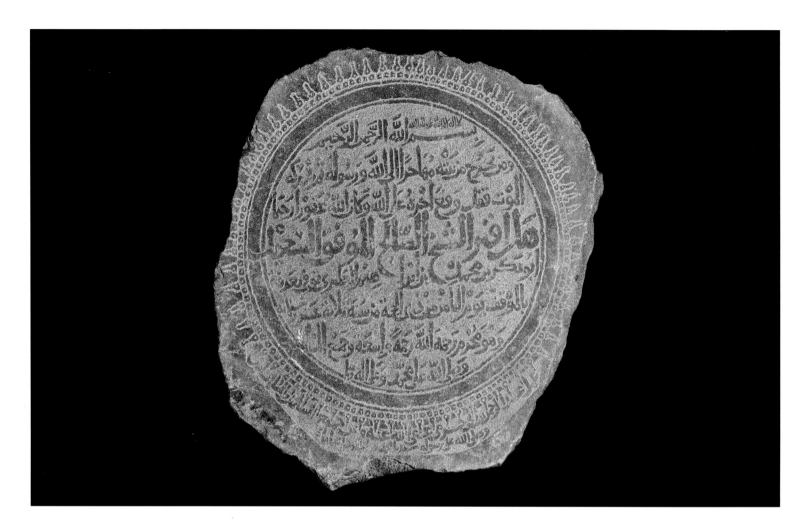

**297. Tombstone of Shaykh Abu Bakr, son of Muhammad, son of Ibrahim al-Tabari**

8 *dhu'l-hijja* 613 H./18 March 1217
Basalt
42 x 37 x 7 cm
Signed by 'Abd al-Rahman ibn Abi Harami
al-Ma'la cemetery, Mecca
Qasr Khizam Museum, Jedda, 453

Bibliography: Al-Rashid 2002, pp. 86–87; Al-Zahrani 2003, pp. 354–57; Al-Rashid 2004, no. 453, p. 498.

لا إله إلا الله و الحمد لله
بسم الله الرحمن الرحيم
و من يخرج من بيته مهاجرًا إلى الله و رسوله ثمّ يدركه
الموت فقد وقع أجره على الله و كان الله غفورا رحيماً \*
هذا قبر الشيخ الصالح الموفق السعيد
أبو بكر بن محمّد بن إبراهيم الطبري توفي بعرفة
بالموقف يوم الثامن من ذى الحجة من سنة ثلاثة عشر و ستمائة
و هو محرم رحمه الله رحمة واسعة و جميع المس[لمين]
و صلّى الله على محمّد و على الله و سلّم

\* Quran, **4**, 100

On the lower contour (signature) :

عمل عبد الرحمن بن أبى حرمى عفى الله عنه و عن جميع المسلمين و المسلمات آمين
و صلى الله على رسوله سيّدنا محمّد و على آله

This stele is a case all of its own, being cited in two 15th-century books: a guidebook of the al-Ma'la cemetery by al-Shaybi and a History of Mecca by al-Fasi (see p. 492). These works provide us with additional information about the activity of this personality, judge and mufti. A native of Tabaristan, north-west of Iran, he emigrated to Mecca in the 1170s. He set up a lineage of Shafi'ite judges in the Holy City, the most famous being his great grandson Ahmad (1218–95).[1] The composition of the epitaph inscribed in a round medallion is very unusual and appears to be inspired by Quran manuscript embellishments, such as the marginal signs indicating the detailed account of the verses. Two other occurrences are known: a foundation inscription, also signed by 'Abd al-Rahman ibn Abi Harami preserved at the Museum of Antiquities of Mecca[2] and a fragmentary tombstone from Dahlak probably by the same stone carver.[3]

C. J.

1. See Bauden "al-Tabari" EI2, Leiden, 1998, vol. X, pp. 16–17.
2. See Al-Fa'r 1984, pp. 322–28 and ills. pp. 411 and 433.
3. Schneider 1983, no. 233, pl. CXXXIII B.

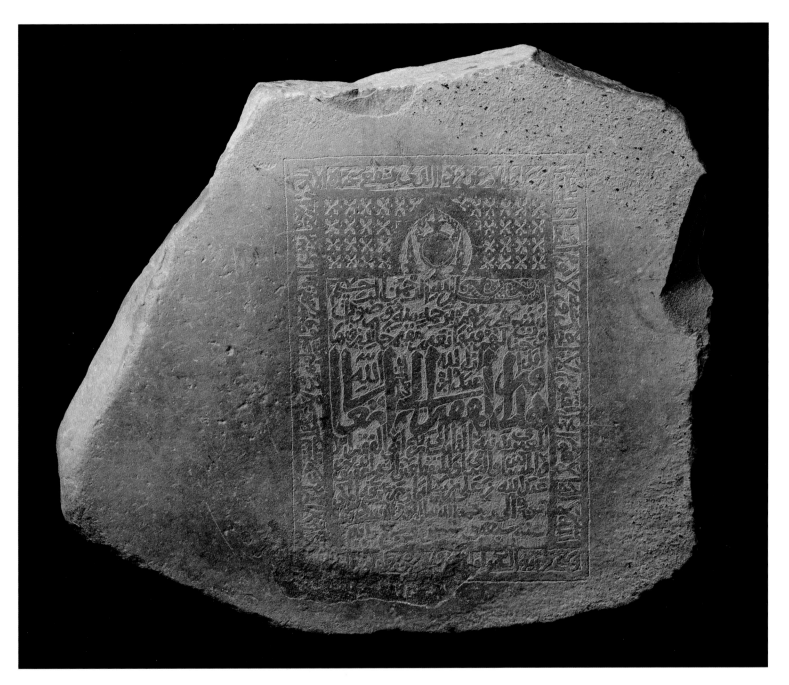

**298. Tombstone of Shaykh 'Afif Allah, son of Abdallah, son of 'Ali, son of Sulayman, son of 'Arafa, al-Makki**

767 H./1365–66
Basalt
50 x 57 x 22 cm
National Museum, Riyadh, 602

Bibliography: Washington, "naskh 03".

Main text:

بسم الله الرحمن الرحيم
يبشرهم ربهم برحمة منه ورضوان
وجنات لهم فيها نعيم مقيم خالدين فيها
أبدا إن الله عنده أجر عظيم
هذا قبر الفقير إلى الله تعالى
المعترف بذنبه التائب إلى ربه أبو الفقراء
والمساكين واليتامى والمنقطعين الشيخ عفيف الله بن
عبد الله بن على بن سليمان بن عرفه المكي
توفى إلى رحمة الله تعالى يوم "السادس" من
سنة سبعه وستين وسبع مايه

In the frame band: Quran, 2, 255

Albeit posterior, this stele belongs to the sequence of late 12th- and early 13th-century productions. The crossbar decoration of the spandrels of the arch recalls mashrabiyas (turned wood screens placed in front of windows or partitioning interior space). The epitaph associates quotes from the Quran and the genealogy of the deceased enriched with pious epithets: "The Unworthy, turned towards Allah, who accepts his sins and trusts in God . . .".

**C. J.**

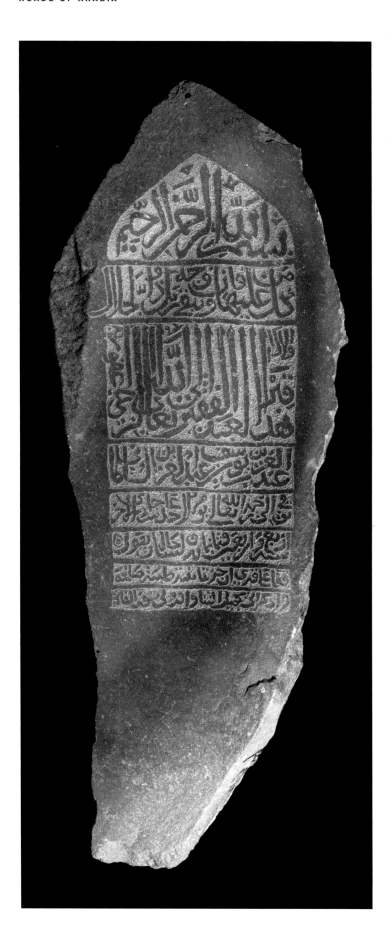

**299. Tombstone of 'Abd al-'Aziz, son of Yusuf, son of 'Abd al-'Aziz al-Sultani**
6 *jumada* II 844 H./2 November 1440
Basalt
94 x 38 x 10 cm
al-Ma'la cemetery, Mecca
Qasr Khizam Museum, Jedda, 350

Bibliography: Al-Rashid 2004, no. 350, p. 386.

بسم الله الرحمن الرحيم
كلّ من عليها فان و يبقى وجه ربّك ذو الجلال
و الإكرام* هذا قبر العبد الفقير إلى الله تعالى الراجي عفو ربّه
عبد العزيز بن يوسف بن عبد العزيز السلطانى
توفّى إلى رحمة الله تعالى يوم الأحد ستّ جمادى الآخر
سنة أربع و اربعين و ثمانمائة و لسان حاله يقول
قفا على قبرى أن جزتما [برفقة] طيبة صالحة
و أذكرانى بجميل الثناء و أقرو لي سورة الفاتحة

\* Quran, **55**, 26–27

The pointed arch shape of the inscribed field recalls 12th- and 13th-century tombstones while in some places the script adopts a monumental style that belongs to the Mamluk period. The epitaph, after the *basmala* and a quote from the Quran, names the deceased "eager for the pardon of his Lord" and indicates the date of death before closing with an address to the passerby inviting him to remember the deceased and recite the *fatiha* (opening surat of the Quran) on his grave.

C. J.

**300. Tombstone of the merchant Nizam al-Din Mahmud al-Sultan al-Kaylani**

Month of *rajab* [9]55 H./August 1548
Basalt
76 x 37 x 12 cm
al-Ma'la cemetery, Mecca
Qasr Khizam Museum, Jedda, 401 A–B

Bibliography: Al-Rashid 2004, no. 401 B, p. 440.

هو
الباقى و كلّ شىء هالك
و ما الدهر إلا هكذا
فاصطبر له أحباب دعوة
الحقّ الصدر المحترم الوجيه
المحسن الخواجا نظام الدين
محمود السلطان الكيلانى
نزيل مكّة الشرفة تغمّده بالرحمة
يوم الجمعة [عشرة] رجب سنة خمسة و خمسينب...

The very studied calligraphy and several letters elaborately extending beyond the cusped frame as well as the initial formula *"huwa al-Baqi"* ("He [God] is the Everlasting") seem to reflect an Ottoman influence and allow the retrieval of the hundreds figure of the date, which had become illegible. The text consists of brief religious expressions, the name of the deceased followed by the date of death. In addition it gives the quality of the personage who was a *khawaja*. This word which we find in the sources only as of the 15th century seems to designate rich merchants involved in trade with the Orient, often slave sellers. A large proportion of them were natives of Iran; such is the case of this merchant whose *nisba* "al-Kaylani" shows that he came from Gilan, a province of north-west Iran. He might belong to a group (a family?) of *khawajas* having the same *nisba*, attested in Mecca by the early 15th century.[1] This stele is a reuse of some importance: the epitaph on the reverse indicates that the tombstone had formerly marked the grave of a son (Shamla), deceased in 1129, of the emir Fulayta ibn al-Qasim, then Sharif (amir) of Mecca.                    **C. J.**

1. Mortel, 1994.

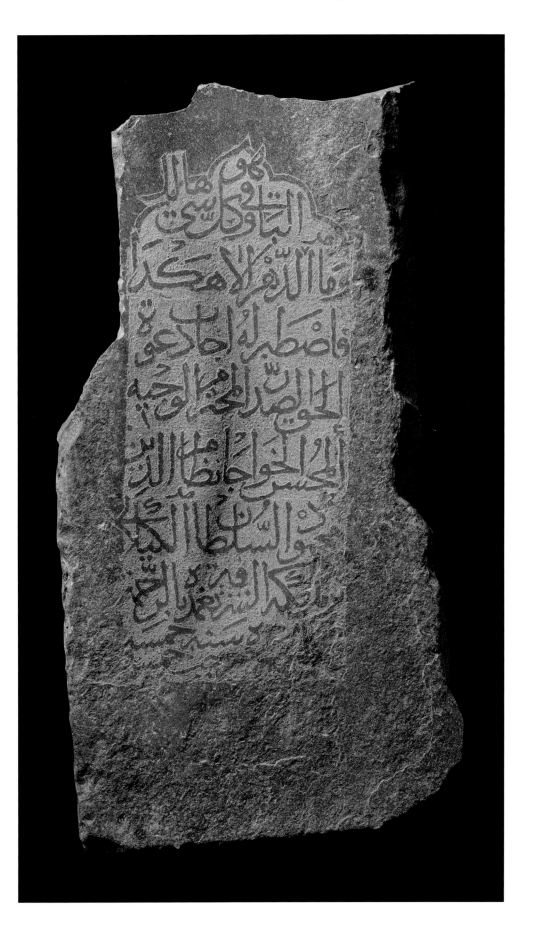

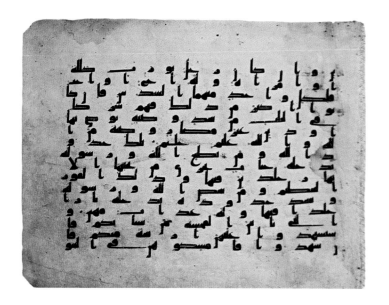

**302. Quran page**
10th century
Ink on vellum
19.4 x 25.2 cm
Surat al-Nisa', 12–19
Provenance unknown
King Faysal Centre for Islamic Research and Studies, Riyadh, 2580
(manuscript given to King Fahd)

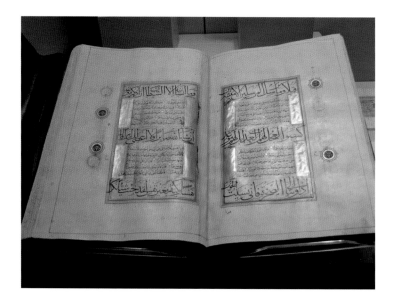

**303. Quran manuscript**
Turkey, 16th–17th century
Inks and gold on paper
Provenance unknown
National Museum, Riyadh, 2

These three examples of Quran manuscripts illustrate the evolution of calligraphy and provide a counterpoint to the tombstone inscriptions. In the earliest days of Islam Quran scripts began to be the object of special care: establishing norms in the design and proportion of the letters, aspiration to an aesthetic, monumental with a rhythmic written surface. Manuscripts from the 9th–10th centuries display a marked preference for the horizontal "Italian-style" format. The sacred nature of the text and preciousness of the manuscript are sometimes emphasized by the use of gold ink (chrysography) (cat. no. 301). The 9th and 10th centuries for Quran manuscripts as well as inscriptions privilege an angular script, known as Kufic, with a strict base line. Conversely the ornamental developments of this script and the use of vegetal elements are characteristic of inscriptions on stone and do not appear in the manuscripts. The layout may be very airy or far more crowded, as on the page written in brown ink (cat. no. 302) where the close-set lines tend to merge. Notation of diacritical signs, separating the letters one from another (small thin lines), and vowels (coloured dots) appears only partially. It is in the 12th century that the Quran manuscripts truly adopt a lithe, rounded script, known as cursive, illustrated here by

a 16th–17th century manuscript (cat. no. 303). It presents the combination of dark ink and gold, highlighted by a few blue and red touches. The orthoepic signs are carefully featured so as to avoid any misreading. Monumentality is assured by a carefully arranged composition, structured by the rhythm of the bands with large script contrasting with the main text in "lower-case letters", in keeping with a manner frequently found on tombstones as of the 12th century. **C. J.**

**301. Three double pages of a Quran**
9th century
Ink and gold on vellum
14.5 x 40 cm (double leaf)
Provenance unknown
National Museum, Riyadh

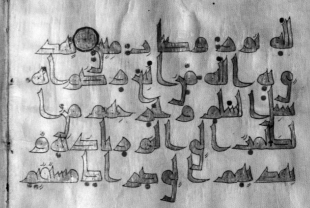

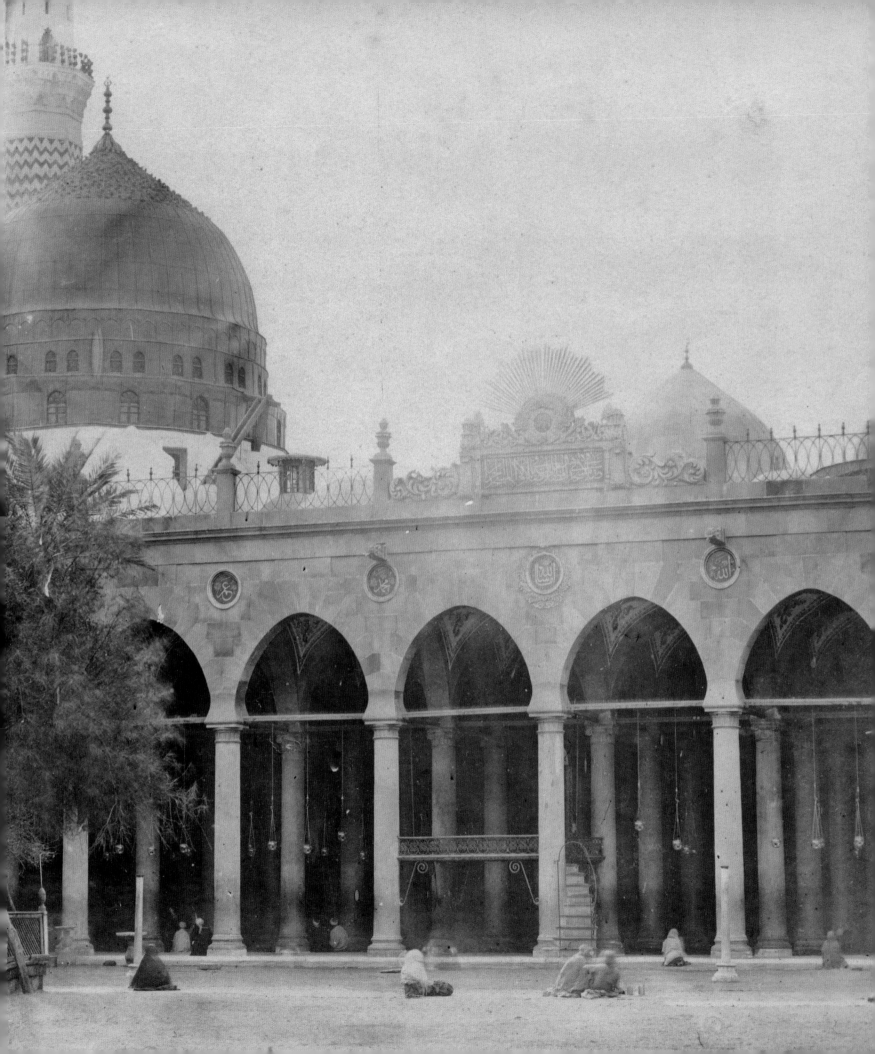

# HOLY CITIES
# OF THE HIJAZ
## UNDER THE OTTOMANS

*Gilles Veinstein*

### The Servant of the Two Holy Sanctuaries

With the collapse of the Abbasid Empire, the holy cities of the Hijaz region, Mecca and Medina, became autonomous governments under the hereditary authority of sharifs who were descendants of the Prophet's family. Because of their unique significance in Islam, the holy sites were points of attraction for many populations, especially during the great annual pilgrimage. However, these cities did not have sufficient local resources to supply their populations or to defend themselves; they were forced to seek the patronage of the Muslim power that could best provide for their needs. A competition ensued between these powers, in which any assistance offered to the sanctuaries resulted in the bestowal of symbolic prerogatives that elevated the beneficiary to the highest rank among Muslim sovereigns. Triumphing over their competitors, the Mamluk sultans, who reigned over Egypt and Syria and who had defended the perimeter of the Muslim world by defeating both the Christian crusaders and the Mongols, established a type of suzerainty over the Hijaz region, beginning in the second half of the 13th century.

As a consequence, they appropriated, from the previous Ayyubid dynasty, the title *Khadim al-haramayn al-sharifayn* – "Servant of the Two Holy Sanctuaries", which conferred upon them a type of supremacy over all of their coreligionists. During the Mamluk period there emerged a clear definition of the privileges and obligations associated with this honorific title, modest in appearance but in practice imbued with utmost prestige. In fact, privileges and obligations were inextricably intertwined, since the responsibilities, however burdensome and costly, were also prerogatives to be jealously defended. Thus the Mamluk sultans contributed more than all the other Islamic sovereigns to the alms collected for Mecca's poor. The sum they paid for this purpose was called *surra;* additionally, it was their annual duty to supply the *kiswa*, the black cloth covering embroidered with inscriptions that is draped over the Ka'ba in Mecca. The name of the reigning Mamluk sultan was invoked at the holy sites during the *khutba* (sermon) of the main Friday prayer ceremony. Lastly, in keeping with a practice that seems to have been initiated by Sultan Baybars, the pilgrim caravans carried a palanquin called *mahmal* (*mahmil* or *mehmel* for the Ottomans) representing the sovereign of the caravan's country of origin and accompanied by his standard.

The courtyard of the Mosque in Medina, photograph by Sadiq Bey c. 1880. King Abdulaziz Library, Riyadh

A specimen from the early 16th century, preserved at Topkapı Palace in Istanbul, provides a concrete example of this type of camel-borne sedan chair. The structure takes the form of a parallelepiped 1.5 metres tall whose colour has varied over time. The Mamluk sultan dispatched two *mahmal*s each year, since two caravans originated from his lands, one from Cairo and the other from Damascus. Upon arrival in Mecca, his palanquins, those of the "Servant of the Two Holy Sanctuaries", were given precedence over those of all the other sovereigns during the rites and ceremonies. In addition, the Cairo *mahmal* had precedence over the Damascus *mahmal*.

By the 15th century, Mamluk supremacy was being challenged by other rising Muslim dynasties, including the Timurids, the Ak Koyunlu and, of course, the Ottomans. At first, the Ottoman dynasty, a new power of obscure origin that was just starting to exert authority in north-western Asia Minor, showed only deference to its illustrious elders. In announcing to the Mamluk sultan his conquest of Constantinople in 1453, the Ottoman Sultan Mehmed II proudly described himself as "the one who accepts the onus of equipping the men who wage the holy war", but he also showed his respect for his correspondent, who assumed the responsibility of an even holier cause: "The onus inherited from his father and his ancestors of renewing once again the ceremony of the pilgrimage to Mecca". However, as his continuing success bolstered his confidence and ambitions, Mehmed II adopted a bolder attitude toward the Mamluks. He contested their influence in eastern Anatolia and even began intruding on their exclusive arena: the holy places, where every action was charged with symbolic value. If one accepts the account of the chronicler Sa'du-d-din, one of the causes of Mehmed II's conflict with the Mamluks, which began to flare up in the final years of his reign, was their refusal to allow the Ottoman sultan to contribute to the repair and maintenance of the water supply system in Mecca.

Under the following Sultan, Bayezid II, a long sporadic war erupted between the two empires (1485–91) over the domination of Cilicia. However, shortly thereafter a new development with worldwide implications would alter the situation, briefly opening the way to Islamic solidarity between the two rivals. The Mamluks had to confront the challenge posed by Portuguese advances in the Indian Ocean and around the Red Sea. Not only were the Middle Eastern towns involved in the lucrative trade in spices and other foodstuffs from the Far East being largely bypassed in favour of the maritime route opened by the Portuguese, but the holy sites were under threat of an infidel attack. The Mamluk Sultan Qansuh al-Ghawri sprang into action, fortifying Jedda and arming a fleet that defeated the Portuguese in March 1508. But despite this success, the Mamluk's vulnerability was soon made evident, especially in terms of naval capacity against such a powerful enemy. At that point, Bayezid II put his hostility aside and gave the Mamluk leader his full and loyal support. The Ottoman sultan unstintingly provided the equipment and trained personnel that the Mamluks sorely lacked – a perhaps not entirely disinterested act of generosity whose interpretation continues to divide historians.

Selim I, Bayezid's dauntless successor, initially pursued this cooperation before radically changing course. After defeating Shah Isma'il, the Shiite sovereign of Persia, in a conflict as religious as it was territorial, at the battle of Chaldiran in 1514, Selim turned against the Mamluks in a large-scale campaign that would last two years (1516–17) and change the face of the Middle East. To justify his aggression, Selim claimed that the Mamluks were colluding with the Persian heretics. This, however, did not prevent him from waging a fiercely brutal war against "enemies" who were incontestably Sunni. In a fluke of history, as a result of this outright violation of holy law he reaped immense material and symbolic benefits that would profoundly alter the Ottomans' role in the Muslim world.

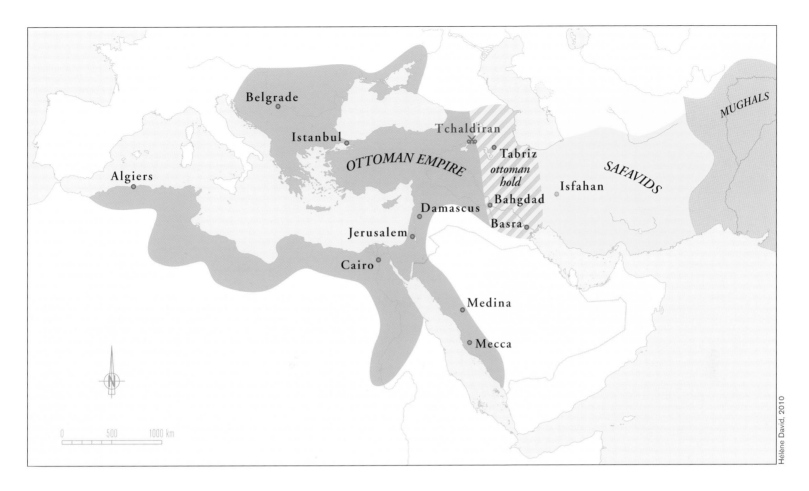

Map of the Ottoman Empire in the 17th century

## From the Mamluks to the Ottomans

In Selim's view, his victory over the Mamluks made him *ipso facto* the Servant of the Two Holy Sanctuaries, with all of the prerogatives associated with the title. He claimed this position immediately after his victory at Marj Dabiq, north of Aleppo, on August 24, 1516, even though he had only seized control of Syria from the Mamluk regime, which, despite the death of Qan-suh al-Ghawri, continued to show resistance under the latter's nephew Tumanbay, who had assumed power in Egypt. On the traditional date, Selim sent a *kiswa* to Mecca decorated with a band of inscriptions "that bore the names of the Sultan and his ancestors" (Ibn Tulun). He could not send it from Cairo, as was the custom, since the Egyptian capital was not yet under his control, so he sent it from the other former Mamluk capital, Damascus. Also from Damascus he dispatched a *mahmal* wrapped in *caffa* brocade – an Ottoman fabric – and an Ottoman flag. Meanwhile, Tumanbay, who still embodied the Mamluk claim to ascendancy, sent another *kiswa* and another *mahmal* from Cairo, although after the usual date. Thus, for the pilgrimage of Hegira year 922 (1516), the Sharif of Mecca received both an Ottoman *mahmal* from Damascus (designated as "*mahmal rumi*" by the chronicler Qutb al-Din) and a Mamluk *mahmal* from Cairo, as well as an Ottoman *kiswa* from Damascus and a Mamluk *kiswa* from Cairo. It is known that the Sharif, not wishing to lose face with either power, had the *mahmals* placed on opposite sides of the Qa'itbay madrasa in Mecca, but there is no record of what he did with the two *kiswa*s.

The situation became quite clear a few months later, when Selim entered Cairo and put an end to Mamluk rule following the battle of al-Raydaniyya (January 23, 1517). Immediately after, in the sermons delivered in the mosques of Cairo, Selim had himself referred to as the Servant

of the Two Holy Sanctuaries, a title that he would henceforth use in all circumstances. At this point, the Sharif of Mecca, Barakat II ibn Muhammad ibn Barakat, who had been maintaining a cautious wait-and-see policy, could only recognize the *fait accompli*. Nevertheless, he waited until July 1517 to make his support official by sending his son as ambassador to the victor. Selim received him on the island of Rawda, not far from the Nilometer. According to the Egyptian chronicler Ibn Iyas, after an agreement was concluded, Selim granted the Sharif, Emir of Mecca, "the military command of the city, recognizing his absolute power over it and adjoining the provostship of its markets". The chronicler notes that in this way "he had treated him with extreme justice. The prestige of Sharif Barakat was singularly enhanced because his son had been received with much honor".[1]

As a result, after 235 years of Mamluk suzerainty, the holy places came under Ottoman suzerainty, which would last for four centuries. The position of Sharif of Mecca remained autonomous: the sharif was authorized to maintain direct relations with all Muslim states other than the Ottoman Empire and to receive offerings from them. However, he was appointed and dismissed by the Sultans of Istanbul, whose names were cited in the sermons in the mosques of Mecca. Hanafi Ottoman qadis (Islamic judges) had jurisdiction over the two holy cities, where their rulings had precedence over the qadis from the other Sunni schools. Ottoman qadis also presided in the other cities of the Hijaz: Jedda, Yanbuʿ and Ala. The Jedda region was designated a *sanjak* (administrative division) and the city was the seat of an Ottoman *sanjak-bey* (governor). The *sanjak-bey* was later granted the position of *Shaykh al haram* of Mecca, to bolster his authority in relation to the sharif. The *sanjak* administrative region was attached to the province of Egypt (*eyalet- i Mısır*). Integrated into an empire traversed by highly active commercial channels, Jedda generated considerable income from customs duties, part of which went to the sharif (*sherif hissesi*).

Thus, the campaigns of 1516–17 allowed an empire that had previously been limited to Anatolia and Eastern Europe to expand considerably in the Middle East. Sulayman the Magnificent was to complete this takeover of Arab lands by bringing Iraq, Yemen and part of the Maghreb under Ottoman rule. No longer merely the "Sultanate of Rum", a bordering sultanate on former Roman territory, the Ottoman state was now the successor to the most prestigious Muslim empires of history. However, in religious terms, as we have emphasized, the only title that Selim gained for his exploits was Servant of the Two Holy Sanctuaries, and not that of Caliph, as was claimed later, and under conditions that will be discussed below.

## Caravans and palanquins

The *mahmals* continued to depart every year with the caravans of pilgrims from Damascus and Cairo, in the name of the Ottoman sultan. Although he never personally took part in the pilgrimage, the sultan was thus always represented. The Ottoman monopoly over the sending of these symbolic palanquins was never contested, except, for a brief period, by the Great Mughals of India under the reign of Akbar in the late 16th century. The cloth covering the wooden structure changed in colour, from the yellow of the Mamluk era to crimson red and green. Similarly, the gilded globes attached to the extremities became more precious under the Ottoman rulers, reflecting their accumulation of wealth. However, the descriptions of Western travellers in Cairo and Damascus during the processions of the *mahmals* that preceded the departure of the caravans indicated another evolution: the sole fact that they were going to Mecca and becoming part of the pilgrimage transformed the *mahmals* (and even more logically the *kiswa*, which

1. Ibn Iyas 1960, p. 188.

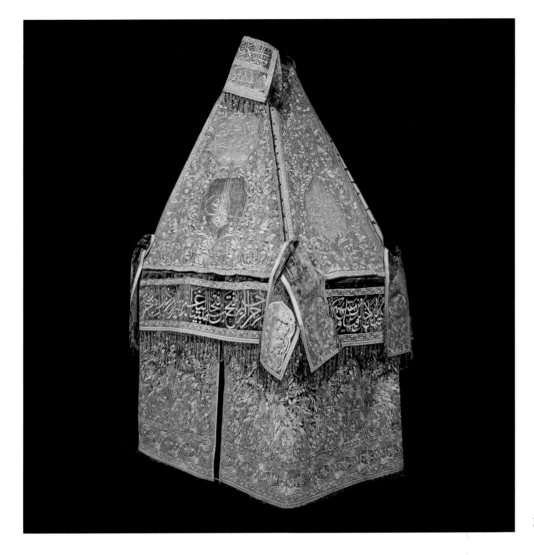

*Mahmal* of the Ottoman Sultan Abdulaziz for the year 1874.
Topkapı Palace Museum, Istanbul, 24/1319, 24/1351-1366

would remain in contact with the Ka'ba for a year, along with the ropes sent to hold it in place), which were originally political symbols, into objects of an extraordinarily fervent devotion that endowed them with supernatural powers. To justify this devotion, a belief (erroneous, as history would have it) arose that the *mahmals* carried a very elaborate, valuable copy of the Quran.

Under Sulayman the Magnificent, the conquest of Yemen brought a third caravan of pilgrims under Ottoman authority, and subsequently a third *mahmal* was sent each year in the name of the Sultan of Istanbul. The tradition of a Yemeni *mahmal* would last only from 1543 to 1630, due to the relative instability of Ottoman dominion over that country. Nonetheless, the ceramic panels crafted in Kütahya in 1666 and installed in three different parts of Topkapı Palace show – in a depiction that was purely theoretical by then – all three of the *mahmals* dispatched by the lord of the land. In contrast, the Ottoman conquest of Baghdad in 1534 was not followed by the restoration of an "Iraqi" *mahmal* on behalf of the Ottomans, although such a tradition existed under the Islamized Il-Khans, Jalayirids and Ak Koyunlu. However, an order to the *beylerbey* of Basra in March 1565 mentions the formation, shortly after the Ottoman conquest of 1546, of a caravan that did not join one of the two large official caravans, but proceeded directly to Mecca, only a twenty-day journey on foot. Since this new caravan had not previously been duly authorized by the sultan, the Sharif of Mecca exacted tribute from its members. Complaints were made to Sulayman, and the inhabitants of Basra requested that a

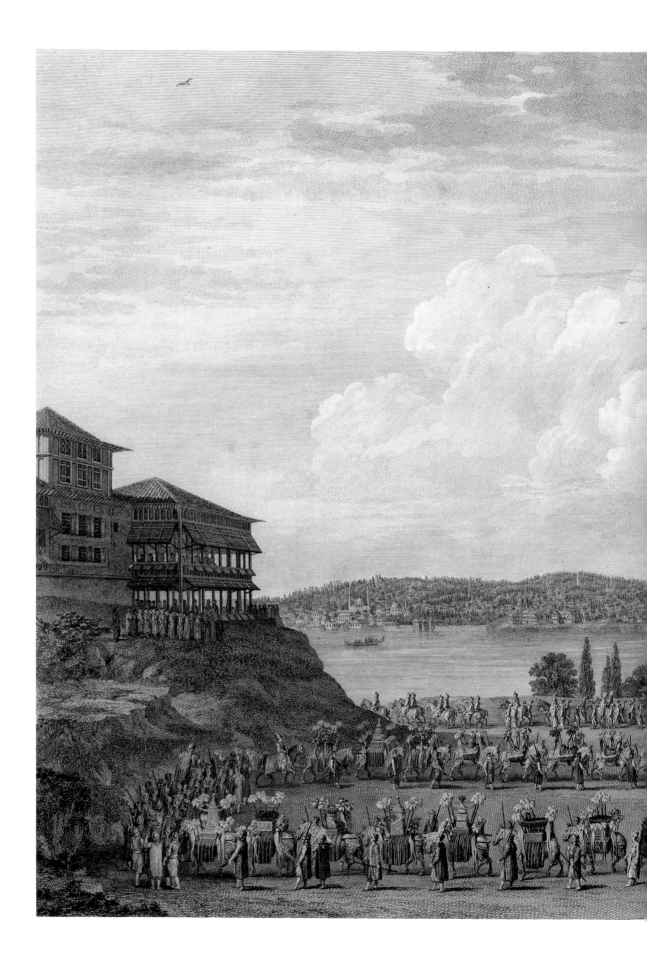

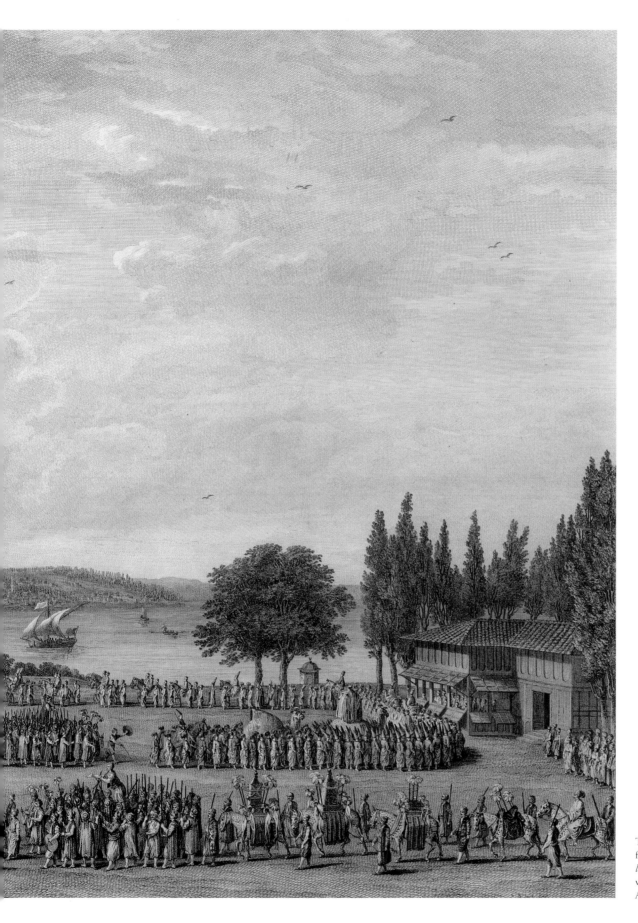

The procession of the *Emin-i Sürre*, engraving
from Mouradgea d'Ohsson's *Tableau Général de
l'Empire Othoman*, published in Paris in 1787,
vol. 2, pl. 47. Bibliothèque nationale de France,
Arsenal, Paris

fourth caravan be formally recognized. The sultan, apparently not eager to take on the additional responsibility, flatly rejected the complaints, explaining, "Since the imperial conquest [of Basra] it has not been my will that a *mahmil* should depart from that place for the glorious Ka'ba, nor that a caravan should leave from there for the pilgrimage".[2] By the same token, the *kiswa*, which was now a gift from the Ottoman sultan, continued to be sent from Cairo, where it was woven in the citadel by Coptic craftsmen. Under the Ottomans it was accompanied by additional embroidered velvet and silk serge decorations, all intended for the Ka'ba. According to the traveller Jean Thevenot (1657), these ornaments were collectively referred to as "Muhammad's jacket". The caravan from Damascus also brought a decorative cloth covering for the Prophet's tomb in Medina.

## Serving the holy sites

The *surra*, the charitable contribution of the Ottoman sultan, was also conveyed to the holy places by the caravan from Damascus, which during the Ottoman period clearly superseded its counterpart from Cairo, previously the larger and more prestigious of the two. According to an account by the Armenian interpreter Mouradgea d'Ohsson, the departure of the *surra* from Istanbul was occasion for a ceremony during which two *mahmals*, mounted on camels, left the palace and joined the procession of the *surra*. However, these *mahmals* did not reach the other side of the Bosphorus; they were dismantled before the crossing and returned to the palace. This rite does not seem to predate the reign of Abdul Hamid I in the late 18th century.

The transport by mule through Anatolia of a large sum in cash allocated by the sultan for the "poor" of the holy cities (a concept more rhetorical than sociological, given that the priority beneficiaries were the sharifs and other prominent citizens) obviously posed a serious security problem. Local authorities were mobilized and held responsible for the mission's success, and any route changes had to be approved by the central authority.

Upon arrival in Mecca, the *Emin-i Sürre*, the dignitary to whom the imperial alms had been entrusted for the journey – a significant honour as well as an onerous responsibility due to the expense entailed – presented the sharif with the "noble letter" from the sultan, had the registers opened and proceeded with the distribution of the alms under the supervision of the sharif and the Hanafi qadi of Mecca. Keeping the registers up to date and giving everyone his due was a formidable task, and the documentation provides many examples of the obstacles and pitfalls encountered.[3]

No serial quantitative study has yet been undertaken of the Ottoman *surra* and the impact that it must have had on the empire's finances. Such an investigation could be based on hitherto unexplored archives conserved in Istanbul, such as the forty-six registers of the *Haramayn Mukata'ası Kalemi* (1479–1863). However, like any quantitative study of the Ottoman era, it would be faced with the problem of discontinuous documentation as well as the ordinary ambiguities of the available data: what specific expenditure does a given entry represent? What, from among the many possibilities, was its source of financing?

An overview of the disparate data currently available reveals that Ottoman alms were paid to the holy sites starting in the late 14th century (an important gesture to establish the status of the rising dynasty, as for any Muslim power) and increased sharply after the conquest of Egypt. After all, any Muslim prince can and must send his contributions to the holy sites, but the *Khadim al-haramayn* must contribute more than the others. As we have seen, he must also supply food for the holy cities, their residents and visiting pilgrims. The latter was accomplished

2. Archives of the Presidency of the Council, Istanbul, *Mühimme Defteri*, VI, doc. no. 761.
3. For example, *Mühimme Defteri*, III, doc. no. 1187.

by relying on Egypt's grain production, in particular the harvests of the imperial pious endowments (*waqf*) and the holdings of the crown (*hass-i hümayun*) in that country, or even purchases financed by the provincial budget.

He also assumed the task of maintaining and improving the buildings and roadways of the two holy cities. The fact that the only known Ottoman urban planning regulations (*kanun-name*) concerned Istanbul and Mecca gives a strong indication of the sultans' solicitude for the holy city. The centuries of Ottoman domination were to be marked by a succession of construction and renovation projects, many of them quite extensive and costly. The renovation of the Great Mosque of Mecca was undertaken in the second half of the 16th century and continued under the reigns of Selim II, Murad III and Ahmad I. The final stages, under Ahmad I, were overseen by Mehmed Aga, architect of the Blue Mosque in Istanbul. Previously, Sulayman the Magnificent had rebuilt two minarets from the Abbasid period and added a seventh minaret. Under Selim II and Murad III, the cupola-topped gallery ringing the Great Mosque was completely renovated. In the early 17th century, under Ahmad I, work began on the Ka'ba, which was in need of repair. The structure was reinforced by an iron band trimmed with gold and silver. The old silver rain gutter, now conserved as a relic at Topkapı Palace, was replaced by a new one in gold, and the three columns inside the Ka'ba were given a new gold and silver decoration. Not long after, under Murad IV (1623–40), a project was launched for the reconstruction of the Ka'ba, in cooperation with the sharif and the high-ranking dignitaries of Mecca, and supervised by Ridwan Bey, a former Mamluk leader who acted as the representative of the Ottoman state.

Very few Ottoman constructions have survived in Mecca. There are more in Medina, but none dating further back than the 19th century. In addition to several late mosques and the Anberiye train station (1908), one could mention the *haram al-sharif*, rebuilt in 1849 under Abdulmecid.

## The protection of the pilgrims

Since its beginnings, one of the most important missions of the Servant of the Two Holy Sanctuaries was to facilitate the annual pilgrimage by organizing the pilgrim caravans and ensuring their safety en route. The Ottomans who inherited this protective function from the Mamluks outdid their predecessors not only by the scope and diversity of the means deployed, but also by the geo-political dimension of their conception of the task. As the ruling power in the Middle East, the Mamluks limited their vision of this protection to that region. Those who claimed to reign over the *Mamlakat Misr wa'l-Sham wa'l-Hijaz* were ready to take responsibility for pilgrims travelling between Damascus or Cairo and the Hijaz. The expansion of the Ottoman Empire, which at its peak straddled three continents, considerably widened and diversified these horizons. The result was a much broader definition of the idea of "pilgrimage routes", and of the various conflicts and obstacles that could affect them. The Ottomans were no longer concerned solely about what took place between Damascus and Cairo, on the one hand, and Jedda on the other. Their attention was now drawn further afield, to the routes bringing Muslims from their countries of origin to the two departure points. Unavoidably, the protection of pilgrims involved a policy on a global scale. It was not until some fifty years after Selim I appropriated the title of *Khadim* that an Ottoman sultan – Selim II, in the early years of his reign (1567–72) – would link the obligations of his position with political and military undertakings characterized by impressively visionary objectives, as well as an equally impressive lack of

realism that doomed them to failure. One telling example is the project, mentioned in an order dated January 1568, to dig a canal across the Isthmus of Suez that would enable the Ottoman fleet to attack the Portuguese vessels that were preventing Indian Muslim pilgrims from entering the Red Sea, and also to neutralize the threat to the holy sites posed by the Zaydi Shiites of Yemen.[4] There was also the so-called Astrakhan Expedition of 1569, an unsuccessful attempt to dig a canal between the rivers Don and Volga, for the purpose – at least officially – of enabling pilgrims from Central Asia to reach the Hijaz without passing through Shiite Iran. Other undertakings, such as the conquest of Cyprus, would also serve the official purpose, or pretext, of safeguarding the pilgrims. In addition to the diverse and not easily controllable risks that the pilgrims took simply to reach the departure points for the caravans from Damascus and Cairo, there was then the danger, much more clearly defined and more directly implicating the Ottoman sultan's responsibility, of Bedouin attacks in the deserts separating Egypt or Syria from the Hijaz. To these perils was added, starting in the late 18th century, the Wahhabi uprising in Arabia.

Maintaining order and security within each of the two caravans was the responsibility of their respective leaders (*amir al-hajj*). In the early Ottoman period these were wealthy, influential local dignitaries – preferably someone with family ties to the desert-dwelling tribes. Later, Ottomans officers fulfilled this function. Starting in the early 18th century, as the journey became even more dangerous, the governors themselves, the pashas of Egypt and Syria, would lead the pilgrimage. Recurrent pillaging raids on the caravans targeted, in addition to the pilgrims' personal effects, the riches they transported on both the outgoing and return trips. The pilgrimage transformed the holy cities, at least temporarily, into thriving hubs of trade between the Middle and Far East, for both professional wholesale traders and opportunistic peddlers. Several tactics were employed to reduce the risk of attack, with varying degrees of success: the neutralization of the tribes through negotiated agreements, the "militarization" of the caravans, the construction of small forts along the roads.... The Ottoman forts that dotted the desert served as both bases from which to quell attacks and caravanserais, stopovers offering lodging for pilgrims and merchants.

Protecting the pilgrimage was one of the foundations of the Ottoman sultans' credibility and prestige. After several centuries of fulfilling this function as Servants of the Two Sanctuaries, they continued to provide protection in the 19th and early 20th centuries as caliphs. From the signing of the Treaty of Kutchuk Kaynardja in 1774, the Ottoman sultans, who had long been calling themselves caliphs but only as a rhetorical and metaphorical title, were recognized as "Supreme Caliph of the Muslims" under international law. Playing on the original definition of the caliphate, the title designates its holder as a sort of spiritual leader of all Muslims, even though, contrary to the traditional principle, he was in this case Turkish and therefore not a member of the nation, much less the tribe, of the Prophet. Perhaps not coincidentally, it was at about this time that a legend began to spread that the last Abbasid Caliph of Cairo had transferred his rights and position to Selim I and his successors. The Ottoman sultans would try to wield this title, which was incorporated into their constitution in 1876, for political purposes both within and outside their empire. A case in point was Sultan Abdul Hamid II, who at the end of his reign in 1900 realized what was apparently a long-standing dream by ordering the construction of the Hijaz railway linking Damascus to the holy cities. As historian François Georgeon commented, it was one way to strengthen Ottoman presence in a contested region as well as a modern way to fulfil one of the dynasty's secular missions: "serving the holy sites".

4. *Mühimme Defteri*, VII, doc. no. 721, January 17, 1568.

**Bibliography:**
Bacqué-Kroell 1988; Barbir 1980; Carcaradec 1981; Faroqhi 1994; Georgeon 2003; Ibn Iyas 1960; Jomier 1953; Laoust 1952; Lewis 1978; Ohsson 2001; Theolin *et al.* 2002; Veinstein 2006.

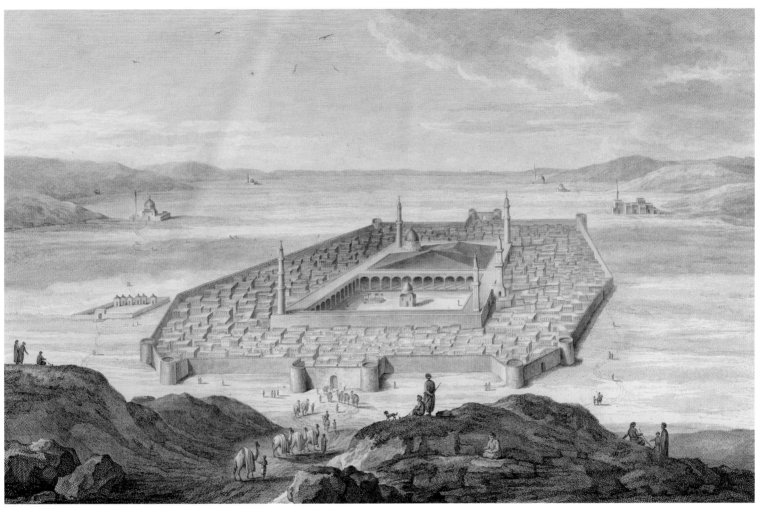

View of Medina, engraving from Mouradgea d'Ohsson's *Tableau Général de l'Empire Othoman*, published in Paris in 1787, vol. 2, pl. 53. Bibliothèque nationale de France, Arsenal, Paris

**304. Inscription bearing the name of the Ottoman Sultan Sulayman**
1520–66 (reign)
Carved marble
37 x 37 x 3 cm
Sanctuary of Mecca
National Museum, Riyadh, 909

Bibliography: unpublished.

عزّ لمولانا
السلطان الملك المظفر سليمان خان
عزّ نصره

*"Glory to our master / Sultan al-Malik al-Muzaffar Sulayman Khan /*
*May his victory be glorified."*

This relief provides no information on its exact date or origin. Was it affixed to a surface within the *haram* or perhaps another building in Mecca? In his unpublished notes on the inscriptions in the *haram*, G. Wiet mentions two three-line inscriptions identical to this one, without specifying the medallion form, on the *Bab al-Salam* and *Bab al-Wada'* doors.[1] This marble slab could be one of them.

In any case, this relief corresponds to the type of epigraphic blazon used by the last Mamluk sultans, Qa'itbay (1468–96) and Qansuh al-Ghawri (1501–16), borrowing their formulation and arrangement: three registers circumscribed in a circle, with the central one more developed, and vegetal motifs decorating the corners.[2] However, the writing incorporates an evolution characteristic of Ottoman calligraphy: the close spacing of long vertical strokes, accentuated serifs (reversed endings of vertical lines), and the systematic displacement of the *nuns* (the letter "n") in the upper part of the inscription.

This symbolic imitation of a visual element traditionally associated with the last Mamluks clearly reflects a desire to assume the heritage of the dynasty that had reigned over the holy sites for two and a half centuries. Other known examples of this type of "appropriation" include a Mamluk-style blazon and decoration at the Coban Mustafa Pasha Complex in Gebze near Istanbul (1523), a blazon of Sulayman at the hospital in Divrigi, and even a fragment of the *nitaq* (epigraphic border) of the Ka'ba bearing the name of Sultan Selim II (1566–74) at the Topkapı Museum.[3] Evidently Sulayman sought to rival the lasting memory of Mamluk patronage, especially that of Qa'itbay, whose fame and prestige in Mecca endured well into the 16th century. Two members of the Banu Qatada lineage – descendants of the Prophet and sharifs of the holy city – bore the name Qa'itbay in the 16th century.[4] He was also the only sovereign to have a door of the *haram* named after him: *Bab Qa'itbay.*

Sulayman was keen to make his mark on Mecca. He rebuilt two of the sanctuary's minarets and added a new one, founded a charitable public kitchen *(imaret)* and a madrasa for the four Sunni schools of law; he also ordered the restoration of the 'Arafa aqueduct.      **C. J**

1. *Thesaurus*, nos 14699 and 25195.
2. See, for example, Atil 1981, nos 101 and 110.
3. Tazjan 1996, no. 28, pp. 89–90.
4. The brother and grandson of Sharif Barakat b. Muhammad (based on a tombstone published in al-Basha 1979, pp. 118–20, and Zambaur, p. 22).

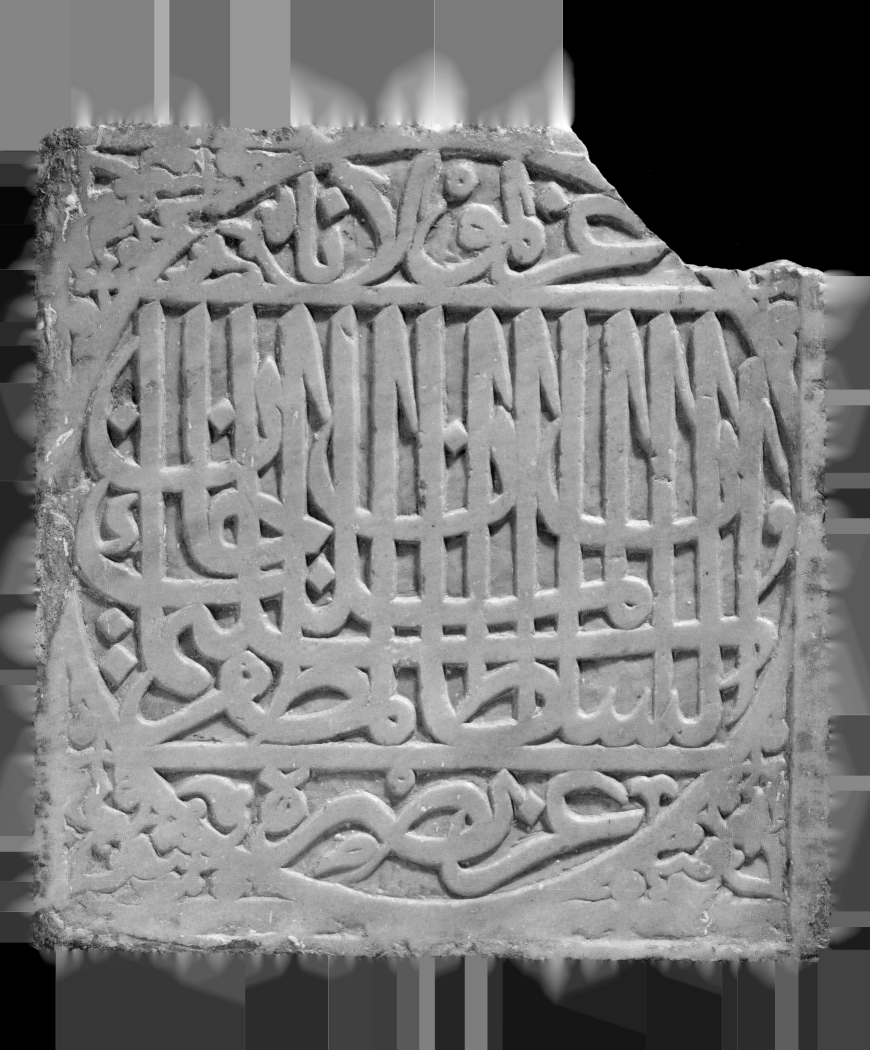

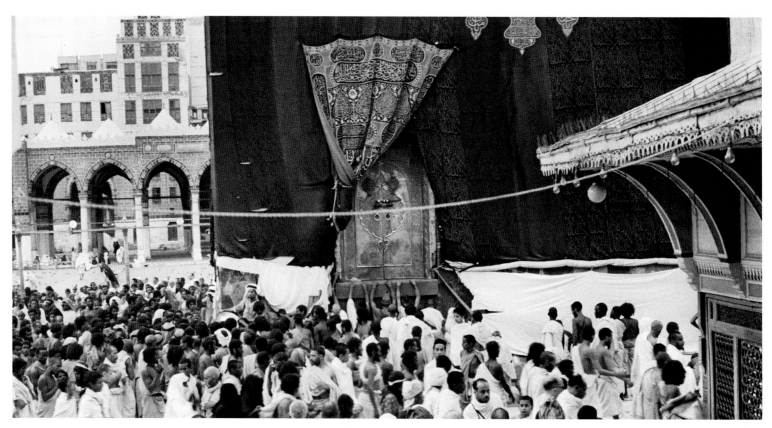

Pilgrims around the door of the Ka'ba, photograph by Philby, 1937, Royal Geographical Society, London

## 305. Door of the Ka'ba

Probably Turkey
1045 H./1635–36
Hammered, engraved and gilded silver leaf on a wooden core
342 x 182 cm
National Museum, Riyadh, 1355

Bibliography: unpublished.

بسم الله الرحمن الرحيم و قل ربّ ادخلنى مدخل صدق
و اخرجنى مخرج صدق و اجعل لى من لدنك سلطاناً نصيراً
قد شرف بتجديد هذا الباب الشريف من له بسقت العناية من ربّ الهداية

مولانا السلطان مراد خان بن احمد خان بن محمّد خان
بن مراد خان بن سليمان خان آل عثمان ادام الله نصره
و ابّد سلطنته من يده في سنة الف وخمس و اربعين

*In the name of God, the Clement, the Merciful. "My Lord, lead me in
with a just ingoing and lead me out with a just outgoing; grant me authority
from Thee, to help me. !"*
*(Quran 17, 80).*

*Has honoured, by the renovation of this august door, he to whom the Lord,
who shows the path of righteousness, has granted a supreme favour / Our
master, Sultan Murad Khan son of Ahmad Khan son of Muhammad (Mehmet)
Khan son of Murad Khan son of Sulayman Khan descendant of 'Uthman,
may God by His assistance prolong his victory and perpetuate his sultanate!
in the year 1045"[1]*

Under the main inscription, in the cartouche above the mandorla: the profession
of faith *(shahada)*

These door panels are strikingly unique, in terms of both their origin
and their decoration. The general composition, featuring a large poly-
lobed central mandorla with trilobate extensions at the top and bottom,
follows a common model for the decoration of books and carpets, like
the vegetal motifs: a dense network of stems, half-palmettes, leaves and
flowers derived from the *saz* style and carved with extraordinary deli-
cacy. The reverse side leaves the wood exposed. Here the decoration is
arranged in a geometrical network of six compartments, delineated by
grooved moulding and punctuated horizontally by three openwork
metal bands with epigraphic decoration. Such exceptional workmanship
points to Istanbul, and quite possibly the Imperial Palace workshops, as
the production site. The historical sources emphasize the lack of skilled
labour and craftsmen in the Hijaz region. Already under Sulayman,
craftsmen were brought in from Egypt, Syria and Yemen for construc-
tions and refurbishings.[2] However, this type of central mandorla compo-
sition was rare on Ottoman doors, but known in Egypt during the
Mamluk period, leading to the possibility that this design was an echo of
another earlier door of the sanctuary. The conservative approach adopted
for the decoration of the holy sites is evidenced by the heavy curtains
that cover the door, examples of which from the 16th to 18th centuries
are conserved at the Topkapı Museum.[3] These drapes are inscribed with
the same Quranic quote (appropriate for an entrance) as this door,
which also once hung at the *Bab al-Salam* (Door of Salvation).[4]

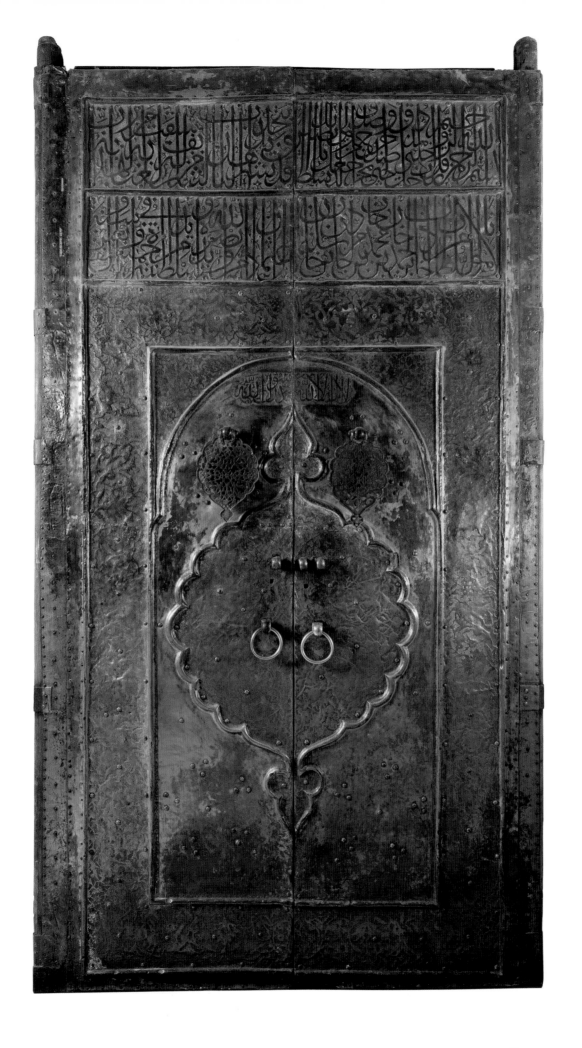

The practice of decorating the Ka'ba door with gold or silver plating began very early, starting in the Umayyad period, according to contemporary accounts.[5] Other renovations of the plating or teak wood door panels are mentioned under the Abbasid Caliphs al-Mahdi (775–85), al-Amin (809–13) and al-Mu'tadid (892–902).[6] The late 9th century andalusian writer Ibn 'Abd Rabbihi[7] and the Persian poet Nasir-i Khusraw in the late 10th century both gave rather precise descriptions of a Ka'ba door similar enough to the one shown here. According to Nasir-i Khusraw, "This door is made of teak wood, with two leaves. The main surface of the door and the baseboard are covered with inscriptions, circles and arabesques of gilded silver.... Two large silver rings, sent from Ghazna, affixed to the leaves... are placed at a height that cannot be reached with one's hand. Two other rings, also silver but smaller in size, are set lower where they can be grasped. A large silver bolt passes through these rings to hold the door closed".[8]

Ibn Jubayr described the installation of a new door made of plane wood and covered with gilded silver under the Abbasid Caliph al-Muqtafi in 550 H./1155.[9] Throughout the first centuries of Islam, numerous sources report on the damage suffered by the Ka'ba door and its decorations, due to floods or the friction of pilgrims' hands wearing away the gilding, for example, as well as public disorder and the cupidity of the local authorities. Later developments shifted power into the hands of the Rasulids of Yemen, who in the late 13th century contributed a new ebony door covered in silver. It was replaced in the early 1330s[10] by the Mamluk Sultan al-Nasir Muhammad, who was keen to establish his ascendancy as Servant of the Two Holy Sanctuaries in the eyes of his Yemeni vassals. A new renovation was reported under the Mamluk sultan Mu'ayyad Shaykh in 1414.[11] Under the Ottomans, Murad III (1574–95) sent the metal needed to regild the door. At the beginning of the 17th century a large–scale restoration of the Ka'ba took place under the reign of Ahmad I, but the sources are unclear as to whether it included any modification of the door. Shortly afterwards, under the reign of his successor Murad IV (1623–40), a major flood in 1039 H./1630 weakened the structure of the Ka'ba, which was already quite fragile. The water level reached the keyhole of the lock on the door. After consultation with the religious authorities, who had previously been reluctant to take any action, a reconstruction project was approved and initiated. Under the supervision of Mehmet Pasha, governor of Egypt, and the Mamluk leader Ridwan Bey, the structure (after being covered with draping) was demolished and rebuilt stone by stone.[12] The sources mention the reinstallation of a silver door framed by two small columns, but not the production of a new door. In addition, the inscription of the door panels shown here, in an extremely graceful, elaborate calligraphic style punctuated with refined vegetal decorations, is dated to 1635–36, which would have been after the reconstruction work was completed.

In any case, this door was not replaced until the 20th century. A photo taken in 1937 by Harry St John Philby (see p. 536) shows it still in place, held shut by a lock with a long bolt. Ten years later, in a photo by Muhammad Helmy,[13] it had been replaced by another door with a different decoration. That door guards the entrance to the Ka'ba to this day, proclaiming the advent of a new dynasty of Servants of the Two Holy Sanctuaries.

C. J.

1. I express my gratitude to Professor Ludvik Kalus (EPHE) for his help in the reading and translation of two difficult passages.
2. Göyünç 1979, p. 178.
3. Tazjan 1996, nos 1 to 11.
4. El-Hawary and Wiet, p. 28.
5. Ibid., p. 35.
6. Ibid. 1985, pp. 66, 68, 77. They also mention sending locks.
7. El-Hawary and Wiet 1985, p. 78.
8. Nasir-i-Khusraw, quoted in El-Hawary and Wiet 1983, p. 91.
9. El-Hawary and Wiet 1985, p. 99–100.
10. Ibid., p. 148.
11. Ibid., p. 201.
12. This reconstruction was described by Evliya Celebi, who visited Mecca in 1671–72, and by Sühayli Efendi in his Tarikh-i Mekke-i mükerrime (Risale); references quoted by Faroqhi 1994, pp. 113–16. See also Eyyüp Sabri 2004, t. 1, p. 449 and ff.
13. Paris 2005, pp. 92–93.

### 306. Lock bearing the name of the Ottoman sultan Ahmad I

1603–17 (reign)
Silver with engraved decoration
24 x 12 x 4 cm
Hujra, sanctuary of Medina
National Museum, Riyadh, 3013

Bibliography: unpublished.

Side A:

اللهم يا مفتاح الابواب
يا فتّاح/ افتح /هو الفتّاح
السلطان احمد خان ابن سلطان
محمّد خان لازالت سلطنته و ايّد دولته
نصر من الله و فتح قريب
يا محمّد شريف المسلمين
الله محمّد/ ابو بكر عمر

*O key that opens doors / O God (He who opens) / Open! / It is He who opens / Sultan Ahmad Khan son of Sultan Muhammad Khan / May his sovereignty endure and his dynasty be eternal / May God help him and victory be near / O Muhammad the most lofty of Muslims / Allah, Muhammad / Abu Bakr, 'Umar*

Side B:

بسم الله الرحمن الرحيم انّا فتحنا لك فتحاً مبيناً ليغفر لك الله
افتاح علينا خير الباب
لا اله الا الله
محمّد رسول الله
عثمان علي/ حسن حسين

*In the name of God, the Clement, the Merciful / "Surely, we have given thee a manifest victory, that God may forgive thee." (Quran, 48, 1–2) / Open to us the greatest of doors / There is no God but Allah / Muhammad is his prophet / 'Uthman 'Ali / Hasan Husayn*

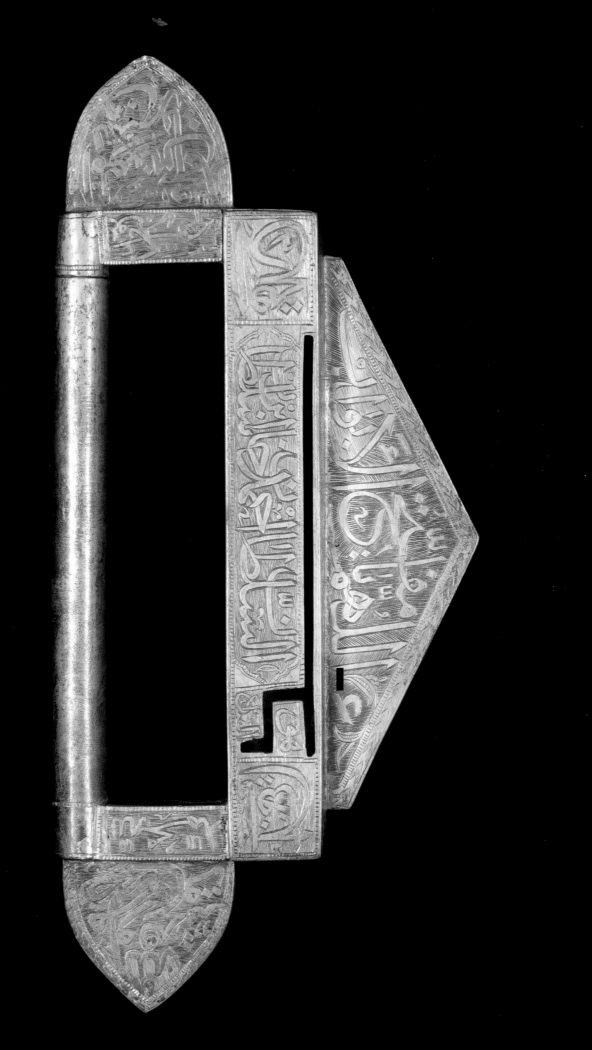

## 307. Lock plate bearing the name of the Ottoman Sultan Ahmad I

1603–17 (reign)
Gilded silver with engraved decoration
23 x 18 x 2.5 cm
*Hujra,* sanctuary of Medina
National Museum, Riyadh, 3005/2/T

Bibliography: unpublished.

براي روضة/ شدّ قفل مجدّد/ بعهد دولت / سلطان احمد/...¹

*Made for the* rawda */ this lock was renewed / under the reign of Sultan Ahmad /…*[1]

These lock components were probably produced in Istanbul, as is mentioned on a lock bearing the name of Sultan Murad III, dated 1002 H./1593–94, at the Topkapı Saray Museum.[2] The keys and locks that have survived are usually indiscriminately attributed to the sanctuary of Mecca, in particular the Ka'ba, but it seems that some could be attributed to the sanctuary of Medina. In these sacred, long venerated sites, a strong conservatism was *de rigueur* and is reflected in forms and decorations that remain essentially unchanged over the centuries. Locks with long bolts were used for the door of the Ka'ba (cat no. 306), and it seems that another type of lock, adopting a more compact rectangular shape like the one shown here, was reserved for the Medina sanctuary. The indication of the provenance of these two pieces bearing the name of Ahmad I substantiates this assumption. The earliest extant examples of this type of lock are dated to 915 H./1509, under the reign of Bayezid II.[3] They bear

an unusual indication: *"bi-Muhammad wa haramihi"* ("by Muhammad and his sanctuary", although J. Sourdel-Thomine translates it as "by Muhammad and his family") that could suggest an intended use in Medina. These locks seem always to come in pairs (the Riyadh museum has another lock identical to no. 3013) presumably because they were designed for the two doors of the *hujra* – the room housing the Prophet's tomb – just like the other locks resembling the one from the Riyadh museum presented here (cat. no. 307). A photo taken by Muhammad Helmy in 1947, showing one of the grilled doors of the *hujra* with a lock plate and lock still in place, strengthens this attribution.[4]

The lock plate shown here includes, in addition to a *saz*-style floral decoration, an inscription in Persian specifying that it was created for the *rawda*, the zone, near the Prophet's tomb. During the Ottoman period this term designated by extension the sanctuary as a whole.[5] This also represents a rare use of a language other than Arabic in the context of the holy sites – Persian was the language of erudition at the Ottoman court.

C. J.

1. I express my gratitude to Prof. Ludvik Kalus (EPHE) for his help in the reading of this inscription.
2. Yilmaz, no. 29, p. 77.
3. Sourdel-Thomine 1971, nos 14–15.
4. Paris 2005, p. 118.
5. An inscription on a rather similar lock plate, bearing the name of Sultan Murad III and dated 1002 H./1593–94, also mentions the *rawda*; see Yilmaz 1993, no. 30, p. 80.

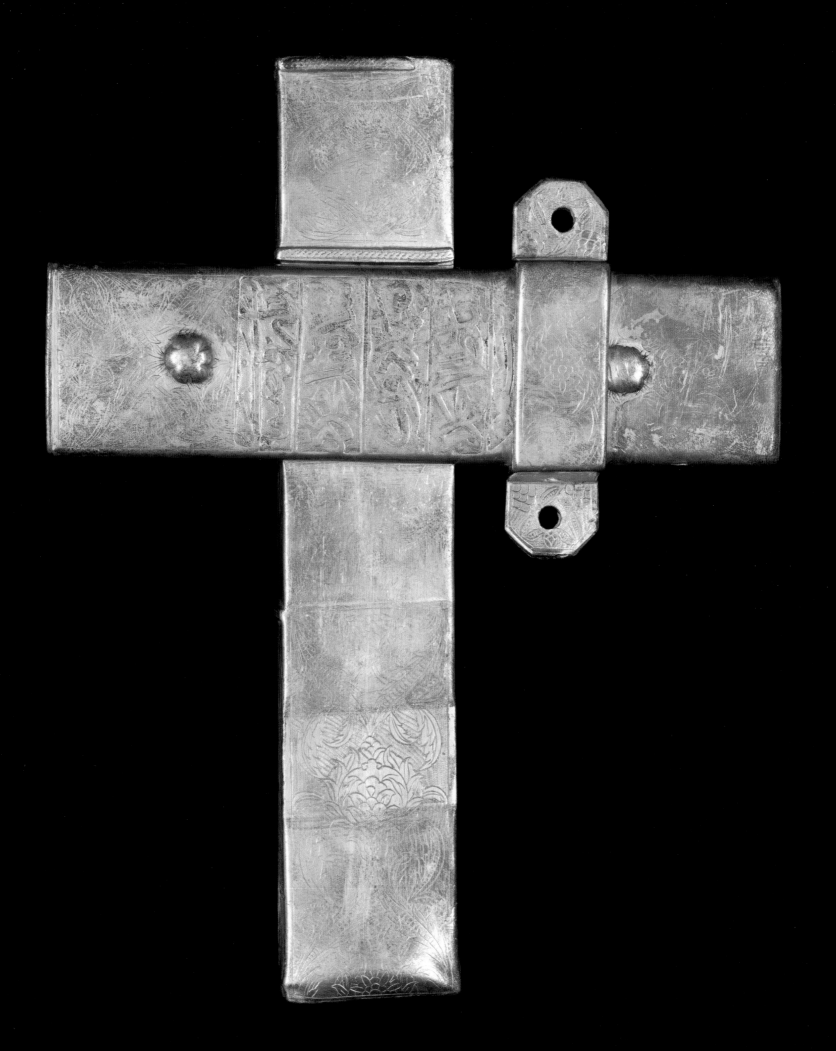

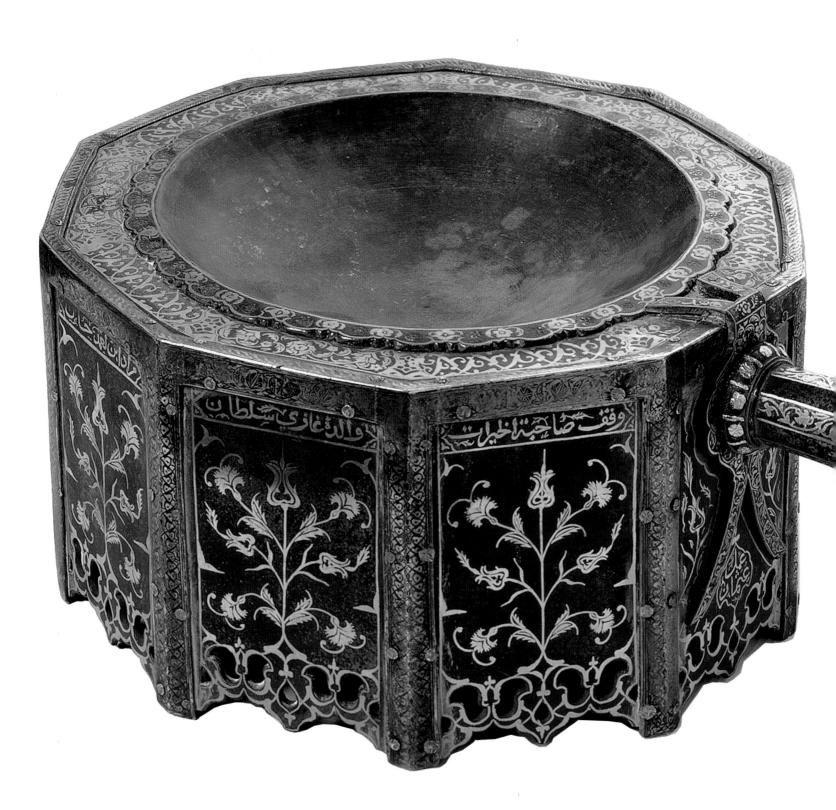

**308. Incense burner commissioned by the mother of Sultan Murad IV**
Turkey 1059 H./1649
Iron alloy, damasquined decoration in gold and silver (?)
H. 14; Max. L. 38 cm
*Hujra,* sanctuary of Medina
National Museum, Riyadh, 2999

Bibliography: unpublished.

It is difficult to find an artefact comparable to this incense burner, privately commissioned for the Medina sanctuary. Its delicate decoration of branches and blossoms adorning each facet of the decagonal base recalls certain Ottoman textiles. The Topkapı Saray Museum[1] possesses, for instance, a metal horse-forehead armor decorated with floral motifs that are simpler but in the same spirit. This piece was most probably produced in Istanbul, and the craftsman signed his work with a small medallion under the base of the handle marked "work by 'Uthman".

Above the floral decoration is a narrow border inscribed in a simple *naskh* script indicating that the object was commissioned by "Valide Sultan Ghazi" ("the mother of the Ghazi Sultan"). The date specified in the inscription would indicate that it refers to the mother of Sultan Murad IV. This sultan, during whose reign the Ka'ba was renovated (cat. no. 305), had assumed the title of Ghazi ("frontier warrior") after his campaigns in Poland in 1596. His mother Mahpeyker, also called Kösem, is remembered as the most powerful Ottoman queen mother.[2] The wife of Sultan Ahmad I, with whom she had many children, she served as regent three times, in 1623, 1640 and 1648, and lived until 1651, under the reign of her grandson Mehmed IV.

Especially from the mid-16th to the mid-17th century, the *valide* wielded extensive power and helped build and promulgate the dynasty's reputation through their active patronage, not only in the capital Istanbul but also at the holy sites. Ottoman sources mention Kösem's works in Mecca and Medina,[3] providing water for the pilgrims, an annual distribution of clothing to the poor of the two cities as well as needy pilgrims, recitations of the Quran, and gifts offered to the descendants of the Prophet, to which no doubt were added precious objects for use in the sanctuaries, like this incense burner.                                                                                              **C. J.**

1. TSM 1/1445, Aydin 2007, p. 118.
2. Pierce 1993, p. 105 and pp. 208–09.
3. See Cavid Baysun "Kösem Walide" in EI2, t. V, Leiden, 1986, pp. 270–71.

The shape of this candlestick, in particular its ringed candle holder (top), and its tombak technique are characteristic of the Ottoman period (16th–17th centuries). An inscription engraved on the shoulder specifies its intended destination, accompanied by a quote from the Quran (**24**, 35) often associated with lighting instruments (such as Mamluk lamps in gilded enamelled glass). According to this inscription, the candlestick was donated as part of a *waqf* (endowment) to the "Noble sanctuary" of the Prophet in Medina and placed in the *rawda* by order of "al-Malik al-Qadir Sulayman al-Wazir".[1] His *tughra* (a type of seal containing the stylized calligraphy of a high-ranking person's name) is engraved on the base of the candlestick. Also known under the name Khadim Sulayman Pasha,[2] he was a eunuch and an Ottoman dignitary who served as governor of Egypt from 1525 to 1538 and led several military campaigns. In 1538 he led an attack against the Portuguese in India. Upon his return to Istanbul he was named second vizier, and he might have donated this candlestick to the Medina sanctuary to mark the occasion. The Museum of Islamic Art in Cairo keeps two candlesticks offered by Sulayman Pasha to the mosque he had built in the Citadel.[3] They bear the same date as the Medina candlestick and are decorated with an identical *tughra*. Another tombak candlestick, now privately owned, has an inscription indicating that it had been donated as *waqf* to the Medina mosque, and including a chronogram that dates it to 1566, the year that Sultan Selim II acceded to the throne.[4]

The offering of functional and precious objects to the sanctuaries of Mecca and Medina was a duty for the Ottoman rulers, sometimes imitated by their dignitaries. The Ottoman archives *(Haremeyn Defterleri)* contain many mentions of this patronage, the earliest dating from the late 15th century and their frequency increasing considerably in subsequent centuries.[5] In addition to the cloths to drape the Ka'ba and the Prophet's tomb, wax candles, candlestick and lamps for lighting the sanctuaries were regularly sent to Medina and Mecca. Among the most prestigious of such gifts were the rain gutter (in gold or silver) and the frame for the Black Stone of the Ka'ba, as well as furniture like an exceptional gold-inlaid silver Quran stand donated to the Ka'ba by Ahmad I, now at the Topkapı Museum.[6] For the Medina sanctuary, Murad III (1546–95) commissioned a sumptuous gold chest to hold the Prophet's *burda* (cloak).[7]          **C. J.**

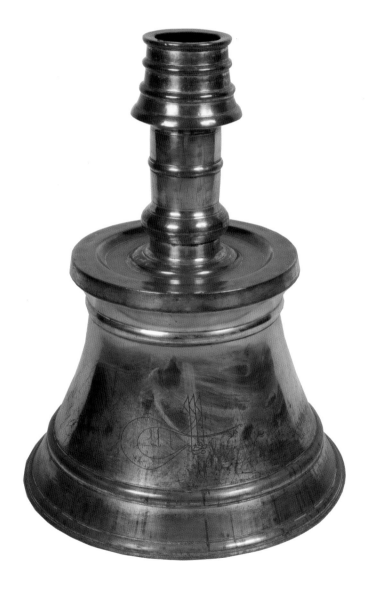

**309. Candlestick**
947 H./1540
Gilded copper (tombak), engraved decoration
H. 96 cm
Sanctuary of Medina
King Abdulaziz Library, Medina.

Bibliography: unpublished.

1. The King Abdulaziz Library in Medina also keeps another candlestick forming a pair with this one.
2. See Orhonles, "Khadim Sülayman Pasha", EI2, vol. IV, Leiden, 1986, pp. 934–35.
3. Wiet 1932, nos 4395 and 4396, pp. 118–20, pl. XXXV.
4. Sotheby's, London October 11, 1989, *Islamic Works of Art*, Carpets and Textiles, lot 145.
5. See Göyünç 1979.
6. Esil 1963, p. 173, fig. 90.
7. *Ibid.*, p. 125, fig. 72.

**310. Quran**
copied in Mecca in 976 H./1568 by 'Ali ibn Sultan Muhammad al-Harawi
Ink and gold on paper
16 x 11 cm; 303 f
King Faisal Center for Islamic Research and Studies, Riyadh, 2535

Bibliography: Riyadh 1985, no.148, p. 229.

This small, modest-looking yet delicately executed Quran offers a fine example of manuscript production in Mecca, of which many specimens are known dating from the 16th century or later – Quranic or other religious manuscripts, plus a few literary works. The fact of their being produced in Mecca gave them a distinction that no doubt made them more valuable to pilgrims. The scribe who produced this manuscript was a learned man, the author of many works and also a well-known Quran reciter in Mecca, where he lived (although he originated from Herat) and died in 1014 H./1568.[1] He produced one copy of the Quran every year, the sale of which provided his main source of income.

Except for an illuminated double opening page, the format is remarkably plain. The inscribed surfaces are delineated by gold and blue rules, the verses are copied in refined *naskh* and separated by small gilt rosettes, and the titles of the surats are written in gold calligraphy. The markings in the margins are verse numbers and indications for reading.                                                                **C. J.**

1. His best-known text is *al-Hizb al-a'zam,* a collection of litanies from the *Hadith* divided into seven parts to be recited over the period of a week, in a spirit similar to al-Jazuli's *Dala'il al-khayrat.*

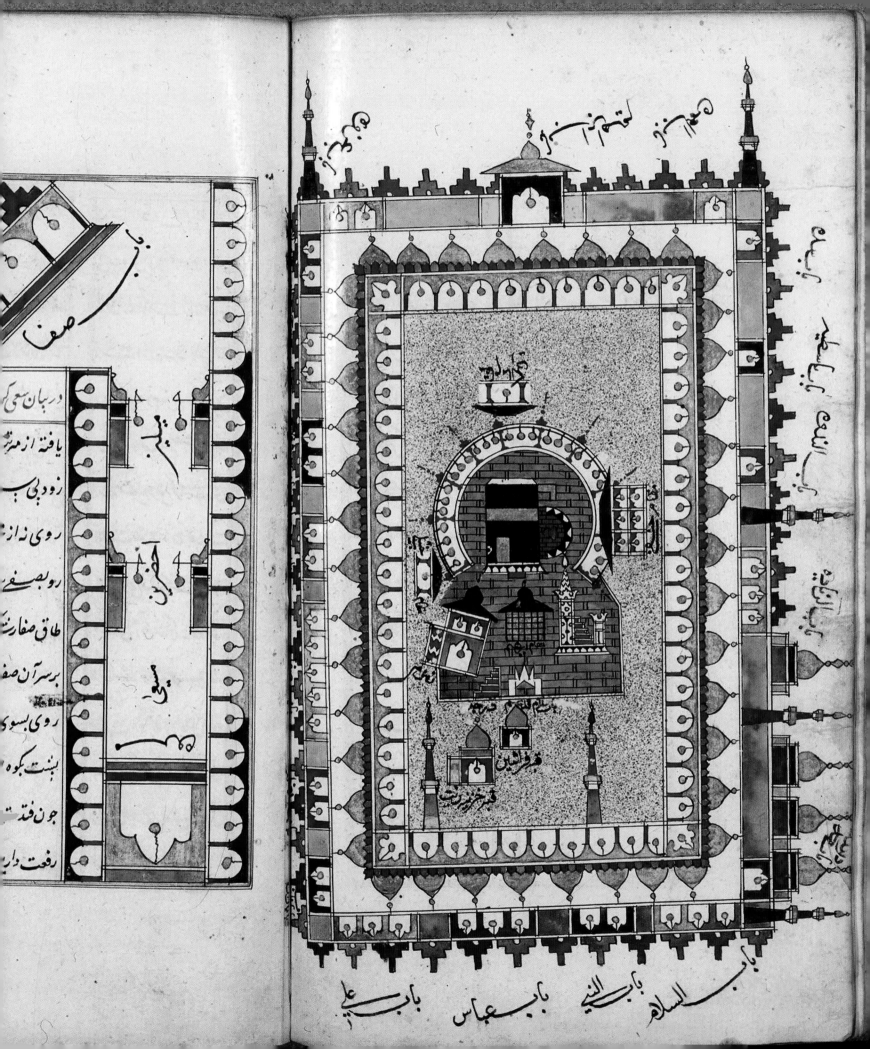

# OTTOMAN REPRESENTATIONS
## OF THE TWO SANCTUARIES:
### FROM TOPOGRAPHICAL DIAGRAMS
### TO PERSPECTIVAL VIEWS

*Charlotte Maury*

*Al-haramayn*, "the two sanctuaries": this is the traditional expression used to describe the sacred territory encompassing Arabia's two holy cities and their respective sanctuaries, namely the Holy Mosque (*al-masjid al-haram*) of Mecca and the Mosque of the Prophet (*al-masjid al-nabawi*) in Medina. In 1517, the Ottoman Sultan Selim I (1512–20) appropriated the prestigious function of "Servant of the Two Sanctuaries" (*khadim al-haramayn*) from the last Mamluk sultan. It thus became his responsibility, and that of his successors, to maintain these buildings, the cities where they stood and the pilgrimage routes leading to them. The pilgrimage to Mecca (*Hajj*) is an obligation for all physically and financially able Muslims, while a visit to the Tomb of the Prophet is seen as a commendable act of piety. Pilgrims performing the *Hajj* have often complemented their journey to Mecca by a visit (*ziyara*) to Medina.

At the beginning of Ottoman domination over the two holy cities, which would continue for four centuries, the Holy Mosque and the Mosque of the Prophet had taken on configurations and dimensions that were to remain largely unchanged by the renovations and improvements initiated by the members of the House of Osman. Any plan to modify either of the two buildings had to be submitted to, and approved by, the local religious authorities. According to tradition, no major modifications were permitted, in particular for the structures considered to be intangible – sanctified by their association with episodes in the history of the prophets. The representations of the two mosques made throughout the Ottoman period and in a variety of media testify to the permanence of their forms.

These images, covering a wide range of representational modes, follow the general evolution of the visual arts in the Ottoman Empire and reflect the growing influence of European pictorial styles.[1] However, this particular corpus is unified by the necessity of fulfilling a cartographic function and of favouring, despite any stylistic evolutions, an informative reading of the image. Whether they were flat projections with no dominant orientation that juxtaposed plan and elevation views, more mimetic evocations using cavalier projection, or depictions using a combination of approaches, these images were meant to inform the viewer, the potential pilgrim, and help him to locate the important sites and structures on the itinerary he would follow, in reality or in his imagination.

Fig. 1. The sanctuary of Mecca, painting from a manuscript of *Futuh al-haramayn* copied by Mulla Salih Muzahhib, *naqqash* of the *Maqam Ibrahim*, presented as a gift to the *Nazir al-haramayn*, 16th century. Bibliothèque nationale de France, Paris, Persan 237, fol. 21r

1. On representations of the two sanctuaries in Islamic art, see Muhammad Ali 1996 and 1999. On representations of the holy sites during the Ottoman era, see Tanındı 1983.

## The *masjid al-haram* during the Ottoman period

The Holy Mosque of Mecca is unlike any other mosque: rather than a sheltered prayer hall, it is a consecrated space in the open air. Marked by a wall since the reign of the second caliph, 'Umar (634–44), its perimeter has been extended several times. Under the Abbasid Caliph al-Muqtadir (908–32) it reached the dimensions that it still retained in the 19th century (cat. no. 321). This vast area comprises numerous places of great historical significance that have been marked for centuries by architectural structures regularly maintained and restored by Muslim sovereigns.[2] The Ka'ba, a cubic structure whose corners are aligned with the four cardinal points, is the most imposing of all, and a focal point of Muslim piety. Its current dimensions and configuration were determined in the late 7th century under the Umayyad governor al-Hajjaj. Worshippers all over the world kneel in the direction of the Ka'ba during prayers, and pilgrims converge upon it during the *Hajj* to carry out the ritual (*tawaf*) of circumambulating the building seven times.

According to Muslim tradition the Ka'ba has been rebuilt several times, notably by Abraham, considered a prophet in Islam, with the help of his son Ishmael. In their day the Ka'ba was not as tall as it is now and had no roof. In order to erect the last rows of stones, the prophet had to climb up on a boulder. His footprints became embedded in the rock, which was later placed in front of the Ka'ba and designated the "station of Abraham" (*maqam Ibrahim*). During the Ottoman period it was protected by a kiosk-like structure topped with a small dome.

Two other sites are associated with the history of Ishmael and his mother Hagar, who was a handmaiden in the service of Abraham and his wife Sarah. The term *hijr* designates the place where they settled and remained until their death. Its limits are indicated by a low semicircular wall between the north and west corners of the Ka'ba, called the *hatim*.[3] After Abraham had left for Syria, Hagar and her son Ishmael were nearly dying of thirst when they discovered a spring. Called the Well of Zamzam, it still flows north-east of the Ka'ba and its water is reputed to have numerous beneficial qualities. During the Ottoman period it was accessible by a roofed well.

The Ka'ba, *maqam Ibrahim*, *hijr* and Well of Zamzam make up the symbolic core of the *masjid al-haram*, to which were added a number of utilitarian structures as well as less permanent elements that have not survived. In Ottoman times, the pilgrims' circumambulations were carried out on a circular paved surface, the *tawaf*, ringed by evenly spaced columns. The pilgrims entered by passing under an arch (*Bab Bani Shayba*). Around the edge of the *tawaf* stood the *maqams* ("stations") reserved for the officiants of each of the four Sunni schools of law. North-west of the Ka'ba, the *maqam* of the Hanafi school, the official school of the Ottoman Empire, became a two-storey open kiosk under the reign of Sulayman (1520–66). To the south-west and south-east, the Maliki and Hanbali *maqams* were smaller, single-level kiosks, and the *maqam* of the Shafi'i school, followed by the inhabitants of Mecca, was located above the Well of Zamzam. These four *maqams* seem to have changed very little in appearance between the 16th and early 20th centuries despite frequent restorations, and can be easily recognized in representations from the Ottoman period. Other structures were found within the perimeter of the mosque, including a mobile staircase used to reach the raised door of the Ka'ba on days when the monument was open, a *minbar* (pulpit), a sundial (*mizan al-shams*) and paved walkways.

Perhaps the most notable change in the sanctuary's appearance was the covering of the porticoes with rows of domes supported by marble columns. This project began during the reign of Selim II (1566–74) and was completed under Murad III (1574–95). These changes are incorporated in most representations from the second half of the 16th century, along with the madrasa built under Sulayman, for instruction in the four Sunni schools, adjacent to the wall of the *masjid al-haram* near its northern corner. The portals to the sanctuary, known under

2. On the history of the two buildings, for the Ottoman era see Sabri Pasha 1883 and 1886, Rif'at Pasha 1935, Güler 2002. On modifications in the 21st century, see Kurdi, undated.

3. For a long time this semicircular space was included in the plan of the Ka'ba, which was not always cubic. The low wall was erected during Muhammad's lifetime, shortly before the first revelations.

different names, had one or several openings – the number of doors seems to have varied over time, and the historical sources are never in total agreement. In addition, the mosque had seven minarets, six of which predated the Ottoman period. There was one at each corner of the wall and a fifth to the north-east adjoining the madrasa built by the Mamluk Sultan Qa'itbay (1468–96). The other two were on the north-west side, one adjoining the madrasa built by Sultan Sulayman and the other at the corner of the *ziyada,* an annex of the mosque.

## Medina: The *masjid al-nabawi* during the Ottoman period

The Medina mosque arose on the site of the mosque of Prophet Muhammad. It was located to the west of his house, which after his death in 632 became the site of his tomb. The first two caliphs of Islam, Abu Bakr (632–34) and 'Umar (634–44), were buried alongside Muhammad. Starting in the Umayyad period, the tombs of the Prophet and the first two caliphs were integrated in the eastern part of the mosque's prayer hall, which was regularly expanded over the centuries. During the first three centuries of the Ottoman period its proportions remained essentially unchanged, with no sizeable extensions being made until the reign of the reformer Sultan Abdul Medjid I (1839–61).

The Medina mosque is an "Arab" type mosque, with a hypostyle hall preceded by a court-yard lined with porticoes. It has several *mihrabs* – niches marking the direction to face during prayer – including the so-called *mihrab* "of the Prophet", the oldest of the niches, dating from the Umayyad era, and the *mihrab* of the Hanafis, the main school of the Ottoman Empire. The Hanafi *mihrab* already existed during the Mamluk period, and was renovated in the early years of Sulayman's reign (938 H./1531–32). The *minbar* of the Prophet did not survive the fires that ravaged the mosque, and was rebuilt many times in its original location. Sultan Murad III offered the mosque a new marble *minbar* that can still be seen to this day. In Medina, the *minbar* took on a particular symbolic significance in addition to its practical role. According to Muslim tradition, the area between the *minbar* of the Prophet and his tomb is an especially propitious place. It is called *al-rawda* (the garden), and prayers pronounced there are considered to have a special value. The *minbar* and the tomb make up the spiritual core of the mosque, and therefore have always featured in even the most minimalist representations. The quadrangular dais supported by columns (*mahfil, dikka, makbariyya*) and reserved for the muezzins of the mosque is also frequently represented, although less charged with symbolic meaning.

During the reign of the Umayyad Caliph al-Walid I (705–15), the room (*al-hujra*) containing the tombs was surrounded by a wall outlining a pentagonal space so that the tomb would not be confused with the Ka'ba. This pentagonal space was then isolated from the prayer hall by metal grilles, which to this day form a quadrangular barrier between the columns of that part of the prayer hall. This area was enhanced by a dome, initially made of wood and later stone. Consequently, the tomb was often represented as a domed quadrangular mausoleum separate from the prayer hall, which is not precisely the case. During a reconditioning project under the reign of Mahmud II (1808–39) the dome was rebuilt and painted green for the first time (1228 H./1813), which is how it still looks today and why it is commonly called the Green Dome. The 19th-century representations did not neglect to incorporate this change. Previously, the dome was often depicted encircled by flames, evoking the even more widespread expression *qubbat al-nur* ("dome of light"). Other frequently represented elements include the herring-bone-patterned fabric draping the *hujra*, as well as the space outlined by a low barrier in front of the *hujra*, traditionally thought to be the burial site of Fatima, daughter of Muhammad and his first wife Khadija.

To the north, the prayer hall gives onto a courtyard lined with porticoes. During the Ottoman era, this courtyard was occupied by an enclosure with palm trees, on the presumed site of Fatima's garden. Nearby was a well and a small domed building used to store lamp oil and tall lamp posts. The mosque could be accessed through four main entrances, dating from the Umayyad period: to the east, *Bab al-Salam* (the "Door of Salvation") near the *qibla* wall, through which pilgrims entered, and *Bab al-nisa'* (the "Door of the Women"), to the west *Bab Jibril* (the "Door of Gabriel") and *Bab al-rahma* (the "Door of Mercy or Rain"). The mosque had five minarets, one of which was added under the reign of Sulayman.

## Flat representations in twisted perspective

The most common representations of the two mosques from the 16th and 17th centuries are plane projections that can be viewed from several directions. They have no spatial depth and served as diagrams for locating and identifying the sites' important features. The elements are shown in plan or elevation views, usually accompanied by captions. The captions, like the frontal views, adopt different orientations. The image must be rotated or turned upside down, or the viewer has to change his own positioning to match each viewing direction. This type of representation is not a faithful reproduction of the real-life perception of a monument. On the contrary, it offers an abstract visualization, producing a multidirectional unfolded effect that must be followed visually and physically. This mode of representation, called twisted perspective, combines several points of view (unlike monofocal mathematical perspective, the theory of which was developed during the Renaissance) and offers an abstract view of the object being depicted.

Twisted perspective offers the possibility of integrating a symbolic orientation. In the case of representations of the mosque of Mecca, it makes it possible to show the roofs of the four Sunni *maqams* converging toward the Ka'ba, in allusion to the ritual orientation of Muslim worshippers and of the imam who leads the prayers from each of these structures. This symbolic orientation sometimes extends to other elements in the courtyard, which seem to be drawn as though by magnetism toward the Ka'ba .[4] As a result of the multiple viewing directions, the eye of the viewer is drawn into a circular motion, like a mental and visual imitation of the pilgrim's movement around the holy building. The rotation of the eyes delineates a movement in space that foreshadows the rite of *tawaf* to be carried out at the site being viewed.

In fact, this type of representation appears in materials conceived to aid or encourage the performance of the pilgrimage, such as commemorative certificates, guides and accounts of the pilgrimage, or ceramic votive plaques to decorate places of worship. These images are anchored in a tradition that dates back to the medieval period. The oldest such corpus is a set of illustrations from pilgrimage certificates produced in the late 12th and early 13th centuries.[5] The plane representations of the Ottoman period are distinguished from older examples by their depiction of the monuments in their contemporary state.

One of the first dated examples is found in a manuscript intended, as indicated in its *ex libris*, for the treasure house of Sulayman the Magnificent. The text, dedicated to the sultan, is a long narrative poem in Eastern Turkish (Chaghatay) entitled *Sifat al-haramayn* ("*The Qualities of the Two Sanctuaries*"). It was composed in 1521, shortly after Sulayman came to power and became the new "Servant of the Two Sanctuaries".[6] The representation of the *haram* in Mecca shows how the monument looked in the late Mamluk period. The madrasa of Qa'itbay and its minaret, built forty years earlier, are highlighted. Although they actually

4. This effect was probably inherited from diagrams of sacred geography, in which the different regions of the world were arranged concentrically around a central circle in which the Ka'ba was depicted, often along with additional symbolic elements of the *masjid al-haram,* all pointing toward the Ka'ba. More rarely, a representation of the sanctuary appeared in the centre of these diagrams (see Munich 1982, no. 46).

5. Aksoy and Milstein 2000. For the medieval period, a slab from Mosul provides a rare example of a plane representation in a medium other than a pilgrimage scroll. Concerning the disputed dating of this stela, see the text by Carine Juvin in the present catalogue (p. 499).

6. Only one copy of this text is known, at the municipal library in Manisa (see Isfahani 2005, pp. 13–14).

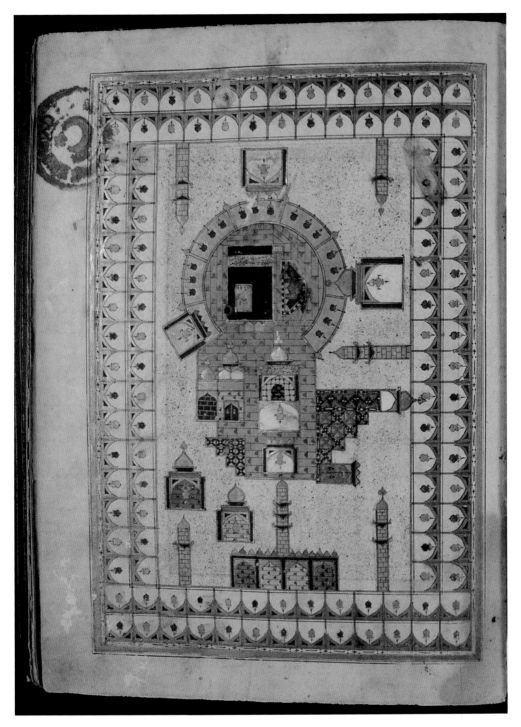

Fig. 2. The sanctuary of Mecca,
painting from *Sifat al-haramayn*, c. 1521.
Manisa Public Library, Turkey

adjoined the mosque's north-eastern perimeter wall, in this image they seem to stand inside the courtyard. There are no domes over the courtyard porticoes, and the Hanafi *maqam* does not yet have two levels. The Medina mosque is shown with only four minarets. The rows of columns in the prayer hall are represented by rows of superimposed wall arches. One can easily recognize the tomb space, surrounded by grilles, and the *mihrab* of the Prophet to the left of the *minbar*. Later in the century it would usually be depicted with the conical tip characteristic of Ottoman *minbars*. In addition, the *hujra* and cenotaph of Fatima (?) are covered with black herringbone-patterned fabric depicted in fine detail, down to the inscriptions.

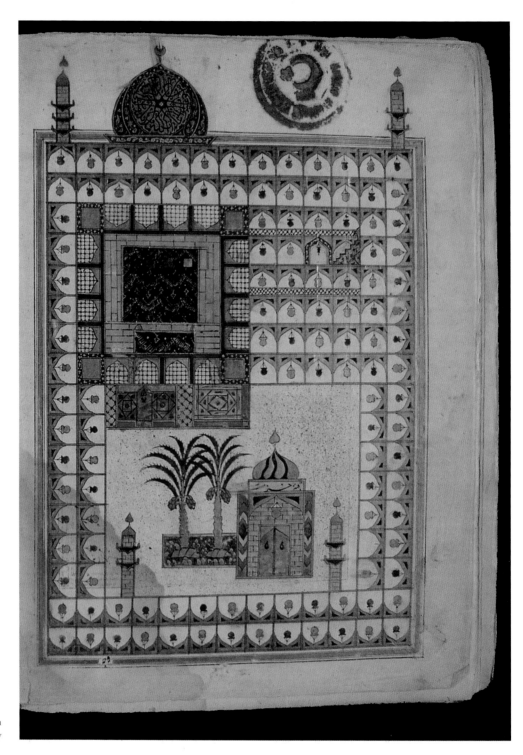

Fig. 3. The Mosque in Medina, painting from
*Sifat al-haramayn*, c. 1521. Manisa Public Library, Turkey

7. Topkapı Museum (Archives, E. 7750). It is pre-
sented in scroll form and was published only very
recently: Istanbul 2008, pp. 204–06, 235.
8. For the *in extenso* publication of the illustrations
of this scroll, see Esin 1984.

Among the representations of the mid-16th century, two documents kept in the Topkapı
Museum are worthy of mention. The first is a letter of gratitude (*teşekkürname*) addressed to
Sulayman by the local authorities of Mecca and Medina, illustrated with representations of the
region's holy sites. In the form of a richly illuminated scroll, this document highlights a works proj-
ect that Sulayman had undertaken to recondition the water conveyance system.[7] The second docu-
ment is a pilgrimage certificate, also in the form of a scroll, attesting to the completion of the journey
to the holy sites by a third party on behalf of the late Prince Shehzade Mehmet, who died in 1543.[8]

The largest corpus of twisted perspective representations from the Ottoman period is comprised by the many illustrated copies of *Futuh al-haramayn*,[9] a poetic text written in Persian that describes the rite of the pilgrimage as well as the configuration of the holy sites (fig. 1). A number of copies from the 16th and 17th centuries were made in Mecca by scribes originating from Persian-speaking regions. It seems that the illustrations were also produced in the holy city and that the documents were then purchased by wealthy pilgrims and taken elsewhere. One copy of the *Futuh al-haramayn,* in the Bibliothèque nationale de France, was copied by a man from Badakhshan, a region that is now divided between Afghanistan and Tajikistan who, according to the colophon completed the writing in front of the Black Stone of the Ka'ba.[10] This text was recopied and illustrated well into the 19th century, with later illustrations following the tradition of the 16th century manuscripts.

A similar conservatism can be seen in the illustrated pilgrimage certificates of the 18th and 19th centuries, including those that use the newly introduced technique of lithography.[11] Toward the middle of the 19th century, the explorer and Orientalist Richard Francis Burton (1821–90) personally attested to the ongoing production of schematic representations of this type, which he described as "a truly Oriental mixture of ground plan and elevation, drawn with pen and ink, and brightened with the most vivid colors."[12] According to the account of his travels in Arabia, Indian artisans living in Mecca specialized in this type of representation, which the pilgrims took home as souvenirs.

Many other works were illustrated with twisted perspective representations, of which an exhaustive inventory has yet to be made. In addition to accounts of the pilgrimage, there are texts on the history of the holy cities or extolling their qualities, as well as geographic works. Among the texts commonly accompanied by representations, two chronicles from the early 17th century are worthy of note, written in Ottoman Turkish by Muhammad Ashik: *Akhbar-i Makka* and *Ikhtisar al-khulasa*.[13] In the copies that we were able to consult, the representations were stylistically consistent with those of *Futuh al-haramayn* but executed using lower-quality pigments. This difference in the production seems to indicate that the illustrated manuscripts of *Futuh al-haramayn* belonged to a more precious and costly category of literary manuscripts.

In the 17th century, twisted perspective representations also started to appear on ceramic plaques and panels produced in the workshops of Iznik or Kütahya for the purpose of decorating places of worship. They form one of the earliest examples of the dissemination of images of the two sanctuaries on a public, and not solely private, scale. An illustrated manuscript or pilgrimage certificate was a relatively expensive souvenir that not all pilgrims could afford. Most of the guides, manuals and other texts on the history or virtues of the two holy cities are not illustrated at all, and the same is true of pilgrimage certificates. The illustrated certificates from the Ayyubid period were for members of the reigning family or high-ranking dignitaries. Based on later testimonies, after the medieval period, certain specialists have suggested that pilgrimage certificates were displayed in the mosques, which would constitute the earliest evidence of a public exhibition of images of the holy sites in a place of worship, although in a material less durable than ceramic.[14]

The ceramic representations were usually mounted on the *qibla* wall, near or inside the *mihrab*. They range from simple square or rectangular plaques to large panels covering the entire surface of the *mihrab*. This type of iconography served as an additional symbol indicating the direction to face during prayers (toward Mecca and the Ka'ba), supplementing the more abstract indication of the *mihrab*. This visual reminder of the direction of Mecca was an innovation of the Ottoman period. Previously, the only iconography associated with the *mihrab* had been the image of a lamp, symbolizing the divine light and illustrating the "verse of light" in the Quran (surat "al-Nur", **24**, 34–35). These representations of the holy sites were also a call

9. On the iconographic cycle of these manuscripts, see Milstein 2006. For the modern edition of the text in Persian, see Lari 1968.

10. Supplément Persan 1389, dated 982H/1574-75

11. Among the dated copies, see Paris 2007, no. 72 (dated 1778); London, Sotheby's, *Oriental Manuscripts and Miniatures*, April 26, 1990, lot 112 (dated 1787). For a lithographed copy from the mid-19th century, see Witkam 2009, fig. 7.

12. This quote also appears in Fisher and Fisher 1982, p. 41.

13. Among the illustrated copies, see the following manuscripts: Pertevniyal 867 (1067 H./1656); Çelebi Abdullah Efendi 249 (1102 H./1690); Halet Efendi 591 (1105 H./1693); at the Suleymaniye Library, Istanbul, and Supplément Turc 1081 at the Bibliothèque Nationale de France, Paris.

14. Aksoy and Milstein 2000, p. 103 and no. 6.

to undertake the pilgrimage, often accompanied by inscriptions, verses from the Quran or poetic verses in Persian or Ottoman. Interestingly, images of Medina are rarer than those of Mecca, and always associated with the latter.[15]

These ceramic illustrations did not appear until the 17th century – the oldest dated plaque is from 1640.[16] Some show the name of the commissioning party, but the circumstances of their production are not specified. Were they ex-votos to betoken the completion of the pilgrimage, or simply a pious gift to the mosque, meant to perpetuate the donor's memory and win the blessing of the faithful? One of the most complete inscriptions is on a panel that can be seen today among the columns to the right of the apse of Hagia Sophia in Istanbul. It was commissioned by a native of Iznik, but the inscription does not shed light on the circumstances of the commission, asking only that viewers give their blessing to the donor.

Other plaques are arranged vertically in sets, recalling the pages of the manuscripts that inspired them. The difference here lies in the addition of a rectangular pediment inscribed with an excerpt from the Quran or, more rarely, the *shahada* (profession of faith). Along with the uniform series there are other cruder examples, rectangular or square in shape. The porticoes are often not included in the representation, which focuses on the features within the courtyard. In certain cases two minarets are superimposed on either side of the courtyard to frame the centre of the image. In addition, all the minarets point toward the centre of the courtyard, accentuating the circular movement mentioned above.[17]

Unlike these minimal representations, other series use twisted perspective, but with panels measuring more than two metres, covering the entire *mihrab* niche or a portion of a sanctuary wall. The most famous of these are kept in the harem of Topkapı Palace in Istanbul, in the oratory of the *Valide Sultan* (the sultan's mother), in the Mosque of the Black Eunuchs and in the Princes' School.[18] Along with monumental representations of the mosques of Mecca and Medina, the panels also include a representation of Mount ʿArafa, the starting point of all celebrations of the *Hajj*.[19]

## The introduction of three-dimensional representation and fewer viewing directions

While plane representations predominated in the early Ottoman period, from the 16th century onward certain images of the two sanctuaries introduced spatial effects. Despite the vertical presentation of the monuments' enclosure, which was not yet developed in depth, the treatment of the structures within the courtyard or the portico arcades began to make discreet use of three-dimensional effects. The multidirectional nature of the image is played down, and the unfolded effect is used less systematically. The viewer is no longer required to rotate the image or look at it upside down. Instead of a backwards depiction of the north-eastern portico, the viewer is shown the outer surface of the perimeter wall. That side of the building is now turned around. Similarly, the four *maqams* are no longer turned toward the Kaʿba but shown upright – a significant change since it renounces the directional symbolism that had previously been the norm. The captions are most often horizontal, in keeping with this trend for fewer viewing directions. However, the unification of the viewpoint is not yet complete, and would not be until the 18th century with the adoption of cavalier perspective and the isometric or perspective rendering of the two monuments.

Representations with a less systematic use of symbolic orientation and incorporating fewer viewing directions were still rare in the 16th and 17th centuries. They became more frequent in the 18th century, a period when cavalier perspective was coming into widespread use. The representations in a copy of *Futuh al-haramayn* from the late 16th century (fig. 4)[20] provide a good example. The paintings in this manuscript are painstakingly executed and comparable to the

15. The ceramic plaques and panels depicting the Medina mosque that are still *in situ* are never isolated, but always associated with the Holy Mosque of Mecca, whereas the latter is frequently depicted alone.

16. Erken 1971, no. 5.

17. See Erdmann 1959, groups B and C; Erken 1971, groups II and III. See also cat.nos 317 and 318 in the French version of this catalogue.

18. For representations of the Holy Mosque of Mecca, see Erdmann 1959, group B; Erken 1971, group V.

19. In the oratory of the *Valide Sultan* and the Mosque of the Black Eunuchs. A final representation of Mount ʿArafat was moved at an unknown date to the corridor of the harem called the "Golden Road"; its original location is also unknown.

20. Nuruosmaniye 1870. This manuscript was copied by Ghulam ʿAli in Mecca. The colophon could indicate the date 1006 H. /1597–98. This name comes back in the colophons of two other copies of *Futuh al-haramayn* completed in Mecca: London, Christie's, *Art of the Islamic and Indian Worlds*, October 6, 2009, lot 221 (65 H./1557–58/[9]); Riyadh 1985, no. 52 (June 1582). If it was indeed the same copyist, he was active for a very long time.

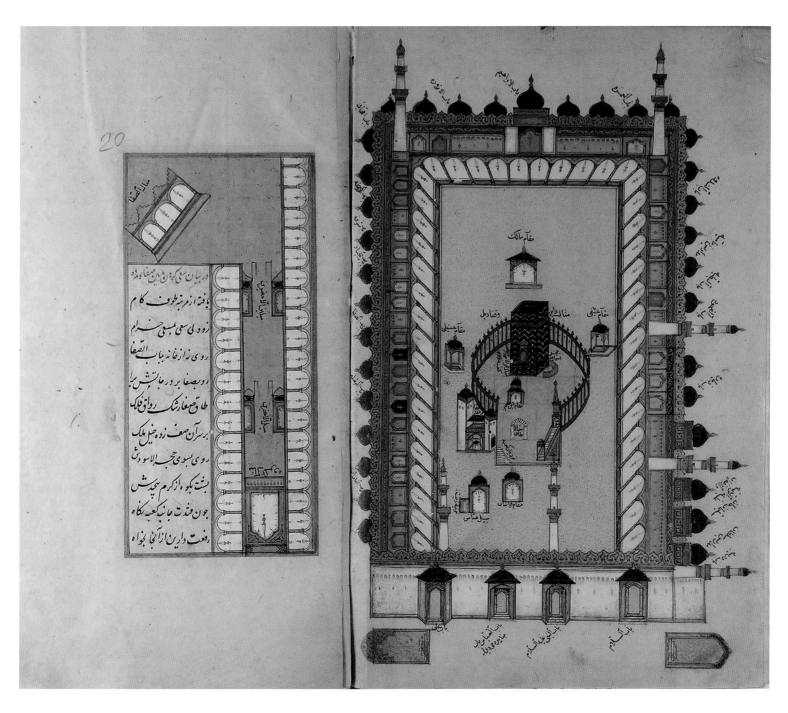

Fig. 4. The sanctuary of Mecca, from a manuscript of *Futuh al-haramayn* copied by Ghulam 'Ali in Mecca, 1006 H./1597–98. Nuruosmaniye, Istanbul, 1870

production of the imperial workshop (*naqqashkhana*) in Istanbul. The fine detailing, the varied palette of colours, the quality of the pigments, the subtle introduction of depth and a certain unification of the viewing direction all distinguish this manuscript from the flat, schematic illustrations most often associated with the famous text. In the representation of the *masjid al-haram*, faint diagonals in the colonnades of the lateral and upper porticoes create a box-like effect; the courtyard is shown as though seen from above. On the other hand, this vertical depth is contradicted by the close juxtaposition of frontal views of the perimeter walls, which are represented in elevation and turned toward the outside. The structures in the courtyard are all arranged along a horizontal line and shown upright. However, in order to read the captions of the portals on the right, the viewer must turn the page 90° to the left, a convention from past practices. In

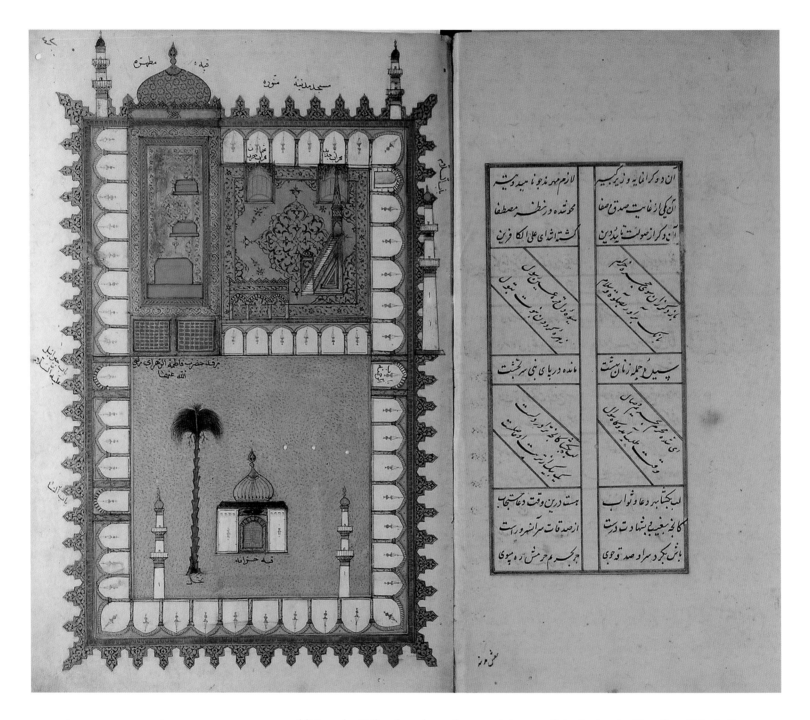

Fig. 5. The Mosque in Medina, from a manuscript
of *Futuh al-haramayn* copied by Ghulam 'Ali in Mecca,
1006 H./1597–98. Nuruosmaniye, Istanbul, 1870

addition, the Ka'ba, the colonnade around the *mataf*, the *hatim*, the Hanafi and Hanbali *maqams*,
the *minbar* staircase and the Well of Zamzam are now depicted in three dimensions rather than a
frontal view or in profile. As a result, the horizontal depth that tends toward a perspective effect
is combined here with vertical depth due to the bird's-eye view.

In the same manuscript, the introduction of a kind of three-dimensional treatment and the
relative unification of the viewing directions is not applied to the depiction of the Medina
mosque (fig. 5), whose outer porticoes are still shown unfolded in four directions. Compared
with most plane projections, this illustration stands out for its extremely delicate execution,
although with only a few details rendered in depth: the two *mihrab*s of the prayer hall and the
*minbar* staircase.

The use of a bird's-eye view for a three-dimensional effect and the disuse of frontal views for certain elements can also be seen in other media, including manuscripts, wall frescoes and ceramics.[21] Nevertheless, the bird's-eye view remained uncommon and three-dimensional effects depended mainly on the use of oblique lines to give objects depth. To this was added a reduction in the number of viewing directions, with the north-eastern portico turned around and the structures in the courtyard shown upright. This pictorial evolution can be seen in a group of ceramic plaques representing the Holy Mosque of Mecca produced in the second half of the 17th century,[22] one of which is in the collections of the musée du Louvre (fig. 6). The above-mentioned rotary movement of the plane representations has disappeared here: all of the structures in the courtyard of the *masjid al-haram* as well as its minarets are aligned horizontally, while the Ka'ba is represented in depth. The porticoes surrounding the courtyard unfold outward and upward, although the lower (north-eastern) one is replaced by a view of the perimeter wall. In front of the wall are various elements shown in frontal view or in depth, forming a somewhat disorderly evocation of the various adjoining constructions and the *mas'a*. At the time the *mas'a* was an open-air path passing in front of this wall and connecting the two hills of Safa and Marwa, each topped by a shelter opening onto three arcades and a single arcade respectively. Pilgrims ran between the hills seven times to commemorate Hagar's quest for water (the *sa'y* ritual), moving faster on a portion of the path indicated by four green pillars. This evocation of the *mas'a*, as well as that of Mount 'Arafa, a small hill at the top of the image, and the presence of a pilgrim tent indicate a desire to combine several stages of the pilgrimage in a single image, a trend that would gain momentum in the 18th century in the cavalier perspective views. Paradoxically, although it is less schematic than a twisted perspective representation, this image is no more accurate. The depictions of many details are inconsistent with the literary sources, and indeed less realistic than certain plane projections. The placement of the structures in the courtyard is more haphazard, and appearance of the four *maqam*s does not match their descriptions in the texts.

A reduced number of viewing directions and the introduction of three-dimensional effects can also be observed in illustrations of *Dala'il al-khayrat*. Dating from the 15th century, this widely read work by the Moroccan mystic al-Jazuli is a collection of prayers in homage to the Prophet Muhammad, prefaced by a list of the names for God and a description of the qualities of the Prophet's tomb. This passage was often accompanied by representations of varying degrees of complexity, from simple diagrams of the tomb and the *minbar* of the Medina mosque to depictions of the entire monument or combined images of the Mecca and Medina mosques, to which could be added views of the Esplanade of the Mosques in Jerusalem. Several illustrations of copies from the 18th and early 19th centuries fall under the above-mentioned category,[23] with the lower porticoes turned around, showing certain elements in depth and introducing shading effects. However, many artists were reluctant to show all the structures in the *masjid al-haram* courtyard standing upright, preferring to retain the traditional directional symbolism. Although rendered in depth, the Sunni *maqam*s still point toward the Ka'ba. These depictions of the sanctuaries could be supplemented by evocations of other stages in the pilgrimage and landscape images, widening the frame of the representation, not unlike the cavalier perspective views of the time.

## Cavalier perspective and widening the frame

Although the tradition of plane projections continued in certain contexts and other pictorial solutions existed in parallel, the 18th century was characterized by the popularization of cavalier perspective views of the two *harams*. This type of representation can be seen in manuscripts about the

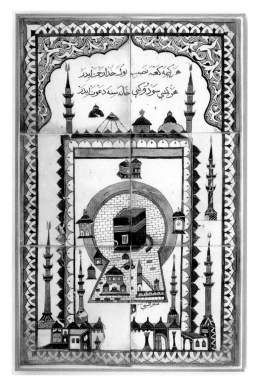

Fig. 6. The sanctuary of Mecca, ceramic plaque, Iznik, 17th century. Musée du Louvre, Department of Islamic Art, Paris, AO 3919/558

**21.** In a manuscript dated from the time of Murad III, *Jawahir al-ghara'ib* by the historian Jannabi, a representation of the Holy Mosque of Mecca (see Portland 1979, p. 34. In Sivrihisar, western Anatolia, a fresco decorating the *qibla* wall of Haznedar Mescidi Mosque also uses this type of representation for the Medina and Mecca sanctuaries, shown here side by side (see Dilaver 1970). This fresco could date from the late 17th or early 18th century. For an example on ceramic, see the plaque mounted on the north-western pillar of the Yeni Valide Cami in Istanbul, Erdmann 1959, no. 13, and Erken 1971, no. 29.

**22.** Other comparable representations are conserved in Turkey and Greece: Benaki Museum, no. 124; Museum of Turkish and Islamic Arts, no. 830. See Erdmann 1959, group B, nos 4–5, and Erken 1971, nos 20–21. These three panels of six tiles are comparable to a larger panel kept in the mosque of Kastamonu. Decorating the *qibla* wall, it dates from 1087 H./1676, which gives an indication of the date for this group. See Erken 1971, group IV, and Yaman 1996.

**23.** There are many copies, including: Istanbul, Suleymaniye Library, Halet Efendi 69 (1165 H./1751); Chester Beatty Library T463 (1798); London, Sotheby's, *Fine Oriental Manuscripts and Miniatures*, October 11, 1982, lot 236 (1243 H./1827); Kuwait 1997, p. 12 1227 H./1812); Paris, Drouot, Claude Boisgirard, *Arts d'Orient*, September 25, 1997, lot 163. See also a manuscript in the Bibliothèque nationale de France, Paris, Arabe 6859.

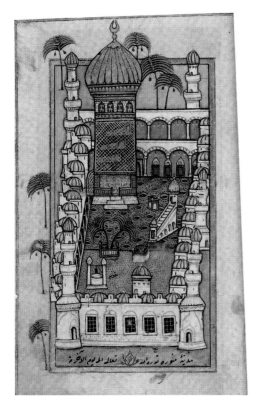

Fig. 7. The sanctuary of Medina, painting from a manuscript of a *Dala'il al-khayrat* signed by Levni, early 18th century. Private collection

pilgrimage or other religious topics, ceramic plaques and panels, frescoes, and also *qiblanumas* (instruments for determining the direction to face during prayers) as well as accompanying *hilya*s of the Prophet – literary evocations of his physical appearance. The technique does not seem to have been used in pilgrimage scrolls, which preserved the tradition of plane projections.

Like plane projections, cavalier perspective views, mostly using an elevated point of view, have the advantage of offering an overview of the monuments. For the sanctuary in Mecca, whose structures are arranged in the courtyard, this type of depiction is ideal. Cavalier perspective can encompass them all while producing a more mimetic image that is close to tangible reality.[24] The same is not true for the Medina mosque, since part of the fittings and other elements of great sacred significance are located inside the prayer hall. To produce a useful visualization, reality must be distorted. The roof of the prayer hall and the rows of columns are usually omitted from the image to allow the *minbar*, *mihrabs*, tomb, muezzins' platform, etc., show through. Since mimesis is not easily compatible with the informative cartographic function of the image, a choice must often be made: whether to remain informative at the expense of altering tangible reality or to remain true to reality but abandon certain visual reference points. For example, the indication of the three tombs inside the *hujra* can be omitted in favor of the representation of a domed building surrounded by grilles through which nothing can be seen, which is more consistent with reality.

A painting of the Medina mosque by Levni (d. 1732) in a copy of *Dala'il al-khayrat* (fig. 7)[25] supplies one of the early examples of cavalier perspective, although undoubtedly not the earliest. The monument is shown from an elevated point of view in front of the image. The rectangular enclosure is no longer depicted vertically but in depth, following two parallel diagonals. However, the *qibla* wall and the tomb have no thickness and are rendered in elevation. The courtyard is distinguished from the prayer hall by a simple change of colour: a yellow background stippled with red for the courtyard and a blue background with red mandorlas for the prayer hall, which is typical of this painter's decorative style. The *minbar* is shown in perspective in a hall with no columns, and the three tombs seem to be floating in the air behind the grille that separates them from the viewer. This awkward attempt at lending depth to the depiction of the monument should be considered in relation to the evolution of Ottoman painting in the time of Ahmad III (1703–10), which Levni was helping to advance. Characteristics of Ottoman classical painting like decorative effects and bright colours were combined with more innovative shading and chiaroscuro effects.

In the 18th century, the adoption of cavalier perspective resulted in a frequent widening of the frame of representation, extending it beyond the confines of the sanctuaries to show the two monuments in their urban and natural environments. These images sought to retain their informative function while incorporating the mimetic potential of cavalier perspective. Such panoramic views could incorporate all the stages of the *Hajj* ritual as well as other sites associated with episodes in the Prophet's life that might be visited along the way. These include Safa and Marwa, Mina (site of the stoning of the pillars and the ritual sacrifice), Mount 'Arafa and the surrounding plain, Mount Abu Qubays (associated with Muhammad's miracle of splitting the moon in two), Mount Thawr (where Muhammad and Abu Bakr took refuge in a cave to escape persecution by idolaters) and the Baqi' cemetery in Medina (where many companions of the Prophet are buried), for example. These panoramas are comparable to the *vedute* that decorated many Ottoman interiors during this same period. A general taste for mimetic images of buildings and landscapes, always devoid of human figures, arose in the 18th century. The treatment in these ornamental works is far from uniform, more or less arbitrarily integrating the various mimetic processes of Western painting.

24. This mode of representation existed before the Ottoman period in illustrations of the Prophet's nocturnal journey from Mecca to Jerusalem. The mosque is not the subject of the representation but one element in the scene. Straddling his horse, the Prophet flies over the courtyard of the *masjid al-haram,* represented from an elevated point of view. See Ettinghausen 1934, fig. 13. On representations of this scene, see Gruber 2005, pp. 255–63.
25. Paris, Drouot, Etude Tajan, *Art de l'Islam,* April 10, 1997, lot 95.

This gradual, uneven integration is also evident in the cavalier perspective views of the two sanctuaries, which followed at least two major trends.[26] The first envisioned the urban and natural setting as a succession of separate, independent units (monuments, elements of the landscape) labelled with captions. This type of cavalier view retains a strong cartographic value. The elements dispersed in the image become a kind of three-dimensional extension of the juxtaposed elements of plane projections, but the raised point of view unifies the reading of the image and gives it a predominant orientation. Because of the widened frame there are more elements to situate, and most of them are depicted in depth. The captions are to be read horizontally or at a slight angle, and the shading effects are still quite modest.

A series of *qiblanuma*s produced c. 1738 (fig. 8)[27] provide an example of this type of representation. Around the enclosure of the *masjid al-haram,* which is developed in depth, various elements are dispersed against an abstract landscape dotted with patches of grass and shrubs, including the structures crowning the hills of Safa and Marwa, the mosques of Khayf and Muzdalifa, and Mounts Qubays, Nur and 'Arafa. However, in this landscape as well as in the rendering of the mosque courtyard, elements depicted in three dimensions (the Ka'ba, the colonnade, the four *maqams*, the above-mentioned mosques) appear next to elevation views of other structures (the *minbar*, the two domed buildings).

This principle of juxtaposition can be seen on ceramic plaques from the same period, as well as frescoes painted for private homes, and it continued throughout the 18th century. These representations are characterized by the accumulation of different elements in a more or less developed way, uneven attempts at shading and the continuing use of captions.[28]

The second trend was for the use of cavalier perspective in more mimetic images. Further removed from the pictorial traditions of the past, these representations sacrificed the informative function in favour of spatial unity and a more naturalistic treatment. They make more expert use of aerial perspective, and the monuments are positioned more accurately in the landscape. Greater sophistication can be seen in the shading and the use of atmospheric perspective. The elements of the images are consistently depicted in three dimensions. These representations are generally free of captions, reflecting a new function of such images as they gradually lost their cartographic purpose. In these cavalier views, the sanctuaries' urban surroundings are evoked by closely clustered houses with terraced roofs, plus a few public buildings, caravansaries or small mosques. Images of Medina might include the city wall and Baqi' cemetery. An example of this type of view is a copy of *Dala'il al-khayrat* in the Bibliothèque nationale de France, Paris, Arabe 6859. Still, however, the prayer hall of the Medina mosque is shown in it with no roof, a custom inherited from older pictorial practices.

This type of cavalier perspective was the final stage prior to the development in the 19th century of what could truly be considered mimetic images. The latter required the ever-greater mastery of aerial perspective, ultimately leading to the use of mathematical perspective with a single, non-aerial, vanishing point. The images also began incorporating human figures, a previously exceptional phenomenon.[29] Soon thereafter, the revolutionary innovation of photography would profoundly alter the role of the image in the Islamic countries. An in-depth study of this final phase in the pictorial evolution that laid the groundwork for mimetic and photographic imagery would require investigations beyond the scope of this article. We will therefore end here this overview of the development of representations of the two sanctuaries, a rich body of work that in itself merits thorough investigation and a synthetic analysis that has yet to be undertaken.

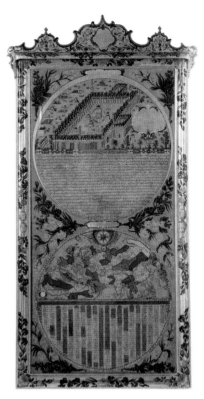

Fig. 8. *Qiblanuma*, Turkey, 1738.
Civico Correr Museum, Venice, M. 34394-34755

26. In order to grasp the diverse range of these representations and their evolution between the 18th and 19th centuries, one must consider not only the specimens found in religious edifices, but also those that decorated private homes in the large provincial cities of the Ottoman Empire. Among the published representations, see Arik 1973 (mosques of Anatolia); Maury 1983, pl. XXIV, XLIX and L (palaces of Sitt Wasila and 'Ali Katkhuda in Cairo, 18th century); Weber 2003, p. 164; Weber 2009, vol. I, pp. 322, 325, 384, 445, 449, and vol. II, pp. 18, 498 (houses of Damascus); Kuyulu 1994.

27. Istanbul 2008, pp. 126–27 and 224; London, Christie's, *Islamic Art and Manuscripts*, October 14, 2003, lot 40; London, Bonhams, *Islamic and Indian Works of Art*, April 24, 2002, lot 380; Ertug and Grabar 1993, p. 89.

28. For examples in ceramic, see Erken 1971, nos 26–27, 31.

29. See in the Topkapı Palace Museum a series of paintings on ivory using monofocal perspective in representations of the courtyards of the two mosques including human figures. These paintings date from the mid-19th century; see Istanbul 2008, pp. 128–29, 224–25. One of the rare examples prior to the 19th century is a 1603 copy of *Futuh al-haramayn* conserved in Leiden, see Witkam 2009, figs 3, 9. The figures associated with the representations of the two mosques do not seem to be pilgrims but rather high Ottoman officials in charge of the sites' maintenance or operations.

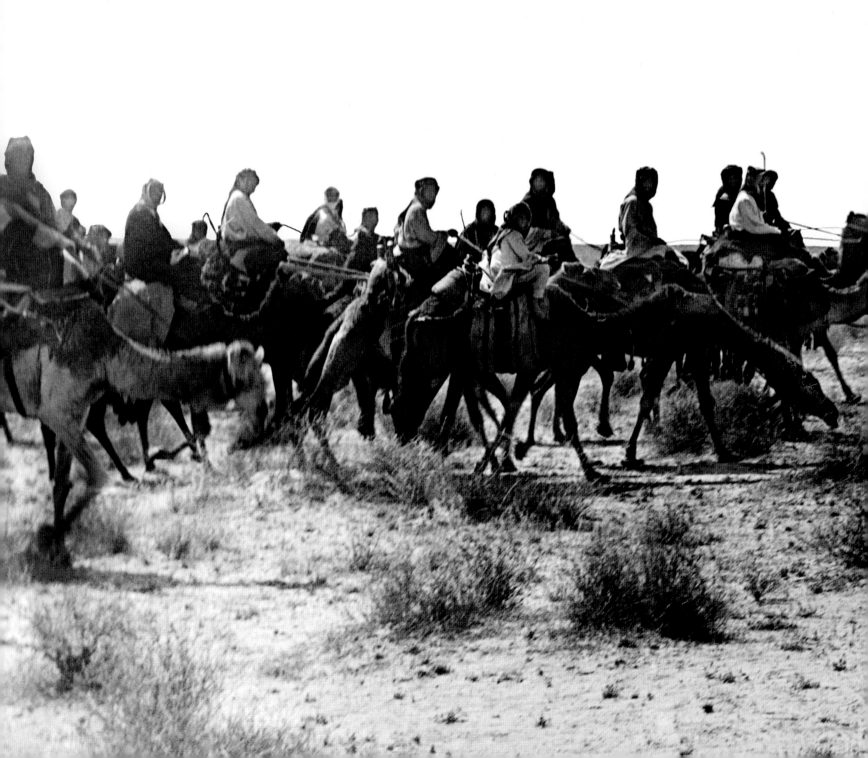

# THE BIRTH OF THE KINGDOM

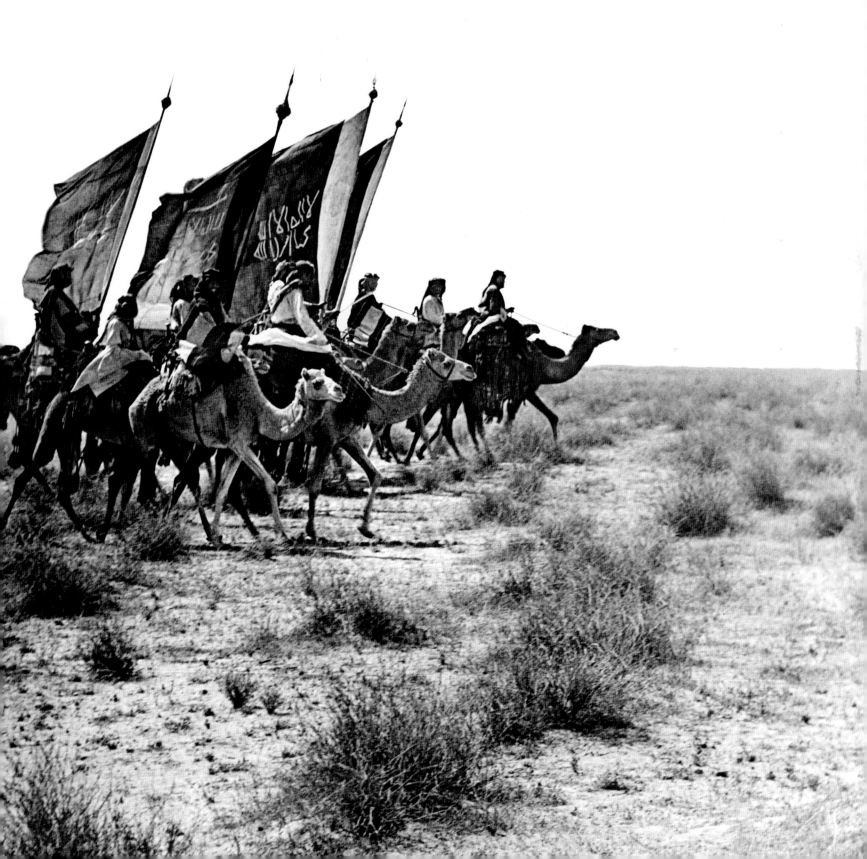

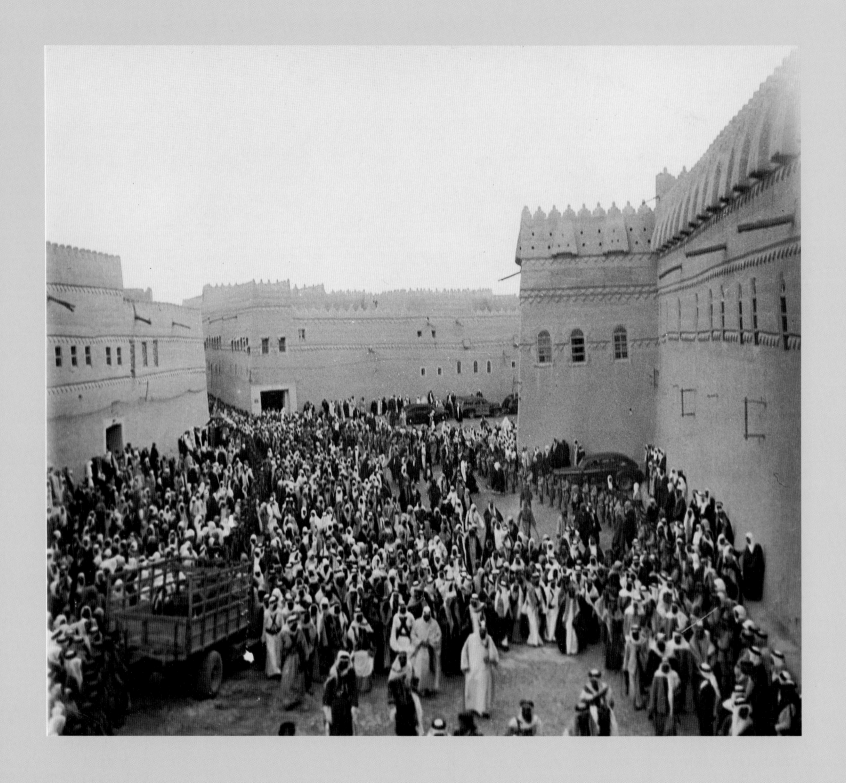

# THE KINGDOM
# OF
# SAUDI ARABIA

*Fahd A. Al-Simari*

The Al Saud royal family descends from the Banu Hanifa tribe, who played an illustrious role in the history of the Arabian Peninsula, especially in the centre of the region, where they established a state centred around Wadi Hanifa and the al-'Arid territory.

With the rise of Islam, a large part of the Banu Hanifa people had embraced the Muslim religion and participated in the conquests of the Islamic state. In the 9th century the Banu Hanifa were dispersed throughout the peninsula in reaction to the prevailing political situation in the region. In 1446 the patriarch of the Al Saud family, Mani' al-Muraydi, left his home in the eastern part of the peninsula and moved with his family and members of his clan to the centre. Upon the invitation of his cousin Ibn Dir', they settled in the al-'Arid region around Hanifa Wadi, where their tribe had lived for centuries. Ibn Dir' granted him the fiefs of al-Mulaybid and Ghassiba, which later became "Dir'iyya", the capital of the first Saudi State. The family's dominion over the region was consolidated, forming a powerful emirate.

Under the reign of Emir Muhammad ibn Saud, who came to power in 1725, the principality enjoyed political stability and considerable economic development, while improving its relations with neighbouring emirates.

## The first Saudi State (1744–1818)

The early 18th century was a chaotic period for the Arabian Peninsula, marked by instability and religious decline. In reaction to the situation, a reformist movement arose calling for an authentic religion and the abandonment of superstitions. The impetus for reform came from a religious leader, Shaykh Muhammad ibn 'Abd al-Wahhab, and his ally the Imam Muhammad ibn Saud, Emir of Dir'iyya, who commanded a strong political position.

In 1744 the alliance between these two leaders led to the founding of the first Saudi State. The new entity extended its power over vast regions, including, for a brief period, the Hijaz, home to the holy sites of Mecca and Medina, which had until then been under

*(preceding pages)*
Abdulaziz's troops in central Arabia,
photograph by Captain Shakespear in 1910–11,
Royal Geographical Society, London

*(opposite)*
King Abdulaziz in Riyadh returning
from Friday prayer,
photograph by De Gaury in 1939,
Royal Geographical Society, London

Ottoman control. Because of the importance of the holy cities, the central Ottoman authority decided to recover them, and entrusted its governor in Egypt, Mehmet 'Ali, with the mission. As a result of the expeditions led by Mehmet 'Ali and his sons, the Ottoman Empire defeated the Saudi State, destroyed its capital Dir'iyya in 1818, and finally executed its last imam, Abdallah ibn Saud, in Istanbul.

The successive leaders of the first Saudi State were:

– Imam Muhammad ibn Saud ibn Muqrin (1744–1765),
– Imam Abdulaziz ibn Muhammad ibn Saud (1765–1803),
– Imam Saud ibn Abdulaziz Muhammad ibn Saud (1803–1814),
– Imam Abdallah ibn Saud ibn Abdulaziz ibn Muhammad ibn Saud (1814–1818).

## The second Saudi State (1824–1891)

Despite the sacking of Dir'iyya by Mehmet 'Ali's army under the command of his son Ibrahim Pasha, and many subsequent episodes of destruction, the Ottomans could not eradicate the foundations of the Saudi State in the Arabian Peninsula. The inhabitants of the region, both rural and urban, remained loyal to the Al Saud family, which they respected for its devotion to the reformist movement. Just two years after the end of the first Saudi State, the members of the Al Saud family re-emerged and began rebuilding their government. Their first attempt dates from 1820, when the Imam Mishari ibn Saud managed to restore Saudi power in Dir'iyya, although only for a few months. In 1824, a second attempt, this time successful, by Imam Turki ibn Abdallah ibn Muhammad ibn Saud, culminated in the founding of the second Saudi State with Riyadh as its capital. Its influence spread over a large region, even though it never reached the size of the first Saudi State.

In 1891, the infighting between his brothers Abdallah and Saud, led Imam Abdulrahman ibn Faysal ibn Turki, the last imam of the second Saudi State, to leave Riyadh with his family, including his son Emir Abdulaziz. The Al Sauds fell from power and the region came under the control of Muhammad Al Rashid, governor of the Ha'il region north of Riyadh. Imam Abdulrahman's family settled in Kuwait, marking the end of the second Saudi State.

The leaders of the second Saudi State were, in order:

– Imam Turki ibn Abdallah ibn Muhammad ibn Saud (1824–1834),
– Imam Faysal ibn Turki (1834–1838 and 1843–1865),
– Imam Abdallah ibn Faysal ibn Turki (1865–1871 and 1876–1887),
– Imam Saud ibn Faysal ibn Turki (1871–1875),
– Imam Abdulrahman ibn Faysal ibn Turki (1875–1876 and 1889–1891).

## The Kingdom of Saudi Arabia

On January 1, 1902, King Abdulaziz ibn Abdulrahman ibn Faysal Al Saud reconquered Riyadh and returned to his homeland with his family, thus opening a new chapter in the history of the Saudi State. This was a true turning point for the region, resulting in the founding of a modern Saudi State that successfully reunified most of the peninsula and ushered in a new cultural era.

Showing all the qualities of a great leader, King Abdulaziz was determined to found a modern state in response to the needs of the people in the region. He was known to all for his piety, courage, gentlemanly spirit and great generosity, as well as his far-sighted political savvy.

The reconquering of Riyadh is an excellent example of a major historical event that reflects the king's personality and abilities in governing, based on his extensive experience. At the head

Painted wooden door, Najd, late 19th–early 20th century, 255 x 124 cm. National Museum, Riyadh, 2108

of a small band of partisans, he succeeded in taking Masmak Fort in Riyadh without causing harm to the population. For more than thirty years following this victory, he pursued his plan to unify the country, ultimately winning most of the peninsula's regions over to his cause. As a result, the present-day Kingdom of Saudi Arabia was officially founded in 1932.

From that moment on, the kingdom has enjoyed a special status in the region and in the international arena, thanks to the king's wise, well-balanced policies. After oil was discovered in 1938, the country used this resource to move its development and modernization forward, maintaining a carefully considered policy for the commercial exploitation of this national treasure. Throughout his reign, King Abdulaziz oversaw his country's growth in terms of education, industrialization, trade, administration, defence and urbanization. The king died in Ta'if on November 9, 1953, and was buried in Riyadh, bringing the founding era of the kingdom to a close.

# KING ABDULAZIZ
## (IBN SAUD)
### 1902-53

*Fahd A. Al-Simari*

King Abdulaziz ibn Abdulrahman ibn Faysal ibn Turki ibn Abdallah ibn Muhammad ibn Saud ibn Muhammad ibn Muqrin was born in Riyadh in 1876. His parents entrusted his education to teachers chosen from among the city's learned men. His family were descendants of the Banu Hanifa people, an offshoot of the Bakr ibn Wa'il tribe that had inhabited the al-Yamama region in the centre of the Arabian Peninsula since the Pre-Islamic period.

In his youth, the future king was taught the arts of cavalry, hunting and warfare. He trained himself to live in the desert, thus transforming the nomadic lifestyle he inherited from his father into a model of teaching that helped forge his character and provided him with invaluable experience. He was aware of the inherent hardships of the Bedouin life and understood that living in the desert demanded a great deal of patience toward himself and others. His strong educational background and early experiences enabled Abdulaziz to assume responsibilities at a very young age.

At the end of the 19th century, Abdulaziz witnessed many of the important events that marked the period of the second Saudi State. The fall of that government, due to family infighting, led him to emigrate with his parents from Riyadh to Kuwait, where they remained for several years. From the very beginning of his time in Kuwait, Abdulaziz was preoccupied with the thought of reconquest of Riyadh and the establishment of a unified Saudi State.

Some years later he succeeded in returning to his homeland, hoping to fulfil the mission he had given himself: to build a modern country upon the foundations of the first Saudi kingdom, created in the 18th century, in the heart of the Arabian Peninsula. He was also able to reunite with his extended family, whose roots and history had been linked to the region since the Pre-Islamic era.

In 1901, King Abdulaziz made his first attempt to retake Riyadh. Just when he was about to attain his goal, a messenger from his father delivered the news that the Ottomans had defeated the Emir of Kuwait, Shaykh Mubarak al-Sabah, in a battle in the al-Qasim region,

Portrait of King Abdulaziz in Kuwait when he was 34 years old, 1910. From a photograph by Captain Shakespear (Royal Geographical Society, London)

about 400 kilometres from Riyadh. Obliged to abandon his blockade of Masmak Fort, King Abdulaziz left Riyadh, filled with a fervent desire to return.

A few months later, more intent than ever to retake and rebuild the Saudi State, the king set out to reconquer Riyadh, accompanied by a small band of loyal followers. Along the way, relying on the experience of his youth and what he had learned from the history of his people, Abdulaziz succeeded in uniting some 1,400 fighters from various tribes.

After several attempts to mobilize Saudi partisans, Abdulaziz and his men came under pressure from the west and the north. Muhammad al-Rashid, governor of the Ha'il region, had warned the Ottoman authorities of the risks posed by Abdulaziz's campaigns and the instability he was creating in the Najd and Hasa' regions. The Ottoman governor of Hasa' issued a warning to the tribes in the region that wanted to support Abdulaziz, and many abandoned the cause. The king then found himself with only a handful of men, those who had left Kuwait with him plus a few others who had joined them along the way. In all, his force totalled no more than sixty-three.

With his support dwindling, and with mounting pressure from the Ottoman authorities preventing the procurement of supplies in the Hasa', Abdulaziz decided to take refuge in the Rubʻ al-Khali desert, knowing that no one would attack him and his men in that inhospitable, inaccessible land. They survived for nearly fifty days, long enough to give the impression that they had renounced their goal and left the region.

Meanwhile, Abdulaziz was planning his next move. In early January 1902 he began advancing toward Riyadh, travelling at night to escape detection, and at the same time strategizing the best way to retake the city.

His first idea was to enter Riyadh with his men at night and attack the governor's house. But when he reached his destination, he learned that the governor had barricaded himself inside the fortress of Masmak in the heart of the city. Abdulaziz abandoned his original plan at the last minute and decided to lie in wait for the governor outside the fort. At dawn a short battle was fought, from which Abdulaziz and his men emerged victorious. On that day, January 15 1902, with Riyadh reconquered, a new kingdom was born.

There followed a period of internal strife as King Abdulaziz strove to unite the country, but he was able to find a solution to every problem. He knew how to make the right decision at the right time. Before launching a military operation, he would always offer his adversary a peaceful alternative to combat. He preferred imposing a blockade to mounting an attack, in order to avoid harming the local populations and risking innocent lives. He also played the role of mediator: he would dispatch missions to all the hostile parties encouraging them to lay down their arms and thus preserve their own lives and the lives of their families. His actions were those of a wise man who had learned the lessons of history, and this quality helped him achieve his goals.

On September 19, 1932, a royal decree formalized the unification of the Kingdom of Saudi Arabia and proclaimed September 23 as the new country's National Day. This unified state was founded on the principles of Islam and the preservation of peace and stability. A man of great piety, the king was determined to apply *sharia* law in all aspects of life, without deviating from the middle way prescribed by Islam. King Abdulaziz then devoted himself to his country's

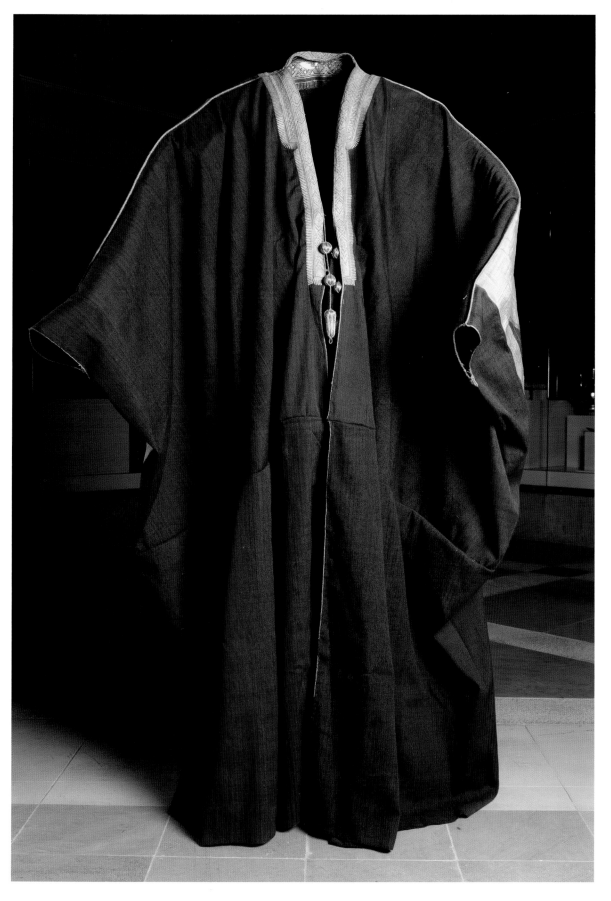

Cloak (*bisht*) of King Abdulaziz

development, administration and economy, as well as its educational systems and cultural institutions. He improved its transportation and communication facilities and opened the market to the global economy.

Social development was an essential element of his policy. The sedentarization of the Bedouins, considered the most far-reaching social transformation project undertaken in the region, was accomplished despite many obstacles. This made it possible to transform the tribal structures of Arab society, which until then had been founded on nomadism and the practice of *razzia* (plundering raids). The project enabled the tribes to settle in areas chosen according to their traditional territories, thus stabilizing and securing the region and helping the Bedouins adapt to the modernization of the country. In this way King Abdulaziz was able to build a modern state under very difficult circumstances, without violating local customs and mores.

The king instituted an effective method for managing the country. He appointed administrators throughout the kingdom, to whom he sent his instructions and advice. Always motivated by a concern for the public interest and the rights of his subjects, he made sure that his envoys were fulfilling their duties and serving justice in every situation, and he asked them to keep him informed on the needs of the local populations. He set up committees of trusted representatives to monitor the citizens' living conditions as well as the behaviour of the princes and officials, to ensure that they were properly handling their responsibilities.

Despite the weight of his own responsibilities, the king never neglected his family and his children's education. He made a special effort to remain close to his family and maintained good relations with all of its members, especially the women and children.

As a pious Muslim and the custodian of the Two Sanctuaries, Abdulaziz gave priority consideration to the pilgrimage and the accommodation of pilgrims. He took action to ensure that the rites could be carried out smoothly. Each year he personally supervised the activities surrounding the *Hajj* and monitored the services provided for the pilgrims to make sure that they had adequate lodging and sufficient food and water. He also undertook the expansion and improvement of the holy sites.

A skilled politician and astute negotiator, he succeeded in defending his positions even in the face of the formidable foreign powers that surrounded the country, with all of their experience in the field of diplomacy. From the earliest days of the kingdom, Abdulaziz founded his foreign policy on clear principles, with the goal of protecting the Saudi State and promoting Arab, Islamic and human causes without interfering in other countries' affairs. This approach enabled Abdulaziz to withstand global crises and avoid exposing his country and his people to major catastrophic events like the two world wars.

In order to protect the interests of the young Saudi State, he established official relations with diplomats representing the local and foreign powers that dominated several of the neighbouring regions. One of his most important international encounters took place in 1916 when he went to Basra to talk with the British high commissioner in Iraq, Sir Percy Cox, in the company of a small team of British diplomats. During these discussions Abdulaziz was informed on the issues affecting the region, and he expressed his position on the war then raging in Europe. The king refused to engage his country on either side, whether in the form of aid or of the opening of Saudi territory for any purpose related to the war.

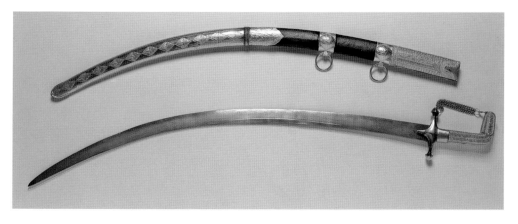

Sword of King Abdulaziz

In 1930 Abdulaziz met King Faisal, who then ruled Iraq with British high commissioner Francis Humphrys, on board the British ship *Lewin* in the Arabian Gulf. The purpose of the visit was to settle a border dispute between the Najd and Iraq.

Abdulaziz signed important agreements with a number of world powers, including the 1927 Jedda accords with the British, the 1929 friendship treaty with Germany, the 1931 peninsula accords with France, the 1932 friendship treaty with Italy, the 1946 friendship treaty with China and the 1933 accords with the United States.

As they were returning from the Yalta conference in the final days of World War II, US president Franklin Roosevelt and British Prime Minister Winston Churchill decided to meet with King Abdulaziz, in recognition of the prestige, respect and trust he enjoyed and the important role he played in the Arab world. Abdulaziz met first with Roosevelt, aboard the warship *Quincy 2* in the Red Sea. The second meeting, this time between Abdulaziz and Churchill, took place at the Fayoum Oasis in Egypt. The reports of these two discussions bore witness to the king's political influence and farsighted positions, reflecting his primary concern for the interests of the Arab-Muslim world.

In that same year, 1945, Saudi Arabia became one of the first countries to sign the Charter of the United Nations in San Francisco, demonstrating the country's determination to play an active role on the international political scene.

Abdulaziz's foreign policy was also instrumental in the founding of the Arab League of Nations. When King Abdulaziz was invited by King Farouk to pay a twelve-day official visit to Egypt in 1946, a great celebration was held in his honour. The entire Egyptian population participated in this homage to an illustrious Arab leader and tireless campaigner for Arab independence.

In addition to his position of imam, Abdulaziz acquired various other titles in the course of the formation of the Saudi State:
– Emir of Najd and chief of its tribes (1902),
– Sultan of Najd (1921),
– Sultan of Najd and its Dependencies (1922),
– King of Hijaz and Sultan of Najd and its Dependencies (1926),
– King of Hijaz and of Najd and its Dependencies (1927),
– King of Saudi Arabia (1932).

After a long life of efforts and accomplishments, King Abdulaziz Al Saud went to his final resting place on November 9, 1953. To this day, the figure of the king remains prominently linked to his impressive achievements. Due to the deep imprint he made on the history of the Arabian Peninsula, his extraordinary personality is a source of pride and admiration, and of fascination to everyone who is interested in Saudi Arabia.

# THE NATIONAL MUSEUM IN RIYADH

*Ali I. Al-Ghabban*

The National Museum was officially opened on January 23, 1999 (October 5, 1419 H.). It is part of the King Abdulaziz Historical Center, founded to celebrate the kingdom's centennial.

His Royal Highness Prince Salman ibn Abdulaziz, governor of the province and chairman of the High Authority for the development of the city of Riyadh, asked the authority to supervise the project, which was implemented by a task force including several world-renowned consulting firms and a panel of experts from various universities throughout the kingdom. These teams were in charge of the scientific studies and the planning of exhibits and events. Another team from the Antiquities and Museums Department was assigned the job of study and display of exhibits.

The National Museum in Riyadh

The museum is located in the al-Murabbaʻa district in the heart of Riyadh, also home to historical al-Murabbaʻa Palace, the former main residence of the late King Abdulaziz.

The King Abdulaziz Historical Center encompasses:
– the palace of King Abdulaziz,
– the al-Murabbaʻa Palace,
– King Abdulaziz Mosque,
– the public section of King Abdulaziz Library,
– King Abdulaziz Auditorium,
– the offices of the Antiquities and Museums Agency,
– a number of old historic buildings,
– a green space including seven main gardens, public squares and parks,
– the water tower and the adjoining al-Watan garden,
– al-Hamra Palace.

The King Abdulaziz Historical Center is a prominent cultural complex in the heart of the capital, as well as one of the city's main tourist attractions due to the diversity of its structures, designed in the spirit of urban development that has characterized the city centre over the past several years. The National Museum is the largest building of this complex, spanning 28,000 square metres and housing exhibition rooms, libraries, administrative offices, services and storage areas.

The permanent exhibition rooms occupy the ground and first floors, presenting ancient and modern works, documents, manuscripts and paintings. These rooms are also equipped with a range of audiovisual facilities for the showing of historical and scientific documentary films.

Drawing of the National Museum

The National Museum exhibits a wide variety of collections on various themes related to the environment, history and civilization of the Kingdom of Saudi Arabia, from prehistory to the dawn of the modern world. Each of the main rooms is devoted to a specific theme.

Eight main galleries house the permanent collections and two other rooms are dedicated to temporary exhibits. The collections are arranged in chronological order and the rooms' interiors were designed to evoke the historical period in question, enabling visitors to discover the works in a series of different architectural settings.

The National Museum is organized in eight sections:
– "Man and the Universe": This section explores four main themes, including the creation of the universe and Earth, and the natural factors behind the formation of the Earth's surface, including a number of fossils and geological samples. The different natural environments that characterize the Kingdom of Saudi Arabia are illustrated. The fourth and final theme is devoted to the oldest archaeological discoveries, artefacts of the ancient peoples who once roamed the Arabian Peninsula.
– "Pre-Islamic Arabian Kingdoms": This room is divided into three sections retracing the period from the 6th millennium BC to the 2nd century AD. The displays portray the ancient civilizations that successively inhabited the peninsula up to the last Arabian kingdoms.
– "*Jahiliyya*" ("age of ignorance"): Named after a term designating the Pre-Islamic era, this section informs the public on the religious, social and political contexts that prevailed in Arabia at the time. It also presents the best-known cities of the period.
– "The Prophet's Mission": This room is devoted to the city of Mecca, from the birth of the prophet Muhammad to the revelations made to him by Archangel Gabriel in the cave of Hira and his exile ("Hegira") to the Yathrib oasis in Medina. The displays illustrate the importance of this historical period, which gave rise to a new dating system, the Muslim calendar.
– "Islam and the Arabian Peninsula": This section presents the main events that took place during the prophet Muhammad's lifetime, under the reigns of the earliest caliphs, and then under the Umayyads, Abbassids, Mamluks and lastly the Ottomans. The room is a trove of precious information on the knowledge of Islamic civilization in architecture, calligraphy and the theoretical and natural sciences.
– "The First and Second Saudi States": Their history is presented in a special room.
– "The Unification of the Kingdom": This period begins with the conquest of Riyadh by King Abdulaziz on the fifth day of the month of *shawwal* 1319 H. (January 15, 1902), marking the founding of the modern Saudi State. The room is distinguished by its circular design, with a display presenting the different regions of the kingdom in the order of their integration into the state. A documentary film recounting the highlights of this formidable undertaking is projected in the middle of the room.
– "The *Hajj* (pilgrimage) and the Two Holy Mosques of Mecca and Medina": This last section traces the history of the Holy Mosque (al-Masjid al-Haram) of Mecca and the Mosque of the Prophet (al-Masjid al-Nabawi) in Medina, as well as the stages in their construction. The main theme of this room is the architectural development of the two mosques since the founding of the Saudi State and their expansion to accommodate ever-greater numbers of pilgrims. The archaeological discoveries and objects related to prayer and meditation are on display here that bring the ancient pilgrimage routes and their way stations back to life.

Map of the National Museum in Riyadh

# INDEX OF PROPER NAMES

Entries in *italics* are the titles of written works or common nouns

# INDEX OF PLACE NAMES

Unless otherwise specified, the entries refer to places in Saudi Arabia

# BIBLIOGRAPHY

**Abbreviations**

*AAE: Arabian Archaeology and Epigraphy.*

*AION: Annali dell'Istituto Orientale di Napoli.*

*BAR: British Archaeological Reports.*

*BASOR: Bulletin of the American Schools of Oriental Research.*

*CRAI: Comptes rendus de l'Académie des inscriptions et belles-lettres.*

*CT: Cuneiform Texts from Babylonian Tablets.*

*DAI: Deutsches Archäologisches Institut.*

*EI2: Encyclopaedia of Islam, 2nd Edition*

*ESHO: Journal of the Economic and Social History of the Orient.*

*OIP: The University of Chicago Oriental Institute Publications.*

*PSAS: Proceedings of the Seminar for Arabian Studies.*

*REMMM: Revue du monde musulman et de la Méditerranée.*

*SAA: State Archives of Assyria.*

*ZDMG: Zeitschrift der Deutschen Morgenländischen Gesellschaft.*

**Abdallah 1975**
Y. Abdallah, *Die Personennamen in al-Hamdani's al-Iklil und ihre Parallelen in den südarabischen Inschriften*, Tübingen, University of Tübingen, 1975.

**Abdul Halim 1993**
See the bibliography in Arabic.

**Abdul Nayeem 2000**
M. Abdul Nayeem, *The Rock Art of Arabia, Saudi Arabia, Oman, Qatar, The Emirates and Yemen*, Hyderabad, Hyderabad Publishers, 2000.

**Abu Al-Hasan 1997**
See the bibliography in Arabic.

**Abu Al-Hasan 2002**
See the bibliography in Arabic.

**Abu Duruk 1986**
H. I. Abu Duruk, *Introduction to the Archaeology of Tayma*, Riyadh, 1986.

**Abu Duruk 1989**
H. I. Abu Duruk, "A Preliminary Report on the Industrial Site Excavation at Tayma, First Season 1408 H./1987 A.D.", *Atlal*, 12, 1410 H./1989, pp. 9–19.

**Abu Duruk 1990**
H. I. Abu Duruk, "A Preliminary Report on the Industrial Site Excavations at Tayma, Second Season 1410 H./1989 A.D.", *Atlal*, 13, 1411 H./1990, pp. 9–19.

**Abu Duruk 1996**
H. I. Abu Duruk, "A Preliminary Report on the Industrial Site Excavation at Tayma, Third Season 1411 H./1990 A.D.", *Atlal*, 14, 1996, pp. 11–24.

**Abu Duruk 2000**
H. I. Abu Duruk, "A Preliminary Report on the Excavation and Finds of the First Islamic Site Al-Bejidi in Tayma 1412 A.H./1992 A.D.", *Atlal*, 15, 2000, pp. 1–33.

**Abu Duruk and Murad 1985**
H. I. Abu Duruk and A. al-Jawad Murad, "Preliminary Report on Qasr Al-Hamra Excavations, Tayma, Second Season 1404/1984", *Atlal*, 9, 1985, pp. 55–64.

**Abu Duruk and Murad 1988**
H. I. Abu Duruk and A. al-Jawad Murad, "Preliminary Report on Qasr Al-Hamra Excavation, Tayma, Fourth (Last) Season 1406/1986", *Atlal*, 11, 1988, pp. 29–36.

**Al-Afghani**
See the bibliography in Arabic.

**Aggoula 1985**
B. Aggoula, "Studia Aramaica II", *Syria*, 62, 1985, pp. 61–76.

**Al-'Ajimi 1409H./ 1988–89**
See the bibliography in Arabic.

**Aksoy and Milstein 2000**
Ş. Aksoy and R. Milstein, "A Collection of Thirteenth-Century Illustrated Hajj Certificates", *M. Ugur Derman Festschrift*, Istanbul, 2000, pp. 73–134.

**Alexander 1993**
D. Alexander, *Furusiyya*, II, Riyadh, 1993.

**Alexander 1996 a**
D. Alexander, *Furusiyya*, vol. 1, King Abdulaziz Public Library, 1996.

**Alexander 1996 b**
D. Alexander, *Furusiyya*, vol. 2, King Abdulaziz Public Library, 1996.

**Ali Bey 1814**
Ali Bey el Abbassi, *Voyages d'Ali-Bey el Abbassi (Domingo Badia y Leyblich) en Afrique et en Asie : pendant les années 1803, 1804, 1805, 1806 et 1807 (rédigé par Roquefort)*, Paris, 1814.

**Alsharekh 2006**
A. Alsharekh, *The Archaeology of Central Saudi Arabia: Investigations of Lithic Artefacts and Stone Structures in Northeast Riyadh*, Riyadh, Ministry of Education, Department of Antiquities and Museums, 2006.

**Amiet 1986**
P. Amiet, *L'Âge des échanges inter-iraniens, 3500-1700 avant J.-C.*, Paris, Réunion des musées nationaux, 1986.

**Anati 1968 a**
E. Anati, *Rock-Art in Central Arabia*, vol. 1, *The "Oval-Headed" People of Arabia* (*Expédition Philby-Ryckmans-Lippens en Arabie, Ire partie, Géographie et archéologie, t. 3*), Bibliothèque du Muséon, 50, Louvain-la-Neuve, Université catholique de Louvain, Institut orientaliste, 1968.

**Anati 1968 b**
E. Anati, *Rock-Art in Central Arabia*, vol. 2, part. I, *Fat-Tailed Sheep in Arabia*; part. II, *The Realistic-Dynamic Style of Rock-Art in the Jabal Qara* (*Expédition Philby-Ryckmans-Lippens en Arabie, Ire partie, Géographie et archéologie, t. 3*), Bibliothèque du Muséon, 50, Louvain-la-Neuve, Université catholique de Louvain, Institut orientaliste, 1968.

**Anati 1972**
E. Anati, *Rock-Art in Central Arabia*, vol. 3 (*Expédition Philby-Ryckmans-Lippens en Arabie*), Publications de l'Institut orientaliste de Louvain, 4, Louvain, Institut orientaliste, 1972.

**Anati 1974**
E. Anati, *Rock-Art in Central Arabia*, vol. 4 (*Expédition Philby-Ryckmans-Lippens en Arabie*), Publications de l'Institut orientaliste de Louvain, 6, Louvain, Institut orientaliste, 1974.

**Anati 1999**
E. Anati, "The Rock Art of the Negev Desert", *Near Eastern Archaeology*, vol. LXII, no. 1, March 1999, pp. 22–34.

**Andrevic 1986**
A. K. Andrevic, "Turkish Tiles and Pottery in Yugoslavia", in *First International Congress on Turkish Tiles and Ceramics (Kütahya 6-11 VII 1986)*, 1986, pp. 25–31.

**Al-Ankary 2001**
K. Al-Ankary, *La Péninsule Arabique dans les cartes européennes anciennes. Fin XVe-début XIXe siècle (collection Khaled Al Ankary)*, Paris, Institut du monde arabe, 2001.

**Anonymous 1982**
Anonymous, "News and Events", *Atlal*, 6, 1982, pp. 139–41.

**Al-Ansari 1966**
A. T. Al-Ansari, *A Critical and Comparative Study of Lihyanite Personal Names*, unpublished Ph.D. thesis, University of Leeds, 1966.

**Al-Ansari 1969**
See the bibliography in Arabic.

**Al-Ansari 1970**
A. T. Al-Ansari, "The Chronology of Lihyan", *Bulletin of the Faculty of Arts*, Riyadh, University of Riyadh I, 1970, pp. 53–60.

**Al-Ansari 1975**
See the bibliography in Arabic.

**Al-Ansari 1982**
A. T. Al-Ansari, *Qaryat al-Fau. A Portrait of Pre-Islamic Civilisation in Saudi Arabia*, Riyadh, University of Riyadh, 1982.

**Al-Ansari 1990**
A. T. Al-Ansari, "Quelques anciennes cités caravanières du royaume d'Arabie saoudite", in *Pétra et les cités caravanières*, Amman, General Direction of Archaeological Monuments, 1990.

**Al-Ansari 1999**
A. T. Al-Ansari, "Une mission archéologique au pays des Arabes", in Paris, 1999, pp. 35–37.

**Al-Ansari 1423H./ 2002**
See the bibliography in Arabic.

**Al-Ansari 2008**
See the bibliography in Arabic.

**Al-Ansari, Aboul Fadl Jamal Eddine Mohamed bin Makram**
Al-Ansari, Aboul Fadl Jamal Eddine Mohamed bin Makram, *Lisan al-Arab*, research by Abdulallah Al-Kabir *et al.*, Dar Al-Maaref.

**Antonini 2001**
S. Antonini, *La Statuaria sudarabica in pietra* (*Repertorio iconografico sudarabico*, 1), Paris, Rome, 2001.

**Anville 1751**
J.-B. Bourguignon d'Anville, *Première Partie de la carte d'Asie, contenant la Turquie, l'Arabie, La Perse […]. Publiée sous les auspices de Monseigneur le Duc d'Orléans, premier prince du sang, 1751*, Paris, 1751.

**Anville 1771**
J.-B. Bourguignon d'Anville, *Atlas général*, Paris, 1771.

**Aqil' 1993**
A. 'Ali Aqil', *Les Bijoux d'Arabie méridionale à la période préislamique*, Ph.D. thesis in archaeology, Paris, Université de Paris I Panthéon-Sorbonne (ed. J.-M. Dentzer), 1993.

**Aqil' and Antonini 2007**
A. 'Ali Aqil' and S. Antonini, *Bronzi sudarabici di periodo pre-islamico*, Paris, De Boccard, Rome, ISIAO, 2007.

**Arbach and Audouin 2007**
M. Arbach and R. Audouin, *Sana'a National*

*Museum. Collection of Epigraphic and Archaeological Artifacts from al-Jawf Sites. Part II*, San'a', UNESCO-SFD, 2007.

**Arif al-Munir 1971**
Arif al-Munir, *The Hejaz Railway and The Muslim Pilgrimage*, trad. J. Landau, Detroit, 1971.

**Arnaud 1845**
Th.-J. Arnaud, "Relation d'un voyage à Mareb (Saba) dans l'Arabie méridionale, entrepris en 1843", *Journal asiatique*, 4ᵉ série, V, 1845, pp. 208–45, 309–435.

**Arvieux 1717**
L. d'Arvieux, *Voyage fait par ordre du roy Louis XIV dans la Palestine vers le grand Émir, Chef des Princes Arabes du Désert, connus sous le nom de Bédoüins, ou d'Arabes scénites, qui se disent la vraïe postérité d'Ismaël, fils d'Abraham*, Paris, 1717 (ed. by La Roque).

**Arvieux 1735**
L. d'Arvieux, *Mémoires du chevalier d'Arvieux, envoyé extraordinaire du Roy à la Porte, consul d'Alep, d'Alger, de Tripoli, et autres échelles du Levant, contenant ses voyages à Constantinople, dans l'Asie, la Syrie, la Palestine, l'Égypte et la Barbarie, recueillis de ses Mémoires originaux et mis en ordre par le R. P. Jean-Baptiste Labat*, 1735.

**Atasoy and Raby 1989**
N. Atasoy and J. Raby, *Iznik*, London, 1989.

**Al-Athar, 1420 H./2000**
See the bibliography in Arabic.

**Atil 1963**
E. Atil, *La Mecque, ville bénie, Médine, ville radieuse*, Paris, 1963.

**Atil 1981**
E. Atil, *Renaissance of Islam. Art of the Mamluks*, Washington D.C., Smithsonian Institution, 1981.

**Avanzini 1997**
A. Avanzini (ed.), *Profumi d'Arabia. Atti del convegno a cura di Alessandra Avanzini*, Saggi di storia antica, 11, Rome, "L'Erma" di Bretschneider, 1997.

**Aydın 2007**
H. Aydın, *Sultanların Silahları*, Istanbul, 2007.

**Bacqué-Grammont and Kroell 1988**
J.-L. Bacqué-Grammont and A. Kroell, *Mamelouks, Ottomans et Portugais en mer Rouge. L'affaire de Djedda en 1517*, supplement to *Annales islamologiques*, Cairo, 1988.

**Bafqih et al. 1985**
See the bibliography in Arabic.

**Bagg (forthcoming)**
A. M. Bagg, "Untersuchungen zu den 'arabischen' Toponymen und zur Rezeption der 'Araber' in den historischen Quellen der Assyrer", in *Tayma*, vol. I.

**Al-Bahnasi 1999**
See the bibliography in Arabic.

**Bahrain 1994**
*A Selection of Abdul Latif Jassim Kanoo's Collection of Islamic Art*, exhibition catalogue, Bahrain, Manama, 1994.

**Bailey, Alsharekh, Flemming et al. 2007**
G. Bailey, A. Alsharekh, N. Flemming et al., "Coastal Prehistory in the Southern Red Sea Basin, Underwater Archaeology, and the Rasan Islands", *PSAS*, 37, 2007, pp. 1–16.

**Baker 1995**
P. Baker, *Islamic Textiles*, London, 1995.

**Al-Bakri, Masalik**
See the bibliography in Arabic.

**Al-Bakri, Mu'jam**
See the bibliography in Arabic.

**Al-Baladhuri**
See the bibliography in Arabic.

**Al-Balawi**
See the bibliography in Arabic.

**Bani Yunis 2000**
See the bibliography in Arabic.

**Barbir 1980**
K. Barbir, *Ottoman Rule in Damascus 1708-1758*, Princeton (New Jersey), Princeton University Press, 1980.

**Al-Basha 1979**
H. Al-Basha, "Ahamiyyat shawahid al-qubûr ka masdar fi al-'asr al-islami", in *Masadir Tarikh al-Jazira al-'Arabiyya/ Sources for the History of Arabia: Proceedings of the First International Symposium on Studies in the History of Arabia, 23rd-28th April 1977*, Riyadh, 1399 H./1979.

**Bastoun et al. 1982**
See the bibliography in Arabic.

**Bawden 1983**
G. Bawden, "Painted Pottery of Tayma and Problems of Cultural Chronology in Northwest Arabia", in J. F. A. Sawyer and D. J. A. Clines (ed.), *Midian, Moab and Edom*, Journal for the Study of the Old Testament Supplement Series, 24, Sheffield, 1983, pp. 37–53.

**Bawden and Edens 1988**
G. Bawden and C. Edens, "Tayma Painted Ware and the Hejaz Iron Age Ceramic Tradition", *Levant*, 20, 1988, pp. 197–213.

**Bawden, Edens and Miller 1980**
G. Bawden, C. Edens and R. Miller, "Preliminary Archaeological Investigations at Tayma", *Atlal*, 4, 1980, pp. 69–106.

**Beaulieu 1989**
P.-A. Beaulieu, *The Reign of Nabonidus, King of Babylonia, 556–539 B.C.*, Yale Near Eastern Researches, 10, New Haven, London, Yale University Press, 1989.

**Bednarik 1994**
R. G. Bednarik, "The Pleistocene Art of Asia", *Journal of World Prehistory*, vol. VIII,
part 4, 1994; pp. 351–75.

**Bednarik and Khan 2002**
R. G. Bednarik and M. Khan, "The Saudi Arabian Rock Art Mission of November 2001", *Atlal*, 17, 2002, pp. 75–99.

**Bednarik and Khan 2005**
R. G. Bednarik and M. Khan, "Scientific Studies of Saudi Arabian Rock Art", *Rock Art Research*, vol. XXII, no. 1, 2005, pp. 49–81.

**Beeston 1982**
A. F. L. Beeston, "Languages of Pre-Islamic Arabia", in *Études de linguistique arabe, Arabica*, vol. 28, nos 2–3, 1982, pp. 178–86.

**Behrens-Abouseif 1999**
D. Behrens-Abouseif, "Qaytbay's Madrasahs in the Holy Cities and the Evolution of Haram Architecture", *Mamluk Studies Review*, 3, 1999, pp. 129–48.

**Beirut 1974**
*Art islamique dans les collections libanaises*, exhibition catalogue, Beirut, Nicolas Sursock Museum, 1974.

**Benton 1996**
J. Benton, *Excavations at Al Sufouh: a Third Millenium Site in the Emirate of Dubai*, Abiel I, Turnhout, Brepols, 1996.

**Berger 1884**
P. Berger, "Nouvelles inscriptions de Médaïn Saleh", *CRAI*, 1884, pp. 377–93.

**Bernick-Greenberg 2007**
H. Bernick-Greenberg, "The Ceramic Assemblages and the Wheel-Made Pottery Typology", in R. Cohen and H. Bernick-Greenberg, *Excavations at Kadesh Barnea (Tell el-Qudeirat), 1976–1982*, Israel Antiquities Authority Reports, 34, Jerusalem, 2007, pp. 131–85.

**Beuger (forthcoming)**
A. Beuger, "Salvage Excavations at the Burial Site of Tàla' (Area S)", in R. Eichmann, A. Hausleiter, M. Al-Najem and S. F. Al-Said, "Tayma – Autumn 2004 and Spring 2005, 2nd Report on the Joint Saudi-Arabian–German archaeological project", *Atlal*, 20, forthcoming.

**Beyer and Livingstone 1987**
K. Beyer and A. Livingstone, "Die neuesten aramäischen Inschriften aus Taima", *Zeitschrift der deutschen morgenländischen Gesellschaft*, 137, 1987, pp. 285–96.

**Bibby 1973**
T. G. Bibby, *Preliminary Survey in East Arabia, 1968*, Jutland Archaeological Society Publications vol. XII 1973

**Bidwell 1976**
R. Bidwell, *Travellers in Arabia*, London, 1976.

**Bittar 2003**
T. Bittar, *Pierres et stucs épigraphiés. Musée du Louvre, département des Arts de l'Islam*, Paris, 2003.

**Blochet 1928**
E. Blochet, *Bibliothèque nationale. Catalogue des manuscrits persans*, t. III, Paris, 1928.

**Boivin and Fuller 2009**
N. Boivin and D. Q. Fuller, "Shell Middens, Ships and Seeds: Exploring Coastal Subsistence, Maritime Trade and the Dispersal of Domesticates in and around the Ancient Arabian Peninsula", *Journal of World Prehistory*, 22, 2009, pp. 113–80.

**Boling 1975**
R. G. Boling, *Judges: Introduction, Translation and Commentary*, Garden City, 1975.

**Boube-Piccot 1975**
C. Boube-Piccot, *Les Bronzes antiques du Maroc*, Études et travaux d'archéologie marocaine 5, 1975.

**Bowersock 1996**
G. W. Bowersock, "Exploration in North-West Arabia after Jaussen-Savignac", *Topoi*, 6/2, 1996, pp. 553–63.

**Breton 1994**
J.-F. Breton, *Les Fortifications d'Arabie méridionale du VIIᵉ au Iᵉʳ siècle avant notre ère*, Mayence, 1994.

**Briggs 2009**
A. Briggs, *Ancient Midian in the Late Bronze to Early Iron Ages: Historical and Archaeological Perspectives*, Sydney, unpublished M.A. thesis, 2009.

**Briquel-Chatonnet and Fauveaud-Brassaud 2008**
F. Briquel-Chatonnet and C. Fauveaud-Brassaud, "Ad majorem scientiae fructum. Le *Corpus inscriptionum semiticarum* dans les correspondances conservées à l'Institut de France", in C. Bonnet and V. Krings (ed.), *S'écrire et écrire dans l'Antiquité. L'apport des correspondances à l'histoire des travaux scientifiques*, Grenoble, Éditions Jérôme Millon, 2008, pp. 215–28.

**Briquel-Chatonnet and Robin 1997**
F. Briquel-Chatonnet and C. Robin, "Objets d'Arabie Nord-Ouest (autres objets d'Arabie), nos 199–204", in Y. Calvet and C. Robin (ed.), *Arabie Heureuse, Arabie Déserte. Les antiquités arabiques du musée du Louvre*, Paris, 1997, pp. 260–64.

**Brock 1999**
S. Brock, "Syriac Writers from Beth Qatraye", *Aram*, 11–12, 1999–2000, pp. 85–96.

**Buhl and Bosworth 1999**
M. L. Buhl and C. F. Bosworth, "Tayma", in *Encyclopedia of Islam (2nd edition)*, Leiden, 1999, pp. 430–31.

**Bunduqji 1400 H./1980**
See the bibliography in Arabic.

**Burkholder 1971**
Grace Burkholder,1971 "Steatite carving from Saudi Arabia" in "Some Results of the Third International Conference

on Asian Archaeology in Bahrain",
*Artibus Asiae*, vol. 33, no. 4 (1971),
pp. 306–22.

**Burkholder 1984**
G. Burkholder, *An Arabian Collection:
Artifacts from the Eastern Province*, Boulder
City (Nevada), GB Publications, 1984.

**Callot 1990**
O. Callot, "Les monnaies dites 'arabes'
dans le nord du golfe Arabo-Persique à la fin
du IIIᵉ siècle avant notre ère", in *Failaka.
Fouilles françaises 1986–1988*, Y. Calvet and
J. Gachet (ed.), Travaux de la Maison de
l'Orient, 18, Lyon, Maison de l'Orient, Paris,
distributed by Boccard, 1990, pp. 221–40.

**Calvet and Robin 1997**
Y. Calvet and Ch. Robin, *Arabie Heureuse,
Arabie Déserte. Les antiquités arabiques
du musée du Louvre*, Notes and documents
des Musées de France, 31, Paris, Réunion
des musées nationaux, 1997.

**Cantineau 1978**
J. Cantineau, *Le Nabatéen*, Paris, E. Leroux,
1978, 2 vols.

**Capdetrey 2007**
L. Capdetrey, *Le Pouvoir séleucide. Territoire,
administration, finances d'un royaume hellénis-
tique (312-129 avant J.-C.)*, Rennes, 2007.

**Carcaradec 1981**
M. de Carcaradec, "Les *mahmils* du palais
de Topkapi", *Turcica*, 13, 1981.

**Carter 2006**
R. Carter, "Boats Remains and Maritime
Trade in the Persian Gulf during 6th and
5th millennium B.C.", *Antiquity*, 80,
no. 307, 2006, pp. 52–63.

**Caskel 1954**
W. Caskel, *Lihyan und Lihyanisch*, Arbeitsge-
meinschaft für Forschung des Landes Nord-
rhein-Westfalen, Geisteswissenschaften, 4,
Cologne, Opladen, Westdeutscher Verlag, 1954.

**Caskel 1966**
W. Caskel, *Jamharat an-nasab. Das
genealogische Werk des Hisham ibn
Muhammad al-Kalbi*, Leiden,
Brill, 1966, 2 vols.

**Caussin de Perceval 1847**
A. P. Caussin de Perceval, *Essai sur l'histoire des
Arabes avant l'islamisme, pendant l'époque de
Mahomet, et jusqu'à la réduction de toutes les tri-
bus sous la loi musulmane*, t. I-III, Paris,
Firmin-Didot, 1847–1848 (reprinted by Graz,
Akademische Druck- u. Verlagsanstalt, 1967).

**Cavigneaux and Khalil Ismail 1990**
A. Cavigneaux and B. Khalil Ismail,
"Die Statthalter von Suhu und Mari im 8. Jh.
v. Chr.", *Baghdader Mitteilungen*, 21, 1990,
pp. 231–456.

**Chabbi 1997**
J. Chabbi, *Le Seigneur des tribus. L'Islam de Maho-
met*, Paris, 1997 (reprint in progress, CNRS).

**Chabbi 2008**
J. Chabbi, *Le Coran décrypté. Figures bibliques
en Arabie*, Paris, 2008.

**Chabot 1902**
J.-B. Chabot (ed.), *Synodicon orientale,
ou Recueil de synodes nestoriens*, Notices et
extraits des manuscrits de la Bibliothèque
nationale et autres bibliothèques, publiés par
l'Académie des inscriptions et belles-lettres,
37, Paris, Imprimerie nationale, 1902.

**Chambéry 1970**
*Arts de l'islam*, exhibition catalogue, Cham-
béry, musées d'Art et d'Histoire, 1970.

**Charles-Dominique 1995**
P. Charles-Dominique (trad.), *Voyageurs
arabes*, Paris, Gallimard, Bibliothèque
de la Pléiade, 1995.

*CIH*
*Corpus inscriptionum semiticarum. Pars
quarta, inscriptiones himyariticas et sabaeas
continens*, t. I-III, Paris, 1889, 1911, 1929.

*CIS V*
*Corpus inscriptionum semiticarum.
Pars quinta, inscriptiones saracenicas continens*,
t. I, Paris, C. Klincksieck, 1951.

**Clarke 1979**
C. Clarke, "Rock Art at Jubbah, Northern
Saudi Arabia", *PSAS*, 9, 1979, p. 80.

**Cleuziou 1988**
S. Cleuziou, "Dilmoun-Arabie en marge de
C. M. Piesinger: 'The Legacy of Dilmun'",
in Salles, 1988, pp. 27–58.

**Cleuziou and Vogt 1985**
S. Cleuziou and B. Vogt, "Tomb A at Hili
North (U.A.E.) and its Material
Connections to Southeast Iran and the
Greater Indus Valley", in J. Schotsmans
and M. Taddei (ed.), *South Asian Archaeology
1983*, Naples, Istituto Universitario
Orientale, Dipartimento di Studi Asiatici,
Series Minor XXIII, 1985, pp. 249–77.

**Conti Rossini 1910**
C. Conti Rossini, "Un documento sul
cristianesimo nello Iemen ai tempi del re
Sharahbil Yakkuf", in *Rendiconti della Reale
Accademia dei Lincei*, Classe di Scienze
morali, storiche e filologiche, Series V, vol.
XIV, 1910, pp. 705–50.

**Contini 2003**
R. Contini, "La lingua del Bêt Qatrayê", in
*Mélanges David Cohen. Études sur le langage,
les langues, les dialectes, les littératures, offertes
par ses élèves, ses collègues, ses amis, présentés à
l'occasion de son quatre-vingtième anniversaire*,
texts assembled and edited by J. Lentin and
A. Lonnet, Paris, Maisonneuve et Larose,
2003, pp. 173–81.

**Courbon 2008**
P. Courbon, "Les puits nabatéens de Mada'in
Saleh", *AAE*, 19, 2008, pp. 48–70.

**Crassard 2008**
R. Crassard, *La Préhistoire du Yémen.
Diffusions et diversités locales, à travers
l'étude d'industries lithiques du Hadramawt*,
BAR International Series 1842, Oxford,
Archaeopress, 2008.

**Crawford and al-Sindi 1996**
H. Crawford, K. al-Sindi, "A 'Hut potin
the National Museum, Bahrain", *AAE*,
vol. 7, issue 2 (November 1996), pp. 140–42.

**Crone 1987**
P. Crone, *Meccan Trade and the Rise of Islam*,
Oxford, Basil Blackwell, 1987.

**Cross 1986**
F. M. Cross, "A New Aramaic Stele from
Taima", *Catholic Biblical Quarterly*, 49,
1986, pp. 387–94.

**Cuvigny and Robin 1996**
H. Cuvigny and C. Robin, "Des Kinaidokol-
pites dans un ostracon grec du désert oriental
(Égypte)", *Topoi*, 6, 1996, pp. 697–720.

**Daems 2004**
A. Daems, "The Terracotta Figurines from
Ed-Dur (Umm al-Qaiwain, U.A.E.):
the Human Representations", *AAE*, 15,
2004, pp. 92–104.

*DAI* 2005
"Jahresbericht 2004 des Deutschen Archäo-
logischen Instituts", *Archäologischer Anzeiger*,
2005, pp. 121–297.

*DAI* 2007
"Jahresbericht 2006 des Deutschen Archäo-
logischen Instituts", *Archäologischer Anzeiger*,
2007, pp. 135–401.

**Dalley 1986**
S. Dalley, "The God Salmu and the Winged
Disk", *Iraq*, 48, 1986, pp. 85–101.

**Al-Daqan 1985**
See the bibliography in Arabic.

**Al-Dar'i**
See the bibliography in Arabic.

**Daum, Müller, Nebes and Raunig 2000**
W. Daum, W. W. Müller, N. Nebes and W.
Raunig (ed.), *Im Land der Königin von Saba'.
Kunstschätze aus dem antiken Jemen*, Munich,
Staatliches Museum für Völkerkunde, 2000.

**David 1990**
H. David 1990, "La vaisselle de chlorite" in
*Failaka. Fouilles françaises 1986-1988*, Y.
Calvet and J. Gachet (ed.), Travaux de la
Maison de l'Orient, 18, Lyon, Maison de
l'Orient, Paris, distributed by Boccard, 1990,
pp. 141–47.

**David 1996**
H. David, "Styles and evolution: soft stone
vessels during the Bronze Age in Oman
peninsula", *PSAS*, vol. 26, 1996, pp.
31–46.

**Dayton 1972**
J. Dayton, "Midianite and Edomite

Pottery", *Proceedings of the Fifth Seminar
for Arabian Studies*, 5, 1972, pp. 25–38.

**Delagnes and Roche 2005**
A. Delagnes and H. Roche, "Late Pliocene
Hominid Knapping Skills: the Case of
Lokalalei 2C, West Turkana, Kenya", *Journal
of Human Evolution*, 48, 2005, pp. 435–72.

**Delougaz 1952**
P. Delougaz, *Pottery from the Diyala Region*,
OIP, vol. 63, Chicago, University of Chicago
Press, 1952.

**De Maigret 1997**
A. de Maigret, "The Frankincense Road from
Najran to Ma'an: a Hypothetical Itinerary",
in Avanzini, 1997, pp. 315–31.

**De Maigret 1999**
A. de Maigret, "The Arab Nomadic People
and the Cultural Interface between the
'Fertile Crescent' and 'Arabia Felix'",
*AAE*, 10, 1999, pp. 220–24.

**De Maigret 2003**
A. de Maigret, "La route caravanière de
l'encens dans l'Arabie préislamique, éléments
d'information sur son itinéraire et sa chrono-
logie", *Chroniques yéménites*, 11, 2003.

**Dentzer 2009**
J.-M. Dentzer, "Espace urbain et
environnement dans les villes nabatéennes
de Pétra, Hégra et Bosra", in F. Dumasy and
F. Queyrel (ed.), *Archéologie et environnement
dans la Méditerranée antique*, Geneva, Droz,
2009, pp. 143–92 (pp. 156–75 on Hegra).

**Déroche 1992**
F. Déroche, *The Abbasid Tradition. Qur'ans
of the 8th to the 10th Centuries AD.
The Nasser D. Khalili Collection of Islamic
Art*, I, London, 1992.

**Déroche 2009**
F. Déroche, *Le Coran*, Paris, 2009.

**Derricourt 2005**
R. Derricourt, "Getting 'Out of Africa': Sea
Crossings, Land Crossings and Culture
Hominin Migrations", *Journal of World
Archaeology*, 19, 2005, pp. 119–32.

**Detoraki and Beaucamp 2007**
M. Detoraki (ed.) and J. Beaucamp (trad.),
*Le Martyre de saint Aréthas et de ses
compagnons (BHG 166)*, appendix on the
oriental versions by A. Binggeli, Collège de
France, Centre de recherche d'histoire et
civilisation de Byzance, Monographies, 27,
*Le Massacre de Najran*, 1, Paris, Association
des amis du Centre d'histoire et civilisation
de Byzance, 2007.

**Al-Dhabib 1998**
See the bibliography in Arabic.

**al-Dhahabi 1996**
See the bibliography in Arabic.

**Dickson 1949**
H. R. P. Dickson, *The Arab and the Desert*.
London, George Allen and Unwin, 1949.

**Diem and Schöller 2004**
W. Diem and M. Schöller, *The Living and the Dead in Islam: Studies in Arabic Epitaphs*, Wiesbaden, 2004.

**Dilaver 1970**
S. Dilaver, "Osmanlı Sanatında kabe tasvirli bir fresk", *Belleten*, 34, 1970, pp. 255–57.

**Dinies and Neef 2009**
M. Dinies and R. Neef, "Zur Vegetationsgeschichte Taymas. Erste pollenanalytische Ergebnisse und Makrorestuntersuchungen", paper presented at the workshop *Neue Forschungen in Tayma – Projektgespräch 2009, 7–8. 12.*, Berlin, 2009.

**Donner 1981**
F. M. Donner, *The Early Islamic Conquests*, Princeton, Princeton University Press, 1981.

**Dossin 1970**
G. Dossin, "Archive de Sumu-Iamam, roi de Mari", *Revue d'assyriologie et d'archéologie orientale*, 64, 1970, pp. 17–44.

**Doughty 1888**
C. Doughty, *Travels in Arabia Deserta*, Cambridge, Cambridge University Press, 1888, 2 vol. (1st ed.; republished under the title *Passages from Arabia Deserta selected by Edward Garnett*, London, Jonathan Cape, 1921, with an introduction by T. E. Lawrence; French ed. *Voyage dans l'Arabie Déserte*, trad. J.-C. Reverdy, Paris, Karthala, 2002).

**Drewes 1986**
A. J. Drewes, "Lihyân et Lihyânites, I. Épigraphie", in *Encyclopédie de l'Islam*, V, 1986 (new ed.), pp. 767–69.

**During Caspers 1994**
E. C. L. During Caspers, "Further Evidence for 'Central Asian' Materials from the Arabian Gulf", *JESHO*, 37, no. 1, 1994, pp. 33–53.

**Edens 1982**
C. Edens, "Towards a Definition of the Western Ar-Rub' al-Khali 'Neolithic'", *Atlal*, 6, 1982, pp. 109–23.

**Edens and Bawden 1989**
C. Edens and G. Bawden, "History of Tayma and Hejazi Trade during the First Millenium B.C.", *JESHO*, 32, no. 1, 1989, pp. 48–103.

**Eichmann 2009**
R. Eichmann, "Archaeological Evidence of the Pre-Islamic Period (4th to 6th cent. A.D.) at Tayma", in Schiettecatte and Robin, 2009, pp. 55–69.

**Eichmann, Hausleiter, Al-Najem and Al-Said 2006**
R. Eichmann, A. Hausleiter, M. Al-Najem and S. F. Al-Said, "Tayma – Spring 2004, Report on the Joint Saudi Arabian-German Archaeological Project", *Atlal*, 19, 2006, pp. 91–116.

**Eichmann, Hausleiter, Al-Najem and Al-Said (forthcoming)**
R. Eichmann, A. Hausleiter, M. Al-Najem et S. F. Al-Said, "Tayma – Autumn 2004 and Spring 2005 – 2nd Report on the Joint Saudi-Arabian-German Archaeological Project", *Atlal*, 20, forthcoming.

**Eichmann, Schaudig and Hausleiter 2006**
R. Eichmann, H. Schaudig and A. Hausleiter, "Archaeology and Epigraphy at Tayma (Saudi-Arabia)", *AAE*, 17, 2006, pp. 163–76.

**Elad 1999**
A. Elad, "The Southern Golan in the Early Muslim Period. The Significance of Two Newly Discovered Milestones of 'Abd al-Malik", *Der Islam*, 76, 1999, pp. 33–88.

**Eph'al 1982**
I. Eph'al, *The Ancient Arabs. Nomads on the Borders of the Fertile Crescent, 9th–5th Centuries B.C.*, Jerusalem, The Magnes Press, The Hebrew University, Leiden, E. J. Brill, 1982.

**Erdmann 1959**
K. Erdmann, "Ka'bah Fliesen", *Ars Orientalis*, III, 1959, pp. 192–97.

**Erken 1971**
S. Erken, "ri", *Vakıflar*, IX, Ankara, 1971, pp. 297–320.

**Ertug and Grabar 1993**
A. Ertug and O. Grabar, *In Pursuit of Excellence, Works of Art from the Museum of Turkish and Islamic Arts*, Istanbul, 1993.

**Esin 1984**
E. Esin, "Un manuscrit illustré représentant les sanctuaires de La Mecque et Médine et le dôme du miradj à l'époque des sultans turcs Selim et Suleyman Ier (H. 922–74/1516–66)", in *Les Provinces arabes et leurs sources documentaires à l'époque ottomane*, Tunis, 1984, pp. 175–90.

**Ettinghausen 1934**
R. Ettinghausen, "Die bildliche Darstellung der Ka'ba im islamischen Kulturkreis", *ZDMG*, LXXXVII, 1934, pp. 111–37.

**Euting 1885**
J. Euting, *Nabataïsche Inschriften aus Arabien*, Berlin, G. Reimer, 1885.

**Euting 1914**
J. Euting, *Tagebuch einer Reise nach Inner-Arabien. Zweiter Theil*, E. Littmann, Leipzig, 1914.

*Evliya Çelebi 1935*
*Evliya çelebi seyahatnamesi: Anadolu, Suriye, Hicaz*, Ankara, 1935.

**Eyyüp Sabri 2004**
Eyyüp Sabri, *Mir'at al-Haramayn*, 1883–1889 (republished Cairo, 2004).

**Fabietti 1988**
U. Fabietti, "The Role Played by the Organization of the 'Hums' in the Evolution of Political Ideas in Pre-Islamic Mecca", *PSAS*, 21, 1988, pp. 25–33

(reprinted in F. E. Peters [ed.], *The Arabs and Arabia on the Eve of Islam*, The Formation of the Classical Islamic World, 3, Aldershot, Ashgate Variorum, 1999, pp. 348–56).

**Fahd 1987**
T. Fahd (ed.), *L'Arabie préislamique et son environnement historique et culturel. Actes du Colloque de Strasbourg, 24-27 juin 1987*, Strasbourg, Université des Sciences humaines, Travaux du Centre de recherche sur le Proche-Orient et la Grèce antiques, 10, Leiden, Brill, 1989.

**Al-Fa'r 1984**
See the bibliography in Arabic.

**Farès-Drappeau 2000**
S. Farès-Drappeau, "RR. PP. A. Jaussen et R. Savignac – Mission archéologique en Arabie (Publication de la Société des fouilles archéologiques), 3 tomes […], Cairo (Institut Français d'Archéologie Orientale), 1997 (2nd ed.)", *REMMM*, nos. 89–90, July 2000, pp. 325–30.

**Farès-Drappeau 2005**
S. Farès-Drappeau, *Dédan et Lihyân. Histoire des Arabes aux confins des pouvoirs perse et hellénistique (IVᵉ-IIᵉ s. avant l'ère chrétienne)*, Travaux de la Maison de l'Orient et de la Méditerranée, 42, Lyon, 2005.

**Faroqhi 1994**
S. Faroqhi, *Pilgrims and Sultans. The Hajj Under the Ottomans*, London, New York, 1994.

**Faure 1987**
P. Faure, *Parfums et aromates dans l'Antiquité*, Paris, Fayard, 1987.

**Field 1952**
H. Field, "Camel Brands and Graffiti from Iraq, Syria, Jordan, Iran and Saudi Arabia", *Journal of American Oriental Research*, supplement no. 15, vol. LXXII, 1952, no. 154, pp. 1–41.

**Field 1971**
H. Field, *Contribution to the Anthropology of Saudi Arabia*, Miami, Field Research Project, 1971.

**Fisher and Fisher 1982**
C. G. Fisher and A. Fisher, "Illustrations of Mecca and Medina in Islamic Manuscripts", *Islamic art from Michigan Collection*, East Lansing, Michigan, 1982, pp. 40–47.

**Fisher and Membery 1998**
M. Fisher and D. A. Membery, "Climate of the Arabian Peninsula", in S. A. Ghazanfar and M. Fisher (ed.), *Vegetation of the Arabian Peninsula*, Geobotany, 25, London, Kluver Academic Publishers, 1998, pp. 5–38.

**Fleitmann, Burns, Mangini et al. 2007**
D. Fleitmann, S. J. Burns, A. Mangini *et al.*, "Holocene ITCZ and Indian Monsoon Dynamics Recorded in Stalagmites from Oman and Yemen (Socotra)", *Quaternary Science Reviews*, 26, 2007, pp. 170–88.

**Frahm 1997**
E. Frahm, *Einleitung in die Sanherib-Inschriften*, Horn, 1997.

**Frahm 1999**
E. Frahm, "Perlen von den Rändern der Welt", in K. Van Lerberghe and G. Voet (ed.), *Languages and Cultures in Contact: at the Crossroads of Civilizations in the Syro-Mesopotamian Realm*, Leuven, 1999, pp. 79–99.

**Frame 1992**
G. Frame, *Babylonia 689-627 B.C.: a Political History*, Leiden, 1992.

**Frankfurt 1985**
*Türkische Kunst und Kultur aus osmanischer Zeit*, exhibition catalogue, Frankfurt, Museum für Kunsthandwerk, 1985.

**Frohlich and Mughannum 1985**
B. Frohlich and A. Mughannum, "Excavations of the Dhahran Burial Mounds 1404/1984", *Atlal*, 9, 1985, pp. 9–40.

**Gadd 1958**
C. J. Gadd, "The Harran Inscriptions of Nabonidus", *Anatolian Studies*, VIII, 1958, pp. 35–92 and pl. I–XVI.

**Gagé 1950**
J. Gagé (ed.), *Res gestæ divi Augusti, ex monumentis Ancyrano et Antiocheno latinis, Ancyrano et Apolloniensi græcis*, Strasbourg, Publications of the Faculty of Literature of the University of Strasbourg, Textes d'études, 5, Paris, 1950.

**Gajda 1996**
I. Gajda, "Hujr b. 'Amr roi de Kinda et l'établissement de la domination himyarite en Arabie centrale", *PSAS*, 26, 1996, pp. 65–73 and pl. I.

**Galland 1704–17**
A. Galland, *Les Mille et Une Nuits, contes arabes traduits en français*, Paris, chez la veuve de Claude Barbin, 1704–17, 12 vols.

**Galter 1993**
H. D. Galter, "'… an der Grenze der Länder im Westen'. Saba' in den assyrischen Königsinschriften", in A. Gingrich, S. Haas, G. Paleczek and T. Fillitz, *Studies in Oriental Culture and History, Festschrift for Walter Dostal*, Frankfurt, Peter Lang, 1993, pp. 29–40.

**Garbini 1974**
G. Garbini, "Note di epigrafia sabea II", *AION*, 34 (N.S. XXIV), 1974, pp. 291–99.

**Garrard and Stanley Price 1981**
A. N. Garrard and N. P. Stanley Price, "Environment and Settlement during the Upper Pleistocene and Holocene at Jubbah in the Great Nafud, North Arabia", *Atlal*, 5, 1981, pp. 137–56.

**Gärtner 2003**
J. Gärtner, "Architektonische Elemente und Skulptur der Nabatäer", in E. Netzer, *Nabatäische Architektur, Sonderbände der Antiken*

*Welt, Zaberns Bildbände zur Archäologie*, Mayence, Philipp von Zabern, 2003, pp. 156–79.

**Gatier, Lombard and Al-Sindi 2002**
P.-L. Gatier, P. Lombard and K. M. Al-Sindi, "Greek Inscriptions from Bahrain", *AAE*, 13, 2002, pp. 223–33.

**Gaudefroy-Demombynes 1954**
M. Gaudefroy-Demombynes, "Le voile de la Ka'ba", *Studia Islamica*, 2, 1954, pp. 5–21.

**Gazdar, Potts and Livingstone 1984**
M. S. Gazdar, D. T. Potts and A. Livingstone, "Excavations at Thaj", *Atlal*, 8, 1984, pp. 55–108.

**Georgeon 2003**
F. Georgeon, *Abdulhamid II. Le sultan calife*, Paris, Fayard, 2003.

**Gerardi 1992**
P. Gerardi, "The Arab Campaigns of Aššurbanipal: Scribal Reconstruction of the Past", *State Archives of Assyria Bulletin*, 6/2, 1992, pp. 67–103.

**Al-Ghabban 1988 a**
A. I. Al-Ghabban, *Introduction à l'étude archéologique des deux routes syrienne et égyptienne de pélerinage au nord-ouest de l'Arabie saoudite*, Ph.D. thesis in press, Aix-en-Provence, University of Aix-en-Provence, 1988.

**Al-Ghabban 1988 b**
See the bibliography in Arabic.

**Al-Ghabban 1414 H./1993**
See the bibliography in Arabic.

**Al-Ghabban 2008**
A. I. Al-Ghabban, "L'influence de Babylone à Tayma et dans sa région à la lumière des découvertes archéologiques récentes", in B. André-Salvini (ed.), *Babylone*, Paris, 2008, pp. 231–32.

**Al-Ghazi 1992**
See the bibliography in Arabic.

**Al-Ghazi 1995**
See the bibliography in Arabic.

**Al-Ghazi 2000**
A. A. ibn Saoud Al-Ghazi, "Dating and ascertaining the origins of al-Ula painted pottery", *Atlal*, 15, 1420 H./2000, pp. 179–91.

**Al-Ghazi 2005 a**
See the bibliography in Arabic.

**Al-Ghazi 2005 b**
See the bibliography in Arabic.

**Al-Ghazi 2007**
A. A. ibn Saoud Al-Ghazi, "Nouvelle collection de céramique en provenance du djebel al-Khariba à al-'Ula", *Périodique roi Abdel Aziz*, no. 3, 1427 H./2007, pp. 83–111.

**Ghoneim 1980**
W. Ghoneim, "Qaryat (al-Faw)", *Archiv Für Orientforschung*, vol. XXVII, 1980.

**Gil 1984**
M. Gil, "The Origin of the Jews of Yathrib", in *Jerusalem Studies in Arabic and Islam*, 4, 1984, pp. 203–24 (reprinted in F. E. Peters [ed.], *The Arabs and Arabia on the Eve of Islam*, collection "The Formation of the Classical Islamic World", vol. 3, Variorum, Ashgate, 8, 1998, pp. 145–66).

**Giveon 1971**
R. Giveon, *Les Bédouins shosou des documents égyptiens*, Leiden, 1971.

**Golding 1974**
M. Golding, "Evidence for Pre-Seleucid Occupation in Eastern Arabia", *PSAS*, 4, 1974, pp. 19–32.

**Golding 1984**
M. Golding, "Artefacts from Later Pre-Islamic Occupation in Eastern Arabia", *Atlal*, 8, 1984, pp. 159–64.

**Göyünç 1979**
N. Göyünç, "Some Documents Concerning the Ka'ba in the 16th Century", *Masadir Tarikh al-Jazira al-'Arabiyya / Sources for the History of Arabia: Proceedings of the First International Symposium on Studies in the History of Arabia, 23rd–28th April 1977*, Riyadh, 1399 H./1979, pp. 177–81.

**Grabar 1985**
O. Grabar, "Upon Reading al-Azraqi", *Muqarnas*, 3, 1985, pp. 1–7.

**Graf 1990**
D. F. Graf, "Arabia during Achaemenid Times", in H. Sancisi-Weerdenburg and A. Kuhrt (ed.), *Achaemenid History IV, Proceedings of the Groningen 1986 Achaemenid History Workshop*, Leiden, 1990, pp. 131–48.

**Grohmann 1962**
A. Grohmann, *Expédition Philby-Ryckmans-Lippens en Arabie, IIᵉ partie, Textes épigraphiques, t. 1, Arabic Inscriptions*, Louvain, 1962.

**Groom 1981**
N. Groom, *Frankincense and Myrrh. A Study of the Arabian Incense Trade*, London, Longman, Beirut, Librairie du Liban, 1981.

**Gruber 2005**
C. Gruber, *The Prophet Muhammad's Ascension (Mi'raj) in Islamic Art and Literature, 1300–1600*, Ph.D. thesis, Philadelphia, University of Pennsylvania, 2005.

**Gubel and Overlaet 2007**
É. Gubel and B. Overlaet, *De Gilgamesh à Zénobie. Trésors de l'Antiquité. Proche-Orient et Iran*, Brussels, MRAH, Fonds Mercator, 2007.

**Güler 2002**
M. Güler, *Osmanlı Devlet'inde Haremeyn Vakıfları (XVI.-XVII. Yüzyıllar)*, Istanbul, 2002.

**Al-Hajiri 2006**
M. Al-Hajiri, "Brief Preliminary Report on the Excavations at the Industrial Site in Tayma", *Atlal*, 19, 2006, pp. 21–26.

**Al-Hajiri et al. 2002**
M. Al-Hajiri, Y. Hussain, M. Al-Mutlag, J. Al-Jurdid, S. Al-Rodhain and N. Shaiks, "Tayma Excavation, Rujoum Sasa, First Season 1418 A.H./1997 A.D.", *Atlal*, 17, 2002, pp. 23–25.

**Al-Hajiri et al. 2005**
M. Al-Hajiri, M. Al-Mutlaq, A. Hashim, S. Al-Shama'n, S. Al-Najem, S. Al-Helwa, S. Al-Radhiyan, "Archaeological Excavations at the Site of Rajoom Sa'sa' – Tayma (Second Season 1421 H./2000 A.D.)", *Atlal*, 18, 2005, pp. 23–27.

**Hakemi 1997**
A. Hakemi, "Kerman: the Original Place of Production of Chlorite Stone Objects in the 3rd Millenium B.C.", *East and West*, vol. XLVII, nos. 1–4, 1997, pp. 11–40.

**Al-Hamdani 1977**
See the bibliography in Arabic.

**Hamed 1988**
A. I. Hamed, *Introduction à l'étude archéologique des deux routes syrienne et égyptienne de pélerinage au nord-ouest de l'Arabie saoudite*, unpublished Ph.D. thesis, University of Aix-en-Provence, 1988.

**Hamilton 1993**
A. Hamilton, *L'Europe et le monde arabe. Cinq siècles de livres des lettrés et voyageurs européens choisis dans les bibliothèques de l'Arcadian Group*, exhibition catalogue, Paris, Institut du monde arabe, 1993.

**Al-Harbi**
See the bibliography in Arabic.

**Harding 1971**
G. L. Harding, *An Index and Concordance of Pre-Islamic Arabian Names and Inscriptions*, Toronto, University of Toronto Press, 1971.

**Al-Harithi 1415H./ 1994**
See the bibliography in Arabic.

**Al-Harithi 2005**
See the bibliography in Arabic.

**Harmand, DeGusta, Slimak et al. 2009**
S. Harmand, D. DeGusta, L. Slimak *et al.*, "Nouveaux sites paléolithiques anciens en république de Djibouti : bilan préliminaire de prospections récentes dans le bassin du Gobaad, Afar central", *Comptes rendus Palevol*, 8, no. 5, 2009, pp. 481–92.

**Hashim 2007**
S. A. Hashim, *Pre-Islamic Ceramics in Saudi Arabia*, Riyadh, Ministry of Education, Department of Antiquities and Museums, 2007.

**Hassell 1997**
J. Hassell, "Alabaster Beehive-Shaped Vessels from Arabian Peninsula", *AAE*, vol. 8, no. 2, 1997.

**Hausleiter 2006**
A. Hausleiter, "Tayma, North-West Arabia. The Context of Archaeological Research", in Y. Gong and Y. Chen (ed.), *Special Issue of Oriental Studies. A Collection of Papers on Ancient Civilizations of Western Asia, Asia Minor and North Africa*, Beijing, 2006, pp. 158–80.

**Hausleiter 2009**
A. Hausleiter, "Tayma during the Hellenistic and Nabataean periods", paper presented at the international workshop *Central Places in Arabia during the Hellenistic and Roman Periods – Common Trends and Different Developments*, Berlin, 3–5 December 2009.

**Hausleiter (forthcoming)**
A. Hausleiter, "Divine Representations at Taymā'", in C. Robin and I. Sachet (ed.), *Proceedings of the Table ronde "Dieux et déesses d'Arabie : images et représentations, Collège de France, site d'Ulm, Paris, 1 et 2 octobre 2007"*, Paris, forthcoming.

**El-Hawary and Wiet 1985**
H. M. El-Hawary and G. Wiet, *Matériaux pour un Corpus inscriptionum arabicarum*, 4th part, *Arabie. Inscriptions et monuments de La Mecque, Haram et Ka'ba*, I, fasc. 1, revised by N. Elisséeff, Cairo, Institut français d'archéologie orientale, 1985.

**Al-Hawas 2003**
F. Al-Hawas, *The Archaeological and Architectural Remains of the Ancient City of Faid in the Province of Hail, Saudi Arabia*, unpublished Ph.D. thesis, University of Southampton, 2003.

**Hawting 1999**
G. R. Hawting, *The Idea of Idolatry and the Emergence of Islam. From Polemic to History*, Cambridge Studies in Islamic Civilization, Cambridge, Cambridge University Press, 1999.

**Hayajneh 2001 a**
H. Hayajneh, "Der babylonische König Nabonid und der *RBSRS* in einigen neu publizierten frühnordarabischen Inschriften aus Tayma", *Acta Orientalia*, 62, 2001, pp. 22–64.

**Hayajneh 2001 b**
H. Hayajneh, "First Evidence of Nabonidus in the Ancient North Arabian Inscriptions from the Region of Tayma", *PSAS*, 31, 2001, pp. 81–95.

**Healey 1993**
J. F. Healey, "The Nabataean Tomb Inscriptions of Mada'in Saleh", *Journal of Semitic Studies*, supplement 1, Oxford, Oxford University Press (on behalf of the University of Manchester), 1993.

**Herbelot 1697**
B. d'Herbelot, *Bibliothèque Orientale ou*

*Dictionnaire Universel Contenant Tout ce qui fait connoitre les Peuples de l'Orient,* The Hague, 1697.

**Herrmann and Laidlaw 2009**
G. Herrmann and S. Laidlaw, *Ivories from Nimrud IV: Ivories from the North West Palace (1845–1992)*, London, 2009.

**Al-Hijri**
See the bibliography in Arabic.

**Hirschfeld 2006**
Y. Hirschfeld, "The Crisis of the Sixth Century: Climatic Change, Natural Disasters and the Plague", *Mediterranean Archaeology and Archaeometry*, 6, 2006, pp. 19–32.

**Horsefield 1983**
G. Horsefield, H. Angles and N. Gluck, "Prehistoric Rock-Drawings in Transjordan", *Journal of Near Eastern Archaeology*, vol. IX, 1983, no. 1, pp. 8–17.

**Howe 1950**
B. Howe, "Two Groups of Rock Engravings from the Hijaz", *Journal of Near Eastern Studies*, vol. IX, no. 1, January 1950, pp. 8–17.

**Hoyland 2001**
R. G. Hoyland, *Arabia and the Arabs from Bronze Age to the Coming of Islam*, London, New York, Routledge, 2001.

**Huber 1884**
C.-A. Huber, "Voyage dans l'Arabie centrale", *Bulletin de la Société de géographie*, 1884, pp. 289–363, 468–531.

**Huber 1891**
C.-A. Huber, *Journal d'un voyage en Arabie (1883-1884)*, Paris, Imprimerie nationale, 1891 (published posthumously by E. Renan, Barbier de Ménard and C. Maunoir).

**Huckle 2003**
M. Huckle, "A Unique Soft-Stone Tri-Compartmentalised Vessel (Probably from Wa'ab 4, in the Wadi al-Qawr, Ras al-Khaimah, U.A.E.)", *AAE,* 14, 2003, pp. 58–62.

**Humayd Allah 1407 H./1987**
See the bibliography in Arabic.

**Huth and Potts 2002**
M. Huth and D. T. Potts, "Antiochus in Arabia", *American Journal of Numismatics*, 2nd series, 14, 2002, pp. 73–81.

**Ibn Battuta**
See the bibliography in Arabic.

**Ibn Bulayhid 1399 H./1979**
See the bibliography in Arabic.

**Ibn Darid 1958**
Ibn Darid, Abou Bakr Mohamed bin Al-Hassan, *La Dérivation*, research by Abdel Salam Haroun, Cairo, Librairie al-Khanji, 1958.

**Ibn Habib 1972**
Ibn Habib, M, *Al-Muhabbar*, 1972.

**Ibn Hawqal**
See the bibliography in Arabic.

**Ibn Iyas 1960**
Ibn Iyas, *Journal d'un bourgeois du Caire, chronique d'Ibn Iyas*, trans. G. Wiet, t. II, Paris, 1960.

**Ibn Jubayr**
See the bibliography in Arabic.

**Ibn Kathir**
See the bibliography in Arabic.

**Ibn Khaldun 1958**
Ibn Khaldun, *The Muqaddimah: An Introduction to History*, trans. F. Rosenthal, New York, Pantheon, 1958.

**Ibn Khurradadhbih**
See the bibliography in Arabic.

**Ibn Manzur**
See the bibliography in Arabic.

**Ibn al-Mujawir**
See the bibliography in Arabic.

**Ibn al-Nadim**
See the bibliography in Arabic.

**Ibn Rustah**
See the bibliography in Arabic.

**Ibn Sa'd**
See the bibliography in Arabic.

**Ibrahim, al-Talhi 1985**
Ibrahim, al-Talhi *et al.*, "A Preliminary Report on the First Season of Excavation at al-Mabiyat. An Early Islamic Site in the Northern Hijaz", *Atlal*, 9, 1985, pp. 109–25.

**Al-Idrisi**
See the bibliography in Arabic.

**Al-Isfahani**
See the bibliography in Arabic.

**Al-Istakhri**
See the bibliography in Arabic.

**Ingraham *et al.* 1981**
M. L. Ingraham, T. D. Johnson, B. Rihani et I. Shatla, "Preliminary Report on a Reconnaissance Survey of the NW Province", *Atlal*, 5, 1981, pp. 59–84.

**Inizan 1988**
M.-L. Inizan (ed.), *Préhistoire à Qatar*, Paris, ERC, 1988.

**Inizan and Rachad 2007**
M.-L. Inizan and M. Rachad (ed.), *Art rupestre et peuplements préhistoriques au Yémen*, San'a, CEFAS, 2007.

**Intilia 2009**
A. Intilia, "Ivories from Excavations in Area O", paper presented at the workshop *Neue Forschungen in Tayma – Projektgespräch 2009, 7–8. 12.*, Berlin, 2009.

**Ippolitoni-Strika 1986**
F. Ippolitoni-Strika, "The Tarut Statue: a Peripherical Contribution to the Knowledge of Early Mesopotamian Plastic Art",

in Al-Khalifa and Rice, 1986, pp. 311–24.

**Isfahani 2005**
A. M. el-Isfahani, *Sifatu'l Harameyn (Dil ozellikleri metin dizin)*, Ankara, 2005, pp. 13–14.

**Istanbul 2008**
*Imperial Surre*, exhibition catalogue, Istanbul, Museum of the Palace of Topkapı, 2008.

**Jacobs and Macdonald 2009**
B. Jacobs and M. C. A. Macdonald, "Felszeichnung eines Reites aus der Umgebung von Taymā'", *Zeitschrift für Orient-Archäologie*, 2, 2009, pp. 364–76.

**Jado and Zötl 1984**
A. R. Jado and J. G. Zötl (ed.), *Quaternary Period in Saudi Arabia*, vol. II, Vienna, New York, Springer-Verlag, 1984.

**Jam'a, (n.d.)**
See the bibliography in Arabic.

**Jameson 1968**
S. Jameson, "Chronology of the Campaigns of Aelius Gallus and C. Petronius", *Journal of Roman Studies*, 58, 1968, pp. 71–84.

**Jamme 1970**
A. Jamme, "The Pre-Islamic Inscriptions of the Riyadh Museum", *Oriens Antiquus*, 9, 1970, pp. 115–39.

**Al-Jasir 1386 H./1967**
See the bibliography in Arabic.

**Al-Jasir 1397 H./1977**
See the bibliography in Arabic.

**Al-Jasir 1402 H./1981–82**
See the bibliography in Arabic.

**Al-Jasir 1404 H./1983–84**
See the bibliography in Arabic.

**Jasmin 2005**
M. Jasmin, "Les conditions d'émergence de la route de l'encens à la fin du II$^e$ millénaire avant notre ère", *Syria*, 82, 2005, pp. 49–62.

**Al-Jasser 1979**
See the bibliography in Arabic.

**Al-Jaziri**
See the bibliography in Arabic.

**Jaussen and Savignac 1909**
A. Jaussen and R. Savignac, *Mission archéologique en Arabie*, t. I, *Mars-mai 1907. De Jérusalem au Hedjaz, Médain-Saleh*, Paris, E. Leroux, 1909 (republished Cairo, Institut français d'archéologie orientale, 1997).

**Jaussen and Savignac 1914**
A. Jaussen and R. Savignac, *Mission archéologique en Arabie*, t. II, *El-'Ela, d'Hégra à Teima, Harrah de Tebouk*, and *Atlas*, Paris, Librairie
P. Geuthner, 1914 (republished Cairo, Institut français d'archéologie orientale, 1997).

**Jawad 1980**
See the bibliography in Arabic.

**Jazim and Leclercq-Neveu 2001**
M. Jazim and B. Leclercq-Neveu, "L'organisation des caravanes au Yémen selon al-Hamdani (X$^e$ siècle)", *Chroniques yéménites*, 9, 2001.

**Al-Jodi and Ghazi 1995**
Al-Jodi and S. Ghazi, *Wasum al ibl und ba'ad al-Qabail*, Kitab al-Riyadh, 14, Riyadh, Al-Yamamah Publishers, 1995.

**Jomard 1823**
E.-F. Jomard, *Notice géographique sur le pays de Nedj ou Arabie centrale, accompagné d'une carte*, Paris, printed Rignoux, 1823.

**Jomier 1953**
J. Jomier, *Le Mahmal et la caravane égyptienne des pèlerins de La Mecque (XIII$^e$-XX$^e$ siècle)*, Cairo, Institut français d'archéologie orientale, 1953.

**Kalsbeek and London 1987**
J. Kalsbeek and G. London, "A Late Second Millennium BC. Potting Puzzle", *BASOR*, 1987, pp. 47–56.

**Kamal 1984**
See the bibliography in Arabic.

**Kapel 1967**
H. Kapel, *Atlas of the Stone-Age Cultures of Qatar. Reports of the Danish Archaeological Expedition to the Arabian Gulf*, Aarhus, University Press, 1967.

**Kawatoko 2005**
M. Kawatoko, "Archaeological Survey of Najran and Madinah 2002", *Atlal*, 18, 2005, pp. 45–59.

**Kennedy 1997**
H. Kennedy, "From Oral Tradition to Written Record in Arabic Genealogy", *Arabica*, 44, 1997, pp. 531–44.

**Kennet 2005**
D. Kennet, "On the Eve of Islam: Archaeological Evidence from Eastern Arabia", *Antiquity*, 79, 2005, pp. 107–18.

**Kennet 2007**
D. Kennet, "The Decline of Eastern Arabia in the Sasanian Period", *AAE*, 18, 2007, pp. 86–122.

**Khalidi 2009**
L. Khalidi, "Holocene Obsidian Exchange in the Red Sea Region", in Petraglia and Rose, 2009, pp. 279–91.

**Al-Khalifa and Rice 1986**
H. A. Al-Khalifa and M. Rice (ed.), *Bahrain through the Ages. The Archaeology*, London, KPI, 1986.

**Khan 1985**
M. Khan, "Rock Art and Epigraphic Survey of Northwestern Saudi Arabia", *Atlal*, 9, 1985.

**Khan 1988 a**
M. Khan, "Rock Art and Epigraphic Survey of Northern Saudi Arabia", *Atlal*, 11, 1988, pp. 61–75.

**Khan 1988 b**
M. Khan, "Schematization and Form

in the Rock Art of Northern Saudi Arabia", *Atlal*, 11, 1988, p.95–99.

**Khan 1990**
M. Khan, "Art and Religion: Sacred Images of Prehistoric Metaphysical World", *Atlal*, 12, 1990, pp. 55–57.

**Khan 1991 a**
M. Khan, "Female Profile Figures from Wadi Damm, NW Saudi Arabia", *Atlal*, 13, 1991,

**Khan 1991 b**
M. Khan, "Recent Rock Art and Epigraphic Investigations in Saudi Arabia", *PSAS*, 21, 1991, pp. 113–22.

**Khan 1993 a**
M. Khan, "Origin of Urbanism in Saudi Arabia", *Seminar on Urbanism*, Kenya, 1993.

**Khan 1993 b**
M. Khan, *Origin and Evolution of Ancient Arabian Inscriptions*, Riyadh, Ministry of Education, 1993 (English/Arabic).

**Khan 1993 c**
M. Khan, *Prehistoric Rock Art of Northern Saudi Arabia*, Ph.D. thesis (in English and Arabic), University of Southampton, United Kingdom, Riyadh, Ministry of Education, Department of Antiquities and Museums, 1993.

**Khan 1996**
M. Khan, "Rock Art Research in the Arabian Peninsula, Levant and Anatolia", in P. Bahn and A. Fossati (ed.), *News of the World I*, Oxbow Publications, vol. LXXII, 1996, pp. 95–103.

**Khan 1998**
M. Khan, "A Critical Review of Rock Art Studies in Saudi Arabia", *East and West*, vol. XLVIII, no. 3, 1998, pp. 427–37.

**Khan 1999**
M. Khan, "Human Figures in the Rock Art of Saudi Arabia", *Publications of the International Rock Art Congress*, Ripon, 1999.

**Khan 2000 a**
M. Khan, *Wusum. The Tribal Symbols of Saudi Arabia*, Riyadh, Ministry of Education, 2000 (English/Arabic).

**Khan 2000 b**
M. Khan, "Bir Himma – The Center of Prehistoric Art and Culture", *Admatu*, 6, 2000.

**Khan 2004–05**
M. Khan, "Jubbah – The Most Prominent Rock Art Site of Saudi Arabia", *Indo-Koko-Kenkyu*, 26, 2004–05, pp. 63–72.

**Khan 2007 a**
M. Khan, "Sacred Images of Metaphysical World-Perspective of Prehistoric Religion in Arabia", in *XXII Valcamonica Symposium 2007. Rock Art in the Frame of the Cultural Heritage of Humankind*, 2007.

**Khan 2007 b**
M. Khan, *Rock Art of Saudi Across Twelve Thousand Years*, Riyadh, Ministry of Education of Saudi Arabia, 2007.

**Khan 2008**
M. Khan, *Rock Art Studies (How to Study Rock Art)*, Riyadh, Ministry of Education of Saudi Arabia, 2008.

**Khan, Kabawi and Al-Zahrani 1986**
M. Khan, A. Kabawi and A. Al-Zahrani, "Preliminary Report on the Second Phase of Rock Art and Epigraphic Survey of Northern Saudi Arabia", *Atlal*, 10, 1986, pp. 82–93.

**Khatt 1406 H./1985–86**
See the bibliography in Arabic.

**Al-Khraysheh 1986**
F. Al-Khraysheh, *Die Personennamen in den nabatäischen Inschriften des Corpus inscriptionum semiticarum*, Marburg, 1986.

**Kienast and Volk 1995**
B. Kienast and K. Volk, *Die sumerischen und akkadischen Briefe des III. Jahrtausends aus der Zeit vor der III. Dynastie von Ur*, Stuttgart, 1995.

**Al-Kilabi 1424 H.**
See the bibliography in Arabic.

**Al-Kilabi 1430 H./2009**
See the bibliography in Arabic.

**King 1980**
G. R. D. King, "Some Christian Wall-Mosaics in Pre-Islamic Arabia", *PSAS*, 10, 1980, pp. 37–43.

**Kirkbride 1969**
D. Kirkbride, "Ancient Arabian Ancestor Idols", *Archaeology*, 22/2-3, 1969, pp. 116–121, 188–95.

**Al-Khiyari**
See the bibliography in Arabic.

**Kjaerum 1986**
P. Kjaerum, "The Dilmun Seals as Evidence of Long Distance Relations in the Early Second Millennium B.C.", in Al-Khalifa and Rice, 1986, pp. 269–77.

**Klasen et al. (forthcoming)**
N. Klasen, M. Engel, H. Brückner, R. Eichmann, A. Hausleiter, M. Al-Najem et S. F. Al-Said, "Optically Dating the City Wall System of Ancient Tayma (NW Saudi Arabia)", *Quaternary Geochronology*, forthcoming.

**Knauf 1988**
E. A. Knauf, *Midian Untersuchungen zur Geschichte Palaestinas und Nordarabiens am Ende des 2 Jahrtausands v. Chr.*, Wiesbaden, Harrassowitz, 1988.

**Knauf 1990**
E. A. Knauf, "The Persian Administration in Arabia", *Transeuphratène*, 2, 1990, pp. 201–17.

**Koenig 1971**
J. Koenig, *Le Site de al-Jaw dans l'ancien pays de Madian*, Paris, Geuthner, 1971.

**Kohl 1974**
P. L. Kohl, "Seeds of Upheaval: the production of chlorite at Tepe Yahya and an analysis of commodity production and trade in South-west Asia in the mid-third millennium". Ph.D. thesis, Harvard University, 1974.

**Kohl 2004**
P. L. Kohl "Chloritgefäße und andere steinerne Behältnisse und ihr Austausch im Gebiet des iranischen Zentral-Plateaus und jenseits davon". In exhibition catalogue *Persiens Antike Pracht. Bergbau, Handwerk, Archäologie*. Bochum 2004.

**Korotayev, Klimenko and Proussakov 1999**
A. Korotayev, V. Klimenko and D. Proussakov, "Origins of Islam: Political-Anthropological and Environmental Context", *Acta Orientalia Academiae scientiarum Hungaricae*, 52, 1999, pp. 243–76.

**Kottsieper 2001**
I. Kottsieper, "Aramäische und phönizische Texte", in O. Kaiser (ed.), *Texte aus der Umwelt des Alten Testaments, Ergänzungslieferung*, Gütersloh, 2001, pp. 176–202.

**Kurdi (n.d.)**
O. A. M. A. Kurdi, *The Holy Ka'bah and the Two Holy Mosques, Construction and History*, n.d.

**Kürschner 2009**
H. Kürschner, "Tayma-Oase und Umgebung – Eine erste Bestandsaufnahme der Flora, Vegetation, natürlichen Ressourcen und Florengeschichte", paper presented at the workshop *Neue Forschungen in Tayma – Projektgespräch 2009, 7–8. 12.*, Berlin, 2009.

**Kuwait 1997**
*The Harmony of Letters, Islamic Calligraphy from Tareq rajab Museum*, Kuwait, 1997.

**Laffitte 2003**
R. Laffitte, "Sur le zodiaque sudarabique", *Arabia*, 1, 2003, pp. 77–87.

**Lamberg-Karlovsky 1988**
C. C. Lamberg-Karlovsky, "The 'Intercultural Style' Vessels", *Iranica antiqua*, 23, 1988, p.45–95.

**Lamberg-Karlovsky and Wight Beale 1986**
C. C. Lamberg-Karlovsky and T. Wight Beale, *Excavations at Tepe Yahya, Iran, 1967–1975: the Early Periods*, Cambridge, 1986.

**Lammens 1911**
H. Lammens, "La république marchande de La Mecque, en l'an 600 de notre ère", *Institut égyptien, Bulletin*, 5th series, t. IV, Alexandria, 1911, pp. 23–54 (study reprinted and developed in *La Mecque à la veille de l'hégire*, Beirut, 1924).

**Langfeldt 1994**
J. Langfeldt, "Recently Discovered Early Christian Monuments in North-Eastern Arabia", *AAE*, 5, 1994, pp. 32–60.

**Laoust 1952**
H. Laoust, *Les Gouverneurs de Damas sous les Mamelouks et les premiers Ottomans (658-1156/1260-1744). Traduction des Annales d'Ibn Tûlûn et d'Ibn Gum'a*, Damascus, 1952.

**Lari 1968**
M. al-Din Lari, *Futuh al-haramayn*, Intisharat-i Ittila'at, Teheran, 1346 H./1968.

**La Roque 1716**
J. de La Roque, *Voyage de l'Arabie Heureuse par l'océan oriental, fait par les Français pour la première fois dans les années 1708, 1709 et 1710. Avec la relation particulière d'un voyage du port de Moka à la cour du roi d'Yémen, dans la seconde expédition des années 1711, 1712 et 1713. Un mémoire concernant l'arbre et le fruit du café*, Amsterdam, Stenhouwer and Uytwerf, 1716.

**Leakey 1971**
M. D. Leakey, *Excavations in Bed I and II, 1960–63, Olduvai Gorge*, vol. 3, Cambridge, Cambridge University Press, 1971.

**LeBaron Bowen 1950**
R. LeBaron Bowen Jr., "The Early Arabian Necropolis of Ain Jawan. A Pre-Islamic and Early Islamic Site on the Persian Gulf", *BASOR, Supplementary Studies*, 7–9, 1950.

**Le Blanc 1648**
V. Le Blanc, *Les Voyages fameux du sieur Vincent Le Blanc, marseillais, qu'il a faits depuis l'aage de douze ans jusques à soixante, aux quatre parties du monde [...] rédigez fidellement sur ses Mémoires [...], par Pierre Bergeron, Parisien. À Paris, chez Gervais Clousier du Palais, sur les degrez de la saincte chapelle*, Paris, 1648 (repub. 1649, 1658).

**Lemaire 1993**
A. Lemaire, "Les inscriptions araméennes anciennes de Teima. Sur les pistes de Teima", in *Présence arabe dans le Croissant fertile avant l'hégire : Actes de la table ronde internationale organisée par l'Unité de recherche associée 1062 du CNRS, "Études sémitiques", au Collège de France, le 13 novembre 1993*, texts assembled by H. Lozachmeur, Paris, Éditions Recherches sur les civilisations, 1995, pp. 59–72.

**Levine 2000**
B. A. Levine, *Numbers 21-36: a New Translation with Introduction and Commentary*, New York, Yale University Press, 2000.

**Lewis 1978**
B. Lewis, "Khadim al-Haramayn", *Encyclopédie de l'Islam*, IV, Leiden, 1978 (2nd ed.), pp. 932–33.

**Lézine, Saliège, Robert et al. 1998**
A.-M. Lézine, J.-F. Saliège, C. Robert et al., "Holocene Lakes from Ramlat as-Sabatayn (Yemen) Illustrate the Impact of Monsoon Activity in Southern Arabia", *Quaternary Research*, 50, 1998, pp. 290–99.

**Lindemeyer and Martin 1993**
E. Lindemeyer and L. Martin, *Uruk: Kleinfunde*, vol. 3. Mainz, 1993.

**Lippens 1956**
P. Lippens, *Expédition en Arabie centrale*, Paris, Adrien-Maisonneuve, 1956.

**Liverani 1992**
M. Liverani, "Early Caravan Trade between South-Arabia and Mesopotamia", *Yemen. Studi archeologici, storici e filologici sull'Arabia meridionale*, 1, Rome, ISMEO, 1992, pp. 111–15.

**Livingstone *et al.* 1983**
A. Livingstone, B. Spaie, M. Ibrahim, M. Kamal and S. Taimani, "Taima: Recent Soundings and New Inscribed Material", *Atlal*, 7, 1983, pp. 102–16.

**London 2002**
London, *Queen of Sheba: Treasures from Ancient Yemen*, London, The British Museum Press, 2002.

**Lora, Petiti and Hausleiter (forthcoming)**
S. Lora, E. Petiti and A. Hausleiter, "Burial Contexts at Tayma, NW Arabia – Archaeological and Anthropological Data", in L. Weeks (ed.), *Death, Burial and the Transition to the Afterlife in Arabia and Adjacent Regions. Proceedings of the Society for Arabian Studies Biennial Conference 2008*, London, forthcoming.

**Lozachmeur and Briquel-Chatonnet (in press)**
H. Lozachmeur and F. Briquel-Chatonnet, "Charles Huber und Julius Euting in Arabien nach französischen, auch heute noch nicht veröffentlichten Dokumenten", *Anabases,* 12, 2010, forthcoming.

**Luukko and Van Buylaere 2002**
M. Luukko and G. Van Buylaere, *The Political Correspondence of Esarhaddon*, Helsinki, Helsinki University Press, 2002.

**Al-Maani 1999**
A. Al-Maani, "La consécration chez les anciens Arabes – Étude de manuscrits", *Al-Manara*, no. 1, 1999.

**McAuliffe 2001–2006**
J. D. McAuliffe, *The Encyclopedia of the Qur'an*, Leiden, London, Boston, Brill, 2001–06.

**Macdonald 1986**
M. C. A. Macdonald, "ABCs and Letter Order in Ancient North Arabian", *PSAS*, 16, 1986, pp. 101–68.

**Macdonald 1994**
M. C. A. Macdonald, "A Dated Nabataean Inscription from Southern Arabia", in N. Nebes (ed.), *Arabia Felix. Beiträge zur Sprache und Kultur des vorislamischen Ara-bien. Festschrift Walter W. Müller zum 60. Geburtstag*, Wiesbaden, Harrassowitz, 1994, pp. 132–41.

**Macdonald 1995 a**
M. C. A. Macdonald, "North Arabia in the First Millennium BCE", in J. M. Sasson (ed.), *Civilizations of the Ancient Near East*, vol. II. New York, Scribners, 1995, pp. 1351, 1355–69.

**Macdonald 1995 b**
M. C. A. Macdonald, "Safaïtique", in *Encyclopédie de l'Islam*, VIII, 1995 (new ed.), pp. 785–87.

**Macdonald 1995c**
M. C. A. Macdonald, "Quelques réflexions sur les Saracènes, l'inscription de Rawwafa et l'armée romaine", in H. Lozachmeur (ed.), *Présence arabe dans le Croissant fertile avant l'Hégire*, Paris, 1995, pp. 93–101.

**Macdonald 1997**
M. C. A. Macdonald, "Trade Routes and Trade Goods at the Northern End of the 'Incense Road' in the First Millenium B.C.", in Avanzini, 1997, pp. 333–49.

**Macdonald 2000**
M. C. A. Macdonald, "Reflections on the Linguistic Map of Pre-Islamic Arabia", *AAE*, 11, 2000, pp. 28–79.

**Macdonald 2004**
M. C. A. Macdonald, "Ancient North Arabian", in R. D. Woodard (ed.), *The Cambridge Encyclopaedia of the World's Ancient Languages*, Cambridge, Cambridge University Press, 2004, pp. 488–533.

**Macdonald 2008**
M. C. A. Macdonald, "Old Arabic (Epigraphic)", in K. Versteeg (ed.), *Encyclopedia of Arabic Language and Linguistics*, vol. III, Leiden, Brill, 2008 [2007], pp. 464–77.

**Macdonald 2009**
M. C. A. Macdonald, *Literacy and Identity in Pre-Islamic Arabia*, Variorum Collected Studies, 906, Farnham, Ashgate, 2009.

**Macdonald and King 2000**
M. C. A. Macdonald and G. M. H. King, "Thamoudique", in *Encyclopédie de l'Islam*, X, livraison 171-172, 2000 (new ed.), pp. 467–69.

**Madjidzadeh 2003**
Y. Madjidzadeh, *Jiroft, the Earliest Oriental Civilization*, Ministry of Culture and Islamic Orientation, Research Body for Cultural Heritage and Tourism, 2003.

**Al-Maqrizi**
See the bibliography in Arabic.

**Maraqten 1996**
M. Maraqten, "The Aramaic Pantheon of Tayma", *AAE*, 7, 1996, pp. 17–31.

**Marchesi 2004**
G. Marchesi, "Who Was Buried in the Royal Tombs of Ur? The Epigraphic and Textual Data", *Orientalia*, 73, 2004, pp. 153–97.

**Marcillet Jaubert 1990**
J. Marcillet Jaubert, "Stèle funéraire du musée de Bahrein", *Syria*, 1990, pp. 665–73.

**Marek 1993**
C. Marek, "Die Expedition des Aelius Gallus nach Arabien im Jahre 25 v. Chr.", *Chiron*, 23, 1993, pp. 121–56.

**Margueron 2004**
J.C. Margueron, *Mari : Métropole de l'Euphrate,* 2004, Picard/ErC.

**Masry 1974**
A. H. Masry, *Prehistory in Northeastern Arabia. The Problem of Interregional Interaction*, Miami, Field Research Projects, 1974.

**Masry 1997**
A. H. Masry, *Prehistory in Northeastern Arabia. The Problem of Interregional Interaction*, London, P. Kegan, 1997 (republished by Masry, 1974).

***Al-Mawaqi' al-athariya,* 1420H./ 2000**
See the bibliography in Arabic.

**Mazar 1985**
E. Mazar, "Edomite Pottery at the End of the Iron Age", *Israel Exploration Journal*, 35, 1985, pp. 252–53.

**McClure 1976**
H. A. McClure, "Radiocarbon Chronology of Late Quaternary Lakes in the Arabian Desert", *Nature*, 263, 1976, pp. 755–56.

**McClure and Al-Shaikh 1993**
H. A. McClure and N. Al-Shaikh, "Palaeogeography of an 'Ubaid Archaeological Site, Saudi Arabia", *AAE*, 4, 1993, pp. 107–25.

**McKenzie 1990**
J. S. McKenzie, "The Architecture of Petra, British Academy Monographs", *Archaeology*, 1, Oxford, Oxford University Press, 1990, p. 117 and n. 32, p. 118.

**Ménoret 2003**
P. Ménoret, *L'Énigme saoudienne. Les Saoudiens et le monde, 1744-2003*, Paris, 2003.

**Mery, Phillips and Calvet 1998**
S. Mery, C. Phillips and Y. Calvet, "Dilmun Pottery in Mesopotamia and Magan from the End of the 3rd and Beginning of the 2nd millennium B.C.", in C. Philips, D. Potts and S. Searight (ed.), *Arabia and its Neighbours. Essays on the Prehistorical and Historical Developments*, Abiel II, Turnhout, Brepols, 1998, pp. 165–80.

**Migeon 1903**
G. Migeon, "L'exposition des arts musulmans au musée des Arts décoratifs", *Les Arts*, no. 16, 1903.

**Migeon 1922**
G. Migeon, *L'Orient musulman*, vol. 1, *Sculptures, bois sculptés, ivoires, bronzes, armes, cuivres, tapis et tissus, miniatures*, Paris, Musée du Louvre, 1922.

**Migeon, Van Berchem and Huart 1903**
G. Migeon, M. Van Berchem, M. Huart, *Exposition des Arts musulmans. Catalogue descriptif*, Paris, 1903.

**Miles 1954**
G. Miles, "Ali b. 'Isa's Pilgrim Road: an Inscription of the Year 304 H. (916–917 A.D.)", *Bulletin de l'Institut d'Égypte*, t. XXXVI, 1954, pp. 479–81.

**Milik and Starcky 1970**
J. T. Milik and J. Starcky, "Nabataean, Palmyrene, and Hebrew Inscriptions", in Winnett and Reed, 1970, pp. 139–63, pl. 26–33.

**Milstein 2006**
R. Milstein, "Futuh-i Haramayn. Sixteenth-Century Illustrations of the Hajj Route", in *Mamluks and Ottomans. Studies in Honour of Michael Winter*, London, 2006.

**Miquel 1967–88**
A. Miquel, *La Géographie humaine du monde musulman jusqu'au milieu du XI$^e$ siè-cle*, Paris, Mouton, EPHE, EHESS, 1967–88, 4 vols.

**Miroschedji 1973**
P. de Miroschedji, *Vases et objets en stéatite susiens du musée du Louvre*, Notes of the French archaeological delegation in Iran, 3, 1973.

**Mollat and Desanges 1988**
M. Mollat and J. Desanges, *Les Routes millénaires*, collection "Origines", Paris, Nathan, 1988.

**Morabia 1993**
A. Morabia, *Le Gihâd dans l'Islam médiéval*, Paris, 1993.

**Morlin 2006**
I. Morlin, "Images pittoresques, texte 'romanesque': la représentation de l'indigène dans le *Voyage* du chevalier d'Arvieux (Paris, André Cailleau, 1717)", *Études littéraires*, vol. 37, no. 3, 2006, pp. 15–36.

**Morony 1995**
M. Morony, "Sâsânides", in *Encyclopédie de l'Islam*, IX, Leiden, 1995, pp. 73–87.

**Mortel 1991**
R. T. Mortel, "The Origins and Early History of the Husaynide Amirate of Madina to the End of the Ayyubid Period", *Studia Islamica*, 74, 1991, pp. 63–78.

**Mortel 1994**
R. T. Mortel, "The Mercantile Community of Mecca during the Late Mamluk Period", *Journal of the Royal Asiatic Society*, Third Series, 4, 1994, pp. 15–35.

**Mortel 1998**
R. T. Mortel, "*Ribats* in Mecca during the Medieval Period: a Descriptive Study Based on Literary Sources", *Bulletin of the School of Oriental and African Studies*, 61, 1998, pp. 29–50.

**Mouton 2008**
M. Mouton, *La Péninsule d'Oman de la fin de l'âge du fer au début de la période sassanide*, BAR International Series, Oxford, Archaeopress, 2008.

**Mouton 2009**
M. Mouton, "The Settlement Patterns of North-Eastern and South-Eastern Arabia in Late Antiquity", *AAE*, 20, 2009, pp. 185–207.

**Al-Muaikel 1994**
K. I. Al-Muaikel, *Study of the Archaeology of the Jawf Region*, Riyadh, King Fahd National Library, 1994.

**Al-Mughannam and Warwick 1986**
A. S. Al-Mughannam and J. Warwick, "Excavations of the Dhahran Burials Mounds, 3rd Season", *Atlal*, 10, 1986, pp. 9–27.

**Muhammad Ali 1996**
A. R. Muhammad Ali, *Al-Masjid al-harâm bi Makka al-mukarama wa rusumuhu fi al-fann al-islami*, Cairo, 1996.

**Muhammad Ali 1999**
A. R. Muhammad Ali, *Al-Masjid al-nabawi bi al-madina al-munawara wa rusumuhu fi al-fann al-islami*, Cairo, 1999.

**Muhly 1984**
J. Muhly, "Timna and King Solomon", *Bibliotheca Orientalis*, XLI, nos 3–4, 1984, pp. 279–80.

**Müller 1889**
D. H. Müller, *Epigraphische Denkmäler aus Arabien (nach Abklatschen und Copien des Herrn Prof. Dr. Julius Euting in Strassburg)*, Vienna, 1889.

**Müller 1978**
W. W. Müller, *Weihrauch. Ein arabisches Produkt und seine Bedeutung in der Antike*, extract from the *Realencyclopädie* by Pauly-Wissowa, Supplement-Band XV, col. 700-77, Munich, A. Druckenmüller Verlag, 1978.

**Müller and Al-Said 2002**
W. W. Müller and S. F. Al-Said, "Der babylonische König Nabonid in taymanischen Inschriften", *Neue Beiträge zur Semitistik. Erstes Arbeitstreffen der Arbeitsgemeinschaft Semitistik in der Deutschen Morgenländischen Gesellschaft vom 11. bis 13. September 2000 an der Friedrich-Schiller-Universität Jena*, Wiesbaden, Harrassowitz, 2002, pp. 105–22.

**Munich 1982**
*Das Buch im Orient. Handschriften und kostbare Drucke aus zwei Jahrtausenden*, exhibition catalogue, Munich, Bayerische Staatsbibliothek, 1982.

**Al-Munjid 1949**
See the bibliography in Arabic.

**Al-Muqaddasi**
See the bibliography in Arabic.

**Al-Nabulsi**
See the bibliography in Arabic.

**Al-Najem and Macdonald 2009**
M. H. Al-Najem and M. C. A. Macdonald, "A New Nabataean Inscription from Tayma", *AAE*, 20, 2009, pp. 208–17.

**Nasif 1413 H./1992**
See the bibliography in Arabic.

**Nasif 1988**
A. A. Nasif, *Al-Ula Historical and Archeological Survey with Special Reference to the Irrigation System*, Riyadh, University of King Saud, 1988.

**Nehmé 2004**
L. Nehmé, "Explorations récentes et nouvelles pistes de recherche dans l'ancienne Hégra des Nabatéens, moderne al-Hijr/Mada'in Saleh, Arabie du Nord-Ouest", *CRAI*, 2004, pp. 631–82.

**Nehmé 2005**
L. Nehmé, "Towards an Understanding of the Urban Space of Mada'in Saleh, Ancient Hegra, through Epigraphic Évidence", *PSAS*, 35, 2005, pp. 155–75.

**Nehmé 2005–06**
L. Nehmé, "Inscriptions vues et revues à Mada'in Sâlih", *Arabia*, 3, 2005–06, pp. 179–225 [text], 345–56 [figs].

**Nehmé 2009**
L. Nehmé, "Central and Secondary Places in North-Western Arabia during the Nabataean Period", paper presented at the international workshop *Central Places in Arabia during the Hellenistic and Roman Periods – Common Trends and Different Developments*, Berlin, 3–5 December, 2009.

**Nehmé, Arnoux, Bessac et al. 2006**
L. Nehmé, Th. Arnoux, J.-Cl. Bessac, J.-P. Braun, J.-M. Dentzer, A. Kermorvant, I. Sachet and L. Tholbecq, with a contribution by J.-B. Rigot, "Mission archéologique de Madâ'in Sâlih (Arabie saoudite) : recherches menées de 2001 à 2003 dans l'ancienne Hijrâ des Nabatéens", *AAE*, 17, 2006, pp. 41–124.

**Nehmé, Al-Talhi and Villeneuve 2009**
L. Nehmé, D. Al-Talhi and F. Villeneuve (ed.), *Hegra I. Report on the First Excavation Season at Mada'in Saleh, Saudia Arabia, 2008*, Riyadh, 2009 [2010].

**Newby 1986**
G. D. Newby, "The *Sirah* as a Source for Arabian Jewish History: Problems and Perspectives", *Jerusalem Studies on Arabic and Islam*, 7, 1986, pp. 121–38.

**Newby 1988**
G. D. Newby, *A History of the Jews of Arabia, From Ancient Times to Their Eclipse Under Islam*, Studies in Comparative Religion, Columbia, South Carolina, University of South Carolina Press, 1988.

**Newton and Zarins 2000**
L. S. Newton and J. Zarins, "Aspects of the Bronze Age in Southern Arabia: the Pictorial Landscape and its Relation to Economic and Socio-Political Status", *AAE*, 11, 2000, pp. 154–79.

**New York 2003**
J. Aruz (ed.) *Art of the First Cities: the Third Millennium B.C. from the Mediterranean to the Indus*, exhibition catalogue, New York, The Metropolitan Museum of Art, 2003.

**Nicholson 2005**
J. Nicholson, *The Hejaz Railway*, London, 2005.

**Niebuhr 1773–76**
C. Niebuhr, *Description de l'Arabie. D'après les observations et recherches faites dans le pays même*, Amsterdam, S. J. Baalde, Utrecht, J. Van Schoonhoven, 1773–76 (revised and corrected in 1779).

**Nigro 2003**
L. Nigro, "L'ascia fenestrata e il pugnale venato: due tipologie di armi d'apparato dell'età del Bronzo in Palestina", *Bollettino dei monumenti, musei e gallerie pontificie*, 23, 2003, pp. 7–42.

**Noja 1979**
S. Noja, "Testimonianze epigrafiche di Giudei nell'Arabia settentrionale", *Bibbia e Oriente*, 21, 1979, pp. 283–316.

**Northedge 1997**
A. Northedge, "Les origines de la céramique à glaçure polychrome dans le monde islamique", *La Céramique médiévale en Méditerranée, Actes du VIᵉ Congrès de l'AIECM2, Aix-en-Provence, 13-18 novembre 1995*, Aix-en-Provence, 1997, pp. 213–23.

**Oates et al. 1977**
Oates et al., "Seafaring Merchant of Ur", *Antiquity*, 6, 1977, pp. 221–34.

**Ochsenwald 1980**
W. Ochsenwald, *The Hijaz Railroad*, Charlottesville, University Press of Virginia, 1980.

**Ohsson 1787–89**
I. M. d'Ohsson, *Tableau général de l'Empire othoman*, Paris, 1787–89 (reprinted, Istanbul, Isis, 2001).

**Olinder 1927**
G. Olinder, *The Kings of Kinda of the Family of Akil al-Murar*, Lund, 1927.

**Paret 1977**
R. Paret, *Der Koran: Kommentar und Konkordanz*, Stuttgart, 1977.

**Paris 1971**
*Arts de l'Islam des origines à 1700 dans les collections publiques françaises*, exhibition catalogue, Paris, Orangerie des Tuileries, 1971.

**Paris 1977**
*L'Islam dans les collections nationales*, exhibition catalogue, Paris, Grand Palais, 1977.

**Paris 1983**
*Le Prince en terre d'Islam*, exhibition catalogue, Paris, Palais de Tokyo, 1983.

**Paris 1985**
*De la Bible à nos jours : trois mille ans d'art*, exhibition catalogue, Salon des indépendants, Grand Palais, Paris, 1985.

**Paris 1999 a**
*Photographies d'Arabie. Hedjaz, 1907-1917*, exhibition catalogue, Paris, Institut du monde arabe, Riyadh, al-Turath, 1999.

**Paris 1999 b**
P. Lombard (ed.) *Bahreïn, la civilisation des deux mers : de Dilmoun à Tylos*, exhibition catalogue, Paris, Institut du monde arabe et Éditions SNZ, 1999.

**Paris 2005**
*Photographies anciennes de La Mecque et de Médine, 1880-1947*, exhibition catalogue, Paris, Institut du monde arabe, 2005.

**Paris 2007**
S. Makariou (ed.), *Chefs-d'œuvre islamiques de l'Aga Khan Museum*, exhibition catalogue, Paris, Musée du Louvre, 2007.

**Parlasca 1987**
K. Parlasca, "Bemerkungen zu den archäologischen Beziehungen zwischen Südarabien und dem griechisch-römischen Kulturkreis", in Fahd, 1987.

**Parr 1969**
P. J. Parr, "Exploration archéologique du Hedjaz de Madian", *Revue biblique*, 76, 1969, pp. 390–93.

**Parr 1979**
P. J. Parr, "Archaeological Sources for the Early History of North-West Arabia", in A. A. Ansary et al. (ed.), *Sources for the History of Arabia*, Riyadh, University of King Saud, 1979, pp. 37–44.

**Parr 1982**
P. J. Parr, "Contacts between North West Arabia and Jordan in the Late Bronze and Iron Age", in A. Hadidi (ed.), *Studies in the History and Archaeology of Jordan,* vol. 1, Amman, Department of Antiquities, 1982, pp. 127–33.

**Parr 1984**
P. J. Parr, "The Present State of Archaeological Research in the Arabian Peninsula; Achievements of the Past, and Problems for the Future", in A. A. Ansary et al. (ed.), *Pre-Islamic Arabia,* vol. 2, Riyadh, University of King Saud, 1984, pp. 34–54.

**Parr 1987**
P. J. Parr, "Aspects of the Archaeology of North-West Arabia in the First Millenium B.C.", in Fahd, 1987, pp. 39–66.

**Parr 1988**
P. J. Parr, "The Pottery of the Late Second Millennium B.C. from North West Arabia and its Historical Implications", in D. T. Potts (ed.), *Araby the Blest. Studies in Arabian Archaeology*, Copenhagen, Museum Tusculanum Press, 1988, pp. 73–90.

**Parr 1992**
P. J. Parr, "Qurayya", *Anchor Bible Dictionary*, 5, 1992, pp. 594–96.

**Parr 1996**
P. J. Parr, "Further Reflections on Late Second Millennium Settlement in North West Arabia", in J. D. Seger (ed.), *Retrieving the Past: Essays on Archaeological Research and Methodology in Honor of Gus W. Van Beek*, Winona Lake, 1996, pp. 213–18.

**Parr, Harding and Dayton 1970**
P. J. Parr, G. L. Harding and J. E. Dayton, "Preliminary Survey in North-West Arabia, 1968.1", *Bulletin of the Institute of Archaeology*, 8–9, 1970, pp. 193–242.

**Parr, Harding and Dayton 1972**
P. J. Parr, G. L. Harding and J. E. Dayton, "Preliminary Survey in North-West Arabia, 1968", *Bulletin of the Institute of Archaeology*, 10, 1972, pp. 23–61.

**Patrich 1990**
J. Patrich, *The Formation of Nabatean Art. Prohibition of a Graven Image among the Nabateans*, Jerusalem, The Magnes Press, The Hebrew University, Leiden, Brill, 1990.

**Payne 1983**
E. J. Payne, "The Midianite Arc in Joshua and Judges", in J. F. A. Sawyer and D. J. A. Clines (ed.), *Midian, Moab and Edom*, Journal for the Study of the Old Testament Supplement Series, 24, Sheffield, 1983, pp. 163–72.

**Peters 1988**
F. E. Peters, "The Commerce of Mecca before Islam", in F. Kazemi and R. D. McChesney (ed.), *A Way Prepared: Essays in Islamic Culture in Honor of Richard Bayly Winder*, New York, London, 1988, pp. 3–26.

**Petit-Maire, Carbonel, Reyss, Sanlaville, Abed, Bourrouilh, Fontugne and Yasin 2010 (in press)**
N. Petit-Maire, P. Carbonel, J.-L. Reyss, P. Sanlaville, A. Abed, R. Bourrouilh, M. Fontugne and S. Yasin, "A Vast Eemian Palaeolake in Southern Jordan (29° N)", in *Global and Planetary Change*, Elsevier, forthcoming.

**Petraglia 2003**
M. D. Petraglia, "The Lower Paleolithic of the Arabian Peninsula: Occupations, Adaptations, and Dispersals", *Journal of World Prehistory*, 17/2, 2003, pp. 141–78.

**Petraglia and Rose 2009**
M. D. Petraglia and J. I. Rose (ed.), *The Evolution of Human Populations in Arabia. Paleoenvironments, Prehistory and Genetics*, Vertebrate Paleobiology and Paleoanthropology Series, Dordrecht, Heidelberg, London and New York, Springer, 2009.

**Petrie et al. 2005**
C. A. Petrie, A. Asgari Chaverdi and M. Seyedin, "From Anshan to Dilmun and Magan: the Spatial and Temporal Distribution of Kaftari and Kaftari-Related Ceramic Vessels", *Iran*, 43, 2005, pp. 49–86.

**Philby 1957**
H. St J. B. Philby, *The Land of Midian*, London, E. Bean Ltd., 1957.

**Philby 1995**
H. St J. B. Philby, "The Lost Ruins of Qurayyah", *The Journal of The Royal Asiatic Society*, CXVII, part 4, 1995, pp. 248–59.

**Phillips 1997**
J. Phillips, "Punt and Aksum: Egypt and the Horn of Africa", *Journal of African History*, 38, 1997, pp. 423–57.

**Pierce 1993**
L. P. Pierce, *The Imperial Harem: Women and Sovereignty in the Ottoman Empire*, New York, 1993.

**Piesinger 1983**
C. M. Piesinger, *Legacy of Dilmun. The Roots of Ancient Maritime Trade in Eastern Coastal Arabia in the 4th/3rd Millenniums B.C.*, unpublished Ph.D. thesis, University of Wisconsin, Michigan, 1983.

**Pirenne 1958**
J. Pirenne, *À la découverte de l'Arabie, cinq siècles de science et d'aventure*, Paris, Le Livre contemporain, 1958.

**Porada 1962**
E. Porada, *Alt-Iran*. Baden-Baden 1962.

**Portland 1979**
*Turkish Treasures from the Collection of Edwin Binney, 3rd*, exhibition catalogue, Portland Art Museum, 1979.

**Potts 1984**
D. T. Potts, "Northeastern Arabia. From the Seleucids to the Earliest Caliphs", *Expedition*, vol. 26, no. 3, 1984, pp. 21–30.

**Potts 1986**
D. T. Potts, "Eastern Arabia and the Oman Peninsula during the Late Fourth and Early Third Millennium B.C.", in U. Finkbeiner and W. Röllig (ed.), *Gamdat Nasr, Period or Regional Style?*, Weisbaden, L. Reichert, 1986, pp. 121–70.

**Potts 1988**
D. T. Potts, "Trans-Arabian Routes of the Preislamic Period", in Salles, 1988, pp. 127–62.

**Potts 1989**
D. T. Potts, *Miscellanea Hasaitica*, CNI Publications, 9, The Carsten Niebuhr Institute of Ancient Near Eastern Studies, Copenhagen, University of Copenhagen, Museum Tusculanum Press, 1989.

**Potts 1990 a**
D. T. Potts, *The Arabian Gulf in Antiquity*, vol. I, *From Prehistory to the Fall of the Achaemenid Empire*, Oxford, Clarendon Press, 1990.

**Potts 1990 b**
D. T. Potts, *The Arabian Gulf in Antiquity*, vol. II, *From Alexander the Great to the Coming of Islam*, Oxford, Clarendon Press, 1990.

**Potts 1991 a**
D. T. Potts, *The Pre-Islamic Coinage of Eastern Arabia, with an Appendix by Rémy Boucharlat and Monique Drieux*, CNI Publications, 14, The Carsten Niebuhr Institute of Ancient Near Eastern Studies, Copenhagen, University of Copenhagen, Museum Tusculanum Press, 1991.

**Potts 1991 b**
D. T. Potts, "Tayma and the Assyrian Empire", *AAE*, 2, 1991, pp. 10–23.

**Potts 1993 a**
D. T. Potts, "The Sequence and Chronology of Thaj", in U. Finkbeiner (ed.), *Materialien zur Archäologie der Seleukiden- und Partherzeit im südlichen Babylonien und im Golfgebiet*, Tübingen, 1993, pp. 87–110.

**Potts 1993 b**
D. T. Potts, "The Sequence and Chronology of Ain Jawan", in U. Finkbeiner (ed.), *Materialien zur Archäologie der Seleukiden- und Partherzeit im südlichen Babylonien und im Golfgebiet*, Tübingen, 1993, pp. 111–26.

**Potts 1994**
D. T. Potts, *Supplement to: the Pre-Islamic Coinage of Eastern Arabia*, CNI Publications, 16, The Carsten Niebuhr Institute of Ancient Near Eastern Studies, Copenhagen, University of Copenhagen, Museum Tusculanum Press, 1994.

**Potts 2001**
D. T. Potts, *Excavations at Tepe Yahya, Iran, 1967–1975: the Third Millennium*, contributions by H. Pittman and P. Kohl, Bulletin of the American School of Prehistoric Research, 45, Cambridge, Peabody Museum Press, 2001.

**Potts 2005**
D. T. Potts, "In the Beginning: Marhashi and the Origins of Magan's Ceramic Industry in the Third Millennium B.C.", *AAE*, 16, 2005, pp. 67–78.

**Potts 2007**
D. T. Potts, "The Mukarrib and his Beads: Karib'il Watar's Assyrian Diplomacy in the Early 7th Century B.C.", *Isimu*, 6, 2003, pp. 197–206.

**Potts 2009**
D. T. Potts, "The Archaeology and Early History of the Persian Gulf", in L. G. Potter (ed.), *The Persian Gulf in History*, New York, 2009, pp. 27–56.

**Potts, Mughannum, Frye and Sanders 1978**
D. T. Potts, A. S. Mughannum, J. Frye and D. Sanders, "Preliminary Report on the Second Phase of the Eastern Province Survey 1397/1977", *Atlal*, 2, 1978, pp. 7–27.

**Pouillon 2008**
F. Pouillon (ed.), *Dictionnaire des orientalistes de langue française*, Paris, 2008.

**Prat 2008**
S. Prat, "La première sortie d'Afrique", in J.-P. Bocquel-Appel (ed.), *La Paléodémographie*

– 99,99 % de l'histoire de la démographie des hommes ou la démographie de la préhistoire, Paris, Errance, 2008, pp. 34–44.

**Prémare 2002**
A.-L. de Prémare, *Les Fondations de l'Islam, entre écriture et histoire*, Paris, 2002.

**Prémare 2004**
A.-L. de Prémare, *Aux origines du Coran. Questions d'hier, approches d'aujourd'hui*, Paris, 2004.

**Pritchard 1974**
J. B. Pritchard (ed.), *Salomon and Sheba*, London, Phaidon, 1974.

**Puech 1998**
É. Puech, "Inscriptions araméennes du golfe : Failaka, Qala'at al-Bahreïn et Mulayha", *Transeuphratène*, 16, 1998, pp. 31–55.

**Qudama**
See the bibliography in Arabic.

**Quebec 2008**
*Les Arts et la vie : le Louvre à Québec*, exhibition catalogue, Quebec, National Museum of Fine Arts of Quebec, 2008.

**Quran**
*The Koran Interpreted*, trans. Arthur J. Arberry, London, New York, 1955.

**Al-Rashid 1970**
S. A. Al-Rashid, "Eine Frühdynastische Statue von der Insel Tarut im Persischen Gulf", in *Gesellschaften im Alten Zweistromland und in den angrenzenden Gebeiten*, 18th International Archaeological Conference, Munich, 1970, pp. 159–66.

**Al-Rashid 1974**
S. A. Al-Rashid, "Einige Denkmäler aus Têmâ und der babylonische Einfluss", *Baghdader Mitteilungen*, 7, 1974, pp. 155–65.

**Al-Rashid 1975**
S. A. Al-Rashid (ed.), *An Introduction to Saudi Arabian Antiquities*, Riyadh, Ministry of Education, Antiquities and Museums, 1975 (2nd ed. updated in 1999).

**Al-Rashid 1980**
S. A. Al-Rashid, *Darb Zubaydah. The Pilgrim Road from Kufa to Mecca*, Riyadh, 1980.

**Al-Rashid 1986**
S. A. Al-Rashid, *Al-Rabadhah. A Portrait of Early Islamic Civilisation in Saudi Arabia*, Riyadh, 1986.

**Al-Rashid, 1406 H./1986**
See the bibliography in Arabic.

**Al-Rashid 1990**
See the bibliography in Arabic.

**Al-Rashid, 1412 H./1991**
See the bibliography in Arabic.

**Al-Rashid 1992**
S. A. Al-Rashid, "A New 'Abbasid Milestone from Al-Rabadha in Saudi Arabia", *AAE*, 3, 1992, pp. 138–43.

**Al-Rashid, 1414 H./1993**
See the bibliography in Arabic.

**Al-Rashid, 1416 H./1995**
See the bibliography in Arabic.

**Al-Rashid, 1421 H./2000**
See the bibliography in Arabic.

**Al-Rashid, 1423 H./2002**
See the bibliography in Arabic.

**Al-Rashid 2004**
See the bibliography in Arabic.

**Al-Rashid 2005**
S. A. Al-Rashid, "The Development of Archaeology in Saudi Arabia", *PSAS*, 35, 2005, pp. 207–14.

*RCEA*
*Répertoire chronologique d'épigraphie arabe*, vol. 1–16, Cairo, 1932–64 and 1982, 1991.

**Reade 1998**
J. Reade, "Assyrian Illustrations of Arabs", in C. Philips, D. Potts and S. Searight (ed.), *Arabia and its Neighbours. Essays on the Prehistorical and Historical Developments*, Abiel II, Turnhout, Brepols, 1998, pp. 221–32.

**Renan 1884**
E. Renan, *Documents épigraphiques recueillis dans le nord de l'Arabie par M. Ch. Doughty*, Académie des inscriptions et belles-lettres, Paris, Imprimerie nationale, 1884.

**Renda 1977**
G. Renda, *Batılaşma Döneminde Türk Resim Sanatı 1700-1850*, Ankara, 1977.

*RES*
*Répertoire d'épigraphie sémitique.*

**Retsö 1991**
J. Retsö, "Road from South Arabia", *Orientalia Suecana*, 40, 1991, pp. 187–219.

**Retsö 2003**
J. Retsö, *The Arabs in Antiquity. Their History from the Assyrians to the Umayyads*, London, New York, Routledge, Curzon, 2003.

**Reynolds 2003**
F. Reynolds, *The Babylonian Correspondence of Esarhaddon and Letters to Assurbanipal and Sin-šarru-iškun from Northern and Central Babylonia*, Helsinki, Helsinki University Press, 2003.

**Rif'at Pasha 1935**
İ. Rif'at Pasha, *Mir'atü'l-haremeyn er-rıhlati'l-hicaziyye ve'l-hac*, Cairo, 1353 H./1935.

**Riyadh 1985**
*The Unity of Islamic Art*, exhibition catalogue, King Faysal Centre, Riyadh, 1985.

**Riyadh 1986**
*Arabic Calligraphy in Manuscripts*, exhibition catalogue, Riyadh, King Faysal Centre, 1986.

**Riyadh 2006**
*Chefs-d'œuvre de la collection des arts de l'Islam du musée du Louvre*, Riyadh, National Museum, 2006.

**Riyadh 2009**
*Unity within Cultural Diversity*, exhibition catalogue, Riyadh, 2009.

**Robin 1974**
Ch. Robin, "Monnaies provenant de l'Arabie du Nord-Est", *Semitica*, 24, 1974, pp. 83–125.

**Robin 1991 a**
C. Robin (ed.), *L'Arabie antique de Karib'il à Mahomet. Nouvelles données sur l'histoire des Arabes grâce aux inscriptions*, REMMM, 61, 1991/3.

**Robin 1991 b**
C. Robin, 1991, "Les plus anciens monuments de la langue arabe", in Robin, 1991 a., pp. 113–26.

**Robin 2001 a**
C. Robin, ""La caravane yéménite et syrienne" dans une inscription de l'Arabie méridionale antique", in B. Halff, F. Sanagustin, M. Sironval and J. Sublet et F. Sanagustin (ed.), *L'Orient au cœur, en l'honneur d'André Miquel*, Maison de l'Orient méditerranéen, collection "Orient-Méditerranée", Paris, Maisonneuve et Larose, 2001, pp. 206–17.

**Robin 2001 b**
C. Robin, "Les 'Filles de Dieu' de Saba' à La Mecque : réflexions sur l'agencement des panthéons dans l'Arabie ancienne", *Semitica*, 50, 2001, pp. 113–92.

**Robin 2003**
C. Robin, "Le judaïsme de Himyar", *Arabia*, 1, 2003, pp. 97–172.

**Robin 2004**
C. Robin, "Himyar et Israël", *CRAI*, 2004, pp. 831–906.

**Robin 2005**
C. Robin, "Himyar, des inscriptions aux traditions", *Jerusalem Studies on Arabic and Islam*, 30, 2005, pp. 1–51.

**Robin 2006**
C. Robin, "La réforme de l'écriture arabe à l'époque du califat médinois", *Mélanges de l'Université Saint-Joseph*, 59, 2006, pp. 157–202.

**Robin 2008 a**
C. Robin, "Les Arabes des "Romains", des Perses et de Himyar (IIIᵉ-VIᵉ s. è. chr.)", *Semitica et Classica*, 1, 2008, pp. 167–202.

**Robin 2008 b**
C. Robin, "La lecture et l'interprétation de l'abécédaire Ra's Shamra 88.2215. La preuve par l'Arabie ?", in C. Roche (ed.), *D'Ougarit à Jérusalem : recueil d'études épigraphiques et archéologiques offert à Pierre Bordreuil*, Orient et Méditerranée, 2, Paris, De Boccard, 2008, pp. 233–44.

**Robin and Vogt 1997**
C. Robin and B. Vogt (ed.), *Yémen, au pays de la reine de Saba*, exhibition catalogue, Paris, Institut du monde arabe, Flammarion, 1997.

**Rothenberg 1972**
B. Rothenberg, *Timna*, London, Thames and Hudson, 1972.

**Rothenberg and Glass 1983**
B. Rothenberg and J. Glass, "The Midianite Pottery", in J. F. A. Sawyer and D. J. A. Clines (ed.), *Midian, Moab and Edom*, Journal for the Study of the Old Testament Supplement Series, 24, Sheffield, 1983, pp. 65–125.

**Al-Roussan 1978**
See the bibliography in Arabic.

**Rubin 1986**
Uri Rubin, "The Ka'ba: Aspects of its Ritual Functions and Position in Pre-Islamic and Early Islamic Times", *Jerusalem Studies in Arabic and Islam*, 13, 1986, pp. 97–131 (reprinted in F. E. Peters [ed.], *The Arabs and Arabia on the Eve of Islam*, The Formation of the Classical Islamic World, 3, Aldershot, Ashgate Variorum, 1999, pp. 313–47).

**Ryckmans 1947**
G. Ryckmans, "Les religions arabes préislamiques", in M. Gorce and R. Mortier (ed.), *Histoire générale des religions*, IV, Paris, A. Quillet, 1947, pp. 307–32 and 526–34.

**Ryckmans 1951**
G. Ryckmans, *Les Religions arabes préislamiques*, Bibliothèque du Muséon, 26, Louvain-la-Neuve, Université catholique de Louvain, Institut orientaliste, 1951 (2nd ed.).

**Ryckmans 1952**
G. Ryckmans, "Trois mois de prospection épigraphique et archéologique en Arabie", *CRAI*, vol. 96, no. 3, 1952, pp. 501–10.

**Ryckmans 1956**
J. Ryckmans, *La Persécution des chrétiens himyarites au sixième siècle*, Publications de l'Institut historique et archéologique néerlandais de Stamboul, I, Istanbul, Nederlands Historisch-archaeologisch Instituut in het Nabije Oosten, 1956.

**Ryckmans 1964**
J. Ryckmans, "Le christianisme en Arabie du Sud préislamique", *Atti del Convegno internazionale sul tema: L'Oriente cristiano nella storia della Civiltà, Roma, 31 marzo-3 aprile 1963*, Accademia nazionale dei Lincei, Problemi attuali di scienza e di cultura, Quaderno 62, Rome, Accademia nazionale dei Lincei, 1964, pp. 413–54.

**Ryckmans 1981**
J. Ryckmans, "L'ordre des lettres de l'alphabet sud-sémitique. Contribution à la question de l'origine de l'écriture alphabétique", *L'Antiquité classique*, L, 1981, pp. 698–706.

**Ryckmans 1985**

**Ryckmans 1985**
J. Ryckmans, "L'ordre alphabétique sud-sémitique et ses origines", in *Mélanges linguistiques offerts à Maxime Rodinson par ses élèves, ses collègues et ses amis*, édités par C. Robin, Reports by the Groupe linguistique d'études chamito-sémitiques (GLECS), supplement 12, Paris, Geuthner, 1985, pp. 343–59.

**Ryckmans 1986 a**
J. Ryckmans, "A Three Generations' Matrilineal Genealogy in a Hasaean Inscription: Matrilineal Ancestry in Pre-Islamic Arabia", in Al-Khalifa and Rice, 1986, pp. 407–17.

**Ryckmans 1986 b**
J. Ryckmans, "Une écriture minuscule sud-arabe antique récemment découverte", in H. L. J. Vanstiphout, K. Jongeling, F. Leemhuis and G. J. Reinink (ed.), *Scripta signa vocis, studies about scripts, scriptures, scribes and languages in the Near East, presented to J. H. Hospers by his pupils, colleagues and friends*, Groningen, E. Forsten, 1986, pp. 185–99.

**Ryckmans 1987**
J. Ryckmans, "Les rapports de dépendance entre les récits hagiographiques relatifs à la persécution des Himyarites", *Le Muséon*, 100, 1987, pp. 297–305.

**Ryckmans 1988**
J. Ryckmans, "Données nouvelles sur l'histoire ancienne de l'alphabet", *Académie royale des sciences d'outre-mer, Bulletin des séances*, 34, 1988-2, pp. 219–31.

**Ryckmans 1989**
J. Ryckmans, "A Confrontation of the Main Hagiographic Accounts of the Najran Persecution", in M. M. Ibrahim (ed.), *Arabian Studies in Honour of Mahmoud Ghul: Symposium at Yarmouk University, December 8–11, 1984*, Yarmouk University Publications, Institute of Archaeology and Anthropology Series, 2, Wiesbaden, Harrassowitz, 1989, pp. 113–33.

**Ryckmans, Müller and Abdallah 1994**
J Ryckmans, W. W. Müller and Y. M. Abdallah, *Textes du Yémen antique inscrits sur bois*, Publications de l'Institut orientaliste de Louvain, 43, Louvain-la-Neuve, Université catholique de Louvain, Institut orientaliste, 1994 (Arabic title of the translation: *Nuqûsh khashabiyya qadima min al-Yaman*).

**Sabri Pasha 1883**
E. Sabri Pasha, *Mi'rāt-ı Mekke*, Istanbul, 1301 H./1883.

**Sabri Pasha 1886**
E. Sabri Pasha, *Mi'rāt-ı Medine*, Istanbul, 1304 H./1886.

**Al-Said 1995**
S. F. Al-Said, *Die Personennamen der minaischen Inschriften, Eine etymologische und lexikalische Studie im Breich der simitischen Sprachen*, Wiesbaden, 1995.

**Al-Said 2000**

See the bibliography in Arabic.

**Al-Said 2002**
See the bibliography in Arabic.

**Al-Said 2009**
S. F. Al-Said, "Eine neu entdeckte Erwähnung des Königs Nabonid in den thamudischen Inschriften", *Zeitschrift für Orient-Archäologie*, 2, 2009, pp. 358–63.

**Saleh 1973**
A. A. Saleh, "An Open Question on Intermediaries in the Incense Trade During Pharaonic Times", *Orientalia*, 42, 1973, pp. 370–82.

**Salles 1988**
J.-F. Salles (ed.), *L'Arabie et ses mers bordières*, t. I, *Itinéraires et voisinages : séminaire de recherche, 1985-1986*, Travaux de la Maison de l'Orient, 16, Lyon, Maison de l'Orient méditerranéen, 1988.

**Salles 1996**
J.-F. Salles, "Al-'Ula-Dédan. Recherches récentes", *Topoi*, 6/2, 1996, pp. 564–607.

**Salman et al. 1975**
I. Salman, U. Al-Naqshabandi and N. Al-Totonchi, *Arabic Texts in the Iraq Museum*, Baghdad, 1975 (in Arabic).

**Al-Samhudi**
See the bibliography in Arabic.

**Sanlaville 1992**
P. Sanlaville, "Changements climatiques dans la péninsule Arabique durant le Pléistocène supérieur et l'Holocène", *Paléorient*, 18/1, 1992, pp. 5–26.

**Sanlaville 2000**
P. Sanlaville, *Le Moyen-Orient arabe. Le milieu et l'homme*, Paris, Armand Colin, 2000.

**Sartre 1996**
M. Sartre, "La Mission en Arabie des Pères A. Jaussen et R. Savignac : historique et bilan scientifique", *Topoi*, 6/2, 1996, pp. 533–52.

**Sass 2005**
B. Sass, *The Alphabet at the Turn of the Millenium. The West Semitic Alphabet ca. 1150-850 BCE. The Antiquity of the Arabian, Greek and Phrygian Alphabets*, Journal of the Institute of Archaeology of Tel Aviv University, Occasional Publications, 4, Tel-Aviv, University of Tel-Aviv, The Sonia and Marco Nadler Institute of Archaeology, 2005.

**Al-Saud 1997**
A. S. Al-Saud, *Central Arabia during the Hellenistic Period*, Riyadh, 1997.

**Sauvaget 1947**
J. Sauvaget, *La Mosquée omeyyade de Médine*, Paris, 1947.

**Al-Sayari and Zötl 1978**
S. S. Al-Sayari and J. G. Zötl (ed.), *Quaternary Period in Saudi Arabia*, vol. I, Vienna,

New York, Springer-Verlag, 1978.

**Schaudig 2001**
H. Schaudig, *Die Inschriften Nabonids von Babylon und Kyros' des Großen samt den in ihrem Umfeld entstandenen Tendenzschriften. Textausgabe und Grammatik*, Alter Orient und Altes Testament, 256, Münster, 2001.

**Schiettecatte and Robin 2009**
J. Schiettecatte and C. Robin (ed.), *L'Arabie à la veille de l'Islam. Bilan clinique. Actes de la table ronde tenue au Collège de France, les 28 et 29 août 2006*, Orient et Méditerranée, 3, Paris, De Boccard, 2009.

**Schmidt-Colinet 1983**
A. Schmidt-Colinet, "Dorisierende nabatäische Kapitelle", *Damaszener Mitteilungen*, vol. 1, 1983, pp. 307–12, pl. 66–67.

**Schneider 1983**
M. Schneider, *Stèles funéraires musulmanes des îles Dahlak (mer Rouge)*, Cairo, 1983.

**Schneider (forthcoming)**
P. Schneider, "On the Organization and Building Techniques of the Large Walls of Tayma", in R. Eichmann, A. Hausleiter, M. Al-Najem and S. F. Al-Said, "Tayma – Autumn 2004 and Spring 2005, 2nd Report on the Joint Saudi-Arabian–German Archaeological Project", *Atlal*, 20, forthcoming.

**Schwiderski 2004**
D. Schwiderski (ed.), *Die alt- und reichsaramäischen Inschriften / The Old and Imperial Aramaic Inscriptions*, Berlin, New York, 2004.

**Selz 1989**
G. Selz, "Ein neuer altsumerischer Brief aus dem Vorderasiatischen Museum zu Berlin", *Altorientalische Forschungen*, 16, 1989, pp. 380–82.

**Sevim 1975**
İ. Sevim, "Abdurrahman Hibri'nin Menasik-i Mesalik'i", *Tarih Enstitüsü Dergisi*, 6, 1975, pp. 111–28.

**Sevim 1976**
İ. Sevim, "Abdurrahman Hibri'nin Menasik-i Mesalik'i", *Tarih Dergisi*, 30, 1976, pp. 55–72.

**Sevim 1978**
İ. Sevim, "enasik-i Mesalik'i", *Tarih Dergisi*, 31, 1978, pp. 147–62.

**Shahid 1971**
I. Shahid, *The Martyrs of Najran. New Documents*, Subsidia hagiographica, 49, Brussels, Société des bollandistes, 1971.

***Silsilat athar al-mamlaka al-'arabiyya al-sa'ùdiyya* 2003**
See bibliography in Arabic.

**Sima 1999**
A. Sima, *Die lihyanischen Inschriften von al-'Udayb (Saudi-Arabien)*, Epigraphische Forschungen auf der Arabischen Halbinsel, 1,

Rahden/Westf., Verlag Marie Leidorf, 1999.

**Simon 1970**
R. Simon, "Hums et Īlâf, ou commerce sans guerre (sur la genèse et le caractère du commerce de La Mecque)", *Acta Orientalia Academiae scientiarum Hungaricae*, 23, 1970, pp. 205–32 (reprinted in *Recherches sur la jeunesse de l'islam*, Budapest Oriental Studies, Budapest, 1979).

**Simon 1989**
R. Simon, *Meccan Trade and Islam. Problems of Origin and Structure*, Bibliotheca Orientalis Hungarica, 32, Budapest, Akadémiai Kiadó, 1989.

**Sourdel 1968**
D. and J. Sourdel, *La Civilisation de l'islam classique*, Paris, 1968 (pocket ed. without illustrations, 1983).

**Sourdel-Thomine 1971**
J. Sourdel-Thomine, "Clefs et serrures de la Ka'ba. Notes d'épigraphie arabe", *Revue des études islamiques*, special ed. 3, Paris, 1971.

**Speidel 2007**
M. Speidel, "Ausserhalb des Reiches? Zu neuen lateinischen Inschriften aus Saudi-Arabien und zur Ausdehnung der römischen Herrschaft am Roten Meer", *Zeitschrift für Papyrologie und Epigraphik*, 163, 2007, pp. 296–306.

**Steimer-Herbet et al. 2007**
T. Steimer-Herbet et al., "Rites and Funerary Practices at Rawk during the Fourth Millennium B.C. (Wadi 'Idim, Yemen)", *PSAS*, 37, 2007, pp. 281–94.

**Stein (forthcoming)**
P. Stein, "Eine neuerliche Annäherung an die reichsaramäische, Kultstele' von Tayma", in *Tayma*, vol. I, forthcoming.

**Steinkeller 2006**
P. Steinkeller, "New Light on Marhaši and its Contacts with Makkan and Babylonia", *Journal of Magan Studies*, 1, 2006, pp. 1–17.

**Stierlin 1987**
H. Stierlin, *Cités du désert*, Fribourg, 1987.

**Strika 1976**
V. Strika, "A Ka'bah Picture in the Iraq Museum", *Sumer*, 32, 1976, pp. 195–201.

**Strika 1979**
V. Strika, "A Ka'ba Picture from Mosul", in *Masadir Tarikh al-Jazira al-'Arabiyya/Sources for the History of Arabia: Proceedings of the First International Symposium on Studies in the History of Arabia, 23rd-28th April 1977*, Riyadh, 1399 H./1979, pp. 145–48, pl. 73.

**Sublet 1991**
J. Sublet, *Le Voile du nom. Essaî sur le nom propre arabe*, Paris, 1991.

**Al-Suluk et al. 1426 H./2005**
See the bibliography in Arabic.

**al-Tabari**
See the bibliography in Arabic.

**Tadmor 1994**
H. Tadmor, *The Inscriptions of Tiglath-Pileser III King of Assyria. Critical Edition, with Introductions, Translations and Commentary*, Jerusalem, The Israel Academy of Sciences and Humanities, 1994.

**Al-Taimā'i 2006**
M.H. al-Taimā'i, *Mantiqat rujum-sa'a' bi-tayma*, Riyadh, 2006.

**Al-Talhi and Al-Daire 2005**
D. Al-Talhi and Mohammad Al-Daire, "Roman Presence in the Desert: a New Inscription from Hegra", *Chiron*, 35, 2005, pp. 205–17.

**Tamisier 1840**
M. Tamisier, *Voyage en Arabie. Séjour dans le Hedjaz. Campagne d'Assir. Accompagné d'une carte*, Paris, L. Desessart, 1840, 2 vols.

**Tanındı 1983**
Z. Tanındı, "Islam resminde kutsal kent ve yöre tasvirleri", *Journal of Turkish Studies*, 7, 1983, pp. 407–37.

**Tardieu 1992**
M. Tardieu, "L'arrivée des manichéens à al-Hira", in P. Canivet and J.-P. Rey-Coquais (ed.), *La Syrie de Byzance à l'Islam VIIᵉ-VIIIᵉ siècles, Actes du Colloque international, Lyon, Maison de l'Orient méditerranéen, Paris, Institut du Monde arabe, 11-15 septembre 1990*, Damascus, French Institute of Damascus, 1992, pp. 15–24.

**Tardieu 1994**
M. Tardieu, "L'Arabie du Nord-Est d'après les documents manichéens", *Studia Iranica*, 23, 1994, pp. 59–75.

**Tarragon 1999**
J.-M. de Tarragon, "Les Dominicains en Arabie", in Paris, 1999, pp. 11–25.

**Tazjan 1996**
See the bibliography in Arabic.

**Al-Thanaya 1424 H./2004**
See the bibliography in Arabic.

**Al-Thanayan 2005**
See the bibliography in Arabic.

**Theolin et al. 2002**
S. Theolin et al., *The Torch of the Empire: Ignatius Mouradgea d'Ohsson and the Tableau Général of the Ottoman Empire in the 18th Century*, Istanbul, 2002.

***Thesaurus***
L. Kalus, (ed.), *Thesaurus d'épigraphie islamique*, 9th ed., Paris, Geneva, 2009.

**Thévenot 1665**
J. de Thévenot, *Relation d'un voyage fait au Levant, dans laquelle il est curieusement traité des Estats Sujets au Grand Seigneur, de Mœurs, Religions, Forces, Gouvernemens, Politiques,*

*Langues et coustumes des Habitants de ce grand Empires […]*, Paris, L. Bilaine, 1665.

**Uerpmann, Potts and Uerpmann 2009**
H. P. Uerpmann, D. T. Potts, M. Uerpmann, "Holocene (Re-)Occupation of Eastern Arabia", in Petraglia and Rose, 2009, pp. 205–14.

**Al-'Umayr 2006**
See the bibliography in Arabic.

**Valencia 2008**
*Three Empires of Islam: Istanbul, Isfahan, Delhi. Masterpieces of the Louvre Collection*, exhibition catalogue, Valencia, Fondation Bancaja, 2008.

**Vallet 2009**
É. Vallet, "1424. Les navires de Calicut se détournent d'Aden au profit de Djedda", in P. Boucheron (ed.), *Histoire du monde au XVᵉ siècle*, coordinated by J. Loiseau, P. Monnet and Y. Potin, Paris, Fayard, 2009, pp. 325–28.

**Van Berchem 1904**
M. Van Berchem, "Notes d'archéologie arabe. Étude sur les cuivres damasquinés et les verres émaillés. Inscriptions, marques, armoiries", *Arts asiatiques*, series 10, t. III, 1904, pp. 5–96.

**Van de Mieroop 2007**
M. Van de Mieroop, *The Eastern Mediterranean in the Age of Ramesses II*, Oxford, Blackwell Publishing, 2007.

**Van den Branden and Philby 1956**
A. Van den Branden and H. St J. B. Philby, *Les Textes thamoudéens de Philby*, t. I-II, Bibliothèque du Muséon, 39 and 41, Louvain-la-Neuve, Université catholique de Louvain, Institut orientaliste, 1956.

**Varthema 1888**
L. di Varthema, *Les Voyages de Ludovico di Varthema*, trad. J. Balarin de Raconis, published and annotated by C. Schefer, Paris, E. Leroux, 1888.

**Veinstein 2006**
G. Veinstein, "La question du califat ottoman", in P.-J. Luizard (ed.), *Le Choc colonial et l'islam. Les politiques religieuses des puissances coloniales en terres d'islam*, Paris, La Découverte, 2006, pp. 451–68.

**Villeneuve, Phillips and Facey 2004**
F. Villeneuve, C. Phillips and W. Facey, "Une inscription latine de l'archipel Farasân (sud de la mer Rouge) et son contexte archéologique et historique", *Arabia*, 2, 2004, pp. 143–90, figs. 63–67 (pp. 229–32).

**Ward 1972**
W. A. Ward, "The Shasu "Bedouin": Notes on a Recent Publication", *JESHO*, 15, 1972, pp. 35–60.

**Washington 1982**
*The Heritage of Islam: Patterns and Precision, the Arts and Sciences of Islam*, exhibition catalogue, Washington D.C., National Committee to Honor the Fourteenth Centennial of Islam, 1982.

**Washington (n.d.)**
*Written in Stone. Inscriptions from the National Museum of Saudi Arabia*, online exhibition: http://www.mnh.si.edu/epigraphy/, Washington D.C., Smithsonian National Museum of Natural History.

**Watt 1953**
W. M. Watt, *Muhammad at Mecca*, Oxford, London, 1953.

**Watt 1956**
W. M. Watt, *Muhammad at Medina*, Oxford, London, 1956.

**Weber 2003**
S. Weber, "Images of Imagined Worlds. Self-Image and Worldview in Late Ottoman Wall Paintings of Damascus", in *The Empire in the City: Arab Provincial Capitals in the Late Ottoman Empire*, Beiruter Texte und Studien, Beirut, 88, 2003, pp. 145–77.

**Weber 2009**
S. Weber, *Damascus, Ottoman Modernity and Urban Transformation (1808-1918)*, Proceedings of the Danish Institute, 6 Damascus, 2009.

**Wellbrock and Grottker 2009**
K. Wellbrock and M. Grottker, "Vorläufige Ergebnisse der hydrologischen Untersuchungen in Tayma, Qurayyah und Dumat al-Jandal", paper presented at the workshop *Neue Forschungen in Tayma – Projektgespräch 2009, 7–8. 12.*, Berlin, 2009.

**Whalen and Schatte 1997**
N. Whalen and D. W. Schatte, "Pleistocene Sites in Southern Yemen", *AAE*, 8, 1997, pp. 1–10.

**Whalen, Sindi, Wahida, Siraj-Ali 1983**
N. Whale, H. Sindi, G. Wahida, J.S. Siraj-Ali, "Excavations of Acheulean sites near Saffaqah in Ad-Dawadmi 1402–1982", *Atlal*, 1983, vol. 7, pp. 9–21.

**Whitcomb 1998**
D. Whitcomb, "Out of Arabia: Early Islamic Aqaba in its Regional Context", *Colloque international d'archéologie islamique, IFAO, 1993*, J. P. Gayraud (ed.), Cairo, 1998, pp. 403–18.

**Wiet 1939**
G. Wiet, *Catalogue général du musée Arabe du Caire. Stèles funéraires*, t. VI, Cairo, 1939.

**Wiet 1952**
G. Wiet, "Roitelets de Dahlak", *Bulletin de l'Institut d'Égypte*, t. XXXIV, 1952, pp. 89–95.

**Winnett 1937**
F. V. Winnett, *A Study of the Lihyanite and Thamudic Inscriptions*. University of Toronto Studies, Oriental Series, 3, Toronto, University of Toronto Press, 1937.

**Winnett 1939**

F. V. Winnett, "The Place of the Minaeans in the History of Pre-Islamic Arabia", *BASOR*, 73, February 1939, pp. 3–9.

**Winnett 1946**
F. V. Winnett, "A Himyarite Inscription from the Persian Gulf Region", *BASOR*, 102, April 1946, p. 2.

**Winnett and Reed 1970**
F. V. Winnett and W. L. Reed, *Ancient Records from North Arabia, Near and Middle East Series*. 6, Toronto, University of Toronto Press, 1970.

**Winter 1971**
F. E. Winter, *Greek Fortifications*, Toronto, University of Toronto Press, 1971.

**Witkam 2007**
J. J. Witkam, "The Battle of Images. Mekka vs. Medina in the Iconography of the Manuscripts of al-Jazuli's *Dala'il al-Khayrat*", in *Theoretical Approaches to the Transmission and Edition of Oriental Manuscripts*, Beiruter Texte und Studien, 111, 2007, pp. 67–82.

**Witkam 2009**
J. J. Witkam, "Images of Makkah and Madinah in an Islamic Prayer Book", *Hadeeth al-Dar*, 30, 2009, pp. 27–32.

**Al-Wohaibi 1973**
A. Al-Wohaibi, *The Northern Hijaz in the Writings of the Arab Geographers, 800-1150*, Beirut, 1973.

**Wooley 1934**
C. L. Wooley, *Ur Excavations II: the Royal Cemetery*, London, Trustees of the Two Museums, 1934.

**Wooley 1956**
C. L. Wooley, *Ur Excavations IV: the Early Periods*, Philadelphia, British Museum, University Museum, 1956.

**Wooley and Litt 1974**
C. L. Wooley and D. Litt, *Ur Excavations VI: the Buildings of the 3rd Dynasty*, Philadelphia, University of Pennsylvania, 1974.

**Yaman 1996**
Z. Yaman, "Küre Hoca emseddin Camii'nde Kabe Tasvirli Çini Pano", *Prof. Dr. erare Yetkin Anısına Çini Yazıları*, Istanbul, 1996, pp. 187–96.

**Al-Ya'qubi**
See the bibliography in Arabic.

**Yaqut**
See the bibliography in Arabic.

**Yilmaz 1993**
See the bibliography in Arabic.

**Al-Zahrani 2003**
See the bibliography in Arabic.

**Al-Zahrani 2007**
See the bibliography in Arabic.

**Zambaur 1927**

E. K. M. von Zambaur, *Manuel de généalogie et de chronologie pour l'histoire de l'Islam*, Hanover, 1927.

**Zarins 1978**
J. Zarins, "Steatite Vessels in the Riyadh Museum", *Atlal*, 2, 1978, pp. 65–93.

**Zarins 1982**
J. Zarins, "Early Rock Art of Saudi Arabia", *Archaeology*, 35/6, 1982, pp. 20–27.

**Zarins 1989 a**
J. Zarins, "Ancient Egypt and the Red Sea Trade: the Case for Obsidian in the Predynastic and Archaic Periods", in A. Leonard, Jr. and B. B. Williams (ed.), *Essays in Ancient Civilization Presented to Helene J. Kantor*, Chicago, 1989, pp. 339–68.

**Zarins 1989 b**
J. Zarins, "Eastern Saudi Arabia and External Relations: Selected Ceramic, Steatite and Textual Evidence: 3500–1900 B.C.", in K. Frifelt and P. Sørensen (ed.), *South Asian Archaeology 1985*, Curzon Press, 1989, pp. 74–103.

**Zarins 1990**
J. Zarins, "Obsidian and the Red Sea Trade: Prehistoric Aspects", in M. Taddei and P. Callieri (ed.), *South Asian Archaeology Conference Roma 1987*, Istituto Italiano per il Medio ed Estremo Oriente, 1990, pp. 507–41.

**Zarins, Kabawi and Murad 1983**
J. Zarins, A. Kabawi and A. Murad, "Preliminary Report on the Najran/Ukhdud Survey and Excavations (1402/1982)", *Atlal*, 7, 1983, pp. 22–40.

**Zarins, Murad and Al-Yaish 1981**
J. Zarins, A. Murad and Kh. Al-Yaish, "The Second Preliminary Report on the Southern Province", *Atlal*, 5, 1981, pp. 9–42.

**Al-Zayla'i 2000**
A. Al-Zayla'i, "Calligraphy and Calligraphers in 'Am-Saudi Arabia, 2nd–5th/8th–11th Centuries", *PSAS*, 30, 2000, p. 243–55.

**Al-Zayla'i 1423 H./2003**
See the bibliography in Arabic.

**Zaza 1984**
See the bibliography in Arabic.

**Zutterman 2004**
C. Zutterman, "The Softstone Vessels from Qarn Bint Sa'ud, Abu Dhabi (UAE)", *AAE*, 2004, 15, pp. 105–14.

# ARABIC BIBLIOGRAPHY

The entries are listed in the order of the English bibliography

**Abdul Halim, 1993**

سيد عبدالمنعم عبدالحليم، (١٩٩٣):
**البحر الأحمر وظهيره في العصور القديمة: مجموعة بحوث نشرت في الدوريات العربية والأوربية**، الإسكندرية: دار المعرفة الجامعية.

**Abû Al-Hasan, 1997**

أبو الحسن، حسين بن علي دخيل الله، (١٩٩٧):
**قراءة لكتابات لحيانية من جبل عكمة بمنطقة العلا**، الرياض: مكتبة الملك فهد الوطنية.

**Abû Al-Hasan, 2002**

أبو الحسن، حسين بن علي دخيل الله، (٢٠٠٢):
**نقوش لحيانية من منطقة العلا – دراسة تحليلية مقارنة**، الرياض، وكالة الآثار والمتاحف.

**Al-Afghânî**

الأفغاني،
سعيد، **أسواق العرب**، دمشق، ١٩٦٠م.

**Al-'Ajîmî 1409H./ 1988-89**

العجيمي، هشام
"**قلعة تبوك**"، مجلة جامعة أم القرى، السنة الأولى، العدد الثاني، ١٤٠٩هـ .

**Al-Ansari, 1969**

الأنصاري،
عبد القدوس، **بين التاريخ والاثار**، بيروت، ١٩٦٩م.

**Al-Ansari, 1975**

الأنصاري، عبدالرحمن الطيب، (١٩٧٥):
"**لمحات عن بعض المدن القديمة في شمال غربي الجزيرة العربية**" مجلة الدارة، العدد الأول.

**Al-Ansârî 1423H./ 2002**

الأنصاري، عبدالرحمن، وأبو الحسن حسين:
**العلا ومدائن صالح (حضارة مدينتين)**، دار القوافل، الرياض: ١٤٢٣ هـ/٢٠٠٢م.

**Al-Ansari, 2008**

الأنصاري، عبدالرحمن الطيب، وسالم أحمد طيران، ١٤٢٩هـ/٢٠٠٨م
**قرية الفاو مدينة المعابد (المدينة في الوطن العربي في ضوء الاكتشافات الآثارية: النشأة والتطور، أبحاث ندوة المدينة في الوطن العربي في ضوء الاكتشافات الآثارية: النشأة والتطور، الجوف ذو القعدة ١٤٢٦هـ/ديسمبر ٢٠٠٥م).

**Al-Athâr, 1420H/ 2000**

الدائرة الإعلامية، ١٤٢٠هـ/ ٢٠٠٠م، **الثقافة التقليدية في المملكة العربية السعودية: الآثار**، ج١، الرياض: دار الدائرة للنشر والتوثيق.

**Bafqih et al., 1985**

بافقيه، محمد عبدالقادر (وآخرين)، (١٩٨٥):
**مختارات من النقوش اليمنية القديمة**، تونس، المنظمة العربية للتربية والثقافة والعلوم.

**Al-Bahnasî, 1999**

البهنسي، عفيف؛ **فن الخط العربي**، دمشق: ١٩٩٩.

**Al-Bakrî, Masâlik**

البكري الأندلسي، أبي عبيد عبدالله بن عبدالعزيز، معجم ما استعجم من أسماء البلاد والمواضع،حققه وضبطه وشرحه وفهرسه مصطفى السقا، القاهرة: مكتبة الخانجي، ط٣، ١٤١٧هـ/١٩٩٦م.

**Al-Bakrî, Mu'jâm**

البكري، أبو عبيد الله عبدالله بن عبدالعزيز،
كتاب **الممالك والمسالك**، تحقيق ودراسة عبدالله يوسف الغنيم، ط١، الكويت، دار السلاسل للطباعة والنشر، ١٣٩٧هـ/ ١٩٧٧م.

**Al-Balâdhurî**

البلاذري، أحمد بن يحيى بن جابر،
**فتوح البلدان**، حققه وشرحه وعلق على حواشيه وأعد فهارسه وقدم له عبدالله أنيس الطبّاع وعمر أنيس الطباع، بيروت: منشورات مؤسسة المعارف، ١٤٠٧هـ/ ١٩٨٧م.

**Al-Balawî**

البلوي، خالد بن عيسى،
**تاج المفرق في تحلية أهل المشرق**،تحقيق الحسن السائح، نشر صندوق إحياء التراث الإسلامي، المملكة المغربية، بدون تاريخ.

**Banî Yûnis 2000**

بني يونس، مأمون أصلان
**قافلة الحج الشامي في شرقي الأردن في العهد العثماني ١٥١٦-١٩١٨م**، ط١، مؤسسة حمادة للخدمات والدراسات الجامعية، ودار الكندي للنشر والتوزيع، إربد، الأردن: ٢٠٠٠م.

**Bastoun et al., 1982**

بستون، أ.ف.ل (وآخرون)، (١٩٨٢):
**المعجم السبئي**، بيروت: مكتبة لبنان.

**Bunduqjî 1400H/ 1980**

بندقجي، حسين حمزة،
**أطلس المملكة العربية السعودية**، دار جامعة أكسفورد للطباعة والنشر، بريطانيا، ١٤٠٠هـ .

**Al-Daqan 1985**

الدقن، السيد محمد
**سكة حديد الحجاز الحميدية**، الطبعة الأولى، مطبعة الجبلاوي، القاهرة: ١٩٨٥م.

**Al-Dar'î**

الدرعي، أحمد بن محمد بن ناصر
**الرحلة الناصرية**، طبعة فاس: ١٣٢٠هـ .

**Al-Dhabib, 1998**

الذيب، سليمان بن عبدالرحمن، (١٩٩٨):
**نقوش الحجر النبطية**، الرياض: مكتبة الملك فهد الوطنية.

**al-Dhahabî, 1996**

الذهبي،
**سير أعلام النبلاء**، تحقيق: شعيب الأرنؤط ومحمد نعيم العرقسوسي، بيروت، ١٩٩٦م.

**Al-Fa'r, 1984**

الفعر، محمد فهد عبد الله،
**تطور الكتابات و النقوش في الحجاز منذ فجر الإسلام حتى منتصف القرن السابع الهجري**، جدة، ١٤٠٥هـ/١٩٨٤م.

**Al-Ghabban, 1414 H./1993**

الغبان، علي بن إبراهيم:
**شمال غرب المملكة العربية السعودية، الكتاب الثاني، الآثار الإسلامية في شمال غرب المملكة**، مطبعة سفير، الرياض: ١٤١٤هـ/١٩٩٣م.

**Al-Ghabban, 1988 b**

الغبان، علي بن إبراهيم:
**النقوش العثمانية الباقية على عمائر طريقي الحج الشامي والمصري في شمال غرب المملكة العربية**، أعمال المؤتمر الثاني لمدونة الآثار العثمانية في العالم، منشورات مؤسسة التميمي للبحث العلمي والمعلومات، زغوان – تونس: ١٩٨٨م.

**Al-Ghazi, 1992**

عبدالعزيز بن سعود الغزي،
«**تأريخ وتأصيل فخار أواخر العصر البرونزي وأوائل العصر الحديدي في شمال غربي المملكة العربية السعودية**» المجلد الثامن، الجزء الأول، ١٩٩٢م، ص ٧.

**Al-Ghazi, 1995**

عبدالعزيز بن سعود الغزي،
**دراسات فخار مدين خلال ثلاثة وعشرين عاماً**، عالم الكتب، المجلد السادس عشر، العدد الخامس، الربيعان ١٤١٦هـ/ سبتمبر – أكتوبر ١٩٩٥م، ص ٤٤٧ – ٤٥٢

**Al-Ghazi, 2005 a**

عبدالعزيز بن سعود الغزي
**دراسة مقارنة لزخارف زبدية نادرة من مدافن الصناعية في تيماء** مجلة جامعة الملك سعود، كلية الآداب، العدد الثامن عشر، العدد الأول، ١٤٢٦هـ/ ٢٠٠٥م، المجلد ١٨، ص ١٥١-١٨٤.
**تشخيص وتأريخ فخار شمالي غربي المملكة العربية السعودية المزخرف بالألوان في ضوء الاكتشافات الحديثة.

**Al-Ghazi, 2005 b**

سلسلة مداولات اللقاء العلمي السنوي للجمعية-٦، الكويت: دولة الكويت ١١-١٢ ربيع الأول ١٤٢٦هـ/ ٢٠-٢١ أبريل ٢٠٠٥م، ص ١٠٥-١٥٥.

**Al-Hamdânî, 1977**

الهمداني، الحسن بن أحمد بن يعقوب،
**صفة جزيرة العرب**، تحقيق محمد بن علي الأكوع الحوالي، الرياض: منشورات دار اليمامة للبحث والترجمة والنشر، ١٣٩٤هـ/ ١٩٧٤م.

**Al-Jasser, 1979**

الجاسر، حمد،

**المعجم الجغرافي للبلاد العربية السعودية - المنطقة الشرقية ( البحرين قديماً ) القسم الأول** - ، ١٣٩٩هـ/ ١٩٧٩م

**Al-Jazîrî**

الجزيري، عبدالقادر بن محمد الأنصاري،

**الدرر الفرائد المنظمة في أخبار الحاج وطريق مكة المعظمة**، تحقيق حمد الجاسر، ط١، دار اليمامة، الرياض، ١٤٠٣هـ/١٩٨٣م.

**Jawad, 1980**

علي، جواد، (١٩٨٠):

**المفصل في تاريخ العرب قبل الإسلام**، ط٣، بيروت: دار العلم للملايين، بغداد: مكتبة النهضة.

**Kamal, 1984**

عبدالعليم، مصطفى كمال، (١٩٨٤):

"تجارة الجزيرة العربية مع مصر في المواد العطرية في العصرين اليوناني والروماني"، **دراسات تاريخ الجزيرة العربية قبل الاسلام**، الكتاب الثاني، الرياض: جامعة الملك سعود.

*Khatt* **1406H./ 1985-86**

**الخط العربي من خلال المخطوطات**، الرياض: مركز الملك فيصل للبحوث والدراسات الإسلامية، ١٤٠٦هـ .

**Al-Kilâbî 1424H.**

الكلابي، حياة بنت عبدالله بن حسين، ١٤٢٣- ١٤٢٤هـ

«**النقوش الإسلامية المبكرة على درب الحج الشامي بشمال غرب المملكة العربية السعودية**»، رسالة دكتوراة غير منشورة مقدمة لقسم الآثار والمتاحف، بإشراف أ.د. أحمد إبن عمر الزيلعي.

**Al-Kilâbî 1430H./ 2009**

الكلابي، حياة بنت عبدالله:

**النقوش الإسلامية على طريق الحج الشامي بشمال غرب المملكة العربية السعودية (من القرن الأول إلى القرن الخامس الهجري)**، مكتبة الملك فهد الوطنية، الرياض: ١٤٣٠هـ/٢٠٠٩م.

**Al-Khiyârî**

الخياري، إبراهيم بن عبدالرحمن

**تحفة الأدباء وسلوة الغرباء**، تحقيق الدكتور رجاء محمود السامرائي، نشر وزارة الثقافة العراقية ودار الرشيد، بغداد: ١٩٨٠م، الجزء الثالث.

**Al-Maqrîzî**

المقريزي، تقي الدين أحمد بن علي،

**الذهب المسبوك في ذكر من حج من الخلفاء والملوك**، تحقيق جمال الدين الشيال، مكتبة الخانجي بمصر، ومكتبة المثنى ببغداد، القاهرة: ١٩٥٥م

**Al-Mawâqi' al-athariya, 1420H./ 2000**

الدائرة الإعلامية، ١٤٢٠هـ/٢٠٠٠م،

**الثقافة التقليدية في المملكة العربية السعودية: المواقع الأثرية**، ج٢، الرياض: دار الدائرة للنشر والتوثيق.

**Al-Munjid 1949**

المنجد، صلاح الدين،

**ولاة دمشق في العصر العثماني**، دمشق ١٩٤٩م

**Al-Muqaddasî**

---

**Ibn al-Mujâwir**

ابن المجاور، يوسف بن يعقوب بن محمد،

**صفة بلاد اليمن ومكة وبعض الحجاز: المسمّاة تأريخ المستبصر**، اعتنى بتصحيحها أوسكر لوفغرين، ط٢، بيروت، منشورات المدينة، ١٤٠٧هـ/١٩٨٦م.

**Ibn al-Nadîm**

ابن النديم، محمد بن أبي يعقوب الوراق؛

**الفهرست**، ط٣، دار المسيرة ١٩٨٨م

**Ibn Rustah**

إبن رستة، أبو علي أحمد بن عمر،

**كتاب الأعلاق النفيسة**، تحقيق ( M. J. De Goeje )، ليدن، ١٨٩٢م.

**Ibn Sa'd**

ابن سعد، محمد، ب. ت.،

**الطبقات الكبرى** (٩ مجلدات)، بيروت: دار صادر.

**Al-Idrîsî**

الإدريسي، أبو عبدالله

**نزهة المشتاق في اختراق الآفاق**، طبعة مصورة، عالم الكتب، بيروت: ١٤٠٩هـ .

**Al-Isfahânî**

الأصفهاني، الحسن بن عبدالله،

**بلاد العرب**، تحقيق حمد الجاسر والدكتور صالح العلي، الرياض: دار اليمامة للبحث والترجمة والنشر، ط١، ١٣٨٧هـ /١٩٦٨م.

**Al-Istakhrî**

الإصطخري، أبو إسحاق إبراهيم بن محمد الفارسي،

**المسالك والممالك**، تحقيق محمد عبد العال الحيني، القاهرة، ١٩٦١م.

**Jam'a, s. d.**

جمعة، إبراهيم؛

**دراسة في تطور الكتابات الكوفية على الأحجار في مصر في القرون الخمسة الأولى للهجرة النبوية الشريفة**، القاهرة: دار الفكر العربي، د .ت.

**Al-Jâsir 1386H./ 1967**

الجاسر،

« حمى الربذة في كتب المتقدمين »،

**العرب**، مجلد (١-٥) ، ١٣٨٦هـ/١٩٦٧م.

**Al-Jâsir 1397H/ 1977**

الجاسر، حمد

**المعجم الجغرافي للبلاد العربية السعودية - شمال المملكة**، ط١، دار اليمامة، الرياض: ١٣٩٧هـ

**Al-Jâsir 1402H./ 1981-82**

أشهر رحلات الحج -

**ملخص رحلتي ابن عبدالسلام الدرعي المغربي**، ط١، منتشرات دار الرفاعي، الرياض: ١٤٠٢هـ/١٩٨٢م.

**Al-Jâsir 1404H./ 1983-84**

الجاسر، حمد

**مقتطفات من رحلة العياشي**، منشورات دار الرفاعي، الرياض: ١٤٠٤هـ .

---

**Al-Harbî**

الحربي، إبراهيم بن إسحاق إبراهيم الإمام،

**كتاب « المناسك» وأماكن طرق الحج ومعالم الجزيرة**، تحقيق حمد الجاسر، دار اليمامة، الرياض، ١٣٨٩هـ/١٩٦٩م.

**Al-Hârithî 1415H./ 1994**

الحارثي، ناصر بن علي،

**النقوش العربية المبكرة بمنطقة الطائف**، ط١، الطائف، ١٤١٥هـ/١٩٩٤م.

**Al-Hârithî, 2005**

الحارثي، ناصر بن علي،

**احجار شاهدية من متحف الاثار والتراث بمكة المكرمة**، الرياض، ١٤٢٦هـ/٢٠٠٥م.

**Al-Hijrî**

الهجري، أبو علي،

**أبو علي الهجري وأبحاثه في تحديد المواضع**، بقلم حمد الجاسر، الرياض، ١٣٨٨هـ/ ١٩٦٨م.

**Humayd Allâh, 1407H./ 1987**

حميد الله،

محمد، **مجموعة الوثائق السياسية للعهد النبوي والخلافة الراشدة**، ط٦ بيروت: دار النفائس، ١٤٠٧هـ/ ١٩٨٧م.

**Ibn Battûta**

إبن بطوطة، محمد بن عبد الله اللواتي،

**رحلة إبن بطوطة**، (تحفة النظار في غرائب الأمصار وعجائب الأسفار)، تحقيق المنتصر الكتاني، جزءان، مؤسسة الرسالة، بيروت، ١٣٩٥هـ/١٩٧٥م.

**Ibn Bulayhid 1399H/ 1979**

ابن بليهد، محمد بن عبدالله،

**صحيح الأخبار عما في بلاد العرب من الآثار**، راجعه وضبطه وكتب بعض هوامشه محمد محيى الدين عبد الحميد، القاهرة، ط٣١٣٩٩، هـ/ ١٩٧٩م.

**Ibn Hawqal**

ابن حوقل، أبي القاسم بن حوقل النصيبي،

**كتاب صورة الأرض**، القاهرة: دار الكتاب الإسلامي، ب. ت.

**Ibn Jubayr**

إبن جبير، محمد بن أحمد بن جبير الكناني،

**رحلة إبن جبير**، دار التراث، بيروت، ١٣٨٨هـ/١٩٦٨م.

**Ibn Kathîr**

إبن كثير، أبو الفداء الحافظ،

**البداية والنهاية**، ١٤ جزءا، مكتبة المعارف، بيروت (مكتبة النصر)، الرياض، ١٩٧٩-١٩٨٠م.

**Ibn Khurradadhbih**

إبن خرداذبة، أبو القاسم عبيد الله بن عبد الله،

**المسالك والممالك**، تحقيق ( M. J. De Goeje )، ليدن، ١٨٩٢م.

**Ibn Manzûr**

ابن منظور، محمد بن مكرم،

**لسان العرب**، بيروت:

دار صادر، تاريخ المقدمة بقلم الناشر أحمد فارس صاحب الجوائب، ١٣٠٠هـ

المقدسي، محمد ابن أحمد،
**أحسن التقاسيم في معرفة الأقاليم**، تحقيق (M. J. De Goeje)، ليدن، ١٩٠٦م.

**Al-Nâbulsî**

النابلسي، عبدالغني بن إسماعيل،
**الحقيقة والمجاز في الرحلة إلى بلاد الشام ومصر والحجاز**، طبعة مصورة بدون تحقيق عن مخطوطة دار الكتب، تقديم وإعداد د. أحمد بن عبدالمجيد هريدي، الهيئة المصرية العامة للكتاب، القاهرة: ١٩٨٦م.

**Nasîf, 1413 H./1992**

نصيف، عبدالله،
**العلا دراسة في التراث الحضاري والاجتماعي**، ط١، بدون دار نشر، الرياض: ١٤١٦هـ/١٩٩٥م.

**Qudâma**

قدامة، أبو الفرج قدامة بن جعفر الكاتب البغدادي
**نبذة من كتاب الخراج وصنعة الكتابة**، تحقيق: دى غويه، ليدن، ١٨٨٩م.

**Al-Rashid 1406H./1986**

الربذة : صورة للحضارة الإسلامية المبكرة في المملكة العربية **السعودية**، جامعة الملك سعود، الرياض، ١٤٠٦هـ/١٩٨٦م.

**Al-Rashid 1990**

الراشد، سعد بن عبدالعزيز،
"أربعة أحجار ميلية من العصر العباسي: دراسة وتحقيق"، **العصور**، مج٥، ج١، لندن: ١٩٩٠م.

**Al-Rashid 1412H./ 1991**

الراشد، سعد بن عبدالعزيز،
«نقوش إسلامية مؤرخة من الصويدرة»، **الدارة**، ع٤، السنة الرابعة عشرة، عدد رجب ١٤١٢هـ/ يناير ١٩٩١م.

**Al-Rashid 1414H./1993**

الراشد، سعد بن عبد العزيز، درب زبيدة :
**طريق الحج من الكوفة إلى مكة المكرمة « دراسة تاريخية وحضارية أثرية»**، دار الوطن للنشر والإعلام، الرياض، ١٤١٤هـ/١٩٩٣م.

**Al-Rashid 1416H./ 1995**

الراشد، سعد بن عبدالعزيز،
**كتابات إسلامية من مكة المكرمة: دراسة وتحقيق**، الرياض: مطبوعات مكتبة الملك فهد الوطنية.

**Al-Rashid 1421H./ 2000**

**دراسات في الآثار الإسلامية المبكرة بالمدينة المنورة**، مؤسسة **الحزيمي** للتجارة والتوكيلات، الرياض، ١٤٢١هـ/٢٠٠٠م.

**Al-Rashid, 1423H./ 2002**

الراشد، سعد بن عبدالعزيز،
نقوش إسلامية مختارة من مكة المكرمة، الرياض: وزارة المعارف، ١٤٢٣هـ/٢٠٠٢م

**Al-Rashid, 2004**

الراشد، سعد بن عبد العزيز،
احجار المعلاة الشاهدية بمكة المكرمة، الرياض، ١٤٢٥هـ/٢٠٠٤م.

**Al-Roussan, 1978**

الروسان، محمود محمد، (١٩٧٨):
**القبائل الثمودية والصفوية - دراسة مقارنة**، الرياض: جامعة الملك سعود.

**Al-Said, 2000**

السعيد، سعيد،
حملة الملك البابلي نبونيد على شمال غرب الجزيرة العربية، دراسة في تاريخ العرب القديم، الرياض: الجمعية التاريخية السعودية، جامعة الملك سعود، ١٤٢١هـ/ ٢٠٠٠م.

**Al-Said, 2002**

السعيد، سعيد،
**زوجات المعينين الاجنبيات في ضوء نصوص جديدة**، أدوماتو، ٢٢٤١هـ/٢٠٠٢م.

**Al-Samhûdî**

السمهودي، نور الدين علي،
**وفاء الوفاء بأخبار دار المصطفى**، تحقيق محيي الدين عبدالحميد، ط٤، دار الكتب العلمية، بيروت: ١٤٠٤هـ/١٩٨٤م.
تحقيق محمد محيي الدين عبدالحميد، دار إحياء التراث، بيروت: ١٩٨١م.

**Silsilat âthâr al-mamlaka al-'arabiyya al-sa'ûdiyya, 2003**

وكالة الآثار والمتاحف، ١٤٢٣/٢٠٠٣م آثار المنطقة الشرقية، سلسلة آثار المملكة العربية السعودية، الرياض.

**Al-Sulûk et al. 1426 H./ 2005**

السلوك، محمد بن علي؛ النفيسة، عبدالعزيز؛ المزيني، فهد؛ العتيق، فهد؛ عسيري، رياض؛ العتيبي، عبد الله؛ الرشيد، فيصل؛ الحربي، جزاء، ١٤٢٦هـ/٢٠٠٥م،
"مسح درب التجارة القديم (درب الحج اليمني الأعلى-النجدي-): الموسم الرابع ١٤٢١هـ"، **أطلال**، ع١٨، الرياض: وكالة الآثار والمتاحف بوزارة التربية والتعليم، ص ص١١١-١٢٦.

**al-Tabarî**

الطبري، أبو محمد محمد بن جرير،
**تاريخ الأمم والملوك**، تحقيق محمد أبو الفضل إبراهيم،١٠ أجزاء، دارالمعارف، القاهرة، ١٩٧٩م.

**Tazjân, 1996**

تزجان، خوليا،
استار الحرمين الشريفين، استانبول ١٤١٧هـ/١٩٩٦م.

**Al-Thanayân, 1424H./ 2004**

الثنيان، محمد بن عبدالرحمن، ١٤٢٤هـ/٢٠٠٤م،
«نقش غيل المنضج (المبرح) الإسلامي المؤرخ في سنة ٩٨هـ (٧١٦-٧١٧ م): محافظة ظهران الجنوب- المملكة العربية السعودية»، أدوماتو، العدد التاسع.

**Al-Thanayan, 2005**

الثنيان، محمد بن عبدالرحمن راشد،
**رحلة الحج من صنعاء إلى مكة المكرمة للعلامة إسماعيل جغمان (١٢١٢- ١٢٥٦هـ/١٧٩٧- ١٨٤٠م): دراسة وتعليق، كتاب الدارة**، ٢٠٠٥م.

**Al-'Umayr 2006**

العمير، عبدالله إبراهيم، وآخرون،
**حفرية مدينة قرح (المابيات) الإسلامية بمحافظة العلا، أطلال،**

Atlal العدد ١٩، وكالة الآثار والمتاحف، الرياض، ١٤٢٧هـ.

**Al-Ya'qûbî**

اليعقوبي، أحمد بن واضح،
**تاريخ اليعقوبي**، دار صادر، بيروت: ١٩٨٨م.
**كتاب البلدان**، طبعة مصورة، دار إحياء التراث العربي، بيروت، ١٩٨٨م.

**Yâqût**

ياقوت، أبو عبد الله، ياقوت بن عبد الله الحموي،
**معجم البلدان**، ٥ أجزاء، بيروت، ١٩٥٥-١٩٥٨م.

**Yâqût**

الحموي، ياقوت بن عبدالله،
**معجم البلدان**، طبعة مصورة، دار صادر، بيروت: ١٩٨٦م.

**Yilmâz, 1993**

يلماز، طرجان،
**الكعبة المشرفة، دراسة اثرية لمجموعة اقفالها ومفاتيحها المحفوظة في متحف طوب قابباستانبول**، استانبول، ١٤١٤هـ/١٩٩٣م.

**Al-Zahrânî, 2003**

الزهراني، عبد الرحمن،
**كتابات إسلامية من مكة المكرمة ق ١-٧هـ/ ٨-١٣ م**، الرياض، ١٤٢٤هـ/٢٠٠٣م.

**Al-Zahrânî, 2007**

الزهراني، عوض،
**تل الكثيب بالعلا: دراسة آثارية مقارنة**، الرياض: وزارة التربية والتعليم، وكالة الآثار والمتاحف، ١٤٢٨هـ/٢٠٠٧م

**Al-Zayla'î, 1423H/ 2003**

الزيلعي، أحمد بن عمر؛
الزهراني، عبدالله بن سالم؛ المزروع، حميد بن إبراهيم؛ العمري، عبدالعزيز بن منسي؛ السلوك، محمد بن علي، ١٤٢٣هـ/ ٢٠٠٣م،
**آثار منطقة عسير: سلسلة آثار المملكة العربية السعودية**، الرياض: وكالة الآثار والمتاحف.

**Zaza, 1984**

ظاظا، حسن، (١٩٨٤):
**"المجتمع العربي القديم من خلال اللغة"، دراسات تاريخ الجزيرة العربية، الكتاب الثاني، الرياض:** جامعة الملك سعود.

# PHOTOGRAPHIC CREDITS

**Athens**
Benaki Museum, p. 415

**Berlin**
DAI Orient-Abteilung, pp. 228, 229, 241, 252; DAI Orient-Abteilung, A. Beuger, p. 216 (top); DAI Orient-Abteilung, M. Cusin, p. 215; DAI Orient-Abteilung, R. Eichmann, p. 212; DAI Orient-Abteilung, A. Hausleiter, p. 212; DAI Orient-Abteilung, A. Initilia, p. 210; Vorderasiatisches Museum, p. 178

**Brooklyn**
Brooklyn Museum, p. 98

**Cairo**
2009 Farid Kioumgi and Robert Graham, pp. 422-23

**Istanbul**
Nuruosmaniye Library, pp. 555, 556; Topkapı Palace Museum, pp. 496, 497, 527

**Jerusalem**
École biblique et archéologique française, pp. 44, 53, 286, 407, 459

**London**
2006 Antiquity Publications, p. 176 (bottom); David Rumsey Historical Map Collection, p. 49; Royal Geographical Society, pp. 404–405, 536, 575, 580; 1997 Stacey International and William Facey, p. 41; 1993 Stacey International and Thierry Mauger, pp. 164, 481; The British Library, pp. 102, 103, 416, 417; The Trustees of the British Museum, pp. 70, 73, 79

**Manisa**
Municipal Library, pp. 551, 552

**New York**
The Metropolitan Museum of Art / Photograph by Paul Lachenauer, p. 177; The Metropolitan Museum of Art / Photograph by Bruce White, p. 191

**Paris**
BnF, pp. 100, 408, 455, 490, 528–529, 533, 546, 558; Hélène David, pp. 28-29, 83, 110, 143, 147, 166, 406, 411, 419, 424, 452, 470, 478, 525; J. Heuting, p. 51; Mission archéologique de Madain Salih, pp. 289, 290, 291, 292, 293, 294, 295, 296, 297, 298, 299, 302, 303; 2010 Musée du Louvre / Thierry Ollivier, back cover pp. 259, 277, 278, 279, 280, 502, 512, 513, 514, 517, 519; Photo Gaële Abécassis: p. 34; Photo Béatrice André-Salvini: p. 39; Photo Françoise Demange: p. 270; Photo Marcel Dieulafoy: p. 115; Photo Philippe Maillard, p. 376 (top); Photo Ministère des Affaires étrangères et euro-péennes, p. 7; Photo L. Nehmé, p. 125; Photo RMN (Institut de France) / Gérard Blot, p. 113, 493; Photo RMN / Christian Larrieu, p. 87; Photo RMN / Daniel Lebée, p. 175; Photo RMN / Franck Raux, pp. 129, 130, 134, 190 (top); François Villeneuve (drawing): p. 125; Thierry Renard, pp. 474, 475

**Riyadh**
King Abdulaziz National Library, p. 522; King Fahd National Library, pp. 500, 501; King Faisal Center for Research and Islamic Studies, p. 520, 545; 2010 Humberto da Silveira: cover photograph, pp. 32–33, 136–137, 158, 170–171, 208–209, 262, 266, 273, 275, 299, 300–301, 308–309, 310, 364, 367, 372–373, 380, 389; Abdul Majeed Khan, pp. 159, 160, 161, 162, 163, 165; Saudi Commission for Tourism & Antiquities, cover, p. 54, 58–59, 62–63, 66–67, 69, 90, 99, 118, 126–127, 132–133, 138, 140–141, 145, 149, 151, 152, 153, 154, 155, 156, 157, 168, 169, 172, 192, 193, 194, 195, 196, 197, 198, 199, 200, 201, 202 (top), 203, 204, 205, 206, 207, 227, 230, 232, 234, 235, 237, 238, 239, 241, 243, 244, 245, 246, 247, 248, 249, 250, 251, 254, 255, 256, 257, 260, 261, 281, 282, 283, 284, 285, 306, 307, 318, 319, 320–321, 322, 323, 324, 325, 326, 327, 328, 329, 330, 331, 332, 333, 334, 335, 336, 337, 338, 339, 340, 341, 342, 343, 344, 345, 346, 347, 348, 349, 350, 351, 352, 353, 354, 355, 356, 357, 358, 359, 360, 361, 362, 363, 367, 369 (top), 370, 371, 374, 382, 383, 384, 385, 386, 393, 394, 395, 396, 397, 398, 402, 403, 420, 421, 431, 432, 443, 444, 445, 446, 447, 448, 449, 450, 451, 468, 469, 476–477, 486, 503, 504, 505, 506, 507, 508, 509, 510, 511, 515, 516, 518, 521, 535, 537, 539, 541, 542–543, 583, 584 (photo retouched by Humberto da Silveira); Said F. Al-Said, p. 264, 265, 266, 267, 268; SCTA / UNESCO: p. 38

**Venice**
Museo Civico Correr, p. 559

**Washington**
Library of Congress Geography and Map Division, p. 47

DR: pp. 34, 77, 88, 94, 107, 109, 117, 146, 150, 190 (bottom), 216 (bottom), 217, 225, 269, 314, 315, 316, 377, 380, 400, 401, 428, 435, 437, 438, 439, 440, 441, 462, 467, 475, 483, 485

Legal deposit: October 2012
Printed in Italy (European Union)

Photoengraving by Quat'Coul (Toulouse, France)
Printed by Grafiche Marini Villorba (Italy) in September 2012